FANTASTIC MAN

FANTASTIC MAN
Men of great style and substance

A compilation of portraits, profiles and other treats
from the fantastic gentlemen's journal

Edited by EMILY KING

Contents

Page 1– 568

CONTENTS

Celebrating FANTASTIC MAN's tenth anniversary, this book is a selection of some of the most engaging, surprising, and amusing interviews, profiles and portraits that have appeared in the magazine so far. This anthology also makes available a wealth of material from the biannual's rare early issues. Also, for your delight, it includes four chapters of particularly special material plucked from the FANTASTIC MAN archive. As with the magazine itself, the book offers a strikingly straightforward view of modern men and modern times. The lengthier profiles have been reprinted here in their original form so it's entirely possible that some subjects have changed jobs, cities, partners, etc. since they were originally published. For the reader's convenience, the subjects are in no particular order.

CONTENTS

Foreword

The esteemed photographer and artist
INEZ VAN LAMSWEERDE on the merits of
having a clear point of view.

GERT and JOP first talked to us about FANTASTIC MAN back in 2004. Whenever they were in the same city as me and VINOODH we would meet, usually over lunch, dinner or tea, and talk for hours about what was missing in men's magazines. They were searching for something that wasn't already there — defining a gap and working out how to fill it. I remember us looking at the 1970s magazine AFTER DARK, which we liked for its playfulness and nonchalance. We talked about the ease of the men in that publication, their spontaneity and also the almost-unfinished look of the layout. Inspired by that magazine and others like it, FANTASTIC MAN has created a new understanding of glamour through its off-centre, off-beat way of portraying men. It has a sense of freedom that feels joyful and it has no fear of ambiguity. On its pages, men can look slightly feminine, or you might just see the back of a head. For a photographer, this allows certain sensitivities — it creates the possibility for all sorts of undertones, which is what VINOODH and I love about working for the magazine.

I think it's particularly clever the way that GERT and JOP have created a clash between a spare — and to my mind, quite retro — layout, and the freedom of their content and the way they portray men. Even after all the meetings we had, that still surprises me. It is the most genius way of tackling a men's magazine, because in formal terms it speaks to a male audience, but the imagery and the writing bring a playfulness and lightness to it. And while other magazines rotate celebrity covers, JOP and GERT manage to find different kinds of personalities — people that you wouldn't expect to have press at that moment. FANTASTIC MAN and its sister magazine THE GENTLEWOMAN are able to be intellectual, while still being beautiful and beauty-focused. It is the perfect combination.

From its underground beginnings, FANTASTIC MAN has become one of the most admired and referenced men's magazine around. I think it opened the door for a lot of other magazines and brands in terms of constructing a singular point of view. I can't name names, but there are many people who have based their career or even their life upon it! In this age, when one can find everything on the internet and there is such an overflow of images, it is so important to have a point of view from an editor. GERT and JOP have created a taste and a voice, directing us to who, and what, we should be looking at. FANTASTIC MAN has been particularly brilliant in positioning itself incredibly clearly. While most men's magazines generate energy from talk of sport or money, FANTASTIC MAN has an optimistic masculine energy of its own.

Like FANTASTIC MAN's editors, the photographer INEZ VAN LAMSWEERDE was born in the Netherlands. She believes this means they share a certain Dutch directness and a tendency to question, tempered by underlying enthusiasm. Living in New York, she works in partnership with her husband VINOODH MATADIN, also of Dutch descent, who was the cover star of FANTASTIC MAN issue nº 6.

Fantasticness

FANTASTIC MAN's editors GERT JONKERS
and JOP VAN BENNEKOM discuss the
magazine's origins and evolution with
EMILY KING

Men's magazine publishing can be divided into two periods: BFM (before FANTASTIC MAN) and AFM (after FANTASTIC MAN). In writing this, I'm well aware of the hyperbole — but what would a piece about FANTASTIC MAN be without a touch of its trademark overstatement? A couple of years after Dutch publishing duo JOP VAN BENNEKOM and GERT JONKERS launched FANTASTIC MAN in 2005, there was barely a men's journal out there that hadn't absorbed some of its tropes. The magazine's elegantly spare typography — in particular its use of the typefaces ENGRAVERS GOTHIC and TIMES NEW ROMAN, its guileless photographic style, its arch formality — characterised by the title "Mr." — and its extravagant copy became ubiquitous in publications and websites that were targeting fashionable men.

I came to FANTASTIC MAN via its art director and co-editor JOP's previous publications, namely RE-MAGAZINE and his breakout collaboration with GERT, BUTT. As a graphic design historian, I was drawn to their work by its form, but I was soon absorbed in its content. Although I can't pretend to have been a devotee of men's publishing beforehand, I found the rambling and intimate conversations in FANTASTIC MAN unexpected and fresh. I remember being particularly taken by GERT's interview with the tailor THOM BROWNE in the first issue (reproduced in this book). When during the interview Mr. BROWNE admitted to feeling as if he were on a date, I knew that something special was afoot. The context was ostensibly that of a lifestyle magazine, but these men were not selling anything, save perhaps each other.

It is hard to remember that FANTASTIC MAN was initially conceived as a reaction against the prevailing trends. Explaining the initial impulse, JOP says, "there was a point in the mid '00s when the male models were getting younger and younger, and skinnier and skinnier. We couldn't connect with the models and men represented in existing men's publications. We thought, 'let's make a new set of rules, starting by breaking existing ones.'" Likewise, GERT remembers that "fashion for men had become a catwalk fantasy. There were no magazines that covered real men, or grown up men. FANTASTIC MAN was very deliberately an older proposition." According to JOP, "the first issue of FANTASTIC MAN was really a pamphlet of our intentions, printed almost entirely in black and white to make clear how different our proposal was," he says. "We went to war, armed with the idea that we didn't want any more objectified boys in high fashion any more. We wanted real men in real clothes."

JOP and GERT's first professional encounter was in 1997 when GERT interviewed JOP about RE-MAGAZINE, a publication that began life as JOP's graduation project at the Jan van Eyck Academy and ran for 12 issues. The early editions of RE- focussed on ordinary but noncommercial themes, such as boredom or reconnecting with one's past, while subsequent numbers revolved around

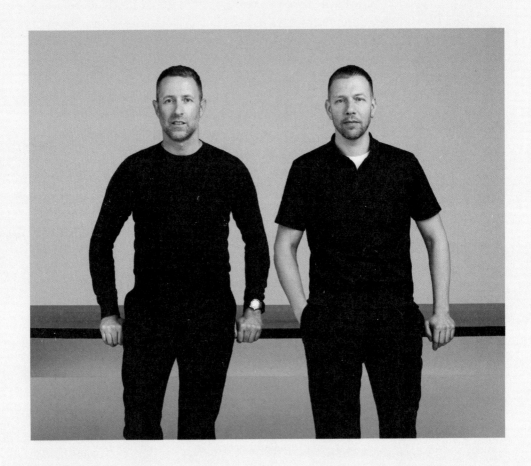

Founders and editors GERT JONKERS (left) and JOP VAN BENNEKOM (right), photographed by
THOMAS LOHR, were coincidentally born just 22km from each other in the Gelderland province
of the Netherlands.

a single person per issue, all of whom were semi-fictional, except for the last subject, a real thirty-something depressed woman. "I was attracted to RE- because it was so realistic and direct, but it was also completely strange. It was about mundane subjects, yet it was very outlandish and somehow it didn't feel at all contrived," remembers GERT.

At that time, GERT was editing the Dutch style magazine BLVD. and soon after the interview he employed JOP as his art director. Only staying at the title together for a year, by the time they left they were already planning their first joint venture, BUTT. "We came from overlapping groups of friends in Amsterdam and we wanted to make a gay magazine that actually spoke to us," says GERT. "We felt it was strange that a big part of our lives were spent in gay circles yet our work had nothing to do with that. We weren't making gay media and also there wasn't any gay media we liked, so there was a weird disconnect between our professional and private lives." Consisting entirely of Q&A interviews set in AMERICAN TYPEWRITER and sexy but open-faced pictures printed on pink paper, BUTT was an unusually warm-hearted foray into gay sexuality.

BUTT was launched in 2001 and was already thriving when the pair started the conversations that would lead to the debut of FANTASTIC MAN four years later. "We really enjoyed making BUTT, there was a realism to it that we liked, but both JOP and I were interested in clothes and the fashion world to some extent. We felt it would be interesting to make a magazine that was more about men getting dressed instead of getting undressed," says GERT.

The move from the cult territory of RE-MAGAZINE and BUTT to the fashion field of FANTASTIC MAN was audacious. "We completely bluffed our way into the fashion system, and from Amsterdam of all places!" says JOP. "When we launched FANTASTIC MAN we were quite naïve. We didn't under- stand why fashion and lifestyle magazines were so predictable. Of course it has to do with the way that media and PR works. It's a system that encourages everyone to feature the same products and people at the same time." Aiming to resist that influence, FANTASTIC MAN tries "to catch people when they are not topical — to find them at a moment when they don't have something to sell and are a bit more vulnerable." Not so much a consumer magazine, FANTASTIC MAN was conceived as an oversized fanzine that devoted to modern men.

JOP and GERT were both over 30 when they launched FANTASTIC MAN, and their age was significant. "Fashion becomes different at that point. For one thing it becomes financially viable for the first time," says GERT. "We really had the feeling that the fashion industry had the wrong idea about menswear, espe- cially back then, because grown-up menswear isn't the kind of thing that changes every six months. Men who spend money on clothes gravitate towards a certain personal style. I think that one of the best things you can achieve as a man is finding your own style and being very comfortable in it.

"We like to show things you actually would or could wear, but that might challenge you," says JOP. "Every issue we try to think of new ways of going about that task. We want to avoid the convention of the fashion shoot: put a model and a fashion photographer in a studio with no purpose other than to shift clothes and fashion credits." The photographic staple of FANTASTIC MAN is a full-length image of a man who confronts the reader face-on and is wearing, if not his own clothes, then something closely approximate. "We love the whole idea of personal style and people being just fabulous," says JOP. "We show men presenting themselves, which is quite different from models posing. With every shoot there is a clear editorial idea. We always aim to communicate a point of view."

FANTASTIC MAN's distinctive photographic style is matched by its very specific tone of voice. As GERT puts it, "JOP and I aim for images that are direct and unfussy, and to an extent we want that in the text too, although you could say that FANTASTIC MAN likes a fussy word here and there". Explaining the hyperbolic form of address that was particularly prominent in early issues of the magazine, he continues, "we were inspired by the copywriting of the '60s and '70s: single page ads with a lot of text on them that have this quite beautiful way of talking around whatever they are trying to sell, whether it was cigarettes, or perfume, or underwear." JOP agrees: "We loved to find sentences such as 'today's man demands elegance and style'. It's consumer language, of course, but it's from a long time ago, so it feels slightly eccentric. I admit that when I look back at the first issues the tone seems really outlandish — I am even a little embarrassed about them because they are so GUSHING. Everything is CHARMING this, or DELIGHTFUL that!" GERT councurs: "I think it was more put-on in the beginning, and I hope that the language has become closer to our natural voice instead of a construction. It has evolved via the people we've worked with, too. CHARLIE PORTER has a different voice than, for instance, ISAAC LOCK or MARK E. SMITH, the people we are working with now."

Among the constant features of FANTASTIC MAN are the recommendations. Initially called "Tips" they have been promoted from the back to the front of the magazine and have changed format almost every issue, yet they remain true to their initial purpose. The aim has always been to pass useful or inspiring information from interesting men on to the reader, whether in the form of a curiously fabulous hotel recommendation (the brutalist HOLIDAY INN Sarajevo featured in an early issue) or inspired techniques for the avoidance of dull party conversation. "If the recommendations are good, they are the highlight of the magazine," says GERT.

Alongside the recommendations, another distinctive perennial is the magazine's still-life photography. This stems from longstanding relationships between the editors and a distinguished group of photographers, including ANUSCHKA

BLOMMERS & NIELS SCHUMM, MAURICE SCHELTENS & LIESBETH ABBENES and ZOË GHERTNER. As with the exuberant yet formal headlines, these images often have an extravagance that hints at nostalgia, particularly those that appeared in the early issues. "The spread of cameras and lenses from the first issue was extremely referential. We were going back to the idea of celebrating photography and that's something we've returned to again and again," says JOP, "We are always exploring how ideas from the past might hold up in the present."

Conceiving of the form of FANTASTIC MAN, JOP and GERT compiled a folder of visual references and used it as a starting point for discussion with a few trusted mentors including the photographers INEZ VAN LAMSWEERDE & VINOODH MATADIN and the stylist JOE McKENNA. JOP remembers the folder's contents including, "a lot of SCAVULLO photographs and a box of CHANEL MONSIEUR soap, and some newspaper clippings, demonstrations of rule lines and sans serif typefaces." "We were looking at newspapers from the '60s and '70s where they would use sans serif typefaces, but they were set in lead so they had a bit of a wonky feeling about them," he says.

One of the first things that JOP created for the magazine was its logo. "When I put the words 'Fantastic' and 'Man' underneath one another in TIMES NEW ROMAN it felt so right," he says. The format of FANTASTIC MAN took JOP far from his design education in the Netherlands. Whereas Dutch typography tends to be ranged left and suggestive of democracy, that of FANTASTIC MAN is centered and touches on classicism. More than that, whereas most Dutch graphic designers are ardent advocates of egalitarianism, FANTASTIC MAN ventures into the arguably elitist territory of fashion. For all his centering and his love of style, however, JOP is true to his Dutch roots in his desire to be direct. "We want to communicate," he says. "The reason there are so many graphic designers in the Netherlands is that there are so many Dutch people who want to make things clear!" "Over time we became more text heavy — more serious, in a way," he continues, "we found it very interesting to create a magazine that is most definitely for readers — it's almost an anti-magazine in terms of proposition."

Looking back, JOP and GERT recall the sense of getting a grasp of the magazine by the third issue. "That was when we thought, OK, we know how to control the process of how images and texts are coming together in a really specific way," says JOP. FANTASTIC MAN's look was and remains very distinctive, yet the magazine has not been held in a formal straightjacket. "The rules that we invented way back in those first few issues, we're still toying around with them, bending and breaking them," says GERT. An issue-by-issue tour through FANTASTIC MAN would demonstrate that the design has shifted each time, yet most people looking at the magazine are struck by its visual consistency. JOP explains, "I don't want to reinvent the magazine every issue — I think it should be a continuation."

A family tree of magazines, from top to bottom: the cover of the first issue of BUTT, 2001; three covers of RE-MAGAZINE, 2001–2004; the cover of the debut issue of FANTASTIC MAN, 2005, followed by two spreads of the issue; the cover of the very first issue of THE GENTLEWOMAN, 2010.

FANTASTIC MAN is associated with a certain style of text, image and layout, but above all, it is a set of subjects. Every issue of the magazine includes a number of extended profiles, the bulk of which come from a talented set of regular contributors including former Deputy Editor CHARLIE PORTER as well as TIM BLANKS, PAUL FLYNN, ISAAC LOCK, CAROLINE ROUX, ALEX NEEDHAM and SUSIE RUSHTON. Asked what makes a man fantastic, JOP says, "A lot of times our subjects are close to us: people whose work we like, people we know. We always feature men who we think are fantastic ourselves." As the magazine has become better known, so have some of its subjects. Exciting though it can be to work with the famous, the process is not unproblematic. "It can be hard to work with celebrities," says JOP. "We already set ourselves so many conditions, it's very difficult to deal with celebrity PRs setting conditions as well."

In 2010 FANTASTIC MAN was joined by a sister publication, THE GENTLE-WOMAN. Believing that a magazine for women should be a magazine made *by* women to get across a woman's point of view, they employed the editor and curator PENNY MARTIN to steer the publication. The magazines may not overlap in terms of subjects, but they do have strong common interests and their influence on each other is apparent. Notably, THE GENTLEWOMAN was on first name terms with its subjects from the start and recent issues of FANTASTIC MAN have taken the same license.

"JOP and I are still involved in the magazine to the point of ridiculousness," says GERT. "That's the magic of FANTASTIC MAN: everything is considered on a very detailed level," adds JOP. "When someone new joins our team, that's when we are reminded that we're doing something very particular, and that we have a very specific frame of reference. I head the design team, but I do get involved with all things textual. Likewise, GERT will be the one taking photographs in Milan that might inspire an entire fashion shoot. We are all constantly having a dialogue — we often have detailed discussions about a single feature that last a whole afternoon."

The fruits of those long afternoons are celebrated in this book. On the following pages is a distillation of ten year's worth of images and text that propose a particularly unabashed form of masculinity. Between them, the magazine's photographers, stylists, writers and subjects have determined the course of men's style and substance over the last ten years. The book's index is a roll call of influence.

EMILY KING is a design writer and curator based in London, with a specialism in graphic design. She interviewed graphic design legend WIM CROUWEL for issue n° 3, her first contribution to FANTASTIC MAN of many. EMILY has edited books for PETER SAVILLE and M/M (PARIS), and now this FANTASTIC MAN bible.

Chapter 1

Page 18-149

David
Alexis
Cerith
Helmut
Peter
Ewan
Thom
Fergus
David
Rem
Rupert
Tyler
Carlo
Moses
Raf
Russell
Hamish

Mr. DAVID WALLIAMS
Featured in issue n° 12 for Autumn and Winter 2010
Portraits by Alasdair McLellan
Text by Charlie Porter

Mr.
WALLIAMS

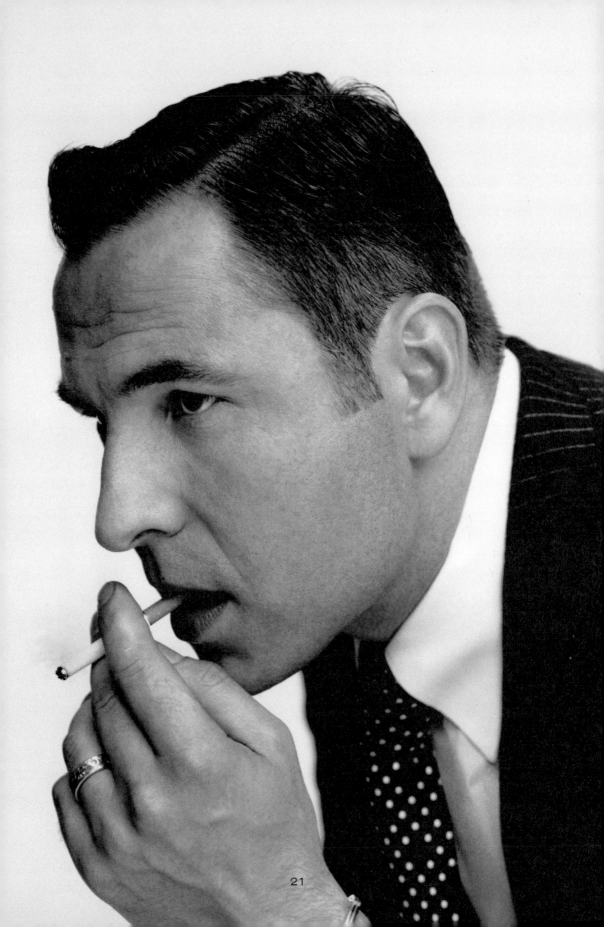

Best known for the comedy television show LITTLE BRITAIN, Mr. DAVID WALLIAMS is one of the most celebrated names in the United Kingdom, as famous for his often-grotesque television appearances as he is for his increasingly dapper personal style. Gregarious and charming in real life, Mr. WALLIAMS is a willing participant in the London social scene, tabloid reports of which only serve to further pique the curiosity he arouses. He is a fan of the products of the APPLE company of Cupertino, California. His prompt and courteous replies to personal emails are always tailed by the words "Sent from my iPhone," or more recently, "iPad".

Right now it's an exciting time to be Mr. DAVID WALLIAMS. "I'm happier than I ever remember being," says the 39-year-old British comedy actor. Two causes of this happiness are the near completion of a new series for British TV and his recent marriage to the model Ms. LARA STONE. "Being married, for the first time in a long time you feel like your life is going somewhere and you can make plans for the future. I rarely ever thought more than a few months ahead. When you're married, you think, when shall we have children? Shall we do this, shall we do that? You feel like your life has begun."

Mr. WALLIAMS is the sort of celebrity who makes no distinction between high and low culture, and his professional and personal life is testament to this. His television work, the best-known example being the sketch show LITTLE BRITAIN, is both popular and populist. He says critics consider it "lowbrow". Because of its success, Mr. WALLIAMS is one of the most famous men in the United Kingdom, and he and his comedy partner, Mr. MATT LUCAS, are responsible for catchphrases that have since entered common British parlance: "I'm a lady," "Computer says no," "Yeah but, no but."

Yet as his fame has developed to mass proportions over the past decade, DAVID has revealed himself to be a man of debonair aspirations and particular taste. While his TV characters are purposefully vulgar and indulge his desire to dress in women's clothing, his everyday attire has become increasingly dapper and luxurious. DAVID, tall and broad, is a loyal client of Mr. TOM FORD, who has become a personal friend. In his years as a single celebrity out on the town, the tabloids regularly printed paparazzi shots of DAVID in TOM's clothes, accompanied by a new flame, usually outside sophisticated London restaurants such as SCOTT'S and J. SHEEKEY.

DAVID met his wife in the summer of 2009 in the bar of the CONNAUGHT hotel in Mayfair. "We were both out with separate friends, but I know someone who works for her agency. She introduced me to her, then we talked a bit that night, and then I asked my friend if she could ask LARA if I could have her number. Then we went on some dates."

LARA is Dutch-born and has spent her adult life in New York and Paris. "She didn't know I was on TV," he says. "But I knew who she was because I'd already seen her in magazines. I'd noticed how beautiful she was."

Because LARA was initially unaware of his celebrity, DAVID says he could pursue her in a normal way. "The thing with her was that she was always jetting off, because her job means that she can sometimes be in three countries in the space of a week. Often we'd have a date and the next day she'd say she had to fly to New York, and I wouldn't know if it was true or not. I have low self-esteem, and I just assumed that she didn't want to see me."

DAVID and LARA were engaged in January of this year, and their marriage took place this summer at CLARIDGE'S, the establishment hotel that played an important role in their courtship. "We had had a fun date at CLARIDGE'S," he says, "so it felt that was a really nice place to get married, because it was a special place for us. I really enjoyed it. You know when people renew their vows? You read that MARIAH CAREY renewed her vows, and you think, what? Now that I'm married, I think, yeah, I'd like to get married again next year to LARA, it was so much fun."

We have met at DAVID's home in Chalk Farm, north London, on a Thursday evening. It is 5pm and DAVID has just finished work for the day. His current routine is to keep office hours at his basement kitchen counter with his colleague MATT to finish the first draft of the new series in time for the scheduled rehearsals. So far, they have completed five and a half episodes of the required six. MATT has left already. LARA is in New York, where she has just been announced as the exclusive face of CALVIN KLEIN.

DAVID's house was once a notorious landmark, as the owner before last was Mr. NOEL GALLAGHER of OASIS, who installed a stained-glass window above the door with which to name it SUPERNOVA HEIGHTS. The owner in between was Ms. DAVINIA TAYLOR, a socialite and toilet-roll-fortune heiress. She removed the stained glass. Mr. WALLIAMS bought the house from her in 2005 and entirely redecorated the place. "I wanted it to be luxurious but minimal. You know the TOM FORD book?" he says. "I hadn't met him at that point, but in the book there's a beautiful picture of his house, and I said, can it be like that please?"

One of the most dramatic changes was to knock through the basement ceiling at the front of the house to create a double-height dining space. "It took me a lot of convincing that it was a good idea," he says. "I thought, why would you get rid of a floor? But now I love it."

This pale-grey, lower-level space is entirely open-plan, with handle-free kitchen cabinets running down one wall, a square cluster of sofas at the other end and a giant flat-screen TV on the opposite wall. The house is on a hill, so the garden is at the same level as the back of this basement floor, behind floor-to-ceiling sliding glass doors.

"I suddenly became able to afford it," he says, "mainly through DVD sales of LITTLE BRITAIN. We only got a small royalty, but it sold so many copies, something like two million. I thought, I've got to do something substantial with it. It was one of those moments in life when it comes together and you have that good fortune."

The new series they are working on is their first with entirely original characters since they piloted LITTLE BRITAIN as a radio show in 2001, before it made the transfer to television. This new show has the working title COME FLY

WITH ME and is to be broadcast on BBC1 by the end of the year. "It's about life in an airport," DAVID says. "It's halfway between a sitcom and a sketch show, all set in an airport. Of course, when we started writing we hadn't thought about filming it in an airport, which with all the security is probably the worst environment to film anything."

Their comedy is character-driven, with much emphasis on the peculiarities of speech. "When I write," he says, "the happiest I am ever is when I've written a phrase that someone would actually say. We had this line about someone making tea and they went, 'It's just TYPHOO, I'm afraid.'" (TYPHOO is a mediocre British tea range. Today, DAVID has made us tea with leaves bought from the Mayfair store FORTNUM & MASON.)

"It's exactly what someone would say," he continues. "It's quite hard when you're trying to tell jokes and you've still got to reflect how people would speak. I'm satisfied when we do something that's got some kind of truth in it."

It is indeed a surprise, the amount of hard graft needed to create a TV series. "Most of our lives is the writing of it," he says. "We'll write for six to eight months and we'll only film for six weeks. People never think about the writing. They say, 'Do you write in advance or do you just turn up on the day?' They can't think that the writing would be a job or would take up time."

There is a nostalgia for the discipline of 20th-century British comedy in their work, and it extends to DAVID's own friendships. This evening he was meant to have dinner with the CARRY ON actress Ms. BARBARA WINDSOR, but she had to postpone. He tells of introducing LARA to BARBARA and the comedy she represents. "LARA and I were about to have dinner with BARBARA and her husband, so before we went, we sat down and watched CARRY ON CAMPING," he says. The film includes a quintessentially British visual joke: BARBARA's bra pings off while she is exercising in a campsite. "LARA really enjoyed it."

Because Ms. WINDSOR has postponed tonight's dinner, DAVID has the whole evening free, so we set off for a stroll. Before we leave I ask if I can use the bathroom. By the sink there's a DIPTYQUE candle, hand wash by JO MALONE, and a pile of clean, folded white towels. On one of the walls is a series of four framed portraits of the singer MORRISSEY. The images are relatively recent and look as if they were shot in Los Angeles, the singer's adopted home. On the opposite wall is a framed MORRISSEY album sleeve that has been signed by the singer. In large marker pen, it reads: "WALLIAMS. WHY?"

Primrose Hill is a neat little park, sat on the first ridge that rises from the flatness of central London. We approach it from the north side, where it seems like the green of a village, and then come over its crown to see the full breadth of London reveal itself. DAVID points out dogs and babies. We sit down by the Regent's Canal and talk about clothes and shopping. "For me, it's one of the greatest

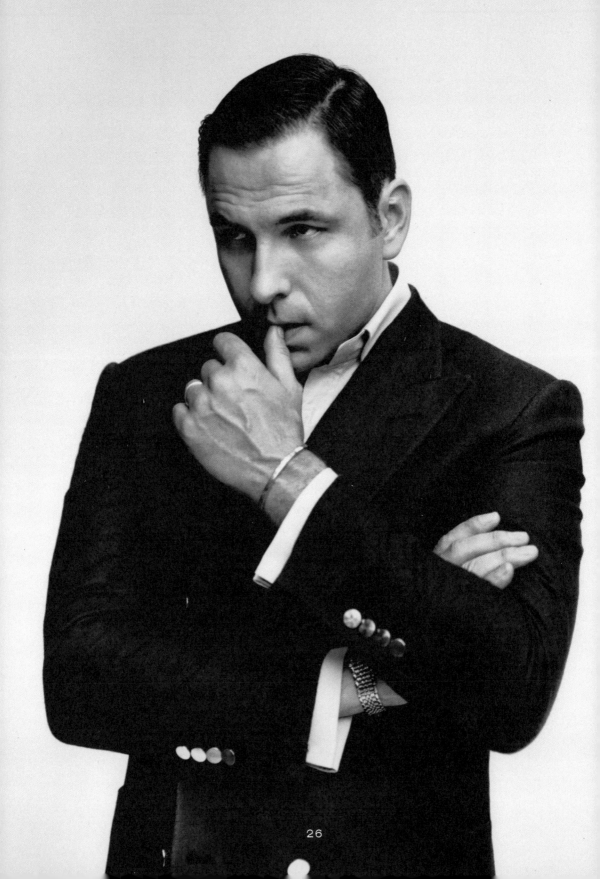

pleasures in life," he says, and then corrects himself. "Not one of the greatest pleasures, but it's a very enjoyable thing to do. It's a good thing if you've got low self-esteem, or if you're upset about something, it does make you feel a lot better. You're also looking forward to your life when you buy clothes, because you think, it'll be lovely to wear this suit when I go out for dinner. It's optimistic, isn't it? In a really nice way."

Today DAVID is wearing TF001 jeans by TOM FORD and also a TOM FORD polo shirt. He got married in a TOM FORD suit, and TOM was a guest at the ceremony.

"LARA refers to him as my boyfriend," DAVID says, "because I'm always talking about him and his clothes, putting on his perfume and everything like that. She'll say, 'I saw a nice photo of you and your boyfriend.' I'll show you a nice picture of me and him at our wedding."

DAVID gets out his iPhone and scrolls through what seems like hundreds of images. He lands on a picture of himself with TOM FORD. "He looks so great." He puts the phone away.

DAVID's build means there is much fashion he cannot wear, and he has participated in many endurance events that have maintained his frame. In 2006 he swam the English Channel and in 2008 he swam the Strait of Gibraltar. Earlier this year he cycled the length of mainland Britain. All these endeavours were for charity.

I ask him if he was always this size. "Yeah, big guy," he says, and involuntarily brings his lips together and makes a smacking sound. There is a pause. "Think so, yeah. I was fat as a child. I weighed more at 15 than I do now. Then one summer I decided to lose some weight and kind of managed to stay relatively not fat. Yeah, but some people... I'm a MORRISSEY fan. Look at him in THE SMITHS. He was skinny. But he's quite beefy now. He still looks good though. In my toilet did you see he'd signed an album cover?"

I say that I did.

"I don't know what he means. But it's quite good. It's quite dismissive in quite a good way. Why is your name that? Why do you exist?"

His name is a pertinent matter, since DAVID WALLIAMS was actually born DAVID WILLIAMS but had to change his name when he became an actor because there was already a DAVID WILLIAMS working in the trade. He was born in Surrey, a county to the south of London.

DAVID was a childhood SMITHS obsessive, and one of his favourite MORRISSEY lyrics is from the song ASK. "'Writing frightening verse to a bucktoothed girl in Luxembourg.' It's a really funny line, isn't it?" He repeats it again to himself. "I really wanted to meet him, and a couple of friends of mine had."

His friends, comedian Mr. RUSSELL BRAND and television presenter Mr. JONATHAN ROSS, eventually arranged a meeting—they went for dinner at

ROSS' house. "MORRISSEY picked me up in a black taxi," says DAVID. "So I got in the taxi and I was sat opposite the person I've loved for 20 years. And it was that thing in a taxi when knees are touching and stuff. It was so overwhelming to be in that situation with him. JONATHAN has a couple of pigs in his garden and MORRISSEY saw the pigs and said, 'Two of them that have been saved...' I like still being a fan."

Does he enjoy meeting the people he admires?

"I do," he says. "Well, who wouldn't? It's fun. It's really, really thrilling. It's a great opportunity. I guess you must love it. I don't know if you do."

A barge full of people and loud music comes into view on the canal. The cluster of people on its deck realise who it is on the bench looking at them. Some wave. "How are you doing?" DAVID calls out. The barge moves on. When it is about 100 metres in the distance, a man shouts back.

"CONGRATULATIONS ON YOUR WEDDING!"

"THANK YOU VERY MUCH!" replies DAVID, and then to me: "See, waits till he's a bit too far away."

From around the side of the barge emerges a stream of canoes heading in our direction. It looks like some sort of adult learning group. One of the canoeists paddles over to another and whispers to him, in a voice we're probably not meant to hear, "It's DAVID WALLIAMS." I ask if it's strange when people have conversations about him in his presence. "It is quite strange," he says. "I actually think it's nice to greet everyone warmly, because they think they know you, so you should greet them like you know them, too. It's nice to be nice to everybody. I'd get excited if I saw someone off the telly if I was in a canoe."

Although most of the canoeists have gone past and are waiting in the distance, some are lingering in front of us, including the man leading them. "He's showing off now," says DAVID. "Going backwards."

I say it's like a peacock display.

"What, going back? Yeah, look. Look! 'I know you're on TV, but I can paddle a canoe backwards, so fuck you.'"

Eventually, the canoeist heads off on his way. The light is beginning to fail, and the temperature has dropped. "Are we going to go somewhere else now?" says DAVID. "Let's go to the pub."

We have taken a table at THE ENGINEER, a public house just north of the canal. DAVID has ordered half a shandy and sea bream with a rocket salad on the side.

Does being happy adversely affect his comedy?

"Not really," he says. "I don't need to be miserable to make comedy. I think as a child if you liked to spend time on your own, you're more likely to develop a kind of creative sensibility. Instead of going out and playing football, I was on my own doing voices and characters. That's how that part of my brain developed.

The desire to make people laugh started then."

When the food arrives, DAVID orders another shandy. "I think with comedy what you've got to be careful of is that it's often like a remove," he says. "I might say something nice to somebody, like my wife, and then make a joke. I don't always have to make a joke. It's like a defence against something that might be real somehow. You know what I mean? Like if you could only say 'I love you' in a funny voice." When he says those three words, he does so in a high, snide tone to prove the point. "It's not really engaging if you want to make a joke out of everything. It's a thing to be quite wary of. I know some comics and everything they say is a funny comment, and I really feel like saying, 'I want to get to know you; I want you to reveal something of yourself.'"

I say I couldn't imagine LARA putting up with that because she's so direct. The one time I've met her was in Paris at the end of the womenswear shows in 2008, when she joined a group of us last stragglers celebrating the end of the season in an Irish bar. She listened to what was said forensically, and then commented freely on what she had heard. She was very funny, very frank, and unafraid of voicing her opinions.

"She was drinking then," says DAVID. "She doesn't drink anymore. I never met her when she was drinking." LARA has spoken publicly about battling alcoholism and how not drinking has transformed her. "She's a great person. She's great. I would recommend marriage. After being married for less than a month, people ask, 'How's married life?' Three weeks in, it's wonderful."

Did he always want to get married?

"I think girls definitely think about their wedding day when they're younger," he says. "They think, what am I going to wear, and things. I don't think men do that. Men often think it'd be nice to be married, but they don't dream of their wedding day. It was something that I wanted but not something I thought was going to happen anytime soon. I think you get to a certain age when you're dating people and you think, this isn't going to become serious, and you get out of it because you're looking for something much more permanent now. Then sometimes things just fall into place."

His first girlfriend was called KATY CARMICHAEL; they met at university. "I didn't really have a girlfriend until I was 21, so I was quite scared of girls. KATY and I were friends and we ended up going out together for four or five years, and I thought, oh, okay, this is what it's like to have a girlfriend. It's nice. I love her. So, um, I got over it." It was with KATY that he first experimented with cross-dressing, which he says was attention-seeking, because both were aspiring actors. He says he gets any dressing-up urges out of his system on TV now. I'd earlier asked him if he'd heard the rumour that both he and LARA were going to wear dresses by Mr. GILES DEACON at their wedding. He said he hadn't. (On

the day, LARA wore two couture dresses by RICCARDO TISCI for GIVENCHY.)

"The experience of being well known — that changes everything as well, because people respond to you in a different way," he says. "When MATT was asked what it's like to be famous, he said, 'You get to have more sex with better-looking people.'"

We laugh.

"Your confidence grows as well. Definitely, if you're successful, you're more confident. Those things that were holding me back weren't holding me back anymore."

Did he enjoy organising the wedding?

"It's a really good test for being married," he says. "Because you've got to make a hundred decisions together, and you've got to agree on things, things that seem trivial but when you put them all together they're important. It's a lovely process, wooing somebody. It's weird when you're married to someone; you look back to the time when you didn't really know her well and you're going on tentative dates and wondering if you'll have enough to talk about."

Our meal is finished; the plates are taken away.

"If I think back to a year ago, it's quite odd."

We finish our drinks and then leave the pub to go back to his house for a cup of tea. We sit at the end of the kitchen counter again, and DAVID serves sweet pre-popped popcorn from a local deli called MELROSE AND MORGAN. We get through two tubs. We end up watching the two most recent full-length videos by LADY GAGA on his laptop. I use the bathroom again, and when I come out DAVID says LARA is calling from New York, and so it is time to leave.

A month later we meet for breakfast at THE WOLSELEY, a chic restaurant on Piccadilly where DAVID is a regular. He and LARA have just got back from a weekend in Nice, in the south of France, where they had dinner with Sir ROGER MOORE and his wife. DAVID shows me pictures on his new iPad.

We talk about LARA's work. "I like that she's in the more arty fashion side," he says. "She doesn't really do cheesy stuff. She works with people like STEVEN MEISEL, the guy who shoots for Italian VOGUE. She's always in more interesting pictures than just pretty ones. And also, when she works with someone like KARL LAGERFELD, I want to hear every detail. What did he drink, who was he with, what did he say to you, what was he wearing? She drip-feeds me bits of information." He asks if I have heard of THE BEAUTIFUL FALL, the book by Ms. ALICIA DRAKE. "It's about the rivalry between YVES SAINT LAURENT and Mr. KARL LAGERFELD. That would be a brilliant film for me and MATT."

DAVID has appeared in some American films, most recently in this summer's DINNER FOR SCHMUCKS, starring Mr. STEVE CARELL, but he is realistic about his place in Hollywood. He says the ranking of an actor's name in

the credits is a telling guide. "When you do movies, people ask, one, two, three, four, five, what number are you? In DINNER FOR SCHMUCKS, I'm number eight. I recently did a children's film called MARMADUKE about a talking dog. I was number 14. The first ten were animals."

LITTLE BRITAIN reached cult status in the United States when it was broadcast on BBC AMERICA. Subsequently, DAVID and MATT made a series of LITTLE BRITAIN for HBO in the States, but he seems particularly committed to focusing on British comedy for his original, British audience. "Our aim is to always do jokes and laughs," he says, as opposed to comedies such as THE OFFICE or THE LARRY SANDERS SHOW that rely heavily on silent pathos. "If a scene isn't funny enough, we start to worry."

I ask how he defines himself, because "comedian" doesn't seem to fit. "I suppose I'm a comedy writer and actor," he says. "I always wanted something to hide behind. I wanted a character. But interestingly, sometimes when you play a character you can reveal more about yourself than if you are being yourself. Even if it is an evil one, having the character frees me to be more outrageous than I would normally be. In our live show I play a children's entertainer called DES KELLY who gets guys out of the audience to play this game called HIDE THE SAUSAGE." When the audience members get on stage, they soon realise, to their cost, that DAVID's character is more interested in playing with fathers than children. A video can be seen on YouTube of record producer Mr. MARK RONSON struggling to retain his composure in the face of DES KELLY. "I used to wrestle these men to the floor and pull down their trousers. If I was dressed as me, that would be sexual harassment. Weirdly, when you're dressed up it gives you licence to do it."

They have finished the first draft of the new series and are in the process of rewriting before rehearsals begin, to be quickly followed by filming. It is that blissful period when something is in the process of being created and before it is judged. "If people don't like comedy they get really angry," he says. "I don't know what it is, but if you don't make them laugh they're furious. If a horror film doesn't scare you, you'd just say it was boring. When you do comedy, all you want is to be loved, especially if people are laughing at you," he says, then stops. "Or *with* you, rather."

There is a bit of a pause. "It's interesting, that 'laughing at' or 'laughing with' thing. I was talking to LARA the other day, and I was saying that if you pretend to trip over something in the street and people laugh, they laugh with you. If you actually fall over in the street, they laugh at you. It's weird, isn't it? To be a comedian is to control people's laughter at you. It's to say to them: 'No, I'm in on the joke.'"

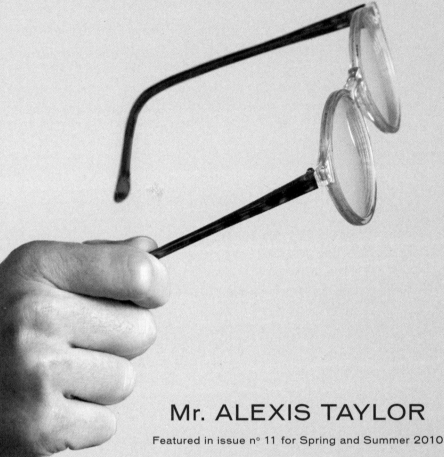

Mr. ALEXIS TAYLOR

Featured in issue nº 11 for Spring and Summer 2010

ALEXIS TAYLOR was 16 when he formed the band HOT CHIP with his school friend JOE GODDARD. On the verge of turning 30 when he was featured in the magazine, he had become a father for the first time the previous year. Writing songs for the band, London-based ALEXIS is inspired by, among others, RAYMOND CARVER, WILLIE NELSON and the Greek-Egyptian poet C.P. CAVAFY. "The emotional side of things is so much at the forefront with all these writers," he says, "I feel most comfortable saying what's most deeply felt, so there's nothing to hide behind."

ALEXIS has a high singing voice that has been described as a falsetto, although he is keen to stress its naturalness. "I have always been quite mistrustful of singers who have invented a singing voice," he says, "It was important to me that I accepted what my voice sounded like, and for a long time people didn't even know if it was a man singing. They thought it was a girl singing, and rather than being frustrated by that, I just think that if you've ended up with an androgynous tone, you may as well put everything on display." ALEXIS wore mustard trousers, a red sweater and tortoiseshell spectacles for his interview with FANTASTIC MAN and he drank jasmine tea.

Portrait by Paul Wetherell

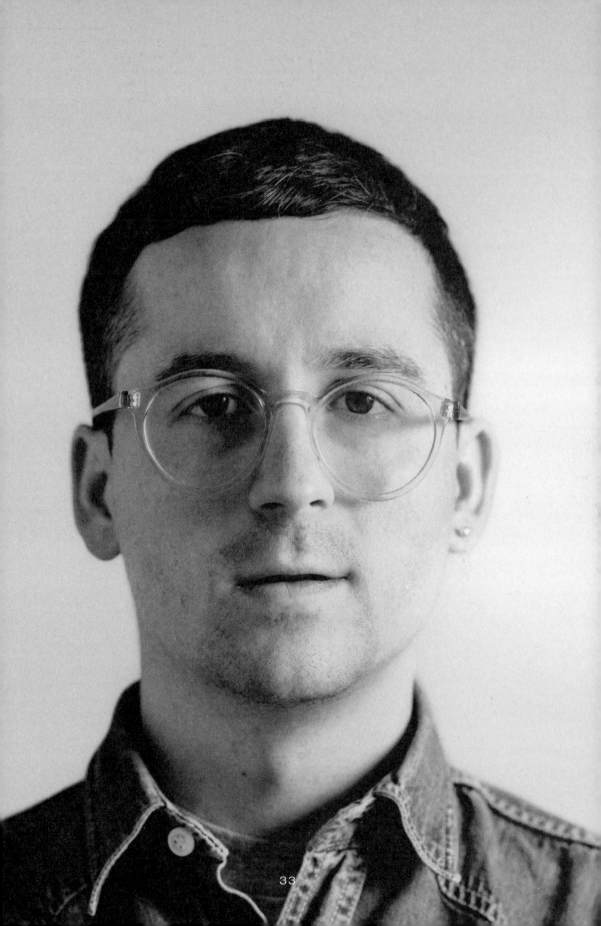
33

Mr. CERITH WYN EVANS

Featured in issue n° 2 for Autumn and Winter 2005

Very Welsh and very well-dressed, CERITH WYN EVANS was caught up in the 1990s YBA (Young British Artists) scene, despite being roughly a decade older than the cohort's best-known practitioners TRACEY EMIN and DAMIEN HIRST. In the 1980s, CERITH had studied film and video at the Royal College of Art and he has worked with the legends of that decade MICHAEL CLARK, LEIGH BOWERY and DEREK JARMAN.

Represented by the renowned London gallery known as WHITE CUBE, CERITH's solo work exhibits a knack for embracing pretention and making it delightful. Chandeliers and fireworks flash philosophical or literary titbits in Morse code — spectacles that are easy to embrace, even if they're hard to grasp.

CERITH was interviewed for issue n° 2 inside his Bloomsbury studio above a dental practice. Something of a bon viveur, he quoted LOU REED, saying, "My week beats your year." CERITH's life is calmer these days, but he remains very good company. Above all, he is among the kindest men in London.

Portrait by Andreas Larsson

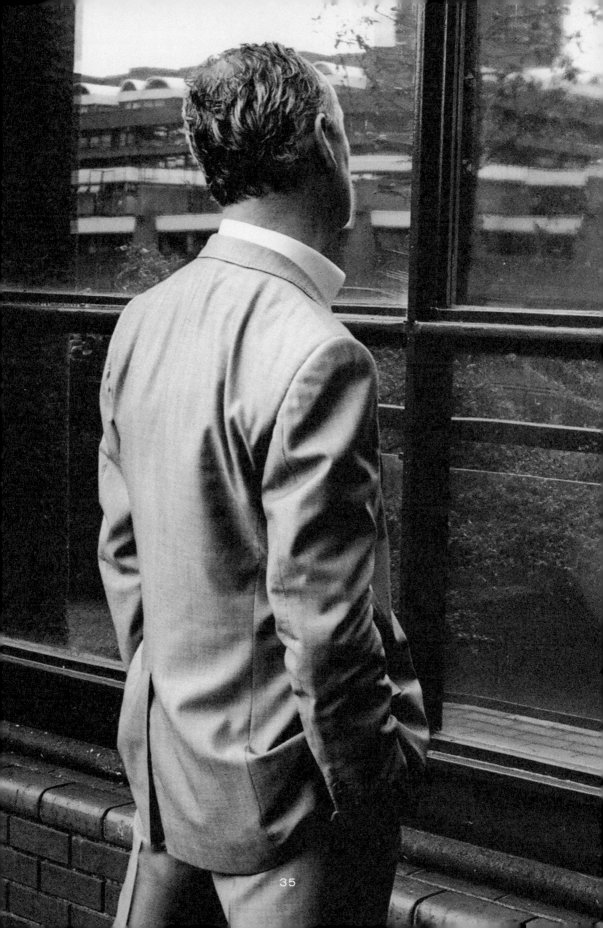

Mr.
HELMUT LANG

Mr. HELMUT LANG
Featured in issue nº 4 for Autumn and Winter 2006
Portraits by Bruce Weber
Text by Tim Blanks

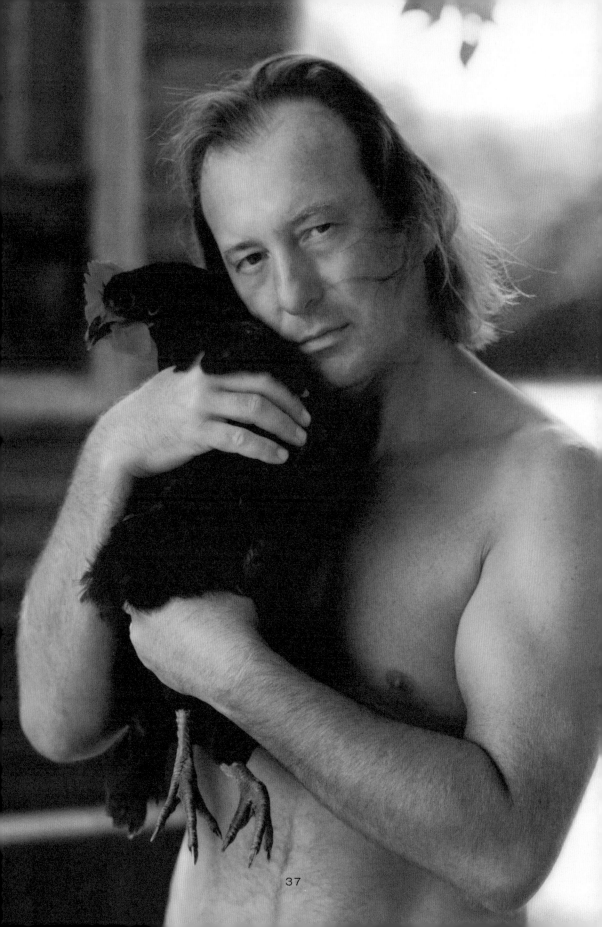

Mr. LANG may be the luckiest man alive. Since leaving his eponymous label in late 2004, the legendary designer has forged a radical new life for himself in the country. At his mid-century mark, he has his health, his wealth, his looks, his dogs and the love of a good man. And he is free.

Ten years ago, HELMUT LANG was the most influential designer in fashion, single-handedly capable of shifting the entire show calendar with his decision to present his collections in New York rather than Paris. He was the first designer to recognise the potential of the Internet, of viral marketing, of designer denim. When he signed a massive multi-million dollar deal with an empire-building PRADA, global domination seemed assured. And when the relationship went wrong, people naturally assumed that, in walking away from his company and relinquishing the rights to his own name, LANG had become one more tragic statistic in the fashion wars of the new century.

But LANG never played by the rules, he just changed them. And he's doing it again. His favourite expression might be "It is what it is."

Fashion is clearly missing that pragmatic spirit more than ever. It's not just that the Autumn and Spring collections were shot through with his sensibility. From a purely selfish perspective, "my suits won't last forever". Like he cares. Mr. Never-Look-Back lives with EDWARD PAVLICK, his partner of ten years and another escapee from the fashion world, either in their New York City penthouse or on a bucolic estate that looks out across dunes to the Atlantic. The seaside house is the most visible fruit of the PRADA deal (purported at the time to have netted LANG anything up to $100 million). It's in East Hampton, but he is quick to point out that he lives on Long Island, not in "The Hamptons", with all their connotations of excessive wealth — or mere excess.

Still, in summer 1999, LANG famously outbid JERRY SEINFELD for the property. WOMEN'S WEAR DAILY reported that LANG offered $16 million to SEINFELD's $10 million — by way of spectacular compensation, the comedian then spent $35 million on the spread one door along from LANG and PAVLICK, which had previously belonged to BILLY JOEL. The neighbours, old and new, underscored the ostentatious new league that LANG had moved into. It felt incongruous at the time, but that was, of course, well before I saw the house itself.

It's in the practical colonial style known as "saltbox". Actually, with its sloping gable roof, it's more a shape than a style (appropriate for LANG, the

master of silhouette). It's sheathed in Shaker clapboards, rather than the shingles that define a lot of other houses in the area. The Shaker style reminds LANG a lot of the mountain architecture he grew up with. The guest house, an 18th-century blacksmith's cottage shipped in from somewhere local, could equally be Alpine in origin. The dining chairs LANG brought from Austria could be Shaker chairs. The dining table is hewn from one huge piece of wood, strong and simple, a grace note that is typical of the unadorned nature of the interior. The walls are bare wood panelling, the floorboards are broad and worn, the decorative objects, such as they are, are things the couple have found on the beach or in the woods: shells, stones, skulls, pieces of wood, whales' teeth. Horseshoe crab shells might have been designed by the Swiss fantasist H.R. GIGER. I'm reminded of a Viennese *Wunder-kammer* — a cabinet of curiosities — from the 18th century. More of the moment is the flatscreen, which silently plays CNN; LANG has always been absorbed by "the news".

After his parents split up and his mother died, LANG was raised by his grandparents in a village called Ramsau am Dachstein, high in the Austrian Alps. Their mountain-top was the highest and he remembers the sensation of looking down at the world spreading out endlessly below and feeling that there would always be somewhere else over the next hill to conquer. "But the thing with the ocean is there is nowhere else to go. There is the good feeling you have arrived somehow, like you're home." It's a sensation that visitors feel too. The previous weekend's guests had been reminded of their home in Brittany; I thought of growing up in New Zealand.

When he used to visualise living by the sea, he imagined Greece or Sardinia, mountain and ocean in tandem. But Long Island may be the place LANG spends the rest of his days. "I'm not keen on travelling lately anyway," he says with the wry little laugh that punctuates his more tongue-in-cheek declarations. (He could be talking about the current state of airline travel, but equally, there are the insane traffic jams that clog The Hamptons' two-way streets during "the season".) He isn't even fazed by the fact that property owners on Long Island are having more and more trouble getting insurance because of the growing conviction that a hurricane is long overdue for the New York area; a KATRINA-sized storm surge would scour the low-lying Hamptons clean. "You could live in fear every day but it cannot be the leitmotif," he says. And should a tsunami sweep through? "We've got a ringside seat." Another laugh.

Once upon a time, journalists would invariably make mention of his ghostly urban pallor, but now at the tail end of a Long Island summer, he has a tan. Though LANG turned 50 in March this year (which makes him a Pisces, and I only mention that because when he finds out I'm a Virgo, he says, "Like TOM FORD? You should open your shirt further," so he has at least a passing familiarity with the

subject of birth signs), he seems remarkably untouched by time. "Because I stopped working like before," he laughs. The milestone left him unmoved. "I have no problem with age. I never had any crisis. It just is what it is. I'm not planning 'the next chapter', so to speak. I'm perfectly happy."

There is never a hint of regret about what's passed. "I think I'm very happy about the decision to change. I think I'm just following up the things I never had time for, things I wanted to do that were maybe part of the work already. But it was a very intense 24/7 job, and now it's probably time to pursue this other thing. For me, it's more raw and surprising. I don't know everything as well. In fashion I know a lot and I can do a lot of things and tomorrow I can probably do a really great collection again. And fashion also has a certain system, but I like it that things now don't have a complete system, that the outcome is just less predictable."

Hindsight suggests that LANG was already seeking the unpredictable in his last collections, introducing elements of chaos. "Yes, chaos," he agrees, "but I also started introducing a lot of organic inspirations, like things I found on the beach." In a way, it was LANG's riposte to the conformity — the absence of chaos — that he felt followed in the slipstream of a relentlessly globalising society. He's particularly struck by the passivity of the young. "There's no counter-movement from young people. Adults refuse to grow up, they want to be young forever so the only counter-movement the young have is that they want to get married early and have one partner and live a completely conservative life — which on one hand makes sense if you see all the old rock stars still performing and adults trying to be hip and skinny."

He also feels a degree of conformity has been imposed by the stratification of urban centres. "They're too expensive now to support a mix of people. I remember in the '80s, in the nightclubs, people were all mixed together and things got exchanged. Anything which is successful now is either partly paid for or common enough that it can cover a lot of ground. In fashion, you can do really great clothes but most of the people involved in the business don't really care when this hand-bag, which can be used by everybody of every colour and every size, is really much more interesting. From that point of view, we've lost a bit of that quality. It's got a little bit stuck."

LANG feels the same diminishing process has happened in music, too. Once, he'd dj on the decks in his old studio, or he'd go out to dance, especially to techno (drug-free, "probably the only person who was", he points out for the record). "It was very important for a long time, there was a lot of zeitgeist in music, but in the last ten years, I haven't cared so much about it," he claims. "Music has a huge emotional input but I just don't need it at the moment. The radio is good enough for me right now." Meanwhile, the only radio station the house picks up is softly playing an odd but appealing mix of '80s classics and early '90s rave anthems.

But, however that may sound, LANG is not a good-old-days nostalgist. "It's never good to say 'oh, in those days...' because time is what it is. I think there wasn't much movement in the first ten years of the last century, and then everything went haywire and developed very strongly. And we clearly all know the global idea has become a reality, so maybe the youth movement now is not about fashion or literature, maybe it's about evolution in the larger, human context." As an arch-devolutionist, I have to call LANG on that one, but he insists that evolution is the right word because "it's always going forward somehow. Structures are moving on and they eventually become something better or they try to destroy themselves —but it's still an evolution of things. And if this moment is a period where things are basically standing still, it's a good moment to start something new."

The idea of protection, of armouring oneself against the world, which haunted LANG's final collections, anticipated not only what was going to happen in fashion but what was going to happen in society. It's not hard to make a case for the man as being way ahead of his time. "The story of my life is I look back on something five or seven years later and it looks like something much more formulated. I think I just have good instincts somehow... I don't know if that's the right word." What if the good instincts aren't always for good things? "Well, if it's good clothes, it's good things," LANG fires back. This time, the laugh is hearty.

Even fashion itself was a happy accident for LANG. "I wasn't planning to do it in the first place," he muses. "I was lucky enough to be in an artistic surrounding in Vienna where I had to think differently. I started thinking what I could do for myself with a budget so small I really couldn't do anything. That's a question of authenticity—nothing was special, nothing was just for a cheap effect somehow. It was always what I believed in, what I thought was best at the time. You can apply this to fashion, but it's part of how I still function somehow. If it comes from inside yourself, then it has a certain truth to it."

There was, however, a lot more deliberation about the re-location to the US. "The two things I was interested in were Paris and New York, and New York was a bigger challenge. It was really interesting in the mid-'90s; it's a little bit too groomed now, but I found it extremely modern. The fact there was no burden of history made it very appealing. But I also thought the melancholic *Mitteleuropa* temperament would go very well into New York. So I made the decision to move here. I've never regretted it, like I regret nothing in my life." And LANG never looked back. He hasn't visited Vienna once since he left in '97.

TOM FORD once observed that America is the enemy of creativity for a fashion designer, but for LANG, it represented an ideal. "Living *not* in America influenced me tremendously, what I understood from American basics like the T-shirt, the idea which was an ideal. But you understand if you live here and you buy a

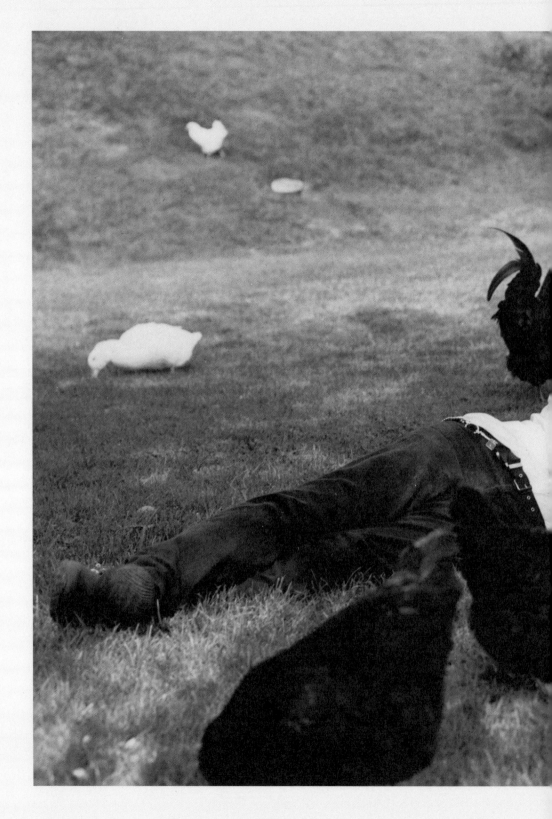

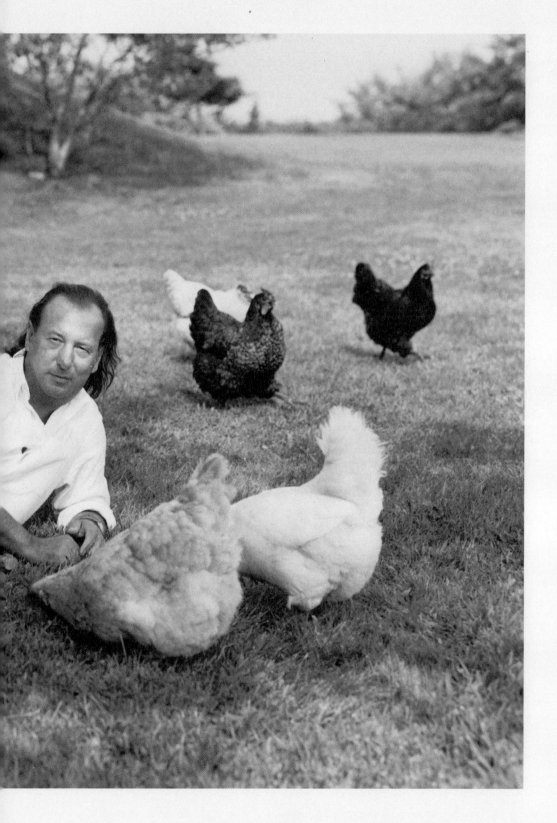

T-shirt every day from K-MART, you don't even have the possibility to look at it in a different way. It's not a cult object."

The gap between the ideal and reality is usually where disillusionment sets in, but LANG's commitment to his new world was never shaken. "I'm not made for that negative concept. Even when times are not favourable, there's a good possibility to do something or to start something. I think if I am interested in something, I've never been so disappointed by it that I was irritated."

That's a remarkably accepting declaration, given everything that happened to LANG after his re-location. First and foremost, there was the deal with the devil, in the form of PRADA's PATRIZIO BERTELLI.

LANG reviews that period with calm detachment (unlike JIL SANDER, whose parallel experience with PRADA allegedly embittered her). "In the mid-'90s, before we moved to America, it seemed a good idea that companies would merge and share experience. We'd had licensed partners before anyway and the business was growing really big. Then we decided to move to the States and put everything on hold. But I thought the only thing I had not tried was the corporate fashion thing. I was also completely aware that if it didn't work out, if the situation was not interesting long enough, I would eventually just have..."

For a moment, LANG's voice trails away.

"I did know that if I sold half of the company, I would eventually sell all of the company. I thought about it long enough before, so I don't think I ever had the wrong idea about that. And that's what I did, I first sold half of the company, then the second half of the company, and after that it was basically time to move." At the time, it seemed like it happened very quickly. "Yes and no," LANG pauses. "I cannot talk about this whole thing... It's also a little bit retro-ish."

Of course, we have to go on talking about the events of late 2004, because the schism between LANG and PRADA had such wounding implications for fashion as a whole. What do they say in fashion? Whatever else happens, hang on to your name, because ultimately that's all you've got (HALSTON being the most notorious cautionary tale). Yet I've always wondered whether LANG wasn't in fact the puppet-master, engineering a situation where the only possible option was the shedding of his designer skin, label and all. He felt he'd done all he could do in fashion, he needed to make a break, and it needed to be definitive, convulsive even.

"I don't know if it was that dramatic. Basically, when I saw I would sell the second half of the company and that I felt okay about it, a lot of people who'd worked with me for a long time resigned. But they stayed for a while with me because we had this agreement that it just stays like it is because, you never know, I might still want to do this kind of fashion, and if you have a whole team, you just don't let it go. But after half a year, I was pretty sure I wouldn't take it up again in

the same form and people moved on to something else. I kept on working with a few of my best people on the personal archive and books and projects. That's basically when I founded HL-ART — and the rest is in development."

It would have been easy to construe the silence that descended after LANG left his company as the warrior retreating to lick his wounds, but that was far from the truth. "I'm sometimes perfectly happy to do nothing," he concedes. "For the first year, I did no interviews. I didn't want to comment on anything. When people asked me what I was up to for the future, my idea was not to be up to anything in particular. You want to clear the head from everything you know, which takes a while because you're in a system. I always tried to be curious and fresh and think about things in quite an innocent fashion, and it's extremely difficult to stay innocent when you're in that whole fashion thing. So I planned nothing. And people would ask 'What are you doing?' and it was kind of odd to say 'I don't do anything specific.' Then I started to do certain things that happened here, and archiving my personal stuff and out of this certain projects are slowly arising. I'm trying to slow them down a little bit."

In the past, LANG called his shows *"séances de travail"*, works in progress. It is still his modus operandi. "I really don't want to name certain things. But the work in progress was also about the attitude in that time, the showing of the work. I wanted it to be less pretentious and more modern in a way. I was clearly inspired by things, but I didn't want it to be always starting somewhere and then ending and the next thing being completely different, because that didn't make sense to me. And maybe now I'm starting to do all these indefinite projects in a way because I like the idea that something goes on and you just take excerpts out if it, different points of view or ideas or emotions."

The name HL-ART is less absolute art than it seems, in English at least. In German, *"Art"* can mean a species or type, which is a tidily generic catch-all for LANG's current activities. So far, he's released morsels of two ongoing projects. One, called LONG ISLAND DIARIES, is best interpreted as an oblique visual record of his life now, incorporating a meticulously maintained daily record of his hens' egg-laying (published in the French magazine SELF SERVICE) and a set of photos of his feet anchoring photo spreads from gay porn magazines, which appeared in BUTT magazine, FANTASTIC MAN's brother publication. The other project, called SELECTIVE MEMORY SERIES, seems Warholian to me in its appreciation of the idea that life is reconstructed from people's ephemera — letters, thank-you notes, photos, articles saved from magazines — not their art.

"I was moving round a lot in my life," LANG explains. "I didn't have any archive of my work early on. At first, we couldn't afford to. You have to re-invest everything to build up your own company. Also, I was never really interested in archiving it all; I was not interested in diaries. The only thing I kept were little

notes from people in a box somewhere in a drawer. But when we started to organise the archive, I started to find it interesting to reconstruct the whole ambience of how it happened. It's a lot of material right now, from the very banal to the very special, all mixed together." The 600 pages of notes run an extraordinary gamut of the people whose paths LANG crossed since 1986, from CATHERINE DENEUVE to BILL MURRAY to ELLEN DEGENERES to QUENTIN TARANTINO. "It's like half artistic context, half who's who," says LANG, "and everyone seems to be intrigued by it." Celebrity factor aside, I suggest to him one reason for the interest might be the potential for social satire in the arrangement of the material. "I guess it could be if you edit it that way," he counters, "but the fashion is important because it's an important part of my life, and I met really great people."

The recent magazine cameos have inevitably sparked conjecture that LANG is building up to a re-entry of some kind. "It's not true. Magazines kept asking for any contribution, whatever I wanted to do, and with all the archiving and the projects I started to respond. If somebody asks you three or four times, they're very loyal to you, so you also come up with something, to respond."

The contributions themselves have sparked conjecture of other kinds. The hen-laying records published in SELF SERVICE were introduced with definitions of the notion of the pecking order, a hierarchical concept which could be construed as a comment on the nature of the fashion industry. They were accompanied by a "self-portrait" of LANG's groin. He is wearing white cotton sweatshorts with the pockets turned inside out, and he holds a razor at his side. He got PAVLICK to take the photo after a day at the beach because the look of the pockets offered a nugget of future fashion inspiration.

The photos in BUTT were also labelled "self-portraits". LANG had been promising something to the magazine for three years, and when he was asked for a self-portrait, he knew he didn't want to do something formal. "It's BUTT magazine and it should be sexy somehow. It's very easy to photograph your feet, and I thought if I put old pornographic photos in the background it's going to look kind of sexy. So that's my self-portrait. I don't get naked, because I can always keep that for later... if I had to." Some BUTT readers missed the feet, which frame the images of tumescent professionals and inevitably speculated that the 'self-portrait' label refers to hard-on HELMUT. "Well, it's not *small*," he teases the wishful thinkers still further.

For the cautious, guarded designer who would cryptically field questions backstage after his shows, anything personal was usually treated as an irrelevance. Now LANG exudes a warmth and ease that suggest an enviable degree of contentment. "First, I didn't have something to share privately before I met EDWARD,

and second, I just thought the work thing was the really important part and the way to express myself. But now this is a big part of my life, so it's become normal —and normal for me to express. In my life, I've managed to go back to a certain energy where you're not constantly thinking 'What does it mean?' It means nothing to begin with, and eventually if it means something to me, or somebody else, that's really good. And if not, it doesn't have to. It's a good place to be."

He agrees he has, in a way, made himself stateless, even in spending more time in ocean-side isolation than in his adopted city. "Things happen somehow partly with instinct, it's never deliberate. EDWARD knew Long Island. In retrospect, one reality is that everything is so global, but on the other side, there's another freedom and directness in a microcosmos... maybe that's not the right expression, call it a smaller circle... I find quite interesting right now. Never neglect the small circle around you because you can really do something by yourself." This is LANG's own spin on environmental awareness.

"The urban context used to be important, but all the secrets I wanted to know I kind of know. I think what we understand in an urban context is so well known that there are no secrets left generally, and somehow nature is a bit more unpredictable. You don't know exactly what's going on. It's more immediate, it gives you a different approach, which I find more stimulating at the moment."

So LANG was raised in nature untamed, in the Alps, and he's ended up back there, on the shores of the Atlantic, almost like a full circle. "Yes, if you see it that way," LANG acknowledges, "but there were a lot of circles in between. You always enter another circle every few years. There's just another circle ahead. I'm kind of thankful for this, it's more liberating and inspiring than the other environments I know well. I think the idea of being able to do this is for me more progressive than adding another 20 years to the same body of work I already have, so to speak. This is actually more evolution and progress, fulfilment and happiness. That might change again, but for now this is a good reality."

My tape runs out to the sound of a rooster crowing exultantly. How's that for a metaphor?

Mr. PETER SAVILLE

Featured in issue nº 3 for Spring and Summer 2006

The celebrated graphic designer PETER SAVILLE has featured in FANTASTIC MAN twice so far. This image is taken from his first outing in the magazine as part of "The Art of Smoking" shoot from issue nº 3. A determined and elegant smoker since his late teens, PETER plans to quit "only when it's too late." PETER's second appearance was a couple of years later in the recommendations section at the back of issue nº 6. His tip was the wearing of white jeans, another habit for which he is renowned. Although PETER has dressed in roughly the same outfit since the late 1970s, he looks perpetually of the moment.

PETER first became known for his sleeve designs for the Manchester label FACTORY RECORDS. In particular, his work for the band JOY DIVISION and later NEW ORDER shaped the visual taste of a generation and led to a series of images that remain in the collective consciousness. Since 2004 PETER has been the creative director to Manchester's city council for whom he coined the phrase "Original Modern".

Portrait by Anuschka Blommers & Niels Schumm

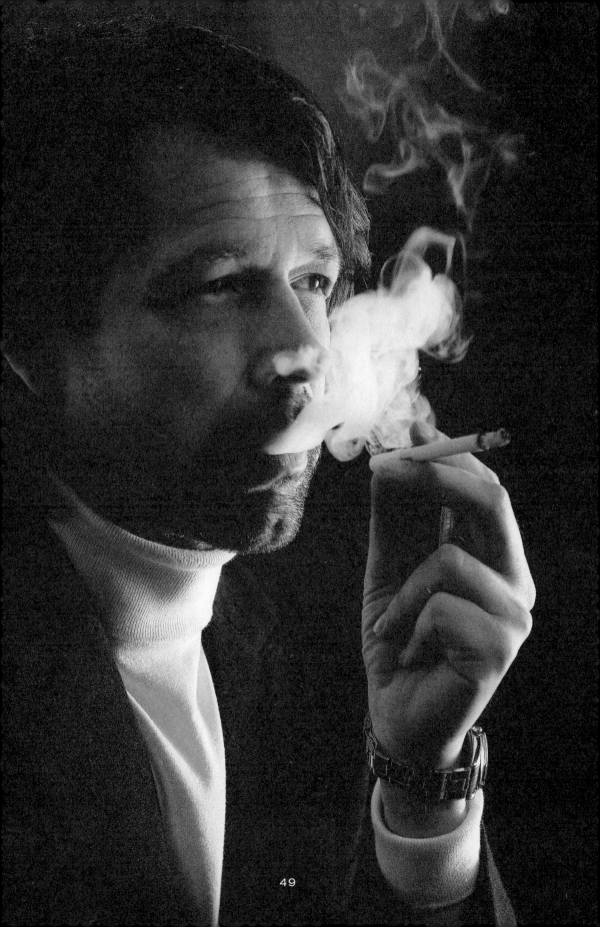

Mr. EWAN McGREGOR
Featured in issue n° 10 for Autumn and Winter 2009
Portraits by Alasdair McLellan
Text by Paul Flynn

Mr. McGREGOR

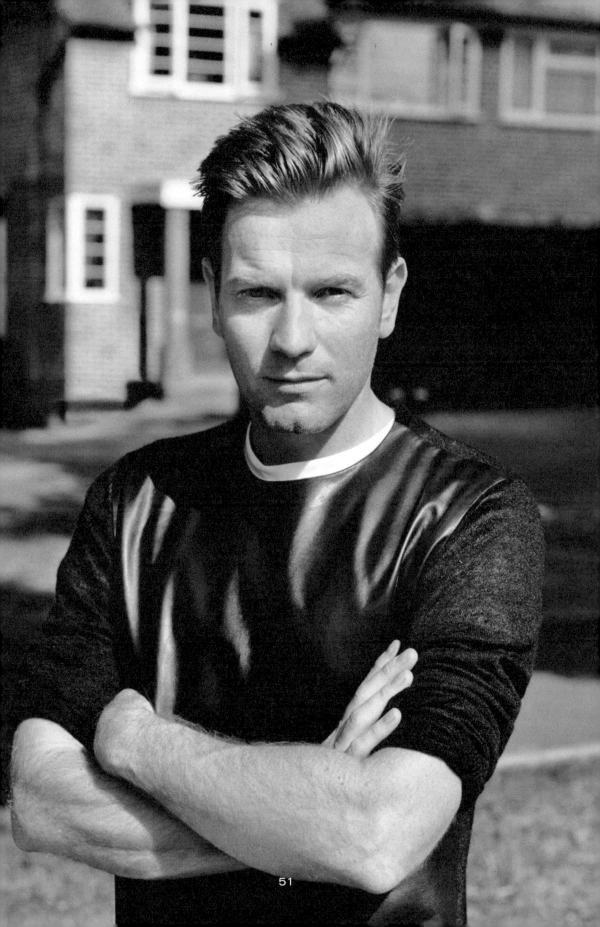

Fulfilling a role in real life as fabulous as those he plays on screen, Mr. EWAN McGREGOR is a world-famous actor and ex-bon vivant who has learnt when to stop in order to start again. His roles in TRAINSPOTTING and MOULIN ROUGE bought him respect, while the STAR WARS trilogy made McGREGOR Hollywood-level famous. In his films he has appeared as various characters, including CHRISTIAN, ANDY, RENTON and OBI-WAN. He will soon appear as PHILLIP, BOB and GENE.

The day before we meet, Mr. EWAN McGREGOR had taken his wife and three daughters for a jolly day out at WIMBLEDON. The British tennis tournament was reaching its climactic stages under an unusually scorching London summer sky. Mistakenly, I assume his visit to the tennis happening to be in loosely patriotic support of his fellow Scot, Mr. ANDY MURRAY, playing on centre-court. But McGREGOR is not an overtly Scottish Scottish-person, despite the fact that some of his Hollywood chums refer to him directly as "The Scotsman". (He says he couldn't, for instance, identify the Scottish Parliament building if he were shown a picture of it.)

After leaving WIMBLEDON he was chastised on the telephone by his mother, with whom he is close. She said that he really ought to have sent a message of support to MURRAY, something she had noted the most famous other Scottish actor than McGREGOR, the very overtly Scottish Scottish-person, Mr. SEAN CONNERY, had done. McGREGOR winced at the very idea of this kind of over-familiarity with a stranger. "And I told her. SEAN CONNERY also somehow managed to get that information to the media." McGREGOR reminds me, quite purposefully, that at 38 years of age, he has now spent more of his life away from Scotland than he did in it. He moved to London at 17.

Last year the McGREGOR clan decamped from London to Los Angeles, to a house on the Brentwood/Santa Monica borders in which, he says, it is perfectly permissible for his children to skateboard around the kitchen. The move seems surprising only in that McGREGOR appears to be such an utterly un-LA person. At one juncture he mentions the fact that he would like to introduce his daughters to the CARRY ON films, the low-budget British comedies from the '60s and

'70s that turned an endless succession of double entendre, screeching camp and hysterical farce into a kitsch British institution. To anybody outside of Britain, where they are loved, the CARRY ON films would make no sense. To an American, they would represent only absurdity.

Mr. McGREGOR has weathered well from his day under the WIMBLEDON sun, though his flesh is still uniquely Gaelic in tone and his accent remains largely untouched by his travels. His name is, of course, the most quintessentially Scottish name ever. He is back in London for a week and appears energised by the familiarity of it all, though we meet in the garden of a house in the exquisitely boring suburb of W7, a postcode I had previously not even registered as existing, by which he looks absolutely and correctly flummoxed. It seems perfectly appropriate for a man who was born into a bungalow.

The open-handed frankness of his character is immediately striking. He scratches his upper-arm tattoo, crosses and un-crosses his legs. The tattoo conveys the sartorial suggestion of a rock star and his attire follows. He is wearing an old T-shirt, slim jeans and CONVERSE high-top sneakers, all in varying shades of washed-out black. His thick head of hair leans upwards. He has something of the fidget about him.

As an actor that has made the full film transition from local independents to global brands, McGREGOR has developed a particular speciality: male sentimentality. "If sentimentality is truthful," he says, "then it is right. I think we are sentimental. It's instinctive. There is a sentimentality to life. You can milk that thing, stretch it and abuse it, or you can recognise the truth of it. That's what drama is about: making you feel."

Before his star-turn in MOULIN ROUGE, this sentimentality was sewn into work that sat outside of mainstream, though plugged determinedly as being part of it. After MOULIN ROUGE, you can feel an admission in the actor that the Hollywood machine he railed furiously against as a young man was perhaps his destiny. The move to LA seems to confirm that. Over the coming twelve months he will prove to himself whether that was the case or not, starting with a fanfare procession of four huge cinema releases that began earlier this year with the DAN BROWN adaptation ANGELS AND DEMONS and will take in co-starring turns with a cast-list of heavyweight awards-magnets: Ms. HILARY SWANK, Mr. KEVIN SPACEY, Mr. GEORGE CLOONEY, Mr. ROMAN POLANSKI, and Mr. JEFF BRIDGES, to name a few.

Through the roles he has chosen, McGREGOR has become a significant British cinematic shorthand for the fundamental relationships that define men. When I mention this, he talks fondly of his time working with Mr. COLIN

FARRELL as brothers in the largely panned, pre-renaissance WOODY ALLEN flick, CASSANDRA'S DREAM, reminding you that an actor's experience of a film is something very different from an audience's.

EWAN McGREGOR's style of acting is a form which he calls "playing"—he has a regular habit of widening his eyes in awe and making you believe him, whatever the circumstance. If his contemporaries Mr. DANIEL CRAIG and Mr. JUDE LAW are employed to bring a very British sort of upper-end glamour into a film, McGREGOR seems to have earned his commercial crust through warmth. Partly because of this, and partly because his breakout role in TRAIN-SPOTTING was such a generational phenomenon, admirers of his work do not think of him as being quite as remote as other film stars. Walking through Scottish cities, particularly, comes replete with problems for the actor: "Men will shout at me on the street 'RENT BOOOOOY!!' Continuously." He doesn't go back much.

McGREGOR is not a remote person. He is remarkably forthright for an actor negotiating the inner realms of Hollywood. His eyes are keen when he smiles and he can suddenly become all nose and teeth when he laughs. His natural disposition is set to affably upbeat. You can see why this might have led to mischief in the past. There is an air about him of a man who was always the last one propping up the bar and who is not afraid, either personally or professionally, to lose some control. They are appealing traits in a middle-aged man.

Two weeks before we meet in London, McGREGOR had been in Shanghai for the film festival, helping the ANGELS AND DEMONS producers get it past the Chinese censors. It turned out that his first mentor, the British director Mr. DANNY BOYLE, who had cast him in SHALLOW GRAVE and then in the role that turned McGREGOR into a worldwide star as one of a socialised, functioning bunch of Edinburgh heroin addicts in TRAINSPOTTING, was the head of the festival's grand jury.

After wiping the board at this year's OSCARS with SLUMDOG MILLIONAIRE, BOYLE can reasonably be considered the hottest commercial yet intelligent film director in the world right now. For certain British men of a certain age and disposition, the names EWAN McGREGOR and DANNY BOYLE harmonise with the tunefulness of a classic song-writing partnership. McGREGOR was the ELTON to BOYLE's BERNIE TAUPIN, the MORRISSEY to his MARR. It is a male relationship that is worth believing in. When the two met in Shanghai, "for the first time in a very, very long time", the actor went through a succession of conflicting emotional responses that he describes as analogous to that of happening upon an old lover: "It was kind of sad. I miss working with him. I miss him. I loved working with him. I think the relationship

we had as actor and director was something that I have never really had since. I don't mean to be rude to other directors I've worked with, because I really have worked with some fucking amazing people, but I had something very special with DANNY that I can never replicate. We made our first film together. Then we made two more together after that. To me personally, at that time, being part of that filmmaking team was more important than anything else in the world. It was a bit like being Scottish. It was that important to my sense of identity. I felt it, strongly, being part of a new wave of British cinema. I was at the front of it because I was working with this one man. DANNY. I suppose all things can't go on forever. They don't go on forever. But it's a shame not to be working together because I think those things would still be there. I'm sure of that. There was something about being on set with him that was like being in love. I felt that. I loved that man. When I looked over and saw him on set I was always happy. You are basically talking about a break-up here."

This has a silent sting for McGREGOR. If seeing BOYLE again really was like coming across an old lover, then it must have been like finding out that they had gone on to marry someone far richer and better looking than himself. With SLUMDOG MILLIONAIRE, DANNY BOYLE has not only trumped TRAINSPOTTING in terms of the international resonance of his own work, he has also very possibly trumped his first leading man's work, too. Until the release of SLUMDOG MILLIONAIRE, there was little competition for MOULIN ROUGE as this decade's defining love story. No longer. The quiet gauntlet that exists between the two has been thrown down again.

McGREGOR says he enjoyed SLUMDOG. "From start to finish it was complete. It has an extra thing for me, obviously, because I loved watching DANNY's touches in it. There were some that made me reflect on our films together. You know?" The question suggests that they were almost meant to. "There was an even bigger shit scene in SLUMDOG than there was in ours. I thought we'd capped that. I thought we'd done the worst that there could be. But no, there was more to come." In one hyper-real sequence in TRAINSPOTTING, McGREGOR's character, RENTON, falls down a toilet pan. In SLUMDOG, BOYLE engulfs his young Indian actor in a swimming river of faeces. "That's very DANNY."

McGREGOR says that when he met DANNY BOYLE in Shanghai, they got on well. He had felt a particular pride for the director watching his film picking up eight OSCARS because he knew in the smallest detail what they meant to the director, both of them being of such a similar class and experience and having so much pivotal shared history. The eagerness to his tone suggests that, from the actor's point of view at least, their story has not yet ended.

In 2001, the same year that EWAN McGREGOR made MOULIN ROUGE, he gave up drinking. The moment of abstinence splits his film career directly in two.

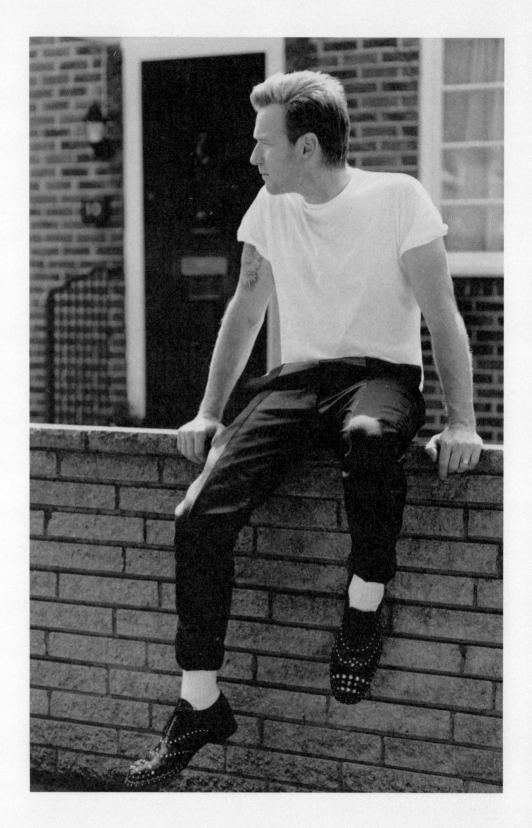

Post-sobriety he landed noticeably more commercial roles, culminating in the STAR WARS sequence. "I just got fed up with it," he says, of boozing. "I couldn't handle it all, really. I was getting drunk a lot. A lot. And I became aware that I couldn't keep all those balls in the air at one time. I was married and I had my first child—at that time it was just CLARA—and I was just overindulging. I was carried away with it all. I always had been. I'd always drunk like that. I was always up for it."

As a drinker, he was not a nice-glass-of-wine type; he was a nice-couple-of-bottles type. "I love the idea of being a one-drink, two-drink person. It'd be nice. Especially now, sitting here, in the middle of the summer. It'd be lovely to sit down with a nice glass of PIMM'S or a glass of beer. But I couldn't do it and I can never remember doing it like that. I was an alcoholic drinker. I drank in a mad fashion. I was never satisfied. It was upsetting when I knew that the end of the night was coming. I couldn't stand it. I was driven to carry on and driven to continue. So I would."

Drink was beginning to interfere with his work. In 1997 he had set up the production company NATURAL NYLON with friends, the best known of which were JUDE LAW, SADIE FROST, JONNY LEE MILLER and SEAN PERTWEE. The idea was to facilitate and lend an aspect to the British film industry that had a similarly hip cachet to the YBA's and British art or Britpop and British music. "It didn't happen. I made one film with NATURAL NYLON: NORA. I'm not into going in and making work happen. I'm not a businessman. JUDE was always much better at taking a book and making it into a film, at working on scripts. He was much more hands-on. I was just, erm..." He pauses. "I was just always in the pub. The offices were right round the corner from a good pub. That's all I did, really. My involvement with the whole company was going down and having a pint. A pint or eight. That's what it was for me. We were quite good at launching it. We were quite good at launching anything, to be honest. But when it came down to the actual making of a film? That was problematic."

From the outside and given the people involved in NATURAL NYLON, it very much looked like the company imploded in a blizzard of cocaine. "Aye. Yes, well it was the '90s. You know?" He laughs. "I was in Glasgow doing YOUNG ADAM when I left." It was 2002 and McGREGOR was sober. "There had been problems with NORA, with crew not getting paid. There were a lot of stories in the press, again, about a film that they were making with DOUGRAY SCOTT and TIM ROTH, which I cannot even remember the name of, and they'd had to stop shooting again. It was always 'EWAN McGREGOR and JUDE LAW's production company'. I don't want to badmouth anyone because we were and are a group of friends, but I just thought I cannot be involved in this. I don't believe that people should work without pay. Actors are expected to do it all the

time. People think of the career of acting as being somehow like having a hobby. The assumption is that you're lucky to have a job. I've always resented that. It's kind of why we end up doing fucking 20-hour days. I've always felt passionately that people should be paid for their work and paid properly. So I couldn't quite reconcile the two things. And on top of that, it became really clear to me that I wasn't doing anything in it. I wasn't really a member of NATURAL NYLON in that I never really actually did anything. I acted in NORA and I went to board meetings, when they happened. And put my tuppence worth in. But I didn't do anything else. I just went to the pub. And I did that to the best of my abilities."

He is pleased with the decision he made to quit drinking. "It's a way of life now. It doesn't feel like that big of a deal after this amount of time. Smoking's the same. Once you stop it's not that big of a deal. I smoked like a Trojan. First thing in the morning? Always. But somehow when you stop you just don't see it anymore."

Last year was the busiest acting year of EWAN McGREGOR's professional life. In terms of an aggressive Hollywood professional assault, he'd had three very quiet years before. "From 2004 to 2007 I did two big motorbike trips, London–New York and Scotland–Cape Town. Then I did two long stints in the theatre. In those three years I did a few movies, but I did less. It must have been a reaction to...something. I must've wanted to do different things. To try something different." In 2004 he ended his relationship with the STAR WARS franchise, after promoting the last of its three prequels, REVENGE OF THE SITH. The magical aspect of acting had disappeared for McGREGOR, if not on screen, then somewhere deeper.

"The actors I like the best to work with are the ones who play. It doesn't happen so much anymore. I have worked with actors who turn it on for their close-up. You see them doing it. And when it's my close-up and they're next to the camera, they're not coming at you at all and they're not entering into that sense of play. I do find it boring. I don't understand the idea of just delivering lines. The scene has stopped being played. The sense is broken. I'm very sensitive to it. Overly sensitive to it, probably. Because I started working in Britain and I started with a very professional, quiet team that would understand that when the director shouts 'ACTION!' and the camera's rolling, well, that time is sacred. People generally were still and quiet. That has got a bit looser. With the STAR WARS films that I did, because there's no tape anymore, it's all green screen or blue screen and there's only two cameras on a crane that are going in and out and there's no set-up time, it just all felt a bit vague. Literally, the producer would walk around the set on his phone during takes. It would drive me nuts. I'm doing my job."

A very male conflict in EWAN McGREGOR is palpable: your sense of ambition wants the big stuff, and your sense of personal pride wants to do the big stuff exactly on your own terms.

He gives some further evidence of the conundrum. He says that the anatomy of choosing a role can be interesting and he has learnt to spot things in scripts that are positioned for a particular calibre of film star. "I can recognise, particularly in a Hollywood script, those specific lines that you might call 'the hero lines'." He mentions Mr. CRAIG and Mr. LAW. "I always find that with DANIEL and JUDE, though I haven't seen as much of DANIEL's work as I have of JUDE's and I'm not saying this in terms of dismissing their work because with JUDE, I think, you can very much empathise with him, too... But I always have problems with those lines. Those hero lines. Those movie-star lines. Because I can only make it feel real, somehow. I can't really work any other way." He says he doesn't like looking at the monitor during playback after a take ("to me that is a little bit like looking in the mirror too much") or seeing a film at the rushes stage. "If you sit and study the bare bones of a performance then you can be left with a feeling of 'Oh. Is that it? That's not very good.' And it's not very good because you are in the middle of a movie."

He considers the suggestion that what he brings to a film is a human quality rather than a star turn. "Yeah... It's interesting what you say. In some respects it's nice. And you are probably right. But in another, everybody likes to categorise. And that's the worry, isn't it? Everyone puts everyone in pigeonholes. And I'll be honest. I'd like to be able to play those starry roles as much as I like playing the empathetic ones."

McGREGOR's life in his 30s, in this decade, has been book-ended by two major, life-changing events. The first was his decision to give up drinking at the start of the decade and the second was moving to LA at the end of it. He says it wasn't about work; the filming that takes place in LA is mostly for television and commercials, not films. "You just fancy a change sometimes." While he was filming THE ISLAND in 2007, McGREGOR and his wife, EVE, had seen a friend of a friend's 1920s Spanish house "and fallen for it." They persuaded the occupiers to part with it.

"I'd railed against LA in my youth, but I came to this realisation that every time I went, I loved it. If you separate LA from the Hollywood system, it's quite an interesting place. I like the look of it and the feel of it. I like driving bikes, you know, so it's an easy place, warm enough, wide open. A lot of LA is just cracked cement and low, shitty buildings. I like that side of it. I keep my bikes lower down in Santa Monica and to get to them you go through Washington. And there's a road where all the bike shops are, and between my house and there it's just all wide, cracked cement. It's baked and the paint has faded and there's something

weirdly beautiful about it. Then suddenly it's all green again and people have gardens and it's chi-chi and nice and you've stepped back over that line into what I think people think of as LA."

There was a further reason to decamp. "It might've just been to break the bond with London." In 2009, on the eve of his 40s, EWAN McGREGOR doesn't any longer need to be the British actor from TRAINSPOTTING, MOULIN ROUGE or STAR WARS. He is the British actor starting over, on new turf, in a new time frame, with new possibilities of male sentiment stretching before him. "It settles me not knowing what's going to happen next," he says. His fidgeting is professional, too. And then later: "There is a sense in this business that is mostly perpetuated by agents that if you step out too long everything will move on without you. That might be true. But at the same time? So be it. Fuck it. Life is more important than work and the truth is that if you are a good actor and people think that you're a good actor then they'll want to hire you."

It has been a reflective time for the actor. Two weeks after bumping into DANNY BOYLE at a film festival in China, he sat and watched BLUR at Glastonbury on the BBC. "It takes me back, you know. Everything was happening at that time. Everything that was going on. I found the whole thing quite moving."

 Rather than book his family into a hotel he has holed them up in his office, two doors up from his London house, now rented. He keeps the office alive in London for the bureaucratic business of his career. "I spend most of my time in hotels. I'm with my wife and my kids. Even if it's my office, at least it's our stuff. It's quite good fun. And it's quite good for them to be tripping over each other, too. It's quite good for them to realise that life isn't just about skateboarding through the kitchen."

EWAN McGREGOR says that he spent some time with his wife talking through the disparity between the life that their children have access to, compared to the opportunities they themselves had as kids. "They've had far more access to the world than I ever had. I've always made an effort with my wife to keep their childhood as normal as possible. This is something that's ongoing with me as well in terms of coming to terms with success or access to things and what path you might tread in the world, which is something you do face a lot. As you get older you spend more time on it. Now I'm not going to hide away because of it. Which is something I've done in the past. I won't deny myself something because of it. I seem to be built that way. I keep remembering details that happened a long time ago and I try not to worry about what's going to happen next."

 Next McGREGOR will play a war-reporting journalist who uncovers a soldier with cryptic powers in Iraq, in THE MEN WHO STARE AT GOATS. Then he

will play JIM CARREY's boyfriend in prison, in I LOVE YOU PHILLIP MORRIS. After this he will be HILARY SWANK's leading man in a tale of thwarted aviation, AMELIA. The lover, the sodomist and the fighter. More men navigating their emotional and sometimes sentimental way through the world.

It is no accident that EWAN McGREGOR lives in a family of four females and him.

Mr.
THOM BROWNE

Mr. THOM BROWNE
Featured in issue nº 1 for Spring and Summer 2005
Portraits by Marcelo Krasilcic
Interview by Gert Jonkers

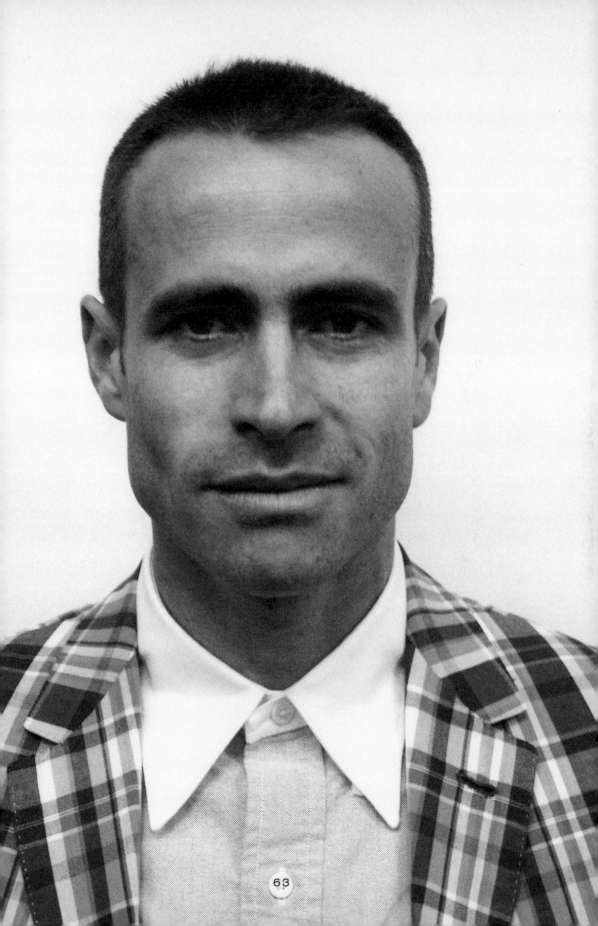
63

THOM's showroom on Little West 12th Street is a miniature Sea of Tranquility in the midst of the hip, hype and happening Meatpacking trendiness. Mr. BROWNE, rumoured to be best mates with Mr. RALPH LAUREN, went from potential Hollywood heart-throb to today's most intriguing menswear designer. The devil is in THOM's detail, from the precise length of a trouser-leg to the perfect timing on something as dull as a voicemail message. "You've reached THOM BROWNE... Please leave your message after the tone... Thank you." It may seem mundane, but it's matchless. That's THOM BROWNE for you...

GERT: I love the music you're playing here. What's this again — FRANZ FERDINAND?
THOM: Don't know. I'm the type of person who always listens to music but never knows the names. I don't really like top 40 type music. It's either alternative or classic rock that I listen to. Or classical music. I must say I'm more of a movie fan. Movies are a huge thing for me. Like old STEVE McQUEEN, JAMES BOND. I like how beautifully-styled they were. And they're, like, *guy* movies.

Can a movie carry you away?
Oh, totally. I'm such a dreamer. I can totally get carried away by a good movie.

Let's talk about your clothes. Tell me about this beautiful cashmere sweater you're wearing...
It's an old ski-sweater-type jumper for next Fall. It's almost like a woven fabric. This is called a "Full Milano" stitch, so it's twisted one way and then knit another way so it looks like a woven sweater.

Is there a machine that does this?
Sure. I use an old family-run factory in Wales. They're amazingly good at doing these classic sweaters. They never do new things, because that's not what people go to them for. They have the royal warrant for cashmere sweaters and so on. So I go to them for their quality. Doing things with them in a new way is what's fun for me. There's something very American and preppy to them. I'm not truly into that preppy thing, but it's fun to make something cooler and more interesting than just preppy.

I think your clothes are quite preppy. But the way that they fit is so opposite to preppy. Like putting embroidered anchors on a very expensive suit fabric — I love how it's not serious. Doing a tuxedo jacket in black seersucker, and then putting the anchors on the trousers. I think that's really cool. I did a jacket in a really nerdy check. I like to balance on that fine line of body-tight clothes but with really nerdy fabrics, something like what I remember my father buying from a SEARS ROEBUCK catalogue in the '70s. This season I also did a double-breasted jacket. I never ever personally bought a double-breasted jacket 'cause I don't really like them, so now I tried to make one that I would actually wear. It's very slim to the body and the shoulders, and it's shorter.

That's what makes it very THOM BROWNE.
I hope so.

What I really love is your dinner jacket made out of terry cloth. It's almost as if you're going to your golf club in a towel.
Yeah. I'm just fooling around. I obviously like a good suit, but when you go to a classic tailor, the clothes are never really for a younger guy. I want things that are less stiff. You can wear a suit, but why not wear it with a tuxedo shirt under it that isn't ironed? Everything I do is made so seriously, so you have to do something to it to make it more alive.

You always wear button-down shirts?
I love button-down. But never with buttoned buttons, that's forbidden. I also love these super-shrunken tennis sweaters. It's good to wash and dry them. Clothes get so much better when

you wash and dry them. I wash and dry all my suits and cashmeres. The first time they may shrink a bit, but afterwards, no. So many people have a thing about washing and drying clothes, but that's how you kind of bring them back to life.

What I hate is when you buy a really expensive white shirt and then it says "dry clean only". I mean, how utterly impractical is that? Going to the dry cleaners every day? Duh.
You should really wash everything even before you wear it, so you get the sizing and everything right. And if you sweat in a shirt before you wash it, you'll never get that little bit of sweat out of it again. Especially with clothing that you work out in, you should always wash and dry before you wear it the first time.

There's something peculiar about the underwear you make.
Really? I've been wearing these boxers forever. BROOKS BROTHERS used to make them, but then they were discontinued. See, you have to alter them with these buttons to make them fit. I wear them really high. I'm so not a low-waist person.

The boxers only come in white?
No, they actually come in all my shirt fabrics. So you have them in blue too.

What about shoes? Are you a shoe collector?
Absolutely not. I have exactly two pairs of shoes. The black ones are the exact same shoe as these brown ones. I got them from an old men's shoe store right around Grand Central. They're one of

the last stores that have the old wingtips in this pebble-grain leather like my father used to wear. I like wearing them a few sizes too big. I even wear shoes like these with my shorts to the beach.

My brother has this theory: he says you only have to look at somebody's shoes to see whether you like the person or not.
I think that's kind of true. It's really hard to find good men's shoes these days. You see all those really bad square-toed nasty, nasty shoes.

Is it natural for you to be modelling your own clothes?
Of course. All the stuff fits me better than anybody else, since I always use myself as a fit model.

Have you ever been a professional model?
I was an actor in HOLLYWOOD for ten years. Right from college until about eight years ago. I did tons of commercials, lots of really boring work. I mean, I made a very good living but it was so boring. I did NIKE and REEBOK and AMERICAN EXPRESS. I did a lot of sports commercials, 'cause I ran a lot and I swam a lot. I guess they also cast me 'cause I'm the "all-American guy".

But are you the "all-American guy"?
I think so. That's definitely what I hope people see in what I do now. That athletic, sporty feel. I like guys to be guys, really masculine. Not so much macho, but active, athletic. I love the OLYMPICS! Do you watch the OLYMPICS?

Sometimes. I watch swimming and diving. The only major sport event I

really love is the TOUR DE FRANCE.
Do you like LANCE ARMSTRONG?

No, well, that's the thing — he's a total
bore, he ruined the TOUR DE
FRANCE. His tactics are so boring and
unexciting, there's no competition when
his strategic plan is put in action. It
might be good for him, but it's terribly
dull to watch. Do you watch football?
Sure, when it's on. But it's not as popular
here as, say, American football, which
I'm not that hot on. I like college foot-
ball, it's so much more charming and
natural. Same with the OLYMPICS.

Have you ever wanted you take part?
In the OLYMPICS? Oh my god, I would
have loved to! I swam in college and I
was good, but not *that* good.

But you can do the butterfly and all
those fabulous swimming strokes,
I guess?
Yeah, they're all kind of natural to me.
But I got so bored with swimming
that I needed something else. Nowadays,
I run.

I could see you playing tennis.
Yes, but tennis... you have to schedule
that, and I'm not a scheduling person.
To schedule sport is a super drag. Do you
do any sport?

I play badminton.
Badminton! Wow, I love it! Do you wear
a very chic white outfit for badminton?

No. I'm not a chic dresser.
Oh you are!

Not when it comes to sport. I just throw
something on.

That makes it even chicer. It's better
when you don't think about clothes.

I wish I could think less about clothes
and getting dressed. It's such a waste of
time to stand in your wardrobe, not
knowing what to wear, what to combine,
which shoes, formal or casual, blah
blah blah.
So, you see, I put on almost the same
thing every day. I like that uniform
thing, it's so much easier. I never have
to think in the morning. Maybe I'm
strange.

I would love to have a uniform. But as
soon as I had decided only to wear
white shirts from now on, I'd wake up
and decide that white doesn't suit my
skin colour or something. It's really
annoying. The funny thing that
happened to me this week was that
when I arrived in New York, my
suitcase didn't turn up. I basically had
nothing to wear but a pair of jeans, and
I borrowed a T-shirt and a tank top
from my friend. That's all I wore for a
week. I was perfectly happy and I
looked just great. Then my suitcase
finally arrived, and all of a sudden the
whole confusion started again. I
suddenly had a lot to choose from. So,
in a way, limitation is good. Which is
what your work is totally about, right?
To have a few perfect classic pieces to
choose from?
Yeah, and to really wear them, as
opposed to waiting for an occasion to
wear them, or only wear them to work.
What I like about the old days is that
guys just always looked appropriate for
pretty much every occasion, since there
wasn't that much of a choice. Guys
wore jackets everyday. I like that.

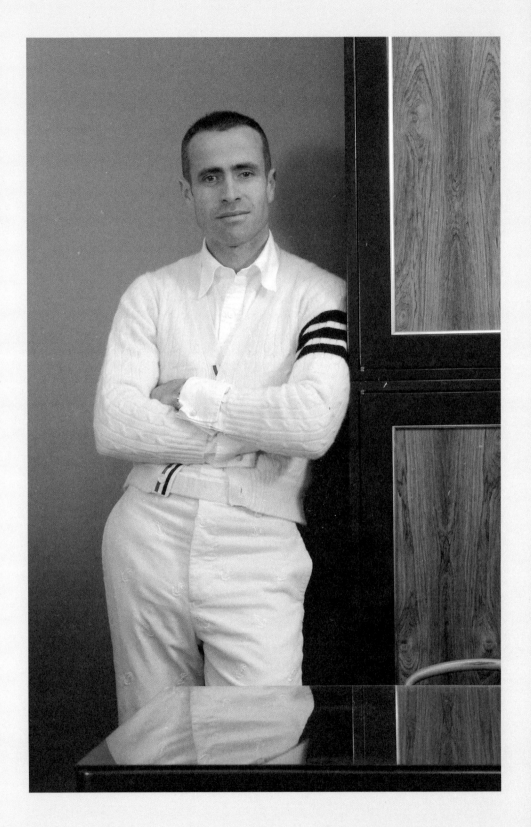

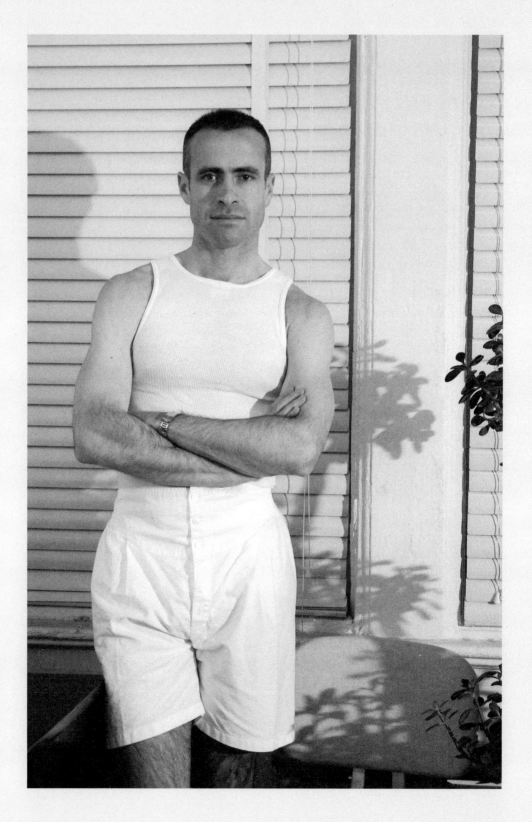

Do you ever feel the odd one out in a crowd?
Always.

Always?
Always. Not that I'm trying to be the goofball, but I do always feel... In a way I've always done that, always done my own thing, always felt that I stood out. I was always the quiet one in the corner. I find crowds intimidating. Not that I'm anti-social, but... the people that I respond to are the real individuals who aren't afraid to be themselves even though it may not be the cool thing. Also what I do for myself, for my label, is exactly what I wanna do. When I started my collection three years ago, I had no clue if anybody would like it or not. But that didn't change anything that I wanted to do. I did it exactly the way I wanted it... 'cause I'd been wanting to do it for so long. The most attractive thing for me in a person is being an individual. And being a bit discreet. It's so much cooler to be understated.

There's a fine line between understated and boring.
No, I think it's easy. Like with clothes, if you focus on quality and fit and things are really seriously made, it doesn't get any more fashionable than that. Like, I'm not anti-colour, but colour for me is a beautiful grey or a beautiful blue. Or take navy — navy is a beautiful colour.

How did you get that typical THOM BROWNE fit right?
I worked hard with my tailor, and — literally — it took me a year to get my first jacket right. Take the shoulders in and then take the armhole up, and if you change one thing you can totally throw off the balance of a jacket. I think it took me about nineteen jackets until I got what I wanted. And still it's evolving. I love my jackets really short. My jackets are significantly short. And after I've worn them for a while, I feel like they're too long. So they keep getting shorter. One of my tailors recently said to me, "Your jackets are gonna become boleros pretty soon," because I want them shorter and shorter and tighter all the time.

Your tailors must have a laugh sometimes.
Sure. They think I'm crazy. I have my studio in Long Island City, where most things are made. I have a group of really beautiful old Italian men that I work with. I love spending time in the studio. The detailing of my stuff is so important that I feel that I have to be there everyday. It's such an important part of what it's all about. Things shouldn't be just right, they should be *exactly* right.

Do your trousers keep getting shorter and shorter too?
No, they can't get much shorter. And of course clients can definitely get them longer. But not too long, I mean, the perfect length is right on top of the shoes, with no break. If they're too long it throws off the whole balance with the jacket. I like it to be one thing, one uniform.

I spoke with TOMMY HILFIGER a while ago and he said he was so fed up with that baggy look that he himself created. He thought the country needed people in smart clothes, guys in suits. It seemed that he was taking responsibility for the well-being of the community and getting that across in his collection. Like,

if people look better, they'll behave better.
I totally agree with that. The idea of bankers being able to wear their golf outfit to work I just never understood, 'cause if I go into a bank, I want to see somebody who looks like he's a little bit more responsible and knows a little bit more about money than I do. So I've never understood this dressing down phenomenon. I think guys, for work, they just should look better. Most of them, they don't know how to get dressed anyway, so with a suit and shirt and a tie, they all look at least appropriate. And it can be comfortable too. I don't understand how people always think it's so much more comfortable in a shirt and blue jeans. I'm equally comfortable in a suit and tie. I don't even have a pair of jeans. I have big thighs, so I wouldn't fit a pair of jeans.

Oh, I bet CALVIN makes jeans for the sporty guy with big thighs.
I don't like baggy jeans. The jeans that I would like are old LEVI'S 501's, and I just don't fit them.

(By now THOM and I have worked our way through a bottle of champagne at the exclusive SOHO HOUSE and we've cabbed to IL CANTINORI, a swanky restaurant in the East Village, where we're at a table in less than no time — even though the place is packed.)
Wow. I feel like we're on a date.

It's fun. Do you come here often?
Very often. Couple of times per week. I love the food here. It's like really beautifully prepared fresh food with the perfect ingredients. Really simple and clean, not fussy. And not a lot. I can be happy with one perfect spring bean, if you know what I mean. I like the idea of eating food to satisfy, but getting stuffed I find off-putting. I like drinking a lot, though. Just have fun with it.

That's of course a thing with neat dressing — you immediately assume that you have to act decently and not misbehave...
Really? I hate to hear that. Of course you can get dressed and have fun. That's what I think the British are the best at. You see these guys out in these beautiful Savile Row suits and they're just getting hammered. I think that's great.

Well, yeah, but if I go to a party I'm like, "I won't wear my wool suit 'cause I might end up sitting on the floor..."
Well, I think that's so chic, to get smashed and end up on the floor in your three-piece suit. And you just wash 'em the next day.

What did you wear when you were a kid?
Pretty much the same thing as now. I come from a family of seven, and my parents both worked and didn't really like shopping, so they pretty much opened up the BROOKS BROTHERS' catalogue and ordered a whole bunch of stuff and that's all we wore.

What did you parents do?
They were both attorneys. We're from Lancaster County, Pennsylvania. Beautiful area. My mother was an attorney for the county and my father was more into banking and finance. He would never ever have thought that he'd be an influence on me with the way he dressed. But I have this one photo of him

and his shoes are just the most attractive thing to me. He has these huge wingtips. I don't know why, but they just look so big. And he has this late '60s, early '70s suit on. If anybody influenced me to do what I'm doing now, it's him in that picture.

Do you ever feel too retro with what you do?
Absolutely not. I'm not retro at all.

Really?
Yeah, I really feel like my work is not retro at all. It's inspired by '50s and early '60s mentality, that mindset. The sensibility of how people lived back then. But it's done in a way that's very modern and very new. I don't want it to feel old-fashioned. I like to make things fit for younger guys, so that they feel like it's been made for them. So really, it's not retro at all. Retro always has that kind of kitschy connotation. Retro for me means that it's dated, and not timeless at all. I hate retro.

So, excuse me for my European background, but what exactly is the BROOKS BROTHERS' claim to fame?
It was just classic American clothing. When you graduated from college, you went to BROOKS BROTHERS for your first suit. That's what it was, your perfect, uniform, classic American clothing; your white or blue Oxford shirt. Stuff that every boy or man needed. The original store is still on Madison Avenue. Totally ruined though; it completely lost its heritage. Became too much like a glorified BANANA REPUBLIC. They just opened this new store on Fifth Avenue which is just terrible. So not what it should be. They

could still be huge. All they need to do is pull back and go into the archives and totally redo what they were all about: that true American style, which is so cool. People all around the world respond to it, that early JFK preppy-but-not-too-preppy American sense of men's dressing. That's what BROOKS BROTHERS was. But then the European influence came...

What sort of European influence would you yourself like to keep out of your collection?
Well, like a softer way of dressing. ARMANI did an amazing job with reinventing the men's jacket, but that's so not what I am about.

One way in which I think you have a little bit in common with ARMANI is that he tends to make his suits a bit too small, the arms a bit too short, so that the guy who wears it almost seems to bulge out of his suit, as if he's too big and too successful for his own clothes.
Really? I never noticed that. But his jackets are so soft and constructed, which is the opposite of what I do.

How did you actually go from acting into fashion design?
I was in sales and merchandising at ARMANI for a few years, and then RALPH LAUREN asked me to be head of menswear design at CLUB MONACO. RALPH is an amazing guy. How inventive must he be to do what he did, building this empire around a name? It's almost other-worldly how one person can do that. And what's great about RALPH is that he recognises talent and nurtures it and never tries to squelch that at all. He tries to build you up and help you,

which, of course, benefits him too. But CLUB MONACO isn't my kind of retailing. It's a real talent to be able to design for that kind of market. I don't think it was my talent; that's why I now do what I do. I want things to be really well done and fabrics to be the best they can be. At CLUB MONACO you can't do that, of course. Now I can do exactly what I want to do.

You can go in tomorrow and decide to use gold thread for everything.
Yeah. I'd always choose platinum, though.

Are you into jewellery for men?
No. A good old ROLEX is okay, but not those big fancy watches. Rings I don't like, they're not in the programme. And even cufflinks; I just like good old silk knots. But I'm hesitant about a lot of things to do with adornment; that's also why my ties are solid and not fancy. I wear a tie made of the same fabric that the suit is made of. Ties need to finish the outfit, as opposed to drawing attention to the outfit. Anything that draws too much attention... My thing is to make a man look better and bigger, as opposed to drawing attention to the actual things he's wearing.

Last week I went to this garage sale and the guy was selling hundreds of fancy RALPH LAUREN ties. They all looked sort of the same to me. I was wondering, what sort of shopping did this guy do, buying more and more of the same thing? So boring.
Well, that's the whole thing with the anti-uniform idea that I don't get. People having so much choice that you always look kind of different, which I think is so boring.

How many suits do you have?
Like, six or seven suits, and they're pretty much all the same. Most of them are these lighter ones. But if somebody is to buy a suit, I tend to recommend the heavier ones, because I think they tailor better, and with air-conditioning these days you don't have to wear a summer suit all summer long. Well, you guys in Europe don't have aircon everywhere, do you?

Thank god, no. I hate aircon.
Really? I love it. I hate being warm. I run around so much during the day and, especially in the summer, I get so warm that I'm always happy to cool off. I love being cold. My air-conditioner goes on in March and doesn't turn off until October. I also love sleeping in the cold.

But I love the feeling of being under a thick duvet. That's what I do summer and winter. To wake up and be totally drenched.
Are you kidding?

Absolutely not. Like yesterday it wasn't cold, but it was totally overcast and dark grey. I got into a cab, aircon blasting, and after a minute or two I felt like it was November. It was so depressing.
See, I love that type of weather. I love grey. Grey isn't my favourite colour for nothing.

Mr.
HENDERSON

Mr. FERGUS HENDERSON
Featured in issue n° 8 for Autumn and Winter 2008
Portraits by Juergen Teller
Text by Susie Rushton

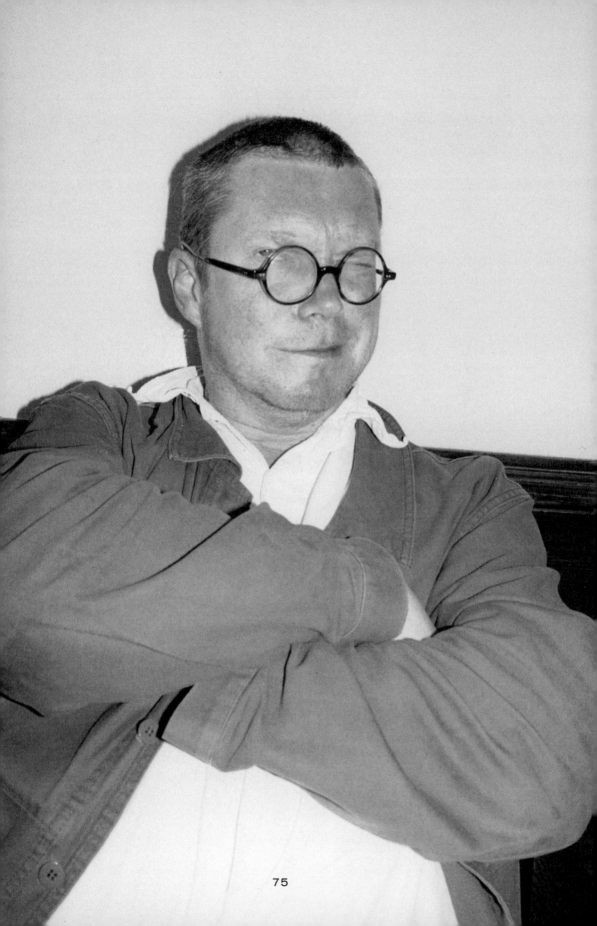

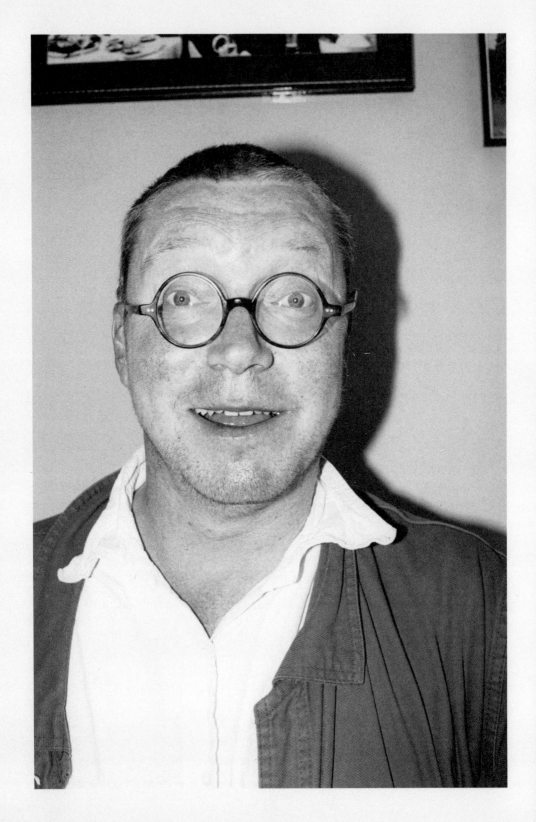

Mr. FERGUS HENDERSON is the visionary chef who has enabled the British to believe they actually have fine food to call their own. The son of two architects, he displays his architectural tendencies in the way he serves his signature Bone Marrow. A contender for the jolliest man in London, HENDERSON is the founder of ST. JOHN, which is now considered the 16th best restaurant in the world.

It is mid-morning, and FERGUS HENDERSON is savouring a small glass of FERNET BRANCA in the daylit bar of his east London restaurant, ST. JOHN.

"Lunch, aha! But I love lunch," he says, blue eyes gleaming behind outsized LE CORBUSIER-style spectacles. "Everything's right about lunch. It's daytime. Your body is just right. You have an aperitif. And everything's just *right*."

Can he really be suggesting that lunch is superior to supper, conventionally rated the more important and more sociable meal, and the most suitable occasion for appreciating excellent cookery, at least if you compare restaurant prices for daytime and evening sittings? Indeed he is.

"Lunch has potential, you see," HENDERSON goes on. "It could last all afternoon. Whereas supper has a full stop—boof. Lunch—cor! Lunch opens up all sorts of things. People toy with lunch. But then it starts to win them over. Some people frown on it, but the more they frown, the more I enjoy it. It doesn't have to be boozy. It doesn't have to go on for three hours—but it might do, which is the joy. You can't beat it."

At 10.30 in the morning, sitting with HENDERSON at a small, scrubbed wooden table, just catching the first notes of the kitchen's orchestra as it warms up, you find yourself agreeing that, yes, yes, yes, lunch is pretty unbeatable—especially when it's going to be lunch for two with a jovial and soft-spoken Englishman for whom a curious turn of events is "a rum do" and friends are always "chums".

At any time of day, the experience of eating at ST. JOHN is ripe with possibilities. Once seated in the austerely white, bright dining room, the diner might start off with a dish of Pig's Head and Radishes or Chitterlings and Dandelion; there then could follow Ox Heart and Chips, perhaps, or Fennel and Berkswell; and finally, if there's any room left, Bread Pudding and Butterscotch Sauce.

Not much is given away by those stark descriptions, which are typed in neat TIMES NEW ROMAN ("for some reason I like serifs," he says) on small white

paper menus that change twice a day. "There's no disappointment here, because we say so little. You can't be misled by any rogue element. So, yes, it's kept quite clipped. There's a chance for surprise." The typical ingredients in a ST. JOHN dish are very English and yet wildly exotic. Who on earth knows what chitterlings are? And what is Berkswell? (Pig's innards, and an English sheep's cheese, as I later discover.)

ST. JOHN opened in 1994. In the early days, dishes like squirrel liver paté startled diners and even caused minor scandals in the press. HENDERSON became famed for his use of offal: the innards, organs and squishy bits of a beast usually thrown away or ground up for sausage meat. Equally as radical was the plainness of his presentation, the minimality of his garnish. Think, for instance, of ST. JOHN's signature dish: Roast Bone Marrow and Parsley Salad. Served with *pain-de-campagne* toast, the diner uses a narrow, pin-like hook to scoop out the clear, meaty jelly from the middle of four sections of veal leg bone that stand, upright, on a plate. The American chef ANTHONY BOURDAIN has called this dish "the best thing I have ever put into my mouth... it's butter from God."

HENDERSON isn't short of gourmand fans. THE SUNDAY TIMES' A.A. GILL wrote an unkind review in the early days of ST. JOHN — which he famously later retracted. "I have few regrets as a restaurant critic," he wrote, "but one is that I didn't give FERGUS HENDERSON a better review when he opened in Clerkenwell years ago. ST. JOHN always looks you straight in the eye, and it does it in an observantly British way. Nothing to do with funny hats or Morris men or beefeaters. It is properly who we are."

And while the British capital becomes ever-more crowded with unfeasibly expensive, MICHELIN-starred dining venues, the original ST. JOHN has them flocking every lunch and dinnertime. The restaurant is currently number 16 in the S. PELLEGRINO WORLD'S 50 BEST RESTAURANTS LIST — in London only GORDON RAMSAY is higher, at 13, and a meal there will cost approximately three times as much.

HENDERSON's first book, THE WHOLE BEAST: NOSE TO TAIL EATING, is now considered a gastronomic classic; when it was first published, in 1999, recipes such as Blood Cake with Fried Eggs and Crispy Pig's Tail unintentionally taunted a fearful dining public. "I see it as a kind of catalogue," says its author. "An artist has a catalogue of his work at some point, and these recipes were my thinking at a certain point."

NOSE TO TAIL EATING is a cute name for a book that also sums up the philosophy of ST. JOHN — that is, the total consumption of a slaughtered beast, from the tip of its crispy snout to its gelatinous trotters. "It was only common sense that you could open the gastronomic floodgates if you looked beyond the

fillet to discover new textures and flavours. Take a pig's head. There are myriad joyful things you can do with it. The ears you can boil and set in jelly — it's fabulous, this wobbling jelly and then the cartilage crunch of ear. The snout makes a fantastic salad. Tongue. Cheeks. Brawn. And that's just the head. It wasn't a gimmick. If you were going to come up with a gimmick to open a restaurant with, it wouldn't be a great one. Eating the whole thing is only polite to the animal, too, which I'm a great believer in."

HENDERSON's handwriting is today discernible on restaurant menus from San Francisco to Sydney, both in a newfound emphasis on local and seasonal produce (he was an early adopter of locovorism) to the trendy fondness for affordable, old-fashioned cuts, such as pork belly and pig's trotters.

But HENDERSON didn't only change the eating public's perception of brains and ears; he also helped turn around a stereotypical view of Britain as the home of bland and badly executed cookery, a backwater where visitors from France and Italy snigger at national dishes that include baked beans on toast, fish 'n' chips or roast beef and Yorkshire pudding. While other chefs of international repute fiddled with *foie-gras*-flavoured foams or ethnic fusion food, over the past 15 years HENDERSON revitalised authentic British fare including cock-a-leekie, jugged hare, kedgeree, Welsh rarebit and haggis — the famed Scottish preparation of minced sheep lungs and oatmeal, all tied up in the animal's stomach. This was a cooking philosophy immune to the influence of imports such as the cheese-burger, nouvelle cuisine and salmon nigiri.

In NOSE TO TAIL EATING there is one recipe, Ham in Hay, which includes the instruction: "To obtain your hay, ask a friendly farmer, if one is to hand or simply ask around," a sentence that speaks to the very soul of every provincial Briton who dreams of escape to a greener life in Devon.

At the vanguard of the New British Cuisine though he may be, HENDERSON would rather not get caught up in nationalistic sentiment. "We're British by default, because we're here. I'm British, we use British meat," he says, "but it's not a jingoistic gesture. I see ST. JOHN as modernist, not as an olde-worlde, stuck-in-the-past type of place. We just cook. They can say what they want."

FERGUS HENDERSON is a celebrity chef in that his cooking is famous — but he doesn't do any of the silly, look-at-me cheffy things for which that archetype is best known. He doesn't appear on television. He doesn't advertise a national supermarket chain or a brand of instant gravy. In a profession known for hot-headedness and the routine abuse of lowly kitchen staff with scalding-hot frying pans, HENDERSON is singularly polite.

He hasn't worked in the kitchen at ST. JOHN since the symptoms of his Parkinson's disease, diagnosed in his early thirties, rendered him too tremulous.

But he insists that his staff share his affable attitude, and even in the kitchen, tempers are not allowed to boil over at the stove. "It's so unhelpful if chefs bicker in the middle of service," he says, mildly. "I believe in a happy kitchen: happy animal, happy carcass, chefs who are happy so they cook happily. If someone's in the middle of all that, going grrr—well, they're ruining the happy chain."

Certain subjects do exasperate him, especially about food. When I mention in passing a news article that day about how the orange-growing business is struggling because harried, contemporary shoppers are now too busy to peel a piece of fruit, he's momentarily furious. "This theory of no time any more, foodwise, drives me mad! That's why I like elevenses. Seedcake and Madeira. You've got time in the day for ten minutes at 11 o'clock. It's not a wild, crazy thing. People think that every moment must be used, but food seems to come at the end of the list. Or, what could be better than having a hare braising in the oven for three hours, leaving a delicious smell in the flat, have a bath, mix a MARTINI, what better time is that?"

HENDERSON's parents are both architects, and so is his sister. "Food was a feature" of his childhood, which was divided between London and Wiltshire. "My dad says that a white table cloth has kept our family together. We were all big eaters and drinkers."

In his youth FERGUS thought that he, too, would grow up to design buildings, and he trained for seven years at the ARCHITECTURAL ASSOCIATION in Bloomsbury. As a student, he lived at his parents' flat in London; THE FRENCH HOUSE, the *vin rouge*-saturated bar in Soho was his "second home". But at his first job in an architect's office, his "buildings ended up being feasts, became recipes for buildings, so there was a clue there..." The budding gastronome had also noticed, with dismay, that at the sacred hour of lunch, the other ambitious young architects did not stop for a proper meal but bought a takeaway sandwich and a can of COKE to consume in front of their drawing boards.

"I didn't understand. Nothing's going to kill creativity more than a sandwich and a can of COKE. So as a spiritual gesture I sacrificed myself to a long lunch. Which suggested to me that the architect's office wasn't the place for me." Yet today his speech often loops back to talk of buildings and ergonomics. He still thinks of himself as an architect, "just a little distracted by food". Both professions deal with design-space, he explains: "As an architect you affect people's manners and how they inhabit space. When you feed them, you affect their behaviour, so I've got it both ways. Like our bone marrow, for instance. It trusts you to instruct yourself on how to eat it. Personally, I'd sprinkle salt on it and eat it on toast. But it's Liberty Hall. If people want to suck the bones, gnaw them, scrape them, it's up

continued on page 93

WRONG — A deck shoe worn with a spectacular calf sock, a sartorial iconoclasm photographed by Daniel Riera for issue nº 17, Spring and Summer 2013.

GLASSWARE — A strikingly fine water glass held by FANTASTIC MAN's house hand model STUART GEE and captured by Daniel Riera for issue n° 12, Autumn and Winter 2010.

SPORT DE LUXE — An array of outfits attaining the headiest heights of wearable technology, photographed by Anuschka Blommers & Niels Schumm for issue nº 19 for Spring and Summer 2014.

POSING SHOES — Exquisite black patent leather loafers thrown into sharp relief with wide ribbed white cotton socks, photographed by Daniel Riera for issue n° 3, Spring and Summer 2006.

CLUTCH — A handle-free bag photographed by Zoë Ghertner for a tantalising photographic preview of THE GENTLEWOMAN, as nestled inside the pages of FANTASTIC MAN issue n° 10, Autumn and Winter 2009.

THE SEASONALS — One of five specific neckline propositions for the Autumn and Winter season 2010: a roll and a scoop neck sandwiching a cotton shirt, photographed by Zoë Ghertner for issue n° 12.

SMART — A white cotton shirt and black wool jacket detailed in "Older", a story devoted to mature style, photographed by Andreas Larsson for issue n° 2, Autumn and Winter 2005.

CAMEL GALORE — Five multi-layered shades of camel in cotton, cashmere, tweed and silk, as photo-graphed by Paul Wetherell for issue n° 8, Autumn and Winter 2008.

PIECE — Leather trousers, not too tight and not too baggy, are a fine alternative to denim in this practical wardrobe proposition for Autumn and Winter 2013, photographed by Daniel Riera for issue n° 18.

GOODBYE — A sturdy sheepskin glove made for outdoor activity is worn atop careful layering at the wrist. Photographed by Paul Wetherell for issue n° 8, Autumn and Winter 2008.

to them—which in its way is doing the same thing as architecture. It affects their manners and how they occupy their space."

HENDERSON, who is 45, taught himself to cook. He read recipe books "like other people read novels" and cites as particularly influential MARCELLA HAZAN's CLASSIC ITALIAN COOK BOOK and CAROLINE CONRAN's DELICIOUS HOME COOKING FROM AROUND THE BRITISH ISLES. His first proper job as a chef was at THE GLOBE, a restaurant in Notting Hill. It was at that time that he met his wife. MARGOT, who is also a cook. Back then, MARGOT was a chef at THE EAGLE, a gastropub in east London; they fell in love, and cooked together at his student haunt, THE FRENCH HOUSE. "Those days sound so simple and romantic. We could get quite cross with each other and then kiss and make up—I can't do that here."

Today, MARGOT is chef of the ROCHELLE CANTEEN, a rather posh café that is only open for lunch, and sits hidden inside the converted Shoreditch schoolhouse where fashion designers GILES DEACON and LUELLA BARTLEY have their studios, as does MICHAEL RAEDECKER, the artist. HENDERSON describes MARGOT's style of cookery as "lovely, chargrilled, racier than mine." They live in Covent Garden, but on the day we meet she is in New York; the couple have three children.

"Around 1998" HENDERSON was diagnosed with Parkinson's disease, at which point, he once remarked, he went out for a good lunch and soon felt better about the whole thing. Over some years the condition caused him to become, as he puts it, "a human windmill. Mainly on the left side. Limping and all sorts of things. The pills worked incredibly well but they caused seizures too, great big moments. I'd flail around and tablecloths would go everywhere. I was nice and thin then; it was a constant workout and I couldn't really eat..." In 2005 he had brain surgery at the National Hospital for Neurology and Neurosurgery in Bloomsbury, central London. Doctors drilled into his skull to implant a wire with four electrodes that would stimulate his brain and reduce the troublesome movements.

HENDERSON is matter-of-fact about the operation and the Deep Brain Stimulation, which is a fairly new treatment. "It's one thing having someone drill into your skull, but imagine drilling into someone else's skull! Chefs get all this coverage in the papers, but not enough is said about these amazing people. They really are angels," he says. Under his shirt on his right side, he tells me, are concealed the battery and controller for his implant, which sends electrical impulses into his brain in order to reduce the more kinetic symptoms of Parkinson's. He admits he doesn't really know how the stimulator works. "I'm an ostrich in the sand about it. I can't face joining a Parkinson's group. It's not for me. I'll

just carry on in my own Parky way. But, phew! It's corny, Hollywood, new-lease-of-life stuff."

With that, we head outside for a pre-lunch cigarette: "Yes, the doctors did want me to stop. But, when I tried giving up, I lost my hearing..."

Shortly before 12.30pm, we settle down at a table in the corner of the white-washed restaurant, diners craning their necks to sneak a look at the chef. Most weekday lunchtimes, HENDERSON is found eating at either ST. JOHN, or ST. JOHN BREAD AND WINE next to Spitalfields Market, which is a more relaxed offshoot specialising in bakery. From this spot, he can watch the entrance as customers are greeted by the *Maître d'*. The place is filling up, mostly with groups of men in suits from the nearby financial institutions. "But, tomorrow, it might be ladies," he says, gaily, "not that we have ladies who lunch!" He orders us Peas in Pods with Gulls Eggs, Asparagus with Butter, and a bottle of MERSAULT. All the wine at ST. JOHN is French, "because it's close. There's something romantic about it. Burgundy is the most misbehaved wine *ever*. Sometimes it's just not coming out to play. And then, three days later, it wakes up again, and it's really good."

A plate with half a dozen hot, fat fingers of asparagus is the first dish to arrive at our table. HENDERSON tips a small pot of golden liquid butter over the vegetables and we prong them with our forks.

At this point in the meal it seems right to cross-examine him on his views on the specifics of dining. Wine glasses should be "utilitarian, not too high" club glasses with short stems, a type hated by wine writers, so he says, for being too small and thick. Plates should be white, not too large, and round — "square plates should be smashed on the floor." Tablecloths should be white paper on top, with linen underneath: "It's PROUST's pillow theory. The combination of the sheet over the pillow is very comforting."

Waiters, meanwhile, should be dressed entirely in white. "But that's not to demean them, because they're not servile, but sentinels of joy, bringing you lunch or supper and making you happy. They should be friendly, which is good, and knowledgeable, too — but not too friendly. No. And they should never crouch at the table." HENDERSON is very firm on this point. "It's just not on. They should be bringers of joy, and if they crouch down to say, 'What do you want for pudding', it's just not on, no, no."

The hubbub in the dining room increases. Our cold, soft-boiled gulls' eggs arrive and we sprinkle salt on the buttery, unctuous yolk that tastes faintly of the sea. The peas-in-pods are raw, and served plain. "Nothing better than going into the garden and getting fresh peas." It is a comforting, if austere, appetiser. But many of the other diners in the room are tucking into the famed ST. JOHN dish of

veal bones. I can't help but notice that these bone-gnawers (all male) approach this dish with the bluster reserved for serious, brow-creasing come-on-be-a-man-challenges. What does HENDERSON, a mild-mannered gentleman who loves food truly and without irony, think of those who view all his offaly creations as "scary" dishes to be conquered by the brave? "Well, that's their choice. But it's wrong. We do get tables of city boys in here, trying to eat the 'scariest' thing on the menu. But *nothing* on the menu is scary," he insists. "It's all delicious. Probably the weirdest thing is spleen. And spleen is a very well-behaved organ."

We are rapidly heading south through the MERSAULT, so it's a relief when the sentinel of joy returns with our main courses. HENDERSON negotiates Ox Heart and Chips, I notice not finishing his dish, while I attack a giant lamb shank ("very FLINTSTONES," he comments, approvingly, of the large joint), which is roasted not to a brownish colour but glistening and still a little pink. No sauce. No clots of garlic. The meat is ungarlanded, naked and delicious. As I tear flesh from bone, he tells me about the new book he's writing, long hand, in his office above ST. JOHN. It is not a recipe book. "It's going to be vaguely autobiographical, and I'm doing the illustrations, too. It's a little like DIDEROT's ENCYCLOPAEDIA, where he chronicled all the crafts and trades. I sort of see myself as a modern-day DIDEROT — a bit presumptuous, I know, but we'll skip over that..."

By the time we share a dessert — a quite devastating Queen of Puddings, with layers of meringue that melt into jam and then a custardy base — our conversation is, to put it politely, rambling. A glass each of *eau de vie pruneaux*, a dark-brown, pongy digestive without the sweetness its name suggests, is an appropriate full stop to a lunch that has fulfilled every last drop of its potential. "I wouldn't recommend cooking, really, unless you love it," says HENDERSON, sagely. "Either you're in an empty restaurant and you're miserable, or a busy one, and you're going crazy. You can only go out when everyone else is at work, and you have to work when everyone is having fun. No, I wouldn't recommend it. But I happen to love it." He smiles — well, in fact, he's been smiling almost the entire time we've been talking — and we both take a swig of *eau de vie*. "Well! That opens the eyes, doesn't it?"

Mr. DAVID BECKHAM

Featured in issue n° 13 for Spring and Summer 2011

The extraordinarily photogenic retired foot-baller DAVID BECKHAM understands how to pose. Freezing his face in the same un-readable expression each time he is faced with a camera, he appears equally handsome in every picture. In preparation for this shoot, FANTASTIC MAN was asked to propose mood boards for location, styling and hair. Of the possible new styles, DAVID settled on a quiff with close-cropped sides and bouf-fant-top, a look that has come to be known as the "Shoreditch quiff". This has since become part of DAVID's regular tonsorial repertoire.

In a nod to his childhood on the east London/ Essex border, DAVID was photographed in F. COOKE's pie and mash shop on Hoxton Street. At the time of the interview, there was speculation that DAVID was about to open a chain of pie and mash shops with his friend the angry British chef GORDON RAMSAY. This has not yet come to pass, although DAVID is currently said to be building a range of branded consumer products in conjunction with the Hong Kong company GLOBAL BRANDS GROUP HOLDING LTD. that will grow into a multi-billion dollar business in five years.

Portrait by Alasdair McLellan

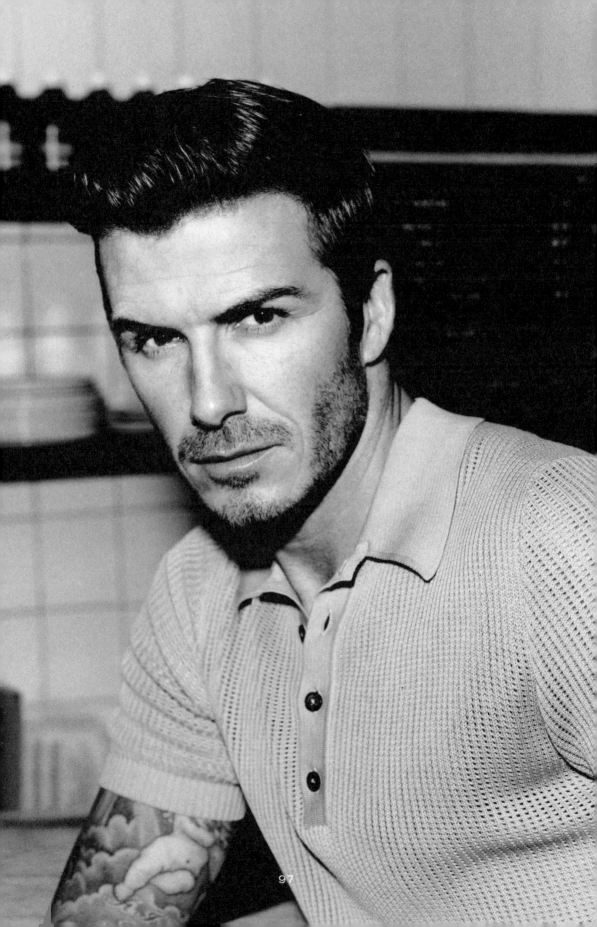

Mr.
REM KOOLHAAS

Mr. REM KOOLHAAS
Featured in issue n° 6 for Autumn and Winter 2007
Portraits by Wolfgang Tillmans
Text by Susie Rushton

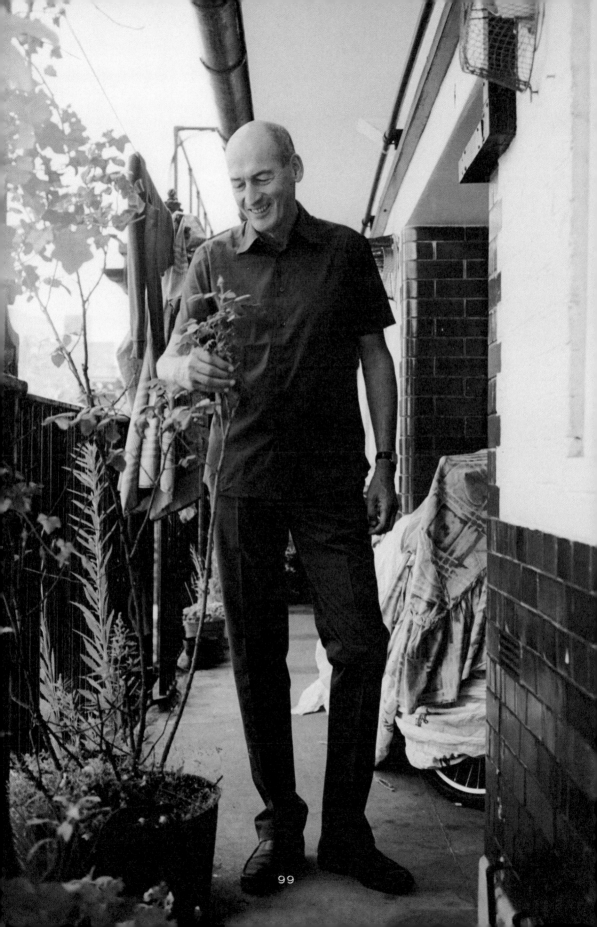

Wearing his global fame as lightly as his PRADA separates, the amazing architect REM KOOLHAAS is the most entertaining conversationalist one could ever hope to meet. The tricky part is arranging these meetings, since REM's customary travel itinerary takes him from London to Beijing to Lagos to Rotterdam and back again in any given week. But once you do, it's fun to go for walks and explore subjects as diverse as his lack of possessions and the loneliness of the long-distance swimmer. He might even take you out for a hair-raising spin in his black 1998 BMW 840, a model chosen by this charming provocateur specifically for its popularity among delinquents.

Architecture, as everybody knows, is the sexiest profession in the world. But, in person, none in the firmament of "starchitects" leaves one breathless in quite the same way as Mr. REM KOOLHAAS. This is meant quite literally. The tails of his three-quarter-length parchment-coloured lightweight PRADA mac fluttering in the wake of his stride, the PRITZKER PRIZE winning architect, urban theorist and hilarious writer is in perpetual motion. Simply to walk from A to B in lockstep with KOOLHAAS requires a certain level of physical stamina. The average week sees him flying to China, Russia, Nigeria, Italy, Dubai and elsewhere to attend to his mega-projects, and wherever he is, he swims every day — and has good-looking forearms to show for it. But between the ages of 30 and 50, he went running to keep fit. In one of his influential books, S,M,L,XL, there is a photograph of a younger KOOLHAAS jogging in the street in Japan. "But then I quit it. I was afraid of looking a bit, you know, desperate," he says, letting his tongue loll out in mock exhaustion. "Besides, I felt it wasn't actually that different from what I was doing all day long anyway."

When he's not on long-haul appointments he lives between a Victorian house in north London and a "tiny, four metres by four metres, Tokyo-style" apartment eleven stories above the river Maas in Rotterdam. KOOLHAAS thinks that "now, you can basically treat the two countries as one," but all the same, it's a punishing commute.

He thinks that it's because he can run that, even when he lived in crime-ridden New York in the '70s, KOOLHAAS has never been robbed. "Or maybe that's because I'm tall." Does he ever use his height deliberately to intimidate others? "No, but I'm aware of it," he admits. "For me, it's more of a vulnerability. You feel too big for the world and it's very easy to get wounded or to hit yourself. It's slightly harder to move. So you have to be more careful. It doesn't feel like something that gives you power. And I've come to realise that the reason that I don't want to get *fat* is that I don't want to be really *imposing.*"

He was born in the very humdrum Dutch harbour city of Rotterdam in 1944, but it was not for nostalgia that, in 1975, he made it home to his OFFICE FOR METROPOLITAN ARCHITECTURE (OMA) and, later, its think-tank twin AMO. Rotterdam offers no distractions from work, he says, and that work today means twenty major projects at any one time, from rethinking contemporary curatorial practices for THE STATE HERMITAGE MUSEUM in St. Petersburg to designing China's second-biggest stock exchange in Shenzhen and its new 230-metre-high CCTV television centre in Beijing, which will resemble a skyscraper bent into a continuous loop.

On the morning we first meet, we eat scrambled eggs in a restaurant that overlooks the central station in Rotterdam. One of KOOLHAAS' first completed buildings used to stand there. It has just been razed to the ground. What was it? "It was a tiny thing that basically welcomed you when you came out of the station. You could get tickets for trams there." A bus shelter, then? "More or less. No big deal," he says, not glancing over at the rubble behind him. But doesn't he mind? It was one of the first things he built in Holland. "Yeah, and one of the last," he says flatly. "These days architects get to build very little in their own environment. Besides. I write a lot about *the provisional,* so I'm willing to take the consequences. It's not logical that everything stays." Would he be sad to see any of his other buildings flattened by the wrecking ball? "Some of them. If it's small, it's easy to destroy. But the buildings we do now are harder to destroy."

One of the many controversial things that KOOLHAAS says about his profession is that beauty shouldn't be the architect's pre-eminent aim. "Beauty isn't what I'm primarily interested in. I think appropriateness is more important," he once told DER SPIEGEL. For KOOLHAAS, the political, social and even psychological context of a site should guide a building's design. To some, the results of this approach may look stubbornly plain or bulky in comparison to the extravagance of ZAHA HADID and FRANK GEHRY designs. KOOLHAAS has described his own work as "flamboyant conceptually but not formally". In the last few years, however, OMA has built major projects that are not only intelligently conceived but also undeniably beautiful. Two particularly gorgeous new buildings are the SEATTLE PUBLIC LIBRARY (finished in 2004) and CASA DA

MÚSICA concert hall in Porto (2005). The former NEW YORK TIMES architecture critic HERBERT MUSCHAMP called the Seattle library "the most exciting new building it has been my honor to review."

Perversely, the OMA/AMO office is split between the ground level and fourth floor of a generic block, forcing the 200-odd employees to walk around the outside of the building when they move between departments. (Perhaps this avoidable irritant is in keeping with KOOLHAAS' own liking for obstacles. He doesn't save numbers into his cell phone, preferring to memorise up to 60 contacts; in his earlier books he wrote without ever using the word "though".) KOOLHAAS' office is on the upper floor. On one side there is a floor-to-ceiling view of Rotterdam's suburbs, on the other, a glass wall on the interior allows surveillance of several projects that are in an early model-making phase: shards of clear Perspex and blue foam cubes daintily arranged on faux landscapes.

KOOLHAAS' office is determinedly utilitarian in that stylish way. Grey floor. Purple leather EAMES MANAGEMENT chair. Grey institutional-style metal shelves that hold hundreds of books: biographies, architectural books, photographic books, monographs of OLAFUR ELIASSON and GERHARD RICHTER, the writings of MICHEL DE MONTAIGNE (in French). His desk is a plain long wooden trestle set with THE ECONOMIST and THE INTERNATIONAL HERALD TRIBUNE (but he's a voracious reader of all press), a big box of red BIC biros, a book about SALVADOR DALÍ and another entitled MACHIAVELLI — A MAN MISUNDERSTOOD. At the moment, he says, he's reading the script of the movie version of shocking French writer MICHEL HOUELLEBECQ's THE POSSIBILITY OF AN ISLAND. OMA/AMO is designing the set, which will be a city in the grip of an earthquake. In front of the books are some intriguing bits and bobs: swimming goggles, a hard hat, PRADA perfume, his PRITZKER PRIZE medal (the highest accolade of his profession, which KOOLHAAS was awarded in 2000), two small wooden plaques reading "Lack of charisma can be fatal" and "Money creates taste". Three more slogan postcards are propped up too: "Mental", "Sorry" and "Liar". There is a story that the latter was once pinned onto KOOLHAAS' office door anonymously by an employee. He is said to have left it there for a week.

In Holland he gets about in a black sports car, usually driving himself. Until recently he drove a MASERATI, until it had what he terms "a meltdown" in Brussels' city centre. "I've now got a 1998 BMW 840 which I bought on the Internet. I think all cars are *so hideous* now. And I remembered in a flash that I'd once seen this car parked near the TATE and that was the last really good car design, so I looked on the Internet and got one. And it's a very nice car because it's popular with drug dealers, police and, equally, with teenagers."

But later on, at lunchtime, KOOLHAAS walks the short distance between the OMA building and the Chinese restaurant where a delegation of officials from the city of Shenzhen are waiting to dine with their architect. That morning he and his project architects had given a presentation to their expectant clients. As at any firm, such occasions are often tense. Having beaten off the competition and won the commission, architects must then go about defending their original winning design from the nit-picking queries of zealous or conservative clients.

The OMA design for the stock exchange features a trading floor that juts out, appearing to float around the waist of a 200m glass skyscraper. The rise and fall of share prices will stream down "digital banners" that hang from the underside of the trading floor. Had KOOLHAAS managed to charm them that morning? "I would say charm and a bit of... intimidation," he says, dryly, although that's not to say he hasn't the highest regard for his Chinese clients. "The only trouble with the Chinese is that they are so *democratic*." Presumably provided by one of the two full-time PARKs (Personal Assistant of Rem Koolhaas) that keep track of his movements, he holds a computer printout map of the streets with which to navigate our route to the restaurant. Two giant red arrows mark the start and finish. "The Chinese are really much more accessible, and the decision-makers among them are very young, that's the great thing," he goes on, crossing over to the sunny side at a pace of around 10 km/h, "In America they are often doddery old men, boards of trustees, in *sweaters*." Crossing a road near the restaurant, he slows his pace in order to force an oncoming sports car to brake. As it swerves away, he narrows his eyes: "Huh. Girl driver."

Mr. KOOLHAAS is surely the only person in the world who can use sarcasm as an effective tool for flirtation. Stylishly, he never laughs or even smiles at his own jokes and witheringly ironic observations. He also has a charming way of being fascinated in an interlocutor, although on most occasions he is the most fascinating person present. Yet, in the air about him, there is often the sensation that his legendary temper could detonate at any second. Sometimes this thrilling possibility is only subtly felt. There were only slight vibrations of it in the exchange he had with the cashier in the café on the morning we meet. "Did you have the full breakfast?" she had asked mechanically, as KOOLHAAS, already making for the exit, hurriedly offered her at least two credit cards from his pocket. "Well, that depends on how you define 'full'," he deadpanned. More seriously, at one moment mid-morning on the upper floor a short, malevolent roar can be heard. Has an Alsatian been let loose into the office? No — it turns out to be a minor outburst from the chief architect. There is a rumour that when ZAHA HADID was working for him, KOOLHAAS once threw a chair at her. I never manage to ask him if this is true (and more importantly, if so, what kind of chair it was). But it seems KOOLHAAS can amplify and muffle his temper at will. Does he think it's fair

that he's sometimes described as "prickly"? "No. I'm patient. I'm incredibly patient," he says, sounding slightly impatient. "I mean — look at a day like this! And it's like this day after day after day. What can I say? No, I don't get annoyed easily, or yes, I do get annoyed easily. Probably both!"

The art curator HANS ULRICH OBRIST recalls that his first meeting with KOOLHAAS almost took place at the Rotterdam office in 1996. He and a colleague made a special trip to Holland to try to talk to the architect about collaborating on an exhibition of Asian art called CITIES ON THE MOVE. But KOOLHAAS was so focused on various projects under way at OMA, "that it quickly became obvious that we weren't going to have time to talk. Eventually he told us that he was flying to Hong Kong the next day. So we changed our schedule and flew there too. The meeting took place, 24 hours later, in Hong Kong." Somehow hitching a ride on KOOLHAAS' itinerant schedule is indeed often the best way to engage him in conversation (although he is extremely fond of SMS text messaging too).

So at around 5.30pm, his presentation over-run, several flights to London now missed and new tickets purchased (a frequent occurrence; PARKs often purchase up to five plane tickets to different destinations on any given day, with KOOLHAAS only at the last minute knowing which he should take) we jump into the BMW. Shooting away from the OMA building, the car takes a sharp right. "I may have to transgress a number of traffic... ah... rules," he says, narrowly avoiding a cyclist.

His car is the only one of KOOLHAAS' possessions that could remotely be described as flashy. Has this late-won success brought him personal wealth? "I'm from a generation and class that never even thought about money, which for a very long time was obviously a huge strength," he says. When he won the PRITZKER PRIZE in 2000, then worth $100,000, "the idea of money was so exotic that just to have it in the bank was exciting. It would have been a lot less exciting to have had two dollars less. The round number was... crucial." He had never thought about money before that? *"Thought?* I never thought about money in my life until five years ago. That has enabled us to survive, to not be commercial, to invest in daring ideas to basically make OMA/AMO a machine for thinking, not for profit. Now there's an *absolutely annoying* situation, which is the total triumph of the market economy. If you look at the income of movie stars, sports stars, singers, even writers, they have astronomically increased. But architecture is one profession that hasn't benefited from the same increase. Now I think it's an issue of justice and humiliation because we are basically the ones that are designing icons for the market economy but we don't participate in it." Do you have enough to buy whatever you want to buy? "No. No. I'm not a millionaire."

To make his point he tells me that he had recently found what he describes as "a hut" on the coast of Sardinia and hoped to make it a holiday home — "I am becoming less and less urban" — but was outbid by another buyer. What does he spend his money on? "Books. I guess, travel. It's not on possessions. I have almost nothing. No paintings, no art." No art collection? "I dread to think about that." You wouldn't want one? "Not right now. There's a lot of art that I find unbelievably stimulating and deeply desirable," he thinks for a minute.

It seems that we're doing more than 200 km/h, weaving through three lanes of traffic. "I'd like to have a headboard by FONTANA, for instance. I saw it for the first time in the GUGGENHEIM a couple of months ago."

Given that he starts work at his office at 6.30am and then often continues until after midnight, one assumes that his private life is inevitably limited. Is there something about the job of the architect, in particular, that precludes serious romantic relationships? His own unconventional arrangement — KOOLHAAS has a wife in London, and also has a long-term relationship with an interior designer in Holland — is publicly acknowledged. He thinks for a moment. "It's not the kind of profession that you can exercise in a half-hearted way. And I think a relationship is typically not something that works well if it is half-hearted. So there's only really room for one fully-engaging thing at one time. And basically because the architect has a fundamental dependency — which I feel to be absolutely insulting — on the schedules of others, therefore I am fundamentally unreliable. That's something that is totally humiliating and it hurts us even more than the people in our lives. Invariably it drives those people up the wall. And in the best case that leads to a kind of resigned scepticism, you know?" Has his personal life been compromised by his professional choices? "No. No," he insists, "I've done really, exactly what I wanted to. Although I think I've made compromises in the larger sense of being absolutely uncompromising, and found people who, if not encouraging, are willing to sometimes encourage it, or at least *tolerate* it." Is there something intrinsically masculine about the job of an architect? He considers for a moment, his long-limbed frame almost folded in two by the car's deep bucket seats. "The answer is definitely yes. And it's partly about overt ambition — somehow the world has become a lot less tolerant of overt displays of ambition. So it's to some extent the last refuge where ambition is not considered to be evil. But it's interesting because architecture also has such feminine sides. It's all at the same time mathematical, financial and touchy-feely — and psychological. So I would actually say it's fifty-fifty." More seriously, why do so many of them have terrible dress sense? "You mean all the black?" The bow ties, the weird spectacles...

"Well," he shrugs, "It doesn't bother me. Lack of fun, I would say. I mean, I think that's certainly the endemic issue that is basically translated into bad dress sense. Or let's say — *an awkward relationship with all kinds of pleasure.*" We

career into the valet-parking area at Schiphol airport. "Were you afraid?" he asks, as we run inside the terminal with only moments to spare, "Because I did that really fast."

It is on aeroplanes that KOOLHAAS has time to be alone, he says. "So I spend quite a lot of time alone. That's when I like to write." He has just completed a book about the urban evolution of Lagos. In a previous career, in his early twenties, KOOLHAAS had been a journalist and scriptwriter. For the news weekly HAAGSE POST he wrote profiles of cultural figures including CONSTANT NIEUWENHUYS and FEDERICO FELLINI. He wrote about cars. He wrote scripts for movies, one of which got made (THE WHITE SLAVE, in collaboration with director RENE DAALDER in 1969). After switching to architecture at 25, he made his name with a book, DELIRIOUS NEW YORK. It analysed the growth of Manhattan's high-rise skyline, but surprisingly, like other books published over his career such as S,M,L,XL, CONTENT and the HARVARD GUIDE TO SHOPPING, it doesn't comprise technical drawings and impenetrable text, but is instead accessible and entertaining. Even more unexpected in the architectural genre perhaps is the amount of sex in his books, either as subtext or more obvious allusion. The original artwork of DELIRIOUS NEW YORK, drawn by his wife MADELON VRIESENDORP, depicted two skyscrapers *in flagrante delicto*. Forgive the national stereotype, but in England we think of the Dutch as being very permissive about sex. Is he typically Dutch in that way? He sniffs. We are sitting in a KLM plane waiting for it to take off. "Well I am probably more typically Dutch than I think I am. Although of course no one is happy to discover they are typical in anything. Everything Dutch is so incredibly straightforward and this is slightly different: it's not that I'm uninhibited about sex, but I want to introduce into a discourse that is ostensibly about other things, a domain that is usually excluded from it. I'm interested in confrontation. I'm also simply protesting against the denial that architects have *any life from the neck down*. I think that's ridiculous. I think that architecture is not only essential but also determines how human bodies feel and interact. So it's a very sexual art. What do you think when you see those references?" he asks. "Does it seem annoying or over the top?"

It's noticeable, but amusing.

"But it's also a secret adhesion to a classical world," he says, somewhat cryptically. "You know, there are moments when I feel very Roman." (KOOLHAAS is not lacking in self-knowledge. "I'm a bit worried," he later admits. "Every time you switch on that tape recorder I feel like I speak in aphorisms.")

Do you ever have time to use porn? "I used to, yes. When I first went to America, in 1972, I was studying in Ithaca and went to the cinema religiously every week to see the new pornographic movie. And I would say that pornogra-

phy then was a lot more fun because it was usually with real people, no artificial breasts, and it had a different aesthetic. They were more existential movies, say about somebody who had to fuck within the next fifteen minutes or they would die. Yes, it even had a plot." Are you saying porn isn't what it used to be? "Well. I always hesitate to say that," says KOOLHAAS, who is famously mistrustful of all nostalgia, "but let's say, it doesn't have that... charm. It's become too niche."

Staying on corporeal matters, is he a good cook? "I can cook Indonesian food," he offers. He lived in Jakarta from the ages of eight to twelve, when his father took a job at a cultural institute there. "It's about manipulating taste, not so much to show something in its pure form but to create impurities and contaminations in everything." He is aghast at the suggestion that he goes out to fancy restaurants with MICHELIN stars. "I have an absolutely *un-mondaine* life. In that sense, the reason we are in Holland professionally is that we can establish a completely utilitarian kind of life. When I go out in London I eat Indian or Ethiopian food. I think I've been to a two-star restaurant maybe *twice* in my life."

On the second occasion we meet, later on in the summer in London, we go for a walk with WOLFGANG TILLMANS, who has photographed KOOLHAAS several times.

Just a little up the road from TILLMANS' home on the top floor of a 19th century social housing project is Calthorpe Street, a terrace of houses where KOOLHAAS first lived on moving to London in 1968, as a student at the Architectural Association. We stop to look at the very basement flat that was once his home: "I cried every time I put the key in the door."

It is hot today, and REM is once again wearing what looks like PRADA: both beautiful and appropriate, suitably enough. The fashion house is one of his clients. In 1999 MIUCCIA PRADA and PATRIZIO BERTELLI visited the OMA office in Rotterdam, "almost unannounced. They basically said they were really bored with their stores, and wanted to rethink them. They said a number of things, in alternating voices, and we wrote them down and kept them as a mantra. We said, 'We don't know if we can do stores. We need time to consider it.' It was our first fashion client, and actually one of the first for shopping. After six weeks, we said, 'We have ideas.' In order to get into it, in a Maoist way we had to read that mantra every day." His firm's involvement with PRADA of course resulted in two EPICENTER stores in New York and LA, but AMO now works with the Italian fashion house continuously on catwalk shows, online projects, special exhibitions and even limited-edition T-shirts.

KOOLHAAS claims not to be fastidious about his own appearance, claiming, "I don't think about it a lot, but on the other hand it's something that plays a huge role in one's professional life. I don't always think in a necessarily European way. I

think it's an Indonesian thing, as in: I don't have a very highly developed idea of where I begin and what I'm about."

Carelessly selected or not, KOOLHAAS prefers to wear narrow, charcoal-grey trousers with a sharp crease that runs the length of the leg, stopping slightly short of the ankle, with black Chelsea boots. The parchment-coloured mac is now slightly crumpled and described by its owner as "the abused coat". The sleeves of his dark-grey cashmere sweater are pushed back; when he is listening or in thought he hugs himself, cocks his head to one side. "At some point I actually wanted to be a fashion designer," he says suddenly. "It wasn't very serious. It was in the '50s, and then, fashion was very important. It was on the front pages. Change would be announced like an earthquake, and a month later everybody on the street would be transformed." Did he subscribe to a particular fashion cult in his youth? "Yeah, there are pictures of me with very narrow ties. As a teenager, the model was Italy. Italian movies. That sort of elegance. When I was 18 I had an ALFA ROMEO. So that was my overall... *Gestalt.*" In the latest men's PRADA show, Spring/Summer 2008, he particularly liked "these kind of thick, knitted pyjamas. They were somewhere between underwear, streetwear and thermalwear. I think it's interesting that she tries to do things that are *practically impossible.* Like to reinvent what the French call *salopettes*... what's the English word? Ah, yes, dungarees. To reinvent dungarees." Does he discuss fashion design with MIUCCIA? "Yes — although I don't want to in that sense *claim* anything — but there is a conversation where we comment quite seriously. And sometimes it's part of a larger discussion, for instance now that they are expanding into China and elsewhere. We are often already working in those worlds so we have had the first experiences with taste — different meanings of colour, of texture. So we communicate about that."

Engaged as he is with global politics, economics and urban design — not to mention dungarees — KOOLHAAS says that people tend to assume he has no spiritual beliefs. Although the ludicrous rumour that he is a SCIENTOLOGIST isn't true, he says, "There's a funny interview, a PROUST questionnaire, in one of the Dutch magazines. One of the questions is, 'Did you ever have a mystical experience?' And every single Dutch person says no, immediately, without even thinking. I think it's essential to have mystical experiences. I have them all the time." He's vague about the details, but most recently, he had one while out on a long swim in the Mediterranean. KOOLHAAS likes to venture out alone into the open sea for up to two-and-a-half hours at a time, and among his many ambitions, he wants to swim from Sardinia to Corsica. Maybe it is out in the sea that his perpetual motions finally cancel each other out. "After a while, it becomes no effort at all. You just float."

Mr. RUPERT EVERETT

Featured in issue nº 1 for Spring and Summer 2005

The talented, handsome and very witty actor RUPERT EVERETT was FANTASTIC MAN's first cover star. Photographed in Miami by BENJAMIN ALEXANDER HUSEBY and styled by NICOLA FORMICHETTI, he is shown over five spreads in black and white and colour, with shirt on and bare chested, swimming-pool slicked and sundried. His slightly tousled glamour is consistent throughout. At the time of the feature, RUPERT was holed up in Florida writing his memoir, the first volume of which, RED CARPETS AND OTHER BANANA SKINS, was released in 2006 to fabulous reviews. Published six years later, the second volume VANISHED YEARS was equally well received.

RUPERT first became famous as the star of ANOTHER COUNTRY, a play loosely based on the life of the double agent GUY BURGESS that led to a film of the same title. Aged 22 when he took the lead role GUY BENNETT at the Greenwich Theatre, RUPERT's ravishing looks and mesmerising stage presence made him an instant celebrity. RUPERT has always been open about his homosexuality, but has often said that his honesty inhibited his career, particularly when he was young. Through his success as a writer, however, RUPERT appears to be having the last laugh.

Portrait by Benjamin Alexander Huseby

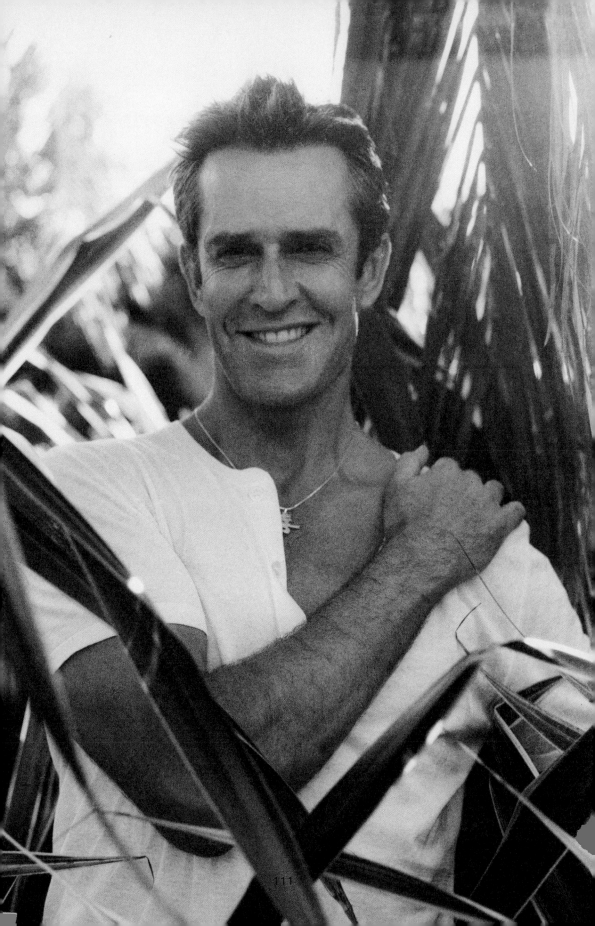

Mr. TYLER BRÛLÉ
Featured in issue n° 8 for Autumn and Winter 2008
Portraits by Tim Gutt
Text by Charlie Porter

Mr. BRÛLÉ

Mr. TYLER BRÛLÉ is the brains behind first WALLPAPER and now MONOCLE, both magazines with the intent to shake up modern media. In the process he has built up a public persona of mythical proportions, with first-class travel, in-house chefs — tall tales that turn out to be mostly true. Canadian born, shot in Afghanistan, BRÛLÉ owns an island in Sweden and commutes between St. Moritz and London.

It is a public holiday in Britain, and TYLER BRÛLÉ is working. He is in the London headquarters of his 17-month-old magazine MONOCLE, which he describes as a briefing on international affairs. This evening he is flying to Istanbul to give a talk at the British consulate before returning the next day to finish off the forthcoming issue. It seems to be a usual Monday/Tuesday schedule for him. His next planned trip will take him from Stockholm to Munich to New York to Toronto to Helsinki, back to Stockholm and then to Zurich, all in eight days.

Does he mind these quick trips? "I do like doing it," he says. "In a way it's just part of my own personal narrative, and I guess the narrative that informs the magazine as well." And how would he describe his narrative? "It's kind of hard to speak of it with distance," he says. "There's the narrative where I become my own personal brand, but it's also the way I live. I'm constantly on a plane and I'm pinballing around the world. That has become the narrative, in one way it's myth but it's also the reality."

Mr. BRÛLÉ's work is full of personal narrative. His magazines are an embodiment of his lifestyle — as he says of MONOCLE: "it's hard to split the 'we' from the 'me'." This narrative is exaggerated by the particular vocabulary he deploys. He is fond of words like "pod" and "hub". The international offices of MONOCLE are called "bureaux", it's writers are "correspondents", meetings take place in "boardrooms" and business partners are "consorts". There is warmth when he says "CEO", "federal" or "municipal". Diplomacy has a particular romance for him — he talks fondly of ambassadors and the UN. It is as if he's transposing what's real into fiction, without changing any of the facts.

His precise and persuasive diction have helped build up the massive BRÛLÉ myth, all grounded in absolute reality. Of Canadian birth, BRÛLÉ is classically handsome and has close-cropped grooming as a central pillar of living. He turns 40 this year, and has already lived an extraordinary life. Shot at as a reporter for the BBC in Afghanistan in 1994, he took two bullets and lost the use of his left

hand — he has since learnt to write with his right. Recuperating in hospital, he came up with the idea for WALLPAPER, the magazine that launched in 1996 and quickly made a name for him by capturing the late '90s ideal of a liberal and affluent international urban lifestyle.

WALLPAPER was born as an independent magazine that behaved with the confidence and panache of an old-media product. At launch, it absolutely knew its potential readership: a global audience who embraced the magazine, and whose support encouraged BRÛLÉ and his team to push the title as far as they could. It thrived on the excesses of the then-burgeoning luxury fashion market, and BRÛLÉ gained a reputation as an expenses-wielding high-flier, complete with the magazine's own in-house chef. Of all the tales, BRÛLÉ's buying a Swedish island was the most myth-making, so magisterial did it seem. (BRÛLÉ still owns the island in the Swedish archipelago, which he uses as a holiday home, but as he says, "if you're Swedish it's not such a big deal.")

TIME WARNER bought WALLPAPER in 1997, but BRÛLÉ stayed on at the magazine, eventually leaving in 2002 after 50 issues. By then he had set up his branding agency, WINK MEDIA, in response to brands wanting some WALL-PAPER-thinking to rub off on their own product. On exiting WALLPAPER, BRÛLÉ bought back the agency, renamed it WINKREATIVE, and was soon involved in the entire rebranding of SWISSAIR into SWISS INTERNATIONAL AIR LINES LTD.

By 2003 he had a weekly column called FAST LANE in the FINANCIAL TIMES, which he has written every Saturday since, bar a brief defection to the INTERNATIONAL HERALD TRIBUNE. Through his writing, he has widened his affluent audience considerably. He uses his column to rant at inefficiencies in global travel, often making an acute point succinctly, like his recent plea for the flight deck to reveal the realities of turbulence: if they know it's going to be a terrible flight, let them give passengers the option of getting off.

MONOCLE eventually debuted in February 2007, its launch highly anticipated with a clock on its website counting down to its street date. Many in the media watched, ready to judge his next game-changing idea. The first cover of MONOCLE featured a photo of a Japanese helicopter pilot. What was BRÛLÉ doing?

MONOCLE comes out ten times a year, a neatly designed package on heavy paper stock that has the overall appearance of a HAYNES car manual. An immediate difference from WALLPAPER is its initial audience: it's much easier to pin down and please readers who want nice frocks and furniture than it is those interested in diplomacy as well as design.

MONOCLE is serious in tone, but feel-good about international affairs. "The magazine is incredibly positive and optimistic," says BRÛLÉ. "You can cover Zimbabwe and have your take on Afghanistan, but you still close the magazine at the end and feel pretty good about the world." Some, expecting a fashion-savvy version of THE ECONOMIST, feel the magazine lacks brawn or bite. "There are a number of people who say we are politically unengaged in the debates," he says, "but those are currently being waged in NEWSWEEK and DER SPIEGEL and U.S. NEWS and WORLD REPORT. Probably the bulk of our readership is already looking at those titles, they've engaged in that dialogue and have made up their minds already. We need to take them somewhere else. It's not shying away from the fight, it's uncovering the next one."

In effect, BRÛLÉ has demarcated new territory for a news magazine, and he is still nurturing the market. He says he has 7000 subscribers across over 80 countries, each paying $150 a year for the privilege. The print run is 150,000 copies, and his fastest growing markets he says are "the United States, Hong Kong, Japan, Germany and Australia." He is also extending the brand to consolidate what the title means, with bags made in collaboration with PORTER and a fragrance produced with COMME DES GARÇONS. MONOCLE ran a temporary café in Tokyo in the swish Omotesando Hills shopping complex. Apparently there are offers on the table for similar, permanent establishments.

MONOCLE represents a subtle shift in emphasis. WALLPAPER was inherently aspirational in its desire for better furniture, fancier clothes, wilder locations. These subjects all appear in MONOCLE, but with a much more considered tone. MONOCLE has replaced aspiration with egalitarianism, hence the quieter design, less showy subject matters. "People thought it was going to be WALLPAPER 2.0," he says, "and a lot of people thought that the first cover with the Japanese navy chopper pilot on it was a mistake, and that we couldn't find the right cover image. But it really was deliberate. We went for a very hard cover because we wanted to say, 'Okay, this is a whole new day, guys'."

There is one part of the BRÛLÉ myth that his office at MONOCLE goes some way to dispel. It is surprisingly, and quite satisfyingly, untidy. His desk is a bumper-car ride of stacked-up magazines and books, all at odd angles to each other. The long pin board is personalised with pictures and notes, and the sofa rendered useless by the shopping bags that fill it. Also cluttering the space is his hand luggage, pre-packed by his assistant. But outside his personal space, all is precise. BRÛLÉ sits on the first floor, with windows out to WINKREATIVE, where the desks are neat and the shelves lined with model aircrafts. Unlike the magazine staff on the ground floor, WINKREATIVE have the public holiday off.

Mr. BRÛLÉ is romantic about print publishing, to which he is utterly committed. "We deliberately made a really bookish magazine," he says. "Print is still

relevant and it does have some sort of place in the world and publishers shouldn't blame the Internet for their decline. It's almost a parallel dialogue that is going on between airline CEOs when they blame fuel prices for their bad results — no, you've got bad results because you've got a shitty airline and you don't offer any service. Media companies blame the Web, when actually they don't put out a magazine anymore, they put out a church pamphlet."

He is indulgent with the processes of magazine-making. Besides the expensive paper, most of the pictures are shot just for MONOCLE and as often as possible are still done on film. The illustrations in each issue are done by MARTIN MÖRCK, who lives on a small island in the North Sea, and are literally etched into lead. "We have a duty, not just being an editor, but being a media proprietor, to keep those crafts alive."

All good columnists work out a way of appearing open to their readers while also protecting their private life. BRÛLÉ is particularly adept at this in his weekly 900 words in the FINANCIAL TIMES. In it he occasionally mentions his partner MATS, who in one column travelled first to the Swedish island to open up the home for the summer, and in another spent a few days with BRÛLÉ on Pantelleria. BRÛLÉ's Wikipedia entry describes MATS as a Swedish banker. When fact-checking a few weeks later, I e-mail BRÛLÉ to ask if this is the case. "I'd rather keep my private/personal life quiet," he replies, "but if you must include this then MATS is with AMERICAN EXPRESS — he's a Marketing Director."

BRÛLÉ wants to maintain the personal brand, but he does not seek to tip this into celebrity. Indeed, a BRÛLÉ trademark is his absolute blind spot for celebrity. He doesn't just wilfully avoid the famous, a cold-turkey gimmick that some media outlets attempt before slapping a star back on their cover as soon as circulation falls. BRÛLÉ seems entirely devoid of any celebrity as cultural reference. Give him LINDSAY LOHAN and he just wouldn't know what to do with her.

This is unusual for anyone in the British media, where even financial desks use images of the famous to pep up their pages. It is a true cliché that for many gay men in lifestyle media, celebrity is a learnt instinct from childhood, which then feeds into their adult career. I ask BRÛLÉ if he has ever been obsessed with celebrity. "I was obsessed with SANDRA BERNHARD for a while," he says, "and I used to hang out with her in London. There are classic celebrities that I like, but it's not something that I gravitate towards."

What about when he was growing up? "Not really," he says. "Funny, no. My heroes and role models have always been either political or design-focused, be they architects or industrial designers."

I don't buy this. Wasn't it weird at the time? "No I don't think so. And I guess more importantly I don't think those around me found it weird, either."

BRÛLÉ also seems to be aware that his first answer is unsatisfactory, because he comes back to the subject voluntarily. "I'd be lying if I said it wasn't a fame thing, but I was only ever interested in reading the news," he says. "That's all I thought about at school. I just wanted to put on a nice suit and a nice tie and read the news every night."

BRÛLÉ can pinpoint this further than just a vague notion. "I guess I will correct myself and say that my role models weren't architects or industrial designers," he says. "The one role model I looked up to was PETER JENNINGS. He was a Canadian newsreader who did well, went to the United States, became the first million-dollar news anchor, probably became the first ten-million-dollar news anchor, was the man in Beirut in the '70s and '80s, and was this real example of a Canadian journalist who became a real household name. That was who I looked up to."

When BRÛLÉ landed in the UK in the early '90s, he found work with JANET STREET-PORTER on a BBC youth news programme called REPORTAGE. It was the sort of show where eager staff could muck in and end up on screen with little training. "I was spoilt going on camera straight away, but I also got presenting out of my system. I realised it wasn't something I wanted to do so much." BRÛLÉ has since tried TV presenting again, in 2004 fronting a BBC4 media show called THE DESK, which failed to make any impact, though much of the blame for this can be laid at the channel, which was new and barely watched.

At the time of WALLPAPER's conception, BRÛLÉ was dating shoe designer PATRICK COX, and the magazine echoed their lifestyle that was about fulfilling their A-grade aspirations. "We were trying to capitalise on the message that consumers and brands needed to recognise this sophisticated international audience out there," he says, "who don't see themselves as penned in by international boundaries. I think we were celebrating a certain sense of urbanism at the time. In many ways it was a response to the reorganisation of cities, whether it be Melbourne or Manchester, which I don't think was being chronicled in other consumer magazines. It was also always bright, sunny and optimistic." Note an echo of the upbeat editorial policy on MONOCLE. In fact, if you study his past issues of WALLPAPER closely, you often find a similar sort of story — manifestos for better air travel, or micro tales about a local community blown up to macro importance — all illustrated with the same eager enthusiasm.

The audacity of his editorial ideas and spending at WALLPAPER added much to the BRÛLÉ myth. Does the legacy of the magazine annoy him? "It's very hard to divorce yourself, when you're linked to the brand as the editor," he says. "People still think you have the same personality as a major fashion designer, in terms of your demands and how you operate." You mean prissy? "Prissy and difficult and hard work. And that just because you've been so tightly tied to luxury

goods and fashion, you're going to have the same airs and graces that a lot of people in that world have."

I'll admit something here — I was obsessive about WALLPAPER during BRÛLÉ's tenure. I still have all of them, including two copies of issue one. When it debuted in 1996, I'd not yet been on a plane, but its effect on me wasn't one of aspiration — it was the glee with which the staff lived their lives through the pages of the magazine. Devoid of celebrity, it was this monthly dose of funny idealism full of BRÛLÉ's fictionalised reality narrative. "I think the whole way through we were having a pretty good laugh at life," he says. "Yeah we were flying CONCORDE and helicopters, but I don't think it ever felt the same for us as it did for MADONNA sitting in seat 1A. I always felt genuine excitement. Maybe the assumption was we were sitting there po-faced, waiting for the next refill of champagne. We were waiting for the next refill of champagne, but with a big old smile on our faces."

But then BRÛLÉ becomes aware of the different ways in which what he says can be taken. When he is complaining about service on an airline, he says, "you know that I'm not flying at the back of the plane. It's shit, but it's not that shit. You can be quite sharp while having a laugh at the same time. Not with everything, but tongue is firmly in cheek."

Starting with the money he earned from the sale of WALLPAPER, BRÛLÉ began buying property overseas. "Rather than daydreaming about it, I've already engaged in a series of experiments, some successful, some failed, in carving out my own urban existence," he says. "My biggest failure being my affair with Zurich, a place I thought would be the be-all and end-all of cities to live in, and I absolutely hated it. That didn't mean writing off Switzerland. I went off and found a great '60s apartment in St. Moritz and did that place up, and that's sort of where I live at the moment." Although MONOCLE HQ is in London, where BRÛLÉ has a duplex, the holding company, WINKORP, is based in St. Moritz, an old-money town that most would avoid, but that in BRÛLÉ's words has "a stir of appeal".

A couple of times BRÛLÉ describes himself as conservative, in terms of his style of clothing, but it sounds more a description of his character in general. This though is conservative with a small "c", since BRÛLÉ doesn't fit with a right-wing political character at all, not least because in a recent issue of MONOCLE, he includes "a McCAIN presidency" as one of the 25 things that shouldn't be in your life right now.

I ask him about the politics of the magazine. "There's a libertarian element running through the title that is more pronounced in parts, and in others played down," he says. Quick refresher: libertarianism is the political theory that places individual freedoms above government control. Although neither aligned to right

nor left, it is a theory often pounced upon by the American reactionary right. "But we're not libertarian in that we think the world should be armed. There's quite a strong element of socialism and collectivism in the magazine as well."

BRÛLÉ was recently in Beirut, writing the May 2008 cover story for MONOCLE, and he left the city just before a sudden resumption of violence. The place seems to be much on his mind. "For all the menacing neighbours in Beirut, they also have a pretty amazing life as well," he says. "There's a certain freedom to living in absolute chaos. No-one's going to come and tell you to pull down the satellite earth station you built on your roof that you share with 100 other neighbours, so you can pay for it only once and pull in whatever TV channel you want. There's a certain press freedom in that. In Britain I can only get what SKY TELEVISION allows me to see. In Beirut I can drive as fast as I want, I can park on the sidewalk, I can do all of those things I can't do anywhere else anymore."

But the realities of the city weigh heavy on him. "Based on my experiences in Afghanistan, I'm obviously gun-shy," he says. "I'm glad we got on a plane the day before the shooting started in Beirut. I wouldn't have been in a good place, and I think that probably five or six years ago, I wouldn't have gone back to Beirut. I wouldn't rush to Baghdad or Kabul at the moment, just because I've been shot at once and it doesn't need to happen again. You value what you've got too much and you've been through it."

Would he consider himself a risk-taker? "It's weird because when there's no physical danger, I'm a much bigger risk-taker than I used to be," he says. "When it comes to business I really go to the wall. It's not that I don't care, but when you're doing something like this right now, you feel you can stake everything on it. But if it means going to serious danger zones, I'll leave that to other correspondents for the moment. If they get the KARZAI interview in Kabul they'd be the first one on the plane, and who knows, I would be too. But it hasn't happened at the moment and I know what it's like to be shot and I don't want to go through that again."

Remember what BRÛLÉ said about separating the "we from the me" about MONOCLE — it is a magazine driven by his personality, and by the value he puts on his own quality of life. The title is currently selling a limited-edition poster charting a programme for "the perfect community". And BRÛLÉ himself has long-term plans to open retreats where "journalists can recover from injuries — both physical and mental," he writes in an e-mail, "one in Switzerland for European/American journalists, and another in northern Japan for Russia and Asia." With his magazine, with his agency, and with the personal narrative that he uses to tell himself and others the story, Mr. BRÛLÉ wants to be part of the solution, not the problem.

Mr. CARLO ANTONELLI

Featured in issue n° 2 for Autumn and Winter 2005

The Italian CARLO ANTONELLI is a man of parts. As a teenager he worked as a DJ, a movie buyer for Italian TV and was involved in starting a new music label before studying law at university. He has been the editor of Italian ROLLING STONE and WIRED magazines, and now edits Italian GQ. He is an occasional actor, scriptwriter and film producer. And he has taught sociology at Bologna University and has been director of the Italian Institute of Culture in Los Angeles. CARLO is an ardent polysexual and has no attachment to private space. "I wouldn't mind getting rid of my house altogether," he says.

A fan of dramatic mood changes, CARLO told FANTASTIC MAN that CLINIQUE Dramatically Different Moisturizing Lotion is among his favourite skin creams. He also has strong feelings about the colour brown. "At university I wrote a thesis in which I actually scientifically proved that if you wear a totally brown outfit, you'll receive fewer phone calls, up to 90 per cent fewer. I swear it's true!", he says, "I started wearing brown — and I'm talking really ugly shit-brown not some nice COSTUME NATIONAL shade of brown — and I counted the phone calls I got throughout the day, and after a while it was 90 per cent down. You know why? Because people hate that colour, because it makes you look like shit."

Portrait by Simon

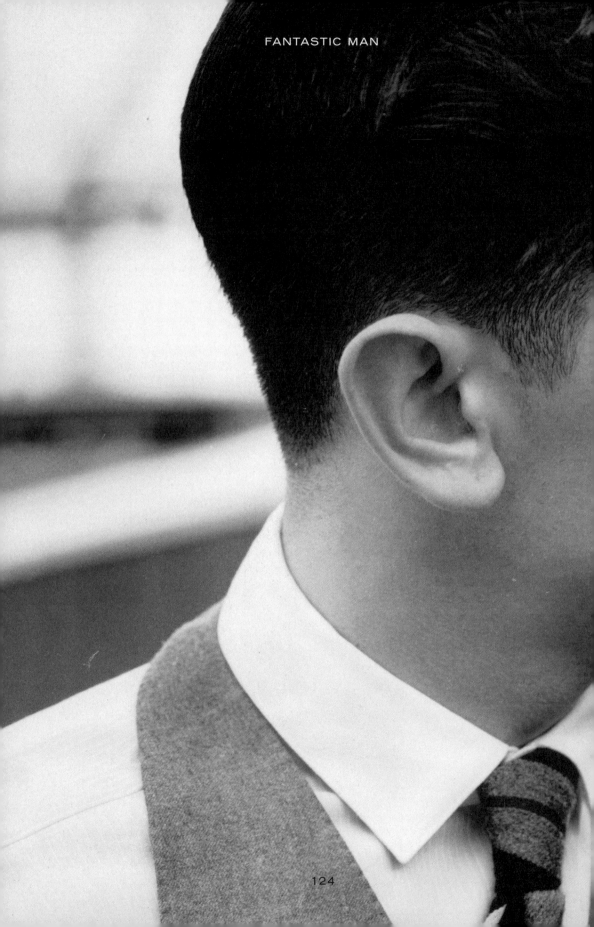

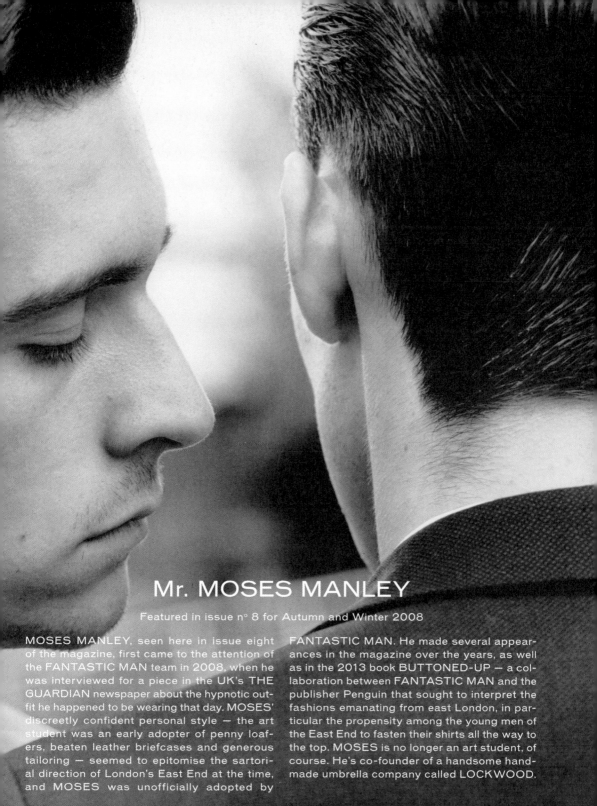

Mr. MOSES MANLEY

Featured in issue n° 8 for Autumn and Winter 2008

MOSES MANLEY, seen here in issue eight of the magazine, first came to the attention of the FANTASTIC MAN team in 2008, when he was interviewed for a piece in the UK's THE GUARDIAN newspaper about the hypnotic outfit he happened to be wearing that day. MOSES' discreetly confident personal style — the art student was an early adopter of penny loafers, beaten leather briefcases and generous tailoring — seemed to epitomise the sartorial direction of London's East End at the time, and MOSES was unofficially adopted by FANTASTIC MAN. He made several appearances in the magazine over the years, as well as in the 2013 book BUTTONED-UP — a collaboration between FANTASTIC MAN and the publisher Penguin that sought to interpret the fashions emanating from east London, in particular the propensity among the young men of the East End to fasten their shirts all the way to the top. MOSES is no longer an art student, of course. He's co-founder of a handsome handmade umbrella company called LOCKWOOD.

Portrait by Robi Rodriguez

Mr.
RAF SIMONS

Mr. RAF SIMONS
Featured in issue n° 14 for Autumn and Winter 2011
Portraits by Willy Vanderperre
Text by Gert Jonkers

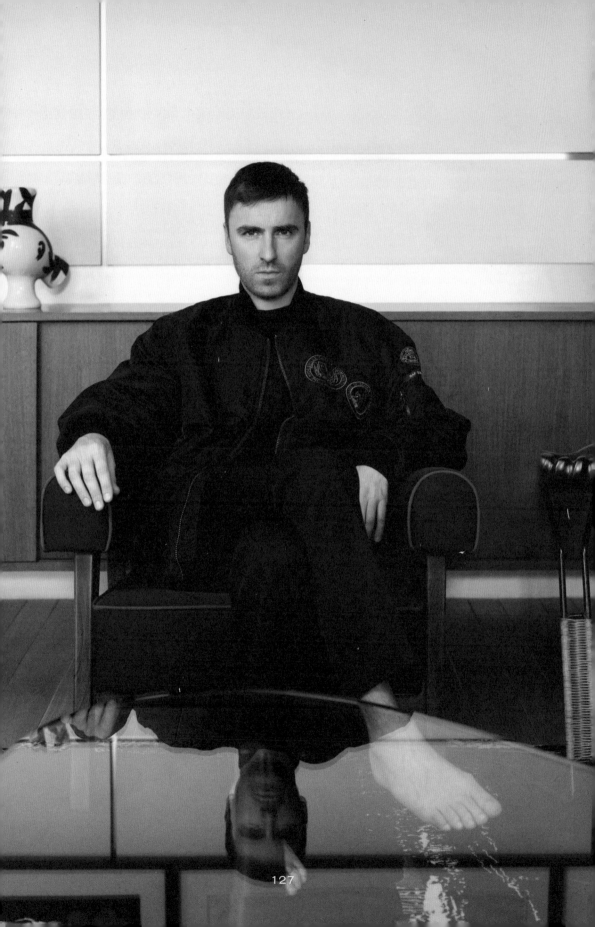

From the city of Antwerp, a hotbed of modernity in fashion, designer Mr. RAF SIMONS has made the most radical menswear of the past 15 years. He makes fashion that feels both natural and completely new by mixing tailoring with the aesthetics of teenage rebellion. RAF is revered for his bold shows and directional collections, as well as for his subversive work for the house of JIL SANDER. Yet he has always kept a surprisingly low profile, rarely allowing himself to be photographed. While avoiding the public eye, RAF has managed to maintain his curiosity for fashion and his love for clothes. The designer is also an avid art collector and a keen advocate of men wearing sandals.

It is a sunny Sunday afternoon in May, and RAF SIMONS is cooking lunch at his home in Antwerp, Belgium. "Well," RAF says, "I wouldn't call this cooking, would you?" He is heating up two small salmon quiches that he'd bought the previous day. He serves them beside a carefully considered composition of chicory leaves, lettuce and tomatoes, and a little heap of prawns covered in pink cocktail sauce. A two-litre bottle of DIET COKE stands in between us. It is just under a month before RAF presents his Spring/Summer 2012 collection for JIL SANDER in Milan, and just over a month before he presents the Spring/Summer 2012 collection for his own label, RAF SIMONS, in Paris.

"It's been a bizarre year for me," says RAF. This is an understatement. Just three days before his RAF SIMONS Autumn/Winter 2011 show in January, it was announced that his business partnership with the manufacturer of his clothes, an Italian company called FUTUREPRESENT, had been suddenly terminated. It wasn't clear if the show would even take place, let alone if anyone would be able to actually make the clothes for the stores to sell. The RAF SIMONS show, usually the highlight of Paris Fashion Week, looked to be a no-show for the first time in ten years.

But there *was* a show, miraculously, and it was a victory — in most people's opinion the best of the season. It felt new and bold, while also harking back to the dark, collegiate themes that appeared earlier in RAF's career. The collection was titled DEAD PRINCE COLLEGE. The clothes have been produced, and his label has survived. But not without the designer paying a hefty toll. "After the show I was seriously sick of it; I got really depressed," RAF says. "Which was weird, as I'm never depressed. But it's all good now; things are opening up again. In a way, I love times like these. I'm super excited about going back to Paris this season as anindependent designer."

In the 15 years since he showed his first menswear collection, RAF SIMONS has sustained a self-perpetuating extremism. He is among the most influential, and least conformist, of all menswear designers. Since 2005 he has also been exerting his authority over womenswear with his collections for JIL SANDER. Yet he remains stubbornly non-famous, not even being particularly well known outside of fashion circles, also because he rarely allows himself to be photographed. His brand RAF SIMONS is a true cult label, currently selling at around 50 stores worldwide. He had more retailers in the past, he says, but the notoriously sloppy delivery practices of his manufacturer turned some off. "A few of the stores that stopped selling us actually sent us flowers, with congratulations, when they heard of our break with the Italians," he says.

RAF is currently in talks to secure financial backing from new partners. "But I'm not in any hurry," he says. "First I need to recover from the breakup, and when I do step into a new partnership, I want the structure and circumstances to be really good this time. I think that what I've learnt by working in a bigger

company like JIL SANDER is how important the structure is. You can have ideas and you can have money, but if the structure isn't right, if everybody at design and management and marketing and sales isn't in the same key, it's not going to work."

As we eat our lunch, RAF is candid as to who he is in talks with and which other designer jobs at various luxury houses he has been offered in the past. He says exactly what he thinks about every other designer working today. He loves talking about the fashion world. "Do you have any good fashion gossip?" he asks, then happily shares the latest rumours. He prefaces these chats with the word "confidentially". It's one he uses often. It is as if he wishes he were able to voice his opinions in public, if only the status quo of the fashion system allowed him to do so.

"I'm very open about things, and I consider the people I work with my family. I don't want to be this elusive person," he says. "I've had the same cell phone number for the past 15 years — anyone can call me. I was a teacher in the fashion department at the University in Vienna; I want to be able to meet people. Sometimes when people call my studio in Antwerp and I pick up the phone myself, they're shocked."

Working with a team, and being open to other people's opinions, is crucial to him. "When we're putting the show together I really like to hear my assistants' or interns' thoughts," he says. "They've been such an integral part of the process of making a collection, so I want to know what they think."

Once you're heading a team without being open to other people's suggestions any more, that's where the trouble starts, in RAF's opinion. He thinks that's what happened to DIOR designer JOHN GALLIANO when he lost STEVEN ROBINSON, who had been his right hand for decades. "Without STEPHEN, he must have become very lonely. That's what I see when I see the online footage of him sitting in a bar. If you lose the friends around you that dare to be critical, that's when you become extremely lonely and impossible to deal with."

Is RAF ever lonely?

"Not at all. I grew up as an only child, so I love being on my own. But when I work, I love to have people around me."

RAF's home in Antwerp is a stunning, spacious three-floor apartment in its original 1960s state. The building's wobbly lift opens directly into the living room. The kitchen has its original wood panelling, though previous owners had installed state-of-the-art kitchen appliances; those stand mostly unused. RAF's balcony, which stretches the width of the entire flat, looks out on a quiet, broad, tree-lined street in the centre of town. "I love the feeling of this place," he says. "I used to like really stark, white, minimal places to work and to live in, but not any more. I'm really into cosiness these days. My apartment in Milan is '60s, too,

and has this great lived-in feel to it." (It happens to be on the same street where MIUCCIA PRADA and DONATELLA VERSACE live.)

His living room is not unlike an art gallery. On one wall is a giant piece by the American artist MIKE KELLEY. In the middle of the room is a large, pro- truding and precarious-looking sculpture by EVAN HOLLOWAY — it's the first big piece of art RAF ever bought. Under the stairs is a piece by JIM LAMBIE, made of concrete and 12-inch album covers. The house looks immaculate. "I used to clean the place myself," says RAF. "Cleanliness is in my blood. My mother was a cleaning lady for most of her professional life. But here in Antwerp there'd be no end to it. I'd return from Milan and it'd be all dusty again, so I finally got a maid."

The apartment is furnished with some spectacular pieces. The dining table and matching chairs are by GEORGE NAKASHIMA. The sofa and set of club chairs are by PIERRE JEANNERET and were made especially for the city of Chandigarh, India. "They're extremely sought after now," RAF says. Chandigarh is the 1950s utopian architecture project by LE CORBUSIER. The long-neglected city was recently in the news when campaigners tried to place Chandigarh on UNESCO's World Heritage List. "The whole town has been more or less cleared by art dealers," says RAF. "Which I guess is a bad thing, and people like me are perhaps to blame. But on the other hand, if we hadn't snatched it up they probably would have burnt most of it." The people of Chandigarh evidently failed to see the beauty of JEANNERET's modernist designs. RAF shows me pictures of enor- mous piles of chairs, just like his, decaying in the open air somewhere in India.

RAF was born in Neerpelt, a town in northeast Belgium, not far from the Dutch border. He went on to study industrial design in the city of Genk. "At school I was laughed at for liking vintage design," RAF remembers. "People were really into PHILIPPE STARCK back then. Do you know him? Terrible."

Were RAF's furniture designs any good?

"Looking back? No. In fact I think they were pretty bad. I remember making a huge circular Chesterfield-style leather sofa on wheels. Very clean — it looked like a spaceship. Back then I thought it was so modern." RAF doesn't own any of his old pieces. "I gave it all to friends. I think my parents still have a few stools that I made."

RAF had planned to embark on a career as a furniture designer. He interned for fashion designer WALTER VAN BEIRENDONCK, for whom he designed packaging, stalls and furniture. VAN BEIRENDONCK took him to Paris, where RAF was completely blown away by an early MARGIELA show. "I had never thought of making fashion," says RAF. "The closest I'd got to fashion was buying a pair of DIRK BIKKEMBERGS shoes."

His star in menswear rose quickly. In 1995 RAF launched his own brand, and in 1997 he staged his first runway show in Paris, causing an instant sensation

with his cultish dark collections, his slim tailoring, his KRAFTWERK-inspired shows, his use of language, his youthfulness. His eighth show in Paris, in January 2000, was the first that I attended. I thought it was incredible. The collection was called CONFUSION — a rather stark offering in black, white and grey. Some of the models arrived on the runway in a DeLOREAN sports car or a black limousine. "That's one of my least favourite collections," RAF says now. "I can see that I was fed up with it all. I was 31, I had a staff of 18 people, things had grown so fast and I wanted to get out." Which is what he did; RAF closed his fashion house and took a season's sabbatical from fashion, only to revive his label one year later with a collection called RIOT, RIOT, RIOT. It was a very apt title. His models were walking in layers and layers of hooded jumpers, bomber jackets, big coats; their faces shrouded in big scarves. Gone, at least for a while, was RAF's sharp tailoring. RAF had done "punk" before, using SEX PISTOLS imagery on T-shirts, but never had he done so in such a radical, grim and grimy manner. It was a direction he'd continue for several seasons, but as radical as it seemed at the time, it would soon mix perfectly with the "old" aesthetics of the house of RAF SIMONS.

RAF has always cast young men from the streets of Antwerp for his shows. His designs seem to be made for the boys that show his collections, yet his work can't be deemed fashion for boys. "You know what teenage boys wear: jeans and T-shirts. That's not what I make," he says. "I'm intrigued by the psychology of men and what happens on the edge of adolescence and maturity."

Often his collections look like old men's clothes cut for a younger body, especially in his earlier shows: black suits, grey cardigans, cableknits, long coats. Yet there were always hints of youth culture in his shows: pictures of the MANIC STREET PREACHERS on sweaters, NEW ORDER and JOY DIVISION on the soundtrack, slogans and a sense of insurgency everywhere.

At some point after lunch RAF stands up to change the music; for the last two hours he has had the debut album of THE XX on constant repeat. "You must be annoyed by now," he says, "but it's literally the only album I've played over the last year. I play it all the time. The first time I heard it, I didn't like it; I thought it was depressing, a bit too much ANNE CLARK. But then I got hooked. It's really the new classical music. It never bores."

Until 2005, RAF SIMONS had never designed womenswear. When it was announced that he would become creative director of JIL SANDER, it caused some shock. "People were like: 'Who's this brat who has never designed womenswear?'" RAF remembers. "So it was a challenge. Part of the audence was sceptical, part was very welcoming. And I was convinced I could do it." He likes the purity of the JIL SANDER aesthetic, but found the heritage of the house to be so precise that it lacked the necessary variety from which he could draw

inspiration. "I had to do my own thing there, otherwise it would have been quite repetitive. The fashion press is easily bored; they want new things, and I want new things too."

In an hour he's off to Milan, where he faces two days of fittings for the upcoming JIL SANDER menswear show, one day of meetings with the accessory team, and two days of fittings for the next JIL SANDER womenswear show in September.

What does that mean for his private life?

"My work schedule is intense, but I get by," he says. Yes, he is single. "Maybe I just haven't found the right person yet? I actually like being alone. I've never had the idea that life would be better in a relationship. It might happen tomorrow, who knows? God knows if I'd have time for it. But I'm a Capricorn, and they say we live our lives backwards. We're born way too serious, and we ease up as we get older."

Do you mean that, by the time you're 50, you'll lead the life of a promiscuous teenager?

"Maybe I already do?" RAF laughs. "Honestly, I feel like I'm 25. Maybe not physically, but in my mind I'm 25 years old."

I suggest he must be the most disciplined person in the world, what with two labels, four men's collections per year, and the Spring/Summer, Autumn/Winter, cruise, resort and pre-collections for JIL SANDER womenswear. "Well, yes, I am disciplined," he says. "For years I doubted whether I was capable of this fashion discipline. You always want to work longer on a collection, but there's never time for it. That's what bothered me so much in my first five years. But I've learnt to accept it, and in fact it's also what fascinates me about fashion. You make something and then you quite easily distance yourself from it. Collection done, and on with the next one. I'm fast to move on with it, and that is something that drives my assistants crazy. They're, like, 'Shut up!' The Summer shows are in a few weeks, but in my mind I'm already thinking about the winter shows. I want new, new, new, new, new."

Today RAF is wearing a pair of paint-splattered denim shorts by ALEXANDER McQUEEN, a check shirt by some skate brand, and RAF SIMONS sandals. He likes wearing other labels than his own. "Of course I started designing because there were things that I couldn't find. But then, over time, RAF SIMONS became a brand, and the brand and I are not the same. They *can't* be the same. I think it should *never* be a rule in fashion that the designer should wear his own designs. I mean, RICK OWENS and STEFANO PILATI do it really well, I think. But what would happen if I would want to wear everything myself? RAF SIMONS would be a much easier label, and I don't want it to be easy. I want RAF SIMONS to be about the psychology and perception of menswear, and how

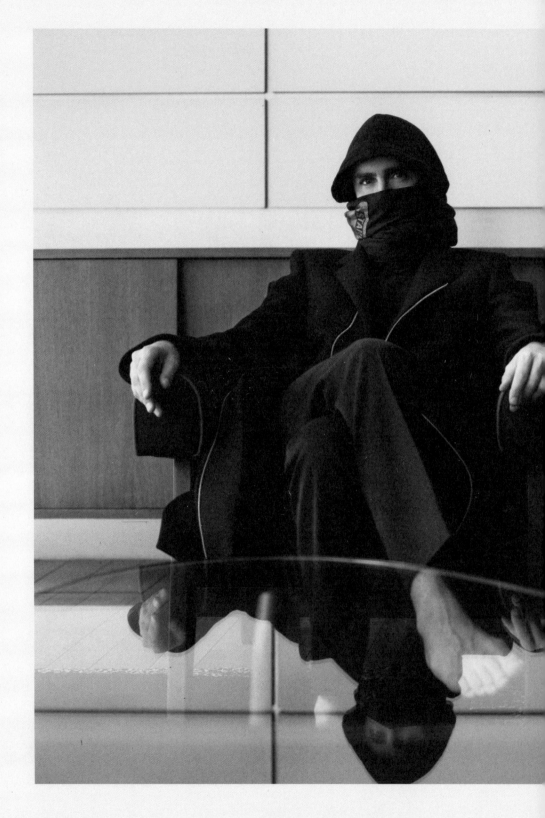

men see themselves and their clothes. I love the idea of 'the mirror'. It's interesting to see a model look at himself in the mirror. It's never about my personal opinion, also because I'm not so extreme myself. I want the label to be extreme."

He cites his Spring/Summer 2011 collection that he showed a year ago: a particularly odd silhouette of baggy and flared trousers, zip-up tops, lots of white and pastels. "It had nothing to do with what I would wear. I was fascinated with how young men can be feminine and androgynous, and for me the show referenced MARTIN MARGIELA's first collections. Should I *not* do that because I wouldn't wear it myself?"

RAF does wear JIL SANDER, though. "I ordered 15 pairs of the same trousers," he says. "I also love PRADA. I think what MIUCCIA does is amazing."

Although he is known for his fashion designs, RAF also has an alternate career as an art buyer for his friend CHRISTIAN CIGRANG, a Belgian shipping magnate. The first time I met RAF was in 2001, when I interviewed him in Amsterdam. I remember that RAF was wearing one of his own black bomber jackets over a navy crew-neck jumper, black denim trousers and white leather sneakers. After the interview we cycled into town, as RAF wanted to visit some galleries to look for works to buy for CIGRANG.

The last place we visited that afternoon was the PAUL ANDRIESSE gallery on Prinsengracht. RAF was especially interested in a vast embroidered painting by the London-based Dutch artist MICHAEL RAEDECKER, which did not come cheap. RAF asked the gallery assistant about the painting. She referred us to Mr. ANDRIESSE himself, who then popped his head around the corner from his office in the back of the gallery. I could see that he was quickly scanning RAF's appearance: the hooligan-esque bomber jacket, the black jeans, the sneakers.

"I don't see clients without an appointment," Mr. ANDRIESSE said.

Okay. Could he get an appointment for today?

"No."

RAF was slightly baffled, and I merely felt embarrassed about the treatment he had received from my fellow Dutchman. Of course RAF never returned to the gallery to discuss a possible purchase.

When I remind RAF of our gallery visit, he says: "Ah, yes. We never managed to buy a RAEDECKER, even though I love his work." However, RAF doesn't seem to find the scene embarrassing. "That's how things work in the art world. You really have to earn your position. It's not a matter of being RAF SIMONS and walking in to purchase a piece. I've done other things as a buyer and a curator since, but that still isn't a licence to get whatever I want."

There's a quietness to art that is lacking in fashion, RAF thinks. "I can't see myself growing old in fashion. I don't think I can do fashion the LAGERFELD way. It's hectic and it's fast, and I don't think you can cope with it forever. But I

can imagine myself being old and still hanging around in the art world." He's thinking of MARTIN MARGIELA and HELMUT LANG when he says: "I can totally understand why MARTIN and HELMUT stepped out of fashion as young as they did."

Over the years, RAF's art profile has risen significantly. As well as buying for the COLLECTION CIGRANG FRERES, he has managed to put together quite a collection of his own, too. "I think ultimately I'm more interested in art than in fashion. My colleague got me an iPad recently. She was fed up with me hanging around the office all night to read artnet.com and the art reviews on THE NEW YORK TIMES online."

It's only days before the Venice Art BIENNALE opens, and RAF is extremely excited about the event, even though he won't be able to go there himself until mid-July. As I am due to visit the event, he is quick with advice. "The first thing you should do when you get to the Giardini is go straight to the Canadian Pavilion: they have STEVEN SHEARER, whom I love." RAF has in fact been trying for years to buy a SHEARER painting. It's not such an unlikely interest; SHEARER's fascination for young adolescents with luscious, long hair is right up RAF's alley. "I once had a chance to buy one through STUART SHAVE MODERN ART in London, but I wasn't sure if I liked that particular painting. Which, of course, I now totally regret; now it's my favourite SHEARER piece." That's the thing with art, he says, and in fact also with fashion: what you find unsettling at first is usually what you end up liking the most.

Due to this year's fashion show schedule, RAF also won't be able to go to ART BASEL, which is about to open. "I hate missing it. I go every year, but it's just impossible now." It was in fact at ART BASEL, three years ago, that he met JIL SANDER herself.

Ever since RAF took over from Ms. SANDER at her eponymous label after she had stormed out in 2004, he had been fantasising about meeting her. The people around him didn't think it was a good idea for him to seek contact. Then, one day in Basel, he was eating a hot dog with his friend, the artist GERMAINE KRUIP, and he thought he spotted Ms. SANDER at a table nearby. "I wasn't sure, so I checked with GERMAINE to see if she thought it was JIL. 'Yes,' said GERMAINE, 'it must be her.' JIL was sitting alone, wearing sunglasses. She'd seen me, too. So for the next ten minutes there was this really awkward situation where we were looking at each other, and neither of us knew what to do. Until I thought, 'Okay RAF, you've got to be the gentleman.' I walked up to her table, which was only about 20 metres away but I felt like MOSES on his exodus through the desert. Whaaaa! I reached her table; she took off her glasses and shook my hand. That was nice. Then she started ranting about the way the PRADA GROUP had treated her house, and the way seamstresses were being laid off and ateliers shuttered, and I *really* wasn't in the mood for that. She went

on like that until her friend joined us, and JIL introduced me to her friend, say-ing: 'This is the man who takes really good care of my brand. I'm really happy that he does it.'"

It is Friday, June 17, the day before the JIL SANDER menswear show, and RAF is finishing the final fittings at the brand's headquarters in Milan. He is wearing the same McQUEEN denim shorts as a month ago, with a black JIL SANDER shirt and black espadrille platform shoes from PRADA.

There is a set procedure to the day. RAF is sat behind a table at one end of the room. Models are dressed by assistants in a dressing room set up behind a screen at the opposite end. As soon as they emerge, RAF picks up his remote control and cranks up the music in the room. The model starts walking towards RAF. The models must have been instructed that whenever the music plays, they walk. The first model I see that day is a young gentleman by the name of PHILIP. As soon as RAF turns off the music, some 15 seconds later, PHILIP stops walk-ing. "Don't like," RAF says. "Can we put him in the snake-print T-shirt and black shorts instead? Plus the plastic coat."

PHILIP changes into the suggested outfit. Music on. Walking. Music off. RAF: "Not the plastic coat. Can I see him in the boxy jacket?"

PHILIP changes into the boxy jacket.

"Not the boxy jacket."

The fittings go on all day. Some looks require considerable time to put to-gether. With RAF giving orders from behind the table, it takes a good 20 minutes for his assistants to juggle with a small snakeskin document wallet that hangs from a chord around the neck of a model. Wallet horizontal? Wallet diagonal? Higher? Lower? Under the jacket? Over the jacket? But sometimes decisions are made with speed and precision. At one point, a model emerges from behind the screen. RAF turns on the music, only to switch it off four seconds later. He says "Love!" — meaning the look is perfect. "What shoes do we have for him?"

There is a calm order to the process that one wouldn't expect on the day before the show. A dozen assistants walk around, carrying in piles of shirts, bags and endless rounds of cappuccino. Bouquets of flowers arrive with encouraging notes attached to them. The make-up team comes in. "We want something natural but pale," says RAF. The hair has already been decided earlier; the models are to appear with a very flat, wet hairdo as if a bucket of water has just been emptied over their heads. "A bit as if they've just stepped in from a toxic rain shower," says RAF. "Think RUTGER HAUER in BLADE RUNNER."

The sturdy, army-like leather shoes, meanwhile, have the initials "JS" and their size written on the heel, in what looks like handwriting in chalk. "It reminds me of how army shoes are stored, and also the codes one finds on JEANNERET's furniture for Chandigarh," says RAF, referring to his own vintage pieces at home.

It's one of the many references that RAF uses in this JIL SANDER collection. The snakeskin-print T-shirts have the words "JIL SANDER MENSWEAR SHOW S/S 2012" printed on the back, in what seems to be a direct reference to HELMUT LANG's T-shirts that had the words 'HELMUT LANG BACKSTAGE' printed on the back. "Absolutely," says RAF. "When I had just got into fashion, I would take the train to Paris to try and get into the shows of HELMUT and MARTIN. We would copy invitations, trying to sneak in. I was obsessed by the models coming out after the HELMUT show with their 'BACKSTAGE' T-shirts on. I never managed to get one myself. So, yes, those T-shirts are totally a reference to him."

The next day, straight after the JIL SANDER show is over, RAF flies straight to Paris to start preparations for his RAF SIMONS show, due to take place in exactly seven days' time.

Backstage, after the show in Paris, RAF is pretty much exhausted but electrified. What he showed is a clear example of the designer rebooting his brand. "Clean up, clean up, clean up," he says. "I wanted to clean up and get back to the basics of the label. This may be the most sober show I've done in a long time. Unlike, eh, next season."

So, eh, you already know what you'll be showing in January 2012?

"I do. It'll be extreme."

As usual, his mother, ALDA, has attended the show. "RAF was such a sweet kid," she tells me when I run into her afterwards. "He's still very sweet, by the way." RAF's mother is a bit hesitant to talk. "Really, I don't know what to say!" I tell her I'm just curious to hear about him from her and that I'm not digging for gossip or secrets or anything. "Oh, but I don't have any secrets. Nor has RAF."

As a kid RAF was very fond of animals, she tells me. "He'd regularly come home with a little bird or an abandoned duck that he had found and that needed to be fed. He once came home with a Danish dog that they were going to put down because his skin pattern wasn't perfect. RAF couldn't bear the thought of killing a dog just for that, and so that dog was with us for eleven years."

In recent years, RAF's mother has befriended MARTIN MARGIELA's mother. They met through a mutual friend, because MARGIELA's mother was really keen to meet somebody who also had a son in fashion. Surprisingly, RAF has in fact spent quite a bit of time with the famously reclusive MARGIELA himself. "The sweetest man I've ever met," he says. "But extreme! Oh my God, MARTIN is so extreme."

RAF and I meet again two days after his show, on June 27th. It is an excruciatingly hot day in Paris. We are sitting in his temporary showroom, a giant artist's studio drenched in daylight in 18th Arrondissement. RAF has been up until very late last night installing and arranging the collection in the showroom; today

the first buyers have their appointments to come and place their orders. At the very last minute RAF had had to hire more staff to handle requests from retailers who were either new to RAF, or who hadn't bought from him for a while. It looks to be quite a fruitful season for him.

Even with having to arrange the showroom, RAF has already had a chance to look through all the new menswear shows online and has an opinion on each of them. It is here that the word "confidentially" enters the conversation again. RAF doesn't think it's been a very exciting season, with only a few standout collections. "Too much busy styling, which to me is not fashion," he says. What was his favourite show? "The show that impressed me most was KIM JONES' debut for VUITTON. I think he did a tremendous job. That collection was very, very together. It's perfect for VUITTON. It makes you want to run to the store and buy it. RICK OWENS was also really strong. God knows how he's going to sell those long dresses for men."

Two weeks later we're in Berlin. RAF has shown up in a brand new JIL SANDER snakeskin-print T-shirt under a JIL SANDER blazer, JIL SANDER trousers and PRADA shoes, to host a dinner in celebration of a weekend of cultural amazingness that he has curated for the launch of MERCEDES-BENZ's new car. At RAF's request, the MICHAEL CLARK dance company, FISCHERSPOONER and THESE NEW PURITANS will perform. Designer PETER SAVILLE has sent his vintage MERCEDES to be displayed; RAF's friend GERMAINE KRUIP is exhibiting two new sculptures; and the Belgian artist PETER DE POTTER, a friend who worked closely together with RAF for years, filled the glass façade of the BERLINER CONGRESS CENTER with his formidable photo collages.

I ask RAF if he'd ever fancy designing a car. "I'd love to," he says, without hesitation.

RAF doesn't have a team as big as the universe, so it's rather mind-boggling how he manages to fit everything into one fashion season: six months of four collections, finding new funding for RAF SIMONS, heading the prestigious jury at the HYÈRES fashion festival, headlining an extravagant weekend in Berlin. Yet RAF doesn't appear at all tired. From Berlin, he will fly to Milan, followed by that snatched visit to the BIENNALE in Venice. Then he'll be in Antwerp for a week. The cycles of his work both continue and change. His upcoming womenswear show for JIL SANDER in September will be his last under the current contract. He's negotiating a possible re-signing. But as one of the most revered fashion designers of today, RAF is also being heavily courted by several other houses; he might suddenly pop up at a big French house, or elsewhere.

But first he's off to the south of Italy, where he's borrowing a friend's house for the month of August. "I'll bring a pair of shorts and flip-flops, and that's it." No books?

"Maybe a book, but I'm not a big reader." There's fruit trees, fresh figs, fish from the market. Friends are welcome to come by on one condition: RAF is absolutely not going to entertain. "I'm just going to sit there, eat, drink fresh strawberry cocktails, and stare over the sea," he says.

Mr. RUSSELL TOVEY

Featured in issue n° 13 for Spring and Summer 2011

Friendly Englishman RUSSELL TOVEY has been acting since he was 11 and first attracted widespread acclaim aged 19 for his performance at the UK's National Theatre in ALAN BENNETT's play THE HISTORY BOYS, which was later made into a film. One of the titular group of unruly, but gifted, pupils in a Northern boys' grammar school, RUSSELL's character, RUDGE, dispenses the memorable line: "How do I define history? It's just one fucking thing after another."

In his interview with FANTASTIC MAN, just days before the marriage of the Duke and Duchess of Cambridge, RUSSELL admitted to a childhood fascination with the historical monarchs EDWARD VI and CHARLES I, and enduring royalist tendencies: "I want to work for THE QUEEN! I'd quite like to be a foot-man," he told ALEX NEEDHAM. Fortunately, though, RUSSELL has continued to act since then. He appeared substantially bulked-up in HBO's critically acclaimed LOOKING, a series about a group of gay friends in San Francisco, and in JIMMY McGOVERN's Australian penal colony drama BANISHED.

Another of RUSSELL's childhood obsessions discussed in FANTASTIC MAN was his enthusiasm for the Pop Art of ROY LICHTENSTEIN and ANDY WARHOL. By 2011, this had blossomed into a full-blown art-buying habit. Not only were the walls of his flat covered with art, but the cupboards were full of it too. "My friend the other day said that waking up in my flat is like waking up in a mini-TATE MODERN. I'm like, 'Good!'"

Portrait by Alasdair McLellan

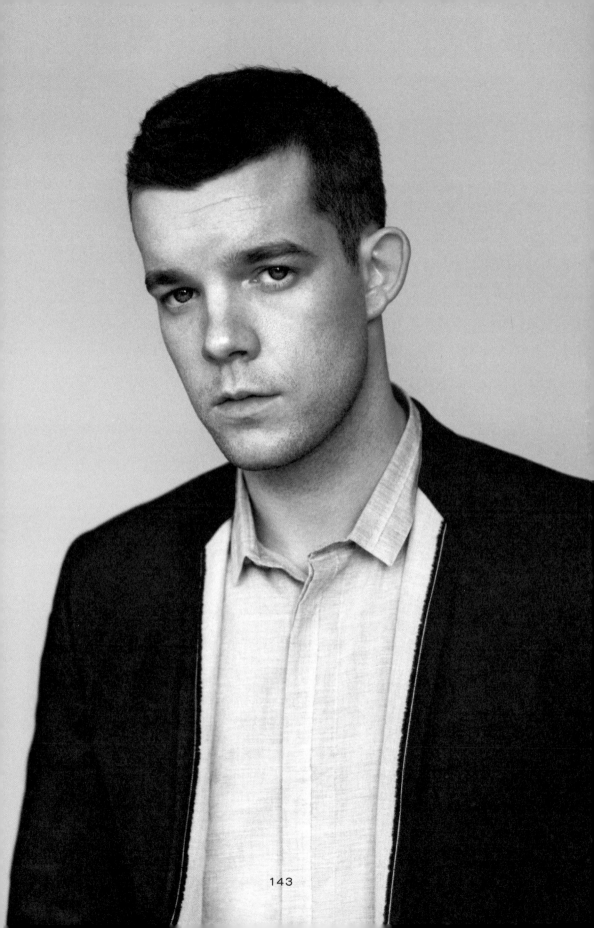

Mr.
HAMISH BOWLES

Featured in issue nº 10 for Autumn and Winter 2009
Portraits by Juergen Teller

HAMISH BOWLES wore several items from his own wardrobe for his shoot for FANTASTIC MAN. Among them was a striking tartan suit bought at the auction of the estate of the English dandy BUNNY ROGER. HAMISH followed a crash diet in order to fit it and admits, "I still have to breathe in." Belying that effort, Hamish adopted a series of debonair poses for the photographer JUERGEN TELLER.

Born in England, HAMISH now lives on New York's Upper East Side and has been the European editor-at-large of American VOGUE since 1995. His interest in fashion became manifest when he was still very young, and by the age of ten he had designed his first collection under the name JAMES OF PARIS, JAMES being the English take on the Scots name HAMISH. As a young man, HAMISH was equally comfortable in men's and women's fashions. "Once I was at a party at CAFÉ DE PARIS and CAROLINE KELLETT, the fashion writer, walked in with great show and a posh new beau. She was wearing the same CHANEL jacket as I, acquired from the same press sale. She was devastated, understandably; I was wildly amused." He still has a collection of around 1,500 women's couture pieces, but lately he has favoured flamboyant masculine styles.

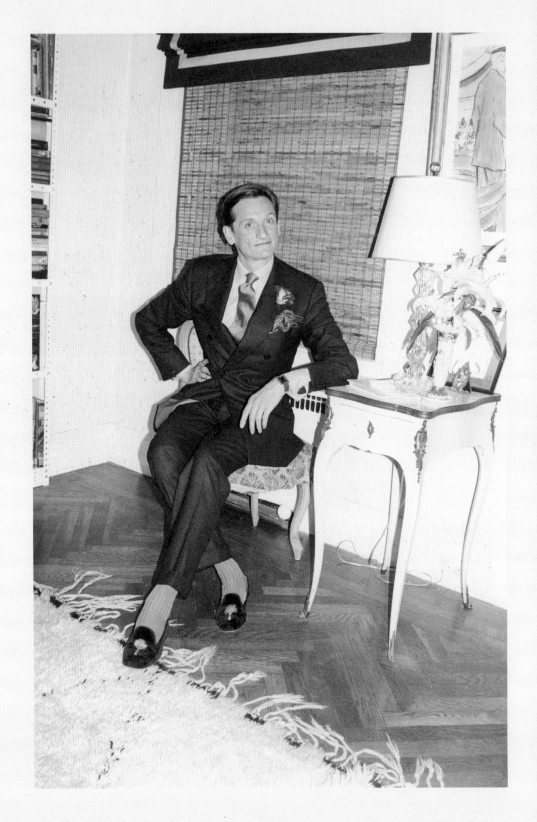

Chapter 2

Page 150-295

Antony
Stefano
Jeremy
Peter
Evgeny
Matthew
Mark
Stefano
Fredric
Charlie
Weiwei
Clément
Bret
Olivier
Malcolm
Lucas
Tom
Richard

Mr. ANTONY HEGARTY
Featured in issue nº 3 for Spring and Summer 2006
Portraits by Inez van Lamsweerde & Vinoodh Matadin
Text by Gert Jonkers

ANTONY

Mr. ANTONY HEGARTY's success may seem sudden and intense, selling out major concert halls and winning the prestigious British rock award, the MERCURY MUSIC PRIZE, for the best album of 2005. But for the thirty-something pop star with the amazing voice and a catalogue of beautifully strange songs, recognition has been a long time coming. His band ANTONY AND THE JOHNSONS made two albums in ten years; even a wonderful, simple song like YOU ARE MY SISTER, which he recorded with BOY GEORGE, took him five years to write, he admits. He's surprisingly modest for someone so charismatically fabulous that he can go by his first name alone, as only a handful of real stars can. Right now, the gentle Englishman in New York is planning a European novelty tour with a stage full of revolving girls. Beyond that, he's just going to wait and see, while he digests his recent tumultuous year. He might even want to tour the North Pole while it's still there.

"Are you a GORE VIDAL fan?" asks ANTONY HEGARTY.

Yes I am.

"Good. You should absolutely do an interview with GORE VIDAL. He's one of the most important figures of our times. Wouldn't he be amazing to speak to? Someone else you should get is JAMES PURDY. Do him while he's still alive."

I tell ANTONY that I've never heard of JAMES PURDY.

"Really? You don't know JAMES PURDY? I'm shocked! He wrote all these incredible books like THE NEPHEW and NARROW ROOMS. You didn't read any of them? I'm baffled. I recently read this interview with him from PLAYBOY in 1972 or so. He was one of the most amazing and subversive writers of the '60s and '70s — an unbelievable Southern poet. He was a huge influence on me. EUSTACE CHISHOLM AND THE WORKS is one of the most incredible books

I ever read. He's there with GORE VIDAL, JOHN RECHY... I'm pretty sure he lives somewhere in Brooklyn. He's kind of an impoverished institution. We should try to find him."

Sounds like a good idea. I think adoration is the best lead for an interview, so why doesn't ANTONY himself go and speak to JAMES PURDY?

"Hmmm. I could do that. But it would be so nice to give him more than just a little air time. It would be great to throw a big pile of money at him. He so deserves it."

What about JOHN RECHY? I had trouble ploughing through CITY OF NIGHT recently.

"How could that be? JOHN RECHY really was a huge influence on me as a kid. BODIES AND SOULS and NUMBERS... Do you know that MARC ALMOND did a 12-inch on NUMBERS with SOFT CELL? He did a lot of that; writing songs about icons from subculture. Do you like MARC's music? I love him so much..."

You sang with MARC recently, didn't you?

"I did. It was thrilling."

Didn't MARC have quite a severe motorcycle accident not so long ago?

"He did, but he's fully recovered now. He's so joyful. That must be how he recovered, 'cause he had quite a serious head trauma, but he has everything back. MARC is the kind of person that really changes you when you meet him. His life spirit... You should absolutely do an interview with him. He's been so important — not only for me. He's a total legend. I discovered half the world through MARC. Like, he did a cover of CAROLINE SAYS by LOU REED and I spent years with that image of LOU that I had through MARC. That was all I knew of LOU. Through MARC I found SCOTT WALKER, JACQUES BREL and SYD BARRETT. There's a picture of MARC with DIVINE on one of his albums and I thought, 'Wow, who on earth is that?!' This was years before I knew who DIVINE was. Through MARC I found JOHN RECHY, NINA SIMONE, BURT BACHARACH... Remember, the artistic subculture and the gay underground that MARC was a part of were still so coded. Information on subculture was difficult to access with no internet. So MARC was my window to that world. He set out a little trail of inspiration and I guess I followed that all the way to New York."

That's a lot of influence for one artist to have.

"Yeah, it is."

Do you feel like MARC ALMOND's role in history is underestimated?

"Absolutely. His body of work is ripe for reassessment, I tell you that. It'll come to pass that he will be totally lauded with praise. It can't be long."

We stick to the subject for a bit more. "A lot of MARC's album covers are by this wonderful painter VAL DENHAM that I've gotten in touch with — she did all

those incredible paintings, also for SCRAPING FOETUS OFF THE WHEEL and COIL and YELLO. She hugely informed my visual aesthetics. She's still painting away in some little cabin in Sheffield or what have you."

Would you ask her to do an album cover for you?

"I should, shouldn't I?"

Which brings us to PETER HUJAR, the legendary black-and-white photographer who died in 1987 and who only published a single book in his entire lifetime, PORTRAITS IN LIFE AND DEATH. "My favourite visual artist," says ANTONY.

"I was thinking about what the greatest, greatest possible art for an album cover for me would be, and the only thing that I could think of was PETER HUJAR's photos. I got in contact with HUJAR's estate, and at some point it looked like I could use the CANDY DARLING ON HER DEATH BED picture, which was an overwhelming sensation to me. That picture has been the centrepiece of my altar for 10 or 15 years — that particular picture! And there were other pictures that had never been published that I could use, like a close-up of CANDY DARLING in hospital. I basically put together a 12-inch especially to have something to release behind that picture. Actually, to be able to use CANDY DARLING's picture for the album was a major drive to finish the album in the first place, 'cause there were times when I didn't feel like finishing the album but completely discarding it instead and starting all over again on a solo album.
It really needed an opening and something magical to happen. You could say it was thanks to PETER HUJAR that the album ever saw the light of day."

What is it that you love about HUJAR's work?

"He dealt with a lot of big questions about life and death. I'm sure that his vision effected me 'cause I spent so much time looking at his pictures. There's something about the notion of the spirit in his pictures. He took an incredible picture of a bush, which sort of exemplifies his eye and vision. He also took the greatest picture of DIVINE that exists. It's DIVINE lying on a chaise longue, forlorn, no wig, just a little light make-up. It's the most soulful image of DIVINE."

We've been talking for a good 20 minutes and we've hardly talked about ANTONY — which must be a novelty in pop star interviews. I ask ANTONY how he is at the moment.

"Me? I'm fine. I'm OK."

How were the last 12 months for you?

"Very exciting."

But still reasonably manageable?

"Well, overwhelming. Really... the success of the album really took me out of one world and into another. I don't know if this success is a permanent thing, you know what I mean? I don't have lots of expectations about it. Never had a lot

of expectations to start with. Seeing what's happening with me is like watching a movie. I have the feeling that it's not even about me. You know that feeling? That you show up for your life, like there's a bigger picture and a whole choreography that you just show up for... It's not about me, I think."

Do you mean that there was a need for somebody and you just happened to fit the role, and otherwise somebody else could have shown up and taken ANTONY's place?

"I wasn't saying that. But it's like weather patterns. I do believe that it's a trajectory that I've been blown along on. It's not like I created the weather. I just think there's a possibility for me right now — there's a window in culture where someone like me can have some sort of... place."

Who do you think opened that window?

"KIKI AND HERB. And maybe KURT COBAIN."

The HEGARTYs lived in Chichester in Sussex, England, until ANTONY was six and the family moved to Amsterdam, in 1977. "Amsterdam was brilliant for me — my life completely changed. The city gave me just the information that I needed at that age. The diversity, the kind of bohemian freedom, punk... I feel that our move to Amsterdam was when my life switched to colour. I grew my hair, started wearing lots of jewellery. I really got into it. It was the dawning of my consciousness. As if I realised who I was and what I wanted. I think I realised there and then that I was an artist. I started drawing a lot, listening to music. Also the school I went to was really great — the International School of Amsterdam."

I'd already had the bright idea of going and finding ANTONY's school and teacher in Amsterdam, since I live only a few blocks away from the building. I realise that we're talking 29 years ago here — but then again, who knows what somebody might remember of a young Mr. HEGARTY? But ANTONY doesn't seem particularly amused by the idea.

Do you remember your teacher's name?

"I do. Why?"

Well, it could be interesting to pay them a visit.

"But I don't think I feel like giving you that name."

Why not?

"Would you want someone diving into your younger years? I wouldn't. I just... eh, I don't think that's such a good idea."

They were in Amsterdam for just a year and a half before they moved to California. ANTONY got a CASIO keyboard when he was 11. "I tried my best to play it, imitating the electronic songs that were popular at the time... NOBODY'S DIARY by YAZOO and SAY HELLO, WAVE GOODBYE by SOFT CELL, songs by THE ASSEMBLY and early DEPECHE MODE. I would wail away in

my bedroom. I guess I learned about music from figuring out how to play those songs, and pretty soon I started diving off on my own, making my own little odes to adolescent angst."

Like what?

"The first song I ever wrote was about this creature who wore gobs of make-up who was being antagonised by a bunch of spiders. I remember the main problem with the song was that I used the word 'Hippocratic' instead of 'hypocritical'."

When was this?

"I wrote it when I was 12."

ANTONY moved to New York ("it felt like coming home") and founded the BLACKLIPS PERFORMANCE CULT in 1992, together with a lady called JOHANNA CONSTANTINE. They had their weekly Monday night at the PYRAMID on Avenue A in New York. Imagine a hell-bent group of transsexuals, a lot of blood-and-splatter humour and a whiff of THE COCKETTES and LEIGH BOWERY.

ANTONY: "In fact LEIGH came to see BLACKLIPS, and he loved it. He was a big, big fan of JOHANNA. She's somebody who always comes up with exciting ideas. That scene in MATTHEW BARNEY's CREMASTER CYCLE of the female goddess emerging from the dunes in deer antlers — that was exactly what JOHANNA was performing on stage in the PYRAMID back in 1992. JOHANNA has a very JACK SMITH-y quality that very few people have. She, and KEMBRA PFAHLER — you should check her out too, she's New York's most important artist."

Even ANTONY AND THE JOHNSONS, his project after BLACKLIPS, started as a kind of performance troupe, modelled after THE ANGELS OF LIGHT, the ensemble started by the legendary HIBISCUS from THE COCKETTES. "But eventually I drifted away from directing and got more and more interested in singing my songs," says ANTONY. The rest is history, with ANTONY AND THE JOHNSONS selling loads of records, winning the MERCURY PRIZE for best British album of 2005 — much to everybody's surprise. Not least because ANTONY, his British nationality notwithstanding, hasn't actually lived in ENGLAND for the last 30 years.

ANTONY has since played THE LATE SHOW WITH DAVID LETTERMAN, sold out countless major concert halls, and is at the tail-end of a year-long tour when we meet in Berlin in December.

ANTONY HEGARTY isn't somebody you get to know easily. It's not that he doesn't talk, and he's fun company, but he somehow tends to avoid himself in conversation. Is he hiding? Maybe. He wears a funny embroidered woolly hat that

he got from his friend KEMBRA. "She said it's from J-LO but it has no label in it. I think she was just kidding." He wears a gothic-y sweater that a fan knitted for him. "I love it; it's just my style."

Are you a day or a night person?

"A night person."

What's your favorite key to play or sing in?

"I think I play a lot of songs in G-sharp, but I am useless with these things."

Are you a good cook?

"I live in a tiny room and haven't had a kitchen for ten years. But I did use to cook, and recently I had a party for all my friends where I got quite ambitious. I like to make dishes up. I am very good at inventing exotic puddings."

Have you ever done anything against the law?

"I am actually hideously law-abiding. I did have a brief period of shoplifting as an adolescent, but by the time I was 16, I had returned everything I had ever stolen. In my youth I briefly attempted a stint at the world's oldest profession, but I was a miserable failure — it was impossible not to take everything personally! So I got a job as a gardener instead."

Are you happier than ever?

"No."

Less happy than ever?

"No. I think happiness is such a relative thing. I feel I'm very fortunate, sure. To have these opportunities... These last months have been crazy and kind of mythical. It's a chapter in my life that I won't forget."

Are there things you regret?

"Well, maybe I've done things last year that I wasn't ready to do. Like, certain things where I felt I wasn't able to give as much as I would have liked to if I'd been prepared. It's been a quandary for me. When life rings at your doorbell you have to do it, 'cause the opportunities don't come every year. I'm 35, you know, not some sort of spring chicken, and there's no guarantee that something like this will be there in a couple of years. So I have to live on extra energy and do everything, as much as I would have liked to spread out this last year over five years. I've been in situations where I had to put on a video camera in my head and film things that were happening, storing them up so that I could process them later. That I have some regrets about. I mean, not regrets, but... Do you believe in regrets? I don't. I only have one regret and that's a private regret, a personal thing."

There are times when I have trouble following ANTONY's theories. He goes on what he calls "a rampage" about the current state of society and how consumerism has made us all lethargic and we're "on a road to hell".

And then there are many more heroes that he tips his hat to, like JACK

SMITH, OTIS REDDING, ELIZABETH FRAZIER of COCTEAU TWINS AND
ANN DEMEULEMEESTER.

"I love dancing," he says. "I just dance around the hotel room, sometimes
without music. My biggest hero is KAZUO OHNO, the one-hundred-something-
year-old Japanese dancer. Do you know him? He's one of the founders of BUTOH,
and he had a huge impact on me as a singer. I think in a way I apply some of his
BUTOH principles to the process of singing. His dance is characterised by lots
of slow, organic movements." And then ANTONY goes off in a theory about "the
dance of darkness — in a way similar to PETER HUJAR's photographs in its
essence of capturing through rigorous transformation beyond your human identity.
Maybe you're moving and you're seeking light; explosions of light in the eye of
a salmon swimming through the ocean... And you're the person who creates this
glow..."

In the weeks that follow our interview I also speak to some of ANTONY's friends.
THOMAS ENGEL HART, now design director at THIERRY MUGLER in Paris,
got to know ANTONY in the BLACKLIPS days. THOMAS: "ANTONY and
JOHANNA were the catalysts of many things happening at the time. I loved their
blood-and-horror black-humour storylines. I did clothes for KABUKI, who was in
BLACKLIPS, and I did some set design. They were pretty elaborate. We brought
huge junkyards on stage."

"ANTONY always touched people," says THOMAS. "It's just amazing to
watch him grow to where he is now, without in any way selling out. It's the same
honest emotion. He definitely is the most extraordinary person I know. He's got
intelligence running out of every pore. I admire the hell out of him, and he's a
good, good girlfriend — do I need to go on?"

"ANTONY is one of those performers who's extremely shy but also a great
performer," says ANTONY's friend, filmmaker CHARLES ATLAS. "You could
say he's almost conflicted, you know, which is one of the things that make him
so special. Just imagine what happened to him. He must have felt completely
overwhelmed with his success and he's just coming to terms with it. I mean, he
played the DAVID LETTERMAN SHOW! When I saw him on TV with DAVID
LETTERMAN I was like, 'Oh my God this is ridiculous, who'd ever have thought
I'd live to see this!'"

ATLAS vividly remembers the very first time he saw ANTONY perform
with BLACKLIPS. "They were doing some kind of weird version of the STAR-
SPANGLED BANNER, the American national anthem. I remember that
ANTONY's voice was just thrilling and chilling, but the detail I loved the most
was that he had all the words for the song written on the inside of his hands and
arms. You know, as performers sometimes do, but I thought it was a big joke —
who doesn't know the words to the national anthem? I didn't know he was English."

Which reminds me of the first time I saw ANTONY, on a Sunday afternoon in November 2004. He played the small room at the PARADISO in Amsterdam, opening for his friends COCOROSIE. It was just ANTONY behind a grand piano. He was chatty, interrupting songs to tell stories about his life, freely associating, seemingly making some songs up on the spot.

His voice was amazing. He reminded me of BRYAN FERRY and SCOTT WALKER, even ancient folksinger JOHN JACOB NILES. One thing I wasn't expecting was what his audience looked like: I was standing in a room full of shiny-rubber-ball goth goddesses of the most seriously depressed kind. "Ah, yes, that was funny," says ANTONY a year later.

His audience in Berlin is twenty times bigger and ten times more normal, naturally. In a way ANTONY seems less comfortable on stage than on previous occasions when I've seen him. He sounds fabulous, even though I'm slightly annoyed that he doesn't play TWILIGHT, the opening song of his debut album — it has the most amazing chord progression since... well, since SCOTT WALKER.

"I'm probably not going to do a lot of touring," says ANTONY about the upcoming year. "I'm excited about going home and reconsidering everything, taking some time to be by myself. The good thing about my situation is that I'm very independent. I have no manager; there's really no one telling me what to do. Probably my label is hoping I'll make another album, but that's about it."

One thing ANTONY will definitely be doing is TURNING, a series of concerts in Europe in the autumn with his friend CHARLES ATLAS. It's a rerun of a performance that they did together for the WHITNEY BIENNIAL in 2004 — a performance that, legend has it, was just amazing. ANTONY and the band played a full set without too much talk in between songs, while a group of female (or female-ish) models, slowly rotating on a small turntable, were filmed by CHARLES and live-edited, morphed and projected on a screen behind the stage. "It's quite... magical," says ANTONY. They only did three shows in 2004, but parts of the footage were used later for the YOU ARE MY SISTER video, and that's beautiful.

One thing he'd love to do, ANTONY says, is create a series of songs for orchestra and choir that could be performed at the North Pole; songs sung for the melting ice and the changing land forms of the region. "There must be so many memories and ghosts pouring out of that ice as it melts, after being frozen for so many tens of thousands of years. There was an article in THE NEW YORK TIMES last week that said that the Northern Polar Ice Cap will completely melt within the next 50 to 100 years, leaving a warm ocean and catastrophic rising tides in its place."

The greenhouse effect gets him started: everyone ANTONY's talked to around the world is aware that something is going wrong. "It does not take a

rocket scientist to realise that the weather is changing. Every shop clerk and taxi driver and gardener knows it's happening. I have asked people all over the world what their impression is and it is always the same... It is a bad thing, and we are all scared."

"It's a suicidal impulse in humanity, especially in the hearts of our world leaders and corporate executives, many of whom truly believe that apocalypse is the destiny of this planet. I disagree. We're not victims of some divine plan; we are doing this to ourselves and to our world. We're choosing our fate with our irresponsible consumerism and our passivity. This may be the greatest challenge we will ever face as a species."

He sighs and then smiles as he stands up and says, "Have mercy."

Mr. STEFANO TONCHI

Featured in issue nº 12 for Autumn and Winter 2010

STEFANO TONCHI was on a shortlist of men recommended to FANTASTIC MAN's editors JOP and GERT by the photographer INEZ VAN LAMSWEERDE. The tip-off came before the launch of the magazine, but it took until issue no 12 to feature him, by which point he was the fashion media's man of the moment. The founding editor of THE NEW YORK TIMES' lifestyle magazine T, STEFANO had recently been poached by CONDÉ NAST to helm the monthly magazine W. This shoot was published just as his first issue of W hit the shelves.

STEFANO was photographed while he relaxed, worked and worked out in his minimally furnished house in the Hamptons. His sense of style is faultless but adventurous and he recounted an episode that had taken place at a black-tie premiere during the CANNES FILM FESTIVAL. Arriving on the Croisette in a cream silk jacket with a shawl collar, he was marched in front of the tuxedo police. The garment broke the rules, but STEFANO's attention to detail seems to have won the day: "Black patent shoes, okay. Black tuxedo pants, okay. White pleated tuxedo shirt with cuffs and silver cufflinks, okay. Black silk grosgrain bow tie that matches the cummerbund and tuxedo stripes on the pants, okay. Cream dinner jacket with shawl collar? Maybe..."

Portrait by Daniel Riera

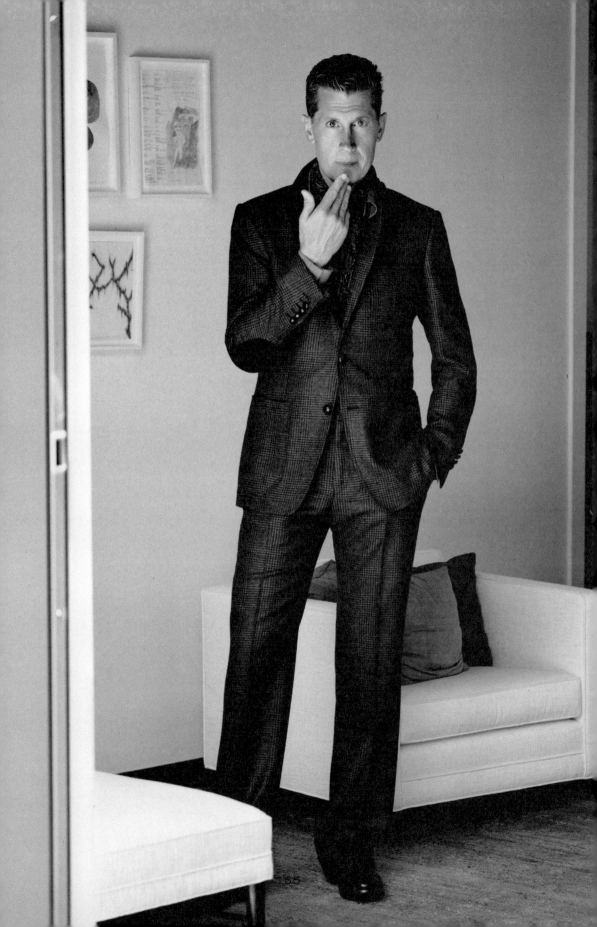

Mr. JEREMY DELLER
Featured in issue n° 17 for Spring and Summer 2013
Portraits by Alasdair McLellan
Text by Isaac Lock

Mr.
JEREMY DELLER

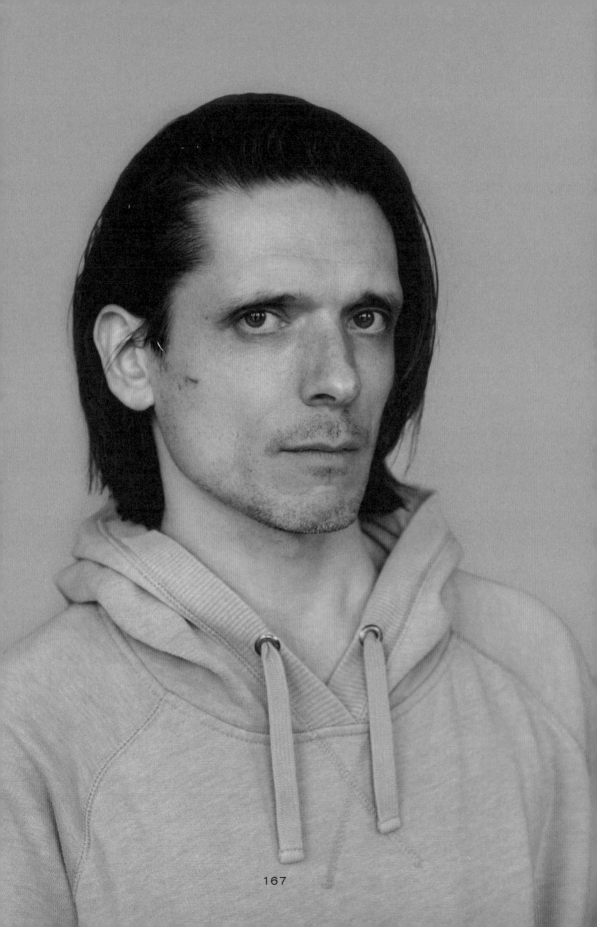

This year, at the 55th International Art Exhibition of the Venice BIENNALE, the nation of Great Britain will be represented by philanthropic artist and pop-culture enthusiast Mr. JEREMY DELLER. Held in increasingly high esteem by the public of the country that nominated him, DELLER produces work that often, but not always, celebrates the endless passions and talents of ordinary people in ways that encourage a maximum of engagement and participation. The 46-year-old lives in his native London and holds great affection for that most fascinating prehistoric mammal, the bat.

On SKYPE, I'm speaking to JONATHAN HARVEY, who served as a platoon sergeant in the United States Army for several years, starting in 1997. Now he's in the Army Reserve, which means that when he's needed, he gets called up for a mission, serves it and then returns to his civilian life in Anchorage, Alaska. In the army, he's a specialist in psychological operations, or "PSYOP". His job is trying to influence people in conflict zones to think in ways that would benefit whatever mission he's on. During the most recent war in Iraq, for example, he undertook a campaign of posters, flyers and face-to-face conversations to try and convince Baghdad locals to report crimes and insurgent activity to the security forces.

Due to the sporadic nature of his work, it's easy for him to take on temporary jobs and projects in between missions. So, when he got back from his mission in Iraq in 2009, he spent six weeks travelling across the US on a 14-stop road trip with the British artist JEREMY DELLER, the Iraqi journalist ESAM PASHA and a trailer displaying the remnants of a car that was bombed in a Baghdad market place in 2007. The project, titled IT IS WHAT IT IS, was instigated by DELLER. His idea was that at each stop, members of the public could meet with people who had been involved in the war and discuss with them the events that had saturated their news for the past few years. It would be a vehicle to get people to interact around a set of difficult and emotive subjects.

"I was surprised to be chosen," HARVEY says of it. "I was in Alaska. There's veterans all over the place, so I didn't think he would pick me. I didn't have much experience of the art world outside of high school, so I hadn't thought about how driving around and talking to people could be considered art."

"And how was it? The driving around and talking?" I say.

"Once I was immersed in the process," he says, "I realised how cathartic it was. How great it was to be able to talk about some of the intense experiences I'd had. I think it was the same for a lot of the other veterans we met. It gave us a way to talk about things that we hadn't necessarily been able to talk about before."

"What did you think of JEREMY, when he first asked you to do it?" I ask.

"Like, my first impression?"

"Sure."

"Short," he says. "He really was a lot shorter than I'd expected."

JEREMY DELLER won the high-profile TURNER PRIZE in 2004. Last year, 2012, he was the subject of a major retrospective, JOY IN PEOPLE, at one of London's biggest and most popular art institutions, Southbank Centre's HAYWARD GALLERY. This year, he's been selected to represent Britain at the Venice BIENNALE. Representing your country in Venice is a high honour in the art world. It is like being selected to perform at EUROVISION. Like being your country's only entrant in the OLYMPICS. It is the kind of thing that can only happen if the art world has taken a lot of notice of you. It is an honour that has

been bestowed upon some of the most notable artists of the 20th century: BARBARA HEPWORTH, FRANCIS BACON, LUCIAN FREUD, and more recently TRACEY EMIN and STEVE McQUEEN.

JEREMY DELLER isn't much like many of his predecessors in Venice, though. His work doesn't really have anything to do with the art establishment. He doesn't make things that can easily sit in a gallery context and be bought and sold by collectors. The only thing he had for sale at FRIEZE ART FAIR in London in 2006, for example, was a stack of posters with the slogan *"WHAT WOULD NEIL YOUNG DO?"* The posters themselves were free to anyone who wanted one, but the idea of the stack and the PDF to make it were for sale, on the condition that once a new stack was made, the new posters would be given away free, too. In the late '90s, when Young British Artists were getting rich from a decade of work that seemed radical but — for all it's shock and sensation — was still essentially pictures and sculptures, DELLER was busy organising mystery tours of Clacton-on-Sea and commissioning a brass band to play cover versions of Acid House classics. DELLER's intended audience isn't the gallery or the rarefied intellectual; it's the wondrously various public. His work is designed to engage. It celebrates the way people interact with each other, their history, their media and their pop culture.
It's public art that has a genuine respect for its public. DELLER is a champion of the overlooked, the ordinary, the suburban and the average.

Last year, he set out another road-trip-based project, SACRILEGE, travelling around the UK with a giant replica of Stonehenge made of the stuff that bouncy castles are made of. In 2009 he mounted a procession in Manchester that featured thousands of the city's residents — goths, unrepentant smokers, street vendors
— and STEEL HARMONY, a Caribbean-style steel band recasting classic New Wave songs as jubilant, carnival anthems. His work is immense in scale, involves as many people as it can, and makes room for all of them.

"JEREMY is one the most interesting artists working today," says RALPH RUGOFF, the director of the HAYWARD GALLERY, who commissioned and curated JOY IN PEOPLE. "He's much more interested in doing things that shine a light on other people's creativity, than in claiming that light for himself. His work activates people's thinking about the world they live in."

The first time I meet with DELLER it's in a family Italian restaurant by Highbury & Islington underground station.

"I'm here to meet JEREMY DELLER," I say, when I arrive.

"Oh," says the woman that meets me. She waves an arm to the entirely empty restaurant. "Sit wherever you want."

When JEREMY arrives, a man who looks like the owner pats him on the

back. "Your second time today!" he booms. "You're here more than you're home!"

JEREMY asks him who's in the kitchen.

"I'm here more than I'm home at the moment," he says to me as he sits down.

"Do you come here every day?" I ask.

"No," he says. "Just sometimes."

He's in a canvas jacket and a big pink scarf and he shuffles from side to side in his seat for the first half hour of our conversation.

"No one's going to be told what I'm doing in Venice," he says, once we start talking properly, about his project for the upcoming BIENNALE.

I tell him that's okay, but he looks a bit concerned.

"I mean that's what happens every time at Venice," he says. "No one says what they're doing. There are no leaks. It's not personal; it's not just me not wanting to tell you. That's the thing about Venice. There has to be a sense of reveal."

Instead, he talks about the ongoing fallout from JOY IN PEOPLE. He talks about the different types of attention he's been getting since the show closed six months ago. The night before we meet, he had an art student drunkenly following him round a party muttering that he was "a cunt". "It happens, occasionally," he says. "You get general resentment from students who think you're in their way." That aside, the reactions have been overwhelmingly positive. "Collectors are a different thing," he says. "You can't second-guess them and I'm fine with that, but the public response to that show has been massive. Really incredible. Unbelievable. I get a lot of compliments now. Which can be quite difficult to take, too."

DELLER doesn't seem the type to shy away from criticism or praise. "Surely doing what you do requires a lot of self-confidence," I say.

"Self-confidence," he says, "but there's probably stupidity thrown in as well. Not thinking things through. A lot of the things I do are just the result of thinking: 'What would happen if I did this?'" He mentions his 2001 project THE BATTLE OF ORGREAVE, for which he enlisted hundreds of former coal miners and police officers to stage a massive re-enactment of one of the defining events of the deindustrialisation of the UK under THATCHER's government, a full-scale confrontation between strikers and police in 1984. "It was the re-enactment of a crime scene," he says. "Like the ones the police sometimes do on television to jog the public's memory of a kidnapping or a murder. It was a way to jog the wider public's memory of this event and get them to remember it and to get angry and upset and do something about it. When we were there, though, there was a moment when I came over the brow of a hill onto the site and saw that I had everyone there camped on the field and the football pitches, hundreds and hundreds of people with horses and dogs and sticks and shields, and I just thought, 'God, I can't believe this. This is ridiculous stuff, that this has happened. Why has

anybody let me do this?' I suppose film directors must feel that sometimes. They go on set and think, 'I've built this castle, I've got this set. I've got a spaceship! But I didn't mean it!'"

The project JEREMY wants to talk about the most is a film he made in 2010, called SO MANY WAYS TO HURT YOU (THE LIFE AND TIMES OF ADRIAN STREET). It's a narrative documentary portrait of the son of an abusive Welsh coal miner who escaped the mines in 1957, aged 16, to transform himself into a spandex-clad, proto-glam-rock, proto-WWF-wrestler-cum-drag performer. The apex of the film is an image of STREET from 1973, back down the mine on a visit home, having found success as a wrestler. He's triumphant and stunning in a lurex blouse and regal fur, pouting from beneath an acre of blonde hair, while his father and his grubby-faced former workmates grin awkwardly on. The feeling of the film is one of sincere pride, a celebration of the man's unique accomplishments. He's a person who could very easily be made into a figure of fun but in fact he's treated with a deep and curious respect. He's celebrated as a totem of reinvention and endurance.

"ADRIAN STREET is the kind of person mainstream telly would love to get their hands on and destroy," JEREMY says. "But I think for British culture he's a very important person. He's basically reinvented himself and made his whole life into this ongoing project of redefinition. His body is a work of art; his performances were a work of art. He makes costumes, he does all the work himself. He's essentially a practical folk artist, but he's also an absolute metaphor for Britain changing. He represents the awkward shift Britain is trying to make from being an industrial economy to a post-industrial one, shifting from being a country based on industry to one based on service and entertainment. Weirdly enough, he wrestled JIMMY SAVILE too."

The posthumous exposure of '70s television personality JIMMY SAVILE as a serial sex offender, and the subsequent arrests of a litany of other high-profile British entertainers in a related investigation, has hogged the UK news agenda in the weeks before we meet.

"JIMMY SAVILE had a short-lived career as a wrestler, and ADRIAN wrestled him and hated him," JEREMY says. "ADRIAN hurt him to the point that he never wrestled again. But SAVILE went on to kind of steal his look. The long blonde hair and the spandex and the gold and silver clothes. A lot of people did, a lot of musicians. I was brought up on that look. Glam rock. That was my first independent musical love, in a way. Glam rock was something I thought I'd found out myself from watching TOP OF THE POPS at home with my parents. It had a huge effect on me. It still does."

"How old were you?" I ask.

"Five or six," he says.

JEREMY lived at home with his parents in Dulwich, one of south London's chintzier boroughs, until he was 31. His mum and dad, an NHS receptionist and a council worker, are "liberal with a small L," he says. "Churchgoers. First-generation middle class." They sent him to the local private school, Dulwich College, making great sacrifices to pay the fees. He was kicked out of his art class there for displaying no talent for working with his hands whatsoever. "Being an artist was as unapproachable for me as being a doctor or a lawyer," he says. "I just didn't have the skills for it."

By the time JEREMY moved out of home, he had already earned two degrees (an art history undergraduate degree from the Courtauld Institute in London and a Master's, which he nearly failed, from Sussex). He had caught the attention of ANDY WARHOL by turning up at the ANTHONY D'OFFAY GALLERY in a "schoolboy-esque" outfit and was invited to spend time with him at THE FACTORY in New York City, which he did. He had staged several reasonably-sized exhibitions and events, including ACID BRASS, the project for which the WILLIAMS FAIREY BRASS BAND from Stockport played Acid House tunes. He did a show he called OPEN BEDROOM, which he put on in his parents' semi-detached home while they were away on holiday. It was a showcase of all of his work up until that point, the majority of which was essentially fan art dedicated to or drawn from the music he was obsessed with.

"I don't think it was normal," he says, "staying at home so long. You could even get Housing Benefit back then. I could have moved out and got Housing Benefit. Quite easily."

I ask why he didn't and he tells me he's lazy.

"Didn't your parents want you out into the world?" I ask.

"Sort of," he says."I'm not an argumentative person, so it wasn't an issue for quite some time. I think I realised that I didn't want to rush. I realised that I wasn't in a boy band, and that two years in the art world is the equivalent of two weeks in the music industry. I could take my time, and see how it went. I'd studied art history so I understood the sense of time in artists' careers and that there's hundreds of years behind you. There's no point in rushing to get on with things. You saw people do that and you saw them crash and burn. Some of them aren't even alive because they wanted it so badly. That's kind of sad. There's no point rushing it."

"You must have been frustrated, though, at times."

"Of course there were bad times, but it was something to work against."

"Did you have girlfriends?"

"Not really. It was impossible for me to deal with that for years. All very haphazard."

"So you'd go to girls' houses, or you literally didn't have girlfriends?"

"More or less the second. It was all very unfortunate. The people I was with

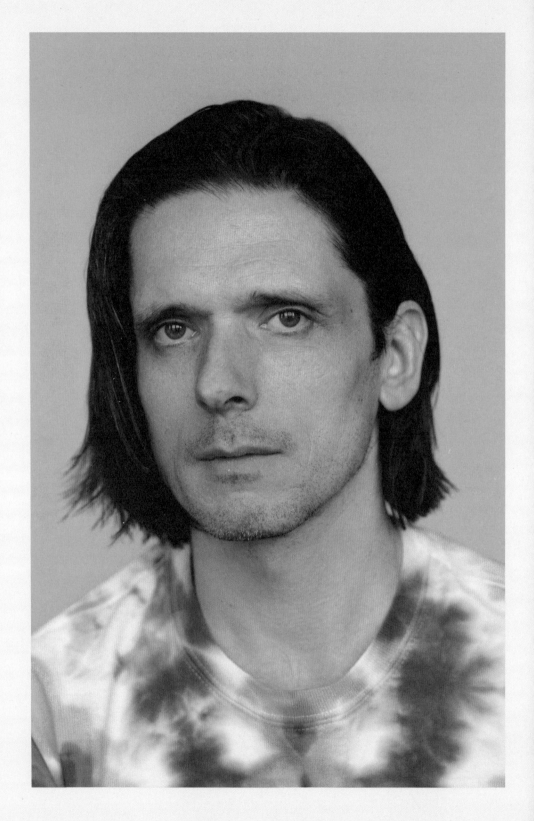

in my twenties, I apologise to now. I try not to think about it too much. Who wants to talk about that side of their life unless they're an exhibitionist?"

"Unless it's funny."

"I wouldn't call it funny. My friends thought it was hilarious that I was an exclusion zone for women, but I don't remember it like that. I was actually quite happy and very sociable. For a time, I worked in a clothes shop and I was out all of the time having a life."

The clothes shop was in London's Covent Garden and it was called SIGN OF THE TIMES. JEREMY worked there between 1993 and 1996, and it was perhaps the perfect fit for a fanboy outsider: the perfect way to get a look at a world that held such a fascination for him. "It was classic," he says. "Post Acid House, pre super-club, post rave. If anyone was in town they'd go to SIGN OF THE TIMES. It was the place to be; it was a time when, somehow, shops had become the places to go. It sounds tacky, but you'd have proper pop stars come in, proper models. DANNII and KYLIE, BJÖRK, HELENA CHRISTENSEN, MICHAEL HUTCHENCE." He almost whispers some of the names.

Back then, JEREMY's work was all about the things he was a fan of: Acid House, MORRISSEY and BEZ, the legendary dancer for the HAPPY MONDAYS who had disappeared after the band's split. JEREMY might have made music, if he could, but he couldn't, so he borrowed the other forms of the bands he loved—posters and T-shirts, the stuff of merchandise stands—to make his work. He'd print the opening lines of a PHILIP LARKIN poem on T-shirts, or the slogan "I ♥ MELANCHOLY", which is the T-shirt that NICKY WIRE, the bass player and lyricist of the MANIC STREET PREACHERS, bought.

The MANIC STREET PREACHERS started life as four working-class boys from a tiny Welsh town. Much like JEREMY DELLER's other fascination, ADRIAN STREET, the MANICS harnessed the power of glamour and camp to propel themselves out of their surroundings. They used dressing up and showing off as motifs for freedom and a life beyond their suburban drudgery. In doing so, they picked up legions of other frustrated small-town kids who, as fans, were inspired by their reinvention. Empowered by their heroes to dress up themselves and make their own bands and art and fanzines, the fans were almost as famous as the band. They were also the first group of people that JEREMY worked with on a large scale.

In 1997 he organised THE USES OF LITERACY, a show of MANIC STREET PREACHERS fan art, featuring hundreds of drawings, photographs, letters and fanzines that he collected from fans by mail. He became a fan of fans. A metafan. Two years later he curated UNCONVENTION at the CENTRE FOR VISUAL ARTS in Cardiff, the capital of Wales. The exhibition showed works by WARHOL,

DE KOONING, POLLOCK, PICASSO and BACON and material from the Vietnam War and the Spanish Civil War, curated according to what JEREMY pictured the MANIC STREET PREACHERS' visual tastes to be. He didn't collaborate with them on it; he just imagined what they might like.

Aside from his impeccable production and organisational skills, I want to know about whatever JEREMY had been doing in that period of his life that made people take him seriously as an artist. I want to know what it was that elevated him beyond the level of the fan.

"I'd call him a professional enthusiast," says NICK ABRAHAMS, who made a film with JEREMY about another group of fans: those of the band DEPECHE MODE. "He always has a genuine enthusiast's approach. What makes JEREMY different is that he's very good at spotting connections between things. He finds new directions for people to go in. And he's very generous. He's enthusiastic and he's generous with that enthusiasm."

"What do you think it's like to be on receiving end of one of his obsessions?" I ask. "To be one of his subjects? Do you think it feels like being an artist's subject, or do you think it just feels like having a really keen fan?"

"You'd have to ask someone who's been in that position," ABRAHAMS says. So I call NICKY WIRE.

"Absolutely brilliant!" says the MANIC STREET PREACHERS' bass player. "I didn't even know about the first show, the fan one, until someone came up to me at a gig in Carlisle and showed me a drawing of me turning into JESUS CHRIST. Which was absolutely brilliant. Not because I have a JESUS complex or anything, but because I was really blown away by it. At that time, we as a band got sent a lot of letters and paintings. A lot of them were quite dark, some even done with blood. A lot of people on the edge of being damaged gravitated towards us. I think it was probably really important and rewarding for a lot of the fans to be recognised and taken seriously for the artwork they were doing."

"What makes it art and not just obsession?" I ask.

"Well, it is obsession, but it's also an artist's sensibility and the drive to create something out of that obsession. Every project JEREMY does, he really is committed to and in love with. I think it's his fanaticism that makes it work. You can really see that it's for real, what he does. He does it with an amazing amount of intensity. He's not faking it."

"It's definitely good then," I ask, "being a subject of his?"

"Oh yes," he says. "Absolutely brilliant! And he does make you smile. He's such an engaging person, and he's so bloody good looking as well! He's still got that glint in his eye that I used to have."

The second time I meet JEREMY it's in his flat, which doubles as his office and studio. ("It's expensive having a separate studio," he says. "It's like having

a second mortgage."). He introduces me to his partner, who is just leaving as I arrive. JEREMY has got his pink scarf on again, but this time it's over a little embroidered Chinese jacket. I ask him if I should take my shoes off. "If you want to," he says. "We do. But then we have slippers." I look at his feet. "Slippers are a great invention." We go through to his office at the back of the flat. When he sits down he tucks his slippered feet beneath his legs.

One of the office walls is made of cork board, but there's not much stuck to it, because it's just been emptied that week. Nothing to do with my visit, JEREMY assures me. The decks are being cleared for his Venice work to commence. The room is markedly ordinary and practical; it looks like a home office in English suburbia that's shared between a father and his teenage son: the desk is functional and grey, similar to one that you might expect to find in a call centre. On one side of it he's got a fake WARHOL MARILYN that he bought in a junk shop in Bacton-on-Sea for £2.50 twelve years ago and that he had elegantly framed. On a shelf there's a small statue of BART SIMPSON and some relics of his earlier work: a mug with the slogan "My Drug Hell" and a notebook with an "I ♥ MELANCHOLY" sticker on it. We talk about cults and doomsday prophets and conspiracy theorists that he's met. He tells me that he's never been in a fight but that at school he'd often start them and run away.

On his computer screen there's an image from the day's events in Gaza: Hamas militants dragging the body of a suspected informer on the ground behind a motorcycle, while firing their guns, jubilantly, into the air. We talk about the power of those kind of images, and the politics of reducing conflicts to instantly affecting single frames. He says that during his 2001 residency in San Antonio, during which he made the film MEMORY BUCKET, a portrait of President GEORGE W. BUSH's Texan home town that would go on to win him the TURNER PRIZE, he became obsessed with watching FOX NEWS. "Watching that stuff is really bad for you," he says. "Obviously."

What's clear is that he's painfully aware of how boiling ideas down to their most instant, absorbable form increases their power. I ask him if that's what his work is about: getting his social agenda heard in an effective way.

"I have my beliefs," he says, "but if you just hammer people with them no one is going to listen. Whereas when you take a car destroyed in Baghdad around the US and present it to people, you create a space where they can come and feel at ease to talk about anything, regardless of whatever position they might have. If you just throw your beliefs at people, then you're a politician."

"Would you have been a politician," I ask, "if you were living in an age when politics was more effective?" He says he wouldn't. He reckons he'd have been some kind of journalist or taken a job in advertising. "I don't have consistent enough views for real politics, and I feel a bit embarrassed when I'm asked to

become part of a campaign or something. I'm not very good in groups. I'm much better as an individual."

"But more or less everything you do is to do with groups."

"I know. It's maybe a way to become part of one. But I'm not a committed activist about anything, which may surprise people, I suppose. Although I did become a vegetarian in the last 18 months, which is interesting. It really annoys a lot of people, which I quite like."

"Because you like getting a reaction from people?" I ask.

"I suppose. When I had the show at the HAYWARD I really liked going there and watching people responding to things or not responding to things. It felt like wandering around like a spare part at your own funeral. I found it really interesting to see if people thought things were funny that I thought were funny. If they'd laugh at the same things as me, or find the same things unsettling. It was interesting to see if the same things unsettled people that unsettled me."

"And did they?"

"You can never guess what's going to affect people or make them laugh. I don't think anyone can. I made a film about BRUCE LACEY, the subject of a show I curated at CAMDEN ARTS CENTRE recently. In the film, he tells a story about someone dying in front of him, but that story makes everyone roar with laughter. It's about a guy in a tuberculosis ward literally drowning on his own blood from laughing so much. The story builds up to this unintentional punchline of 'and then the guy dies,' and then BRUCE says something like 'and that was just the worst possible thing that could have happened to me at the time.' When people watch it they laugh all the way through this totally traumatic moment. We never expected them to laugh. At least not beyond the punchline."

JEREMY talks a lot about BRUCE LACEY, the cantankerous 85-year-old British artist, inventor and celebrated eccentric whom he calls a "modern day magus in brightly coloured clothes". In JEREMY's film, BRUCE is belligerent and erratic but brilliant. He endeavours to fart audibly and tells the custodian of a fighter plane that being in his cockpit is so much like falling in love that it makes him want to masturbate there and then. As it progresses he emerges more and more as a phenomenally benevolent bon vivant. Archive footage is shown of him touring English fairs and urban parks with climbing frames and giant bouncy pillows, inviting local children to play and draw and dress up in costumes and make things in elaborate temporary complexes he builds in old army marquees. Hundreds of kids in face paint roam and cackle all over them. "I saw myself as a fairy godmother," LACEY says in the voice-over, "giving everybody the chance to be creative and explore their imagination."

In his pursuit of unbridled mischief and his drive to bring pleasure to the public BRUCE LACEY seems to be a figure whose legacy looms large for

JEREMY, so I decide to try and track him down. Eventually, he returns one of my phone calls. He tells me he can't speak all that well on the phone, and asks me to meet him the next day in the small Norfolk village he's lived in since the mid '70s.

As I'm driving there, he phones me.

"ISAAC?" he says. "It's BRUCE LACEY here. I've decided I can't do this interview any more. I'm exhausted and traumatised by the whole thing."

"That's fine," I start to say. "But just so you know, I am already on my way."

"I don't wish to enter into a discussion about it. Good luck!"

I go to JEREMY's to collect a new edit of the film the next day. He offers me a cup of tea. He drinks his out of a miner's strike commemorative mug. There's a pile of books on 19th-century socialist and textile designer WILLIAM MORRIS and Neolithic English history on the kitchen table. He's just set up a new record player, on which he's playing a record of BRYAN FERRY's rearrangements of his greatest hits as jazz standards. He starts to tell me about his recent focus on English prehistory—the bouncy Stonehenge project, an archaeologist he's visiting, various henges and barrows he's been to.

"I've been interested in prehistory since I was kid," he says. "You never lose interests, do you? You just collect more. They lay dormant maybe, but once you're interested in something, that's it. It's got you."

JEREMY's partner interrupts us from the next room. "JIM DAVIDSON's been arrested," she calls. We go through to watch a news report about the notoriously bigoted English comedian, the latest arrest in the JIMMY SAVILE investigation.

Back in the kitchen, I tell JEREMY my BRUCE LACEY adventure. "BRUCE LACEY told me he was traumatised and exhausted," I say. I immediately feel a bit like I've punched a puppy. "It wasn't clear if he meant traumatised by you or by something else or just in general," I offer. "His tone suggested that traumatised was his general state." I tell JEREMY that I was surprised by it, which is true: everyone else I speak to about JEREMY goes out of their way to emphasise his overwhelming good nature. The only explanation I can think of is that the weight of JEREMY's enthusiasm could get to be too much if you were a subject of it, but even that seems unlikely.

"He's a self-confessed hypochondriac," JEREMY says, "and he is 85. He gets pretty worn out, not least because he's super enthusiastic about everything he does. He really gets involved. He's in his eighties, but he still throws himself into it all like he's a kid. An 85-year-old kid. He loves it all."

"Lots of people have said similar things about you," I say.

"Maybe they do," he says. "I do feel like that sometimes. Like a big kid somehow getting away with doing all of this stuff."

A few weeks pass and I arrange to see JEREMY one more time. We meet outside Highbury & Islington station. He's wearing a huge down jacket that looks like it was once high-visibility orange. I've told him I want to see him "at work," so he's taking me to Balham in south-west London to see the rehearsal of a steel band who are arranging a series of cover versions for him. What I want to see first-hand is what he does in his working process—how he interacts with people, what he does to elevate the everyday into something extraordinary, how he makes "doing all of this stuff," with people who are also just doing stuff, into something more.

"I don't want you to write about which songs the band are covering for me," JEREMY says on the tube ride there, "or how I'm going to use them."

I agree, and to change the subject he starts telling me his plans for his after party for the Venice BIENNALE opening. "I just want it to be big and fun and I want it to be something everyone can come to. Like a wedding reception."

We get to Balham early, so JEREMY suggests we look around a second-hand bookshop, where he finds a title on prehistory.

"Prehistory, that's even before my time!" the shop's owner says when JEREMY goes to buy it.

The band rehearse in a long room on the end of an old school, and when we arrive they're only halfway through a number, so we wait outside. "This is one of their own," JEREMY says, grinning like a child. "Hear that cowbell? Classic sound of the steel band." He didn't find the band himself—they found him. They wrote him offering their services after seeing the ecstatic STEEL HARMONY cover versions from his Manchester PROCESSION.

Inside, there are 25 people behind steel pans. There's a couple of babies and some very young kids too. The oldest members of the band are in their sixties; the youngest are two teenage girls who find JEREMY incredibly funny or incredibly attractive or both. They giggle and nudge each other the whole time he's there, but he doesn't notice. Some of the members have been in the band since it started, in 1987; some of them have just joined. The members play on their drums and their phones and the babies gurgle and threaten to cry while JEREMY talks to two women, ANNE and AMY, about the arrangements they've put together.

"Right," ANNE says in the middle of the room, when the conversation is done. There's an instant hush, which the babies ignore, and ANNE gestures to one corner, from which a steel major chord rises. Soon, the whole room comes together in a staggeringly euphoric recreation of one of the defining rock anthems of the early '70s. JEREMY is dancing along. This delights his two teenage admirers. "It must be great to be in a band," he says to me when the rehearsal is finished and when he's finished talking about technicalities and making jokes with the members. "How great must it feel to be able to do that?"

He can't. But his band, here in a drafty school hall in the suburbs, can, and

they'd do it just as well without him. What the band does, in coming together and creating this sensational music, is already simultaneously ordinary and extraordinary. JEREMY's contribution, aside from suggesting the song, or rather his way of elevating it, is just seeing the brilliance of it—finding the spectacular in the everyday and showing it to the world.

"What is it about cover versions?" I ask him when we leave. "So much of what you do is cover versions."

I mean the actual cover versions with ACID BRASS and the steel bands, but I also mean all of the other reinterpretations: THE BATTLE OF ORGREAVE was a cover version of a major historical event. ADRIAN STREET is a jazzed-up cover version of the man himself. SACRILEGE is a cover of Stonehenge—and one that made it much more fun than the real thing, at that.

"There's an alchemy in covers," he says. "Taking one thing and turning it into another." He talks for a while about how ubiquitous cover versions have become and how the bad ones that lurk out there—the twinkly, Christmas-y ones that are used for television adverts—can rip the soul out of something. "The good ones do the opposite of that," he says. "Good covers are brilliant because they show the power of music and the amazing adaptability of people. They show how great people can be at taking things from their past and adapting them. They show people's constant potential to do amazing things. There's a kind of magic to them, but at the same time, it's not magical at all. It's a magic made of people who are just doing their ordinary stuff."

Mr. PETER MURPHY

Featured in issue n° 6 for Autumn and Winter 2007

The lead singer of the influential early-1980s English band BAUHAUS, PETER MURPHY has the same sharp-cheekboned gauntness in his 50s that he had aged 25. PETER's fusion of glam rock and ghoulishness earned him the sobriquet "Godfather of Goth", a title he describes as "gratifying" in his interview with TIM BLANKS. "BAUHAUS were the first manifestation of a certain scene," he said, "Not punk at all, not ex-punk." It was after seeing the RAMONES and the SEX PISTOLS perform that MURPHY remembered saying, "No, fuck that, I'm not a punk, it's a complete scam anyway. What's in our head is going to be far more marvellous and wonderful and scary." He wasn't wrong on that front.

Living in Istanbul since the late 1980s, PETER has established a relationship with Sufism, the mystical manifestation of Islam, although he denies being a convert. He lives with his wife the dancer BEYHAN MURPHY and has two grown-up children, HURIHAN and ADEM.

Portrait by Inez van Lamsweerde & Vinoodh Matadin

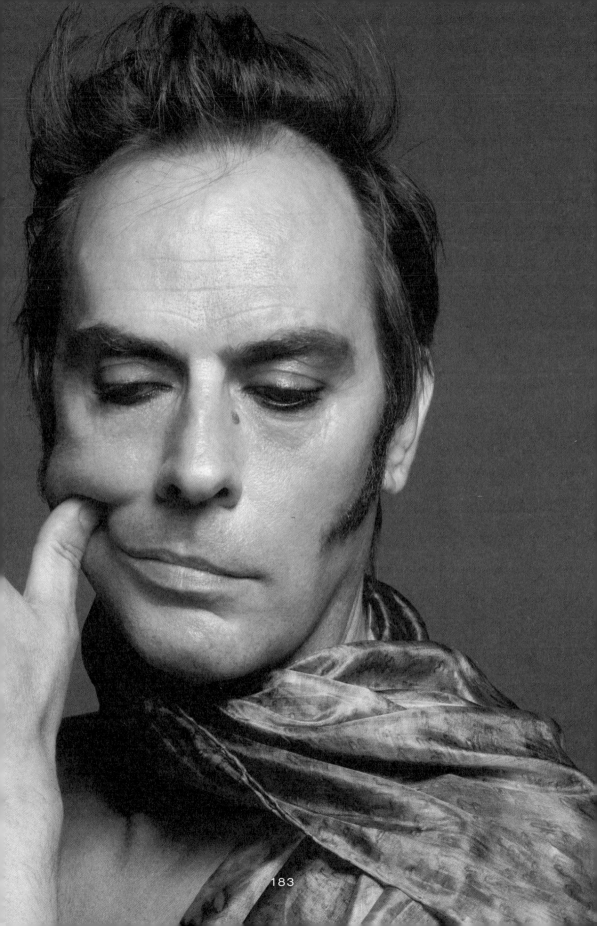

Mr. EVGENY LEBEDEV
Featured in issue nº 13 for Spring and Summer 2011
Portraits by Andreas Larsson
Text by Alex Needham

Mr.
EVGENY LEBEDEV

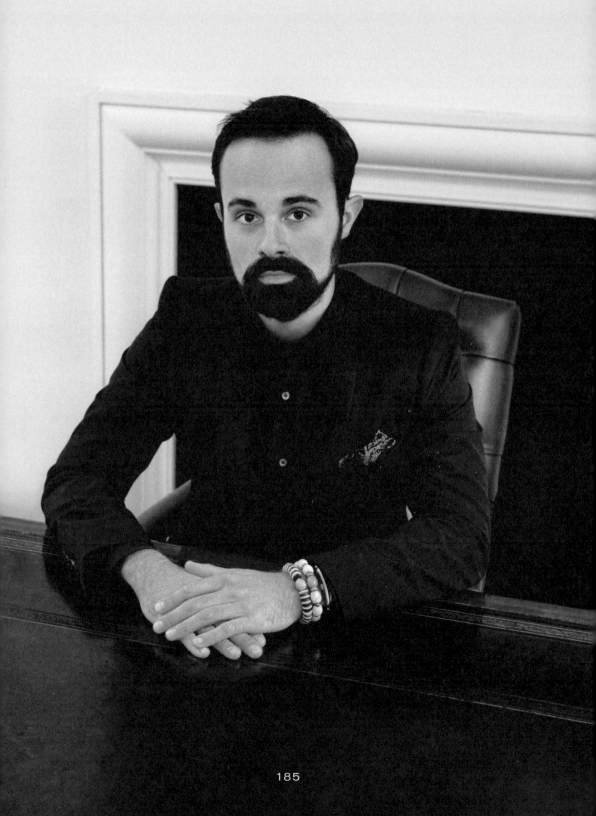

Mr. EVGENY LEBEDEV is a man of extraordinary wealth and power for a 30-year-old. The son of a Russian oligarch and former spy, EVGENY has firmly established himself in British society by buying THE INDEPENDENT and the LONDON EVENING STANDARD newspapers, on which he claims to impose no editorial agenda. A noted figure on the party circuit, EVGENY's thick and lustrous beard has become something of a trademark, as much as his dapper dress sense. EVGENY also owns a sushi restaurant in London and a hotel in Umbria, which has an outdoor pool and a jacuzzi.

South of grimy Oxford Street in London, the district of Mayfair is a gleaming bubble apparently untouched by the recession. Here, businessmen scrutinise their iPhones in stratospherically priced restaurants, the super-rich step out of CLARIDGE'S hotel and into chauffeur-driven limousines, and the ROLLS-ROYCE showroom in Berkeley Square flogs luxury motors in a "refined and unhurried atmosphere."

A short walk away, in an elegant side street, lie the London offices of 30-year-old Russian oligarch Mr. EVGENY LEBEDEV. In the room where his assistant works, the putty-coloured walls are decorated with framed front pages from the newspapers EVGENY owns with his father, ALEXANDER: the British dailies THE INDEPENDENT and the EVENING STANDARD and Moscow's only liberal newspaper, the NOVAYA GAZETA. The table is spread with newspapers and newsweeklies, but no tabloids — LEBEDEV doesn't like them. On the floor waiting to be hung is a photograph of an African tribesman crouching with a leopard and a picture of a rose by GARY HUME, reproduced on the front page of the special edition of THE INDEPENDENT that was edited by ELTON JOHN on World AIDS Day last December. The picture is signed by ELTON JOHN and his partner DAVID FURNISH with a note to LEBEDEV that reads "I love you."

The man himself appears, looking dapper in a military-style jacket, jeans, black trainers and a blue LANVIN scarf. His beard is so densely furred, and so neatly trimmed, it makes him look a bit like an ACTION MAN doll. Small,

slight and friendly, he invites me through to his office, a large room dominated by an enormous desk covered in art books on which also stands a bottle of luxurious scent. An antique mirror is in the corner. Marble pillars hold up the ceiling. The room is festooned with contemporary art. A vast image of a woman on a mattress in a wood by GREGORY CREWDSON hangs on one wall. In the corner is a JAKE and DINOS CHAPMAN sculpture of a youth with a huge penis for a nose. "Bloody Fuckface," chuckles EVGENY, in one of only two occasions that he will swear during our 93-minute conversation. "I just thought it would be a good piece to put in here to break up the harmony of the office; otherwise it becomes like a furniture shop." The chairs are old-fashioned, with leather and studs. EVGENY suggests that we talk at a small table near the window looking onto a courtyard. The whole room smells of hyacinths.

Mr. LEBEDEV — whose first name is pronounced "Yoov-genny" — speaks softly with an accent that might be mistaken for Scandinavian, which is to say his English is excellent. Born in Moscow in 1980, he spent four years, from 1988 to 1992, at school in London while his father was "working in foreign intelligence" there — that is, spying for the KGB. In that time, he says, "I grew to really love this country — when I went back to Russia I remember seeing London on the news and really missing it." He went to a Church of England school — the Russian embassy rules didn't allow him to go to a "capitalist" private school — and remembers being made to feel welcome. "London has always been a very cosmopolitan city, although I guess Russians were quite rare," he says. "So I have very good memories."

His education prepared him admirably for the way his life would turn out. "Russia, especially when I was growing up, offered me a brilliant education. The Soviet Union always prided itself on its great educational facilities, and I was very lucky to have the exposure to both British and Russian culture. It has allowed me to exist between the two worlds, meaning that I can understand both cultures, both nations, both peoples, whereas a lot of the time they don't really understand each other."

By way of illustration, EVGENY says he adores the British sense of humour, which is very different from the Russian one — "show ALAN PARTRIDGE to a Russian and he'll think it's a documentary" — and he laughs at the British propensity to complain about everything from politicians to the weather, though he says that the Russians are far more cynical than the Brits. Throughout Russia's violent history, he says, "we depleted our society of every sort of nutrient, so it's unsurprising that people are full of distrust and cynicism. I think what the Soviet state tried to achieve was a spineless nation, and the present state has very happily inherited that."

He sums up Russia's current situation. "I come from a country that pretends to be a free, liberal society where democracy rules and where we have elections and a free press and freedom of speech, but actually it's not as simple as that. Television is controlled by the state, the press is mainly controlled by the state, journalists get beaten up or otherwise intimidated, people get poisoned abroad." With the latter, he's referring to ALEXANDER LITVINENKO, the journalist and former KGB agent who was killed by poisoned sushi in London in 2006, almost certainly on orders from the Russian authorities whom he had criticised in two explosive books.

As chairman of INDEPENDENT PRINT LTD and EVENING STANDARD LTD, EVGENY runs the LEBEDEVs' British newspapers: his other businesses include two London restaurants, SAKE NO HANA and THE SILVER ROOM. He's produced two Russian films (YURI'S DAY and PAPER SOLDIERS) and runs a charity for children with cancer: the RAISA GORBACHEV FOUNDA-TION, which has a lavish annual fundraising gala in London. Last year's was attended by guests including YASMIN LE BON, HUGH GRANT and ALAN RICKMAN and raised £1.7 million in an auction for lots including a wrestling match in jelly with supermodel LARA STONE refereed by DAVID WALLIAMS, her husband. "When LEBEDEV has a party, you go," claimed Russian ELLE — and EVGENY himself is often photographed at parties, an immaculately dressed figure with that thick, black beard.

He divides his time between Italy and London, where he has two houses: a flat in Mayfair and STUD HOUSE, an 18th-century building in the grounds of Hampton Court Palace. His father is based in Moscow, looking after the business interests he amassed after he left the KGB in 1992, described by his son as "banking, airlines, agriculture, affordable housing construction, property." He controls a third of AEROFLOT, as well as the NOVAYA GAZETA, which is also part-owned by MIKHAIL GORBACHEV.

The LEBEDEVs are worth an estimated £1.3 billion. Given their vast wealth, and the violent incidents that regularly afflict the LEBEDEV businesses — armed police burst into his father's bank last November, which he blamed on business rivals — one might expect EVGENY to be intimidating, but in fact he's easy to talk to. He's scrupulously polite (he asks my opinion and pours me glasses of mineral water — though sometimes it's to stall for time when I pose a difficult question) and he has a kindly demeanour that seems unfeigned.

The comedian and actor DAVID WALLIAMS has known EVGENY for four years. "When you think, 'Ooh, this Russian oligarch in London owning newspapers,' you think he must be a serious, intense and rather scary figure, but that couldn't be further from the truth," says WALLIAMS. "He's great fun and

has a really naughty sense of humour. He loves anything rude. I was out with him last night actually. ELTON and DAVID had invited us to a dinner for the ELTON JOHN AIDS FOUNDATION. We had a lot of fun together, but it's all too rude to be discussed in a family magazine like FANTASTIC MAN."

His love of rude jokes aside, EVGENY is a man of refined tastes. He studied art history at CHRISTIE'S, the London auction house, for three years: "A great thing to do." He's patron to a group of young Russian artists including ALEXEI BELYAEV-GINTOVT, whose work he shows me: heroic portraits of Slavs parading in Red Square, hugely controversial in Russia. One wall of his office is dominated by huge photographs of matadors by DENISE DE LA RUE, which are ultimately destined for a 12th-century castle EVGENY is restoring near Assisi in Italy. When he bought it a year ago, it was "literally a ruin. I'm restoring it very sympathetically to what a mediaeval castle would have looked like in terms of the structures and interiors, but I would like to mix it up with a bit of contemporary art." Originally the place was intended to be another hotel, like his other property in Umbria, PALAZZO TERRANOVA. But EVGENY has con-cluded that a luxury hotel with only eight rooms wouldn't make economic sense. "So I'll probably just use it as a house."

EVGENY has a further property in Lucerne, Switzerland that he's contem-plated turning into a gallery, "but what do you put in there to get people to go?" That said, the LEBEDEVs seem to seek out ventures that don't make economic sense. When, in 2009, they bought a 76 per cent stake in the EVENING STAND-ARD from ASSOCIATED NEWSPAPERS for the nominal sum of £1, the paper was losing £28 million a year. THE INDEPENDENT and its sister paper THE INDEPENDENT ON SUNDAY, which they bought a year later, lost less money (a mere £12 million a year) but they're the least successful papers in their market, and sales are on a relentlessly downward trend. Unlike THE INDEPENDENT's great rival THE GUARDIAN, which responded to a decline in paper sales by investing in its website, where traffic was booming, the LEBEDEVs' strategy was completely print-focused. (Full disclosure: I work for THE GUARDIAN.) EVGENY says there's no aesthetic reason for this. "Print is where the largest revenue stream comes from. There isn't really a profitable website in existence, and even if there were, the profits compared to print are minimal."

Er, Google and Facebook?

"Yes, but I mean as media brands. Google and Facebook were not launched as news providers. One school of thought says that print is dying, but if you actually go on the tube you see how many people read newspapers. Statistically, it's more than ten million people daily. But on the other hand I think that digital — iPads, Kindles — is very important as well, so one needs to focus on both things. It's just that after having just taken over a very important and respected title, but one that hasn't been successful financially in the last few years, we

needed to focus more on making the actual print product, which is the source of the main revenue stream."

To this end, shortly after buying the EVENING STANDARD, with a billboard campaign bearing the slogan "Sorry" (which annoyed its former editor, VERONICA WADLEY, to no end), the LEBEDEVs renounced the aggressively partisan and negative editorial direction pursued under previous owners ASSOCIATED NEWSPAPERS. Then, audaciously, they reduced the EVENING STANDARD's cover price to zero, more than tripling its circulation from 500,000 to 1.75 million and managing to increase its advertising revenue, with its yield up 60 per cent. EVGENY now says that if the British economy holds up, the STANDARD should be in profit by next year—an amazing turnaround in an area where print products seem to be in inexorable decline.

Owning both THE INDEPENDENT and the EVENING STANDARD allows the LEBEDEVs access to two sets of London's movers and shakers: one aristocratic and Tory (represented by the STANDARD, which takes a distinctly patrician view of London), the other progressive and left-leaning (THE INDEPENDENT). Father and son seem good at balancing—or perhaps the better word is annexing — people from different worlds, from art to business. Nevertheless, sensitive to any inference that he meddles in the editorial line of either paper, EVGENY bats away my theory that the STANDARD reflects his father's interests, while THE INDEPENDENT expresses his own. "I wouldn't say that. My father probably as well as me would be more of THE INDEPENDENT standpoint. We don't really dictate to the editors what the standpoint of the newspapers should be, and it was quite good to have that proven at the last election, where THE INDEPENDENT called for a Liberal vote and the STANDARD called for a Tory vote, hence it being obvious that we don't dictate to the papers what they should and shouldn't say."

That said, the LEBEDEVs' influence on the British establishment is undeniable. Last October, when EVGENY obtained British citizenship, ELTON JOHN threw a party in his honour at which BORIS JOHNSON, the mayor of London, gave a speech; DAVID CAMERON and MIKHAIL GORBACHEV sent their congratulations; and guests included TATE director, Sir NICHOLAS SEROTA and artists ANTONY GORMLEY and SAM TAYLOR-WOOD.

Later, we're discussing the theatre when he mentions that he saw KING LEAR the previous night and had dinner with the theatre's eminent director, MICHAEL GRANDAGE, after the show. The theatre is EVGENY's idea of a good night out these days, after a more hedonistic period in the '90s. Was he a party animal? "It's a term that's quite relative, I think," he smiles. "I don't think I was ever a party animal in the present-day description, as in a round-the-clock party every day. But I certainly enjoyed odd nights out as any student or one in their early twenties

does. I never thought London had particularly good clubs; I always thought they were sort of dingy and underground, small and packed and squashed."

The task of turning THE INDEPENDENT's fortunes around isn't something one would want to approach after a heavy night out. Having obtained permission from then Prime Minister GORDON BROWN to take over the paper, the LEBEDEVs couldn't simply repeat the STANDARD trick. Since THE INDEPENDENT is a national publication, turning it free would have been hugely expensive — the LEBEDEVs rely on commuters to disseminate the STANDARD throughout London, giving it away at a few central locations, which has led some commentators to remark that it can no longer be truly regarded as a London-wide local paper. Instead, the LEBEDEVs decided to launch a new product for young and time-crunched readers: a condensed print version of THE INDEPENDENT, called "i". "It's doing good actually," says EVGENY. "It's doing" — he pauses — "it was, um, doing well after its launch, not as well as we were hoping it would do, but since we've launched the television ad it's been doing very encouragingly well." Two weeks after Mr. LEBEDEV and I meet, "i" eventually posts its first official sales figure: an average of 133,472 sales a day for the month of January, which media commentators judged to be a reasonable success, especially as it didn't seem to have eaten into sales of THE INDEPENDENT.

"If 'i' is not going to work then I can't quite see what else can," says EVGENY. "Launching a new newspaper is a very difficult task." He adds that at one point they had planned a third, iPad-sized incarnation of THE INDEPENDENT but concluded that three versions of the same paper would be too confusing.

Even given the LEBEDEVs' presumably bottomless pockets, THE INDEPENDENT must be costing them a fortune. EVGENY laughs: "It's all relative, but yes — it's clearly not cheap. But one couldn't leave it as it is. It being the lowest-circulation newspaper in the market, we had to try something else."

But why buy THE INDEPENDENT at all?

"Why buy it? I think it's a really interesting product," he says, sipping his mineral water. "One of the results of BLAIR's government was that Britain became a liberal, slightly left-of-centre society. And yet the spectrum of newspapers seems to be not reflecting that. You have the MAIL, the EXPRESS, THE TIMES, THE TELEGRAPH, THE SUN, all reflecting — judging by the last election — a minority percentage of the population, so I think there is real potential for THE INDEPENDENT. I just think it needs support, and it's great what it stands for: for independence of opinion, for independence of political parties, independence of proprietors." He laughs. Certainly he seems committed to funding journalism: he's planning to set up an investigative journalism unit to work on "stories that nobody touches because they're too expensive. Like the price of oil, that's an interesting story." EVGENY also visited Papua New Guinea last summer and saw

first hand "the treatment of New Guineans by nations who come and mine their natural resources, their oil, their gas, and have complete disregard for whole communities who are poor and don't get anything back from what's taken from them. And while I was out there I discovered that GEORGE BUSH JR. has a firm that provides security for all the oil extraction, which would be an interesting thing to investigate."

"EVGENY claims that his social life isn't just about rubbing shoulders with posh people. When I ask if the STANDARD's enthusiasm for people who went to the elite private school ETON — from London's mayor, BORIS JOHNSON, to the STANDARD's editor, GEORDIE GREIG — reflects the social group the LEBEDEVs mix with, he replies: "I socialise with a really wide variety of people, from the people you describe to left-wing socialists."

His best friends, however, are ELTON JOHN and DAVID FURNISH, whom he met ten years ago. "I think ELTON's quite an extraordinary individual," EVGENY says fervently. "He's got the kindest heart out of everyone I know, because he's constantly prepared to help. We're thinking about doing something together in Russia, because Russia hasn't really addressed its AIDS problem. When he guest-edited THE INDEPENDENT, he was there from 9.00 in the morning to 8.00 in the evening and did all the news conferences. I went to see them when the baby was born and I'm very happy that they're very happy."

"EVGENY has incredible manners and really is as sharp a social observer as a TOM WOLFE," claims JEFFERSON HACK, founder and publisher of DAZED AND CONFUSED, who has known EVGENY "for years". In 2008, the pair attempted to launch a Russian edition of DAZED AND CONFUSED, but canned it after making a dummy issue. "The world economy started to collapse just as we were getting the show on the road, so to speak," explains EVGENY, adding that he wasn't convinced that it would work.

"I go through periods when I think Russian kids really could do with a publication that would encapsulate fashion, reportage, serious journalism and thought-provoking writing, and then I look around in Moscow and I think it's pointless because no-one actually wants it."

EVGENY's Russianness isn't expressed in bling or the purchase of football teams in contrast to his fellow oligarch ROMAN ABRAMOVICH, who now owns CHELSEA FC. EVGENY quotes CHEKHOV and once took JEFFERSON to see the monasteries in Rostov, the ancient capital of Russia. That day ended in spectacular style. "As part of the monks' winter ritual," says Mr. HACK, "we jumped naked into a hole cut in the thick ice, into freezing lake water."

"I think we must have drunk a whole bottle of cognac immediately as we got out, just to get warm," remembers EVGENY.

Though he's got dual nationality—officially so—EVGENY once described himself as having a Russian soul. "It means that I like it when it's dark and raining and moody," he expands, looking at the books lining the shelves, including countless art tomes and the autobiographies of British politicians PETER MANDELSON and GORDON BROWN. "I don't like it when there's sunshine all the year round. Living in Los Angeles would be a nightmare for me. I like contrasts in everything and in my mood as well. It can be very upbeat and happy and it can be very thoughtful and dark. I like to spend time alone and immerse myself in my reading or writing or thinking. Most people can't stand to be alone; I actually really enjoy it."

Perhaps it was this introspective side that prevented him from enjoying his foray into the fashion business. In 2007, having seen his clothes in HARVEY NICH-OLS, EVGENY met designer JSEN WINTLE and bought just over 25 per cent of his menswear label WINTLE. When the label showed at LONDON FASHION WEEK in September 2009, EVGENY sat with JOELY RICHARDSON—an actress whom he is long said to be dating—and DAVID WALLIAMS in the front row, but by then EVGENY had already realised that it wasn't viable in the current financial climate and decided, with the designer, to "put it into hibernation." Fashion, he concluded, wasn't an industry that one could dabble in part-time. "It's a tough industry, and it's one where you need to completely immerse yourself in it—even if you are just running the business side of it—or not do it at all." He'd also discovered that he didn't like the fashion world. "I find it very draining and energetically vampiric—everyone is scrutinizing everybody else."

So you don't like going to fashion shows? "I will never go to another fashion show in my life," says EVGENY vehemently. "I just think the whole experience of it—who's sitting in the front row, who's sitting in the back row—it's so poisonous and off-putting." His interest in fashion is now confined to wearing it himself—and what a dandy he is. "I should have been born in a different era," he agrees. "I like to wear beautiful things."

So what's with the beard? "I've been growing it sort of on and off, two or three years, various lengths," he shrugs. "It's just easier not having to shave every day. It's interesting that it seems to be a big subject of conversation everywhere I go—everyone seems to feel the need to make either a positive or a negative comment. There's an interesting discrepancy: in this country, people tend to say that it looks very ROMANOV"—as in the last dynasty of tsars—"and in Russia people tend to say that it looks very Chechen-rebel. My grandmother's always saying 'You should be careful walking round Moscow because you might be mistaken for a Chechen rebel and get beaten up by some skinhead youth.'"

It's a reminder not only of EVGENY's multi-faceted nature, but also of the violence that seems to overshadow life in Russia. When I suggest to EVGENY

that doing business there seems quite a hair-raising experience, he laughs: "Ha! Certainly is!"

He says that he's used to the danger it entails: "I sort of grew up with it, because doing business in the '90s was even more dangerous than now. At least now, there usually aren't assassination attempts. When my father started doing business in the early '90s we had some really scary moments when there were grenade launches and people around us with machine guns protecting us and having to leave houses because of the potential threat, so having grown up in that environment as a teenager, I suppose it's quite terrifying at first and then you get used to it."

Perhaps a life lived between such extremes of luxury and danger breeds a character like LEBEDEV: someone with a portfolio of interests who can't be pinned down; a hard-headed businessman whose true love is the arts; a modern media mogul who hangs out in Russian monasteries. He gives me his mobile number and leaves me with a quote from CHEKHOV about the tragedy of the Russians being that they can't decide whether to face Asia or Europe. But unlike CHEKHOV's Russians, EVGENY LEBEDEV seems perfectly comfortable stretching himself across two cultures, a Russian soul at the heart of the British establishment.

Mr. MATTHEW MONEYPENNY

Featured in issue nº 21 for Spring and Summer 2015

MATTHEW MONEYPENNY's glorious surname is likely connected to the JAMES BOND character MISS MONEYPENNY via an aunt who knew the author IAN FLEMING and, according to MONEYPENNY family lore, could drink him under the table. MATTHEW himself shares 007's passion for cars (his current model is a BMW) and tailoring. His appearance in issue nº 10 of FANTASTIC MAN saw him modelling a series of "city suits" around the streets of Manhattan.

Of course, MATTHEW's métier is not espionage, but fashion imagery. The CEO of the image-licensing agency TRUNK ARCHIVE, he describes his mission there in simple terms. "We are interested in artists being paid fair market rates for their gifts and their output," he said. MATTHEW — who was raised in Dallas, educated in Vassar and spent the early years of his career in Hollywood — is currently generating waves in the fashion world. Over the last few years he has assembled a conglomerate of agencies that cater to the makers of fashion imagery. On the rare occasions that he is not working, MATTHEW spends time in his garden in the Hamptons. "Me and a dogwood that needs a good pruning? It's like four hours of fun," he said.

Portrait by Alasdair McLellan

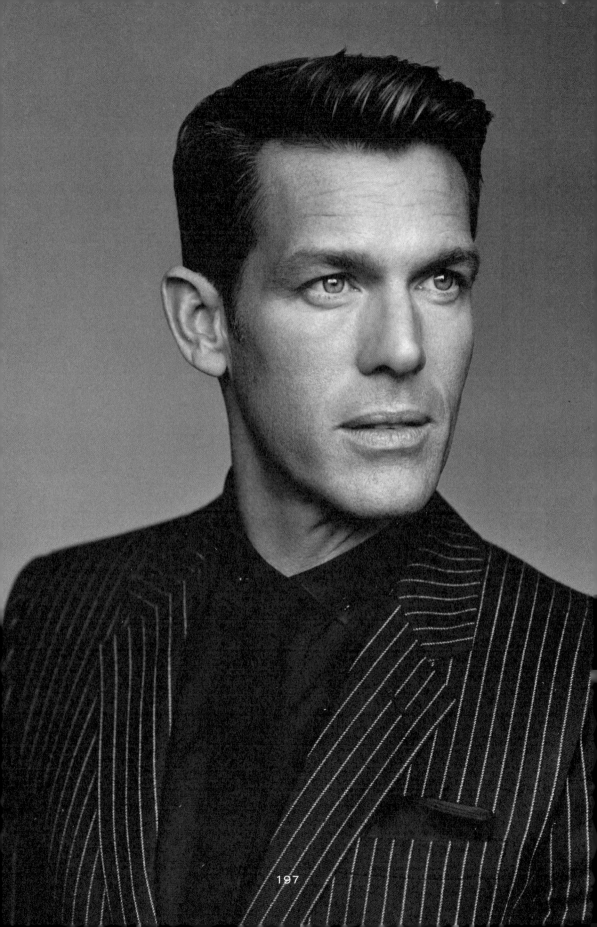

Mr.
MARK E. SMITH

Mr. MARK E. SMITH
Featured in issue nº 4 for Autumn and Winter 2006
Portrait by Andreas Larsson
Text by Alex Needham

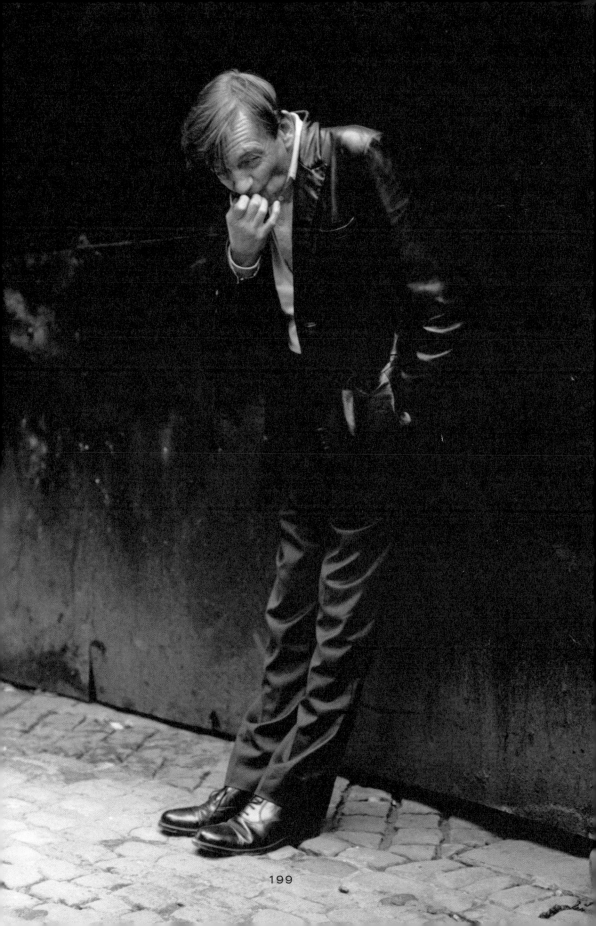

The legends that surround MARK E. SMITH are themselves rather legendary. When word gets out that I am interviewing the fine gentleman, people start phoning me with stories. How he developed his trademark shouty vocals by working as a bookie at the races. How he would demand to be paid for even promotional interviews. And how he would occasionally beat up fellow band members. True or not — and with many of them, SMITH himself now seems unsure — myth and mystery continue to follow the Mancunian working class hero around. As do the many trendy bands that he despises. Indeed with his artfully truculent air and albums that go by the names of PERVERTED BY LANGUAGE, THE UNUTTERABLE and GROTESQUE, SMITH has turned misanthropy into a stylish art form.

When the famous British broadcaster JOHN PEEL died in 2004, much was made of the fact that his favourite group of all time were Manchester's THE FALL — "a band," he had said, "by which in our house all others are judged." Given the mood of mourning that consumed the nation, it must have seemed a good idea to get THE FALL's frontman, MARK E. SMITH, on the BBC2 programme NEWSNIGHT. What followed was classic SMITH. Instead of paying tribute, the singer pulled faces, snarled, treated fellow panellist FEARGAL SHARKEY of THE UNDERTONES with barely concealed contempt and kept repeating the mysterious phrase "Are you the DJ?" to the disconcerted interviewer.

Later claiming that he was the victim of a malfunctioning earpiece, SMITH had, of course, just demonstrated exactly why PEEL was a devotee. Unsettling, unsentimental and unique, the 49-year-old FALL frontman has stood apart from pop music for almost thirty years. Aptly, given that his first public act was heckling PAUL WELLER at a JAM gig in Manchester in the late '70s, SMITH has spent his life at odds with everything, wearing flares during punk, spending years

playing with his back to the audience, and overturning the old romantic rock myth of the band-as-gang by hiring and firing so many musicians that more than 45 people have now passed through THE FALL.

The music that results from this is equally defiant of convention. Deliberately stripped down and lo-fi, involving elements of krautrock, garage, punk and reggae without really sounding like any of them, its defining sound is SMITH's voice: slurring, atonal and famously making every other word finish in the syllable "ah" ("Free range-ah!"). Then there are the much admired, if often barely comprehensible, lyrics. Over an enormous body of work that spans 25 studio albums, innumerable EPs, compilations and live recordings and two spoken-word records, MARK E. SMITH has written about subjects from drugs and football to politics and the occult with a strange and sardonic pen.

The song titles alone—like EAT Y'SELF FITTER, MERE PSEUD MAG ED, ROWCHE RUMBLE and HEY! STUDENT—give a strong flavour of SMITH's warped inventiveness, while one, CEREBRAL CAUSTIC pegs precisely his combination of intelligence and bile. Step into his band's universe and you go into a place SMITH summed up in a 1984 album title: THE WONDERFUL AND FRIGHTENING WORLD OF THE FALL.

Given his proud Northern working-class hatred for anything soft or pointlessly luxurious, the wood-panelled plush of the bar at the MALMAISON HOTEL, Manchester, seems a strange place to meet him. (He later says it's because it's close to the train station so journalists don't "have to wander around.") The mood is one of trepidation. Stories are legion about the man's catankerousness, unpredictability and (not unrelated) prodigious appetite for alcohol. It's only a few years since SMITH wrestled one NME journalist to the ground mid-interview and bit him on the neck; one of his many PRS once got dangled off a crane with a drunken SMITH at the controls. However, today SMITH has an emissary, a young man who looks like a FISHER-PRICE LIAM GALLAGHER in round glasses and a mod haircut called AUSTIN COLLINGS who surprisingly turns out to be ghost writing SMITH's long-awaited autobiography, to be published by PENGUIN next year.

SMITH appears five minutes afterwards, wearing a large black leather jacket, a pale blue polo shirt and black slacks pulled up high round his waist. MARK E. SMITH's attitude to fashion is much the same as his attitude to music. Despite a brief period in the mid-'80s when (possibly influenced by his glamorous first wife and fellow Fall member BRIX SMITH) he started wearing eyeliner, SMITH has always taken pains to look as unlike a rock star as possible. Nevertheless, his unique anti-style hasn't gone uncelebrated: in 1999, designer label YMC paid homage by creating a MARK E. SMITH jacket.

SMITH also has typically strong views about what his fellow bandmates should wear onstage. "If they just stumble on in T-shirts and training shoes — I don't like that," he says, ordering a pint of KRONENBOURG. "It's a sensitive issue with musos, you know. They take it really personally. And if you say things like, 'We're all wearing masks tonight, lads', they don't take it as a joke. I've got a weird sense of humour but they don't like it at all."

I guess musicians believe they're expressing themselves, and clothes are part of that, I tell him.

"Correct," SMITH replies crisply. "Express yourself in your own time is what I say. Or if you want to express yourself, write a good fucking tune."

MARK E. SMITH — whose initial stands for EDWARD — is entertaining but somewhat intimidating company. His nasal, slurred Lancashire accent masks a very sharp mind. His total intolerance for bullshit makes you watch what you say, his reputation for violence even more so. At least one FALL line-up has ended in an on-stage punch-up, thanks to SMITH habits like dismantling his bandmates' instruments onstage. This afternoon however he's reasonably friendly, complimenting me on my jacket. (It's DIOR HOMME.) Like his Mancunian contemporary MORRISSEY, he likes to ask questions of the interviewer, which I take as a sign of his courtesy, although it's also slightly discomfiting, as SMITH surely knows. Recognising me as a fellow northerner, he asks me where I'm from ("You've got more of a Rotherham sort of accent than Leeds"), and in response to a question about his family whether I've got sisters myself — he has four, all younger. I don't, however, get "Are you courting?" — the delightfully old fashioned enquiry he traditionally makes of journalists.

There's one weird thing — the same involuntary face-pulling that bemused the viewers of NEWSNIGHT. At frequent intervals, SMITH screws up his face, opens his mouth and pokes his tongue out like an aged turtle. I'm too polite to ask why he does it but AUSTIN later agrees that it's most likely a consequence of long-term drug use. Since the age of 15, SMITH has been an enthusiastic consumer of acid and speed, though he stopped taking ecstasy in the late '80s after it "turned me into a bloody sex maniac." An antipathy to the Catholic Church was intensified when POPE JOHN PAUL II visited Manchester in 1982 by helicopter, flattening SMITH's local magic mushroom field when he landed.

SMITH eyes suspiciously the iPod on which I'm recording the interview and keeps moving it away. No lover of modern technology, he's not keen on mobile phones — or, as he calls them, "porta-phones" — "they really puzzle me, how people walk around with them. What are they talking about?"

He doesn't own a computer either, though he points out that he had a ZX

Spectrum in 1984. "I didn't like the way it controls the way you construct things," he says. "You get in a routine. It's a bit like when I worked in an office, everything's got to be in a business type of letter and I think computers are very much like that. Someone like me who writes in a flowing way or a very abrupt way, it's very difficult on a computer. To me, it still takes ten times longer to write something down on a computer than it does to write it down in biro. I don't know if you find that."

No, I find it quicker to type.

"Well, I use a typewriter a lot."

This is pretty much the most you'll get on how SMITH goes about writing his songs. He's fiercely protective about his methodology, believing fervently that other musicians will read the interview, adopt his songwriting techniques and start making their own version of his music — hence the famous pronouncement "Notebooks out, plagiarists!" in one of his old songs. Yet his paranoia is in some way justified. While THE FALL's dense, difficult music has ensured that they have never had any significant commercial success, SMITH is an object of fascination to fellow musicians from DAVID BOWIE (who SMITH says asked to collaborate with him, and was turned down) to JACK WHITE of THE WHITE STRIPES, who made a point of watching THE FALL's recent show at the READING FESTIVAL from the side of the stage. And people do rip off THE FALL, from '90s indie heroes PAVEMENT, whose American take on THE FALL's sound particularly displeased SMITH, to LCD SOUNDSYSTEM's open homage.

SMITH doesn't like to talk about his song lyrics, either, once grimly joking that he was "plagued by graduates" trying to analyse them. He never reads his own reviews, relying on his bandmates or wife ELENI POULO (who also plays keyboards in THE FALL) to feed back the general verdict. The reason seems to be bound up in SMITH's considerable pride — he doesn't want to be demystified, or to admit that anyone else's opinion would count compared to his own. Nothing can shake his utter single-mindedness. 1999 saw him appearing onstage in Leeds with bloodstained clothes after a fight with one of his band members. In 2004, he slipped on some ice and broke both his knee and hip, necessitating the insertion of a metal rod. Given the alcohol-ravaged state of his body, SMITH was lucky not to have his leg amputated — yet despite this, he completed an American tour, delivering his vocals sitting at a table.

This total commitment to what he does, coupled with a very Northern work ethic, is what makes SMITH so admirable. Managers and band members come and go, but come hell or high water THE FALL will release at least one album a year, to artistic standards beyond most young bands, never mind ones over a quarter of a century old. (Last year's FALL HEADS ROLL was one of the best of their career.)

MARK E. SMITH is very proud of being working class, and—again, in defiance of romantic rock 'n' roll clichés—to him, work is exactly what THE FALL is. He enjoyed the WORLD CUP not because of the football, but because the fact that everyone was watching it meant he could get stuff done. "Saturday and Sunday," he says, "no phone calls, nobody's ringing me up, nobody's mithering me,"—a Northern dialect word whose meaning lies somewhere between moaning and worrying—"neighbours are all quiet, it's great. Get a bit of business done, get a lot of writing done." He laughs. "It's a bit like the Royal Wedding or something. It's all silent."

Manchester is utterly central to what MARK E. SMITH does. Just as JOY DIVISION's music captured the atmosphere of late '70s Manchester's desolate mills and deserted underpasses, THE FALL's music embodies the rough, dogged quality of the place and its inhabitants.

SMITH still lives in northern Manchester, where he was brought up. He once described his sensibility as distinctly "North Mancunian," but when I ask him what this means he clams up suspiciously: "Who said that?"

You did.

"Oh right. I would think so, yes. It's more Salford, really."

Weeks later TONY WILSON, founder of the iconic Manchester record label FACTORY (and once witheringly described by SMITH as "the poor man's RICHARD BRANSON") helps out. "In South Manchester," he says, "you've got the Wilmslow Road, and that reminds you that ten miles away there are footballers with HUMMERS and the most champagne per head consumed in the UK, but North Manchester is completely industrial and working class."

SMITH's first job was as a shipping clerk at the Manchester docks: according to local indie lore, he would often ride past JOY DIVISION's IAN CURTIS, a contemporary, on his way to work. As a teenager, SMITH had been top of the class despite being disliked by the teachers. A classic autodidact, he taught himself to read before he even went to school: "I was one of those clever dicks." THE FALL are named after the novel by CAMUS, but SMITH's favourite authors are gothic novelist H.P. LOVECRAFT, RAYMOND CHANDLER ("very succinct and straight to the point"), and modernists like WYNDHAM LEWIS—whose paintings SMITH also admires—and EZRA POUND. POUND's writing, says SMITH confusingly, is "rubbish, but it's good. I just like the approach. What the hell's he talking about? One minute he's talking about the I CHING, the next he's talking about Notting Hill Gate. I like that. You don't get that a lot any more."

There's also a very strong mystic strain to SMITH's work, which makes comparisons with WILLIAM BLAKE (whose poem JERUSALEM THE FALL covered) not altogether far fetched. "That's the real stuff," he says approvingly. "You're

talking proper writing now." Just as BLAKE believed he literally saw angels sitting in trees, SMITH believes he has encountered ghosts. His scepticism has not precluded a considerable interest in the occult. "He was very interested in witchcraft and believed himself to have powers," revealed BRIX SMITH in SIMON FORD's FALL biography HIP PRIEST. "He wasn't a devil worshipper or anything like that, but he definitely thought of himself as an empowered person and able to control things."

Since THE FALL has also been compared to a cult with SMITH as the leader (not least for his habit of going out with the female members) I ask him whether his intuition runs to knowing which musicians will last the distance with THE FALL when he hires them. "I don't know," he laughs. "Like THE TWILIGHT ZONE, where the ones who are going to die have light round their eyes? It's always surprising, the ones that go and the ones that stay. Contrary to opinion, it's not my fault that they go. They might crack on that it is."

Given that SMITH's working methods include giving musicians the address of the wrong studio so that they're furiously angry when they finally get to play, this remark seems rather disingenuous. Is being in THE FALL really such a good life?

"I think it's too good — that's the problem," says SMITH. "It seems a lot of 25 to 35 year old blokes have a lot of stress in their lives. These '70s babies. The last lot were going through midlife crises at 30 and 31 and I can't really relate to it, you know? I mean, how old are you?"

Thirty-two. He laughs. "It's the prime of your life, innit?"

Yes. How were your thirties?

"Alright, yeah," says SMITH. "Bit rough, but I wasn't getting miserable about everything like a lot of people seem to."

SMITH's musical ambitions were galvanised on 4 June 1976 when he went to see the SEX PISTOLS play at Manchester's Free Trade Hall, along with such later Manchester music luminaries as MORRISSEY (who SMITH claims used to give him "dirty phonecalls") and JOY DIVISION's BERNARD SUMNER and PETER HOOK. "I would have a marvellous job in shipping if it wasn't for the SEX PISTOLS," he once joked.

THE FALL received music press acclaim pretty much right from their first gigs in working men's clubs, the only places that would put them on. Though they've always struggled to accommodate their resolutely uncommercial vision within the music industry machine, getting through ten managers and multiple record labels, THE FALL have been consistently revered.

JOHN PEEL's patronage is only the start, and THE FALL has been influencing bands ever since. "I've said this before, but if I was very rich and had a lawyer I'd put up a thing saying you can't mention THE FALL as an influence," SMITH

says. "It's very misleading to young fans. American kids go, (he imitates a South-
ern drawl) 'What the goddamn hell has FRANZ FERDINAND got to do with
THE FALL?'" He laughs. "They go, 'If they sound like FRANZ FERDINAND,
who wants to see them?' But if they go and see us they're converted."

As well as his distaste for their music, it's clear that SMITH resents having
the kudos that comes from three decades of not giving an inch to commercial
pressures assimilated by bands much more amenable to compromise. Instead,
SMITH prefers to work with people like German post-techno duo MOUSE ON
MARS ("they're more of a pop band in Germany, quite a teeny band," he says
improbably) and the Icelandic electronic artist GHOSTIGITAL. "A lot of the
groups today are like business units," he says. "THE FALL were never like that."

Unusually for a rock band, THE FALL have been embraced and used as a refer-
ence point by artists like PAUL HOUSLEY and GRAYSON PERRY, British
comedians FRANK SKINNER and STEWART LEE, TRAINSPOTTING author
IRVINE WELSH — even CALVIN KLEIN has professed himself a fan. "We've
got fans in strange places. I think it's a lot more important than some daft group
saying they like us," says SMITH proudly. "Some artists have said to me they can
only paint to THE FALL. I think it's because we're on a different rhythm to a lot of
other groups. It gives them a kick in the head, that's what I've heard from painters."

SMITH doesn't have an art collection. "I get sent all this stuff, get a lot of
artists writing to me, giving me pictures and that," he shrugs, "but I'm one of those
people who has a big spring clean. I spend most of my time chucking shit out. I
haven't got copies of my first singles. Front covers of magazines and that, long
gone." To SMITH it seems, nostalgia is just more pointless self-indulgence,
antithetical to the relentless modernism he promotes in his work, while expensive
personal possessions bog you down and make you comfortable and self-indulgent.

THE FALL's intersection with high culture flowered in the mid-'80s, when they
began to collaborate with ballet dancer MICHAEL CLARK, performing on
British TV show THE OLD GREY WHISTLE TEST together in November 1984.
The show concluded with the dancers, in arse-revealing costumes designed by
LEIGH BOWERY, force feeding a pantomime cow with cartons of milk while
THE FALL thrashed away in the background. BOWERY also starred dressed as
"a clerk on acid" in the macabre video for 1985's CRUISER'S CREEK directed
by artist CERITH WYN EVANS, and appeared in SMITH's one and only play,
the 1986 work HEY! LUCIANI, described at the time by NME as "incomprehen-
sible". Given his plain-speaking dislike of pretension you might suppose that
SMITH would avoid such arty endeavours, but there is a side to him that admires
the flamboyance of someone like CLARK, as well as identifying with his back-
breaking work ethic and proud outsider status.

The high-water mark of THE FALL and CLARK's collaboration was a full ballet, I AM KURIOUS, ORANJ, which premiered at the Stadsschouwburg in Amsterdam in June 1988. A snippet on YouTube reveals that it looks amazing, BRIX SMITH whirling across the stage on a giant hamburger to the strains of CAB IT UP. Would SMITH do another ballet? "Yeah, I would actually," he admits. "That was good. But half the people who did that are dead, you know, like the guy who choreographed it. But that was great. Hard to do them things in Britain, money-wise. That's one thing with rock music, you can be a bit autonomous."

The question about MARK E. SMITH is where he gets this drive and this fury from. SMITH believed when he was starting THE FALL in 1977 that he was doing something both important and totally original, saying two decades later that "there were no groups around that I thought represented people like me or my mates. No-one was speaking to the clerks and the dockers. If I wanted to be anything, it was a voice for those people. I wanted THE FALL to be the band for people who didn't have bands."

Twenty-nine years on, the urge is undimmed. "I never feel like I've said enough. If I ever get fed up — and I've had times when I was fed up of the business — then you see some crap on the TV and you think you just can't leave it."

Mr. STEFANO PILATI

Featured in issue n° 3 for Spring and Summer 2006

Forever a seismic force in fashion, STEFANO PILATI was head designer at YVES SAINT LAURENT when he appeared on the cover of the third issue of FANTASTIC MAN, photographed by two of his most cherished comrades in image-making, INEZ VAN LAMSWEERDE and VINOODH MATADIN. Resplendent in a bespoke lace beard as crafted by the make-up maestro PETER PHILIPS, it was a characteristically uncompromising statement. As STEFANO said at the time, "You can work out your obsessions in your work. That's what I'm doing."

Having relocated his studio from impossible Paris to renegade Berlin, these days STEFANO sits at the helm of the suitably invigorated ERMENEGILDO ZEGNA COUTURE collections, where he continues to push the boundaries of possibility in menswear. A recent presentation saw STEFANO experimenting with recycled yarns and sending models down packed-earth runways. He's also responsible for the verdant output of AGNONA, the revered super-deluxe Milanese womenswear label that's also owned by the ZEGNA GROUP. The newspaper INDIA TODAY recently included STEFANO's white boxer in a chart of "Celebrity Hot Dogs".

Portrait by Inez van Lamsweerde & Vinoodh Matadin

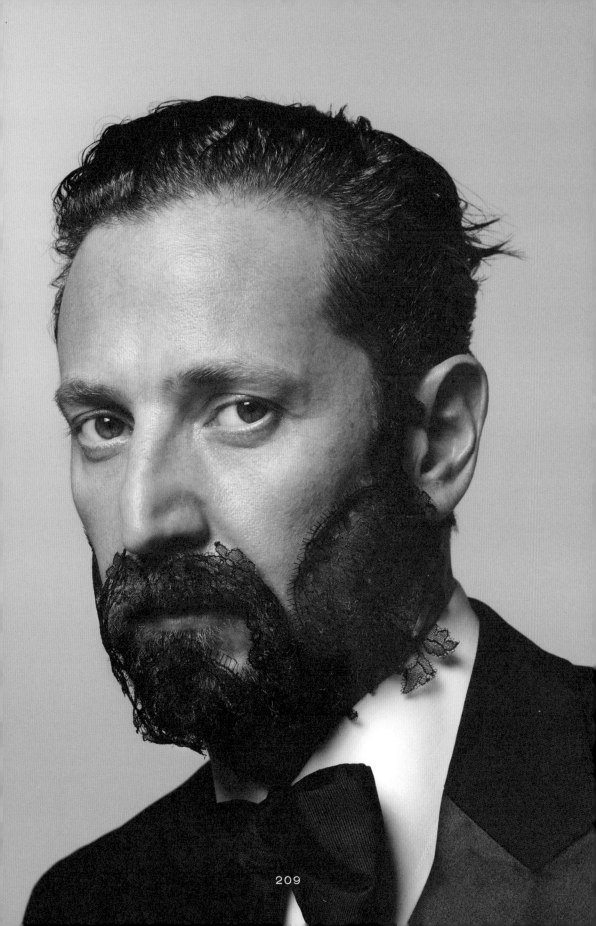

Dr. FREDRIC BRANDT
Featured in issue n° 9 for Spring and Summer 2009
Portraits by Andreas Larsson
Text by Charlie Porter

Dr. BRANDT

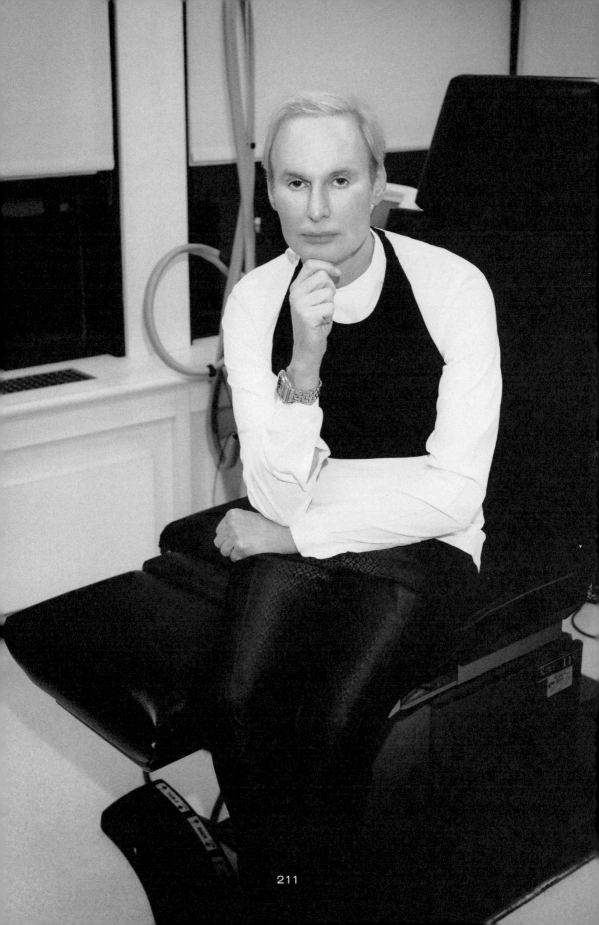

The fearless dermatologist Dr. FREDRIC BRANDT is famous for moulding the NEW NEW FACE. Dr. BRANDT's A-list patients wait for months and pay thousands of dollars just to spend a few minutes with him and his needles. He is a pioneer in changing the shape of the face without using plastic surgery and is proud to be the world's largest user of BOTOX. If clients are fabulous enough, he will travel the world to treat them, but he usually divides his time between his clinic in New York and the one in Miami, where he keeps his three dogs, two of which are pure bred and one is a mutt.

Dr. FREDRIC BRANDT is singing as he injects a woman's face with filler. The song is his own version of LIFE IS JUST A BOWL OF CHERRIES, an old BOB FOSSE standard, with the word "cherries" changed to "berries". He sings it throughout the day I spend with him and often uses the title as a catchphrase. The woman he is injecting is highly excitable, often joining in to sing the song. When she talks, she flits between being self-mocking and needing reassurance. She is 68. He is 59. "I don't have to be too depressed, do I?" she says when Dr. BRANDT holds her face steady to look at his work. "I'm not going to look like W.C. FIELDS?"

When Dr. BRANDT injects, the needles go in as if skin were no barrier. Along with filler to lift her cheeks, he uses BOTOX in areas away from the usual frown lines and crow's-feet. "Ears grow longer with age, so BOTOX lifts and tightens them," he says as a needle goes into her ear. Dr. BRANDT pioneered the use of BOTOX on the neck to tighten up the skin and re-establish a jaw line. And as the needle moves to the centre of her face, he says he also uses BOTOX "for rosacea; it gets rid of redness and shrinks the nose."

Towards the end of her consultation, the woman has a moment of clarity. "Are we vacuous or clever?" Dr. BRANDT's answer is succinct. "No," he says. "It's only part of our personality." And she is finished. The farewells are warm, though he is firm when he tells her to smile and relax for a couple of hours to help it all set naturally. "It's not God," she says. "It's FRED BRANDT." She is the first of 32 patients he sees that day.

Dr. BRANDT is proud of the fact that he is the world's largest user of BOTOX. He is a dermatologist who has seized the initiative for the possibilities of non-invasive surgery. As the quality of fillers and treatments has improved, he has found that you can change the shape of the face without resorting to the knife. It has brought him recognition, helped by the fact that his most famous client is apparently MADONNA, and while he is secretive about the identities of his well-known patients, Dr. BRANDT is renovating the celebrity lift at the back of his surgery to prevent boldface names from being spotted. He is a regular on American TV, where his joviality and quips make him a personable advocate of procedures that some might find controversial. He has also developed his own high-end skincare line.

Dr. BRANDT's offices in New York are nondescript. His base in Miami is apparently much more impressive, but his Manhattan offices are in a block on East 34th Street, right where traffic emerges from the Queens-Midtown Tunnel. Most of the office is taken up by treatment rooms, but Dr. BRANDT has a small space of his own. When I first arrive at 9am, Dr. BRANDT is off somewhere else, so I have time to scan the contents.

On the back of the door is a DOLCE & GABBANA silver quilted coat from the collection based on spacesuits. Up the corner is a camouflage LOUIS VUITTON holdall made in collaboration with artist TAKASHI MURAKAMI. Piled up on the windowsill are books on BRANCUSI, ED RUSCHA, MANOLO BLAHNIK and the catalogue from an old Japanese illustration exhibition called LITTLE BOY. There is also a catalogue from SOTHEBY'S and a pop-up book on GRACELAND. On his desk is an OBAMA '08 badge and an etched-glass drawing of three dogs. On the wall is a framed sketch and plan of THE GATES by CHRISTO, including a swatch of one of the orange flags that hung in Central Park in 2005.

When Dr. BRANDT emerges, he is wearing head-to-toe PRADA, including the back-to-front shirt from Autumn/Winter '08. How does he do it up? "I fasten the top and the bottom, then get the girls in the office to do the rest," he says. He never wears a traditional doctor's white coat when seeing patients, and he bought the back-to-front shirts in bulk. "It's hard to find the pieces you want, you know what I mean?" he says. "Because the stores get so much of the non-runway, you have to really hunt it down and get them to save it for you. PRADA stores don't get many catwalk pieces. In this city most of those go to the SoHo store."

Later on, as he is treating a patient who has declined to have her face numbed and so grimaces and yells with each injection, I ask him how he coped with the PRADA collection from the winter before—could he treat patients dressed in a teddy-bear fur knit jumper? "I bought one for the weekend," he says. "I wore the pants with stirrups for treatments though."

I first met Dr. BRANDT a couple of years ago, when he was on a whistle-stop tour to London, the rumour being he was there to treat one of his famous clients. He also took the opportunity to promote his skincare line, and so I was invited to meet him at CLARIDGE'S. When I arrived in the tearooms, unbeknownst to me he was having a nap on the banquette hidden behind the table. Five minutes later, he shot up rigid, like a body sprung from the grave. I knew this man would be a hoot.

Because I come from a family of wonky teeth and proud laughter lines, surgery offers no temptation for me. But I am fascinated by those who are brazen about their interest in changing their face: if you're going to have work done, at least don't pretend otherwise. Dr. BRANDT would never deny that he has done work on himself. He sees it as a selling point that he's tried all his treatments on himself first. "I don't like to look like everyone else," he says, when we meet for breakfast to talk a couple of days later. "You can see that, right?"

We are at the FOUR SEASONS hotel on East 57th Street, where Dr. BRANDT has been living for the two weeks a month he is in New York and where, at this time, he would normally be doing his yoga routine. His main base is in Miami, where he keeps his art and his dogs, but that city seems to be a paradoxical home for him: one of Dr. BRANDT's main skincare tenets is to stay out of the sun — tricky in Florida.

I ask him about his education. "When I got into medical school, I was interested in internal medicine," he says. Today's PRADA outfit includes another back-to-front shirt and one of those intriguing cummerbund pieces with the V of fabric tucking into the trousers. Other than on the catwalk, I've never seen anyone wear one before. "I was actually hoping to go into oncology, treating cancer patients, and I did a lot of work at Sloan-Kettering on leukaemia. But in the middle of it I decided to go into dermatology."

Skin provided a new fascination. "I liked the idea of visualising things and became interested in skin and how it was a manifestation of everything else that was going on in your body." He finished his residency in the early '80s, at a time when non-invasive procedures were scarce. "There were some cosmetic things going on but not to the degree that there are these days," he says. "I think it was when collagen injections had just been approved and we had some peeling, that type of thing, and dermabrasion, hair transplants, but that was about the limit."

Dr. BRANDT set up his own office, and as treatments became more sophisticated, he became more eager. "For a while we did collagen and peels, and then BOTOX came about in the mid '90s and we began using that," he says. "Then I started developing a lot of new techniques, like the neck lift, so we were expanding the horizons of what you could do with it. At the same time, all the new fillers started getting approved. Before we were just filling lines and wrinkles with collagen, and the duration was great but it wasn't exceptional. But then we had fillers that could work synergistically with the BOTOX, so we could achieve total

facial rejuvenation. It's not just filling in lines and wrinkles, but changing the contours of the face in a volumisation process."

Dr. BRANDT is known for championing something called the "NEW NEW FACE", which draws from features found in those faces that are deemed aesthetically pleasing. A heart-shaped face is seen as the ideal, with a defined jawline balanced by high and full cheekbones. It renders the old-fashioned facelift redundant, replacing the pulled-back appearance with skin that is actually allowed to be plump in specific places. For this NEW NEW FACE he charges a four-figure sum for each session. I overheard his receptionist try to soften the blow by reading out the final figure in two parts. "That'll be forty-three fifty-five," she said to one freshly injected client.

Whereas the old facelift made everyone look the same, the NEW NEW FACE is relatively subtle and specific to the individual — Dr. BRANDT's patients shouldn't have any recognisable stamp other than unexpected youthfulness. "I'm obviously not trying to make patients look like someone else; I'm enhancing their own face," he says.

Making someone beautiful must have immediately pleasing effects for him, different from what he would have to deal with if he had pursued his cancer studies. "I never really thought of it that way," he says. "Oncology can be depressing, but it can be rewarding too. I just like what I do because I can look and see the results, and it has the visual combination of being very aesthetic and scientific at the same time. How's your breakfast, good?"

The word "aesthetic" seems important to Dr. BRANDT. Indeed his personal interest in art is well established. While he is treating one ageing woman with BOTOX in her *décolletage*, I ask him about his collection. He lists some works: he has a KEITH HARING; a RICHARD PRINCE he was canny enough to buy in 1991 for $28,000; work by BARBARA KRUGER; pieces by JOSH SMITH; a GILBERT & GEORGE called SPUNK MOON and work by SYLVIE FLEURY.

In the corridor of his New York offices is a blown-up image by STEVEN KLEIN from a series shot for L'UOMO VOGUE based on a film called THE SWIMMER. It features the taut and chiselled model CHAD WHITE lying naked on a poolside recliner, with Dr. BRANDT emerging from sliding glass doors wearing DIOR HOMME cutaway tails and with a needle in his hand.

There is something subversive about this image being on such public display to patients who are about to be treated. You would expect a surgery to hide the realities of what takes place in treatment rooms, but Dr. BRANDT flaunts the implications of the needle to the extreme. It's one of the curiosities of his character — he is intensely dedicated to his profession: working long days with patients, running his skincare line, undertaking research and clinical trials for the US Food and Drug Administration (FDA) at his lab in Miami, and not seeming to

have a great deal of time for himself. This amount of focus could make a man extremely boring. Yet there is also a side to him that is incredibly naughty.

I had already been thinking about this when I overheard a conversation he had with a patient. She was talking about going to a place called LA GRENOUILLE on East 52nd Street, recently celebrated by VANITY FAIR as the last of Manhattan's "grand French restaurants." She asked if he ever dined there. Dr. BRANDT's answer was succinct. "It feels like you are at dinner with your parents, your relatives, and you have to behave," he said. "It's no fun."

Over breakfast I tell him that he seems naughty to me. "I do?" he says. "Naughty? I wonder what you mean? As far as being funny? Playful?" It is as if Dr. BRANDT has subversiveness contained within him—ways of living and choices of appearance that please his pronounced desire to be different from the norm. It seems to be a long-term construction in his life, allowing him to balance out how seriously he takes his work.

During my day with him it was a shame not to have seen Dr. BRANDT work on any men, so afterwards I e-mailed one of his male patients to ask why he went to Dr. BRANDT. I was expecting a reply full of the same sunny flippancy I'd heard from many of his female clients who sounded like they would list BOTOX treatments as a hobby. The reply that I got from the male patient, a late middle-aged antiques dealer, was stark.

"About two and a half years ago, I underwent a SCULPTRA procedure done by another dermatologist," he wrote. SCULPTRA is a collagen treatment. "Unfortunately she had not done the mandatory skin tests as prescribed by the manufacturer. The results were devastating. Several clinics could not help me, when fortunately a client of mine, a South American lady, passed by at my store and, realising that I needed help desperately, called Dr. BRANDT's office and pleaded that he should see me as soon as possible. From the moment I met Dr. BRANDT I felt to be in the hands of a most skilful and compassionate physician. During the past two years, with great patience and expertise, he has alleviated most of the symptoms. His support and encouragement gave me back confidence."

To which one reaction might be: "You shouldn't mess with nature in the first place." But that argument sits in some alternate reality, because the fact of the matter is there are many people who, given the opportunity, would want to change their appearance, and there are many who are willing to change it for them. "I definitely think even if something is genetic, you can alter it," says Dr. BRANDT.

For many years now, the doctor has kept himself on a strict diet that posits sugar as the enemy. There are strong chimes back to his youth on this: his father was diabetic but ran a candy store in New Jersey. "How ironic, right?" says Dr. BRANDT. We are talking a month later over breakfast—Dr. BRANDT is at

the FOUR SEASONS again. "My father died when he was 47. It was from complications from the diabetes. This was a long time ago, when we didn't have the understanding of diabetes that we do now."

How was Dr. BRANDT's own diet when he was a child? "My mother tried to watch us, but it was very hard when you're a child and there's a candy store accessible. It's like putting a bee in a pot of honey. As a child my diet was not the best."

Did his father's death have an impact on his diet? "It probably created an awareness for sure, I may have become aware of it on a subconscious level. I became interested in my diet towards the end of medical school, but not as much as I am now."

Dr. BRANDT is disciplined with his meals. "I eat no meat, nor do I eat white flour," he says. "For breakfast I eat a lot of grains and rye toast, then for lunch I usually have a vegetarian dish of beans and rice. My fruits of choice are blueberries for the antioxidants and pineapples for the enzymes. For supper I'll have tofu or some kind of fish. Last night I had sea bass."

He has been this strict for the past three or four years. He sees the aim of perfecting the body as being part of the same thought process as the perfection of the face. "You can modify things by having a healthy lifestyle, so that getting fat doesn't have to happen to you. Even though it may be somewhat genetic, you can also alter it. Obviously some people are more genetically blessed than others with their hair and skin, but you can be the best of who you can be."

When did Dr. BRANDT first start having treatments himself? "I would say when I was about 35 or 36," he says. "I started doing a little collagen injection, that was the filler that was available. I noticed that I was starting to get a little hollowness in my cheeks. I did that and filled in some of the lines on my forehead. That was pretty much when I started."

I'd often heard Dr. BRANDT say that he tested the treatments on himself, but did he mean that he got someone else to inject him, or did he actually work on his own face? "I did it," he says. "I was doing it on other people, so I figured why not do it on myself?"

Surely there's a difference between working on someone in front of you, and working on yourself? "It was definitely a little more difficult," he says, "I started out slowly, very gingerly, and then I got used to it. But doing things on myself helped me understand how things worked, and also how it felt, so when I was doing it to patients I knew what they were going through."

Did anything ever go wrong? "No, pretty much everything I've done has been judicious," he says. "I may have once done my lips a little too big, but that's it. Initially it was more like filling in some lines and wrinkles. Then with newer fillers that add volume, I could change some of my features and give myself a different look."

What look was he going for when he gave himself a new face? "Well I thought it was good if I made my jawline a little broader, more like that BRAD PITT look," he says. "I built up my cheekbones so I was able to change my face and add a little volume. As you age, your face becomes very thin and loses structure. By broadening the jaw line, you tighten the neck; redefining the cheeks not only helps to give you a slightly more chiselled look, but it also lifts the face."

After the initial shock of that first meeting in CLARIDGE'S, I got used to the stark creation that had become of his own face. Because he is not trying to be normal in himself, it fits with his otherworldliness. But his face is not without reality. When he concentrates on injecting a patient, he has an involuntary clenching of the jaw, which brings with it some flesh that escapes from the clutches of the BOTOX. It must be a captivating sight, watching him at work on himself in the mirror, jaw clenched but trying to be perfect. It could be parallel to some art, like the work of ORLAN. "Exactly," he says, "It's like being your own work of art. Chisel the image so that you would look your best."

The day I spent with Dr. BRANDT the month before had been painfully long, especially since I am no fan of needles. We dashed from room to room, heading on to the next patient as soon as he was finished with the previous one. These patients had already been waiting for at least an hour, and as the day dragged on, the delay got longer. So much so, patients would pop out of their rooms, gesturing at their watches, telling of the flights back home they had to catch right now. But they still stayed, because they'd waited long enough to get their appointment.

That day, the patients didn't know the doctor had a writer on his tail. I would walk into the room behind him, and his patients were so relieved that he was finally there, that when he explained who I was and what I did, none objected. Indeed, I would often become a foil for the procedure. As the needle went in, the patients would often fix their stare on me, looking for some sort of reassurance. Occasionaly, the doctor would ask me what I thought or if I could see a change. I would have to say yes, even though I often couldn't, because I didn't know them before or because the BOTOX hadn't yet taken hold. If I'd have said no, the patient would probably get upset and demand more injections. If the doctor thought they'd had enough, I did too. I was complicit.

Dr. BRANDT never knew who would be in each room but was guided wherever he had to go by his staff, who shouted out the next room number. But as he opened one particular door, I could tell there was something different. Rather than breezing in, he immediately mentioned he had a writer with him. The woman, who I was later told was an actress, screamed at him: "ARE YOU KIDDING?" Before I could get in the room, the door was closed in my face, and so I could slip out of what for me had become a monotonous routine.

Back over breakfast, I ask if he ever had the same feeling. "You know I

always say every patient is completely different, and everyone represents a challenge," he says. "I always feel I'm learning by watching what happens to the faces I work on. It's not a static process; it's a dynamic process."

When is Dr. BRANDT happiest? "I love when I'm injecting," he says, "and I love doing research on new products. I love working with the chemists and coming up with new things and seeing how they affect the skin. I love being creative. That's the thing that makes me happiest."

By now Dr. BRANDT has finished breakfast and is heading out to hail a cab. He's wearing DOLCE & GABBANA drawstring trousers with another PRADA back-to-front shirt and jacket. Only, on the way out of the hotel, he has a wardrobe malfunction. "Oh my god, my pants are falling down," he says. "Oh my god, it happened! Oh my." There is a general kerfuffle. The hotel doorman helps to pull them up. "Oh my god, it's so funny!" says Dr. BRANDT as he gets the taxi, and off he goes to learn some more.

Archive (II) — GOOD LOOKS
Top-to-toe fabulous clothes, worn well

L'HOMME EN JUPE — The president of the 30-strong French campaign group "Hommes en Jupe",
DOMINIQUE MOREAU, is photographed in his own "Roskilde" skirt by Paul Wetherell for issue n° 9,
Spring and Summer 2009.

UNDERWEAR — White mesh briefs produced by THE WHITE BRIEFS in collaboration with FANTASTIC MAN are modelled by rugby player-turned-actor DUNCAN and photographed by Andreas Larsson for issue nº 13, Spring and Summer 2011.

BOLD — An architect named NICOLAS is photographed for a story proposing bold summer fashion to be worn by gentlemen of quite marvelous shape by Andreas Larsson for issue n° 11, Spring and Summer 2010.

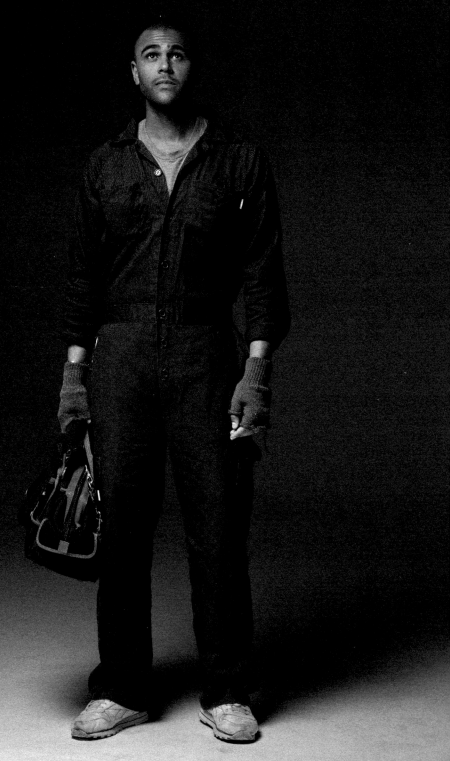

OVERALL — Stylist ELGAR JOHNSON is captured as he arrives at the studio in his own boiler suit, accessorised with trainers, a tool-bag and fingerless gloves. Photographed by Daniel Riera for issue n° 9, Spring and Summer 2009.

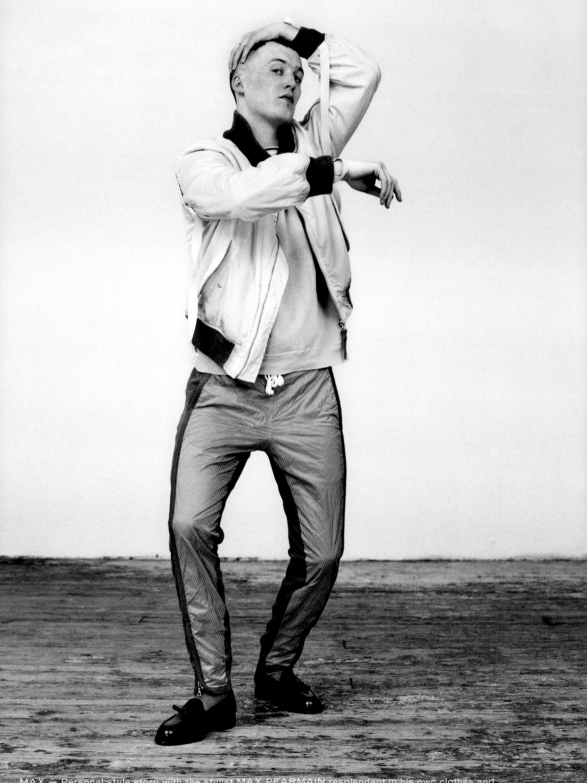

MAX — Personal style story with the stylist MAX PEARMAIN resplendent in his own clothes and photographed by Jason Evans for issue n° 21 for Spring and Summer 2015.

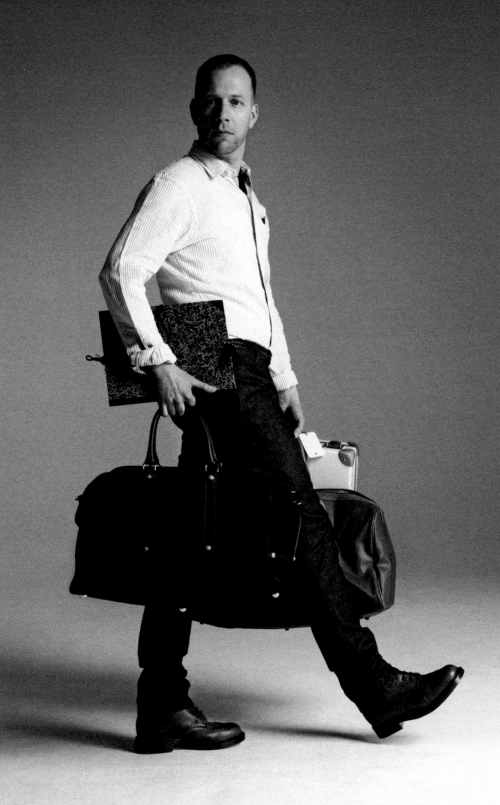

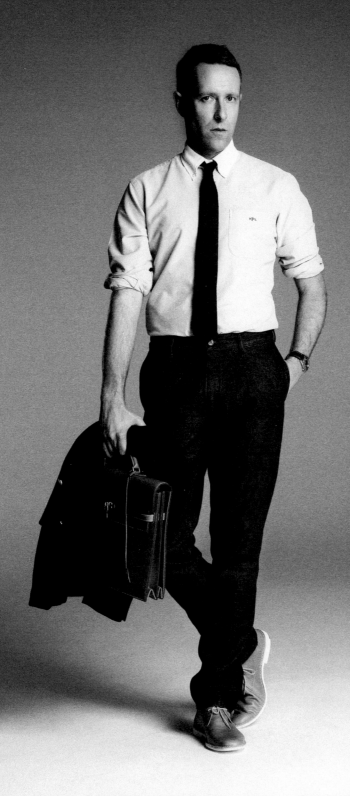

GENTLEMAN'S JEANS — FANTASTIC MAN's founders and editors JOP VAN BENNEKOM and GERT JONKERS debut the smart pleated jeans they designed in collaboration with ACNE. They're photographed by Andreas Larsson for issue n° 7, Spring and Summer 2008.

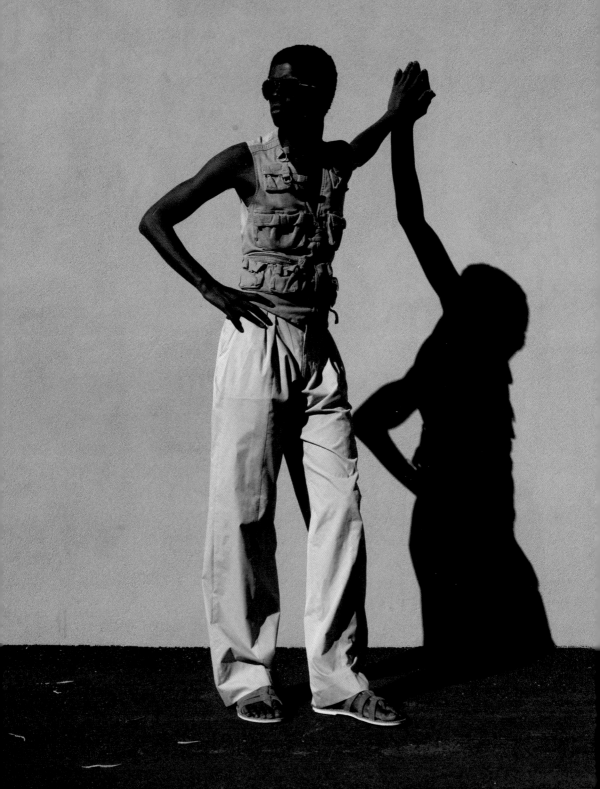

SUMMER SUITS — Elegant looks for hot climates are spied on GIBRIL GEORGE by the artist Viviane

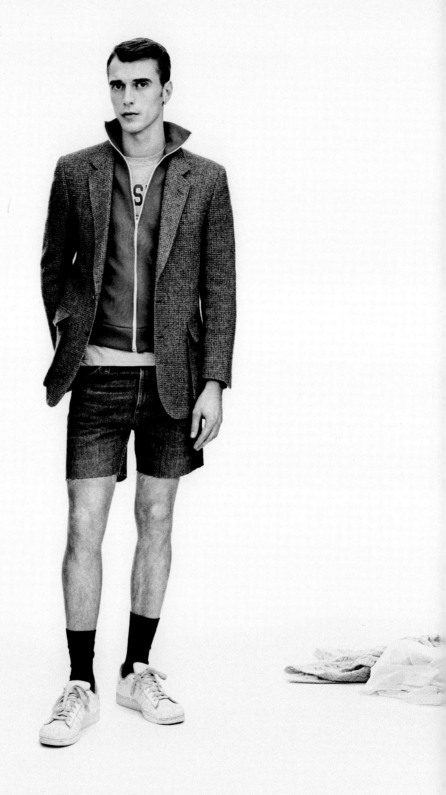

THRIFTY — CLÉMENT CHABERNAUD is dressed in charity shop finds, right down to his vintage socks, photographed by Karim Sadli for issue n° 19, Spring and Summer 2014.

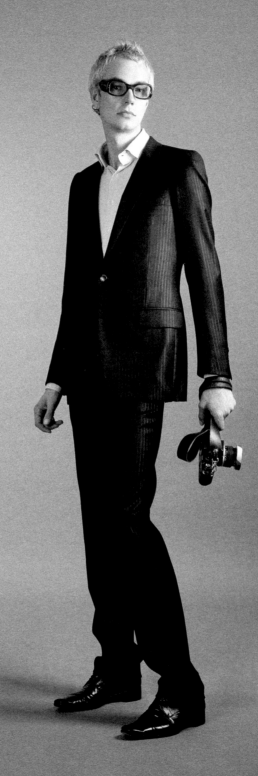

THE PHOTOGRAPHER — The tall man from Amsterdam BART JULIUS PETERS wears the best looks from the Paris catwalk with his own spectacles and camera. Photographed by Anuschka Blommers & Niels Schumm for issue nº 1, Spring and Summer 2005.

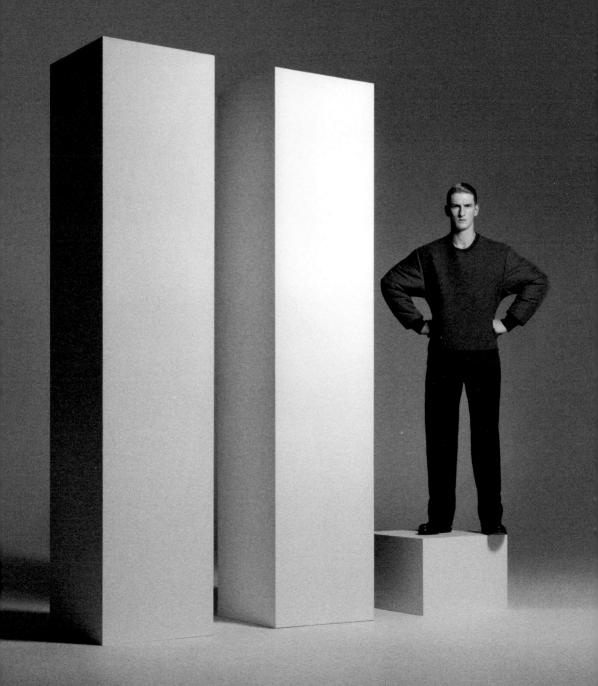

RANDOM — The 11th look on the catwalk offers a snapshot of the state of men's fashion in issue nº 14. Here, a sporty silhouette from CALVIN KLEIN COLLECTION Autumn and Winter 2011 is immortalised by Andreas Larsson.

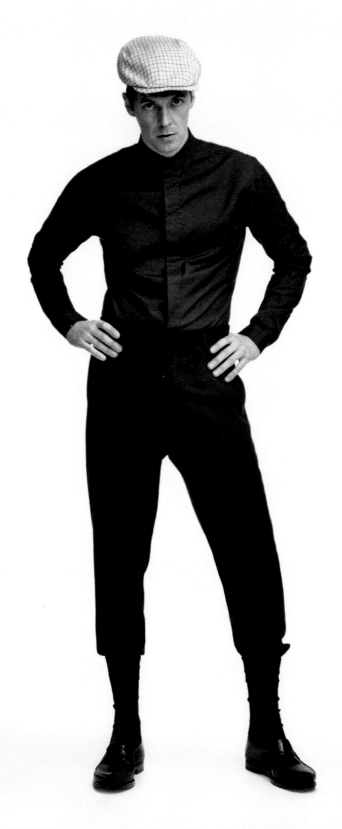

LAD — JAMIE ATKINSON is photographed by his childhood friend Alasdair McLellan for issue n° 15 in a series of "90s lads" looks revisited by stylist Olivier Rizzo for Spring and Summer 2012.

MEN OF THE BRITISH ISLES — Sturdy Welshman SIMON DAVIS appears in company of men from Scotland, England and Northern Ireland, as well as his Welsh compatriots. Photographed by Alasdair McLellan for issue n° 16, Autumn and Winter 2012.

LESBIANISM — Menswear ideas turn out to be rather appropriate when worn by lesbian friends, as photographed by Andreas Larsson for issue n° 8, Autumn and Winter 2008. Here, LAUREN models a fetching moleskin boilersuit.

BAGGAGE — The stylist SIMON FOXTON proposes and models outfits suitable for expeditions, including several very practical rucksacks from his own collection. Photographed by Daniel Riera for issue n° 9, Spring and Summer 2009.

Mr. CHARLIE PORTER

Featured in issue nº 12 for Autumn and Winter 2010

The accomplished British style writer and phenomenal blogger, CHARLIE PORTER, was FANTASTIC MAN's cherished Deputy Editor for a period spanning issues 8 through 15 of the magazine. In service of a reportage entitled THE FASHION TEST that appeared in issue nº 12, CHARLIE agreed to break the habit of a lifetime by embracing the challenges of the two-piece suit, a garment from which he had hitherto been a wary stranger. Never one to do things by halves, CHARLIE gamely wore his suit — a navy pinstripe one from the ERMENEGILDO ZEGNA store on Bond Street in London — for an entire month, documenting its effect on his self-perception and the reactions of others. He even wore it to the popular and muddy summer music festival known as GLASTONBURY.

These days, CHARLIE is the men's fashion critic for the FINANCIAL TIMES and his writing has appeared in British newspapers from THE GUARDIAN to THE TIMES. He's a familiar face on SHOWSTUDIO's Live Panel dissections of the menswear shows and has worked with FASHION EAST and the retailer TOPMAN's MAN initiative to support emerging designers in London. He occasionally wears a suit.

Portrait by Tim Gutt

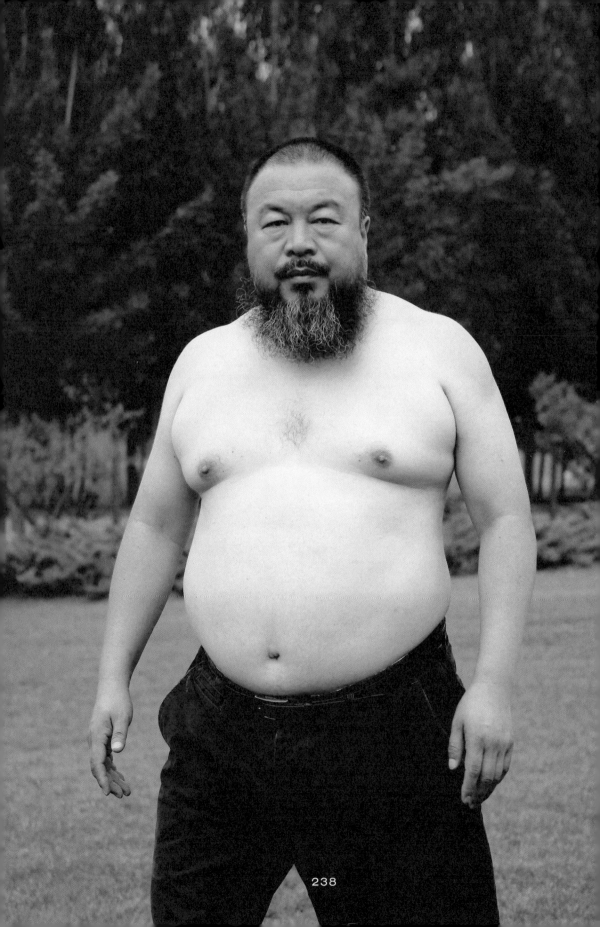

238

Mr. AI WEIWEI
Featured in issue nº 12 for Autumn and Winter 2010
Portraits by Ai Weiwei
Text by Aric Chen

Mr. AI WEIWEI

The TURBINE HALL at London's TATE MODERN is one of the world's most coveted exhibition spaces, and the next artist to fill it is Mr. AI WEIWEI. Although a veteran of major art events such as DOCUMENTA 12 and the 48th Venice BIENNALE, in his home country of China, Mr. AI is as much known for his activism as he is for his aesthetics. Based in Beijing, where he is under constant surveillance, the artist brazenly flouts the law to bring his view on modern-day China to the rest of the world. He is an avid user of fashionable social networking sites, and on an average day he tweets approximately 107 times.

"Okay, let's start," says the artist Mr. AI WEIWEI, greeting me with a wide smile and half-squinched eyes.

It's 9am on a sunny Beijing morning — so much for creative types sleeping late — and Mr. AI has already been up and at it for several hours. Given his reputation, I assume he's been irritating the Chinese government and tickling his legions of followers by way of his famously acerbic Twitter feeds. (Consider: "The system doesn't follow the law. The people don't believe in the law. So who's out of luck?")

I have made what's been called the "ritual pilgrimage" to the compound Mr. AI designed and built for himself in the city's northeast outskirts. It's a journey previously taken by the likes of Mr. GERHARD SCHRÖDER, Ms. DIANE VON FÜRSTENBERG and countless others who fancy themselves sophisticated and international. From the centre of town, you go past unremarkable high rises and light industry zones, beneath highway overpasses and railroad tracks and, finally, along a quiet, gingko-lined road. A blue metal door marks the entrance to Mr. AI's fabled home and studio, which he shares with his wife, the artist Ms. LU QING, and which these days also happens to be under surveillance by Chinese authorities.

Inside, the word "FUCK" is mounted on a garden wall in big neon letters. Otherwise, the scene is quite tranquil. Mr. AI is sitting next to a pleasant, grassy lawn framed by cypress trees, antique stone fragments and thickets of bamboo. He's accompanied by a member of his 30-or-so-person studio — a young woman, Germanic, I'd say, possibly Scandinavian — and several of his unconfirmed number of cats and dogs. ("We don't really know how many we have," he admits.) Mr. AI has close-cropped hair, an unruly beard and an ample belly that together define what you might call the AI WEIWEI look. Wearing a periwinkle T-shirt and shorts, he politely leads me across a patio and into his loft-like, grey-brick home.

"That's DU DU," he starts off, catching me glancing at another free-roaming canine as we sit down at a huge wooden table.

DU DU?

"Yeah. And there's DANNY," he adds, pointing to a female cocker spaniel. "We also have two of her children here."

Ignoring his pet-naming decisions, I ask how his day is going.

"Normally, I give two interviews in the morning, but today I only have yours," he says, continuing the small talk. Mr. AI is known to be accessible. "Don't hesitate to ask me anything you'd like," he offers.

Ever since 2006, when the architect Mr. JACQUES HERZOG first insisted that I try to meet him — they had collaborated on the design of Beijing's BIRD'S NEST stadium, a project Mr. AI later disavowed as a "fake smile" serving Communist propaganda — the Chinese artist, architect and dangerously outspoken activist has been a distant yet recurring motif in my life.

There he was, popping up at the architecture biennale in Venice and at exhibition openings in Beijing — always with an entourage and rarely without an assistant videotaping his every move. Once, I briefly interviewed him over a bowl of beef noodles. Another time, I visited his studio on a day I was told he wouldn't be there, only to find him typing away at his computer.

Mr. AI has a knack for being somewhere even when he isn't. He infiltrates things. As part of a massive, high-concept exercise, he took over DOCUMENTA 12 in Kassel, Germany, in 2007 with no less than 1,001 ordinary Chinese whom he'd flown in for the occasion. Earlier this year, he helped organise a protest march on a highly symbolic thoroughfare in central Beijing. The demonstration was totally unauthorised and quickly halted by police, but at least one Communist Party newspaper covered it — and guess whose name was on the photo credit?

Mr. AI, 53, is a conceptual artist who's become known for his activism and an activist whose provocations verge on art. He named his studio FAKE DESIGN, but it's really his life that his art imitates, and the other way around. This October, Mr. AI will become the latest artist to transform London's TATE MODERN as part of the museum's blockbuster series of Turbine Hall installations. For many, he's the godfather of contemporary Chinese art, the man — no, the concept — around which an intriguing image of China begins to emerge.

So who, or what, exactly is AI WEIWEI? A figure of controversy in his home country, for a start. "In China, the newspapers and magazines used to report on me a lot — but mostly fashion publications," he tells me. (I kid you not: as I write this, a friend has stopped by my home, randomly wearing a COMME DES GARÇONS T-shirt emblazoned with a watermelon and the words "THANKS TO AI WEIWEI".)

"People on the internet have seen me on CCTV" — the Chinese state television network — "and said, 'WEIWEI, what the fuck? You're on CCTV,'" he says. "Maybe they're using old programmes, but it's a big joke because I've been censored by them. Officially, they cannot mention my name." Programmes must sometimes slip through the cracks.

What about the TATE installation? What are you doing for that?

"I really can't talk about it; they even asked me not to talk to you in particular about this."

So now you're being censored by the TATE?

"Partially," he says with an ironic chuckle.

The proper way to address Mr. AI is, in fact, Mr. AI. The Chinese place their surnames first; his is pronounced like "eye". But mostly, WEIWEI ("way-way"), as many call him, is an enigmatic yet omnipresent abstraction, an iconoclastic artist and philosopher whose contours are hard to grasp. He works in a range of

media, from sculpture, installations and photography to architecture, film and, for lack of a better word, "actions", while at various times moonlighting as an antiques trader, gallerist and curator. Until recently, he was also the proprietor of QU NAR ("Go Where?"), a restaurant specialising in the cuisine of Zhejiang province, at which he frequently held court before it was demolished to make way for a new development last year.

As for his art, Mr. AI is unapologetically irreverent and sardonic. He can be seen flipping his finger at the White House and Eiffel Tower in his well-known STUDY OF PERSPECTIVE photographs, and he has painted the COCA-COLA logo on ancient pots. All the while, his work often relies on earlier wreckage, the kind of creative destruction that defines China's contemporary crossroads. There's DROPPING A HAN DYNASTY URN (1995), a photographic triptych in which he smashes a 2,000-year-old vase. And MAP OF CHINA (2003), a hulking, geographically correct sculpture made of wood salvaged from demolished QING dynasty temples. Mr. AI hits a nerve shared by Chinese and non-Chinese alike. As the artist later puts it: "What does 'China' mean?"

Nowadays, however, the more pressing question may be just how far he can push the Chinese authorities. Mr. AI has become a gigantic thorn for the powers that be, a vocal critic of the government — for its corruption, human rights shortcomings and other injustices — in a country where life has been known to get difficult for vocal government critics. He doesn't go about it quietly and misses few opportunities to act or speak out. During our first interview, he tells me how one week earlier, he'd driven into the mountains to rescue an activist who he says was abandoned there after being beaten by secret police. "He announced it on Twitter, said he didn't know where he was," Mr. AI says of the man, an advocate for migrant workers. "We had to go out and find him."

Then, during our second meeting, he's interrupted by a phone call. "That was the people from the earthquake area," he says. "They're still calling me."

"The earthquake" refers to Mr. AI's biggest cause to date — more specifically, the thousands of children who died in the 7.9-magnitude tremor that roiled China's Sichuan province in May 2008. Most of the area's young perished when their schools collapsed, as a result of shoddy construction that was widely attributed to the negligence and corruption of local officials. Fearing the ensuing outcry, the government silenced protests and failed to produce the names, or even a tally, of the victims.

In response, Mr. AI sent an army of volunteers to the region to help fill the gap. The list they produced grew to more than 5,200 names. Even two years later, Mr. AI daily sends out the names of the victims via Twitter on their birthdays. (Twitter is technically blocked in China, though that's easy to get around.) For a recent exhibition, he covered the façade of Munich's HAUS DER KUNST with 9,000 coloured backpacks forming a quote in Chinese characters taken from one

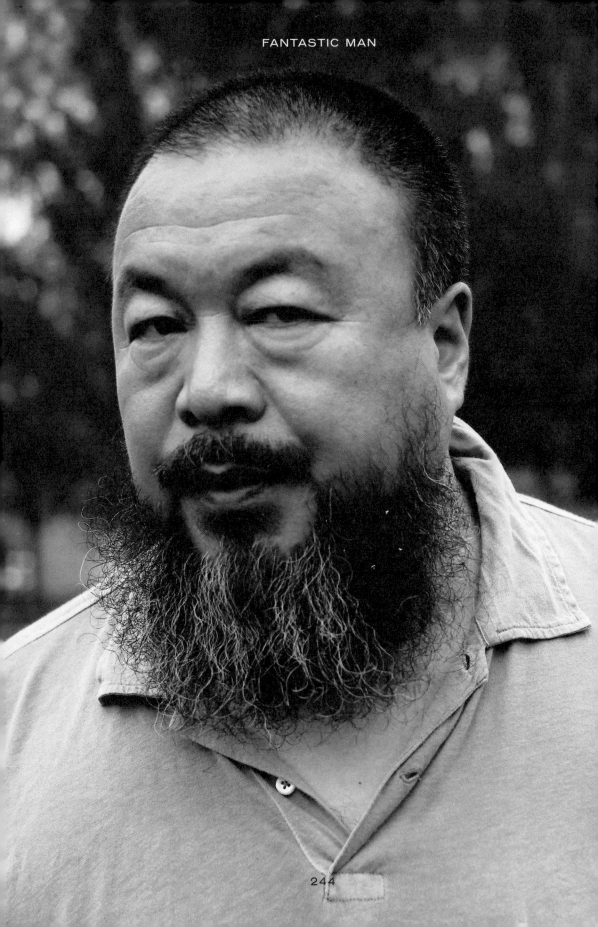

of the children's mothers. He's flung open his doors to the press while producing documentaries about the tragedy; they are part of a series tackling a range of issues. "We've sent probably 50 or 60 thousand documentaries out on DVD for free," Mr. AI says, "though millions have seen them on the internet."

Last year, Chinese censors shut down the popular blog Mr. AI had started writing in 2005. "We had maybe over 50 million readers," he laments. Meanwhile, he says his email accounts have been hacked, his bank accounts investigated, and his home staked out by mysterious men in parked cars; the latter have since been replaced by closed-circuit cameras.

"The machines are much friendlier," he says, nodding toward a pair of surveillance cameras, mounted on telephone poles that are aimed at his front gate. "Before that, the guys waiting outside weren't so nice." (Even as a mark, Mr. AI is a true gentleman, having once asked his surveillants if they might like some water. When they reacted poorly, he called the police on them.)

If it sounds like Mr. AI is flirting with martyrdom, he's got the scars to prove it: two of them, on the right side of his head. In August 2009, Mr. AI was in the Sichuanese capital of Chengdu to attend the trial of a fellow earthquake activist when police broke into his room at the ANYI HOTEL. It was the middle of the night, and according to Mr. AI, he was roughed up and suffered a blunt blow to the head. A month later, surgeons in Germany had to drill holes in his skull to relieve the pressure from a serious brain haemorrhage.

"It was very dangerous; the doctor said he sees this level of severity, so much blood in the brain, maybe only once every three years," says the artist, who was in Munich preparing his HAUS DER KUNST exhibition when the injury was discovered. "If we waited just one day longer, I may have lost my life." He pauses. "So life is very fragile."

In fact, Mr. AI learned that lesson early on. His father, Mr. AI QING, was one of China's most revered poets. And to understand what happened to him requires placing him in the context of 20th-century Chinese history — which, to put it simply, was a mess. Having first been imprisoned by the Nationalist Party for his leftist sympathies, the elder Mr. AI was later denounced as a "rightist" by the communists. Which, to continue the ideological wheel spinning, was basically an unfounded accusation stemming from the madness of a reactionary purge.

What followed was more than a decade of exile, first to Manchuria and then the remoter Xinjiang region. AI QING was relegated to cleaning public toilets, while the family, which also included Mr. AI's mother and younger brother, had to scavenge for food. During the Cultural Revolution, things got worse: AI QING was pelted with stones and, to add to the cruel humiliation, had ink poured over his face. "He couldn't wash it off, since we didn't even have soap," says Mr. AI,

who laboured making bricks and working the fields, starting at age ten. "I would have to go out and shit, you know, because there's no bathroom. And then you look at the sky and you see it's just yourself there in the desert."

"My strongest influence on me is my earlier life," he goes on. "The conditions we were in, how my father was treated, my family facing such insults and punishment. You know, I never believed in the system, and it seems I always had the most sympathy for the weak."

Much of his art might tap into the suspicions among some of his compatriots that Mr. AI is somehow anti-China. I ask him if he is. "You know, if somebody is critical, the Chinese government always blames it on some kind of anti-China, foreign force," he says. "So I jump on the internet and say, yeah, I'm anti-China."

But is he really anti-China? Like, anti-all-of-it?

He thinks for a moment. "I am anti-China. I'm more anti-China than anti-Communist. What's the big deal?" he says, without losing his cool. "What does 'China' mean? Is it the history, the values, the people? What's the problem with being an individual who's anti-China, or any other place? This is your own individual position."

Clearly, Mr. AI is not wholly anti-history, anti-values or anti-people, with regard to China or otherwise. He's obviously quite the opposite. If he is anti-China, it depends on how you define China. But in my mind, Mr. AI is simply anti-being-told-what-to-think-and-do.

After all, he's exhibited a rebellious streak from the get-go, both in China and the West. Cut to New York, 1981. Mr. AI, now in his mid-20s, has moved into a tiny hovel in the East Village. Back in China, Chairman MAO has died and the Cultural Revolution is over; Mr. AI's father has been rehabilitated and the family is back in Beijing. Alone in New York, after stops in Philadelphia and Berkeley, Mr. AI soaks up Manhattan's bohemian vibe. He enrols in Parsons School of Design, drops out, makes art and befriends Mr. ALLEN GINSBERG. He supports himself with odd jobs; in fact, he seems made for New York.

There, he took an interest in gay rights and the AIDS epidemic and demonstrated against the first Gulf War. In 1988, in an effort to clean up seedy Tompkins Square Park, the New York City police instituted a curfew. The protests that followed were met by police brutality, and Mr. AI was there to catch it on film. "We took some photos and sent them to the American Civil Liberties Union, got some police dismissed," he recalls. To his list of occupational titles, one might add photojournalist: while in New York, Mr. AI sold pictures to THE NEW YORK TIMES, the NEW YORK DAILY NEWS and NEWSWEEK.

It's a little unnerving when Mr. AI points his camera at you, totally without warning. In my experience, it usually happens when you're talking, in mid-sentence. First, he casually lifts his camera or phone. Then he slyly squints — act natural,

you tell yourself, and keep talking — before bringing the lens up close in a way no one besides your dermatologist should do. It's as if he's reminding you that he's watching you as carefully as you are him. Or perhaps it's his way of bringing you into his orbit; without realising it, you've become part of the AI WEIWEI show, a co-conspirator.

Pictures rarely lie. Or at least that's my explanation for Mr. AI's obsession with documentation. He makes a point of leaving a paper trail, filing police reports when they'll likely get him nowhere and invoking China's equivalent of the Freedom of Information Act knowing full well that a response won't be coming anytime soon. His first blog posts were like a Warholian scrapbook, filled with images of the minutiae of his life alongside nearly everyone he'd come in contact with. Unlike many others with strong beliefs, Mr. AI has a remarkable capacity for self-reflection. At one point, he tells me the Chinese saying he wants on his tombstone: "He was the perfect example of the defects of his time."

In short, Mr. AI embraces transparency; it's like he's on a perpetual fact-finding mission while wanting to prove he has nothing to hide. Yet he also plays with truth. Besides calling his studio FAKE DESIGN, he's made mutant furniture from real antiques, and faux objects (watermelons, sunflower seeds) using only the most authentic craftsmanship (and the former imperial porcelain kilns in Jingdezhen).

At the last DOCUMENTA, Mr. AI built a monumental outdoor sculpture from antique wooden windows; a storm unexpectedly sent it crashing down. Two years later, while visiting one of his workshops, I saw the piece being recon-structed — this time in its collapsed state, as if it was always supposed to be that way. "I'm constantly dealing with people's perception of what is real, what is fake, how we make our value judgement," he says.

Mr. AI wakes up around 6.30 or 7.00 in the morning. He spends about four hours working at the computer and receiving the unending stream of museum groups, journalists and others who come by.

Afterwards, he'll have lunch — he has a penchant for noodles — and work with his studio on its various projects. In the afternoon, he'll spend time with his only child, a toddler son he fathered with a filmmaker from one of his documen-taries. "Then maybe I'll handle other issues, call friends and have dinner, discuss some matters, you know, have a little bit of a social life," he says. "After-wards I'll come back, jump back to the computer for another four hours or more. So that's a day." It sounds oddly prosaic.

In fact, Mr. AI has a funny habit of repeating a phrase that goes something like this: "I had nothing else do to." He deploys it to explain nearly every turn of his life — such as everything he got up to during his years in New York. ("Basi-cally, I had nothing to do," he shrugs.) And when he returned to China in 1993,

after his father took ill, and started dealing antiques while continuing with his art. ("There was nothing else to do.") And when, four years after his father died, he built his current home so that he could move out of his mother's. ("She was annoyed, because I had nothing to do.")

When he says he had nothing to do, it's as if Mr. AI is excusing himself for doing whatever he's done, and has done it despite himself. He says it with humility, and perhaps there are fatalistic tendencies at work: "Life is unpredictable and has unexpected effects," he emails me at one point. It helps explain his vulnerability to distractions — say, an activist who's been stranded by the police in the mountains and needs to be saved. But maybe it's also his way of defusing the criticism that he can seem like a celebrity artist, that he's a bit overeager to give his audiences what they expect and want.

Therein may lie the biggest irony. If one takes him at his word, Mr. AI has never wanted to be known as a Chinese artist per se. "In the '80s, when ALLEN GINSBERG read me his poetry, and I showed him my portfolio, he said, 'WEIWEI, I can't think of a gallery that wants to show Chinese artists' work,'" Mr. AI recalls. "At that time, it bothered me. I said, 'ALLEN, I don't think of you as an American poet. You're just a poet.'"

What's more, Mr. AI is a champion of what he considers to be universal values. "The only thing I would not accept is regional thinking, because with today's globalisation and the internet, the world is completely different," he emails me.

But at the same time, Mr. AI's resonance depends in large measure on the extent to which he mirrors one's feelings about China. While few question his integrity, his critics sometimes find him too quick to judge an evolving system that, given the long arc of history, has made dizzyingly rapid strides. On the other hand, his supporters see him as a voice for the underdog, a much-needed reality check for a nation at risk of complacency, of being blinded by its current success.

For some, there's also the otherness factor. That is to say, he feeds into fears about a rising power they don't fully understand. When Mr. AI brought those 1,001 Chinese people to DOCUMENTA, he tapped into the West's anxieties about being overrun by the Eastern giant. However, "My intention was focused on the 1,001 people and how this would affect their lives," he says. "Any work, especially one related to worlds as different as China and the West, can carry completely different, even contradictory, meanings. And in general, people can only approach the surface; this is very normal."

For him, he says, the piece was more about the process of making it, which included everything from an open call on the internet to securing passports for participants from Chinese minority groups who didn't have last names. Referencing Kassel's status as home of the BROTHERS GRIMM, he called the experiment FAIRYTALE.

That said, how Mr. AI's own story will turn out is impossible to predict. "I can't answer why the government still hasn't put me in jail, but I'm ready to face it," he says, laughing nervously. "I would encourage them to not put me in jail. But I have to be prepared."

Theories abound as to why Mr. AI has so far avoided imprisonment. One explanation goes that, while he criticises the government, he doesn't cross the line of questioning its legitimacy.

"That's wrong," he shoots back. "From the very beginning I questioned the legitimacy of the Communist Party, though I don't have to say it all the time."

Some people say he's protected by his family background.

"That's underestimating the system. Look what happened to my father, so what's that background for?"

Maybe it's that he's too established.

"Throughout Chinese history, even those in the highest positions could be punished."

At one point, I wonder if it's because he's avoided hyper-touchy subjects like Tibet. But then he tells me about the meeting, albeit back in 1989, that he had with the DALAI LAMA. ("He liked my beard.") So the most obvious answer, I think, would also help explain why he's talking to me: in effect, he's shielded by the international media.

"Could be. But I don't know, maybe that's also an illusion. No one's that influential."

He's probably right. Overestimating yourself is risky, since finding your limits often means it's already too late. But Mr. AI seems fearless, or at least brave enough to face fear. And then he says something that sounds truly hard to believe, at least coming from him: "You know, people forget you from one minute to the next."

Mr. CLÉMENT CHABERNAUD

Featured in issue nº 12 for Autumn and Winter 2010

The French model, CLÉMENT CHABERNAUD, has made regular appearances in the magazine since he started his career by walking the DIOR HOMME show in June 2005, aged 16. His image spans editorial and advertising to the extent you would be hard pushed to find a single CLÉMENT-free issue.

With its high cheekbones, neat chiselled chin and straight nose, CLÉMENT's face is extremely photogenic, but also protean. In certain campaigns he is almost unrecognisable. This is a virtue in a model, but, nonetheless, CLÉMENT is at his best when he's completely apparent. "I think he's the perfect man," said designer RAF SIMONS, "I like that he's extremely natural, almost naïve — he's a bit of a hippie. He's not a body builder, but he's masculine. Somehow he's the perfect mix of a boy on the street and an über-male model. Plus, don't forget he's very beautiful." As well as his good looks, CLÉMENT is cherished for his relaxed-yet-professional approach to modelling. Interviewed in issue nº 18 he told FANTASTIC MAN's editor GERT JONKERS that he relishes the sillier show garments rejected by other models because being asked to wear them is a stamp of approval.

The subject of a Tumblr account called "CLÉMENT doing normal things better than you," CLÉMENT claimed to have little interest in social media himself, but admitted that fan websites can serve as a handy record of where he's been and what he's done.

Portrait by Willy Vanderperre

Mr.
EASTON ELLIS

Mr. BRET EASTON ELLIS
Featured in issue n° 9 for Spring and Summer 2009
Portraits by Jeff Burton
Text by Paul Flynn

The legendary Mr. BRET EASTON ELLIS is still challenging himself to depict the brutal ways of the world. Author of six startling, honest and funny books, including AMERICAN PSYCHO and GLAMORAMA, Mr. ELLIS is currently finishing his seventh, a follow-up to his still-shocking debut LESS THAN ZERO, due to be published next year. Mr. ELLIS has lived most of his adult life in New York, a city whose style he helped define by what his characters wore. Now an inhabitant of Los Angeles, Mr. ELLIS lives on the 11th floor of an apartment block in West Hollywood, overlooking the city in which his long-awaited new book is set...

Before the tape is switched on, Mr. BRET EASTON ELLIS wonders about the parameters of the conversation. "But I am not promoting anything," he says, as if that might somehow derail what is to come. It is apparent that BRET EASTON ELLIS in full promotional swing is a startlingly different character from BRET EASTON ELLIS in full work mode. It is almost as if they are two separate people.

He sits on the near edge of a putty-coloured corner sofa in his pristine Los Angeles apartment, knees splayed and ankles crossed. I take the implication of his statement to be: "And if I am not promoting anything, then why would anyone be interested in me?" To which the answer, in my head at least, is: "Why would anyone not?"

Right now, BRET EASTON ELLIS' life mostly consists of finishing a new novel, his seventh. It has the working title IMPERIAL BEDROOMS and is a follow-up to his debut, LESS THAN ZERO, the book that nailed his reputation at the precociously young age of 19 and that he read over and over again before writing his last one, LUNAR PARK. "And a weird thing happened. I wanted to know what was going on with the narrator and what he was doing now. Where were the other people?" Another thing happened to light the initial touch-paper of his intense creative process. "I became really obsessed in the last decade or so with RAYMOND CHANDLER. I wanted to write a RAYMOND CHANDLER type of novel. I put the two together and who knows? It could be a disaster. It could be terrible. But it is the thing that I really want to write. Now as the book is moving forward and I'm further along in it, that's when the writing tends to pick up. It's always harder at the beginning. It's all kind of boring. The process is boring."

Whenever he talks of his work, Mr. ELLIS looks locked into his own brain. If it is an incredible space to delve into for the subsequent reader, it is also a difficult space to occupy for the writer.

Interrupting Mr. ELLIS' mind-set at this juncture is fascinating, if a little uneasy. He is precipitously close to finishing the work and anticipates doing so in May. He says he has little to no interference from his editor. "Every time I am at this stage of a book," he says, "I tell myself that I will never write another one."

There is a flurry of BRET-EASTON-ELLIS activity about to happen, delighting the army of fanatics that swarm to his work. He has adapted a screenplay for his book on "the death of the soul," THE INFORMERS, which was recently premiered at the SUNDANCE FILM FESTIVAL. A film treatment for LUNAR PARK, written by someone else, should go into production this year. "The last I heard, BENICIO DEL TORO was attached," he confides, looking pleased at the potential coup. He talks vaguely of some screen work for TV he has in development, though doesn't jinx anything by going into detail.

Immediately there is a sense that the author lives in a world that is devoted to his work: that little to nothing else exists in this moment. He says he procrastinates over everything, right down to naming the characters. "I procrastinate all the time. That is part of the process. I don't think it's a negative thing. It is what it is. If you're writing novels, usually you know how to do it before you write the book. You get used to it. And you're not so surprised by the rhythms it takes. You're not so surprised by the long periods where nothing really happens. Then there are the bursts of intense writing where there are things that you never thought would be put in the novel. There's also, I notice, compared to screenwriting, an immense amount of relief in working on something that is all your own."

A particularly intriguing detail emerges throughout my three-and-a-half hour conversation with Mr. ELLIS. The author appears to be the only man on earth right now who is absolutely ambivalent on the subject of BARACK OBAMA becoming The President of the United States of America.

"I have no feelings on that subject. None either way," he says. It sounds just as complete in its emotional brutalism aloud as it looks written down, as if he has purposefully anaesthetised himself to the central world event of the last 12 months. When I suggest that Mr. OBAMA is of both the age and the disposition to perhaps have read a BRET EASTON ELLIS novel, he points out that GEORGE W. BUSH told him that he had read and loved LESS THAN ZERO when BRET met him in 1986, cannily reminding me of his extraordinary life whilst making his oblique point.

"It will be interesting to see how long this collective national and international fantasia of OBAMA-ism lasts," he says, as if it is a foregone conclusion that any moment now his apathy towards it will be richly rewarded. And perhaps it will. On the subject of the non-event of the American election alone, he appears convinced. Elsewhere, when he is dissecting the minutiae of his own life, notes of abject uncertainty prick most sentences that drop gently from his mouth. It is possible that the two are related.

Mr. ELLIS sits far enough away from me to warrant gravity between inquisitor and subject and close enough to study the recesses of his doleful eyes. There is nothing to suggest any dishonesty about them. Quite the opposite. He prevaricates in answering everything, though, from the brand of coffee he favours (PEET'S) to the intimacies shared between the author and his shrink. He says that, yes, sometimes he has a crisis of confidence about what the music he chooses to play in his car says about him, even if he is alone. He drives a BMW 5 SERIES and often has trouble locating it in car lots, such is the model's ubiquity in LA. "They are everywhere. Everyone has one. Men of a certain age..." It is black. "Ubiquitous car, ubiquitous colour."

His tone is deeply considered, and despite being locked in the serious pursuit of his work, there is a sense in which he still wants the myth of BRET EASTON ELLIS — the whirlwind author, the cultural trouble-shooter, the agent provocateur — to be upheld. At the end of the conversation, as I make to leave his apartment, he taps the side of my shirtsleeve and says, "Just make me sound good, okay?" attempting a half-smile that looks kinder than the question sounds. The only way you can honour the invitation is to say what you see.

With as yet no finished work to promote, BRET EASTON ELLIS seems inclined to negotiate the outer reaches of his own alienation. Part of this you could put down to his move back to his childhood home of LA. "It really is an incredibly isolating place," he says, "worse than any place I've ever lived." To cement the isolation, the breadth of the city stretches out of a floor-to-ceiling view that extends for the length of the 11th floor apartment, from THE GETTY CENTER at one corner to downtown at the other. At the jollier ends of the conversation, the view looks breathtaking; at the more disorienting moments it is as if we are hovering above the city. But part of this alienation you must put down to the condition of being BRET EASTON ELLIS. Anyone who has read the contents of his unique brain spilling onto the page knows that Mr. ELLIS is singular. Yet at this stage of his writing process, it comes as some surprise to find him quite so separate.

He says that part of the appeal of the apartment block was its similarity to his living conditions in New York: the security guard at reception, the very idea of shared living.

The flat itself is stark but not minimal. Any colour shading seeps into the whole. The paraphernalia of a man living alone is nowhere to be seen. You would have to search to find the TV remote control. When I ask if he still has manuscripts from his early works he says yes, they are stored away somewhere, and it's clear that he means not in this apartment. The entirety of the place feels like a new start, in which nothing will crowd his head; no art on the wall, nothing extraneous. A woman would never live like this.

The space between BRET EASTON ELLIS and his work has long been a concern for the author. He tells me that someone recently asked him about writing a memoir. "I told him to look back at the six books I've written. That's it! You can trace where I am, any aspect and part of my life through reading those books. Those are my journals." He is a writer of absolute confidence and conviction, which heightens the problem of distinguishing the author from the work.

The written universes he provokes you into are the poisoned apples in the Garden of Eden of contemporary fiction — perhaps even of contemporary morality. They are never quite what they seem. On his six-book journey he has conjured

worlds that are hard, fast, glamorous and amoral. From the classroom (LESS THAN ZERO, THE RULES OF ATTRACTION) to the industries of high fashion and international terrorism (GLAMORAMA) to the story of authorship itself (LUNAR PARK) and the anatomy of serial killing (AMERICAN PSY-CHO), his books are dotted with a cast list of the beautiful and the damned; characters with a "so it goes" attitude to battling their way through the modern condition. They support loveless sex by ingesting sexless drugs. Their dress codes are manacled to their moment. They ooze so much modernity that they cannot help but hate it.

When he tells you that for IMPERIAL BEDROOMS he has had to fight hard to rediscover the voice of the LESS THAN ZERO protagonist, last recalled when he finished the novel at 19, the first questions that flash across your mind are: "What cell phone does he use?", "What underwear does he sport?" and "Does he hate himself for watching AMERICAN IDOL?" A BRET EASTON ELLIS character is someone who implicitly understands that at the end of the 20th and beginning of the 21st centuries, the exterior life is part of the key to unlocking the interior, for better and for worse.

The accusation of superficiality has boringly followed him around for over two decades now. But no writer of his age understands the depths behind shallow feeling and dialogue any clearer. Because he writes in a moment of time, he is excused from the constant search for gravitas of his literary peers, most of whom he dislikes.

"There is a certain kind of writer that I cannot stand that is very popular with academics and with critics. Carefully written, streamlined, generic lyricism. It's very, very smooth and almost polite and very conscious of its metaphors and very conscious of its punctuation. Very careful. Often you're reading a book narrated by someone that would never use this language in a million years. There is also a kind of craving for respect from the critical community. That's a limitation. Because you are writing for a reaction. You cannot do that. You have to write because you are obsessed by this material and because it says something about yourself. Good manners can work for you for a while as an artist. I suppose as much as bad manners can."

The proximity between Mr. ELLIS and his work is an enduring fascination for his fans. You can call BRET EASTON ELLIS fans "fans" in a way that you cannot with other authors but that you might with a rock star or a film director. BRET himself tells of a fan that runs a blog under the name LONDON PREPPY who has "BRET EASTON ELLIS" tattooed inside his biceps. "My mother has something locked in on Google where if there is something about me posted she gets it. She sends me all these links. So that's really how I keep up."

BRET EASTON ELLIS takes the hero worship that follows his work politely. "I guess ultimately it's nice to have people respond to your books that way."

Pause.

"It's a good thing."

Pause.

"I can't even begin to think about what would be particularly negative about it."

Pause.

"And there is nothing I can do about it and realistically it is something that I have no control over, so... You certainly do not decide your own reputation."

How does it feel to know that there is a stranger wandering about with your name tattooed on him?

"It's strange, you know?"

This time there is a longer pause than usual.

"It makes you feel like that's the other BRET. There is the BRET that is dealing with all of this stuff in his life right now and it's all very mundane and typical and work-related and relationship-related and family-related and all these very simple things that everyone deals with. And it's a very simple life, too. So it's very weird to see that. But you get to a point where you're used to it and you realise that they're referencing something different from the mundane reality of that life. They are referencing BRET EASTON ELLIS, not BRET ELLIS, which is the name on all my cheque stubs. It's BRET EASTON ELLIS. They are referencing this thing that has been sometimes, over the years, great. And it suggests a whole litany of associations and references."

The more time you spend in his company, the more evident the delineation between BRET ELLIS and BRET EASTON ELLIS appears. As he is 45, you cannot help but think it must come as some relief to him. The showboating stuff of spectacular legend has been left behind at a New York party, just in the nick of time, before it descended into cliché; the human being allowed to prosper creatively in close proximity to his family at a computer screen in West Hollywood.

The mundane details of the life of BRET ELLIS turn out to be gratifyingly less dull than he implies. He can smoke his own salmon and makes gravadlax too, which he sometimes takes to his mother's house in Sherman Oaks, where he dines every Sunday evening with his family, just like an episode of the TV show BROTHERS & SISTERS. "Someone else said that to me, also," he says, momentarily alarmed enough to raise an eyebrow that the life of BRET ELLIS also sounds semi-fictitious.

The moment passes.

"I should check that out."

He works in silence, though he confesses to switching on the TV at least once a day ("Oh, at least") and usually sets it to CNN, which he hates. "I've been going through a lot of work, I've had a lot to do and I've been quite stressed about it. Having CNN on doesn't help the cause at all. It's just so dramatic. They have the most dramatic music. The CNN theme is so menacing. And you find yourself in some relentless adventure movie. And then what shouldn't even be news is news. A private plane with no one remotely known crashes some place and you see the coverage of it for an hour. And then people are dead in the plane and there's all this smoke and people are upset and it sometimes lasts forever, you know? Literally, you can look up from your desk and watch that for 40 minutes. It is like watching a film to see how it ends."

If he has trouble finding the inspiration to write, which he does sometimes, he will go to the gym, see a movie or go to a museum. For breakfast this morning he ate a seeded waffle. "And an Asian apple-pear, which sounds fancy, but isn't here in LA." He says he finds it difficult to bring in the grocery shopping under $70 or $80, and does it twice a week. A trip to the grocery store can incur the feelings of isolation implicit to his new life in LA. "You have to make a list of things you have to get. And then you have to find your car, get in your car, drive some place, get your stuff and come back to your place. It's how this city is built, geographically. It's not people friendly. You're not walking the streets and meeting people or bumping into a friend in Union Square. You are alone a lot. You are not confronted with people and with humanity every time that you step out of the house. This is a very quiet town."

Do you sleep well at night?

"Yes. Well, sometimes better. Well, not. Are you asking me 'Do I have problems sleeping?'"

No, I'm asking you if you generally get a good night's sleep.

"No. Not. Generally I do not sleep well. Generally I tend to fall asleep all right but I don't stay asleep. And if I wake up I have to take something. So, um, no. But last night was okay."

He seems a little agitated by this talk of sleep.

"Do I get up early? Well, if someone has stayed over then I'm up early. Do I like mornings? If someone has stayed over then I like mornings. But I don't know. It's very strange being a writer and working from your place. Increasingly, since a lot of the business is done by phone or e-mail or whatever, it is a very solitary existence. Even if you're in a relationship, it still is a very solitary thing to do and to do well. It's just the nature of it."

His favoured method of communication is text messaging and he doesn't worry if the phone doesn't ring. If isolation is a feature of his life, then he doesn't necessarily seem unhappy about it. He doesn't know whether he prefers to be in or out of relationships. "It's a case-by-case scenario." He makes no allusion

whatsoever to being in one during our conversation and, besides, as he says, "We're all ultimately alone, aren't we?" — an emotional rallying cry known mostly to the childless and one possibly magnified by LA.

BRET ELLIS says he moved to LA because "it just seemed like the party was over" in New York, the city he had lived in for most of his professional and adult life. There was not a specific moment that the party ended. "No, no, it wasn't like that at all." But it finished, nevertheless. "I was very tired of the lit world. Of book parties. Of literary gossip. I'd been visiting LA a lot. It wasn't dramatic. Just that the more time I spent here the more it seemed like I should be here. It was more a general feeling of: 'Let's try this out.' That is all. The party ends for everybody after a while. You just don't want to go to parties. You're tired of the place you live in. It's kind of a vague malaise, I guess."

BRET ELLIS is not a fan of social-networking sites. He has been "caught out" by someone on a dating site, though understandably doesn't care to flesh out that story. He won't try it again. He is, however — and on this subject he is highly animated — a huge fan of MTV's scripted reality series of the young and the monied in LA, THE HILLS. "I think THE HILLS is the greatest show that I have ever seen in my life," he says, sincerely. "It is a modern masterpiece. I think that ADAM DiVELLO is a mad genius. He creates it and controls it perfectly." Mr. ELLIS is very specific about the way he watches THE HILLS. "I'm holding off on Season 4 right now. I started watching a bit of it, but I'm waiting until the DVD comes out because I want to see it all so beautifully mastered. Even if you download the show there is that irritating MTV logo in the corner. It doesn't work for me that way. It has to be on a big screen with the sound right up. It blows me away."

BRET ELLIS likes reality as a genre. "I do not consider myself above that medium." BRET EASTON ELLIS presciently foresaw its rage across the main-stream in GLAMORAMA, when the protagonist imagined himself to be followed around by a film crew, all day and all night. Like many master fictionalists, he understands that at its best, reality can function as a new way of telling a story and can alight upon truths that fiction can only dream of, because it is a composite of design and accident, pre-meditated thought and physical impulse. He likes the alpha-male British celebrity chef GORDON RAMSAY, though sometimes gets annoyed by hearing the scriptwriter's voice in Mr. RAMSAY's televised narra-tive. "But THE HILLS is the first one that really does something new. It's scripted reality, unapologetically presenting itself, then breaking the fourth wall by having these characters interacting with the real world in a way that's completely created. Whenever HEIDI and SPENCER are looking at a house with a realtor in Malibu that costs $17 million, the people telling them to do that know that it is going to

be all over the place for a 48-hour cycle. People will obsess about that thing. HEIDI and SPENCER go to DISNEYLAND? They're dressed for it. He's wearing his NRA T-shirt so you know he votes Republican. I'm sorry, but whoever invented HEIDI MONTAG and SPENCER PRATT are just... nothing matches it. I've never seen LA look more beautiful in a work of art. There are no movies that are as beautiful as that and there are certainly none that understand the beauty and the isolation of this city better."

The line between the myth and the reality comes up time and again with BRET ELLIS. He talks of reading other authors' memoirs and his mixed feelings on them. "The best things that JOHN CHEEVER ever wrote were not the short stories or the fiction. His published journals were breathtakingly well written. Their quality is so much stronger than the fiction. To a lesser degree you get someone like CHRISTOPHER ISHERWOOD, who was famous for his journals, but those make you think: 'Hmmm, I don't know whether this is a good idea?' That really does alter your perception of the man and I'm not sure that that's really the perception that I want."

Because he's so much rougher in them?

"Yes." He thinks about this for a moment. "I don't know that this is about pleasantness or anything like that. There is a mystery to writers and to novels. And there is a part of me, which I guess is very old fashioned, that likes that. I like to look at the art and not at the artist. I guess everyone likes to look at the artists and everyone wants to know about their love lives and if they were nice or if they were mean, but what that also threatens to do is to alter your perception of their work. It can take away some of the mystery that was the power of their work."

Perhaps this is where BRET EASTON ELLIS comes in. BRET ELLIS would not describe himself as a happy man.

"Is that the goal, to be happy?"

Well, is it?

"What is happy? I mean, what is it? I think that aiming for not going crazy... that's the aim. In a world that's really quite brutal and chaotic and that's so difficult to navigate just as a person, happiness is just an added pressure."

Is there an alternative way of thinking about this, that everyone is basically crazy and just getting on with life under those circumstances?

"Well, that's what I'm thinking. Purpose of life? That makes me think: 'What?' Once you make peace with the what-the-hell-are-we-doing-here thing, it can go either way. You can either go 'Okay, I'm at peace with it,' or it can drive you even more crazy. So, yeah. It's just not something that I can be concerned with."

It's all too grand to condense?

"Yes."

Is life controlling your own craziness? That's a very modern way of thinking about it.

"Controlling it? Or displaying it? Our society is such an exhibitionistic culture in which people display so eagerly their insanity. Just as long as people are interested in us, life is not about what we do. That's what is so coursening about celebrity culture. And I can't believe that I am complaining about this still."

I tell BRET ELLIS that I met BRET EASTON ELLIS once before. I interviewed him for a British newspaper ten years ago, during his whirlwind book tour for GLAMORAMA, a part of his life that would end up fictionalised as the first episode of LUNAR PARK. I was deeply impressed by the force of nature seated opposite me in a London hotel. The interview was not so much a case of question-and-answer as it was wind-him-up-and-watch-him-go. He cascaded monologue after monologue, brimmed with overt self-confidence. He was flirtatious, cheeky and louche. He was nicely plump then and prone to extravagant gesture. He was wearing a suit and tie and had two fixed expressions: delirious happiness and total fear.

The reason I remember the encounter so vividly was not only my fondness at meeting for the first time an erudite and brilliant man of words talking about his own purpose, but also because a question came to me out of nowhere that I normally wouldn't ask a relative stranger in the interview process. I said: "Have you ever thought about suicide?" and he tossed his hair back, laughed aloud and replied on the upstroke, "Have I ever not?" before ordering another drink. At the time, the distinction between the life and work of BRET EASTON ELLIS and the significance of his middle name was alien to me.

In the intervening decade, BRET ELLIS has had a lot of therapy. His most intense work was with a strict Freudian, female shrink in New York. He is not currently in therapy. He finished in April, 2008.

With his New York therapist, he kept a diary of his dreams and realised that his dream life followed a continuum similar to his actual life and bore a startling similarity to his fiction writing. "I had a lot of anxiety and a lot of stress and we knew exactly what those things were but not why they would drive me so crazy. She was trying to remove me from those anxieties and fears and so part of my therapy was to keep a dream journal. I was very diligent about it. So the moment I woke up I scrawled them all down and later on I would type it all up.

I realised after about 30 entries that I was writing a novel. Why did I keep on going back to Nevada? Why was I in an auditorium full of black people? And what was that leopard doing? It came back three nights later and I was a different person. But the *same* different person. The stuff that would've faded from memory maybe half an hour after waking up was now committed to paper. We finally

did figure a couple of things out. Ultimately it was sort of therapeutic. But it was very interesting on a creative level because it made me understand that you are dreaming another life."

Mr. ELLIS says that he prefers therapy to medication. "Therapy is more interesting than medication, definitely." And then later: "America is overmedicated. Whatever I feel about that, I dealt with in LUNAR PARK. I don't know about the Western world and our need for a quick fix. Maybe this is just how we are?" In his last two novels, Mr. ELLIS' work has become more audacious and unhinged, his storytelling has swung into magic-realism, fantasy and horror to accompany the hard documentary realism that was once his signature. Just as he judges his life to be more mundane, his fiction has entered the realm of limitless possibility.

I ask if anything has changed in the last ten years, since he quipped about suicide in a fun interview to promote a book. He pauses generously when confronted by the semi-fictional character that he becomes to play out his public life. "It's funny that I said that. God."

There is another long pause.

"Okay. Honestly? No. Do I think about death a lot? The release of death? That takes you out of all the pressures of... whatever? Yes. But I don't think about self-annihilation. No."

When it comes to the hard thinking, there is a sense with BRET ELLIS that perhaps having a near alter ego to bridge the gulf between his fantasy and his reality is not so much blight as blessing. For a second he becomes BRET EASTON ELLIS: "And you know what? You're always thinking about suicide on a book tour." He laughs at the proclamation. It sounds just the same as the laugh he let out a decade ago only, somehow, more soulful.

Mr.
OLIVIER ZAHM

Featured in issue n° 4 for Autumn and Winter 2006
Portraits by Juergen Teller

It was entirely JUERGEN TELLER's idea to photograph OLIVIER ZAHM for FANTASTIC MAN issue n° 4 wearing only underwear, boots and a gold watch. An unforgiving premise, perhaps, for which Paris-born OLIVIER prepared himself with a rigorous programme of diet and exercise.

OLIVIER has always relished a challenge, though. In 1990 he co-founded PURPLE magazine with ELEIN FLEISS. A small-format publication, it had the mission, according to ZAHM, "of defining creativity, of taking a stand against a society increasingly typified by the extreme violence implicit in unbridled worship of money." The magazine, which included literature, poetry and cultural critique alongside fashion and erotica, has spawned various offshoots over the past 25 years, most significantly PURPLE FASHION which OLIVIER now edits and publishes. A couple of years after he was featured in FANTASTIC MAN, OLIVIER started the blog PURPLE DIARY, of which he is the indubitable star. He also exhibits his own photographs.

In the 2006 interview that accompanied those splendid shots by JUERGEN, OLIVIER sought to address the potential conflict between his various cultural and commercial interests at the time. He admitted to finding himself in a potentially ambiguous position. "Art has been appropriated by corporations since the 1980s. But then, whatever we develop at PURPLE is so quickly appropriated by capitalist culture, which is totally schizophrenic. PURPLE is extremely symptomatic of the schizophrenia present in modern culture. My life is as well."

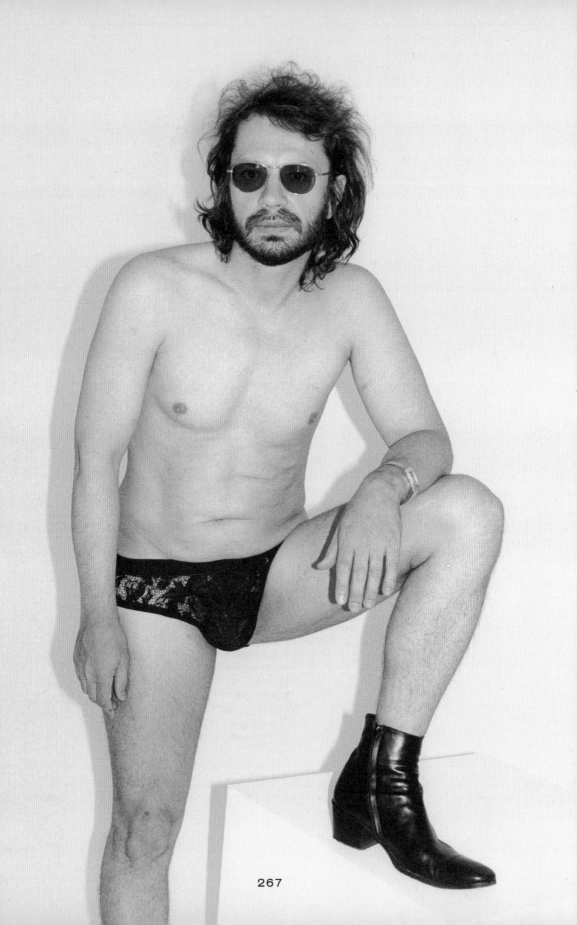

267

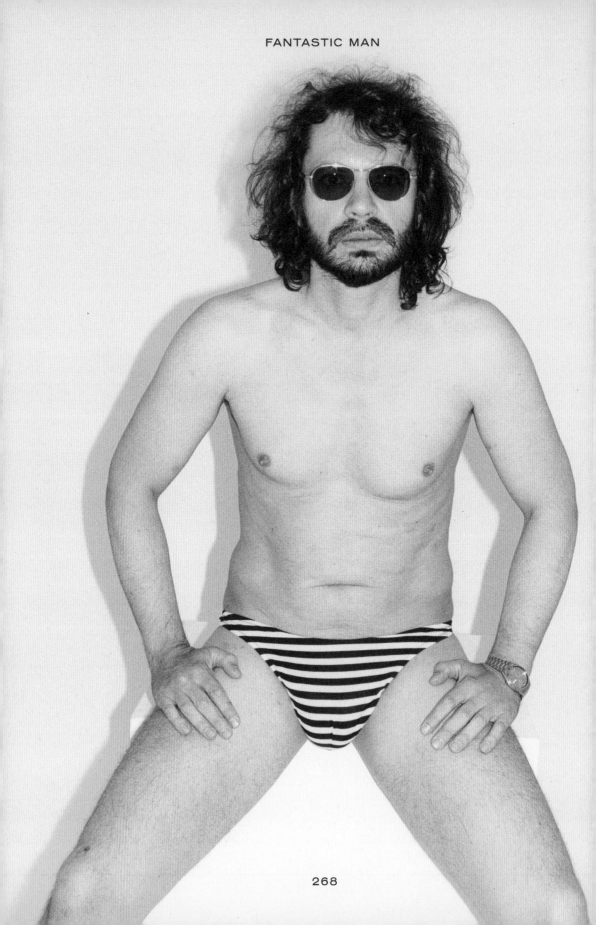

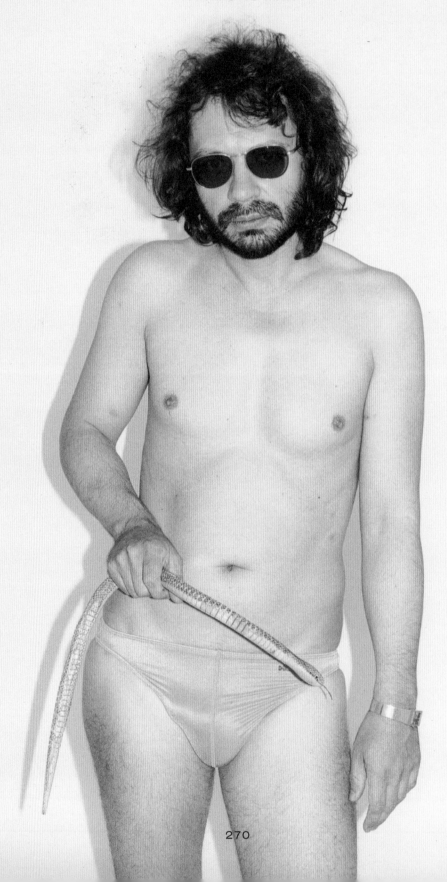

Mr. MALCOLM McLAREN
Featured in issue nº 1 for Spring and Summer 2005
Portrait by Slavica Ziener
Interview by Jop van Bennekom & Gert Jonkers

Mr. McLAREN

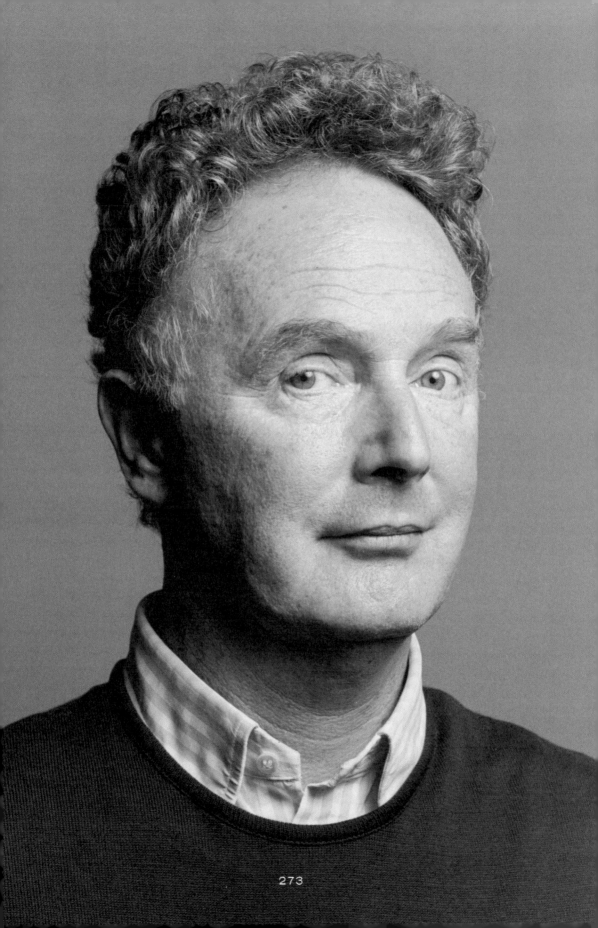

MALCOLM McLAREN is really happy to talk about just about everything, from SUSAN SONTAG, punk, and holidays on St. Barth's to VIVIENNE WESTWOOD, setting light to Goldsmiths College's library, and where to buy the perfect suit. Mr. McLAREN and his girlfriend YOUNG currently call Paris "home", but they'll be heading to LA soon to get involved in the film biz again; it's all very hush-hush, but it may have something to do with his possible participation in a film based upon the best-selling FAST FOOD NATION. Being in MALCOLM's company is a truly delightful experience — listening, laughing, dozing off and waking up again in the midst of another wicked MALCOLM McMONOLOGUE...

Where did you learn the art of talking?
In LA. Actually, HOLLYWOOD.
HOLLYWOOD teaches you to tell
stories as succinctly, quickly and
efficiently as possible because out there
they don't have a long attention span. If
the story lasts longer than five minutes,
you're gone. Forget about it. They're
taking another call. That's where I really
learned. Also, I went on this massive
lecture tour in the Far East at the end of
the '80s, for six months. Stretching from
New Zealand into Australia through
Malaysia and ending in Hong Kong;
talking about myself. Life and times. It
was called YESTERDAY, TODAY AND
TOMORROW, or something like that. It
was really freaky because I had to talk in
front of two thousand people in huge
spaces like opera houses and big concert
venues. Imagine a big fucking stage and
you walk on and all that's there is a
lonely little microphone. And you look
into the audience and you see nothing
because it's pitch black, you're looking
into this giant black hole. You can hear
all these shuffling feet and mumbles and
grumbles but you can't see anyone.
Everyone is looking at you. I had to
speak for two-and-a-half hours. I mean,
it was this whole show and people were
paying $40 for it. I came back after half
a year with a packet of money. I don't
know what happened after that. I just
hung around Paris, went back to London,
New York. But I never got back to
LA. After I split up with VIVIENNE
WESTWOOD, I went to Hollywood in
1983 or 1984. After fourteen years with
her I thought I'd served well. Part of the
reason I went to Hollywood was to get as
far away as I could. I managed to get a
job with SPIELBERG and COLUMBIA
and hung out for four years or so. That

was my tenure in LA. And now YOUNG
and I are going back, getting back
involved in the movie biz. We have our
eye on this condo in Venice one street
off the beach. It's the best air in town,
down in Venice. The air's shit in LA and
the light is harsh. It's almost like there is
a hole in the sky. You are permanently
wearing sunglasses. Down in Venice the
light's a little softer. And there's a sea
breeze blowing all the shit away, and you
can walk. It's the only part of LA where
you can walk. You don't have to drive
to get a pint of milk. Bit of a clamber up
the motorway to Hollywood if you are
doing business or to Bev' Hills. But it's a
nice area. Living in LA, people don't
talk to you. People spend so much time
in cars they don't know how to commu-
nicate. Venice is more of a community.
People talk to you. It's a cooler place.
You don't have the space there and you
won't get very big apartments. It's quite
small. The houses are quite small. I don't
mind. I don't need a big space as long as
I can get a decent studio. All the houses
I've lived in in LA have a history that's
full of tragedy. They all have weird
vibes. Someone killed themselves... who
knows? The houses are kind of haunted.
That whole LA area has been built on
ancient Indian burial grounds. I don't
know what it is but it has a whole bad
karma to it. Generally speaking, it's a
little weird. I'm not superstitious in any
way. I used to know this guy whose
name was LOUIS BLUE FEATHER and
he was a Cree Indian and he worked with
the Bureau of Indian Affairs that goes
back to the Indian Treaties in the 19th
century. They basically manage and
protect as much of the Indian burial
grounds as possible. When you drive
around LA, especially in the West

Hollywood area, there are what look like debris sites where massive apartment complexes are about to go up. But they are not debris sites. They are ancient Indian burial grounds that the Bureau of Indian Affairs is trying to protect. These guys just spend their lives watching, campaigning, trying to hold on, blah blah blah. The film industry is a very peculiar business. People are elevated to the top and then dropped to the bottom. A lot of people go to HOLLYWOOD as a last resort. They go there to reinvent themselves or to start anew. HOLLYWOOD was, and still is, a business that trades on dreams. They buy other people's dreams, whatever they might be: making a movie or being an actress. It's the only town that you can sell ideas. Name me any place on earth where you can sell ideas. It's very difficult to sell an idea. But HOLLYWOOD trades them. It's the attraction, especially for creative people, who have ideas and want to see them manifested in something. So it attracts a very strange group of people who are dreamers. And the road they travel in HOLLYWOOD is filled with tracks and lots of hazards. So many problems are created, so much tragedy. And there's nothing worse than somebody's dreams being crushed. It might be called "the city of angels" but it's really the city of crushed dreams.

Will you keep your house in Paris when you move to LA?
Sure. Actually I just got this place. I like it a lot. It's newly built. It could be anywhere. It doesn't look French at all. It could be Munich, it could be NYC. It's three floors. I like it. I like to escape. I like different floors. I like to jump

away. And this is the perfect place for that. It's enough to walk around and soak Paris up without having to be part of the woodwork. This apartment looks like nothing, which is okay. I like it for that. We went to see so many houses, all with their screechy floors. You don't know who's been there. They're full of ghosts. This whole town is full of ghosts. Paris is a very strange place. It reveals things to you once you are deeply entrenched within it. Sooner or later you become part of it. It becomes hard to rise out of it. You tend to forget what is happening everywhere else. Maybe Paris was fun in the '60s and the early '70s. It's a bit boring now.

What is your fascination with Paris?
It was fashion that first took me here. In the '70s when I started my stores on King's Road, the really cool clientele was French. I don't know why. The French always bought things with such a commitment, not just a pair of socks. They always chose something that was big and cool. I had connections through all those clients some of whom were budding fashion designers. I met REI KAWAKUBO that way and YOHJI YAMAMOTO, LAGERFELD... They all drifted through the shop. I had no fucking idea who they were. I didn't have a background in fashion in that way. But after a while I got to know them. And that brought me to Paris more often than not. Actually, when it comes to the SEX PISTOLS, Paris was their fourth or fifth gig. This was before they were even known. In fact, when I made the first pair of bondage trousers with VIVIENNE, I made them for JOHNNY ROTTEN to wear on stage here. The whole bondage suit was unveiled right

here in Paris at the CHALET DU LAC which was some crazy little folly in the Bois de Vincennes. And cross-legged on the floor in the front row were KENZO, KARL, CASTELBAJAC, YVES... They were all there. First and only gig in Paris.

YVES SAINT LAURENT sat cross-legged on the floor at a SEX PISTOLS' gig?

It was fantastic. It was great. Another reason I ended up in Paris was that I had to escape England on account of the SEX PISTOLS trial. My case didn't look good. It wasn't going well. We weren't losing terribly, but we weren't winning. And it looked like the black clouds were descending towards the end. It was a long trial. There were two weeks or more to go and I decided it was better to quit before the verdict. So I arrived at the bank at 10.00 in the morning on Oxford Street. I didn't tell VIVIENNE, I didn't tell my office. I just went in with my passport and withdrew £50,000. In those days you weren't allowed to carry more than £50 out of the country. So I sat in this taxi trying to find every possible pocket to put money in. I just wanted to slap it all over my body. I was putting it in my socks, between my shoe and my foot, all around my knickers. I had wads all around my belt and in my inside pockets and in my shirt pockets and in my belly, in my sleeve. Just everywhere. I was a walking fucking pound note, a capitalist-terrorist that escaped to Paris. And I arrived at the airport and it was at that period in time that they started those crazy electronic machines. I think it was due to IRA terrorism. So anyway I go through, but they were much looser than they are today. And there was this guy standing on the side and since my face

had been on the front page for weeks and weeks and weeks I was instantly recognisable. So this guy said, "Mister MALCOLM McLAREN?" And I said, "That's me. I've got to catch that Paris flight." And he said, "Straight through Mr. McLAREN, don't worry about it. No problem. Straight through." So thank god I didn't have to go through that metal detector, since every pound note has a thin sliver of metal in it, I would go off like a fucking... I was going to explode! And I was terrified. I thought, "I'm going to die in one of these machines. I'm going fry." What a way to end! I finally got onto the plane, it took off immediately and I had to go into the toilet and unload all the cash. When I arrived in Paris, the verdict was in. The banks had been frozen, the office had been closed down. The police confiscated everything. I had just escaped. So Paris became a second home in that respect. This was 1979. I hung around in Paris for quite some time. I loved to go to the Beaubourg library. I was fascinated by the librarians. I would listen to all kinds of ethnic music in the library. I knew this guy who was working for this little funky record company called BARCLAY. In his spare time he made all these pornographic films, which were doing a roaring business. And he said, "Okay MALCOLM, you put the music together." So my job was to find music that nobody had to pay for. Some Polish classical orchestra or Russian waltzes recorded in Moscow or something from Bonga Bonga land. So I did that for three or four months and I discovered all these African beats that I thought were brilliant, especially when you speeded them up. So, at that point VIVIENNE

was constantly calling me from London telling me to come back. So I came back to London with this idea of doing something tribal. I wanted to get away from this nihilistic look, this razor's edge, dark, punk rock look. I wanted something ethnic, diverse and colourful. I'd been looking at all these record covers from Africa in the library. And I literally gave this idea to ADAM AND THE ANTS, and that began. And then so did BOW WOW WOW. And with VIVIENNE I worked on the clothing and the collections. And that's how the tribal idea and the whole pirate look started to develop out of Paris. So Paris has been good to me in this regard. I've been drawn to it in a strange way. After that I didn't come to Paris for a while. Paris wasn't a very stylish city back then. I don't think Parisians ever look very good really. They have all these old ladies walking around in fur coats and everything. And they tend to have this typical Parisian chic. It's all stuffy and very old fashioned. It's terribly bour- geois and very safe. And the only people who really have style in Paris are people who've been imported to Paris. Ger- mans, Australians, whatever. Not many French people themselves. That's rare, in my experience. I've never found any of them very attractive. They tend to be second hand, they are never on it when you should be on it, they are always on it two years later. Perhaps that wasn't the case in the dawn of the '60s, when Paris was leading Europe in music. But that music was created by black American musicians who couldn't play in America on account of their race. So they found harbour here and created a scene inadvertently. And young people flocked to it and the look of that music became

a style: better known as that Bohemian, black polo neck, existential kind of look. All of that. Paris did invent that look and that look did ultimately become a European rock and roll look exhibited by THE BEATLES and THE ROLLING STONES, and so on. But that's the only look Paris ever created. There's never been another look. When I was here making my album, PARIS, in the dawn of the '90s, there was a kind of mini-re- vival of that period, a softer jazz. Lounge music, as it became known, was a definite style that came out of Paris. That emerged while I was making PARIS. And it kicked off with AIR a year or so later. But lounge music never had a look. The look that emerged in the '60s was a distinctly European look as opposed to an American look. It was intellectual, philosophical in its leaning. It required the notion that boredom could be an interesting proposition, which is some- thing that Americans could never pick up on. So Paris made boredom a look. Like what we did with punk. You basically dressed an army of disenfran- chised youth. You basically created this beautiful image of disarming failure. Punk wasn't about career and fitting in. It was about the exact opposite.

Did you dress like a punk yourself?
I did. But when I went to Hollywood I changed. In Hollywood I got really into surfing and I would wear surfing shorts. Or actually I'd buy COMME DES GARÇONS and cut the bottoms off and throw them away after a season. I don't like keeping clothes. You have to reinvent yourself. Clothes don't last. But of course suits last. But you get bored with them. And you don't feel very fresh. And you're not a banker.

You want to look fresh. I've never been one for keeping clothes. Even with VIVIENNE in the shop I'd be changing clothes all the time.

Where do you buy your clothes in Paris?
It's not easy. I suppose I shop where everyone else does. MARTIN MARGIELA for trousers, or a sweater or two. Actually the MARGIELA trousers are nice, very nicely cut; a very 19th century incroyable mixed with a stovepipe. They are a marriage of the two. They have no waistband. Even if you are a little plump, MARGIELA's trousers make you look quite elegant. They are good cut. I don't like trousers if they're too wide. I like the stovepipe shape which is a straight cut. The thing with MARGIELA is that you have to stay with dark colours because he doesn't do bright colours and sometimes I feel like a bright colour. And then I buy things from a shop window. Like in Milano or wherever I find myself. I buy suits from a French tailor up the road called ARNYS. They make kind of anonymous suits. A little boxy. I try to buy them long. Luckily they do different lengths. They are very tailored because they are driven to accommodate different heights. If you buy them long, they tend to have a little more elegance. I like to go to a tailor. I never bought, for instance, a KENZO or a DIOR suit. I kind of like the anonymity of a tailor's suit. When you reach a certain age, as you get older, it's much better to look more anonymous. I don't know why. It feels more comfortable not to strut around like a peacock. ARNYS is a bit French-dandyish. That's the part I don't like, that dandy look. Otherwise they are very nicely made and they use nice cloth.

They are not brilliant cuts, so you have to compromise. They're not that expensive. Between 1,200 and 1,800 euros. 2,000 euros, maybe, maximum. It depends on the cloth. The shoulder is the most important part of the suit. The better suits have the shoulder put in by hand. It's not so square. I like it sloped and rounded. Square is good on a young figure. But on an old figure, square doesn't work well. You need a suit that goes with the flow, not a straight jacket. To get something right you have to go to SAVILE ROW. But the problem with all those guys on SAVILE ROW is they never make you what you want, they make you what *they* want. You have to fit into their style. Each individual tailor has his own cut and he won't change his cut under any circumstances. And you think it's bespoke, but it's only bespoke to them. They only do regular suits. That's the problem with SAVILE ROW, so you have to find what's called a showbiz tailor. A showbiz tailor will listen to you because in his mind he's making a suit for showbiz.

What's the difference between French and British tailoring?
French is closer to Italian but not as well fitting in the trousers. Italians are excellent in trousers. But they are not so great in jackets. In Italian cuts, the jackets are a little dodgy. And the French are not so great in jackets. For some reason the English make a great jacket. The English usually use Ireland for manufacturing purposes. The Irish still make a semi-bespoke jacket. Ireland kept this artisan spirit going. And that's where most of the clothes in England were made up until ten years ago. That's gone too. I was there at the tail end of it. I think

more or less everything's made in China or in Italy. Nothing's made anywhere else. It's not a satisfactory situation by any stretch of the imagination.

Why have you never written the definitive MALCOLM McLAREN book?
There isn't a book per se. My former secretary put one out. Then there's ENGLAND'S DREAMING, by JON SAVAGE. It's a well-researched book. That's my next project, the MALCOLM McLAREN book. I'm going to put it together with an editor in Berlin, this summer actually. And you know what? If you make a book like that you have to tell it all. There are all these untold and unrevealed stories. When I was 17 or 18 and a student at Gold-smiths, I used to steal books from the library and sell them at Charing Cross Road for a pittance. Eventually the college brought the police in because all these books were disappearing all the time. And I was so concerned. They were getting close to nabbing me. I was good, but not good enough. And like lunatics we decided the best thing to do is to burn the library down so there would be no fingerprints. We thought... let's burn it down. And that's what we did. We burnt down the Goldsmiths College library.

And this is one of the stories that are going to be in the book?
You have to tell all. Or nothing at all.

But is it true?
I'm afraid so. But with good cause. And hey man, I set up punk rock and the King's Road shops. It wouldn't have happened otherwise. All things that appear to be uncool turn out to be cool.

Did you finish Goldsmiths?
Well, yeah. I came out of art school in the mid '60s. I think in those days art school was a place where you were never to consider that you were going to have a career. The word was anathema back then. The philosophy in the '60s was to create an adventure, you had to create an adventure and the adventure was based on an understanding of fearlessness. The attempt to change life and break rules; change the culture. And you were delivered lectures on how it was better to be a failure, a magnificent failure, rather than any kind of benign success. Because failure taught you to understand the continuing saga of a never-ending journey where you're always getting it wrong on the way to trying to get it right. That's how they always understood an artist's role in life; that was the framing of most students in those days. I was totally framed by that. It was totally different to my middle-class existence. In the evening I'd to go back to my middle-class household and there'd be my family manufacturing cheap copies of the latest fashions. My family owned a dress factory, my grandfather was chief tailor and I was brought up surrounded by fashion from the age of five. I was coated with com-merce and design. But commerce first. My grandmother came from a very middle-class family. She was the rich one. The mother of my mother. She was this little strange Jewish-Portu-guese-Dutch lady. She brought me up because my mother got married when she was 16 and had me, believe it or not, when she was 18. My grandfather made suits for the stars. In those days stars were, like, boxers. Wrestlers. He would make these suits privately to make

money. He was a cutter in a big factory but he also had private clients. I learned a lot from him. I was surrounded by fashion; the latest cheap fashions; DIOR pared down a bit. Everything pared down a bit; real rag trade.

Do you actually find life boring?
No. Not at all.

Do you enjoy it?
Do I enjoy life? Of course. I tell you, I went to SUSAN SONTAG's funeral. Incredible. Incredible. Do you remember SUSAN SONTAG? She died during Christmas and she was buried in Montparnasse. The whole literary world turned out, from London, New York and so on. And it was amazing. To get buried in Montparnasse is not an easy job. It's not a big cemetery. There's no space. They must have dug someone up who was less illustrious and sent him off to the suburbs. Maybe a lesser-known poet from the 19th century. She had his grave that was right bang in the middle, round the corner from her was SAMUEL BECKETT. To the left was SERGE GAINSBOURG. And I thought, "She's got the best seat in the house!" It was quite extraordinary. But when you left this cemetery, you definitely preferred to be alive. It's like what BALZAC said—he used to go for walks in cemeteries and it would cheer him up. He'd walk around Père-Lachaise then go for a nice big lunch. I had a great, great, great Christmas holiday in St. Barth's myself. St. Barth's is a fantastic place. What I would call a very decadent, dilettante holiday destination. Between Christmas Eve and New Year's Eve it's just one big party after another where the rich can fondle and do whatever they do to each

other any time of day, because there is nobody to take notice. There's no paparazzi! Everyone is really discreet. There are hardly any police on the island. It's very festive. It's terrific. It's really a fun, fun, fun, thing. By 2nd January everybody's shipped back to where they came from. So after that you can have a very chilled-out holiday. One good thing about the French is that they make everything French wherever they go and they do it much better than anyone else does. You go to the equivalent English island and it's all kind of rough and the food is naff and the native islanders hate them. So you get a lot of angry islanders who were once African slaves and they haven't forgiven the English. But in St. Barth's you have nothing but the French because it was a desert island and nothing could grow on it. The soil wasn't good. It doesn't have that bad vibe. It has tiny little beaches, very particular, very sharp. I saw GIORGIO ARMANI scrambling across the rocks to literally get to a beach. Suddenly, out of the blue, who appears, but a DURAN DURAN-y. NICK RHODES, still covered in eyeliner and make-up, I thought, "Quite a feat in this heat to do that. 88 degrees. Does he think there's paparazzi?" He looked like he was ready to go on stage with DURAN DURAN. I couldn't believe it. A little bit of a tum on him and a silent teenager in tow, who I assume was his daughter. And then on the beach—wow, technicolor!—this sheer naked crowd of exclusives. The rich and the famous, whoever they were. It was one of the best holidays ever.

Mr. LUCAS OSSENDRIJVER

Featured in issue n° 5 for Spring and Summer 2007

FANTASTIC MAN's editor and art director JOP VAN BENNEKOM has known LUCAS OSSENDRIJVER since the two were at Arnhem's art school together in their early twenties. At that point LUCAS was already absorbed by menswear. He was one of those rare people who leave education knowing exactly what they want to do. After graduation, LUCAS worked for several years at KENZO and then with HEDI SLIMANE at DIOR HOMME, before landing the job as the head of menswear at LANVIN in 2006.

Under his direction, LANVIN for men has become the fantastic force in fashion that it is today and one of the most influential menswear brands of the last ten years. Dutchmen are sometimes cruelly characterised as parsimonious — not a charge that could be levelled at LUCAS! The materials he sources for LANVIN are unusually lavish, with prices to match. For his shoot in FANTASTIC MAN, LUCAS was photographed strolling the streets of his adopted city, Paris. Appropriately for a man who's redefined Parisian chic, he appeared completely at home there.

Portrait by Daniel Riera

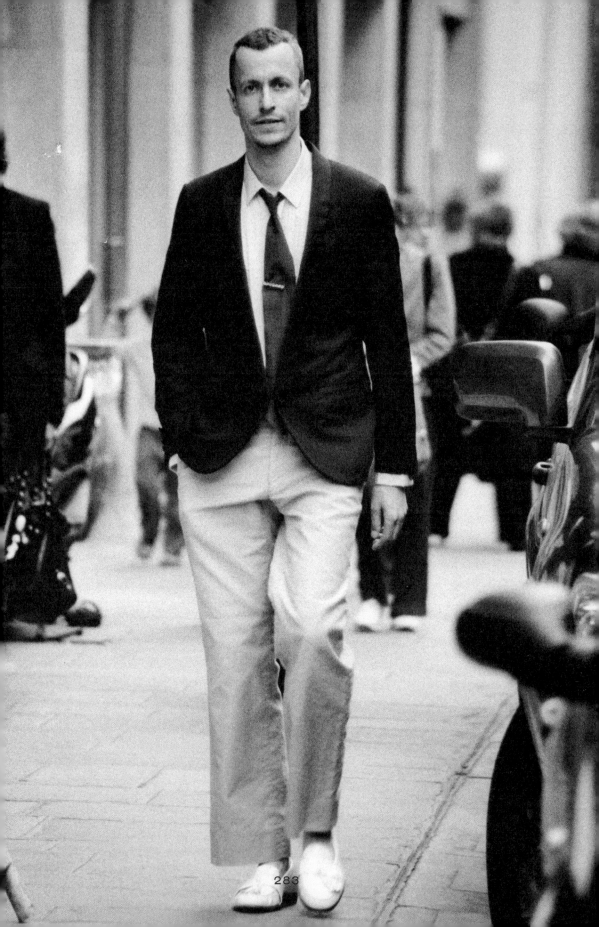

283

Mr. TOM FORD
Featured in issue nº 7 for Spring and Summer 2008
Portraits by Jeff Burton
Text by Stephen Todd

Mr.
TOM FORD

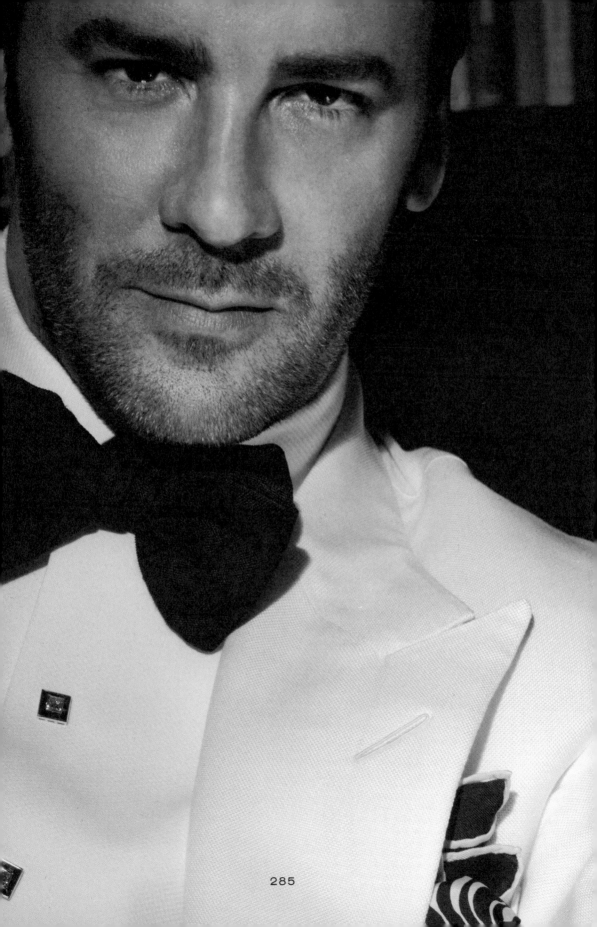

There was a time when TOM FORD claimed he'd never start a label under his own name. Since then, however, the magnetic Texan's priorities have clearly changed. After all, why bother sexing up yet another forgotten label when you can do it all for yourself? And so, in 2007, the TOM FORD label was born. An intriguing new hybrid of bespoke tailoring and classic ready-to-wear, his menswear line is only part of the story. With the new brand, the fragrance and the eyewear range all up and running, and with time racing on, the fantastic Mr. FORD is getting ready for a new addition to the family...

What do you wear to a meeting with TOM FORD? A slim-cut suit, style circa-1976? White flat-front slacks (yep, they'd have to be "slacks") and a dark turtleneck sweater? Stripper shorts? During his ten-year tenure as creative director of GUCCI, FORD was the ultimate "Man For All Seasons", every six months sending out signals about how men should — and inevitably would — dress to be at their (slightly retro, disco-sexy) best. TOM FORD's departure from GUCCI in 2004 left men the world over treading water until the recent launch of the menswear label bearing his own name, an all-encompassing collection that has put him back in the style stakes and somewhere near the top of his game.

 That is all well and good, but I am still left here in Paris, staring at my wardrobe, with a distinctly sinking feeling. The GUCCI jacket? No, too obvious. The YSL sweater? Too tricky — TOM's time as that house's creative director was not his most trouble-free. A MARC JACOBS suit? Wrong: JACOBS was TOM's boss at PERRY ELLIS in the late 1980s, and the two have never shown any overt sign of camaraderie. In the end I settle for my usual uniform of blue jeans (LEVI'S 501s — waist size and trouser length indicated on the hip tag so no need to try them on), white CALVIN KLEIN T-shirt (even TOM can't argue with that all-American classic) and a pair of handmade GUCCI shoes. The look I'm working — for those who haven't noticed — is one of effortless classic chic. If only there wasn't that white stain on my MARGIELA sweater, the one I noticed in the taxi on the way to the EUROSTAR, by which time it's too late to return home and too cold to take the damn thing off. Effortless, that's me...

TOM FORD's London headquarters is in a red-brick Georgian building on the King's Road, Chelsea. The very area where, as FORD was hitting puberty in small-town Texas in the early '70s, London's newly nascent punks were roaming the streets, looking for trouble and the latest VIVIENNE WESTWOOD rip-torn porno-print T-shirt. "I would have been about 12 at that time," remembers FORD. "I would have been wearing flared pants, moccasins, beads. I was very much wrapped up in the post-hippy moment. I was not the world's most athletic thing, I didn't play American football, so I wasn't so popular." But then a funny thing happened on the way to adolescence. "At 14 or 15 all of a sudden I became *very* popular because — and I'm not saying this in an egotistical way — I became good looking. I wasn't even aware of it but other people were all of a sudden aware that I was handsome. I was having sex with girls when I was 14, and that was because they were pouncing on me. I wasn't even aware that I preferred men. It felt good, and it all worked and I was like, 'Okay, this is great...' I started to realise that I was attractive and that I can work that."

Today TOM FORD is working it in grey fleck woollen trousers, patent black shoes and a black shirt unbuttoned to south of the sternum. At 46 years old, FORD is in remarkably good shape. He's trim, slightly tanned, his short hair receding in two perfect arcs that give him the high-forehead look of the intelligent. A look further enhanced by his aviator-shaped spectacles, the cross-bar of which seems perfectly calibrated to offset his trademark askew squint. The glasses are part of the eyewear collection that marked FORD's much-anticipated comeback in early 2007. "I remember when I started to do eyewear, people were like, 'Oh he's so weird. Why is he doing eyewear? What's that about?' But I of course knew that the revenues from the eyewear line would finance the fragrance, which would finance the rest. I had a master plan." That master plan involves the roll-out of some 18 menswear stores carrying his name around the world this year. Dubai, Qatar, Kuwait, Milan, Zurich, St. Moritz, São Paulo, two in Moscow... "You know, everywhere. About 50 stores in the next two years." Except Paris. "Paris is not a priority. Our stuff is not aimed at tourists coming in and taking a lot home — and Parisian men don't know how to dress!"

That TOM FORD is able to arbitrate on Parisian men's lack of style (or that of Australian men living in Paris for that matter) is a given — FORD is the arche-typal global nomad. Sentences like the following roll effortlessly off his tongue: "We moved here — to London — in 1996, but we had a place in Paris from the time we moved to Milano in 1990." He says "Milano" like an Italian. "Quai de Conti" like a Parisian. Both with a baseline of Texan tenor, and with a tendency to dramatise with spoken italics.

The "we" in the above sentence is a reference to his long-term partner, journalist RICHARD BUCKLEY; the itinerary is a reflection of FORD's peripatetic

professional lifestyle. BUCKLEY's career seemed to take second seat to FORD's since, as BUCKLEY has often quipped, "I married well." FORD smiles wryly at the reflection. "Oh, he just *says* that 'cause he doesn't use... If he *cared* about such things... He doesn't *maximise* that. He's very much his own person. He does his *own* thing, has his *own* income. He could live *exactly* the same life without me." Multiple houses. An art collection with a value in the millions. You do the maths.

So what art does FORD own? "Oh *God,* don't ask me that," he squirms in his seat — not unbecomingly, it must be said. (I suspect "unbecoming" is not part of TOM FORD's repertoire.) "That's *pretentious."* But insist slightly and he'll admit, "I made a lot of money and have everything I ever wanted. So I have, I don't know, *fifteen* WARHOLS — and they're okay ones too. And I have all the classics: CALDER, FRANZ KLINE, MOTHERWELL... When I first made any money I bought things that were iconic to me growing up. It's only probably in the last ten years that I have started buying real contemporary art produced by my generation or younger. But I just buy things that *mean* something to me."

TOM FORD admits to reading a lot, but insists, "No, I wouldn't say I'm an intellectual. RICHARD's the intellectual. I think I'm *intelligent.* There's a differ-ence. I act intuitively." The books on his office shelves, he shrugs, are just "the basics. You have to have a JEAN-MICHEL FRANK book, a DUPRÉ-LAFON book, the ROULMANN book. I mean, I use them all the time. DUPRÉ-LAFON is probably somebody I've knocked off more than just about anybody in the whole world. For my shop interiors, for my house..."

How many houses does he own? "Oh *God,* I don't even know, I have to think. I'm *serious* — I really don't, 'cause there used to be more. I live in London, I have a house in Los Angeles. I have a house in Santa Fe. An hour from there I have a very large ranch. I have a house in Texas, so I only have five."

FORD's determination to appear unpretentious is the foil to an evident pride in his incredible success. Born to a couple of middle-class Texan real-estate agents in 1961, his life is a parable: that of the Great American Achiever, the ordinary guy done good — and looking damn sexy while doing it. His career in fashion began almost by accident: while he was studying architecture at Parsons in Paris, a friend left her internship at CHLOÉ and offered the post to TOM. He thought he would do it as a summer job. But while the position consisted of "just sending shoes out all day to magazine shoots, I thought, 'What a great, cool business,' and one much more suitable to my frivolous personality than architecture was." After completing his undergraduate architecture studies, FORD put together a portfolio of fashion sketches and "started banging on everybody's door."

He landed a job with New York designer CATHY HARDWICK in 1986, and then moved on to PERRY ELLIS. In 1990 FORD was hired by GUCCI's

influential creative director DAWN MELLO as head women's ready-to-wear designer, and when the house was acquired by Bahrain-based INVESTCORP in 1994, he was named creative director. A star was born and a new era in highly sexualized fashion had begun.

Today FORD travels extensively house to house, meeting to meeting, store to potential store, but the constant movement is laughed off as just a slightly crazier version of an everyday working man's life. A supersonic BOY'S OWN story. In the two weeks preceding our meeting, by his own estimation, TOM FORD had been to "Los Angeles, New York, London, Milan and Moscow. After Moscow I came back to London for one day, I went to New York for two days and I just came back." Does RICHARD travel with him? "Most of the time. He didn't come to Moscow with me, because it was just for 24 hours. So he went to New York instead. We were together in California the day before, so we split for a day and met back in London."

Clearly FORD thrives on the Olympiad pace. He insists he does not miss the GUCCI days, "having to design 16 collections a year and make a lot of silly stuff I really didn't care about." He says, "leaving GUCCI taught me a lot about who is a real friend and who is a friend for business. Even though no one would know that because I never said, 'You're an asshole,' but in my mind I filed them away. Click." He is equally adamant about the positive aspect of his own new brand. "These days are great," he smiles, as I sip on my second vodka tonic at around 5pm. ("I already had two before you came here. We start cocktail hour rather early...") "I am in a unique and wonderful position in that I am just starting. So right now I am able to put in only the things that I really believe in."

What FORD seems to believe in is a certain suave masculinity, infused with a heady sense of mid-'70s chic. Like his art collecting, his fashion sense seems to be about "things that *mean* something" to him. Things like HALSTON. Disco. AMERICAN GIGOLO... FORD's aesthetic is intrinsically linked to his own formative years as a late teenager in Manhattan, doing the "Bus Stop" and the "Bump" as ANDY the eternal voyeur looked on. When STUDIO 54 opened its doors in late 1977, FORD had just turned 16. By the time it closed, the 1980s were upon us, and the spectre of AIDS loomed large. If there is a nostalgia to his menswear collections, it is a tensile one, buoyed up by a high-strung sexual tension. "Sex is part of my image," he readily admits. "It's a part of me. I'm extremely sensual. If I like someone I want to touch them, if I love them I want to hold onto them. I'm very physical. But also I don't find sex offensive, I don't find the human body offensive. I don't find a guy's cock or a woman's vagina offensive, in fact I find them beautiful. I would put them on an ad with a perfume bottle if I could get away with it. But when I design something I'm not necessarily trying to think, 'How can I get the biggest rise out of people?' I'm thinking, 'How can I make the most beautiful image?'"

That said, FORD clearly knows how to press the right buttons. Over the years his GUCCI ads featured girls with G-shaped pubic hair, a guy with a prominent erection showing through his pants, and piles of naked bodies wildly writhing. Perfumes have been given names like ENVY, or RUSH, a 1970s name for poppers. With each new season, deliberately or not, TOM FORD actioned an aesthetic that was bound to keep his image at the fore. "I am a hybrid of businessman and designer. I am very much a designer, but I am not an *artist* and I have never pretended to be. There are fashion designers who are artists — ALEXANDER McQUEEN is an artist; NICOLAS GHESQUIÈRE is an artist — but I actually enjoy designing more when I have a box, meaning, when I can say, 'What's missing? What does the world need? What can I do that's the best thing from a design standpoint but that fits into that box? So I start with the bigger picture and move in. When looking to start my own line and stores, I couldn't do so until I figured out a unique way of doing it, that wasn't already out there, that is valid and that means something that I can stand behind."

The TOM FORD menswear collection riffs on the classic gentleman's wardrobe — riding outfits, tennis gear, evening wear, as well as the obligatory chunky sweaters, clean-cut trousers and impeccably crafted shoes — while pushing it into the now. BRIDESHEAD is not so much REVISITED, as re-edited. There may be nothing ostensibly new in that fine tweed suit, that piqué shirt, that tennis-stripe waistcoat. But FORD has always understood that menswear is not about unnecessary novelty or gimmick. It's about the careful curation of classics, fine-tuned and tweaked to resonate with the contemporary consumer. As the TOM FORD website mantra puts it: "Style is most potent when it is least complicated."
　　While the exclusive member's club aspect of the stores evokes the hallowed halls of Savile Row, the offer is in fact much more unique. The "box" TOM has identified in this case consists of a hybrid high-fashion company and a traditional tailor. "It's very different," he insists. "We don't do bespoke suits from the ground up. We work off four different bases, we take your measurements, work out which base is right for you, modify it, send all this away to our factory in Italy, and then once it comes back we have a sample room in each store location where we can do quite dramatic alterations. When you go to a bespoke tailor you can have almost anything made. When you come to us, you come for a certain TOM FORD look and then it's modified. This is a hybrid that did not exist. There's much more customisation than you can get from any other designer company. At the same time it's got a bit more of a personal stamp than Savile Row." So what he's saying is that somebody can't walk in and have a total disaster made up in canary-yellow check? "No, definitely not."

Like the best success stories, the plan is ultimately very simple: identify a gap,

then fill it. Based on the accolades coming from the likes of GEORGE CLOONEY and BRAD PITT, the plan appears to be paying off. In fact, like most of TOM FORD's endeavours, it appears to be a raging success. It's hard to image the long tall Texan—TOM of FORDLAND, the man fashion editors the world over refer to simply as "TOM"—ever having a moment of doubt. He almost coughs up his vodka at the suggestion. "The GUCCI experience was horrible. *Horrible*. When I left I thought, 'Oh shit, I'll never do anything good again. I really thought that was it—that I didn't want to go back to fashion. I was burnt out from working too hard and I was *exhausted* from the experience and a certain disillusionment and an inability to see my future. Luckily I had made enough money to not have to work for the rest of my life, and I seriously thought I'd play tennis and golf for the rest of my days. I mean, *golf?* I imagined the fantasy of retirement. But I got that out of my system. I will not retire until I literally drop dead."

So today, with the TOM FORD brand, he is trouble free? "No! I worry *every* day. If I design a pair of shoes in the afternoon I go to bed that night thinking about them, thinking 'Oh shit...' So I'll write a note, send an e-mail, make a call, *change* the chain, the buckles, *whatever...*"

I take the cue to bring my handmade GUCCI brogues out into the open, to wave a flag of solidarity with their maker. "They're quite worn out," TOM frowns. "*Quite* worn out. You need shoe trees." I have shoe trees. Forests of shoe trees. I use shoe trees... There goes effortlessly elegant, slinking in shame out the door and down the block to buy a packet of cigarettes and smoke up a funk. I wonder if my stained sweater should join it, but keep that thought to myself.

FORD says he "feels great" about where he is right now. "It feels natural, like a natural progression. I am where I should be today." Does he regret not finishing his architecture degree? *"Never.* Because I get to build things all the time right now. I make enough money that I get to build a lot of houses. And I get to build stores. And I work with architects, so I get to do the fun part, you know, the sort of 'Yes, No, Figure it out, Calculate that...' bit."

So what's missing in this apparently idyllic life? The houses, the art, the travel, the money enough to retire at the age of 42? "I have everything. Except one thing—I'm going to have a kid in 2008. RICHARD knows I've wanted this for a long time. He's just resisted it. He would be a *spectacular* father. *Spec-tac-u-lar.* It's going to give his life new meaning."

How is he going to get a kid? "It's all worked out. It will be biologically mine. I mean, I'm a lot younger. If things follow their natural order he'll probably leave the planet ahead of me and I can't not have had something I've wanted forever. I've always wanted kids. I don't want to get to 75 years old and just have made a lot of dresses, done some houses. I don't know what any of this life's about. For

me, honestly, there are many moments when life is all stupid and useless. But to at least impart that to the next generation to let them resolve it. Maybe one day, generations from now, it will all make sense but at least I will have transferred the best of myself, the best of my generation, to the next wave.
It feels like part of our purpose in the kind of giant flow of... I don't know." FORD pauses for a second and says, "Who knows why anyone wants to have a child?"

It's a good question. And one to which, quite honestly, I have no answer. But all of a sudden my stained sweater, my beat-up GUCCI shoes, my old jeans — hell, even TOM's impeccable patent pumps and tweed trousers and perfectly pressed black shirt — don't appear quite so important. For a moment, anyway.

Mr. RICHARD QUEST

Featured in issue n° 19 for Spring and Summer 2014

The garrulous anchor of the Monday-to-Friday CNN International show QUEST MEANS BUSINESS, RICHARD QUEST is known for his idiosyncratic delivery. "There's a comment I always remember which said 'it sounds like he's been gargling with broken glass,'" recalled RICHARD in his interview with ANDREW TUCKER for FANTASTIC MAN issue no 19, "and not long ago somebody actually told me I should go and see a specialist." That's exactly what RICHARD did. "They shoved a tube down my throat and told me I have prominent false cords, which creates a raspy sound, but I am happy to say, it's perfectly normal." ANDREW describes RICHARD's cadence as "straight out of a 1950s infomercial, but with enough self-deprecating humour to make it endearing rather than irritating." Quite!

Raised in Liverpool, RICHARD is the son of a doctor. He fell in love with broadcasting aged 10 and would borrow his father's dictaphones to make radio plays. By the age of 13, he was volunteering for hospital radio, and after studying law at university, he was accepted on the BBC Traineeship Scheme. Since joining CNN, his interview subjects have included the IMF boss CHRISTINE LAGARDE, JOAN COLLINS and the DALAI LAMA. He also hosts CNN's BUSINESS TRAVELLER, and is suitably obsessed with aviation. He has nothing but praise for the orange-hued bus of the skies, EASYJET.

Portrait by Roger Deckker

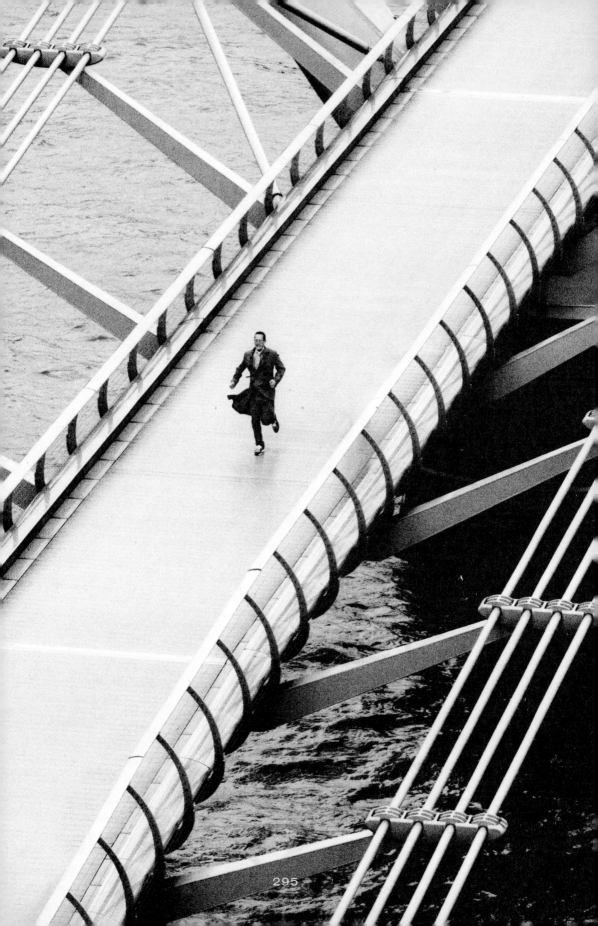

Chapter 3

Page 296-427

Bryan
Vinoodh
Antonio
Wolfgang
Steve
Jonathan
Matthew
Tim
Peter
Ricky
Tobias
Konstantin
Christoph
Jonny
Patrick
David
Roberto
Spike

Mr. BRYAN FERRY
Featured in issue nº 12 for Autumn and Winter 2010
Portraits by Juergen Teller
Text by Paul Flynn

Mr.
BRYAN FERRY

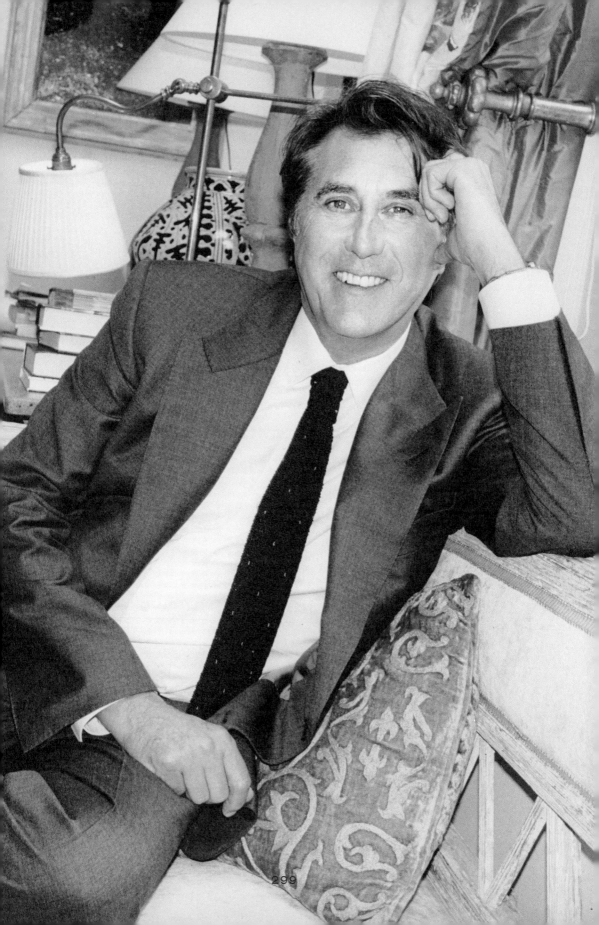

At 64, the fantastic Mr. BRYAN FERRY is about to release a new solo record that proves him to be as vital as ever. Born in the north of England, in his twenties he formed ROXY MUSIC — a seminal band with which he often still plays. Mr. FERRY has a firm belief that clothing and appearance actually enhance musical output, and his outfits continue to be meticulous. Always completely at home in the presence of supermodels, Mr. FERRY provided the musical entertainment at the 2003 MISS WORLD contest.

On both occasions that I have met Mr. BRYAN FERRY, bringing up the subject of his hair has proved irresistible. At 64, he is still a sexy man with sexy hair that slopes memorably towards his left eye. His is one of those iconic haircuts that don't appear to get any longer or shorter. There is a permanent one-and-a-half-inch rub behind the ears that simply settles into place. When he runs his hand through the parted fringe, it falls flawlessly back into position.

This is a stage trick he learnt early, and kept. The first time I met him, I actually told him I was jealous of his hair. He said, "Ah, but the shape of your head suits it," referring to my balding, and afterwards I waltzed down the street outside his west London mews residence with renewed vigour.

At this moment, FERRY is juggling commitments for his gilded rock outfit, ROXY MUSIC, and the preliminary engagements for a new solo record, OLYMPIA, which he has just completed after a lengthy and painful gestation. He says that the last time he cried, he was alone in his studio. It was the moment he had finished writing the lyrics for what has turned out to be one of the last songs on the record, REASON OR RHYME. It is a song that has existed in one form or another for over five years now.

His new record is made up mostly of his own songs, with the exception of covers of TIM BUCKLEY's SONG TO THE SIREN and TRAFFIC's NO FACE, NO NAME, NO NUMBER. When he sings other people's songs, the words are pronounced clearly; when he sings his own, the pronunciation becomes blurred within his uniquely forlorn delivery, almost as if he were embarrassed at having written them. "I always think if a song makes you cry then it might mean something to the listener."

Might?

"You are so immersed in the emotion of it sometimes that your whole life will flash before you during it. Certain things make that happen. I always find songs very hard to finish. Every time I have to go back to one to finish off a lyric I think: 'I don't want to go back into that painful world.' Each time that I went into the world of that song I found myself very affected by it. In one sense, that is great, of course. But it is also... awful."

FERRY often records wearing a tie. "I like what NICK CAVE once said about always wearing a suit to go to his little office to write. 'Because it's serious work.' *That* is cool."

Anyway, back to the hair. British chat-show host Mr. JONATHAN ROSS has asked ROXY MUSIC to play as musical guests on the occasion of his last broadcast for the BBC. In Britain, ROSS' bowing out is being handled with the pomp and circumstance of a state ceremony. It has become front-page news. ROSS is an ardent ROXY MUSIC devotee, and his favourite song is commonly known to be IN EVERY DREAM HOME A HEARTACHE, from the second ROXY MUSIC

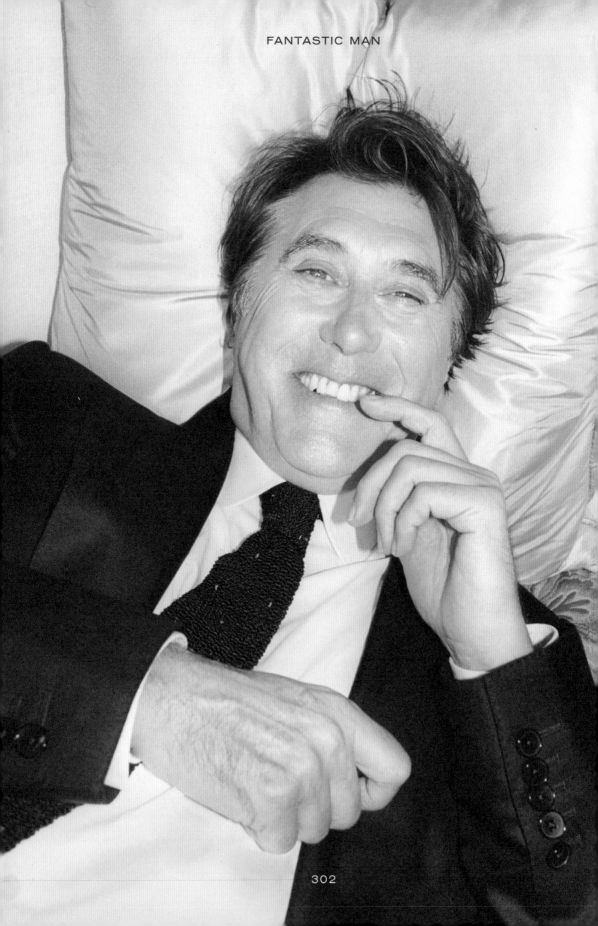

album, FOR YOUR PLEASURE. At the event, FERRY will perform this strange
song — about falling in love with a blow-up doll — as a gift to ROSS after the
cameras have stopped rolling. ROSS' veneration for ROXY even stretches to his
attempting the FERRY haircut. This is common amongst British broadcasters with
full heads of hair: the arts commentator Mr. MELVYN BRAGG tries the same
trick.

JONATHAN ROSS nicked your hair, didn't he?

"He improved on the model," says FERRY. This is a kind lie that envelops a
deeper truth. Everything ROSS does sartorially is a genuflection at the altar of
FERRY's exquisite taste: tailor-made suits, print ties, a fondness for loafers — all
are nods of approval that only serve to prove that some men have it and some do
not. It is a joy to note that, starting with his hair, FERRY has never stopped caring
about getting it right.

This is not the only time the subject of hair comes up in our riveting, if
rambling and distinctly non-linear conversation. It's how FERRY talks, and for
this very reason, he doesn't like doing chat shows. "I'm not awfully good at
promoting myself in that sense," he says. "I guess some people like the sense of
sitting on a sofa and talking about themselves and are very prompt at remember-
ing their anecdotes. But I always forget the good things that happen. Shocking,
really. The trouble with those sorts of shows is that yesterday it was LEONARDO
DiCAPRIO or whoever, and then the next day it's another person, and it can
become a little like a celebrity carousel that you are picked off for a moment and
then put back on."

For FERRY, ROSS is still preferable to one of his American counterparts. "At
least you're not freezing to death like you are when you're doing LETTERMAN.
You know how Americans are obsessed with air conditioning? The Green Room
at LETTERMAN is like being locked in a fridge. Everybody complains about it.
But it does make you dance a little more... fitfully."

Anyhow, back to hair. The day we meet, he has just spent the morning in an
edit suite in Soho, supervising and art-directing the completion of the video of the
first single from his album, another in the long canon of FERRY songs about danc-
ing: YOU CAN DANCE. Among ardent FERRY fans, there is a complicit under-
standing that dancing is his close lyrical metaphor for sex; in all his best songs,
there is something perennially pre-orgasmic or post-coital going on, lyrically.

The video was filmed in WILTON'S MUSIC HALL, a historic East End
landmark that was also used as a location in the first video for FRANKIE GOES
TO HOLLYWOOD's RELAX. The video sounds like comfortingly familiar
FERRY visual fodder. "Cast of thousands, all kinds of girls dancing around.
Which is what we like. Hair in the wind, that sort of thing. It would make a rather
good hair commercial, actually." He doesn't mean a modern one. "I don't think
hair commercials are quite as camp as they used to be," he mutters disapprovingly.

FERRY's cover girls are legend. For OLYMPIA, he has revisited the idea of sanctifying a hot model on the sleeve of a pop record, and this time it's Ms. KATE MOSS, wearing a necklace that he had brought along to the shoot. He cast her himself after his son ISAAC got him her number through a mutual friend, and FERRY spent the shoot marvelling at her on-set professionalism. "KATE is the one, really, isn't she?" he says. He looks delighted that she chose to do it, though unsurprised.

I recall first fixating on a ROXY MUSIC record as a boy. My elder brother had a cassette copy of FLESH + BLOOD that he played on loop. I stared at the cover for days, with no idea that FERRY himself had art-directed it. When he was finalising his last album, DYLANESQUE, a suite of DYLAN songs rendered and shaped to his own style, he actually fitted the release date around the availability of the photographer Mr. ANTON CORBIJN, so he could shoot the cover. The cover of OLYMPIA was shot by former MARIO TESTINO assistant Mr. ADAM WHITEHEAD.

Over the 30 years since I first came across one, I have bought every album FERRY has released as an ongoing life treat. I found three I didn't yet own at a car-boot sale once, liked the scuffed edges of their sleeves and immediately fell in love with his intoxicating rendition of THESE FOOLISH THINGS. In an occasional fantasy scenario played out in my head, this is the first dance at my wedding.

I bought BOYS AND GIRLS, his most commercially successful solo record, from an HMV shop in Manchester city centre on the day it was released, poring over the sleeve notes on the 109 bus home. He made that album in a world of New York luxe. "We started recording when I was renting BETTE MIDLER's apartment in Tribeca. NILE RODGERS set up a studio in the corner of the loft. I used to see that wonderful photographer with the bandana on his head in the elevator. BRUCE WEBER! That's it."

It came as an inevitable disappointment that OLYMPIA arrived on my computer by email in a zip file from a member of the record company staff. I felt a little bereft. Look, some men have Mr. PAUL WELLER as their masculine musical icon, for whom I could not care less. Because I was not angry as a teenager and because I dreamt long and hard about the idea of luxury, I have FERRY.

He is not a modular artist. Unlike BOWIE, he has never, for example, made a drum-and-bass album. You can pick out any FERRY or ROXY MUSIC record (aside from the first three wilfully strange albums) and the impact will be similar to the others. The two words I scribbled over my notes on OLYMPIA, listening to it on repeat the weekend before meeting him, were "virile" and "melancholy". "A handsome combination, Mr. BOND," he says when I tell him, batting back his vague embarrassment at the compliment.

Because of some exemplary DJS' fondness for the sheen and groove of songs like ANGEL EYES and SAME OLD SCENE, there is a rolling and slightly disconcerting effort being made at his record label to remix old, untouchable classics and sell them again to whatever audience has yet to fall in love with his work. When you have slaved over these productions, as he always does, paying attention to every tiny detail of the master tapes, it seems almost blasphemous to sully them with momentary musical whims. Besides, potential fans all tend to find his music eventually. Ms. SOFIA COPPOLA opened up a raft of new admirers with Mr. BILL MURRAY's karaoke singsong to MORE THAN THIS, delivered straight to a smitten Ms. SCARLETT JOHANSSON in the defining frames of LOST IN TRANSLATION.

Like GRACE JONES, FERRY does not make records in accordance with the musical times. This distinction elevates them both above the strictures of the pop-music model. FERRY is in rarefied company here. MORRISSEY works in the same way, as do SADE and KATE BUSH. You wouldn't expect a new collection of songs by prestige artists like these — who basically operate in playing fields of one — to have a particularly hard commercial impact, though SADE's multimillion-pound iTunes receipts appear to buck the rule. When sales are not the priority, an intimacy between listener and audience magically forms. The fans of all these acts tend to feel a sense of ownership over them, allowing the artists to hover somewhere above the notions of what is hot or not at a particular point in musical history. They are not avant-garde in the traditional sense of the word, making awkward or disorienting noise. They are singular.

Rather than with his British peers, of whom there are few, FERRY feels a latent kinship with the American R&B fraternity. "You see a beautiful girl like RIHANNA or BEYONCÉ," he says, "and they seem to have a similar engagement with their videos to what I had with my record sleeves. There always has to be an element of glamour. Yes. It's about being fabulous. There are so few of us that are determined to hang on to the things that I believe in and respond to. I feel vindicated by them."

He recently duetted at a charity function with the singer ALICIA KEYS, joining her for the second verse of a radically revamped LOVE IS THE DRUG. "She is a talent," he responds, when asked what the deciding factor is in saying yes to a request like that. "She did something wonderful with the piano on it. It was quite a black audience, I believe. I suppose you would think of us as two different kettles of fish, but I understand where those artists come from."

Fabulosity is a specific, non-negotiable notion in FERRY's world — one that is not just money-driven but also sophisticated and refined. He has two London homes (he gave up a New York apartment in the West Village, regretfully, at the end of the '90s). The one I visit he uses mostly for work, but he stays there sometimes

too. Subtle taste clues are stamped around these quarters like a puzzle of late-20th and early-21st century artefacts.

On both of my visits here, I have felt a dynamic similar to that of taking one of his records out of its sleeve. It feels just as you hoped it might. Both times he has been sporting a PRADA tie; this one is knitted, in mustard and black. There is a delightful smell to the place, as if chemicals have never touched the furniture, and everywhere you look, a new visual stimulus pops out. There are three separate front doors, each one black gloss with brass fittings. He first moved into the basement, now his recording studio, almost 40 years ago and has accrued more of the property as time and finances have permitted. For the interview he sits in front of shelves full of fashion magazines, all lovingly catalogued. I spot a row of untouched copies of Mr. MICHAEL BRACEWELL's definitive book, RE-MAKE/RE-MODEL: BECOMING ROXY MUSIC, to his immediate right.

The soundtrack to his life, he says, consists of dusty old jazz records: "COLEMAN HAWKINS or CHARLIE PARKER," which in a concession to modernity he listens to mostly on CD. "It adds texture to a room," he says. Outside of the studio in which he creates it, he doesn't allow his own music in the house. "In fact, if somebody put it on I wouldn't go in the room."

He doesn't watch much TV. He has never seen an episode of THE WIRE or LOST or MAD MEN. "Actually I have seen one of MAD MEN. I thought it was rather slow, but I loved the clothes and the big girl with the red hair. Somehow I didn't get involved." He will allow himself the odd indulgence in one of the CSI cop show franchises. "CSI is a bit snappier. A bit more wham, bam. It's all done in laboratories in the dark with very glamorous equipment everywhere. It's a total fantasy, which I quite like."

Today his scent is the PINK fragrance from the Mayfair chemist D.R. HARRIS. He rushes to the bathroom to show me the packaging when I enquire after it. He is a scent fetishist, though not in the same way his fellow pivotal ROXY alumnus Mr. BRIAN ENO is. "You know ENO is very into scents? He likes the chemistry of it all. How they're made. But I like this one because it's very English. It makes you think of England."

FERRY says that his male friendship patterns have remained steady over the years. "I don't have any of what you might call 'macho' friends." It hardly comes as a surprise. "One or two of my closest friends are in the banking world, but that's unusual for me. That might be because they are more interested in collecting decorative things. That's usually a factor in all my friendships. An aesthetic awareness. I don't have men that I go to rugby with. My friendships aren't like that at all. Though I do have one or two that I can discuss football with, but more as a social phenomenon than a technical game, ha ha."

He mentions two individuals: a Swedish-American, New York-based art

dealer who had been a house guest the previous weekend and the retired Oxford University don Dr. JEREMY CATTO. "Your best friends are the ones who make you smile just by hearing their names." He develops the point by mentioning designer Mr. ANTHONY PRICE and breaking into one of those smiles. He says that the first person he played OLYMPIA to after completing it was THE GUARDIAN sports journalist Mr. RICHARD WILLIAMS, who will contribute sleeve notes. As then-editor of MELODY MAKER, WILLIAMS was also the first person he played the first ROXY MUSIC demos to. It's a circularity he finds pleasing. Age is no barrier to friendship with FERRY. "The best parties always have a spread of the generations," he says, by way of a social etiquette flourish.

Strangely, as the conversation winds up, we return to the subject of hair. BRYAN FERRY talks me gently through his morning shaving routine. Because his speaking voice is as gentle as his singing one, it casts a hypnotic spell around his marvellous drawing room. "I like the feel of a keen blade. I don't consider myself to have shaved properly until I've felt that," he says.

He sees no reason why schoolboys should not be taught how to shave properly, just as they are taught mathematics and geography. "Why does that not happen? Why do they not teach boys how to sharpen a cut-throat razor?" At this moment you cannot help but think of FERRY as a father. "I really do like shaving brushes, doing it properly." He begins rambling, in his charming, slightly pathos-addled way, forgetting the anecdote just as he does on chat shows: "Do you have a beard all the time? Do you have one of those things to adjust the length? I like the feeling of wet shaving and I did have a kind of beard in the late '70s. There are a few pictures of me around with one, but people didn't actually think that it was me. It was strange. I always start shaving here, come to think of it." He points to the immediate right of his lips.

"My first two motions are there and there." He brushes an imaginary razor along the underside of his lip.

"And then I can't think what I do afterwards. It would be an interesting study to film someone shaving every day, to see how the routine happens and how similar it is. Do we do exactly the same thing every day?"

He seems reassured, not numbed, by this possibility.

"I always get a little scared around here," he continues, the imaginary razor by now reaching his throat. "Scared that I might cut myself. Funny, isn't it? You always use a little bit of tissue if you do nick yourself. And then of course you feel slightly ridiculous when you walk out with it."

At this thought, the immaculate Mr. FERRY bristles. "That is a feeling unique to all men. We all know what that little disappointment, that failure, feels like."

Mr. VINOODH MATADIN

Featured in issue n° 6 for Autumn and Winter 2007

The first-class fashion photographer VINOODH MATADIN's image on the suitably gold-spangled cover of FANTASTIC MAN's sixth issue is a self-portrait both taken with and depicting his work- and soul mate, INEZ VAN LAMSWEERDE. The pair have collaborated since the mid-1980s and have been a couple since the early 1990s — with spectacular and ubiquitous results. Still, as FANTASTIC MAN's interviewer OLIVIER ZAHM notes, it's always "fairly mysterious as to who does what." Asked the question point blank, VINOODH says, "INEZ is the real photographer. I'm more the person who "steals" the picture... I always shoot from a different angle, capturing the same moment from another perspective. Mine seem to be more unfinished pictures. They're more voyeuristic; they show a completely different sensibility." INEZ is like the lead singer. "Work is the easiest part of our life," owns VINOODH, "and it's a great life."

INEZ and VINOODH were both raised and educated in Amsterdam, but they moved to New York City in 1995 and have lived there ever since. Along with the fruits of their strikingly successful joint photography career, they have produced a son, CHARLES STAR MATADIN. In the last few years they have launched a line of fragrances as well as a delightful jewellery brand.

Portrait by Inez van Lamsweerde & Vinoodh Matadin

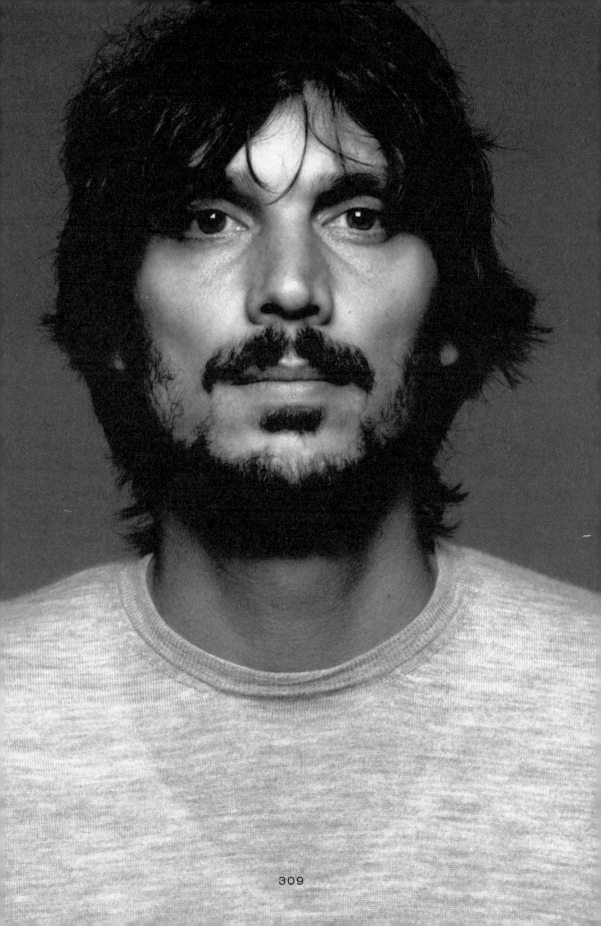

Mr. ANTONIO BRACCIANI

Featured in issue nº 9 for Spring and Summer 2009
Portraits by Andreas Larsson

ANTONIO BRACCIANI is menswear's most successful fit model. Based in Milan, he has determined the sizing of clothing from, amongst others, PRADA, GUCCI, JIL SANDER, MARNI and BURBERRY. He describes himself as "normal", but admits, "to be normal is quite difficult. I have managed to stay exactly the same since I was 18." Indeed, the life of a fit model is a disciplined one.

ANTONIO is a classic size 48: he is 184cm tall with an 84cm waist, his chest is between 98 and 100cm, he has a 40cm collar and shoulders of 47cm, his back from waist to collar is 48cm and his arms from centre back are 88cm each. He is model handsome, but that is almost beside the point. It is his proportions, not his looks, that are his fortune.

ANTONIO is married to a fellow fit model CHRISTINA with whom he has a daughter. On his retirement from active fit modelling, he plans to open an agency representing fellow practitioners. Unusually, but perhaps not surprisingly, the clothing ANTONIO wore for the FANTASTIC MAN shoot required no tucks or pins.

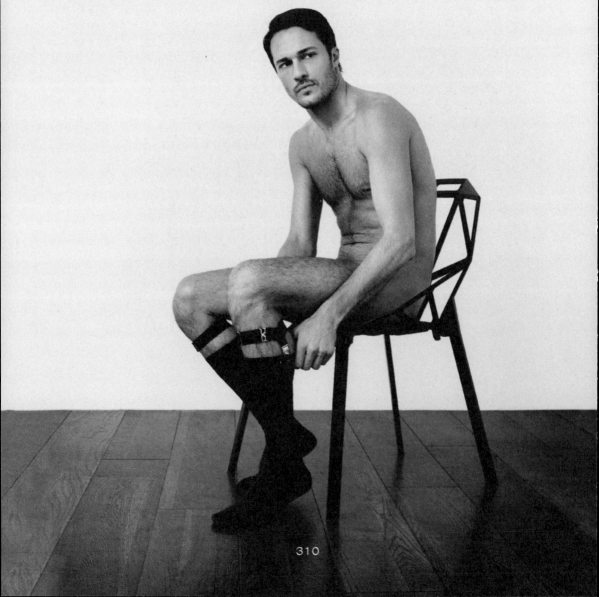

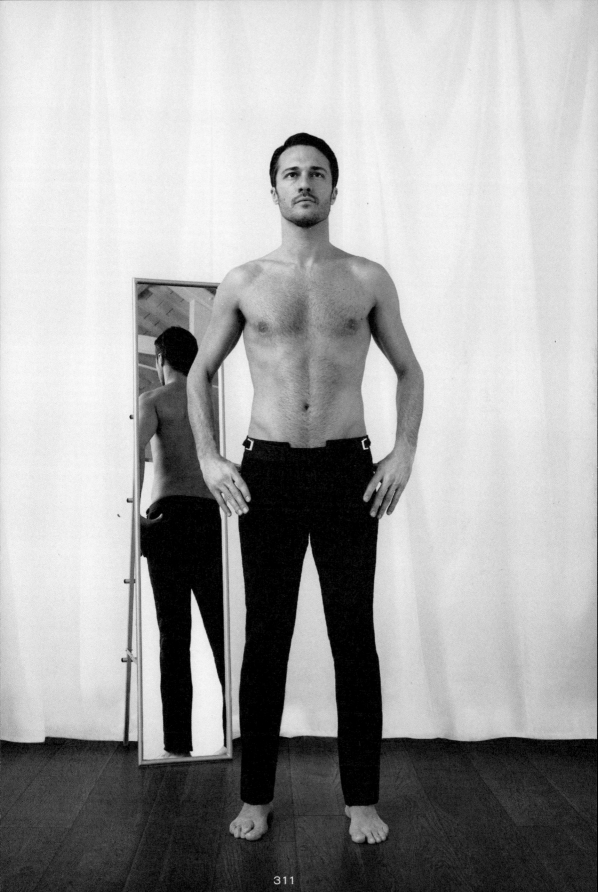

Mr. WOLFGANG TILLMANS
Featured in issue nº 11 for Spring and Summer 2010
Portraits by Alasdair McLellan
Text by Paul Flynn

Mr.
TILLMANS

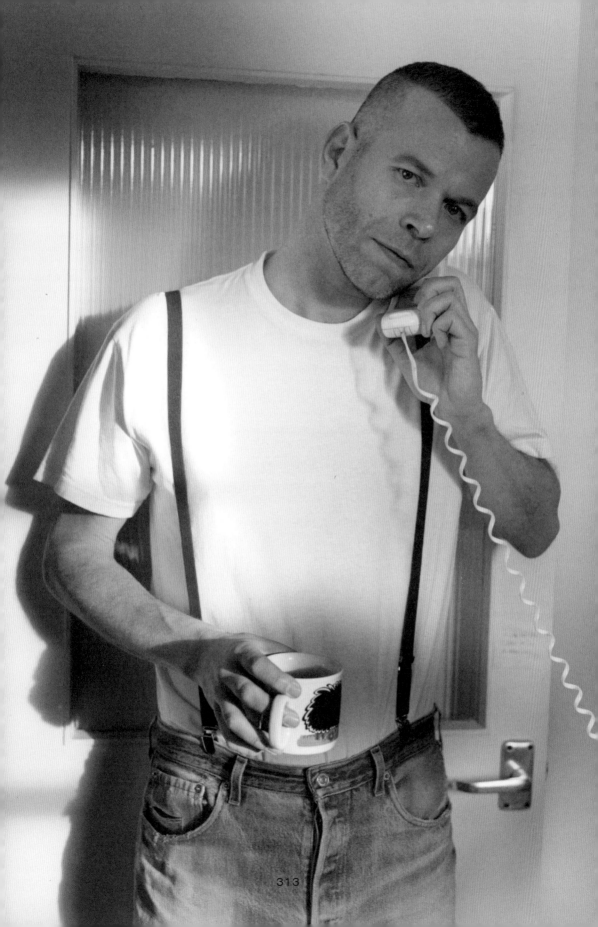

For nearly 20 years now, Mr. WOLFGANG TILLMANS has brought new meaning to photography, and to the way in which images are displayed and understood. Born in Germany and based mainly in London, WOLFGANG creates a community around himself with his graciousness and his curiosity, characteristics that both play a vital role in his work. The first photographer to win the TURNER PRIZE, WOLFGANG never questions the veracity of the medium but uses it to find truth in art itself. On the eve of a major TILLMANS exhibition in London, FANTASTIC MAN's reporter travels with the artist between London, Berlin and New York, to see just how much of the man it takes to make the picture.

LONDON

Mr. WOLFGANG TILLMANS sits in his workspace in east London. It is Saturday evening, and he has already spent several days contemplating a scale model of an exhibition of his work that is to open in New York in three weeks' time. It will be his first US show in a year and a half. At some point during the two hours we spend together in the studio, he casually asserts that I will be granted access to anything and everything I'd like to see him do in the run-up to the show, whether in London, Berlin or New York.

The scale model of the exhibition fits onto half a trestle table and stands some 30cm high. Small versions of the pictures are delicately taped to the thick, white cardboard walls. The real pictures are taped around his studio, a 300-square-metre industrial unit in a rare pocket of east London that has yet to show any surface signs of gentrification.

The studio looks like it could be one of his pictures. "Aha," he says, "that is funny. What you see is a still life; what I see is a bunch of flowers for the studio."

WOLFGANG is tall, with sympathetic eyes and a huge smile. His German accent is heavy, despite 20 years living in London, and his vocabulary is immaculate. When he smiles, his face works in almost comic slow motion, his whole head rising with his lips. He is a committed pacifist with a fetish for armywear, the irony of which he is all too aware. He is a gentle man.

WOLFGANG had intended to take 2009 off, but his plans not to exhibit for at least a year were interrupted by a request to show at the Venice BIENNALE. He nevertheless managed to fit in some travelling with his boyfriend, the artist Mr. ANDERS CLAUSEN. They travelled to the Far East for the first time, to China and Thailand, with an unintentional stop-off in Dubai on the way back. "Have you been there?" he asks. "Awful."

Throughout the period that was meant to be a holiday he could not ignore his artistic impulse. Hanging on the wall is a picture of the mirrored ceiling at a nightclub in Venice, taken at an unusual angle. "Awful," he says again, of the club, not the picture. "But I have to be careful that the work does not descend into kitsch or condescension." He mentions the photographs of Mr. MARTIN PARR — "I don't want to be mean to him; what he does he does very well" — as a negative benchmark by which artistic levels of kitsch can be gauged.

The new exhibition is a deliberate U-turn for WOLFGANG. It will feature none of the abstraction that he had introduced to his work in 1998, and will continue his earlier practice of hanging the work, unframed, with tape, nails and bulldog clips. The most significant move forward with the coming exhibition will be its international feel, away from the artist's familiar territories of east London and Berlin. The scale model includes a picture of a man bathing in the Ganges

(WOLFGANG has deliberated long and hard whether to include it), and a shot of a Shanghai skyscraper, alongside several more homespun and immediately recognisable still lifes with textiles, mostly his own clothing.

WOLFGANG is now 41. Throughout all his work, from his first international solo show in 1993 to winning the TURNER PRIZE in 2000, and beyond, there is the sense of a single underlying question: what makes a picture? That question is still noticeably present in the work to be shown in the New York exhibition. One picture is of a sheet of glass being transported in a factory. Another features glossy gossip magazines on a shelf. There is a still life of a rain drop on an orchid that WOLFGANG took in Thailand. "I mean, this could almost be the cover of a menu in a restaurant," he says, pointing to it. With tricky subject matter, there is always a delicacy and often an idiosyncrasy to WOLFGANG's eye that belongs only to him. With every picture he takes, he asks himself: what is it that I am attracted to here?

WOLFGANG is contemplating which picture visitors to the gallery should see first. At the moment, taped to the cardboard wall in the entrance foyer of the scale model is a large picture of a baby in the car seat of a very suburban car. It is titled ROY. "It is so not what you would expect of me," he says, staring intently at the image. I slowly begin to carousel with WOLFGANG's manner. He is certainly one of the most thoughtful men I have ever spent long periods of time with, though he can also punctuate the patience of his purpose with quick, sprightly decisions. I find him almost mystically serene.

In the picture of the baby, a reversed tax disc sticker is visible on the window of the car. Because of the font used, when reversed, the year 2009 printed on the sticker appears to spell out the word "poof". He responds immediately and kindly to any observation of his work and laughs gently at this one. "But this is the reality of how many people live their lives," he says, pointing at the picture without judgement.

WOLFGANG's studio is just a few footsteps away from the gallery of his London dealer, Ms. MAUREEN PALEY. It used to be an umbrella factory, and when bidding for the lease of the building just before his TURNER PRIZE win, he was competing with a group of local African churches who wanted to turn the space into a place of weekly worship. He says that his Indian landlord shows no sign of being impressed by what he does. "He has never commented on any of the photos, for example." WOLFGANG's artwork is everywhere in the studio. "He only cares about whether the rent is paid on time." It always is.

For the past few years, WOLFGANG has also used the studio for his own summer parties, which have become the stuff of local legend. These parties are a direct reflection of WOLFGANG's world. The mythical boundaries between the sometimes very separate worlds of art, fashion, music and nightlife collapse

within the confines of his studio. Because he is an inclusive person, his parties are, too. They are cool in a liberal usage of the word, as in the opposite of uptight.

These parties cut deeper, too. They are part of his ongoing, egalitarian interaction with the world. "It's fun to give something that you also get so much back from. It's very interesting to occupy my mind with something outside of myself. Even though I deal with the outside world with my camera, it is still dealing with my own stuff, day in, day out. I find the parties a very refreshing thing to do for my mental agility."

WOLFGANG does not throw his summer parties as a launch, or to coincide with an exhibition, but simply for the sake of having a party. "It's good to think about something that isn't just furthering my own direct interests, and I put a lot of time and effort into them. They are not truly altruistic. They are altruistic because they can be. I am aware that a lot of people don't have the space or the money to do that. As someone who is fortunate enough not to have to just survive, it's good to utilise my resources. I don't have any particular lifestyle needs."

In a week, WOLFGANG will visit Berlin, where he will replace some art he has hanging in the PANORAMABAR, part of BERGHAIN, probably the most influential club in the world right now. "There is a lot of bad art involved in clubbing. I don't think that art necessarily lends itself to many applications. The moment it serves a function, it is not purposeless, yet I think purposelessness is quite crucial to art. Otherwise it is an illustration. In the PANORAMABAR they have just the right understanding. They are making a mad place, but they are also very realistic about it. It is a reasonable undertaking to have a great techno club with a sex club attached to it, architecturally. Then sometimes the whole place becomes a sex club and the closed-off area has theme parties. It's so caring for the human mind and the different receptors of what people might want, to offer this playground paired with an aesthetic sense that has never been trashy."

BERLIN

WOLFGANG's studio in Berlin is in a building that was designed by Mr. MAX TAUT, the less famous brother of BAUHAUS architect Mr. BRUNO TAUT. Mr. WIM WENDERS once occupied the top floor and Ms. NINA HAGEN's manager operated out of a studio here when WOLFGANG first moved in. The stairwell was prominently featured in a film by the avant-garde filmmaker Ms. ULRIKE OTTINGER. At 680 square metres, the studio is twice the size of his London space.

WOLFGANG is very precise about certain aspects of his working conditions. For example, he is most specific about the weight of lead in the pencils that he uses to sign his art. His pencil of preference is by the Austrian brand CRETACOLOR. He uses their 7B graphite. Its marks, he notes, are heavier than those

of 8B pencil leads from other brands, yet the CRETACOLOR 7B pencil has the satisfying performance aspect of leaving no indenture on photographic paper, a carelessness that other pencil factories may wish to correct.

All this could lead the reader to believe, incorrectly, that WOLFGANG is a fussy man. There is no doubting that he is incredibly particular. But his particularities are ones that are easy to warm to, and that are mostly deployed in the service of his work. Some aren't. He never smokes a cigarette before 6pm, or example. Whenever I am with him, at some point between 6.05 and 6.25pm a rogue, unopened packet of MARLBORO LIGHTS will appear close by. While there is a satisfying certainty about entering and re-entering his world, one can never be certain of where the day, or more specifically the night, will end.

While roaming around the studio I notice a recent family portrait showing WOLFGANG with his sister, Ms. BARBARA FORKEL, 44, and brother, Mr. CHRISTIAN TILLMANS, 46, all smiling in the family kitchen. He thinks it must have been taken by his father, Mr. KARL A. TILLMANS, now 79. His mother, Ms. ELISABETH TILLMANS, is 72.

WOLFGANG was born in the small town of Remscheid, Germany, in 1968. He moved first to Hamburg at the end of the '80s and then, for a few weeks during the crazy acid-house summer of 1989, to Berlin. From 1990, after having read in an interview that the fashion photographer Mr. NICK KNIGHT had attended the Bournemouth School of Art and Design, WOLFGANG spent two years studying photography in the incongruously-sleepy British seaside town of Bournemouth. He loved it. "People always laugh, but I had a great longing for the English seaside. Rainy, sad, autumnal... falling in love and spending time on the pier. I was happy to be in a provincial place and I relished the local gay disco, THE TRIANGLE. The other foreign students couldn't wait to go to London for the weekend. But I moved to Britain because I had an affection for English culture." Since 1992, WOLFGANG has lived mostly in London, with a gap of two years in the mid '90s, when he lived in New York.

It is lunchtime, and there is another scale model of the upcoming New York exhibition at the far end of the studio. WOLFGANG's German assistant, Ms. CARMEN BRUNNER, presents him with a series of postcards of his own work, from which he must choose an image to send to the building's caretaker. "What is the celebration? Christmas? New Year? Maybe just 'Thanks for your help'," he says, before spending a full 20 minutes deciding on a tone that is appropriate for a man whose first name he does not know and whom he refers to only as NEUEN-DORF. He says that it is not unusual in Germany to call another man by his surname, nor is it considered impolite or overly formal. WOLFGANG says that as a professor of interdisciplinary art at the Städelschule in Frankfurt, he is some-times referred to as PROFESSOR TILLMANS.

In the late afternoon, we stroll in the sub-zero temperature between distinct aspects of WOLFGANG TILLMANS' Berlin. He spends 15 minutes at his framers' shop in serious discussion about a particular type of rivet. Afterwards we catch a cab to the PANORAMABAR to oversee the lighting and hanging of his art. His feelings towards the nightclub are affectionate and sincere. He was last in the PANORAMABAR for New Year's Eve, where he observed and participated in a 36-hour party and noticed a man napping, mid-afternoon, on a banquette with the music, lights and detritus of the nightlife pulsing around him.

The PANORAMABAR and BERGHAIN were founded five years ago, metamorphosing from the lawless club OSTGUT. For the opening, WOLFGANG installed in the PANORAMABAR two abstract images and a portrait of a vagina. The new pictures are two enormous abstract paintings with light and a visceral but oddly poetic portrait of the backside of a man bent over, revealing his open anus. "It is the last taboo," he says.

In 1998, WOLFGANG began experimenting in the darkroom with exposure and light, moving away from photography into something less certain. He showed his first set of abstracts in 1998, a series of 60 prints titled PARKETT EDITION, dated 1992–1998. It was a radical and significant shift in his art, away from his signature ability to find the extraordinary in the ordinary through his camera. The abstractions moved his art into a whole new realm of visual language. He began his ongoing series of PAPER DROP studies in 2001. "The name came from the hanging and falling shape of the first ones," he says. "Only in 2005 did I start the horizontal type where the paper actually resembles a drop shape. So the title became a self-fulfilling prophecy."

When he presented the three new art works to be hung in the PANORAMA-BAR, its owners, Mr. NORBERT THORMANN and Mr. MICHAEL TEUFELE, unfettered libertines, responded with the words "The arsehole is perfect!"

While we are still in the nightclub, just after 6pm, WOLFGANG smokes a cigarette. We dine that night at a corner restaurant called the OPPENHEIMER CAFE and we talk almost immediately about being from a generation of gay men that grew up in the '80s under the morbid suspicion that one's sexuality might also result in one's death, and what a curiously unsettling perspective that afforded youths. For extended periods of time during his teen years, WOLFGANG would sit in his bedroom just being angry, listening only to JOY DIVISION. Some of his pictures of cloth and worn clothes have mistakenly been associated with the idea of loss and emptiness, and as a comment on AIDS. In fact, the opposite is true. WOLFGANG likes the association with bodies, the intimacy of clothing just shed.

Over dinner he says, "My ultimate, ultimate truth is that ultimately I don't know. People pretend that they do. My fundamental understanding is that I might always be wrong. I may be assured or confident, but I could always be wrong. I think that's probably one of my biggest strengths, that I don't fear failing. Or that

I know that the fear of failing is a huge inhibitor. So many people don't achieve what they want to achieve because they are too precious about losing face in the short term. And so, for example, with photography as a medium, you have to be embarrassed sometimes. When you ask someone to sit for you, that moment always includes the potential for rejection. If you can't handle rejection or you just want to avoid rejection at all costs, you are not taking the risks that make good pictures."

He recounts two stories about early personal failures and humiliations. In the first he is 13 years old, volunteering to give a talk at a local fair about his first obsession: astronomy. WOLFGANG had just learnt about stars and believed himself to be equipped to talk on the subject. When it came time to give his talk, his projector failed and he couldn't speak; he left the stage acutely embarrassed. The second took place at college in Bournemouth. In an attempt to nourish one of his early ambitions of becoming a rock star—"more of a MARC ALMOND-type synth star, actually"—he offered to be the singer in a band at the graduation ball for the class ahead of his, only to find out on the night that he could not sing in time or in tune. "These incidents vaccinated me against failure. As a 19-year-old, having just done my A levels, I moved to a big city, Hamburg, and within a few months I approached a respectable artists' cafe, the GNOSA, about showing my work there. To make these photocopies and to really believe this is art was wonderful... It could've been equally embarrassing if they had been bad. It probably seemed a little mad to people that I had this drive and this belief that the work was good and that it mattered. And that somehow if this mattered to me, there might be some relevance in it to the outside world."

After dinner we return to the studio. WOLFGANG studies the scale model of the New York exhibition for another three-quarters of an hour. He is still somehow perturbed by ROY, the picture of the baby in the car seat. "What is it now? Have I only just discovered babies? Parenting?" He blanches at the idea. "There is always a disconnect for me with straight men. I never feel the same. I think there is a fundamental difference. It's almost like there are men and women and then there are gays. I don't believe so much in just a gradual 'Oh, we're all just different shades of grey.' I think there is something that I have felt from very early on that is very different from the straight world that I grew up in."

He replaces the baby picture with a shot of a group of motorcyclists standing on a Berlin street, in full, garish and slightly ghastly techno leathers. He turns to me after he has made the switch. "You liked the baby," he says. I say nothing. It is past midnight.

LONDON

Back in his London studio, Professor WOLFGANG TILLMANS offers an academic-sounding theory of success: "I hadn't necessarily predicted my success,

but it has never surprised me and it always seems to come at the right time. I have always felt a sense of purpose, that I had something to say and that I wanted to say it. That if in a certain phase I believed in something very deeply, then there might be 50 per cent of the population that might possibly relate to that. And if only five per cent actually do relate to that, well, that is a lot. One usually thinks of success or fame in a 100 per cent kind of way but that is not at all right. It's quite amazing if you even manage to speak to one per cent. Speaking to five per cent does not seem like hubris. You must always remember that BEING BORING was only ever number 20 in the charts and that BLUE MONDAY was only number eight in the charts; there were seven songs that were deemed more successful at the time. If you can really touch a small number of people, I think that that is a more meaningful success than being one of the three or four artists that are in the press all the time. In the last ten years or so I have dropped out of that, because it's so uninteresting. I have become less and less interested in the idea of mainstream success. It comes at a cost: you also have to compromise on the art side. What is talked about in the EVENING STANDARD is maybe not what is considered really important in other places. That kind of success requires upkeep and maintenance. Winning the TURNER PRIZE is one of the few experiences where an artist gets close to feeling famous in a real-world sense, rather than an art-world sense. In the days after I won the TURNER PRIZE it was slightly unreal how people would discuss my work."

The day after WOLFGANG won the prize in October 2000, the DAILY TELEGRAPH headline ran: "Gay Porn Photographer Snaps up TURNER PRIZE", predating by a full four years the DAILY EXPRESS headline: "Booker Won By Gay Sex", in reference to ALAN HOLLINGHURST's victory for his novel THE LINE OF BEAUTY.

WOLFGANG remembers that the public reaction to his win was more sensitive. "The day after I won the prize, I stepped out of the house and a cyclist drove past shouting, 'Congratulations'. Then the newspaper agent knew me and suddenly I was literally recognisable in the street. People would stop me and say they had seen me on TV last night. Within seven days it had diminished to a quarter of the number of people saying it and within a month it had gone back to the five per cent. I realised that in order to be famous you probably have to be in the media three times a week on a continuous basis. There was no reason to continue that. There was nothing driving it. That whole experience happened once, I never asked for it again and it somehow drifted away."

This summer, WOLFGANG has a major exhibition at the SERPENTINE GALLERY in London. He last showed in his adoptive hometown at MAUREEN PALEY in 2008. "After the last show I had with MAUREEN, there was a piece in a newspaper saying that I was making a comeback. In the previous eight years I

had had ten major museum shows around the world. So the hours that I put into the show in New York or into whatever I do are always for the very small audience that I imagine. I almost have a handful of people in mind that I am doing this show for."

It is important to WOLFGANG that his confidence in his success not be mistaken for certainty — about anything. "My work is about doubt," he repeats. "I think that's really where it is at. The people that I feel touched by or care about or who interest me usually have an inherent sense of doubt and uncertainty about who they are and what the world is. They have retained a kind of flexibility in their head, not shutting down but being open about their fears and uncertainties. Even though of course I might come across as self-assured, I fear nothing more than losing a sense of uncertainty and doubt about myself. I am really most mindful of that. The moments where I recognise that I have lost track of that are moments of real tragedy for me."

NEW YORK

It is Friday, the day before the exhibition opens, and WOLFGANG arrives at the gallery of his New York dealer, ANDREA ROSEN, at 11am. Tuesday he had been at the gallery until 4am, Wednesday until 5am, and yesterday until 1am, giving himself a break to attend one of the regular parties held by the photographer Mr. RYAN McGINLEY in Chinatown. He is a little hungover; nothing that a power-nap at 7pm won't solve.

He is clearly loved by the gallery staff, not just for his art, but for who he is. "It's the exhibition that you always look forward to," says ROSEN's right-hand woman, BRONWEN. WOLFGANG says that he always assumes people are on the same side, a surprisingly rare attitude in artists from any medium. The tenderness of his art, even when the subject matter is profane, comes directly out of the behaviour of the artist.

It is only when faced with the reality of the gallery that I understand the significance of the scale models and the hours spent in preparation for the show. WOLFGANG has spent three days and nights taping to the wall the exact final cut of the exhibition, and now two technical staff at the gallery are helping him with the precise measurements for taping the pictures to the wall.

I watch WOLFGANG's body contort into unusual shapes as he unravels pictures from a stepladder. He almost becomes one with them, copying the paper's curve with his spine as the image is slowly revealed. He instructs the men in the studio to hold the photos only by the corners, between their forefingers and thumbs. The tape he uses to hang his pictures is made by TESA, a German brand he imports especially. Theirs are the only tape dispensers without serrated blades; they create a clean, finite cut.

When he started exhibiting, there were two major misconceptions about

WOLFGANG's work. "People thought it was a grungy gesture to tape them up," he says, adding categorically: "It was not." The other was that, because there was an intense air of reality to them, they were simple snapshots. In fact, his work has always been a mix of the staged and the unstaged.

When he notices diagonal lines across two adjacent pictures, he questions their positions next to one another. Ms. ANDREA ROSEN is with him. "I don't think that people looking at your work think you make these formal decisions," she says. As small but intricate changes happen to the structure of the show during the day, ANDREA is displaying some half-comic concern about a still life of faeces in grass, called SCHEISSE, hung at knee level.

ANDREA has been WOLFGANG's East Coast US dealer since 1993, when she and two other prominent New York interests courted the artist. She was first alerted to his work after receiving an invitation to his second solo show in Cologne. The picture on the invite was one of WOLFGANG's most immediately eye-catching and iconic gifts to the contemporary art culture: ALEX IN THE TREES. It was enough for ANDREA to board a plane to Germany and then follow the artist to his home in London, eventually winning his trust.

Now, in the foyer of her gallery, the baby in the car seat is back as the first picture of the show. On a right-hand wall of the foyer is the only framed piece in the exhibition, showing the decadent nighttime at OSTGUT, intertwined with pictures from churches. It is called OSTGUT/DECEMBER EDIT. "They were made in a very intense and passionate time of my life," he says.

Early in his career, WOLFGANG had distinguished himself from the then vogue-ish Brit Art conglomerate by choosing specific mediums other than art galleries to display his art. Because some of his work appeared in style magazines, most particularly in i-D, he was mistaken by the British art media as a jobbing portrait and club photographer. The major art territories of Paris, Cologne and New York had no problem with his work appearing in magazines, as it occasionally still does.

Some of WOLFGANG's New York collectors insist on seeing the new show before the public opening the next day. There is mention of Mr. MARIO TESTINO popping by before he leaves the city. A gentle conga line of interested parties interrupts the afternoon's hanging, and WOLFGANG talks each one through the show. With each interested party he is patient, attentive and affects a pleasantly passive position. There is a fascinating intimacy to this exchange between artist and collector. Everything up to the point of sale is foreplay, on both sides, prior to the satisfying union of passing a piece of art from the creator to its new home.

At one point the traffic in the gallery heats up as an art consultant arrives with her client and a small child, perhaps five years old. But suddenly the client has to leave, as her husband is trapped in the restroom of his favourite restaurant. "Have

they called the fire department, even?" she asks when he calls her on the phone. Another collector is an impressive man with a booming voice, a side-parting in his hair and heavy-framed spectacles, who is sitting in ANDREA's office at the back of the gallery and telling WOLFGANG enthusiastically what he likes about the latter's work. "You see the whole world," he says, his voice amplifying with every statement. "Vice, technology, sex, nature. It's about everything spinning in front of your eyes. The thing is, in this world, everything is spinning out of control. There is a madness to the whole world. You are capturing the madness of this world."

At 4.45pm, the singer Mr. MICHAEL STIPE arrives with his boyfriend, the photographer Mr. THOMAS DOZOL, and STIPE kneels involuntarily prostrate in front of the picture of the techno bikers, which is now positioned in the second room. DOZOL takes his portrait from behind. STIPE wows openly at the exhibition. "It is deep. It is moving, which people need right now." A pause. "By the way, ANDREA told me not to tell you that she told me to tell you to lose the poop." The first sale is made at 5.14pm to the man who was trapped in the toilet.

When sleeving some of his work in the suite of offices at the rear of the gallery, CRETACOLOR 7B pencil in hand, WOLFGANG notes that no one who has seen the exhibition seems to have found any of it funny yet. "Look, WOLFIE," says TAMSEN, one of ANDREA's staff, "I am not going to stand in front of one of your pictures and start laughing, and then find out that it is the one you consider to be the most meaningful in the exhibition." The staff at the gallery adore him. All the women call him WOLFIE. As an aside, WOLFGANG notices the distinction between the male and female members of staff at ANDREA ROSEN. All the men, bar one, are engaged in manual labour and technical activities; the women are all at desks.

When I ask him later about his relationship with his own masculinity, he says, "It of course depends on what one sees in the word masculine." And then: "I don't want the work to be hard. I can play with hardness and I like to play with images of hardness and masculinity and dress, but I never want to be hard. You know I see myself as gentle, which isn't in contradiction with masculinity."

There is a light interchange between the artist and some of the staff as they prepare to leave. When WOLFGANG asks ANDREA, "Are you going to wear your brown leather catsuit tomorrow?" his mouth and head upturn into one of his great smiles. She flips back, "I promise you I'll fit into it by the SERPENTINE," referring to his forthcoming London show. WOLFGANG will not leave the gallery until 4am.

It is 1pm on Saturday, five hours before the opening of his show, and I meet WOLFGANG in the lobby of his hotel. He is wearing an EVERLAST tracksuit top, jeans and trainers, and has clipped his own hair. He asks if the line around his

head is even. It is. "Oh, super." "Oh, super" seems to be something of a catch-phrase for the artist. In the time we've spent together, I've often heard this casual affirmation.

We wander around art galleries, starting at GAVIN BROWN'S ENTER-PRISE in Greenwich Village, where the artist SILKE OTTO-KNAPP, whom WOLFGANG knows, has a new collection of watercolours on display. Walking into an art gallery with an important artist presents its own peculiar dynamic. In every space we enter there is a sly little confirming nod from the receptionist. Someone always wants to speak to him. Because his disposition is kind and interested and he sets up the tone of his conversation in this way, he almost forces the people he happens upon to respect the pleasantry. In company, WOLGANG possesses the quite incredible natural duality of having the impeccably good manners of a shy person while not being remotely shy.

At REENA SPAULINGS FINE ART in the East Village, a woman cannot believe that he could be so casual as to stroll around galleries on the afternoon of his opening, as if perhaps he should be sat in the empty gallery, fretting. "I am unusual among artists," he tells me, "in that I like other people's art. I am inter-ested in it."

At his own opening, what WOLFGANG calls his "grin muscles" are lively and active. He is a diligent if unassuming host. He takes a glass of champagne with the gallery staff at 5.45pm and by 6.15pm the trickle of excitable patrons has turned into a full gallery of admirers despite it being the coldest night of a biting New York winter. The attendees of a WOLFGANG TILLMANS gallery opening in New York are an interesting mix of downtown and up. WOLFGANG refers to the opening as like being caught in the frame of a WOODY ALLEN movie. A succession of erudite New Yorkers offer their verbal applause.

If an opening is the direct reflection of the artist it celebrates, he should be thrilled with his. Boys in anoraks and outsized boots, wearing an air of concerted deliberation and occasional restlessness, rub shoulders with prominent art-world powerbrokers from MoMA. The age, race and gender mix is impossible to pin-point. At one point Mr. JOHN WATERS turns up and blends seamlessly into the evening's demographic.

The opening is followed by a dinner at INDOCHINE, a restaurant with particular significance for both WOLFGANG and ANDREA. When WOLFGANG used to come over to see ANDREA in the early days of his international career, she would take him to dine at the ASTOR PLACE Restaurant, which was an old WARHOL favourite just prior to his death. As well as marking WOLFGANG's opening, the meal is also to celebrate the 20th anniversary of ANDREA's gallery.

The dinner progresses from the civilised to the raucous the more the wine flows. I sit between two of WOLFGANG's collectors, one who owns two popes by

FRANCIS BACON, and another who has just bought 25,000 square metres of real estate upstate, where he intends to set up an art foundation. WOLFGANG begins the night seated at our table. The collectors are amicable men, passionate about modern art, a lawyer and an MD, simultaneously able to crumble and affirm the fabulosity of the New York art set.

Between them, WOLFGANG and ANDREA manage an effortless waltz amongst the diners. At certain moments you can see them beaming at one another, her with her immaculate New York finesse, him with his inviting northern European bluffness.

I ask the collector seated directly opposite me whether he liked WOLFGANG's new show.

"Yes, there is important work there," he responds.

Were there any pictures that he considered particularly important?

"Yes. The baby in the car seat when you just walk in."

I find WOLFGANG TILLMANS at 1am, sitting on someone's knee, drunk and laughing. He will go on to THE BOILER ROOM, an East Village gay bar, and only leave there at 3am.

"Not a *very* late night," he later says.

Mr. STEVE McQUEEN

Featured in issue n° 6 for Autumn and Winter 2007

English artist and filmmaker STEVE McQUEEN appeared in the magazine in 2007, several years after his TURNER PRIZE win in 1999, but just ahead of his triumphant entry into the movie firmament with the film HUNGER in 2008. STEVE followed that debut with SHAME (2011) and 12 YEARS A SLAVE (2013), the last of which won the award for best film at the OSCARS, the BAFTAs and the GOLDEN GLOBES.

Growing up in west London, STEVE moved to Amsterdam in the late 1990s to be with his future wife, the writer BIANCA STIGTER. He remains in the Kingdom of the Netherlands, resisting the lure of Hollywood, although in an interview for the RADIO 4 programme DESERT ISLAND DISCS he did admit to being bowled over by an encounter with PRINCE at MADONNA's OSCARS party. As well as PRINCE's RASPBERRY BERET, STEVE's choice of music on that show included MICHAEL JACKSON's ROCK WITH YOU, THE SPECIALS' TOO MUCH TOO YOUNG and KATE BUSH's THIS WOMAN'S WORK.

Portrait by Viviane Sassen

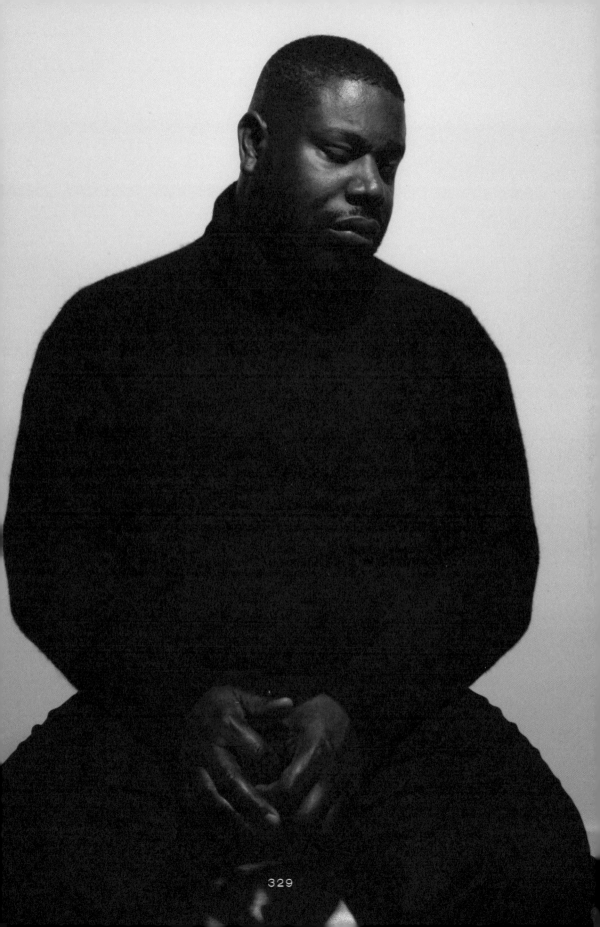

Mr. JONATHAN ADLER

Featured in issue n° 2 for Autumn and Winter 2005

FANTASTIC MAN dubbed the American interior designer JONATHAN ADLER "the prince of the polo shirts and pottery." Not just any polo shirt: JONATHAN was photographed for the magazine wearing several iterations of his signature look: a vintage LACOSTE shirt, short or long sleeved, LEVI'S cords or slim, flat-fronted khakis and a ROLEX watch. "Basically it's the same look I've been wearing since my Bar Mitvah," JONATHAN said. "There's an element of feel-good nostalgia to my LACOSTE fixation. It takes me back to tennis camp. I'm a bit of a closet sporting enthusiast — there, I said it. I play squash and, um, tennis. So I personally like the fact that LACOSTE is not too sexy. More preppy and sporty." JONATHAN guessed he had more than 80 such shirts.

In terms of pottery, JONATHAN launched his first ceramic collection at BARNEY'S in 1994 and has not looked back since. He now has 26 shops around the world and a thriving e-commerce site that carries a huge array of items including a ceramic peacock lollipop holder for $98. JONATHAN also publishes books on interior decoration under titles such as 100 WAYS TO HAPPY CHIC YOUR LIFE and MY PRESCRIPTION FOR ANTI-DEPRESSIVE LIVING. In 2008 he married his long-term boyfriend SIMON DOONAN, the creative director of BARNEYS New York. They have homes in Greenwich Village, Shelter Island and Palm Springs.

Portraits by Roger Deckker

331

Mr. MATTHEW SLOTOVER
Featured in issue nº 15 for Spring and Summer 2012
Portraits by Alasdair McLellan
Text by Caroline Roux

Mr. SLOTOVER

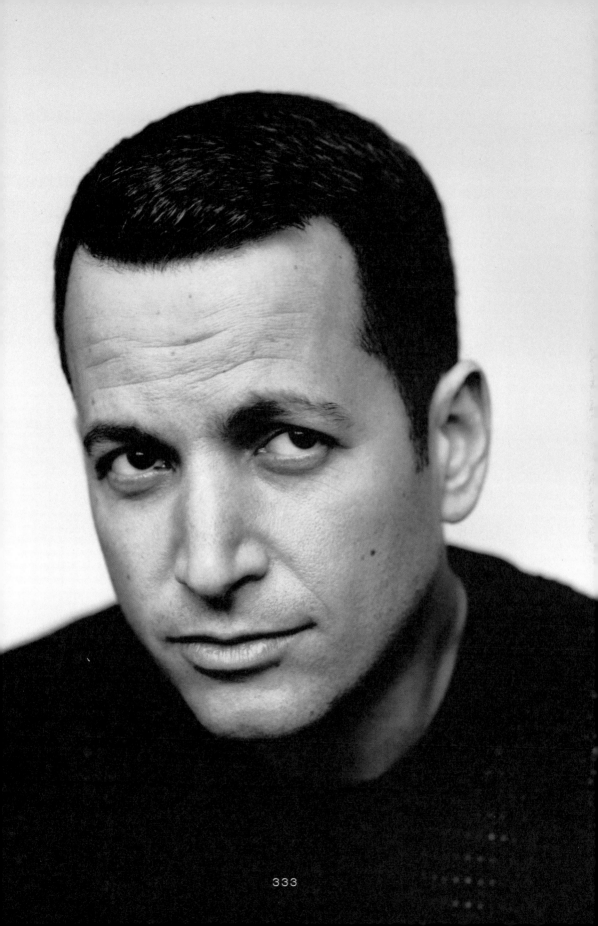

As the founder of FRIEZE magazine and the co-director of FRIEZE ART FAIR, MATTHEW SLOTOVER has already changed the cultural landscape of the United Kingdom, bringing the contemporary art market to his hometown of London and redefining how the Brits see modern art. Mr. SLOTOVER is about to attempt the same in the United States, with the launch of FRIEZE NEW YORK in a city still struggling with the contemporary art fair phenomenon. It's a big leap, but Mr. SLOTOVER and his colleague Ms. AMANDA SHARP have the charm and the patience to pull it off. Mr. SLOTOVER is a supremely friendly man, always happy to chat, even when in the midst of multimillion deals. He's also a great cook and an ardent fan of the pop group THE SMITHS.

MATTHEW SLOTOVER is sitting in LEILA'S, a café in Shoreditch, east London, known for its Polish sausages and excellent coffee. It is close to the headquarters of FRIEZE, where Mr. SLOTOVER is founder of FRIEZE magazine and co-director of the FRIEZE ART FAIR. He is dressed in a cute green COMME DES GARÇONS sweater, chinos and replica trainers by MAISON MARTIN MARGIELA ("art world standard issue," he says). He's talking about how the reaction of everyday Londoners to contemporary art has changed. "You don't have that conversation with a London taxi driver anymore about what a load of crap contemporary art is," he says. "They'll say: 'I went to TATE MODERN the other day. I quite liked some of it, and there was one piece I really liked.' In fact, I had a driver the other day who'd noticed that there's a bit of road in Gray's Inn Road near King's Cross where the leaves stick to the tarmac, and in the autumn this section turns red. Apparently it's to do with the newer tarmac that has a non-slip surface on it — that's why the leaves stick. Anyway, he said, 'I could take a picture of that and call it art.' And I thought, 'You're right, you could.' We've really come a long way."

Though all soft-spoken charm, winning smiles and a handsome, unlinedface — Mr. SLOTOVER is, at 43, one of the major engines behind the British public's newfound acceptance of contemporary art and London's increasing art-world importance. Casual, modest and self-effacing as he might appear to be, Mr. SLOTOVER is a mover and shaker. He is an art-world legend in his own lifetime, as much for his unflappability as for his crystal vision. In 1991, when other contemporary art magazines were doing the dance of death, along came Mr. SLOTOVER with a new magazine — filled with white space, lightly seriffed type and emerging talent — called FRIEZE. It was an immediate success. In 2003, with his childhood friend AMANDA SHARP, he pulled off the ultimate coup of launching an art fair, also called FRIEZE, that North American galleries wanted to take part in and classy European collectors added to their social calendar.

FRIEZE week now transforms London. Each October, it is impossible to get a taxi or a hotel room for the duration of the fair, and don't even think about booking a table at SCOTT'S, THE WOLSELEY or any other restaurant with an art-based clientele. Stores from DOVER STREET MARKET and SELFRIDGES to the chic boutiques of Mount Street see peaks in profits. There are parties all over town, the most important of which is, of course, the one FRIEZE puts on itself. The fair is also a huge popular success: in 2011 it attracted 60,000 visitors over four days. "FRIEZE has really changed the cultural landscape, too," says SARAH THORNTON, a sociologist and author of SEVEN DAYS IN THE ART WORLD, a best-selling account of the art market. "If you're interested in emerging art there is no competition. It's a proper big fair that focuses on the new and the avant-garde."

There are two key indicators of the FRIEZE duo's rising power, both within the art world and in a wider context. In the most recent ART REVIEW POWER 100, Mr. SLOTOVER and Ms. SHARP ranked 24th, just below MARINA ABRAMO-VIC, who was up from 41st in 2010. Rival fair ART BASEL was 20th. And then, at the beginning of the year, both Mr. SLOTOVER and Ms. SHARP were made Officers of the Order of the British Empire (OBE), their names appearing on the New Year Honours List, which commemorates achievements by British citizens. "They send you a photocopied letter in November asking if you'll accept," says MATTHEW. At time of writing, he was due to receive his OBE from a member of the Royal Family on 14 March at Buckingham Palace.

Now, Mr. SLOTOVER and Ms. SHARP are about to discover whether they can have the same effect in the United States. This May, in the same week as the contemporary art auctions at SOTHEBY'S and CHRISTIE'S and the COSTUME INSTITUTE GALA, they are launching FRIEZE NEW YORK, a mirror version of the London event, for a city that has so far struggled with the international art fair boom. While London has FRIEZE and ART BASEL has events in Basel, Miami and now Hong Kong, no one in New York has yet succeeded in luring the world's galleries to show the best in contemporary art to dealers, collectors and, most importantly, the increasingly art-hungry general public.

With FRIEZE NEW YORK imminent, it was inevitable that I bumped into MATTHEW at ART BASEL MIAMI last December. He was wandering the aisles of the art fair with his usual understated presence (chinos, A.P.C. T-shirt). He was accompanied by his wife, the writer and curator EMILY KING. "I'm off-duty," he said, when our paths coincided somewhere between MATTHEW MARKS and GAGOSIAN during the early afternoon of the opening day. "Well, semi-off-duty." He is a public figure in this context, and besides it's never the wrong moment to charm a gallerist, a collector or, indeed, a journalist. He was making slow progress, keeping all those people happy. Miami, during the art fair, is overrun by fashion-sponsored dinners (BALLY, LANVIN and PRINGLE OF SCOTLAND were among the houses wooing the art crowd this season), but MATTHEW had been staying close to the art world. "I went to the WHITE CUBE party at SOHO BEACH HOUSE last night, there's a dinner held by a Mexican gallery in a collector's apartment tonight, and the ARTFORUM dinner at the WOLFSONIAN tomorrow," he said of his schedule. ARTFORUM, North America's major art publication, had surprised him. "Far from behaving like a competitor magazine, they're very excited about us coming to New York with the fair," he said.

MATTHEW lives with EMILY (who contributes to this and other maga-zines and has a doctorate in typeface design of the late 1980s and early 1990s) and their three teenage daughters in a four-storey house in Camden Town, north

London. His is not the life of the billionaire art collectors he services with his art fairs. "I've bumped into him a few times cycling to work in his helmet," says JAMIE FOBERT, the London-based Canadian architect who was responsible for the design of SELFRIDGES gargantuan shoe department and who designed the FRIEZE tent in 2006 and '07. "I like the fact that he's an art world wheeler and dealer who cycles to work from his family home." Mr. FOBERT also mentions a recent dinner held by the SERPENTINE GALLERY to celebrate the opening of an exhibition of the work of LYGIA PAPE, at which MATTHEW was sat on his left. "He got out his iPhone and started showing me pictures of his children. He's a very proud father," he says. When he isn't on two wheels, he drives a black TOYOTA PRIUS.

The FRIEZE empire, to which he cycles daily, is now nearly 50 staff strong and run from an airy office perched on top of the ROCHELLE SCHOOL studio complex, just round the corner from LEILA'S shop and café. The former Victorian school is owned by JAMES MOORES, heir to the enormous Liverpudlian LITTLEWOODS POOLS fortune, and he likes to keep it filled with creative companies. GILES DEACON and LUELLA BARTLEY have both had spaces there. Artists GOSHKA MACUGA and GILLIAN CARNEGIE, both previous TURNER PRIZE nominees, are among the current tenants. FRIEZE arrived in 2010, moving into its new, custom-built rooftop addition by local architect LAURENCE QUINN. The offices, which are wrapped around a central courtyard, are spacious and filled with uniform desks designed by MATTHEW with help from Mr. QUINN. "I love this stuff," says MATTHEW, who spends quite some time examining the joining system of his favourite VITRA examples.

Last year saw the publication of the 100th edition of FRIEZE magazine — no mean feat in a climate that hasn't been kind to print publishing of late. Its circulation currently stands at 25,000, divided equally between the UK, the US and the rest of the world, and its website receives around 100,000 visitors a month. There are satellite FRIEZE offices in Berlin, where a German edition of the magazine is made, and New York, to manage the new fair. Over 160 galleries have already signed up to take part in FRIEZE NEW YORK. Meanwhile in London this October, alongside the usual razzmatazz of the FRIEZE ART FAIR, FRIEZE MASTERS will appear for the first time: a new fair presenting everything from antiquities and old masters up to works from the last century. "What we're really excited about, actually," says MATTHEW about FRIEZE MASTERS, "is mixing the old masters up with 20th century. Because when we started FRIEZE, you know, historical art was the thing, in the museums and homes and for collectors. And no one was interested in contemporary art. Now it's almost gone the other way round."

This brand expansion is not, insists MATTHEW, so much about empire

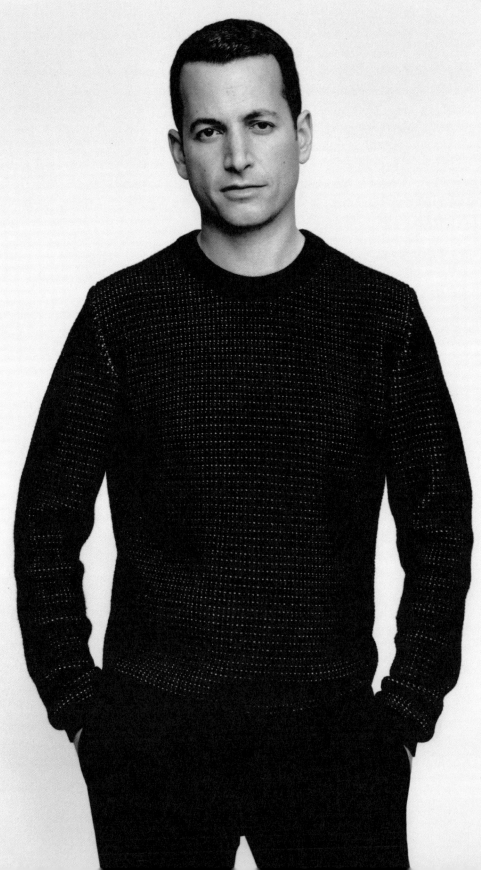

building. "It's about keeping ourselves excited," he says with such enthusiasm that it's easy to forget that running an art fair is about more than just putting on a show and having a passion; it's very big business. Gallerists who are lucky enough to get through the selection process pay £320 a square metre in London and $720 in New York. The average booth is 50 m². Multiply that by 160. Then there's the sponsorship from DEUTSCHE BANK, among others. And then there are ticket sales: full-priced on-the-day entry was £27 in 2011. You get the idea.

MATTHEW grew up in one of the very smartest stuccoed parts of London, though he hates to admit such a thing. The household was a cultured one. His father, ROBERT, is an agent for classical musicians — HARRISON BIRTWISTLE and STEVE REICH are among those on the company roster. His mother, JILL, worked as a children's book editor and reviewed children's books for the FINAN-CIAL TIMES.

MATTHEW, who had the typical teenage boy's obsession with pop music (and most especially THE SMITHS), could never get his father on his side. "He thinks that all pop music's rubbish," he says. "He saw BJÖRK, whom we would regard as the most intelligent and experimental of contemporary pop artists, talk to STOCKHAUSEN, whom my dad represented and whom she loves, and he said all the questions she asked him were just completely... oh, maybe we shouldn't go there. He thinks that even the most intelligent pop stars don't really engage with the contemporary classical music that they love in a very knowledgeable way."

The young MATTHEW wanted to be a designer. "I remember being taken to Paris, and taking loads of pictures, on an INSTAMATIC camera, of the POMPIDOU. I really loved it," he recalls. "I remember walking down a very old street and seeing all the POMPIDOU's coloured pipes — the contemporary archi-tecture next to the old architecture — and I just thought it was amazing." The ambi-tion was quickly curtailed by his failure to get onto the "O" level art course. "You had to submit a sort of audition piece. So I did a pencil drawing of my hi-fi stereo, which for a 13-year-old boy is the most important thing in your life," he says. "In retrospect I think it's a really honest piece of pop art. And okay, my lines are all terrible and everything, but conceptually I think it was quite valid!"

Art apart, MATTHEW's academic career was an impressive one. At the prestigious St Paul's Boys School in Barnes, west London, he took his "O" levels at age 14 and his "A" levels at 16 (students who take these exams are usually 16 and 18 years old, respectively) and went to Oxford at 17 to study psychology. "I was, in retrospect, probably a bit too young still. It was quite hard to be taken seriously by girls at that age." I mention that he still looks young. "My mum looks young, my daughters look young. There's definitely a young thing going on." He also always looks impeccably groomed. "That's thanks to GUY HEALY," he says, referring to his hairdresser. "He does everyone — ANGELA BULLOCH, MATT

COLLISHAW, MICHAEL GRANDAGE." The first two are artists; Mr. GRAND-AGE is a theatre director who has just completed a ten-year run as director of the DONMAR WAREHOUSE, London's most vaunted small-theatre space. As well as a hairdresser, Mr. HEALY is also something of a swap shop. "I give him FRIEZE tickets for the head of something at SONY," MATTHEW says, "and he helps me get seats at the DONMAR."

MATTHEW began to get interested in art when a friend from his teenage years, freshly enrolled at Central Saint Martins, started taking him along to exhibitions in 1989, the year MATTHEW graduated from Oxford. "I saw DAMIEN HIRST's shows MODERN MEDICINE and GAMBLER — that's when he first showed the cow's head being eaten by maggots — in BUILDING ONE, an old biscuit factory in Bermondsey. And then, in 1991, his BUTTERFLY show in Woodstock Street. There was MICHAEL LANDY's MARKET show at BUILDING ONE too," he says. By this point, MATTHEW had begun an evening course in magazine production at the London College of Printing. MATTHEW, who hitherto had devoured the music press with the forensically geekish zeal his friends say he applies to all his interests ("The NME was my bible. I still have every issue from 1982 to 1989," he says of the NEW MUSICAL EXPRESS, the British weekly music paper that was then in its heyday), started looking for the same kind of information on the art world. The magazines he dipped into — ARTSCRIBE, ARTFORUM, FLASH ART — were inaccessible, and he says, "at that time poorly written and badly designed." For someone brought up on THE FACE and BLITZ, which carried a very engaging art column by ANDREW RENTON (the first person to document the 1990s rise of British art in his book TECHNIQUES ANGLAISES), there was clearly a gap in the market.

"So MATTHEW had this stupid idea to do a magazine," says Ms. SHARP, the childhood friend who joined forces with MATTHEW just after the launch of FRIEZE's pilot issue. We're speaking on the phone, as she is based in New York where she's now lived for 13 years. "We'd talked about doing a restaurant before, but that's pie in the sky when you don't have oodles of money." MATTHEW enlisted the help of the artist TOM GIDLEY on the editorial side and persuaded the then designer du jour, TONY AREFIN, to come on board. His parents lent him the £1500 he needed to get it started. A 36-page pilot issue was launched in summer 1991, with a HIRST butterfly on its cover and what must have been a hefty cover price of £3. It contained articles on the artists CHRISTIAN BOL-TANSKI, ANGUS FAIRHURST and, rather erroneously, ALBERT IRVIN. "DAVID BATCHELOR (the influential Scottish artist) still takes the piss out of me for that," sighs MATTHEW. "I mean, BERT IRVIN is a pretty good abstract painter, and I just liked the work, and I thought: 'Oh, we should put it in.' But I

continued on page 357

Archive (III) — GRAND STILLS
Exquisite arrangements, pictured perfectly

WHOOPS! — Blue ballpoint ink on the pocket of a white cotton Oxford shirt is an everyday disaster that can be put right with the aid of dry cleaning. Photographed by Zoë Ghertner for issue nº 19, Spring and Summer 2014.

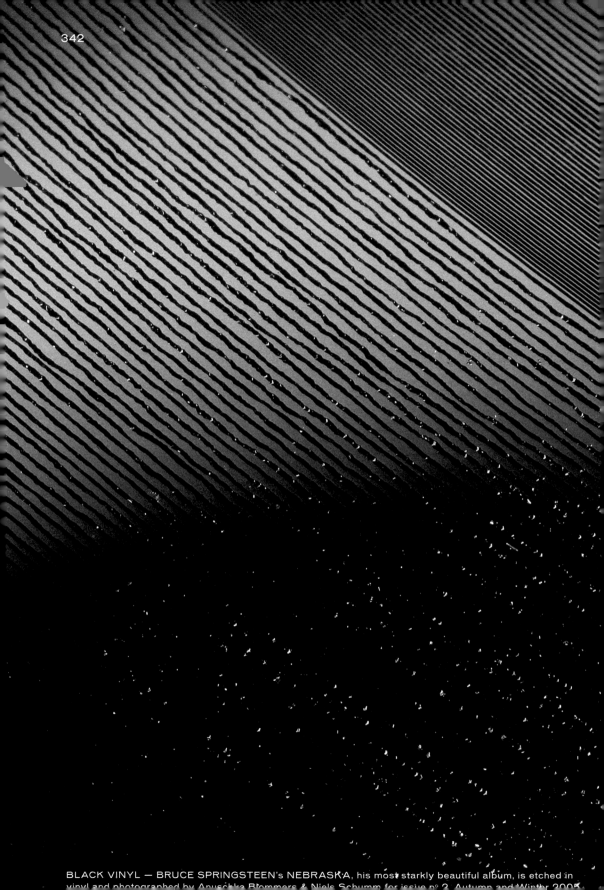

BLACK VINYL — BRUCE SPRINGSTEEN's NEBRASKA, his most starkly beautiful album, is etched in
vinyl and photographed by Anuschka Blommers & Niels Schumm for issue n° 2, Autumn and Winter 2005.

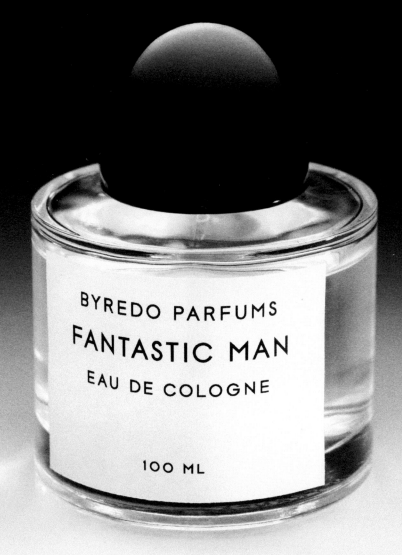

THE GENTLEMAN'S COLOGNE — FANTASTIC MAN's very own eau de Cologne makes its delicious debut in issue n° 9, Spring and Summer 2009. Concocted with BYREDO PARFUMS, its top notes are bergamot, cardamom and star anise.

PHOTOGRAPHY — A roll of KODACHROME 64 Professional Film is memorialised by Anuschka Blommers & Niels Schumm in a celebration of analogue photography for FANTASTIC MAN's first issue, Spring and Summer 2005.

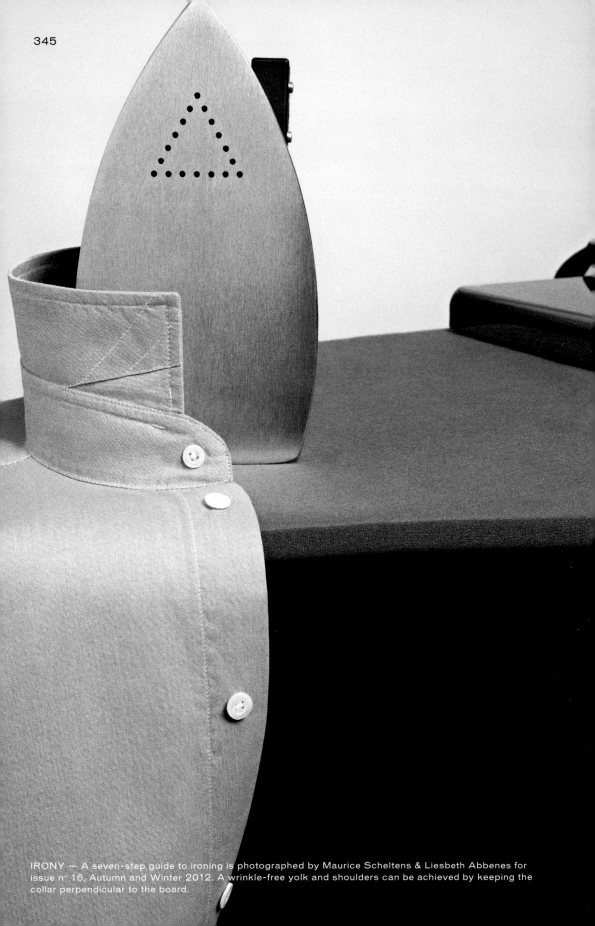

345

IRONY — A seven-step guide to ironing is photographed by Maurice Scheltens & Liesbeth Abbenes for issue n° 16, Autumn and Winter 2012. A wrinkle-free yolk and shoulders can be achieved by keeping the collar perpendicular to the board.

THE ART OF SMOKING — The centerfold of a story devoted to that endangered species, the smoker, is this smouldering cigarette, as photographed by Anuschka Blommers & Niels Schumm for issue n° 3, Spring and Summer 2006.

BLUE STUDY — Midnight blue suiting that's nearly black and the sky blue knit detailing on a cardigan are among the beautiful blues photographed by Maurice Scheltens & Liesbeth Abbenes for issue n° 13, Spring and Summer 2011.

SHIRT — The perfect understated white shirt is a timeless wardrobe ideal, photographed by Maurice Scheltens for issue n° 5, Spring and Summer 2007.

PACKING — Precious clothes can be protected in transit by alternating garments with layers of tissue paper. Useful transporting techniques are photographed by Maurice Scheltens for issue n° 7, Spring and Summer 2008.

PRESSE PAPIER — An elegant paperweight is the working desk's only extravagance, as photographed by Zoë Ghertner for issue n° 14, Autumn and Winter 2011.

DUTCH EARRING — Auricular adornments of this ilk, photographed by Bart Julius Peters for issue n° 8, Autumn and Winter 2008, are a wardrobe staple of the man of the small Dutch fishing village called Urk.

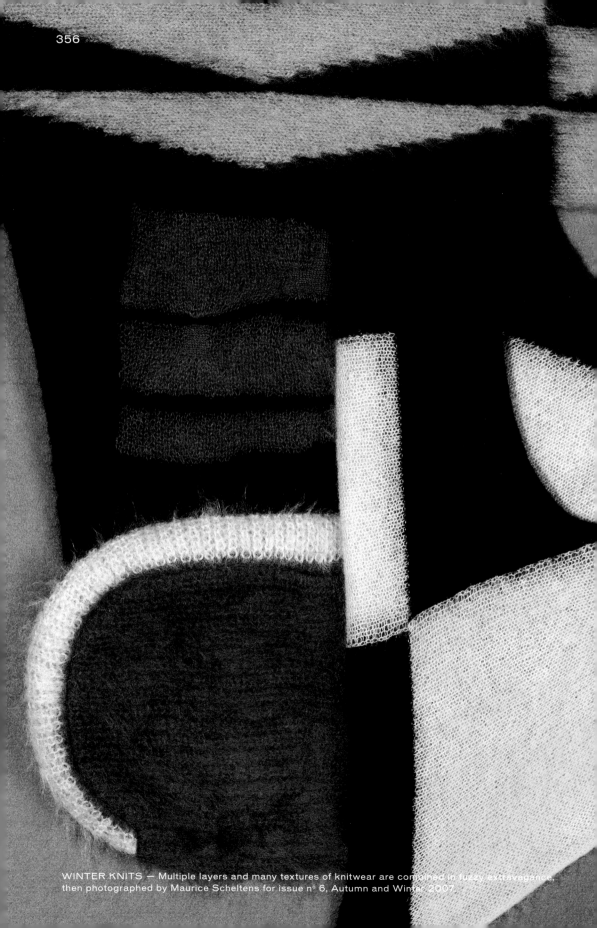

WINTER KNITS — Multiple layers and many textures of knitwear are combined in fuzzy extravagance, then photographed by Maurice Scheltens for issue n° 6, Autumn and Winter 2007

didn't realise putting the conceptual artist group ART AND LANGUAGE and a painter like BERT IRVIN in the same magazine was a total faux pas. I really had a lot to learn."

Faux pas or not, the pilot was warmly received. "Anyone of my generation seeing those early editions would have felt compelled to connect with the magazine," says GREGOR MUIR, now director of the ICA, then an upcoming writer and curator. (Anyone interested in the Young British Artist years should be sure to read his book LUCKY KUNST — a rollicking personal account of drinking, drugs and the emerging art scene in '90s London.) "It was beautifully designed, it had the artists who interested me, it stood head and shoulders above everything else." Mr. MUIR, who'd studied art at Camberwell and hung out with the scruffier art crowd that included TRACEY EMIN, SARAH LUCAS, MATT COLLISHAW and GARY HUME, says, "MATTHEW was a bit different from us. He wore smart designer jackets — he was a bit of a soul boy. And he didn't come from an art background. But I now realise he rather cannily took the long view. He had the presence of mind not to immerse himself in certain ways that wouldn't fit so well with someone on their way to becoming an important editor."

The pilot issue also helped MATTHEW woo EMILY. "Our first real date was at a Royal College degree show in June '91, and it was the day that the FRIEZE pilot came back from the printers," says MATTHEW. "I had about ten in my hand and was giving them out. She knew I was working on an art magazine, and she knew about art, and she thought it was going to be terrible, so she was dreading it. And then she looked at it, and everyone was saying how good it was, and it was the perfect pulling moment. My one opportunity!" MATTHEW and EMILY were married on New Year's Eve in 1994 at Marylebone Registry Office in PAUL SMITH (her) and KATHARINE HAMNETT (him). His childhood friend ED VAIZEY, the conservative politician who is currently the Minister for Culture, was best man. The friendship has led some to believe that MATTHEW is a Tory too, but he says he's always voted Green or Labour, and that currently, like so many mid-to-left-leaning British folk, he wouldn't know which way to go. He is, however, a supporter of ARSENAL football team.

AMANDA SHARP and MATTHEW SLOTOVER first met at a bar mitzvah when they were 12 years old. They became friends at Oxford, where Ms. SHARP was studying politics, philosophy and economics at the women-only Sommerville College. "He was so beautiful and charming," recalls AMANDA, who is known for her outstanding, unruly mop of curly brown hair and the acuity of her thinking. "And we became very good friends. We've got similar backgrounds and taste but we're not remotely similar people. He's rigour and I'm speed. I'm the glass being half empty, and he looks for the positive in everything. When it comes to the fairs, I do the client-facing stuff: working with the galleries, the collectors and

sponsorship; MATTHEW does marketing, PR and logistics. We always say I make the money and he spends it."

The idea of launching a fair was not an overnight decision. "We first started thinking about it in 1997, '98," says MATTHEW. "By 2000 we even had a mortgage from the bank that we'd had to guarantee personally. And we'd booked a warehouse in Clerkenwell." The warehouse, however, was sold six months before the fair was meant to happen, and the fair never took place. Meanwhile TATE MODERN opened its doors in May 2000. The international art world came to London to celebrate. "It sounds strange now, but at the time, we didn't know if they would," says MATTHEW.

The first FRIEZE ART FAIR finally opened in its DAVID ADJAYE-designed tent in Regent's Park on 15 October 2003 (Mr. ADJAYE, through his close association with the increasingly celebrated artist CHRIS OFILI — Mr. ADJAYE designed both his house and a breathtakingly beautiful installation for the artist's UPPER ROOM series that's now owned by the TATE — was the art world's architect of the moment.) A photograph by social snapper DAFYDD JONES of its opening moments shows photographer JOHNNIE SHAND KYDD, DAVID ADJAYE, AMANDA SHARP, artists MICHAEL CRAIG-MARTIN and GAVIN TURK, socialite ROSARIO SAXE COBURG and actor HUGH GRANT streaming down the blood-red tunnel into the show. It's a prescient snapshot of the way that FRIEZE would bring together several worlds.

The timing couldn't have been better. The stock market had hit rock bottom in 2001, but two years later the financial boom that would so colour Britain for the rest of the decade was gaining momentum. The London art scene that had revolved around the attention-seeking antics of the YBAs in the 1990s was beginning to grow up. The American heavyweight gallerist LARRY GAGOSIAN had opened a London gallery in Heddon Street, central London, in 2000 and a second in King's Cross in 2004. The serious Swiss gallery HAUSER & WIRTH, who include LOUISE BOURGEOIS in their stable of A-list artists, arrived in the city in 2003, taking over a former bank on Piccadilly that had been designed by the architect Sir EDWIN LUTYENS in 1922. Clearly gambling on FRIEZE being a success, they launched the gallery with a standout show by the dark and icono-clastic American artist PAUL McCARTHY the day after FRIEZE began.

Of course, there is competition. Lots of it. The major player is ART BASEL, whose mega fair happens in the Swiss city in June. There is TEFAF in Maas-tricht, the biggest fair of all, that's now 35 years old and mixes jewellery, armour, furniture and icons in with the (extremely valuable) art. There's ART BASEL's little sister in Miami. In New York, which is still the major auction market for modern and contemporary art, the existing fairs happen in March: THE ARMORY, which has become a depressingly banal affair at Piers 92 and 94;

THE INDEPENDENT, a lively roundup of fresh galleries in the former DIA building but not large enough to have a really commanding presence; and the ART DEALERS ASSOCIATION OF AMERICA's event, which is good but only allows US galleries.

Not everyone is so sure about the New York setting, however. FRIEZE NEW YORK will be housed in a tent on Randall's Island in the East River, adjacent to Harlem. For your average Manhattanite, it's a hike. "Randall's fucking Island?!" exclaims a New York dealer who wishes to remain nameless. "I play tennis out there. It's like Mars. Most New Yorkers don't know where it is." MATTHEW, bearing out AMANDA's assertion that he always looks for the positive, takes a very different view. "It's a fantastic location," he says. "It's on the river and it should be beautiful weather. We'll have boats that run from Downtown up to the site. I know people are not going to go there and say, 'Oh god, not another art fair!'"
 The tent for FRIEZE NEW YORK is being designed by the architecture firm SO-IL. I meet SO-IL's co-director FLORIAN IDENBURG in his Brooklyn studio, where he is finessing the 22,500m^2 tent, creating a design out of standard marquee sections that will concertina beautifully along the waterfront. "MAT-THEW genuinely seems concerned with the experience of those who will come to the fair," says Mr. IDENBURG. "But it must be stressful for them, breaking new ground." And costly. "I didn't realise quite how expensive New York would be until we started doing the costings," says MATTHEW. "The tent is probably three times more than in London; it's, like, $1.5 million for those four days. We're hoping to break even in year two."

Mr. SLOTOVER and Ms. SHARP's mission from the outset has been to supply "not another art fair" — not least because they had made the complicated move of crossing over from the critical to the commercial. This being the case, they have always included a cultural component. FRIEZE PROJECTS, for example, is a sponsored series of work with its own curator and no commercial imperative. For the past three years, the London fair has included FRAME, an area of smaller booths dedicated to young galleries from around the world, usually selling more challenging work. Meanwhile talks and other events are programmed to alleviate the relentless wheeling and dealing. Most other fairs have followed suit. For MATTHEW, it's been quite a learning curve. "I've learned how knowledgeable a lot of collectors are, which I didn't realise at the beginning. I think coming from magazines and the critical perspective, you think they're just the idiots with money who fund the whole thing. But it turns out, most of them are pretty successful idiots who've had to be pretty smart to get where they are, and a lot of them apply that same knowledge and intelligence to art. Good collectors will know about artists way before magazine writers do. They've got more money to travel, so they

have an international perspective."

He has also learned how hard it is to be a dealer — "they have to balance collectors and artists, and both can be equally difficult" — and how hard it is to please a dealer. "I remember the first day in 2006," says JAMIE FOBERT, "We'd created a system of open squares that interrupted the aisles, for people to gather in and to open up the usual corridor system that you get at a fair. People thought they didn't want to be on the squares — though now they do — and one German dealer was screaming and a woman from New York was literally balling her eyes out about where her booth had been placed. MATTHEW calmed them both down. His voice is like butter. He's quiet but consistent and he listens."

MATTHEW's schedule is tireless. He is invited everywhere. We sat in his office going through a week of his January diary and it included the following: the PRADA 24-H MUSEUM in Paris — an installation by FRANCESCO VEZZOLI — where diners sat in a cage and KATE MOSS was a DJ; a quick look at the GIVENCHY haute couture presentation ("my first — all quite fetishistic but the detail was amazing"); a friend's 20th wedding anniversary; GARY HUME and IVAN PUTROV's MEN IN MOTION dance piece at SADLER'S WELLS; the opening and dinner for CHRISTINA MACKIE's show at the east London gallery CHISENHALE; DINOS CHAPMAN's 50th birthday celebration at a new private members' club in Mason's Yard, by the large WHITE CUBE building; and a two-day conference on art patronage in the Middle East.

Ideally, though, MATTHEW entertains at home. There is a big wooden table in the couple's basement kitchen that is the regular site of small friendly suppers. "I don't know if he'd like me to say this," says AMANDA, "but dinner at MATTHEW and EMILY's is not dissimilar to what it used to be like at his parents'. The children drift in and out, there's an ease of hospitality, an interesting level of conversation." The day we met at LEILA'S, he was having the documentary maker NICK BROOMFIELD to dinner "because he's seeing a friend of EMILY's from Oxford." DINOS and TIPHAINE CHAPMAN are good friends.

MATTHEW likes to do the cooking. "Whole grilled sea bream is my ultimate meal. And I chop up new potatoes and roast them, so they're like little chips. And then just salad and cheese. But tonight, I'm cooking a fish stew. For AMANDA and me — we both share this actually — food is a very important part of our lives. And my dad actually always cooked lunch with his staff."

The SLOTOVERs, or indeed ZLOTOVERs, originally came from Lithuania. MATTHEW only went there a few years ago, because he was invited to an art fair in Vilnius, and was not impressed by the food there, particularly the dumpling-based diet. His own grandfather had immigrated to Newcastle in the early 20th century and made some decent money in the furniture business.

"My mother's father had his own company too, and my uncle, DICK KRAVITZ, moved to London from America in the 1950s. My grandfather imported magazines; he brought MARVEL COMICS to Britain, and MAD magazine, and ESQUIRE. I suppose you could say that pretty much everyone in my family was self-employed."

His two brothers and one sister have taken the media route (MATTHEW is the eldest). Brother number three is a FORMULA ONE racing commentator — the man in the pit. He calls himself TED KRAVITZ. "He's a really big deal for petrol heads," says MATTHEW. "He's got 56,000 Twitter followers and a fan site. I sat next to someone at dinner the other day who was almost breathless when I said TED was my brother."

No one in the family had ever collected art. In fact, until the beginning of the fair, neither did MATTHEW. "I had a bit of an us-and-them thing about art collecting," he says. "Partly because of the magazine, I felt that it was a conflict of interests. And I didn't have the money either. But at the first fair, on the second-to-last day, the dealer GAVIN BROWN, who is a good friend, asked me if I'd bought anything. He was a bit shocked when I said no. He said: 'How can you do a fair and tell people they should be buying stuff, and you're not?' So we bought a PETER PERRY drawing, and the next year we bought a JOHN STEZAKER — EMILY had taught with him at the Royal College — and now we try and buy something from FRIEZE each year. A few things throughout the year."

They also own a drawing of their daughter THEA, when she was two, by ELIZABETH PEYTON. "She did it when she stayed at our house," says MATTHEW. And a little painting by IVAN SEAL from their friend CARL FREEDMAN's gallery. So what will happen to the SLOTOVER collection, which in itself will come to represent a fascinating document of a life in the art world? "We'll probably just end up giving it to a museum, although I'm not going to make that promise in print right now."

Recently two of the dealers MATTHEW has bought from asked if he'd like to sell the work back to them. "I felt slightly insulted," he says. "It's, like, what do you think I am? Occasionally I'll say to EMILY: 'God, this artist is doing really well now,' and she says, 'Yeah, but it doesn't matter does it? Because you're never going to sell it.' I bought this work because I wanted to live with it."

Mr. TIM BLANKS

Featured in issue n° 15 for Spring and Summer 2012

The writer TIM BLANKS is a long-time regular contributor to FANTASTIC MAN and a cherished friend of its founding editors. In spite, or possibly because of that, TIM was overlooked as a subject for the magazine until its 15th issue. This was a significant omission, given TIM's runway reviews for STYLE.COM had long set the tone for fashion commentary. On a personal level, TIM's taste in short-sleeved shirts made from loud prints and his warm masculine looks — he has the aura of a jaded-yet-kindly HOLLYWOOD chief detective — render him among the best exponents of splendid individual style.

TIM had his fashion "rosebud" moment as a boy in Auckland, New Zealand. Spotting a lurid red material with a palm tree pattern in a fabric shop, he persuaded his mother to buy a length and make him a shirt. For years he was a fashion outlier, but recently menswear has caught up with him and now he is a devotee of PRADA's fabulous prints. "A lot of men are really scared of print and colour, but for me both are easy — I am not subtle. I do not take great pleasure in a two-millimetre difference in the width of a lapel; I am a broad-strokes guy and a sucker for the obvious. Put it this way: I am quite geared towards easy emotional responses to things. I easily cry at movies and with TV commercials. Not real life, just TV commercials."

Portrait by Roger Deckker

Mr. PETER PHILIPS
Featured in issue n° 10 for Autumn and Winter 2009
Portraits by Willy Vanderperre
Text by Susie Rushton

Mr. PHILIPS

With a dream career, Mr. PETER PHILIPS of Antwerp is now in command of the vast, multi-million make-up empire at CHANEL, deciding which lipstick is used on the catwalk and which nail varnish is sold in-store. PHILIPS has turned his lack of formal training to his advantage, taking risks with fellow Belgians who have also since risen to similarly giddy heights. PHILIPS splits his time between the CHANEL offices near Paris and his home in New York, with the option of spending weekends at his apartment in Antwerp.

Shortly before the Autumn/Winter CHANEL catwalk show, the designer KARL LAGERFELD gives PETER PHILIPS a brief: The clothes in the new prêt-a-porter collection will have "jade accents". All the girls will be wearing hats. The end.

Based on this scant information, it is Mr. PHILIPS' job, as Global Creative Director for CHANEL Make-Up, to conceive a uniform beauty "look" for 40 models: one that will both complement the clothes — which he might not actually see until a day or two before the show — and stand scrutiny from beauty journalists intent on spotting the trends that will influence which shade of eyeliner ordinary women will want to buy in six months' time.

So does he spend two days furiously blending blushers and lip glosses in his creative studio on the 4th floor of CHANEL's production headquarters in the western suburb of Neuilly-Sur-Seine? He does not.

"I wanted to do something graphic. So I went to LESAGE." Founded in 1868, the house of LESAGE, as students of haute couture know, is Paris's most prestigious embroidery workshop. It's here that the biggest names of French fashion gild their designs with precious beads and silk. LESAGE had a stock of things they had embroidered for PHILIPS: masks he had used for V magazine and i-D, not to mention the cover of FANTASTIC MAN in spring 2006 showing Mr. STEFANO PILATI with lace decorating his beard.

"So I asked for something, in the same spirit, on false eyelashes. On the day of the make-up test, I showed it to KARL, and he said, 'Let's see,' because it's kind of an abstract concept. But in the end he loved it — and in a rush I had to ask LESAGE to make 80 pairs, the Monday before the show. They had to be meticulously made, because it's two parts: one long piece that goes under the eye, and another on each side, made from black beads, and in between them, white sequins

with crystals. The inspiration was '60s pictures of TWIGGY."

You think you can picture what he's describing, but after we meet one afternoon in Antwerp, the city where Mr. PHILIPS was born, I look at close-up pictures from the show on the internet. The models' faces are impossibly dewy, their lips apparently left bare. Around each girl's eyes are alluring, heavy outlines of black *kohl*. Fringing their lower lashes are miniscule, flinty chips of shiny colour. The models look half human, half mosaic: eye make-up by GUSTAV KLIMT.

"It's kind of original," PHILIPS had told me, "never done before." That sounds like a boast, but he spoke without obvious pride. Yet over the past decade, PETER PHILIPS has taken the conventional definition of make-up, torn it to shreds and recreated it out of lace, crystals and surrealist flair.

Besides making up faces for catwalk shows and in advertising, a large portion of his role at CHANEL — an appointment that was made public last year — is to develop the new products that are sold at zillions of department stores, airport departure lounges and chemists worldwide. It is a unique post. No other beauty director in the world has a scope that ranges from shop floor to ad campaigns to the haute couture catwalk.

So will there be a day when women from Aberdeen and Washington DC will be able to buy mass-produced, crystal-embroidered lashes at the CHANEL beauty counter?

"Maaaybe," he says, in a cagey way that makes it sound like the research-and-development guys are already on it. "Maybe."

CHANEL's sales figures are not released; it is a privately owned company controlled by the billionaire WERTHEIMER family, who first became partners in COCO's fragrance business back in 1924. But it's widely known that beauty, in general, is a very profitable business. Hand-stitched couture isn't a big money-maker. So it can be deduced that the person behind the make-up at an enormous company like CHANEL is, in creative terms at least, controlling a great part of a luxury brand's business.

PETER PHILIPS' job is such a monumental prize, one so enviously eyed by every make-up artist in the business, that he had to be trained for the role in total secrecy for years before his appointment could be officially announced.

"I signed a contract which had a confidentiality clause, which was kind of hard because I wanted to shout about it. But it was also the best way, because the pressure from the outside would've been too nerve-racking." The secret training lasted for two years. CHANEL's spokespeople describe that period as an "engagement", the final contract being a "marriage". He replaced long-time co-directors Ms. DOMINIQUE MONCOURTOIS and Ms. HEIDI MORAWETZ; MONCOURTOIS had been the last employee to have been hired by Mlle. CHANEL herself.

Mr. PHILIPS, who is 42, loves his new job, he says, along with lots of other things you'd expect him to say: It's a challenge every day. It's a big step. But also: "It's kind of hard—no, it's not hard—it's just a different world, the whole corporate side. I've got so many more things to do, like meetings and working on packaging and marketing. When I used to work as a freelance make-up artist and I did loads of beauty campaigns, I never realised what's behind it. Now, if I make a collection, the way it's launched worldwide at every counter at the same time, the whole choreography of it, the machinery of it: it's really impressive."

Historically, certain CHANEL beauty products have been tearaway successes. ROUGE NOIR, the blackish nail varnish worn by Ms. UMA THURMAN in PULP FICTION, is the best known. The performance of PHILIPS' GOLD collection and bubblegum-coloured ROBERTSON nail varnish (named after the CHANEL boutique in LA on Robertson Boulevard) suggests he'll score a ROUGE NOIR soon enough.

Mr. PHILIPS develops products with a team of nine assistants—the researchers, chemists and technicians who mix pigments and create cute new brushes, applications or formulae—at a dedicated studio in Neuilly, far from CHANEL's famous fashion headquarters at Rue Cambon in Paris. "I don't think we shake up the world every time. We work with our own instincts. I don't want to scare people with make-up, with statements, but we do take risks. Of course, you have to listen to what women in Japan or South America want. Because then you can actually deliver what they need but still be creative yourself."

Make-up creation is informed by the mighty marketing machine that drives all major beauty brands, and PHILIPS tells me how the specific demands of consumers in different parts of the world can vary wildly. But, he says, CHANEL resists the temptation to simply copy what's selling well now. Instead he tries to predict what might be the big hit in several years' time. "We work on the cosmetics for, say, new types of foundation two to three years in advance. If it's about a long-lasting brush application now, by the time you develop your product, it'll be dead and women will have moved onto something else."

His marriage to CHANEL now means that he lives "between Paris and New York", mostly in an apartment in Chelsea, New York, with his boyfriend, the stylist Mr. DAVID VANDEWAL. They've been together 21 years. "Don't see each other too much," he says of their formula for long-lasting love, "which is easy, because I travel a lot. Don't lie. Keep the finances separate." The couple own a shiba inu, the Japanese breed of dog that has a fluffy coat and a curious, curly tail. "He's called JUDAS. He's not very loyal. But he's very good-looking, and he knows it."

Since January, having tired of French hotels and obliged to spend lengthier periods in France, PHILIPS has also rented a home in Paris, near the Arc de Triomphe.

Now that he's got weekends off (an impossibility for the freelance fashion make-up artist, who works whenever, wherever shoots take place), PHILIPS has also started using the apartment he keeps in Antwerp, a two-hour train journey from Paris.

It's on one of his new-found weekends that we meet in Antwerp, in a grand and completely deserted café above a theatre. Dressed in bespoke white shirt, black JIL SANDER tie, pale trousers and white trainers, his blondish hair cut short, he looks impossibly crisp. "I've got a fairly basic wardrobe, because of travelling. I don't look good if I try to make too much of a fashion statement."

He's a good-looking man, with a slight tan, blue eyes, and pale stubble on his chin. PHILIPS has said before that he thinks he could be mistaken for "a bank manager", although I've never met a bank manager who wore CARTIER sunglasses, as he does today, or handmade shirts cut and sewn by CHARVET in Paris. "I have a lot of shirts because they get dirty so easily from the make-up." He's quite happy to point out that he's not the tallest guy in the world, joking that THOM BROWNE is one of his favourite designers because the cropped trousers and cropped sleeves fit his limbs just perfectly.

Does working in fashion make him more critical of his own appearance?

"I'm shooting and at shows with young, thin people. Male or female, they're always beautiful. So you become... aware of the way you look. On the other hand, I'm happy with myself. I'm not a model. But I don't feel comfortable backstage when the press come. They always arrive 45 minutes before the show starts, and I'm never in the most flattering pose, shouting at assistants."

Even before CHANEL went down on bended knee to offer him a diamond ring, PHILIPS' career was the stuff of fantasy. As a freelance make-up artist, he worked with Mr. CRAIG McDEAN, Mr. IRVING PENN, Mr. STEVEN KLEIN, Ms. INEZ VAN LAMSWEERDE and Mr. VINOODH MATADIN, his faces making the cover of every prestigious fashion magazine on the shelf.

Represented (as he still is) by mega-agency ART + COMMERCE, he was booked for work — with at least three competing "options" on each day — for a month in advance. "I'd work seven days out of seven. And it was a constant balancing act. Let's say you have an option for a job in Puerto Rico for five days, the next day an option for a good editorial in Paris, and the next a good American VOGUE shoot. All overlapping. You have to make a good mixture of commercial (with large fees) and editorial work." He hasn't let go of that life entirely, and still takes on one or two editorial shoots a month, often with young photographers like Mr. DANIEL JACKSON or Mr. DAVID BENJAMIN SHERRY. But that's it.

High-fashion photographic work requires not just skill and imagination, but diplomacy, spontaneity and pragmatism. Occasionally, a photographer has a clear idea about the make-up they want; usually, as with LAGERFELD's pre-show

instructions, direction is vague.

"It's different from shoot to shoot," PHILIPS explains. "All photographers have their own concept. For example, they'll say, 'We're doing a short-sleeved story for American VOGUE and we're using flower prints.' That's the kind of brief you get three days in advance. I try to come up with something. If it's extreme — for example with INEZ and VINOODH — most of the time I know in advance what they want. It's quite often on a trip, so you have to take enough material with you, and I travel light. I don't have 16 suitcases; I have two, which includes my clothing and make-up stuff. Sometimes I'm able to make things. I've got my basic kit to make masks, so I can improvise. I'm actually much better when it's improvised than when it's really well prepared. But the first thing I do is look at the clothes. That's where my background in fashion helps."

His mother and stepfather, now retired, used to run a butcher and catering business in central Antwerp. Mr. PHILIPS' father, who now lives in Brussels, is a painter. Working on wood, using a type of lacquer paint that's very tricky to handle, he makes surrealist paintings that often feature his sons (PHILIPS has a brother who works in the diamond industry in Africa, and two half-brothers).

"It's a funny story, my family," he tells me. "My mum and dad were married when my mum was just 20. I was born nine months after the marriage. My father painted, and he also taught art, and he had a relationship with one of his students, who got pregnant. She was the daughter of a high-ranking general in the Belgian army. She's called ANN, and they're still together now. She's an amazing woman, but it was a big scandal at the time and he could no longer teach, so instead he was obliged to make a living from painting. He's still painting, at almost 70, and he's very disciplined. He starts every morning at 9am and works until 4.30pm, every day except Sunday."

As a student, Mr. PHILIPS studied graphic design in Brussels, but by the very early '90s he changed direction and enrolled on the fashion design course at the Antwerp Academy. It was here that he made friends with Mr. WILLY VANDERPERRE and Mr. OLIVIER RIZZO. VANDERPERRE quit the fashion course after the first year to go into photography. RIZZO and PHILIPS stuck it out, graduating in 1993. PHILIPS paid his own way through fashion school by working as a barman. The trio would make their first fashion pictures together.

He's telling me about all this, rapidly, in deadpan Flemish-American inflected English, as we leave the café and head for another restaurant, located in the back of a smart interior-design shop. After lunch, walking to his top-floor flat near the art museum in the south of the city, he'll point out the flat where he lived at college — Ms. ANN DEMEULEMEESTER rented the same place when she was a student. Walking along Nationalestraat, the straight, boutique-and-fast-food-joint-lined road that connects the tourist-crowded squares with the student-y

southern district, he says he'll usually see four or five people he knows on this particular street alone. If Antwerp is a small city, the circle of Academy-trained fashion professionals can sometimes appear extremely snug.

Take, for instance, one of the models in his graduate show, the designer Ms. VÉRONIQUE BRANQUINHO. "She wore a pair of gold trousers, a yellow hand-bag, huge sunglasses, and a purple shirt. She looked great — she's got the longest legs ever!" Not that he nurtured ambitions to be a designer himself for long.

"I was looking at my final-year collection recently, as I was unpacking boxes of photos of it. It's got a bit of style: it's very graphic, a bit tongue in cheek, very colourful, and I took a theme of beauty pageants. I mean, I took it very seriously, but I knew I wasn't going to be a great designer. I'm a very rational person. It's a mistake that a lot of people make — they're not very objective about their own work."

In the meantime, travelling to Paris twice a year with the other fashion students to work as a "dresser" backstage at the shows, something else caught his imagina-tion. "I saw the make-up teams and realised you could make a living out of that."

At the age of 22, without any formal training or skills to speak of, PETER PHILIPS gave himself three years to succeed as a make-up artist. VANDER-PERRE and RIZZO, now a stylist for PRADA, were his collaborators. "We all started out together. Testing and trying out. We knew we were doing really good things. Every time WILLY, OLIVIER and I shot something, our standards were really high. We would do it thinking, 'Okay, this is for V magazine, this is for i-D.' And we started sending pictures to those magazines, and eventually i-D published something. Then they started calling us. I mean, we came from the Academy, so our standards were kinda high. We didn't just do anything."

Another friend in Antwerp was Mr. RAF SIMONS. "I met him through OLIVIER. He asked me to do his first show, and I'd only just started doing make-up. I said, 'I can't take the responsibility. I've never done a show in my life.'" By SIMONS' third show, PHILIPS felt confident enough to agree; he still does all the designer's presentations, including those for JIL SANDER.

Probably the best-known image produced by PHILIPS is a MICKEY MOUSE cartoon he painstakingly painted on the face of Mr. ROBBIE SNELDERS, RAF SIMONS' house model; the clothes were by RAF SIMONS; RIZZO was the stylist, VANDERPERRE the photographer. The black-and-white picture was part of a shoot published in V magazine in 1999. MICKEY's face is in profile, his black ear obscuring ROBBIE's eye. It's as if the cartoon has been projected onto a human face.

"It doesn't sound as good at it looks," he says. "But when ROBBIE came out, with that make-up on his face, everyone was... 'Wow.' We shot the most amazing

pictures of it. Lots of photographers asked afterwards: 'Can you do the MICKEY MOUSE?' And I would say no. I did it once, and it was perfect. I'm not going to cannibalise what I did before. I can always find something else. It's always nice to try and push a bit further. Most of the time, it works, and now, my reputation is good enough that people trust me for that."

PHILIPS thinks that the large number of men's shoots he worked on early in his career gave him greater latitude to experiment. "It definitely helped me stand out from all the other make-up artists. I did very strong statements in the men's stories, so they really popped out. My approach of make-up for men was so different from what anybody else did."

Yes: men in make-up. It's a subject on which PHILIPS, given his portfolio, is surprisingly equivocal. "I don't believe in blusher or a mascara or lip gloss for men. For me, if a man wears make-up, it should be something punk or tribal in its reference. I don't feel attracted to — and I don't think women feel attracted to — a man in visible mascara or blusher. I mean, if you're going to go for it, then really go for it: make a statement! Be a man!"

This can be seen on the Spring/Summer 2005 catwalk of ALEXANDER McQUEEN, where PHILIPS painted the faces and torsos of some of the models entirely blue or red; or at KIM JONES, where for spring/summer 2004 he copied the cartoon mushroom that was on the clothes and repeated it on the naked torsos of male models.

MICKEY MOUSE and lacy masks might have made him famous, but PHILIPS is no theatrical face-painter. Look at his online portfolio and there are as many immaculately natural, unmasked faces as there are audacious, eccentric looks. "I never put pressure on. I don't want to have a model or actor feel uncomfortable in front of the camera." On set, a make-up artist, even one with PHILIPS' reputation, doesn't have ultimate control; he has to be pragmatic.

"Let's say I do very strong make-up. The rest of the team feel obliged to also do something strong. And then the image becomes weaker, I think. It becomes this fight between hair, styling and make-up." If he sees this happening, he removes the make-up. "And suddenly the whole thing looks better. And I don't have a problem with that. It doesn't always have to be the PETER PHILIPS SHOW."

Late in the afternoon, PETER PHILIPS and I are standing in his Antwerp apartment, admiring his fabulous black, poured floor. Renovation work has recently been completed, and it is now a monochrome minimalist dream, the perfect urban second — third, in fact — home.

"I didn't have weekends for 15 years," he says, "so when I started working for CHANEL I was totally lost. I didn't know what to do at the weekends. It's so touristic in Paris, crowds everywhere. So I started coming back to Antwerp."

There's an enormous flat-screen TV in the living room. There are 12 giant bottles of CHANEL fragrance in the bathroom ("for guests"); a little office with lots of drawing materials; shelves tightly packed with dozens of copies of THE FACE and VOGUE, some dating to 1987; a very loud VERSACE bedspread in the bedroom. PHILIPS bought the property 15 years ago. From two terraces there are views across the Gothic-y skyline of the city.

His mother MIEKE is in the apartment when we arrive — she keeps an eye on PHILIPS' home while he's away. She doesn't speak English, so we can't communicate beyond smiling, but I'd asked him earlier whether she was enjoying a steady supply of gifts from CHANEL.

"It's funny but, to her, CHANEL is a bit old-fashioned. She associates it with her mum. I gave her a BALENCIAGA handbag six years ago and she loved it. When I gave her a CHANEL handbag, she said, 'It's kind of mumsy, isn't it?' But then all her girlfriends loved it, and now she carries it all the time. And she uses CHANEL make-up, of course."

PHILIPS had told me a story about the first time his mother allowed him to do her make-up; it's a story that reveals the phenomenal power of cosmetics — perhaps even more than clothes — to delight, give confidence and extend human happiness. "She had never let me do her make-up," he said. "But then, eight or nine years ago, she had to go to a ball. I was in town, so I said, 'Like it or not, I'm going to do your make-up.' When it was finished, my stepfather said, 'My God, you look like... you look young again! You look like you did 10 or 15 years ago!' After the ball she even went to sleep with her fake lashes on. She loved it so much. And now she only regrets I hadn't been doing her make-up all along."

I notice an interesting absence in Mr. PHILIPS' home: a computer. He claims not to know how to switch one on and is mistrustful of the internet. "Maybe it sounds old-fashioned, but there's too much information now. People get lazy. They call it 'being inspired' but it's just copying. I love books, the touch of paper."

The factors that contributed to PETER PHILIPS' ascent to the top of the global beauty business are many. But I wonder if his innocence in terms of computers, in particular of the digital post-production that invisibly transforms almost every single picture published in every fashion magazine, isn't among the most important. His craft is expressed with brush, paint and hot-glue gun, not mouse and pixel.

Earlier in the day, at lunch, PHILIPS told me a story that both illustrated his creative ambition and made me question whether his achievements will ever be repeated: "When I started, I didn't realise how far photographers were pushing re-touching. I'd flick through magazines and my goal was to make her look as good as that. That's how my foundation got so strong. I once did a shoot with STEVEN KLEIN. It was for a cover of W magazine, with GWYNETH PALTROW. And

STEVEN said, 'I want her to look like this,' and showed me an old shoot he'd done with CLAUDIA SCHIFFER. It was retouched, but done in a really subtle way—but I didn't realise that. And actually, in the end, GWYNETH PALTROW looked amazing. She looked, without retouching, almost as good as CLAUDIA SCHIFFER in that picture—despite being older than CLAUDIA had been. Later, STEVEN showed me the picture of CLAUDIA without retouching. Fucking hell. I had been aiming to achieve a perfection that was actually achieved in post-production. Then I realised: I can do pretty good make-up."

Mr. RICKY CLIFTON

Featured in issue nº 14 for Autumn and Winter 2011

Preeminent New York interior designer RICKY CLIFTON seldom appears in public without headgear of some description, and his photo shoot for FANTASTIC MAN was no exception. RICKY brought along an array of choice CHAPEAUX, among them this magnificent turban from PRADA. RICKY has a prestigious client list and unusual working methods. Operating without an office or assistants, he has designed homes for fellow creatives including the fashion designer DIANE VON FÜRSTENBERG and the artist couple JOHN CURRIN and RACHEL FEINSTEIN. "I sort of just do whatever comes along," he said, modestly. In the past he has been a New York cab driver and a picture framer. RICKY described the CURRIN/FEINSTEIN apartment as a mix of Third World dictators' homes, the designer CARLO MOLLINO and the London nightclub ANNABEL'S.

RICKY is tirelessly sociable. "Whenever I go to a party, people say, 'RICKY's here, that means it's a really good party.' I don't know what it means. It's kind of obnoxious," he said, "but then FRANCESCO VEZZOLI, the artist says, 'RICKY's at the party, that means it's time to leave the party.'"

Portrait by Roger Deckker

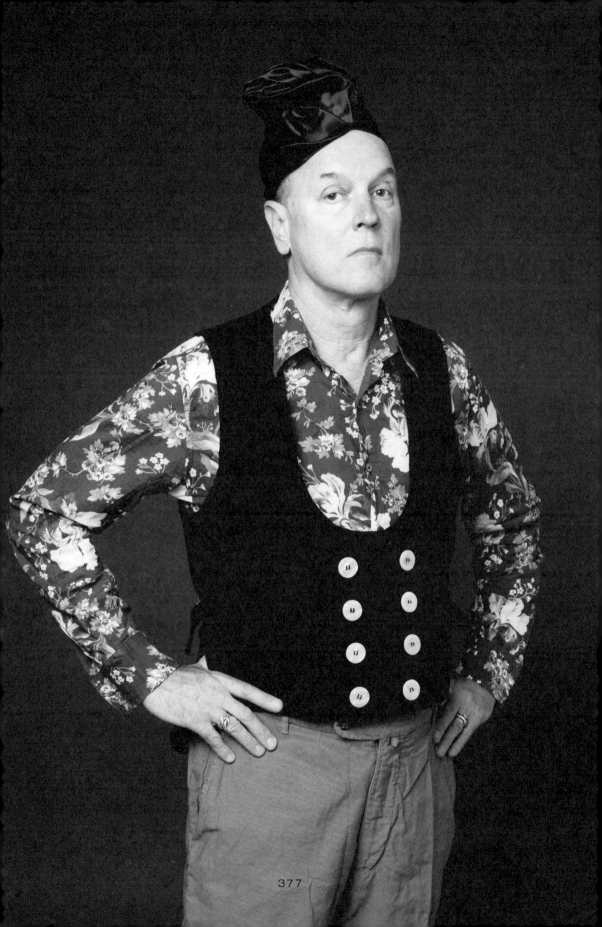

Mr.
TOBIAS MEYER

Mr. TOBIAS MEYER
Featured in issue nº 7 for Spring and Summer 2008
Portraits by Terry Richardson
Interview by Joan Juliet Buck

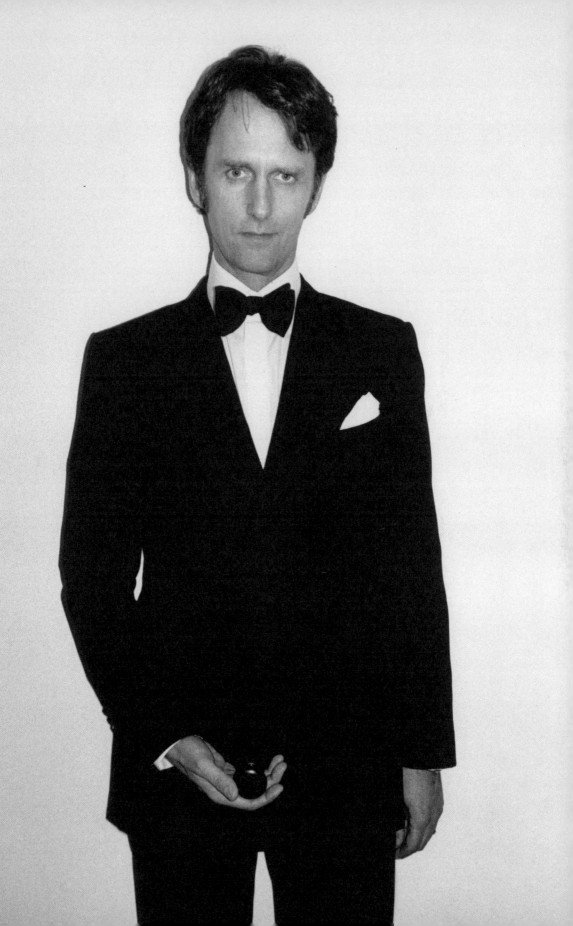

The sun is not quite setting, the Empire State Building is visible and there are jet trails in the sky. TOBIAS MEYER, the worldwide head of contemporary art and mesmerizing auctioneer of SOTHEBY'S, and JOAN BUCK, writer and sometime playwright, are sitting in an anonymous office space sixteen floors above Chelsea, contemplating the wondrous absurdities of modern art. In 1997, the German-born Mr. MEYER was rudely propelled into the heady New York art scene. And it was under his hammer that PICASSO's GARÇON À LA PIPE sold for a record-breaking 104.2 million dollars in 2004. Wow...

JOAN BUCK: How much art did you sell last year?
TOBIAS MEYER: More than I thought. When I last looked, we sold 1 billion and 300 million dollars' worth of art, which I can hardly even say as a figure, it's so wild. I just lost track of how much it was and I forgot that these 17 million dollar objects, or 50 million dollar objects, all add up. I remember when I started my first auction in 1997 in New York, it was 13 million dollars all in.

What does that tell us about the world?
I think when I started to work with contemporary art, it was something for a small community of people who didn't really want to belong to the mainstream. And they also considered themselves avant-garde. And something happened around 1999, 2000, where the avant-garde actually didn't really buy contemporary art, but the bourgeoisie started to buy it. So for the first time since the 1860s, the contemporary artists did not enrage the bourgeoisie, but actually started to make things for them to buy.

Who was this new bourgeoisie?
A very affluent, financially minded, successful community of people who have made their money based on an economy on an upward surge.

So they floated up like a bunch of twigs with the tide?
They were the ones who made the right decision and got a financial degree instead of an art history degree. And they said, "Okay, this is what's going on in the world, this is where the economy's going so I'm going to hold on to something and that something will become very valuable." They did it with their

companies, and they're doing it with art.

You're on the receiving end at SOTHEBY'S. Can you say, "No, we can't sell this"? Or...
I can say, "No, we can't sell this," but the minute it has a value and the minute the value is a certain price point I can't say "no". I cannot be a censor. I'm an auctioneer. If you're a curator, you can be selective. I cannot. And I cannot judge either. I can only accept. I have to suspend judgement.

And the value comes from the hands it's been in and how much it costs?
The hands it's been in — and also the value comes from people wanting it. When people want something very badly, like JEFF KOONS' HANGING HEART, it's 23 million dollars instead of 3 million dollars. Bought by somebody who didn't know KOONS a year ago.

A new...
New buyer, new market, new money, new smart man, new fearlessness... Let's just presume from a new economy. It's a whole new world. I used to be able to predict with a certain accuracy what would happen in a market, because it was really only determined by Americans and Europeans and now it's out of our hands. There's China, there's the Middle East. All kinds of people who are not constrained by anything are buying now, and they have a very different value system. In New York, people associate prices of art with real estate prices. The price point for a great work of art is probably 60, 70 million dollars because that's the price of the greatest Park Avenue apartment — say a duplex at 740 Park Avenue. These new buyers are not

restricted by any association with any other wealth. They think in their own parameters, which are not the parameters of the West any more.

It's all changing?
Many of the buyers that I've traditionally worked with are being priced out of the market, they can't compete with that amount of wealth and that amount of fearlessness. In the Western world there is a certain sense of hesitation to spend with this abandon, the idea that you can do other things with that money — especially in America, there's the idea of charity, although philanthropy is seen around the world.

Are there moments up there at the rostrum during an auction, when you just ride the wave as it goes up? Or do you control it?
I want to control it, but I can't, because it's not my money. When I auctioneer, I really only think about the next bid. At *that* moment. If you listen to how I count, I say 56, 56.5, 60. I don't say 60 million. Because that becomes too much. You almost have to abstract it for yourself, otherwise you get too flabbergasted. Why I like auctioneering so much is really you become almost nothing. I'm just *the moment* and I'm just *that bid*. And I think that only then can you be a good auctioneer, when you allow yourself to ride that wave, to be that consciousness of the larger group and not of yourself. You become the other. In a way, you vanish.

Are you aware of your consciousness becoming like a compass looking for the next bid?
Someone I know well once said,

"TOBIAS, when I'm in the auction room you don't look at me. There are 1200 people in the auction room. But when I want to buy something, about two lots before, you start to catch my eye." And that's instinct. And I can do it up there; I can't do it in daily life because I'm actually very, very introverted. Up there I can become that other being that smells the desire.

And do you ever find yourself drawn to somebody who you didn't know was going to bid?
Yes, because their body language changes and I pick it up. It's that arched back, it's the alertness of the eye. In London the sales were different because people look at the catalogues, and they don't really pay that much attention. My first time on the rostrum in New York, my first contemporary art auction, I suddenly felt this surge of attention. This animalistic consciousness came over me like a wave, and I almost fell back. It was really incredible. But privately I'm not comfortable with attention. I like one-on-one. I'm intense, but I'm not gregarious.

When I'm a bidder, my mouth gets dry, my heart starts going — you get into a state of alertness before you bid, and you feel fear.
I went to my first sale as a 14-year-old, and I bought something for five pounds, and my mouth also went dry, and I also got excited, and my heart started to beat and I had that sort of feeling of compulsion.

Yes! It's like the beginning of sex...
It is an engagement, absolutely. What people feel with me as an auctioneer is

that I'm complicit with them. It's a pseudo-erotic engagement, absolutely. You lock, and you say, "It's okay. We can do this." I'm the great tempter. I say at that moment, "Come on, let's try one more." And there *is* one more. And at that moment I can let inhibitions drop a little bit.

And what happens when you come down, do you collapse?
Somebody gives me a glass of white wine, because I need something. Sometimes I have to make a speech or hold a press conference afterwards, but I have a hard time doing that, because I can't remember almost anything. I get very tired and normally go to bed after an evening sale at 10.30pm, but then I wake up at 2am because that adrenaline rush comes back.

Do you ever have the feeling, "God, what have I done?"
No. Because it's what *we* have done. Don't forget, we are in a pseudo-erotic environment where people bid with you, and if something doesn't sell, you feel deflated, like they've refused your advances. As an auctioneer I have never really experienced a bust. Like the rest of my economic compatriots in that landscape, I've ridden the wave upwards. Every sale that I've done since I started in 1993 has been better than the one before.

What are the most famous things you've sold? The most groundbreaking? The ROTHKO?
I put a sale together in 1994 with works by JOSEPH BEUYS and they all broke world records. It was 1994 and one BEUYS collage made $700,000, which

at that time was unbelievable. I so identified with that object, it was this mystical collage of a head behind glass and it was very, very removed. My enthusiasm translated to several people and it made that price. And the next big moment was WARHOL's orange MARILYN in 1998, which we sold for 17 million dollars. For almost ten years that was the highest price of any contemporary work of art. I was in awe of this object, and I knew that whatever price somebody would pay was the right price. After the sale I said, "This is actually cheap." And people looked at me like I had lost it. And it *was* cheap. Because that picture is now worth 100 million dollars.

Why were you so in awe with it?
It was bigger than me. It was bigger, and it had a permanence about it. I knew it would transcend any idea of taste and fashion. The next thing was PICASSO's GARÇON À LA PIPE that made 104.2 million dollars. And the ROCKEFELLER ROTHKO moved me like the orange MARILYN. I like works of art that are bigger than the artist, larger than what just one single human being could create. The ROTHKO had that, all the longing of the middle of the last century, and all the longing for release. Longing is the one thing I understand. When the artist matches that longing with a work of art that is bigger than his or her consciousness, that is when you get moved.

It happens with old paintings too?
The German Renaissance — ALTDORFER, GRÜNEWALD. There is an amazing painting by HANS BALDUNG GRIEN in the KUNSTMUSEUM in Basel called DEATH AND THE

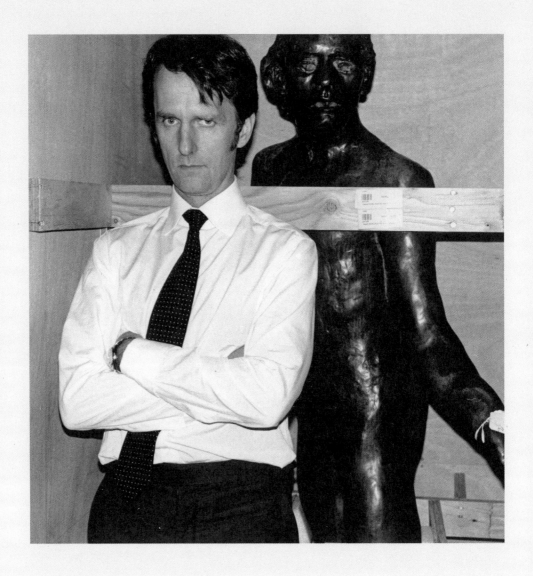

MAIDEN. A young maiden being dragged into hell by the devil. And it's so sexy. Everything about sexual guilt and seduction comes into it. This... not being able to resist. And the rapture we all long for, being taken away by something. At the core of my soul, and the core of what I'm good at in my job, is understanding rapture, understanding how great it feels if you allow yourself to succumb to it.

Like the Greek and Roman Galleries in the METROPOLITAN...
Great works of art relate to you in a physical way. Big or small, there is a physicality to them that has an impact on the way you are. It can be a small sculpture of a lioness that has this incredible vibration or it can be an enormous MONET water lily painting. I have this emotional connection to art from my mother, because when she took us to exhibitions, we would both run immediately to the most emotional work of art.

Are you an only child?
I have an older brother. As children we fought a lot; now we're incredibly close. It wasn't exactly uncomplicated, but I don't think any sibling relationship is entirely uncomplicated.

Tell me about your father.
My father started life as a scientist, but he was very good at getting things done, so he began to run companies, from a technical standpoint, not from a business standpoint. He invented a spinning machine that destroyed the textile industry, because it spun out artificial fibre much faster; he started to build these and export them to Asia. I was told by my parents that for security reasons I could never tell anybody what my father did. In the '70s people were worried about being abducted. And my father said, "TOBIAS, you have to speak English, and you have to finish school, you have to play one social sport, either tennis or golf, and you have to make your hobby into your profession."

It's true.
I never work. I have to do things of course, but at the end of the day I still think that I've hit the candy store.

You knew that it was going to be art-related?
My father sent me to England because he said I needed to learn English, and I ended up with this very interesting woman, the mother of KELLY LeBROCK. Very free-spirited and she had this neo-gothic house out in Hastings or St. Leonards-on-Sea. She took me to my first auction — a local auction house in St. Leonards in some sort of garage. And I bid on some silver spoons. I just thought, oh, maybe that's something nice. I was 14. And afterwards I was so upset. I had pocket money but my father told me not to spend any. And she said, "TOBIAS, your parents should be very happy." So she gave me permission. She was like my AUNTIE MAME. And art was always important to me because visual things were important to me. As I got older, at 13, 14, it was a way to look at things instead of looking at boys.

Let's go into that.
I'm 14 and I clearly know that what attracts me is not what I'm supposed to be attracted to, and looking at art is a replacement for looking at what physically and sexually attracts me.

A replacement, but also another way of doing it.
It was more removed. I wouldn't look at art for sexual thrill. I wouldn't start to swoon in front of a beautiful sculpture of APOLLO. I remember looking at WARHOL very early. And I remember the first set of MARILYN prints that came to Germany with the MUSEUM LUDWIG in Cologne. I hid my own desire quite well.

From yourself and from others?
The real kicker is that I did hide it from myself. When I finally allowed myself to have a boyfriend, at 21, I was worried that I would lose my talent for looking at art.

As if reality would cancel it out?
I have this visual memory bank. I can recognise things in almost an autistic way. I thought maybe I would lose that access to the projection space, if you want to call it that.

When did you start going to a shrink?
We all moved to Vienna when I was 15. The language of psychology is there. There's a reason why FREUD was Viennese. When I went to see the shrink, I thought it was very interesting. Although, after one year I got bored because I tried to entertain my shrink.

Vienna is such a strange place.
It's a dark city. That's why I was so anxious to get out of it. I finished university there, art history, and worked for the only international dealer in Vienna. He had fantastic Renaissance silver and great French bronzes and we used to go out and buy things. He said, "Be smart and use your eyes."

So, you went to London.
When I was 18 I did this CHRISTIE'S course. I had voraciously read APOLLO magazine, which my parents subscribed to. I looked at everything, saw everything, read everything, looked at the ads. We had this test, there was this piece of furniture and all they wanted to know was where it came from, whether it was French or German. And I said, it was a bureau bookcase, it was German, it was made by KIMMEL in Dresden, it was to be sold at MENTMORE in 1978, but it was bought by the state and it's now in the V&A, and it's one of the most important German pieces of furniture, about 1745. And that got me my job at CHRISTIE'S as a graduate trainee, this 18-year-old kid who regurgitates information.

Where does that come from?
It's somewhere in your head, in this other world that you go to, and you don't quite know when you go there or when you come out of it. Sometimes things come out, but they can't be premeditated, it's just there. I wanted to learn about contemporary art, so I started to catalogue really bad paintings in the basement, and was getting super-bored. I got a call from a former boss of mine. "They are looking for the head of the department at SOTHEBY'S in London." I went to see LUCY MITCHELL-INNES, who was running the contemporary art department for SOTHEBY'S all over the world. She was first of all incredibly beautiful. She had an incredible way of moving. She moved slowly, which I found very, very erotic.

On high heels...
Yes, BLAHNIK shoes. She looked me

straight in the eye and she said, "TOBIAS, for what would you leave CHRISTIE'S?" I said, "If I had responsibility. If I can do things the way I think they should be done." And then she called the next day and said she would like me to be the head of the contemporary art department for SOTHEBY'S.

What year, what day?
1992. I put the phone down, I laughed. Because I didn't know anything, I didn't know anything about contracts, or putting a sale together, and I said to her, "I don't really think I'm the right person." She said, "Don't worry, we will give you experience. You just come with your energy." And so I said "yes". And from that moment on, which was the 18th of October, 1992, I worked really hard. And I got very lucky. I was on fire. I remember sitting in a car with somebody who was supposed to look at some painting, and he was talking to me about having bought a figurative painting by an artist whose name he couldn't remember. I asked him if it could have been a GERHARD RICHTER and he said "yes". It turned out to be this really important painting and I convinced him to sell it. I was very intense. I was, like, "This is going to be really, really expensive." I was 29 years old. It hasn't stopped since then.

And then?
Then after three years in London, DEDE BROOKS said, "You should come to New York. This is where your career is." And I said "no", because I really was afraid of that big theatre. I perceived New York as very restless, as very anxious, as very charged. London has this wonderful human layer. People are judged as human beings before they're judged as professionals. Here in New York you're judged as a professional only. Every relationship is based on a professional relationship. You don't have dinner with people because you like them, you have dinner because you think they could lead to something interesting. You have to own it, it's part of that nature. I just felt it wasn't for me. I liked the sort of slight setback of London. But then my ambition took hold of me. I was 33. I said "yes" and moved here.

To Chelsea?
No, I had seen too many WOODY ALLEN movies. I wanted one of those pre-war apartments with lots of moldings. So I moved to the 150 East 72nd Street. Also I had started to see, and sort of very delicately date, my now partner, MARK.

When did you meet?
We'd met five years before at an art fair and I thought he was so handsome. But he didn't look at me. After a while we started to talk to each other a little bit. He moved to London the same day that I moved to New York. I helped him with his visa application, so we started to talk to each other a little bit more and I realised—I knew this instinctively again—that he would be the love of my life. It was just a question of time. So as my job was really taking off and things were really happening, MARK moved to New York in 1998. And then the next thing happened, and that's very personal...

Something you want to talk about?
I had always been afraid of my mother dying. She died of cancer, in great pain.

I always knew that would be one of the hardest things. She died with me. After that, I really stopped being afraid of anything. I realised that many of the things we do are important, but you know, we're not curing cancer. I'm very passionate, I love art and I love all these things, but let's have a little perspective. That was the moment I stopped being bourgeois.

What's bourgeois to you?
Being restricted. Worried about conventions, worried about doing the right thing, what other people consider the right thing.

Was there a change in your taste at that time?
A complete change of taste, particularly in our house. Before, it was always very proper. I believe that there are great unique and irreplaceable works of art, and if you can live with them by looking at them that's a great gift. But many things are also just one physical manifestation, and then they can be something else again. There is no absolute great taste. It doesn't exist. You can live with one great AGNES MARTIN painting, and that's fantastic. You can also live with a sort of wall painting by a young artist and some weird installation.

What about the items that you had in your place when you first came to New York?
When I first came to New York, I had very pure Danish BIEDERMEIER furniture. White walls, very austere, a THOMAS RUFF photograph of a social housing complex in Germany.

That's austere.
A very early ELLSWORTH KELLY painting of the Brooklyn Bridge. A SAMUEL MARX lamp made in 1941, which was a Chinese lamp, very beautiful, simple. Very simple things. I found it weirdly restrictive, and I don't like that taste anymore. I just bought a very beautiful silver candlestick in Vienna that was made in 1801 and it looks like BAUHAUS and it's exquisite. Do I need to have it? No. Does it give me joy to have it? Yes. Will I miss it? No.

I tend to think things carry a charge. There are things that I'm afraid to get rid of even if they're awful.
Yes, they carry a charge. There's a Swiss psychologist who has written about that charge. Collectors recognise the charge, or the spirit of an object, and they have to protect it. But the psychologist, a Jungian, says it is not the object, but rather you who gives the charge to the object.

Are there contemporary things that have that charge for you?
There are artists — MATTHEW BARNEY. I went to a performance in his studio in Brooklyn. It was raining, he was walking around a car wreck with a dog on his head, women were lying on the car and a bull with painted horns came out. Something was happening. It was so intense and so beautiful and spine chilling and you couldn't really explain it at all. But I have a hard time relating to things that are being made right now. I sometimes need five years to look. Some people can recognise what is now. MARK has that.

What's MARK's job?
He helps people to buy very young art, he discovers very young artists. He starts talking about one name and you think,

"What is that?" And then six months later every curator is talking about that. But if I needed to name one artist of the second half of the 20th century who gets me, I think it is ANDY WARHOL. He knew about death, and he knew about sex. And those are already very big subjects.

Off the top of my head, WARHOL knew about worship and longing. But not about sex and death.
I'm thinking about MARILYN, I'm thinking about ELVIS. But for him, and maybe also for me, sex and death and worship and longing are very related.

EROS and THANATOS.
EROS and THANATOS are the key words in our existence and that's what it's all about.

Money? In New York...
The idea that money is meaningful comes out of the denial of sensuality in this culture.

Which is why New York is the least sensual place in the world.
You have to work and you cannot enjoy your life as much and you can't stay out late and you can't be really spontaneous. But New York has given me this opportunity to become what I have become. If I had stayed in Vienna I would have been depressed, if I had stayed in London I would have never... What I love about New York is that people say "yes" before they say "no". They always will listen to something that they might consider interesting because it's a town based on ideas of opportunity.

I used to say it was haunted by the phantom of opportunity.

For somebody who grew up in an environment that was about whether or not your grandfather had polished shoes, and things already defined long before you were born, it was enormously refreshing. New York is the place to self-realise in a cerebral way. It's not very sensual. And New York is not America, this idea of a moral utopia — that is also so weird about this culture. America is one of the biggest producers of meat in the world, but the most popular way of eating meat is by hiding it between two pieces of bread. And when you show them a piece of meat, like you might in France, with maybe a leg attached to it...

Oh, they freak out.
Once you go into the realm of the privileged, privilege is extraordinary! Where in Europe do you have doormen and people that bring things up to your apartment?! It's a very 19th century town in that way. You can actually have your breakfast delivered. And all of this is nurtured by an immigrant culture. I had a very funny experience — somebody that I worked with once said, "You're a heartless bastard." And I thought, "Well then I've really made it in New York."

Mr. KONSTANTIN GRCIC

Featured in issue nº 9 for Spring and Summer 2009
Portraits by Erwin Wurm

Already a celebrated product designer when he was featured in the magazine in 2009, KONSTANTIN GRCIC has gone from strength to strength since. He has created covetable items for just about every major furniture company including VITRA, MAGIS, FLOS and ARTEK and been the subject of a one-man touring exhibition that launched at VITRA DESIGN MUSEUM. Any time there is a prize for "best chair", KONSTANTIN tends to win it.

KONSTANTIN was photographed for the magazine by the artist ERWIN WURM. The designer's poses relate to WURM's ONE MINUTE SCULPTURES, a series of works begun in the late 1980s in which the artist instructs participants to place their bodies in relation to everyday objects and pose for 60 seconds. The positions are odd and in some cases silly, but KONSTANTIN is nevertheless able to enact them with a guilelessness that amounts to dignity.

Like his poses in the photographs, KONSTANTIN's designs can appear a little awkward at first glance and they rarely settle easily in the mind. Something to do with balance, perhaps, or maybe it's the scale.

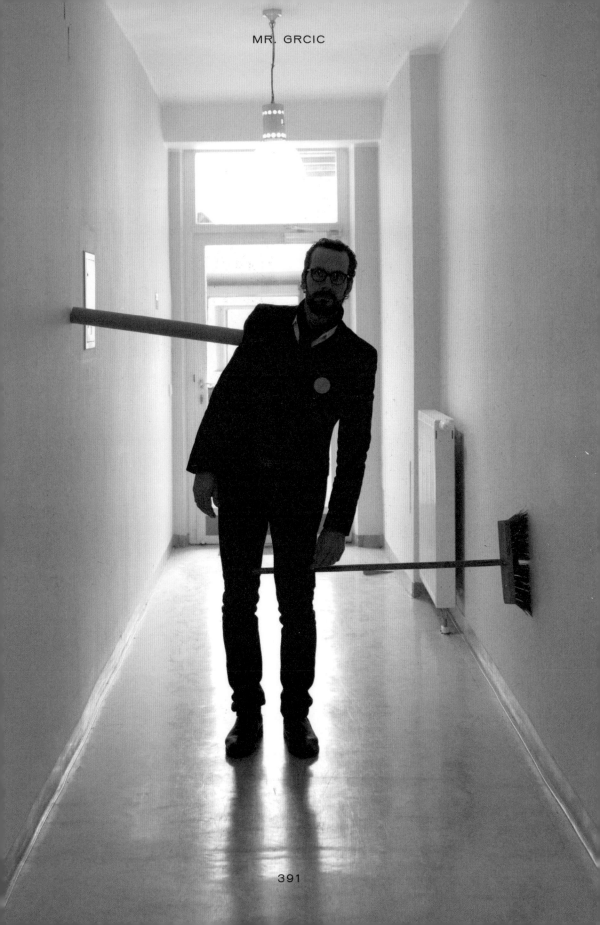

Mr. CHRISTOPH WALTZ
Featured in issue n° 20 for Autumn and Winter 2014
Portrait by Alasdair McLellan
Text by Susie Rushton

Mr.
CHRISTOPH WALTZ

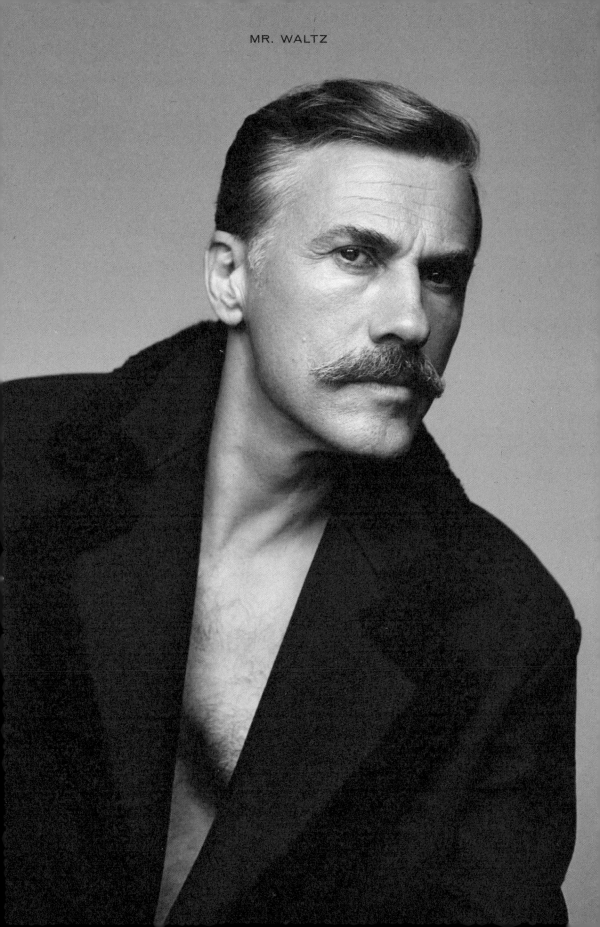

This story in FANTASTIC MAN considers and celebrates at length the successes of Austrian actor CHRISTOPH WALTZ. Naturally, the two OSCARS he has won for his films with QUENTIN TARANTINO are mentioned, as is his new moustache, his deadpan delivery, and his upcoming roles in BIG EYES, TARZAN and HORRIBLE BOSSES 2. He loves playing the villain but hates skiing, an aversion he picked up in his native Austria, where he had a healthy television career before going global. As a child CHRISTOPH played the classical guitar, he judges cars on the quality of their stereos and he directs operas in his downtime. And please note the aptness of his last name: WALTZ.

Shading his face from the sun with a hand, CHRISTOPH WALTZ stands on the ridge of Parliament Hill, the southernmost slope of Hampstead Heath in north London, and looks out at the city skyline below. What a good idea it was—mine—to take the actor for a walk on the heath. WALTZ didn't need much encouragement. Sliding on his large brown PRADA sunglasses as we stepped out onto the pavement, he walked and talked, talked and walked, only stopping to look at a little Georgian street: "Nice little corner here!" Or the local wildlife in the park: "Look, big rat over there! Massive!" Or a man with a badly bleeding leg who asks him for 20p: "Get yourself help, eh?"

We make our way up the sloping path that ascends London's most glorious park, buggies weaving between us, only the occasional passer-by glancing backwards at the movie actor. It's the voice, musical and sardonic, that gives him away.

One of the most talked-about character actors of the moment, CHRISTOPH WALTZ is at the crest of his career, at the age of 57. Since appearing in QUENTIN TARANTINO's INGLOURIOUS BASTERDS in 2009, WALTZ has been picked for starring roles by ROMAN POLANSKI, TIM BURTON and TERRY GILLIAM, among others, and garlanded with two OSCARS, plus BAFTAS, GOLDEN GLOBES and the top acting prize at Cannes. He is now, as GILLIAM

puts it, "a bankable star—his name helps movies to actually get made, in financing terms." Audiences feel the WALTZ effect too. As American film director SEAN ANDERS, who cast him as a swindler in this autumn's comedy HORRIBLE BOSSES 2, says: "In the early showings, you could actually see it: when CHRISTOPH appears on screen there's a visible reaction. The audience just knows he can do things so *deliciously*."

As befits a block-booked movie star, WALTZ arrived from LA last night, ostentatious moustache in place on his top lip for his latest role, in TARZAN, which he is filming at the WARNER BROS. STUDIOS in Leavesden.

Where is that?

"Good question. Near Wat-ford."

The actor can do a good awight-geezer London accent. He probably picked it up when he lived here in the late '80s. WALTZ caught the end of the THATCHER years: "which changed this city altogether. And not for the better." In our very pleasant three hours together zigzagging over the heath, the conversation glides over politics, urbanism, film theory, classical music prodigies, foreign language acquisition and contemporary art. He is dryly funny, too, but this erudition—commented on by everyone who works with him—can't help but have percolated into his two best-known performances so far, as SS COLONEL HANS LANDA in INGLOURIOUS BASTERDS, of course, and as Dr. KING SCHULTZ in DJANGO UNCHAINED, both TARANTINO films, both performances for which WALTZ won Best Supporting Actor OSCARS, in 2009 and 2012.

Not bad for someone who was, to borrow from sporting terms, the wildcard entry. As TERRY GILLIAM, the director who cast WALTZ as the lead in his new picture THE ZERO THEOREM, says: "What's intriguing about CHRISTOPH is that he became an international movie star at the age of 52. So much had already happened to him, all the frustrations of being an actor. But put all that aside, really: he's a guy with a really great sense of humour." Which is a reasonable plaudit coming from a PYTHON.

Nobody does deadpan like WALTZ. What is your role in TARZAN? I ask, getting the pleasantries out of the way, as we begin our ascent of the heath.

"Belgian asshole with a moustache."

So, is it an action role?

"Everything is action."

You know what I mean...

"I know what you mean, but it's an adequate answer, because in this movie, everything *is* action. It's no use pretending it's *nouvelle vague*. It is what it is, and that's a good thing! I have a problem with superhero movies that pretend to be more than they are. I have a problem with people who pretend to be more than

they are. It's called pretension. And this movie," he concludes, "is *an action-packed adventure for the international market.*"

CHRISTOPH WALTZ's transition from journeyman actor of TV miniseries and minor movies—almost exclusively European, no big-time English-language roles—to internationally acclaimed stardom is rare. In middle age, he was "discovered" by TARANTINO at a casting call for German actors. Which, as a way into major motion pictures, he says is "very conventional—and at the same time, highly unusual." So unusual that when he first heard that TARANTINO was looking for native French and German talent to cast in a new movie, WALTZ believed it to be bogus. "Those casting sessions in Germany for American productions are usually to get the EU subsidy process rolling. I've been to so many of them. So I said, 'No'. I find it humiliating. It's undignified to go there and be a poodle. They have not the farthest intention to think about casting me."

Assured that the casting was for real, WALTZ read the script, and was offered the part. TARANTINO has since repeatedly claimed he was on the verge of abandoning production of INGLOURIOUS BASTERDS because he couldn't find a suitably malevolent actor who was fluent in French, German and Italian, as required by the role he'd written. "HANS LANDA is a linguistic genius, and any actor who played him had to be, too," TARANTINO told a Cannes press conference. "I wanted poetry in various different languages, and I didn't think I was going to find it." After WALTZ had read him two scenes, TARANTINO announced to his crew that he'd found his man: the show was back on.

Did it also feel like a second chance for WALTZ?

"Look," he says, not for the first time adopting a tone of exaggerated patience, "I'm neither naive nor stupid. I kept it away from me," meaning the hype, the expectation. "I wanted to play the part."

It's amazing, I tell him, how fluently he plays those verbal digressions that make the character of COLONEL LANDA—the "Jew Hunter" with a stylistic debt to SHERLOCK HOLMES—so much more sinister than the typical Holly-wood Nazi. Did he improvise at all? "Why would I do that?" he splutters. His speech just seems so fluid, so believable. "You know what, that's what I do for a living. Improvisation is very fashionable right now, but I'm terribly traditional: the writer should do his job, and the actor should do his job." It was all in the script? "Yes, really. Nobody writes dialogue like he. It jumps out of the page. *It's that good.*"

An actor who wanted to act, rather than a kid who always dreamed of being famous, WALTZ was born into a Viennese family that had been involved in theatre and performance for four generations. "Oh, you know everything," he exclaims, when I mention this. WALTZ is understandably queasy about interest

in his personal life, but family background is, at least, relevant: his parents worked in theatrical design. Austrian director MICHAEL HANEKE is a relation, by marriage. WALTZ grew up in the pleasant suburb of Grinzing, he tells me, on a gentle slope where the houses peter out into vineyards. His parents were liberal, and his childhood was soundtracked with classical music — which he still adores. In a long anecdote, he tells me about the rewards and drawbacks of learning musical instruments, as he (on classical guitar) and his siblings did, and the commitment needed: "I have a brother-in-law who started piano at five and had the typical prodigy career: no football, five hours of practice every day, Juilliard School, became VLADIMIR HOROWITZ's assistant — and got sick of it at 35 and chucked it in. He's got enormous back problems now. Doesn't own a piano any more."

WALTZ meanwhile had the ordinary pastimes of a happy, bourgeois Viennese teenager. "Skiing was obligatory. Every year we had a ten-day skiing trip with my class. Hated it." He never tried skiing again. "But I once went up with my children and I felt really, really old. You know, there's music on the slopes and after two o'clock everybody's drunk. I thought skiing was an industry back then, which is why I didn't want anything more to do with it, but now it's an industry gone mad, like everything else!"

What about those lovely Austrian delicacies, cake and knödel?

"Weeell, not so lovely when you grow up with them. But when I'm there I still go back to the same café that I went to when I was 15, BRÄUNERHOF. I went there because it was around the corner from where everybody else went, so it was a refuge. Café culture is one thing that I've always missed in other cities."

WALTZ remembers his first trip to the cinema in Vienna in miraculous detail. "I went with my grandmother, I was five, we saw a series of MICKEY MOUSE shorts, I remember everything about it. I remember the theatre — it doesn't exist anymore. I remember where we sat. There was one story with MICKEY and a giant, and another with GOOFY as a matador." Vienna was, and is, a conservative city. "And *yet*, it's got that underbelly. It's not the whipped-cream-white-horses-Sachertorte-rococo situation at all," he says, and when I suggest that the English and Viennese share a love of both irony and complaining, WALTZ can't agree enough, and launches into a big kvetch, ironically enough. "One thing about the Viennese is they are *relentlessly intolerant*. And that's the biggest burden when you come from there. There is this *harsh judgement* that knows no gracious relaxation." He laughs, "You know, when you get something, you get it by the throat and squeeeeze."

A great many of WALTZ's roles have had him playing a violent sadist, albeit of the charming kind. If you spend the day strangling someone for a scene in a movie, or blowing them away with a shotgun, how can you disconnect from those

emotions afterwards?

"No, of course I'm not disconnected from that," he says. "Think of it like having an argument with a cab driver. When you get out of the cab, the emotion carries on."

It's a chemical reaction, right?

"It's a kind of reality, acting, but it's a different reality. When you go to the butcher's shop to buy a sausage, you run your errands and go to the dry cleaners, you still know you're supposed to get a shirt. You don't ask for another sausage. Does that make sense?"

Leaving Vienna for New York in his early twenties, WALTZ had plenty of time to cogitate upon the theories of acting — and argue with cab drivers, presumably. He attended the Lee Strasberg Theatre and Film Institute. He took up a pattern of studying in New York, living in warehouses in Tribeca years before the money moved in. "I constantly had to go to Europe to make money; then I'd go back to New York to spend it. I wasn't a union member so I couldn't work in the States." He perfected his English there, which is why he sounds so American in his normal speaking voice — with hardly a trace of the wonderful, brittle Germanic inflections brought to his Hollywood roles. "Yes, I am totally Americanised," he says flatly. He lets his gaze wander to a smart apartment that backs onto the heath. We are sitting on a bench in one of the most idyllic corners of Parliament Hill. "Thats a beautiful little roof terrace. Why didn't they rent that apartment for me? It looks empty..."

In the late 1980s WALTZ moved with his American wife to London, where he raised a family. "My children are basically English," he says.

That's a very nice thing, I offer.

"Well, just as nice as having Nigerian or Malaysian children."

He worked prolifically. For three decades WALTZ was well known in Germany as an actor in TV miniseries and occasional film roles, playing international terrorists, gang leaders and leads in period pieces. On Channel 4's on-demand service you can still see the 1991 drama series he starred in, THE GRAVY TRAIN, about Brussels bureaucrats, in which WALTZ played a hapless German civil servant who gets into scrapes with two great British character actors, IAN RICHARDSON and ALEXEI SAYLE. It's still rather funny, I tell him, but he waves me away as we cross a busy road, "Oh, I'm sorry... I'm sorry you did all that homework," he says, a bit embarrassed.

By his own reckoning WALTZ thinks he has completed MALCOLM GLADWELL's prescribed 10,000 hours to perfect his craft. "Maybe I should try to get 20,000," he wonders. "I could be *that much better.*" He might have a chance to do that, as the Hollywood roles are stacking up. Is being a movie actor like being a businessman in some respect? "I have a fabulous agent, and a lawyer. I

don't have a personal manager. And then I'm extremely particular myself. Between the three of us, so far it's been working out fabulously. One takes care of the looking around, one takes care of the looking at the legal side, and I look into the things I'm interested in."

Does he have a career strategy?

"Oh, I wouldn't know what strategy would be necessary. It's too much... fussing. Fussing, and futzing," he laughs. "Too much, too much." But it probably helps to have two ACADEMY AWARDS, how much does he think about that? "I can't run about every day thinking that I have two OSCARS. But in the back of my cupboard, where they are... I can't deny it does something for the confidence, confidence that the effort to maintain this level I've been working at doesn't seem to be totally in vain."

It must be satisfying to get the recognition.

"Yes it is. Especially after so many years where recognition was never... on a wider scale." His parents are "impermeable", he says, to his newfound stardom. "They're more concerned about, you know, the sanity aspect." Fame is something he tolerates with reluctance, disliking intrusion into his family life (Will you tell me about your children? "No. Nothing.") and minimising its impact on his life. "It's not that big a problem. I'm not LEO DiCAPRIO."

I get the impression that celebrity isn't his favourite topic, so we get up from the bench we've been resting on, and through the trees London's priapic new land-mark tower glimmers in the haze. "Oh, I love the Shard. I get so excited by it," he says. "Not so much from this distance but when you're really close, it looks infinitely higher and loses itself in the sky, like a tower of Babel. I remember when St. Paul's Cathedral was the most prominent building in London. All of these towers," he waves a hand, "came in the last ten or twenty years. I was still living here when they built Canary Wharf. And it's all the result of the deregula-tion of the financial markets. Meaning the creation of wealth that doesn't exist. Disconnected wealth. I find it very troubling."

In this second act of CHRISTOPH WALTZ's career, he lives between LA and Berlin — with his second wife, a costume designer, and his young daughter. He hangs out with QUENTIN TARANTINO ("He really became a mentor. Despite the fact he's five years younger, I seek his advice.") and he has begun to pursue another passion, directing opera. His production of DER ROSENKAVA-LIER was performed at the Vlaamse Opera in Antwerp and Ghent earlier this year. "But it's not a hobby; it deserves exclusive attention. I don't do it because it's chic to direct opera, or sounds good in a magazine interview." He's signed up for another in 2017.

Does he buy art?

"Not contemporary art. The things I'd like to buy are older — and therefore

too expensive." He doesn't own a car, he says, before qualifying, "Well, I have this affiliation with AUDI. They give me promotional cars to drive in. I like them because the sound system is incredible, and the most important thing for me, in a car, is the stereo. And the engineering; the fact that a button feels good when you push it means far more to men than what the button actually does."

WALTZ will admit that fame now means he gets to meet "interesting people" — MIUCCIA PRADA, MEL BROOKS, STEVEN SONDHEIM, JULIAN SCHNABEL, DAVID LYNCH — some of whom he simply approaches with the line, "Hi, I've always wanted to meet you." That's how he met TIM BURTON, walking up to the director at an airport and extending a hand — a handshake that led to his casting in the lead role of BURTON's film BIG EYES, out later this year. In it, WALTZ plays a man who passes off his wife's paintings as his own, and who becomes fabulously wealthy before being exposed as a manipulator and fraud. Does he mind being associated with these charming yet sinister characters? People just seem to love those gentleman villains, but has he had enough of them yet? "Well, first of all, I like them myself too," he insists. "I find it an attractive mix. Only evil... is boring. Only good... is tedious to the degree of coma. The *mix* is what's interesting, in any person. I find that has more to do with human beings, and the world. I haven't consciously pursued those roles, but then they turn out to... work quite well for me."

BIG EYES is based on the true story of MARGARET KEANE, whose wildly successful paintings were passed off by her husband, WALTER, as his own. The story culminates in a courtroom scene where both have to paint a picture on the spot in order to prove who's the real artist, with WALTER keeping up the pretense until the very end by pleading a shoulder injury. (He lost.) WALTZ now actually *owns* a MARGARET KEANE painting, he tells me. She gave it to him when he went to visit her in San Francisco. "Go and pick one," she'd said to him. "Anything you want."

By now we're walking down through the long grass — unusually hot London sun heating the air, WALTZ with his jacket slung over one shoulder.

What plans for the afternoon?

"Well, I just got in, so I'll get settled a little bit. I'm here until late September, early October, with breaks in between."

How does a typical day unfold, on set of a movie like TARZAN, for an actor assigned to play a Belgian asshole with a moustache?

"Well, I only took a glance at the schedule; there's lots going on. There are two units, and you know, you do a scene with the director, then a second unit comes back and picks up other details..."

Having every minute of your day accounted for, the waiting around, doesn't it get tiresome? He'd told me earlier in the interview about a book he was reading,

a novel called GEORG by German film theorist SIEGFRIED KRACAUER, which sounded interesting, if not exactly lightweight. Does he read on set?

"A little, but you can't really read very engaging things when you're supposed to be engaged in something else: making a movie. So you more or less just... do empty stuff. But I don't get bored, oddly. Sometimes it can be boring. When they call you at 10am and you don't shoot till 4pm. But there's this old saying, "he says, delivering a final, deliciously deadpan line as we part on the pavement: "You get paid for waiting. The acting is for free."

Mr. JONNY WOO

Featured in issue nº 1 for Spring and Summer 2005

East London's cherished master of drag performance JONNY WOO — also known as JONATHAN WOOSTER — is usually photographed in elaborate make-up and costume combinations. Not so in the first three issues of FANTASTIC MAN, for which JONNY enthusiastically turned his hand to modelling more conventionally masculine get-ups. His debut appearance saw him with tousled hair and beard, wearing a series of men's pyjamas. Without make-up, JONNY's face is handsome and kindly.

From 2003 to 2006 JONNY hosted the regular art party RADIO EGYPT at Shoreditch's GEORGE & DRAGON pub. This led to many invitations to perform for luxury brands, in art spaces and at private parties. His "Tranny Talent" and "Tranny Lip Synching" competitions at the east London restaurant BISTROTHEQUE are the stuff of legend. These days, JONNY is the co-owner of THE GLORY pub in Haggerston, where his current concerns include the male beauty pageant, MISTER GLORY.

Portrait by Benjamin Alexander Huseby

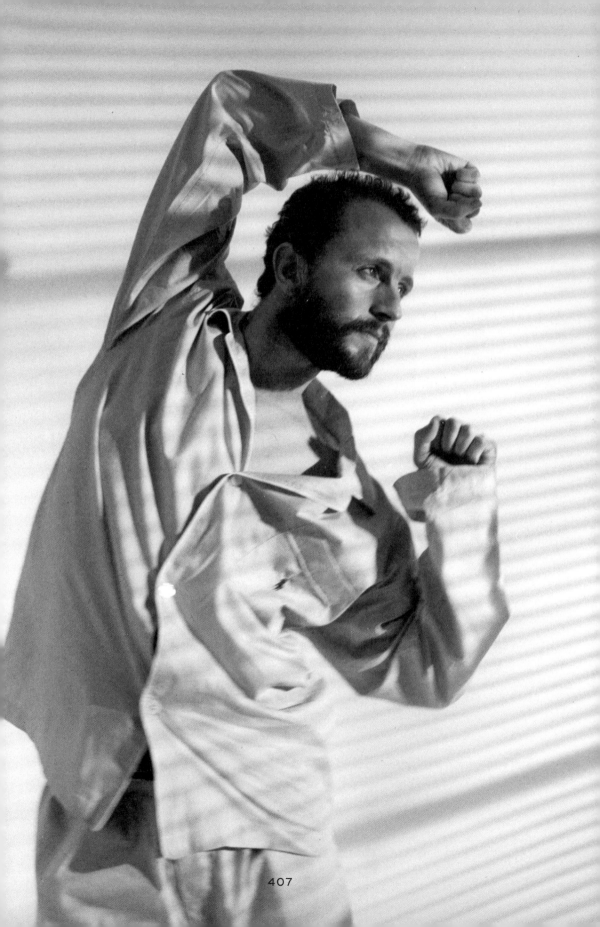

407

Mr. PATRICK GRANT

Featured in issue n° 8 for Autumn and Winter 2008

PATRICK GRANT is the owner of the 187-year old Savile Row tailors NORTON & SONS and the ready-to-wear brand E. TAUTZ. He was photographed for issue no 8 of FANTASTIC MAN wearing a set of four structured suits, among them a NORTON & SONS bespoke tweed number made of Glenurquhart plaid. The shoot marked the move away from the skinny silhouette to a more generous cut in menswear as a whole. PATRICK has matinee idol good looks and became a celebrity in the United Kingdom for his role as a judge on the television series THE GREAT BRITISH SEWING BEE. As a youth he was an enthusiastic rugby player, but his career in sport was cut short by a shoulder injury. PATRICK also appeared in issue n° 11 of the magazine modeling sweat-shirts in Malta.

Portrait by Andreas Larsson

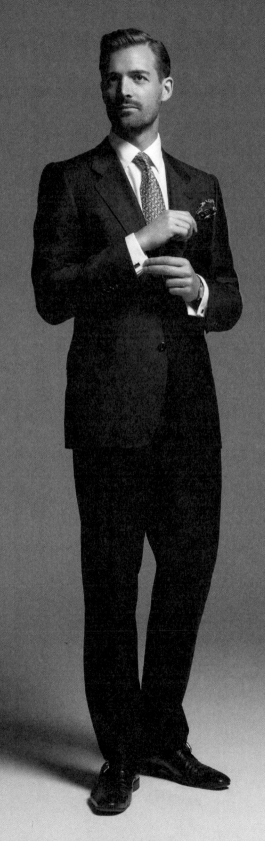

Mr. DAVID BAILEY
Featured in issue nº 5 for Spring and Summer 2007
Portraits by Juergen Teller
Text by Tim Blanks

Mr.
DAVID BAILEY

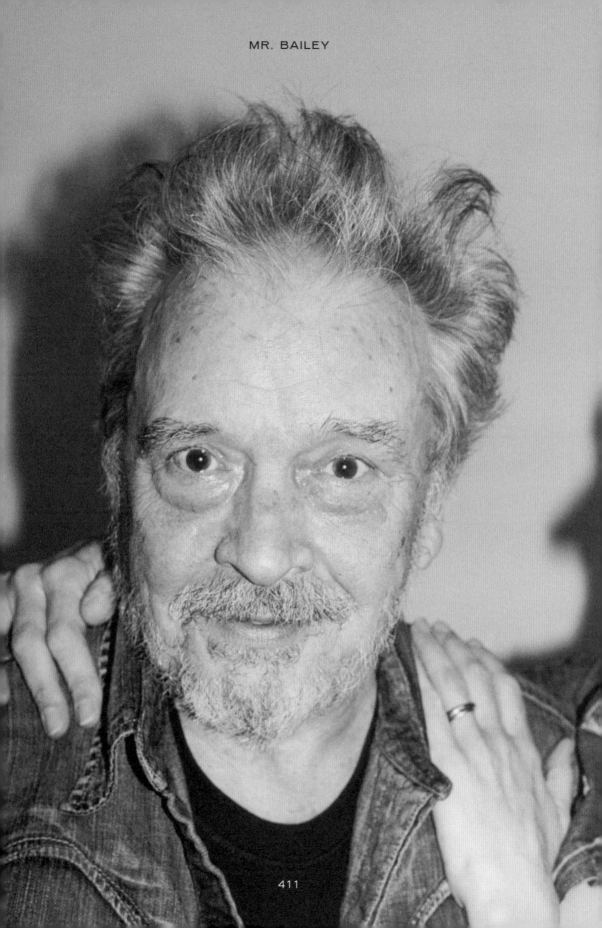

"If there is just one photographer's name that people know, it is DAVID BAILEY." So runs the blurb for one of BAILEY's new books from his publisher STEIDL. And even allowing for promotional hyperbole, it's probably true. After all, he was the inspiration for the swinging London fashion photographer main character of ANTONIONI's '60s classic BLOW-UP. You don't get his kind of résumé—from ADOLF HITLER to KATE MOSS and a marriage to CATHERINE DENEUVE, with cameo appearances from every species of high and low life in between—without being thoroughly woven into the fabric of the times you're documenting.

It helps that Mr. DAVID BAILEY has always had careless charisma to spare, and a way of telling a story where one scurrilous anecdote folds breezily into another, all of them shot through with a filthy cackle that lets you feel like you're in on the joke. He's also engagingly curious, asking dozens of questions where just about anyone else in his position could barely be bothered to catch your name. And even —maybe especially—now, he's as photogenic as any of the beauties he's snapped over the years. His decades can be checked off in a string of famous images: sexily shirtless in his air force barracks in 1957, a fey faun in Chelsea boots in 1965, louchely white-tied in the '70s...

On the wall of the Bloomsbury studio he has worked in for the past 25 years, there is a huge portrait of BAILEY by HELMUT NEWTON. It's signed "from the fan and the debutante" (HELMUT and his wife, JUNE). "I don't mind having my picture taken but most photographers are quite boring. There was a guy in here a few days ago. He didn't ask me to do anything, just took roll after roll. Finally, he said, 'Can you do something different?' I thought, 'Oh, good'. And he asked me to put my leg up!" BAILEY practically chokes with laughter. His own *modus operandi* is legendarily more aggressive, bordering on physically abusive. That was DAVID HEMMINGS doing BAILEY when he all but raped VERUS-CHKA with his camera in BLOW-UP. (And that was MIKE MYERS doing HEMMINGS doing BAILEY in AUSTIN POWERS.)

It's not true that he snorted coke off PRINCESS MARGARET's tits, but he looks exactly like the sort of little devil who would have done something like that for a laugh—that is, if he'd ever taken drugs in the first place. ("I never did actually. If I smoked two joints in the '60s it would be a lot; not for anything moral, but I felt quite stoned all the time anyway.") It's easy to see the young cockney rebel in the older BAILEY. He's cheerfully scathing about many of the legends whose paths he has crossed. HORST was "a miserable old bugger," CARTIER BRESSON "a pretentious old fart," TRUMAN CAPOTE "a real old-fashioned vicious queen." And CECIL BEATON was also vicious, for all BAILEY's good works on his behalf. "He had fallen out with ALEXANDER LIBERMAN, so I arranged a comeback shoot for him with JEAN SHRIMPTON. And BEATON said to LIBERMAN, 'I can't really see the point of DAVID BAILEY. I suppose he has some kind of vague cockney charm.'"

A mild understatement. Old queens must have melted when they were confronted by this cheeky piece of cockney rough. FRANCIS BACON ("FRANKIE the Pig") hit on BAILEY the same year that SALVADOR DALÍ picked him up in the lift at the ST. REGIS. "This guy got in with a walking stick with a propeller on it with two naked dolls on the propeller and he said, 'Have you met my brother and my sister?' and he pressed a button and the two little figures spun round—and that's how I met DALÍ."

BAILEY just turned 69, an event which was a mixed blessing. "I was worried about dying last year because my father died when he was 68, and I couldn't wait to be 69 because I thought history might repeat itself. Then I found out the cunt died at 61. I was worried for a year for nothing!" In his new book, PICTURES THAT MARK CAN DO, there is a cell-phone snap of a scruffily bearded, startlingly gaunt BAILEY holding a skull up to his face ("It's HAMLET, isn't it?" he says). Am I only imagining the fear in his eyes? Thankfully, he's back looking well upholstered after an expansive Christmas.

But he claims he's always thought about death anyway. "I guess it was being brought up in the war, and I didn't know a time when there was *not* a war. I remember putting my sister under the table when we were bombed because there was all this glass... and I was like a hero." Maybe it's the nagging worry of his 69th year that took BAILEY back to those early experiences. In his journal, among the holiday snaps of his kids and the CARAVAGGIO repros and the visual *aides-memoire,* there are pages of brightly coloured drawings of explosions and ruined buildings, with Nazi rockets sticking out of the rubble. They look just like the pictures drawn by traumatised kids in war zones. And pinned on the walls of his studio are prints he's been making of HITLER. They may look like comedy montages — BAILEY reading over HITLER's shoulder, ADOLF with his dick hanging out — but they also track back to childhood trauma. "I'm obsessed with HITLER because he was the bad guy in my life when I was a kid," he explains. "They used to say, 'If you're bad, HITLER will get you.' Then, late '44 or early '45, the cinema up by Upton Park got bombed by a V-2. That's where I saw BAMBI and MICKEY MOUSE, so I thought HITLER had killed BAMBI, the fucker."

So his work has always been some sort of *memento mori.* He certainly isn't taking photographs to capture the moment and stop time. "No, it's the opposite," he declares, waving at a wall lined with some of his most famous portraits. "It's all about dead people — WARHOL, BACON, HITLER, MAN RAY, LENNON, LARTIGUE, HELMUT, JOSEPH BEUYS, they're all gone." And BAILEY isn't having any of it that they're living on in his pictures. "They can't fuck, and if you're not fucking, you're not living."

With THANATOS, there is inevitably EROS. Sex and death are the great themes for aging artists and BAILEY is no exception. If he is absorbed by death, he is equally capable of sounding like one of those mythical male beings who thinks about sex an average of every seven seconds. "Aging? Well, I'd rather be getting young. But VIAGRA helps a lot, and anyone over 40 who tells you he doesn't need it is lying." When I make the mistake of suggesting that there are pleasures other than sex, BAILEY jumps in quickly, "...what other things? Is there something else that's as important as sex?"

A hairdresser colleague of his recently told me there is nothing DAVID

BAILEY doesn't know about sex. He bastes his chat with the odd hint of poly-morphous perversity. "TERRY RICHARDSON asked me the other day if it's true his father stuck his tongue down my throat. It's true. The only two men who ever kissed me were BOB RICHARDSON and FREDDIE MERCURY. I was with PENELOPE and ANGELICA, they went out to get cigarettes and the next thing you know BOB's jumped on me and stuck his tongue down my throat and I said, 'C'mon BOB, give us a break, what're you fucking doing?' This is like '67. But he was a great photographer, he had a vision, a fucking magic, where did that come from?"

For BAILEY, any kind of erratic behaviour is justified in pursuit of a per-sonal vision. His early heroes were — still are — the great Victorian eccentrics and obsessives who explored and uncovered the world (none more so than SIR RICHARD BURTON, among whose coincidental accomplishments was the first explicit English translation of the Indian Tantric sex guide the KAMA SUTRA, which would surely have provided fantasy fodder for a young rake like BAILEY in the uptight '50s). The key to BAILEY — his "Rosebud", if you like — may be his boyhood passion for natural history. The naturalist's urge to identify species is reflected in the photographic essays in which BAILEY captures sub-sections of society, and his own palpable thrill of discovery when he identifies and docu-ments something "new" (whether it's something as broad as the London scene in the mid-'60s, or as intimate as the nude studies of his wife CATHERINE), is what gives his best work its power. It's the same sensation I get from the pho-tographer BAILEY claims as his greatest influence, the 19th century French pioneer NADAR.

One of BAILEY's most recent photographer-as-naturalist exercises was a book called DEMOCRACY (because all the subjects were treated exactly the same). It's comprised of 150 or so images of naked Londoners, and he'd been wrestling with it at least since the early '70s because, as he tells it, it represented a major conceptual sticking point about photography itself. "There's a difference between taking nudes and shooting people naked. After EDWARD WESTON's nudes in the sand, there was nowhere to go. But there's nowhere to go with photography anyway, like there's nowhere to go with drawing. No one can draw better than LEONARDO or MICHELANGELO; you can only draw in another way. All the ideas in photography had already been done by the '30s, so now you have to do what *you* do with photography." In other words, all that's left is the power and conviction of the personal vision. And DEMOCRACY was BAILEY's vision, literally stripped to its essence: no props, no make-up or retouching, same fram-ing, same light and six shots for each subject.

This vision thing is life's blood to him. It dates back to his passion for PICASSO. Though he always took photos as a kid, processing them clumsily in

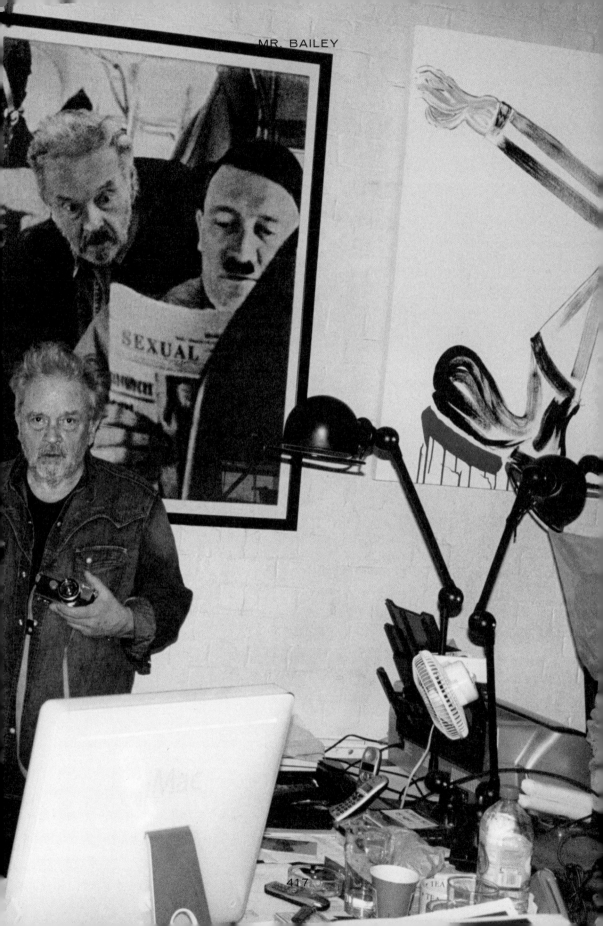

his mum's cellar, it was PICASSO he loved. "I saw his pictures of DORA MAAR when I was 16 or 17, and thought, 'Fucking hell, there are no rules.' PICASSO taught me the only rule is that there are no rules." In his first self-portrait from 1957, BAILEY lies on a camp bed in his barracks in Singapore with DORA MAAR on the wall behind him where the other men would have had their pin-up girls.

The first photograph that really knocked him out was a CARTIER BRESSON shot of four girls in the Himalayas. But there simply wasn't the access to much else photographic. "The only books you ever saw in the '60s were MASTER PHO-TOGRAPHERS, which was dull, and ANSEL ADAMS' fucking trees and rocks. So the only way you saw pictures was in VOGUE." That's where BAILEY came across the work of IRVING PENN, who, along with the English photographer BILL BRANDT, influenced his own pictures. "The white background came from JOHN FRENCH. He wasn't a very good photographer, but I was his assistant and I thought, 'Shit, this is good because it doesn't interfere with anything, there's no distraction in the picture'." NADAR had the same unadorned directness.

Before the interview, I was looking through ARCHIVE ONE, an overview of BAILEY's work in the '60s. Right afterwards, I flicked through a similarly themed volume of work by RICHARD AVEDON. They shot many of the same subjects ("Well, they were the people around," says BAILEY now), a fact that allows for an instructive comparison of their respective viewpoints. "I'm not interested in photography," BAILEY says flatly. "I'm interested in the relationship you can have with somebody. That's where AVEDON and I completely part company, because he said it's got nothing to do with sex; I think it's all about sex. It's sexual when I take a picture, whether it's of a man, a woman or a dog... (he pauses dramatically) well, not so much a dog, unless it's a big dog."

When BAILEY gave THE LADY IS THE TRAMP, his collection of photos of his wife CATHERINE, to AVEDON, he wrote "something personal" across it in big letters, "because he did that book NOTHING PERSONAL and I disagree totally with his theory that photography is not personal or sexual, because that's what it's all about for me. I'm in love with people when I take their picture. The reason why I like 4x5, 8x10 is I can talk to them, and hit them, and make love to them. I'm not just looking at them through something. I talk to people before I take a picture, watch them, see how they sit. I don't want them to get bored."

"AVEDON was cold, clinical, nouveau riche in a way. But those pictures he did for VERSACE were fantastic because they were made for each other. They're so vulgar—the luxury, the opulence, the boys, the girls, the money..." BAILEY has particularly fond memories of his own work for VERSACE (even though the designer dropped him for AVEDON). "He was one of the few Italians that ever paid me, him and MISSONI. I shot CATHERINE for him and that other girl who

became famous, the one who's got no face... I mean, you could make her face any-thing you want, like that South African flower that changes its form." He means the protea — and it turns out he's talking about LINDA EVANGELISTA.

But BAILEY doesn't shoot much fashion anymore. "Most of my stuff is people or projects. I'm doing three, maybe four books this year." The quirkiest, called PARADE, was inspired by his son SASHA dressing up in FEDEX boxes and looking like a cubist costume from the surrealist piece of the same name that JEAN COCTEAU wrote for DIAGHILEV's BALLETS RUSSES in 1917. Appro-priately, the book juxtaposes surreal "parades" of things like ELVIS look-a-likes and the skulls of executed men (BAILEY needed a special licence to acquire them.) Then there's PICTURES THAT MARK CAN DO, a collection of snap-shots whose ease and simplicity is supposed to reflect the fact that his assistant MARK could have taken them. After that, there will be a whole book dedicated to a personal and professional milestone: the shoot BAILEY did with JEAN SHRIMPTON in New York, in January 1962. Though he'd already been at VOGUE for two years before he met SHRIMPTON, he had to overcome the fashion editor's reluctance. "They said, 'We're not going to use this girl just because you're bonking her,' and I said I wouldn't do that because it would be bad for me anyway. So it was the first big story I did for VOGUE with JEAN, and they were the first street pictures they ever used." And — he needn't add — it was also the beginning of the greatest model/photographer pairing in fashion history.

What immediately stands out about the last project is how modern SHRIMPTON looks and how dreadful the clothes are. BAILEY agrees. "The '60s were awful for clothes. People thought it was all MARY QUANT, but it was mostly Mrs. EXETER. And you had to show them as well. Mind you, I do think a fashion picture is kind of pointless if you can't see the clothes. It's not anything then. If you can see the clothes, even the worst fashion picture is at least a docu-ment of a period."

Which introduces another running theme of our conversation — the general inadequacy of contemporary fashion photography. BAILEY's particular bête noire is BOX STUDIOS in NEW YORK, whose owner, PASCAL DANGIN, is the wizard of the retouch. For BAILEY, it's important to make mistakes. "That is why I don't really like American VOGUE photographers. And it's why I like HELMUT. He made mistakes. And GUY BOURDIN made terrible mistakes. Only the fifth picture was good with GUY, but when he got it right, it was fantas-tic." (In the BAILEY pantheon, there are, however, mistakes and mistakes. He is exercised, for instance, by ANNIE LEIBOVITZ's latest book, which would seem, superficially at least, to be something personal, even agonisingly so. "It's so indulgent," he fumes. "She's not in a position where anyone is ever going to say,

'ANNIE, I think you got it wrong, girl.' That's the trouble. It's nice when people say that. GERHARD STEIDL soon tells me if he doesn't like something. That's why I like working with him.")

"Very few fashion pictures transcend into something you'd put on the wall, maybe a few PENNs, a few AVEDONs," BAILEY continues. "My pictures weren't about fashion, they were about the woman. I was interested in photographing the woman in the dress, not the dress on the woman. The only time I noticed a dress, it usually turned out to be BALENCIAGA or SAINT LAURENT. The rest were just frocks. That's why I don't like fashion pictures now. They all look the same. They're so generic, there's no woman coming through. You'll soon be able to do it on the computer anyway, but you won't be able to do what I do because I photograph *you* and I get your personality, and a computer isn't going to be able to do that."

WOLFGANG TILLMANS, another graduate of the dirty realism school of snappers, once said, "Photography always lies about what is in front of the lens, but it never lies about what is behind it," a notion that is given a provocative wrinkle by RICHARDSON and TELLER who seem to put themselves in front of their own lenses as much as behind. BAILEY's response? "Well, it's easier to get themselves to strip off than to get someone else to strip off. Anyway, it's always about you, it's something lacking in you that you want to get."

That sounds a lot like BRUCE WEBER, one of BAILEY's best friends for nearly 30 years, and the modern elegist for whom he reserves his highest praise. "BRUCE is an artist more than a photographer. Most photographers just photograph what's in front of them, but he has got a sort of FRANK CAPRA view of America." As far as WEBER is concerned, you always photograph what you want to be. "Yes, your photos are your friends," BAILEY agrees. "And you're friendly with people because they have something you don't have."

The thought that BAILEY felt "completed" by his photos, JERRY MAGUIRE-style, conjures up irresistible speculation about some of the people in them. How, for instance, would it have felt to be "completed" by psycho-gangster RON KRAY, whom he admits was probably the scariest person he ever met? "You couldn't let him know you were scared. If you did, you were finished." KRAY was another of the idiosyncratic gay personalities that weave their way through the BAILEY saga (though any mention to his face of his sexuality would also get you iced). "I was in a car once with RON, we were in the front seat, REG KRAY and FRANCIS WYNDHAM in the back seat, when someone gave him the finger and cut him up. RON took out a pistol—I suppose it was a .38—put it in his lap and said, 'Let's get the fucker.' I thought, 'Never again will I give someone in a car the finger because it could be RON KRAY with a pistol.'"

Nights like that (fortunately, it ended well, as did the time he was arrested as

a spy in Khartoum, but that's another story) make it easy to appreciate why literal-minded movie folk would see BAILEY as a talent worth corralling. He has made over 300 commercials in his career, but attempts to attach him to movie projects have met with much less success. Before KUBRICK finally made the project, WARHOL and he talked about starring the ROLLING STONES in a film of A CLOCKWORK ORANGE. There was also talk of him directing DON'T LOOK NOW with TERENCE STAMP and JEAN SHRIMPTON. "And I was going to make OUT OF AFRICA for TED ASHLEY at WARNER BROS, but when he called me in for a breakfast meeting about a year later, I knew it was off because, if it was on, it would have been dinner." BAILEY imagined AUDREY HEPBURN and PETER FINCH in the roles that were later played by MERYL STREEP and ROBERT REDFORD.

Any one of these would make it onto a dream list of great might-have-beens, but BAILEY insists he was never that interested in filmmaking. His single attempt was a 1999 thriller called SUSPICION. One online review slates it as "a worthless piece of crap". "It's horrible," he agrees. "I've never actually seen it finished." His lack of interest has nothing to do with that failure, however, and everything to do with his belief that "you can't have team art. I prefer painting or photography, where the vision is just one person." (The same line of reasoning helped turn him off fashion photography, which also tends to be a team effort.)

For all this single-vision malarkey, BAILEY is singularly unprecious about the creative process. "MICHELANGELO would have knocked off a pair of ear-rings if you had the money. I hate all that myth about 'I wouldn't do that, I'm an artist.' It's bullshit. All those RENAISSANCE artists did as they were told, they were jobbers." He loves DUCHAMP's URINAL. "Art's to be pissed in, basically."

BAILEY himself has always painted as well as photographed. "They're bad, but I do them for me; they're not done for a gallery." Still, if they all had the cartoon-ish vim of his HITLER painting that's hanging on the wall, he might yet give his mate DAMIEN HIRST a run for his money. Aside from being a close friend (they're off to Mexico together for three weeks), Hirst has now overtaken SHEIKH SAUD of Qatar as BAILEY's biggest collector. He has about 70 images. Given that the cheapest silver prints now sell for £6000, that represents quite an investment. But BAILEY's classic work is generally drawing increasingly serious prices. His BOX OF PIN-UPS, a boxed set of 38 gravures of London personalities that was published in 1964 with a cover price of £3, recently sold for £20,400. "We couldn't give them away at the time," he says with a hint of regret that he didn't just squirrel away a stack for himself. Still, the mere existence of the BOX OF PIN-UPS does suggest that, even as he was making the work, BAILEY was already able to take a long view of its documentary importance.

I like to think that's because his photography has always been a labour of love — and his most enduring love object has been his hometown, even with the

four wives and any number of spectacular girlfriends. ("Well, it seemed pointless to go out with the ugly ones," he cackles incontestably — and who knew NICO was a scalp on his belt? I didn't.) "I'm in love with London. It's like a mistress you never get bored of," he rhapsodises. "It's endless. I still go down streets I've never been down. I've been down every street in New York and I don't even live there."

His favourite book is PETER ACKROYD's biography of the city, and his own work would make at least one major chapter in such a sprawling narrative. BAILEY once said that CECIL BEATON invented Edwardian England but, in the same way, he himself has shaped posterity's vision of London at a watershed moment in its history. "Well, yeah, more than the BEATLES for sure. They were kind of a joke when they came to London with that silly haircut and their silly little suits. They looked like a bunch of squares from up North." (BAILEY was always a STONES man, not just because they were friends, but because they came out of the blues scene he loved.) He has gone on to devote whole books to London neighbourhoods: NW1, where he used to live, and the East End, where he grew up. The East End is the subject of one of his new books and it's now probably the fastest-changing part of London, but BAILEY feels no nostalgia for the old days. The book's cover shows the interior of one of the KRAY's clubs, a huge photo of a pre-teen PRINCE CHARLES and PRINCESS ANNE smiling down from the wall. "The place was firebombed ten minutes after I took that picture," BAILEY says matter-of-factly.

His intimate experience of change in the city he loves is one reason museums are always knocking on his door to do then-and-now shows. "I say, 'What for? It's not interesting.' It would be better if you went the other way and you got better as you got older. Maybe you do mentally, but you don't physically." As if he needed a reminder of the relentlessness of time, BAILEY was just re-united with JEAN SHRIMPTON for VOGUE's 90th anniversary issue. "It took me an hour on the phone to persuade her. They didn't retouch me but they retouched her. I told her I'd look better than her one day, and now I do."

Which suggests that, whatever else happens, BAILEY will get the last laugh — and it will undoubtedly be a filthy one.

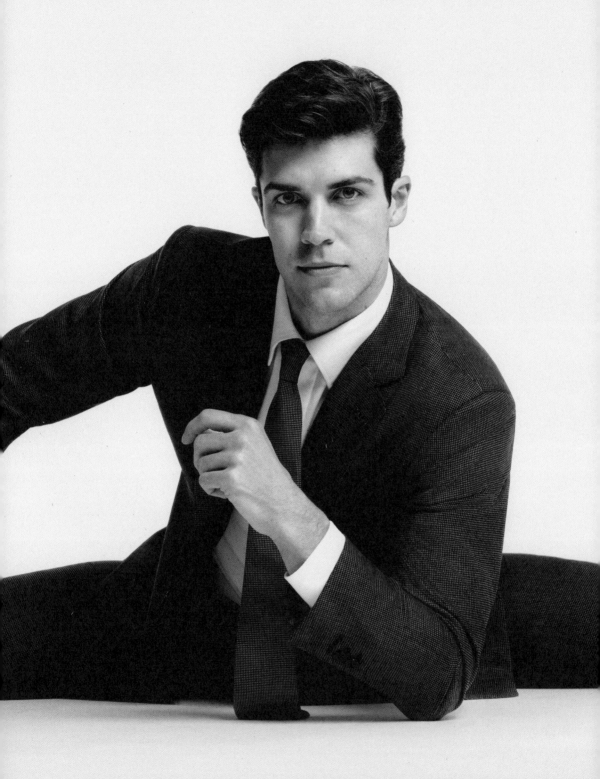

Mr. ROBERTO BOLLE

Featured in issue nº 17 for Spring and Summer 2013

The Italian dancer ROBERTO BOLLE is a phenomenon. He began his career in the LA SCALA ballet company of Milan, rising to the position of principal before going freelance at the age of 21. Latterly he is the star of the AMERICAN BALLET THEATRE, but he continues to make guest appearances with other companies around the world.

ROBERTO discovered that his body would do "exactly what [he] wanted" as a teenager. "I whipped it like a racehorse. But eventually I learned to be more forgiving and listen more to my body," he said. Asked if he appreciates his physique, he replied, "I do, especially the musculature of my legs. I like how my muscles are strong yet elongated, which are two opposites that only really come together in a dancer's body." The photographer BRUCE WEBER is also a fan of ROBERTO's body and in 2009 he published a book devoted to images taken of the dancer over a three-year period titled ROBERTO BOLLE: AN ATHLETE IN TIGHTS.

As well as being a crazily talented dancer and compellingly emotional actor, ROBERTO is not averse to playing clotheshorse from time to time. For FANTASTIC MAN he adopted a series of all-but-impossible positions, testing the give of the fabric in suits from TOM FORD, BRIONI, RICHARD JAMES, DE FURSAC, PAUL SMITH, RALPH LAUREN and GIORGIO ARMANI. His favourite actress is the also-very-adaptable MERYL STREEP.

Portrait by Andreas Larsson

Mr. SPIKE JONZE

Featured in issue nº 18 for Autumn and Winter 2013

FANTASTIC MAN interviewed the American director SPIKE JONZE while he was editing his fourth feature film, HER. Sequestered in a house in the Hollywood Hills, SPIKE and a close-knit group of trusted editors, producers and assistants had already been working on the post-production of the movie for a year or so. The film would go on to win the OSCAR for Best Original Screenplay in 2014, a dazzling validation of SPIKE's collaborative working processes.

The first films SPIKE ever made were skateboarding videos. These led to music videos, short films and, eventually, his first feature BEING JOHN MALKOVICH in 1999. That and his other features ADAPTATION (2002) and WHERE THE WILD THINGS ARE (2009) have all been critical and commercial successes, yet SPIKE has never cut his ties to skating. "Skating is so much more than just skating at the highest level. It's about being with your friends, being out looking for a spot, skating around the city... It's not a team sport where you win or lose. It's did you satisfy yourself, or did you disappoint yourself?" he said.

Portrait by Collier Schorr

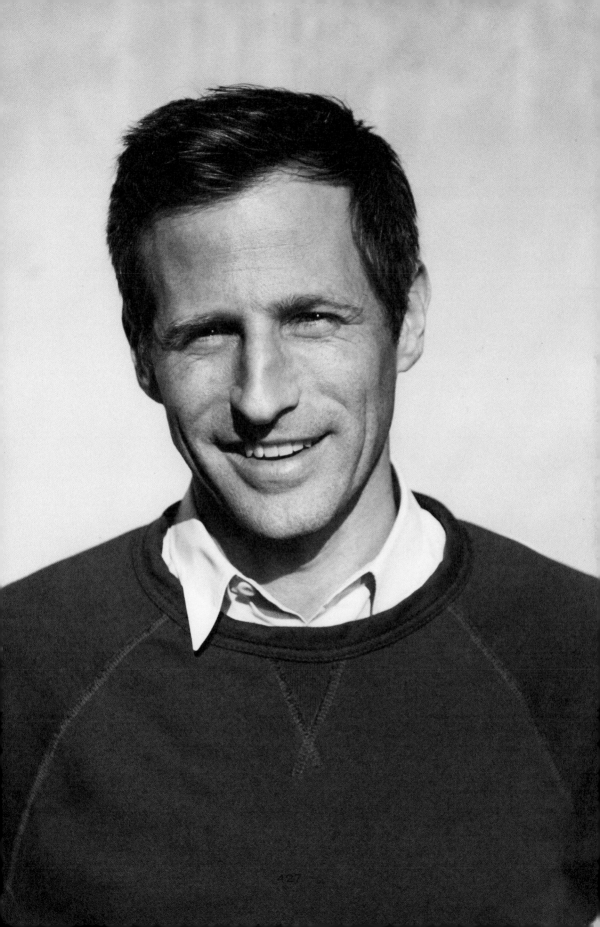

Chapter 4

Page 428-537

Wim
Peter
Gavin
André
Okwui
Peter
Oliver
Giles
Joe
Benoît
Francesco
Xavier
Chris
Johnnie
Claude
Ollie

Mr. WIM CROUWEL
Featured in issue n° 3 for Spring and Summer 2006
Portraits by Viviane Sassen
Text by Emily King

Mr.
WIM CROUWEL

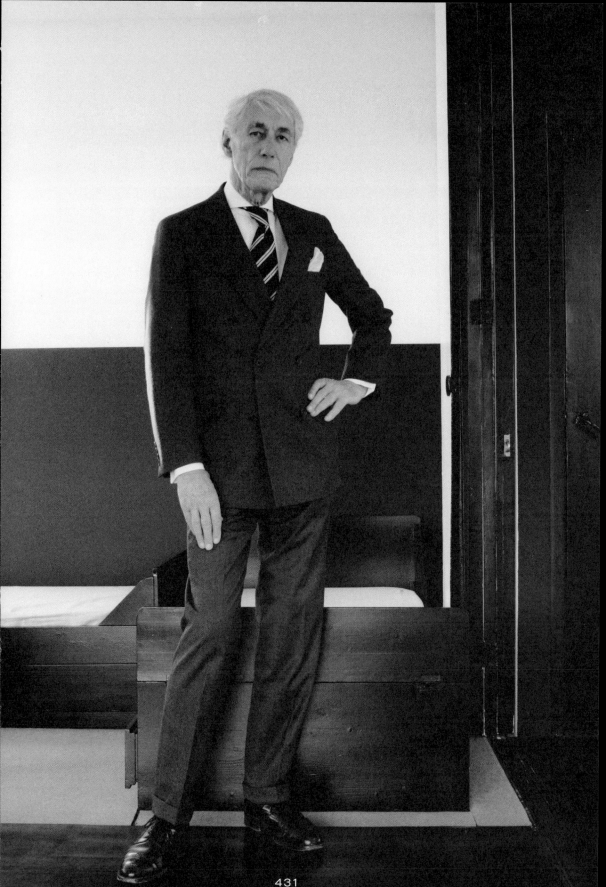

Forty years ago, WIM CROUWEL was the Netherlands' unofficial chief designer. With his company TOTAL DESIGN, he created the graphic identity of just about every major Dutch cultural and commercial institution. From the Amsterdam STEDELIJK MUSEUM to the phone directory to the logo for the RANDSTAD employment agency, his aesthetic was impossible to avoid. Restricting his design palette to a handful of grids and two sans serif typefaces (UNIVERS and HELVETICA), CROUWEL rendered Holland the most visually consistent of all nations. By his own admission, he was a dogmatist: several times during our afternoon's conversation he cups his hands around his eyes to illustrate the blinkered nature of his erstwhile vision. If he says so it must be true, but it is hard to reconcile the gracious, open-minded, loose-limbed, seventy-something Mr. CROUWEL with this image of a stubborn hard-liner. These days, the designer harbours a more flexible approach and a passion for fast cars — although he's still not sure about FRANK GEHRY.

WIM CROUWEL spent the day before our interview being photographed for FANTASTIC MAN at the world-famous RIETVELD SCHRÖDER HOUSE in Utrecht. The outrageous De Stijl architectural experiment by modernist architect GERRIT RIETVELD was built in 1924 for TRUUS SCHRÖDER and drastically renovated after SCHRÖDER's death in 1985. CROUWEL was part of the renovation committee, so he knows the building down to the last detail. The weather was perfect on the day of the shoot, and every member of the team was captivated by the beauty of the building in the low-angled winter sun. Bringing his own clothes to the shoot, CROUWEL rejected most of the stylist's suggestions and, for the only time in the entire afternoon, he verged on intransigence. "The shirt, it was an awful shirt. It was much too big for me, so I couldn't wear it!" he says the following day. "And these bow ties... I use them every now and then, but in my opinion you can't wear them with a double-breasted formal jacket. I am precise in these matters."

As the author of some of the most stringent codes in graphic design history, it is no surprise to find that CROUWEL is an enthusiastic subscriber to what he calls the "unwritten rules" of dress. Yet for all his unstinting modernism, his particular preference is for traditional English-style bespoke tailoring. It's a passion CROUWEL shared with his great friend, the late fashion photographer PAUL HUF. In the '50s and '60s the pair were near doppelgangers and emphasised their similarities by using the same tailor. "We were always being mistaken for one another — we'd ring each other up and say, 'I had another one today!'" HUF and CROUWEL's last made-to-measure suits were acquired as payment in kind for photography and design work for the tailoring company VAN GILS, a major Dutch menswear brand — they made the best skinny suits in the world and they still do quite nice men's fragrances.

CROUWEL is a temperamental minimalist who inhabits structured formal clothes and unadorned spaces with perfect ease. He shares this bearing with a previous generation of modernists — men like LE CORBUSIER or LASZLO MOHOLY-NAGY, who justified their preference for tailoring on the grounds of functionality. Of course, in practical terms, it's a moot point whether a perfectly cut jacket really does have the edge over a boilersuit, but photographed against the horizontals and verticals of RIETVELD's architecture there is a clear winner.

CROUWEL's apartment is in Amsterdam Zuid, an area of the city planned in the early years of the 20th century by the major Dutch architect BERLAGE. Although BERLAGE himself was a functionalist, the individual buildings were designed a couple of decades later by the expressionist architects of the AMSTERDAMSE SCHOOL, and as a result sport brickwork flourishes which I sense CROUWEL disapproves of. His living room is arranged as a conversation

between major modernist designers. A pair of EAMES chairs (a LOUNGER and a 1958 ALUMINIUM GROUP office chair) face an original RIETVELD RED BLUE chair and a reissue LE CORBUSIER chaise longue. Off to one side, set slightly apart, is an early-'90s FRANK GEHRY made of ribbon-like strips of moulded maple. A present from the staff at the BOIJMANS VAN BEUNINGEN museum in Rotterdam, where he ended his career as museum director in 1993, it has been accepted by CROUWEL, but not quite brought into the fold. "At the beginning I didn't like it at all; I kept it upstairs. But it sits so comfortably, and my wife likes it, so finally I brought it here. But I don't like all the swinging lines — there's a lot going on in that chair. It's typical GEHRY, no?"

The obvious prize piece of the room is the RIETVELD chair. Originally designed in 1918, it was made for CROUWEL in 1954. "GERARD VAN DE GROENEKAN was the furniture maker for RIETVELD. He was an old man and he made all the originals until the family sold the rights to CASSINA in Italy. I went to RIETVELD and asked him, 'Can I buy one of your chairs?' He said, 'OK, go to VAN DE GROENEKAN, tell him you have my permission and let him make you one.' So I went and ordered a chair for 80 guilders — about 35 euros!" As a nod to the comfort of his visitors, CROUWEL has added a small blue cushion to the chair's sloping seat. Obligingly I lower myself onto it, while CROUWEL takes the bouncy, upright EAMES. At the time I didn't feel uncomfortable, but listening back I find the interview recording is dotted with fidgety creaks.

As the light of the grey Amsterdam afternoon fades around us, CROUWEL takes me back through the seismic moments of his career. Starting with his personal shock of the new — the CASSANDRE posters on the wall of his art school in Groningen in the late '40s — he runs through the high modern era of the '60s and turbulent postmodern fallout of the '70s and '0s. Overall his story is one of triumph, as his current status as a grandee of Dutch design culture attests.

CROUWEL started out as an art-school rebel, the student who rejected Arts and Crafts in favour of clean lines and mechanical processes. After graduation and two years' compulsory military service, he found an outlet for his modernist urges designing exhibitions intended to sell efficient industry and farming to a war-scarred Dutch public. These displays were funded by MARSHALL AID, American money channelled into post-war reconstruction, but the idealistic young CROUWEL was drawn more to the schematic left-leaning rationalism of European modernism than its ad hoc, commercially-driven US counterpart. That said, though a political radical and a design purist, CROUWEL was financially ambitious. In the early '60s, having taken the advice of the successful British corporate designer FHK HENRION that "institutions like talking to institutions", he established the five-partner design firm TOTAL DESIGN with the aim of wooing corporate clients.

TOTAL DESIGN proved a success from the start. "We designed all of Holland, more or less. At least, that's what our competitors said!" They created a de facto visual identity for the country, with each of their clients, from museums to multi-national corporations, subjected to the same strict graphic treatment. "We had an ideology, an ideology of grids. In the beginning we invented a new grid for each commission, but then we found out that you only need four or five basic grids in total. So we had these grids printed in grey; the office was full of piles of paper grids. With each new commission, we made an analysis of the job and then found the grid to fit. We also had a very strict philosophy on typography. We only used the clean, functional sans serif typefaces UNIVERS and HEL-VETICA."

The TOTAL DESIGN mantra did not convince everybody. For instance, CROUWEL remembers initiating "a lost battle" by suggesting to the New York publisher ABRAMS that he use UNIVERS, a sans serif face, for the text of a book on REMBRANDT. Although CROUWEL backed down and set the book in the more traditional serif typeface BEMBO, he maintains that he was right. "It made no sense. The book was designed in 1970 and we should have used the means of 1970." For the most part, however, CROUWEL met with little opposition. Dutch graphic modernism was at its height, and few in Holland bucked the trend.

In 1967 CROUWEL designed his NEW ALPHABET. A set of 26 letters and ten numerals built solely from horizontal and vertical strokes that simplify them to the point of abstraction, it has become his best-known work. In more recent years graphic designers have used it to convey a part-hopeful, part-sinister sense of modernity. This trend was led by PETER SAVILLE, who used the face on the cover of the 1988 JOY DIVISION compilation SUBSTANCE. I always thought there must have been an element of fantasy to the font, and this belief was rein-forced by a late-'60s PAUL HUF fashion story (first published in the Dutch magazine AVENUE and reprinted in CROUWEL's monograph MODE EN MODULE) which showed CROUWEL dressed in CARDIN-style space wear. When I tentatively bring these images into the conversation, CROUWEL immedi-ately challenges my interpretation. He may have worn a funnel-necked tunic, but his design has always been driven by practicality rather than sci-fi romanticism.

"I came to it from a completely different angle. The basic idea concerned the digital translation of typefaces. In 1965 I saw the first DIGISET typesetter, and the results looked awful, clumsy. I realised the only way to make the dots stay in line was to create a typeface that had only straight lines and 45-degree angles. The second idea was to make each letter the same width, so that they align one beneath the other. That's why the 'n' and the 'm' are exactly the same shape, but with a line beneath the 'm' to distinguish it. I loved grids so much, it verged on the neurotic!"

In the late '90s the NEW ALPHABET was digitised and since then it has been used and abused on a regular basis. CROUWEL seems pleased by its currency; he even approves of the liberties art directors take with his creation. "Oh yes, they all alter it, but I don't mind. They make it readable, where before it was not."

Having appeared unshakable throughout the '60s, TOTAL DESIGN's design totalitarianism began to falter at the turn of the decade. The shine was rubbing off modernism, and there was a growing suspicion that efficient corporations and governments were using it to serve their own interests rather than those of the people. CROUWEL cites the 1968 Paris uprisings as the beginning of the end. "We faced a lot of criticism from 1970 onwards: architecture and design were seen as ruining the environment. Of course terrible things were done in the name of modernism, but in my opinion the reaction was worse than what they were reacting to. Since I was an exponent of modernism, they hit at me quite hard. There was one specific art critic, who had a column in a major Dutch magazine: every week she used it to attack design. And so then we had this period in architecture when they built nice little pedestrianised neighbour-hoods, full of houses with traditional roofs. It was the beginning of a longing for the past, but at the same time it was what we now call postmodernism. It was anti-design, and I hated that."

During the '70s CROUWEL continued to defend his orthodox brand of modernism both in person and in print. He stood against the tide of fashionable opinion that design should be personal and poetic. CROUWEL insisted on efficiency and an objective approach. But the backdrop to this staunch idealism was simply professional pragmatism.

Over the last 30 years his relationship with his modernist convictions has become more complex. He now acknowledges that graphic modernism's ultimate goal of the unhindered delivery of information through neutral and timeless design was hopeless. But when asked at what point he changed his mind, he demurs. "Oh, at the end of the '70s, beginning of the '80s," he says vaguely. "At the time I was doing hardly any design; I was mainly thinking about design." I suggest a comparison with the designer JAN TSCHICHOLD, who famously rejected modernist typography on the grounds that its laws were stringent to the point of being dictatorial, but CROUWEL refuses the drama of the analogy. "Well, TSCHICHOLD changed completely; I've never changed that much. Maybe I just became a little more flexible. The older you grow, the less you want to fight to the last. You recognise the idolatry of certain beliefs and you realise there are other ways of thinking that are just as good..." Not so much a Damascene conversion then, as a gentle, equivocating pragmatism.

Unable to achieve timelessness through design, CROUWEL has instead chosen to conserve it by becoming involved in the restoration of modernist buildings. Of course he is fully aware of the ironies of his current preservationist agenda, not least that he is often working to save buildings that their own architects would have willingly seen torn down. "When RIETVELD built the RIETVELD SCHRÖDER house in Utrecht it was at the very edge of the city and so had an open view. Then, after the war, they raised the road and created a dike in front of the windows. RIETVELD suggested demolishing it and building in another part of town, but fortunately the owner, Mrs. SCHRÖDER, refused." In the late '80s CROUWEL was on the committee that decided to restore SCHRÖDER's house to the state it had been in 1927, exactly three years after it was built.

The culmination of CROUWEL's interest in historical modernism was his work at the prestigious museum of modern art, BOIJMANS VAN BEUNINGEN in Rotterdam, where he held the post of director for the last eight years of his career between 1985 and 1993. During that time he added several major pieces to the museum's design holdings and built a pavilion dedicated to their display. At the end of his tenure, CROUWEL was asked to curate an exhibition on his influences and immediately turned to the modernism of the years between the wars. "It's a vast period, and when I started to research I soon found out that there was too much to show. So I decided to narrow it down to my own year: 1928, the year of my birth. Once I'd taken that decision, I discovered that all the important furniture of MARCEL BREUER, CHARLOTTE PERRIAND and LE CORBUSIER was made in '28, and MIES also did some beautiful things in that year. And the BUGATTI race car, and so on and so on..."

"How far all this is nostalgia for a better time, I don't know," he admits. "I wouldn't like to have lived in that period at all—it was probably a pretty awful time. Except for design: the direction was so interesting, so full of spirit and well thought out. I am still under its influence." Asked about aspects of the contemporary that excite his interest, he mentions space technology and NORMAN FOSTER's buildings. On hearing these perfectly respectable but slightly predictable responses, his wife JUDITH CAHEN, who is sitting a few feet away from us computerising her address book, shouts, "Cars!"

Immediately it's obvious where CROUWEL's true passion lies. "I have an old English car that I restored over a period of ten years, an MG TC from 1947—now it's as good as new!" he enthuses.

"The new BENTLEY?" suggests CAHEN.

"Oh, the modern BENTLEY," nods CROUWEL in agreement. CROUWEL's own car is an ALFA ROMEO designed by GIORGETTO GIUGIARO, a man he declares a genius.

As evening approaches, CROUWEL and CAHEN get ready for an evening

out. They are on their way to a friend's 90th birthday party and CAHEN is laden with tulips. Impeccably gracious to the last, CROUWEL eases his solid but sporty charcoal grey car through Amsterdam's narrow streets, negotiating both the canals and the intricate one-way system to drop me at the door of my hotel. He complains a little about the intractability of the contemporary city, but his navigation is effortless. After retrieving my bag from the car's boot and carrying it up the steps, he leaves me with a new insight that says as much about the man himself as his famous aesthetic. Steely rigour doesn't necessarily preclude those most human qualities — charm and humour.

Mr. PETER YORK

Featured in issue n° 18 for Autumn and Winter 2013

The writer, broadcaster, Londoner and management consultant PETER YORK logs social trends at a frequency with which most of us change our socks. (Incidentally, PETER is very fastidious about his own socks: "Knee-high navy-blue PANTHERELLAs, cotton in summer and wool in winter, and if I'm feeling reckless, coloured ones from BERLUTI.") As the co-author of the 1982 book THE OFFICIAL SLOANE RANGER HANDBOOK, he was partly responsible for popularising the expression "Sloane", a term that "still represents a version of how the rest of the world sees the English, which is exactly what an accurate definition should do," he said in retrospect. Even the most casual encounter with PETER will yield some exquisite nugget of information that he will deliver with characteristically precise diction.

Slightly impatient during the shoot for FANTASTIC MAN, PETER kept an eye on his gold CARTIER watch throughout. That said, he has lots of time for clothes and his exactitude in socks extends to the rest of his wardrobe. His diktats are reproduced here in summary: no brown shoes, only wear ties of a standard width, don't be a label snob or a slave to bespoke, but do learn how to instruct your tailor. And above all, never, ever, wear your shirt untucked.

Portrait by Andreas Larsson

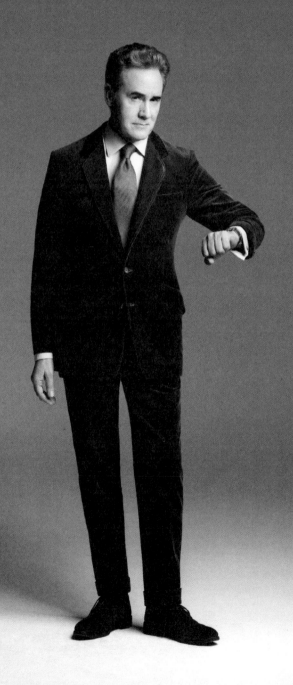

Mr. GAVIN MACDONALD

Featured in issue nº 16 for Autumn and Winter 2012

Handsome tree surgeon GAVIN MACDONALD is considered to be the embodiment of Scotch charm to the extent that he was awarded the title of Mr. Scotland in 2010. Two years later, GAVIN appeared in FANTASTIC MAN as one of 21 Welsh, English, Scottish and Northern Irish men in ALASDAIR McLELLAN's lavish photographic survey of the United Kingdom, "Men of the British Isles".

GAVIN was depicted against the back-drop of the manmade St. Margaret's Loch in Holyrood Park, Edinburgh, but he was born in Oban, a small fishing village set amongst the hills approximately 100km northwest of the city of Glasgow, where he now runs his own business, GREENCUT TREE SPECIALISTS. GAVIN comes from a family of tree surgeons and his father RONI MACDONALD is also a talented chainsaw carver who's a regular at the Scottish Open Chainsaw Carving Competition. GAVIN worked as a graphic designer before taking up tree surgery and says that there are certain similarities between the two trades: "You have to be very precise... even with seemingly small things, such as the angles that you cut when your remove branches. If you leave them horizontal, the rainwater will soak in and rot the tree, undoing all the good work you've done."

GAVIN attaches himself to the tree at two points and wears chainsaw-proof trousers.

Portrait by Alasdair McLellan

Mr. ANDRÉ BALAZS
Featured in issue n° 5 for Spring and Summer 2007
Portraits by Terry Richardson
Text by Alice Rawsthorn

Mr.
ANDRÉ BALAZS

Once a freelance journalist who co-founded the futuristically monikered BIOMATRIX biotech company with his dad and made a fortune when it went public, the world now knows Mr. ANDRÉ BALAZS as the mastermind behind the complete transformation of LA's seedy, run-down CHATEAU MARMONT hotel into one of Hollywood's most fabulous addresses. He quickly followed with THE MERCER, the STANDARD HOTELS and a handful of other local yet absurdly influential projects. In a way, Mr. BALAZS is one of those people who has defined the aesthetic of the world that we live in today. Although his natural habitat is among celebrities, he claims not to be one himself. In fact, there's an unexpected shyness about him which belies his recurrent PAGE SIX visibility. Mr. BALAZS lives in New York, but he's never home, of course.

When journalists search for words to describe ANDRÉ BALAZS, even the sensible ones seem to channel JACKIE COLLINS. Exhibit A: "His face is barely creased with age, and there is nothing about him that is blemished — the shave is close, hair freshly cut, expensively understated clothes well pressed." (NEW YORK MAGAZINE) Exhibit B: "He's rich, he's handsome — and his girlfriend is UMA THURMAN. Is this really the man who has everything?" (THE INDEPENDENT) Exhibit C: "Avec son charisme discret, donc irrésistible." (Paris VOGUE) You get the drift.

Sitting in his Manhattan office, Mr. BALAZS does indeed tick most of the boxes on Ms. COLLINS' bonkbuster-hero must-have list. Yes, he's handsome. Yes, he's diligently conserved — impressively so for 49. Yes, he's smartly dressed in a (probably PRADA) shirt and trousers. Yes, he's dating UMA — at least he was, according to PAGE SIX, in the week that we met. And, yes, judging by the glowing descriptions of THE LOCUSTS, his 55-acre estate on the Hudson River that once belonged to the super-posh ASTOR family and not-so-posh BOB "PENTHOUSE" GUCCIONE, he's rich.

Mr. BALAZS is also very polite. One of those feline guys with a gentle voice and smooth movements, he softens his conversation with qualifiers, often couching statements in the form of questions. Both of the above are textbook tactics for clever women, who're eager to assert themselves without seeming aggressive, but are surprising in such a confident man. Although by far the biggest surprise about Mr. BALAZS is that what looks like a complete collection of HIP HOTELS books is sitting on one of the shelves behind his desk.

HIP HOTELS on ANDRÉ BALAZS' bookshelf? It seems as strange as spotting a Paint-By-Numbers kit in GERHARD RICHTER's studio, ARCHITECTURE FOR DUMMIES in TADAO ANDO's office, or THE BLUFFER'S GUIDE TO MARXISM in HUGO CHÁVEZ's presidential library. Mr. BALAZS really doesn't need to mug up on what's hip in hotels these days. As the owner of the CHATEAU MARMONT in Los Angeles and THE MERCER in New York, he's done more than anyone else (with the honourable exception of IAN SCHRAGER) to define it. Because for those of you who haven't stayed in either place and have successfully (if inexplicably) avoided exposure to their guests' antics in tabloids, trash-mags, MySpace and E!, they've been the hippest hotels in their respective cities for over a decade.

To elaborate, the CHATEAU (as regulars, including Mr. BALAZS, call it) is the Sunset Strip sin-bin where Hollywood hotties have historically misbehaved. "If you must get in trouble, do it at the CHATEAU MARMONT," HARRY COHN, the founder of COLUMBIA PICTURES, counselled his wayward male leads, GLENN FORD and WILLIAM HOLDEN, in 1939, little knowing that his advice would eventually be posted as a soundbite on the CHATEAU's website. JEAN HARLOW slept with CLARK GABLE there in 1933, while she was honeymooning with another man; and the teenage NATALIE WOOD sneaked in to play jailbait to NICHOLAS RAY, when he was directing her in 1955's REBEL WITHOUT A

CAUSE. The CHATEAU's star dimmed during the 1970s when several members of THE EAGLES checked in, and based the interminable HOTEL CALIFORNIA album on it. But that star has sparkled again under Mr. BALAZS' stewardship. As LINDSAY LOHAN's adoptive home, the scene of NICOLE RICHIE's spat with RACHEL ZOE over a plate of asparagus, and the location of the balcony where BRITNEY was papped snogging COLIN FARRELL, the CHATEAU is enshrined on YouTube as LA's celebrity-central.

THE MERCER plays much the same role in New York. It's the SoHo hotel where KATE MOSS and PETE DOHERTY play hide'n'seek with the paparazzi, where RUPERT MURDOCH and his family camped for a few years before moving into a lookalike loft nearby (they liked THE MERCER so much that they hired the same interior designer), and where RUSSELL CROWE chucked a phone (and, possibly, his career) at a receptionist.

Mr. BALAZS shows no sign of stopping. Having restored AL CAPONE's old haunt, the RALEIGH in Miami, into South Beach's answer to the CHATEAU and opened one of his cheaper STANDARD hotels there as well as two in LA, he's now planning another STANDARD in New York along with a new luxury hotel which, he says, will out-swank THE MERCER. He'd love to open a hotel in London, and to build a baby chain of resorts. And he'd like to think that the QT, his lad-friendly hotel in New York, where anyone under 25 gets a 25 per cent discount, has baby-chain potential too.

As if that isn't enough, he's also turned real-estate developer. Having

worked with the architect RICHARD GLUCKMAN on a swish apartment building on Kenmare Square in downtown Manhattan, he is close to completing a second in SoHo, designed by JEAN NOUVEL, and has started work on a third, the WILLIAM BEAVER HOUSE off Wall Street. Each project has been more ambitious than the last, with the BEAVER HOUSE promising to deliver everything to its upwardly mobile young residents from dog walking and what the marketing bumph calls "wardrobe management", to rent-a-chefs, reflexology and a sports bar.

Regardless of whether you've met Mr. BALAZS, checked into one of his hotels, or fancied calling upon the services of BEAVER HOUSE's shoe shiner, he'll have changed your life in some way. He's one of those people who've shaped the world we live in, not just because of what they've done, but how it's been copied. There are hints of the CHATEAU, THE MERCER, the various STANDARDS and QT not only in every other hotel and restaurant, but in banks, department stores, airport lounges and bus depots. And what's much more interesting about Mr. BALAZS than the current tabloid consensus on whether he is or isn't with UMA THURMAN, is how he's done it.

Before he tells us—a few facts. He was born in Cambridge, Massachusetts, to Hungarian émigrés who'd fled to Sweden in 1945 after the Soviet takeover and moved to the US in 1954. Both of his parents were academics: his doctor father taught at Harvard Medical School and psychologist mother at McLean psychiatric hospital. Mr. BALAZS studied humanities at Cornell, and later

business and journalism at Columbia. After working as a freelance journalist and for the political strategist DAVID GARTH, he and his father co-founded a biotech company, BIOMATRIX, to commercialise BALAZS Sr's research concepts. It went public in 1986 and was bought by a large pharmaceuticals group.

Mr. BALAZS emerged as a wealthy man, who could afford to be self-indulgent in his next choice of business. He began by investing in nightclubs and restaurants, and then hotels starting with the CHATEAU in 1988. In the meantime, he married KATIE FORD, whose mother, EILEEN, had founded the FORD MODELS agency, and with whom he had two daughters, now teenagers. He and FORD divorced nearly four years ago, and his on-off affair with UMA has since made him a PAGE SIX regular.

He runs his business from the Puck building on the cusp of SoHo and NoLITa. The offices are smart, but not neurotically so. Mr. BALAZS' own office is unexpectedly small with a view across the Lower East Side rooftops. A clunky vintage wooden bodyboard is propped up beside the door. The shelves are packed with design books: serious ones on JOE COLOMBO and MARC NEWSON, as well as the HIP HOTELS series. The pinboard behind his desk sports snapshots of friends, like the late HELMUT NEWTON with his wife, JUNE, CHATEAU memorabilia and frat boy cartoons that must have tickled his sense of humour.

One of the things he likes best is bathing, not ordinary splash-in-the-bath bathing, but the serious business of soaking or steaming in wet or dry heat. And he especially loves the seedy old Russian Turkish Baths on the Lower East Side for its searing wet heat. His favourite hotels include CLARIDGE's in London and THE RITZ in Paris, whose founder CÉSAR RITZ is his hotelier-hero.

Like Mr. RITZ, Mr. BALAZS is a shameless control freak who obsesses over every detail of his projects. He's one of those lucky people who've prospered by capitalising on their enthusiasms — by commercialising the things they love in a way that strikes a chord with the rest of us. But over to ANDRÉ and how he actually first became interested in design.

ANDRÉ BALAZS: I was always interested in it. The house that I grew up in, the furniture that we had was 1950s Scandinavian design. I covet the same pieces today. When I went back to the house in Boston where I grew up, there was a book from the 1950s, DESIGN FOR MODERN LIVING. I opened it up, because I'd just bought the same book for about $400, and it had all these notes that my father had marked in '54.

ALICE RAWSTHORN: And when did your interest in hotels start?
When I was young my father took me to Baden-Baden, and there was something about the majesty of the spa hotel there. There was something magical about it. But I wasn't seriously interested in hotels at all until 15 years ago. In my childhood I wanted to be a sculptor. Part of the attraction was the ability to create something out of nothing, but one of the things I found frustrating was working in a vocabulary that very, very few people understood. In hotels, I found a way of dealing with 3D space in a way that connects with people.

How did your interest transform into actually working in the hotel business?
We'd started a nightclub in LA down the road from the CHATEAU. I was staying there, and some friends brought it to my attention that the two partners who owned it wanted to part company. It was right after JOHN BELUSHI died there. At the time BOB WOODWARD described the hotel in his book WIRED as a seedy, run-down place. The partners brought a lawsuit against him, and did not win. They loved the hotel, but not each other, so I bought them out in 1988, one after the other. Basically hotels had the same components that had interested me in restaurants and nightclubs. STEVE RUBELL and IAN SCHRAGER had just done MORGANS and then the ROYALTON, and they clearly came to it from a nightclub mentality. It wasn't just the look, it was the energy. I looked at the hotel industry and was stunned by the lack of imagination and creativity. I thought it could really use innovation. The hotel business was divided into development and operation, so there was never a seamless execution between vision and execution. What I tried was to do it all from the beginning to the end.

So how did that translate into a renovation plan for the CHATEAU?
It was very, very decrepit. I had a sort of idea about the way it should go, but it took quite a lot to figure out the right language. We literally did full-on redesigns with three different designers, and then we settled on a vocabulary. It was about the time when HELMUT NEWTON was staying there. I remember sitting down with him and saying what we wanted to do. He said, "Oh no, no, no. It's perfect as it is. Don't touch it." He leaned back, the seam of the sofa ripped and a spring popped out. We became fast friends, and he and his wife, JUNE, would come back for four months every year. They became my smell test as to whether we were doing things right. If they came back and we'd made massive changes, but they couldn't pinpoint what was different, they'd say, "The place looks great." That became the methodology for the repositioning of the hotel. We did a lot of historic research to create a fantasy of what the CHATEAU could have been.

You mean in order to restore the building to its original design?
Well, not exactly. The question of what's authentic is a difficult one. When they started building the CHATEAU in 1925 as a faux Loire Valley château, it wasn't even inside of the city boundary. It was designed as an apartment building and completed in 1929, so it opened straight into the stock market crash and the recession. They bought all this high-end furniture from estates that went bankrupt and came up for auction. Then six or seven years later they bought this group of little craftsman cottages, the BARBIZON APARTMENTS for young bachelors, and that precipitated a new vernacular. Then we have the CRAIG ELLWOOD CASE STUDY HOUSES, built in 1956, in another vocabulary. But in the end we simply re-fantasised what was there. Authenticity in this case is something that evokes the feeling that you imagine was evoked back then. It's not as simple as what it looks like. Striving for something that feels just right is something we do all the time. In the main building, the lobby looks different from the penthouse. The reason

is that I found some wonderful images of HOWARD HUGHES and how he used to live in the penthouse. We used 1934 images for the lobby, but the penthouse images were taken decades later, so it has a different feel. People always say how fabulous the CHATEAU is, and that it's always been this way. The truth is that there isn't a single surface or a piece of anything in there that's original, but it all seems so familiar.

And then you started working on the THE MERCER. Did you take a different approach now that you had a clean canvas to work with, rather than a bundle of HOLLYWOOD noir history?
THE MERCER is the most elegant building in SoHo, a warehouse and fur processor, built by JOHN JACOB ASTOR in 1898. I was trying to buy it for years. I pretty much moved to SoHo in 1984. The first place I lived in was on Greene Street on the top floor of a typical SoHo building above four floors of a rag merchant's warehouse. Every morning you had to climb around the trucks to get out of the building. It's hard to imagine today, but there was one restaurant and not a single fashion shop in SoHo then. From the turn of the (20th) century, its history had been mercantile, and then the artists moved in after World War II when manufacturing started to flee the city. Then the galleries came, and that was about the time we started. The idea was to create something that was simple, yet elegant, that would recognise the straightforwardness of its mercantile past. Someone mentioned CHRISTIAN LIAIGRE's name, so I looked him up. Then I realised he'd done HÔTEL MONTALEMBERT (in Paris), which I did not feel was appropriate for

SoHo, so I put him out of my mind. About a year later I saw some photographs of some work he'd done for a residence in Bangkok, and that inspired me because it was much cleaner. When he started working for THE MERCER his style was still evolving. You'd get piles of drawings, and some would be totally in the traditional French style that characterises the MONTALEMBERT, and some in this simpler, newer way. A lot of my experience of living in SoHo went into THE MERCER. SoHo is very intimate, the streets are short and the buildings are not tall. It's a unique neighbourhood in the context of Manhattan, and one of its characteristics is the light and air in the streets. That makes it pleasant to stroll through, but SoHo at that time was very rough. To me, THE MERCER always needed to be a house, offering you that sense of safety and calm. No grand entrance. You open the door and boom! You're safe, off the bustle of the street. Even the name of THE MERCER KITCHEN (the restaurant) was meant to evoke a kitchen in the house. There's always a cook there, so when you come in at 2am, you can eat. At the end of every great party your closest friends gather in the kitchen, no matter how beautiful the house is or how garish the kitchen lighting.

How important is service to your hotels?
It's essential to all hotels, to all good hotels.

What are your objectives for it? And how does your service differ from the service at other hotels?
The challenge is always finding the right tone, understanding the right service that the guests want and figuring out how to

deliver it. Service is something you have to learn to appreciate, like good food. You either grow up in an environment where you have the opportunity to enjoy it, or you learn about it in other ways. One of the challenges is to discern where in the cycle your audience is. Real service is not so much about doing extraordinary things, it's about doing ordinary things with the right tone.

What would be the wrong tone?
The most egregious example of getting the tone wrong is the idea of nametags announcing your first name to a total stranger, as if the thought that Mary is your server is somehow going to make your dining experience better. That's an example of utterly forced intimacy. The best service, like being well dressed, isn't something that's noticeable, it's about something that you rely on and appreciate but that isn't in your face, like simply never having to look for a waiter. You never need to ask, because they're always suddenly there. Good service is a combination of judgement and tone and moment. It's not a catalogue of items, but if there's one expression that should cover it, it's never saying "no".

Yes.
But what fascinates me about this business is the people. This business is not about design, it's about making people feel good and that's not done by the shape of the chair; it's done by the atmosphere, the social aspect. Scale is very, very important, and we work in a relatively small scale. THE MERCER was the smallest hotel to open in New York since THE LOWELL in 1923. The attitude of the staff is important too, and how they interact with the people.

Lighting is unbelievably important. I don't think there's one thing that's more important and it's one of the most difficult things to control. It's a lot of work to get it right, and it's even more difficult to keep it right.

Because the staff tinker with it?
Everything. You can pre-program things, but the nature of the weather is such that between September and November you have to pre-program the thing 15 times. Every day it's 15 minutes later, and you can have a cloudy day or a sunny day. The best thing is to program some of it and to train the people who are there on the spot to try to feel it. Last night was a case in point. I happened to go over to THE MERCER late at night, and the lighting was completely off. I called the engineer and changed all the lights on the spot.

Is that a frustrating thing about running hotels, that you plan perfection, but as you can't control everything yourself, glitches creep in?
Things can get fucked up a little because that's the way things are. To make things too perfect is one of the difficulties with a certain kind of minimalism. It doesn't allow people to feel comfortable because this certain element of out-of-control-ness is missing. Part of the business of design is making people feel comfortable, and that means that things may get skewed or be amiss.

Do you mean that you have to anticipate how people will change things during the planning process?
You can anticipate, but the most important thing to anticipate is that you can't anticipate! It's not only unreasonable

to think that you can control things, it's no good because it denigrates the inter-action: 99 per cent of people don't even notice, and maybe the last time they really felt comfortable was at their mother's house where the lighting is terrible. It's like home cooking. There's no cooking like your mother's, but most people's mothers can't cook. This busi-ness is not a formula, and it's not fin-ished. You don't get there; you're just slogging all the time.

You get your fair share of salacious tabloid coverage of celebrities staying at your hotels — for example the RUSSELL CROWE phone-throwing incident at THE MERCER. Is there a point at which such coverage becomes damaging, rather than picaresque?
At every point. Let's leave it at that.

And what of your own media visibility? How do you feel that people's percep-tions of you as an individual relate to the business?
Oh, I have no idea. These are the kind of things that one has so little perspective on. I'm not a celebrity...

How do you feel about THE MERCER's influence on SoHo? Do you feel like some sort of architect of SoHo's destruc-tion, now that VICTORIA'S SECRET has moved in and the area is so commer-cialised?
Architect would be overstating it, but I've certainly contributed to SoHo's evo-lution. It's happened every single time we have been some place, with much the same bittersweet result. We created this little hotel out on Shelter Island, SUN-SET BEACH, and I have a house a mile and a half from there. Most residents

would say the hotel has transformed the island. Half would probably say for the better, and half wouldn't be quite so sure. The same thing happened in down-town LA after the STANDARD opened there. Call it fortuitous, call it serendip-ity, but the fact is that, since the STAND-ARD opened, downtown LA has been transformed from an utter wasteland.

Elements of THE MERCER and your other hotels have been ripped off by countless other companies. How do you deal with that?
Everything we do gets ripped off so fast. It's hard to overstate the impact that THE MERCER has had on the hotel and interior design worlds. It's been huge. Virtually everything coming out of the boutique hotel industry has touches of THE MERCER, from literally copying it, to the unbelievable use of the vernacu-lar of the dark and light of the wengé wood. POTTERY BARN basically surged into popularity based on that.

Don't the rip-offs pose a problem for you by cheapening perceptions of the original and making it look dated? Can THE MERCER evolve to avoid that? It's not a reinterpretation of history like the CHATEAU; it was designed just over ten years ago and reflects the fashion of that time.
I don't have the answer to that yet, because I haven't quite accepted that the case is chronic enough to struggle with it. I've thought about this in the case of the ROYALTON (PHILIPPE STARCK's 1988 post-modernist showstopper for IAN SCHRAGER). Personally I wouldn't touch that, though I think it's going to be ruined. You shouldn't be such a victim to fashion. It takes a bit of

self-confidence and perspective not to succumb. In THE MERCER's case, the fashion is this notion that the authenticity of the original design is somewhat in jeopardy because of the inauthenticity of the imitations. I think maybe the right thing to do is just hold the course. You know, trust in the fact that one has a perspective on these things, and say "so what."

How do your real-estate projects relate to the hotels?

Each one has become successively more like a hotel. The first, KENMARE SQUARE, was just a straight, intelligently designed residential condominium. The second, 40 MERCER, had more public space and allowed for a greater set of amenities. This last one, the WILLIAM BEAVER HOUSE, is for all intents and purposes a hotel. It just happens that the rooms upstairs are apartments that can be purchased. The idea of visioning a residential building as a full environment is quite old. There was a time, in the early 1900s, when it took a stretch to move people out of town houses to live on top of each other. Amenities needed to be laid on to allow them to live in the style of a grand home, and somehow to forget the fact that their door was 20 feet away from their neighbour's door. The most elegant version was the RIVERSIDE with clay tennis courts, pools, restaurants, bars and banquet halls. Originally it had its own marina on the East River. After World War II all those niceties just went by the wayside and, much like the hotel business, it became boxes on top of boxes. Now there's a shift going back, and developers are being forced, kicking and screaming, to do more. So the

BEAVER HOUSE has more services and amenities than most hotels. We envision it as a place where people will stop off after work to enjoy socially. If you're a single person who works until 11 o'clock at night, you can come home and run into your friends, just as you would in a hotel bar.

And what's next after the BEAVER HOUSE?

We're building a STANDARD on the High Line (the elevated railway line running on the West Side of Manhattan) and a luxury hotel there that's like a private club as well. It's new, first because people buy rooms for blocks of time in a fractional ownership package like NETJETS' and trade their time with other members — and also physically, in the way it's designed. It's very exciting, because it's completely new.

Mr. OKWUI ENWEZOR

Featured in issue n° 8 for Autumn and Winter 2008

The powerful curator OKWUI ENWEZOR, who lives between New York and Munich, has a keen interest in clothes for both men and women. Growing up in Nigeria in the 1970s, he says he was influenced by the style of African-American musicians and cites QUINCY JONES as a particularly compelling icon. Paradoxically, when he moved to the USA, arriving in New York as a teenager in 1982, his sartorial focus shifted toward the Japanese avant-garde and the British New Wave. These days OKWUI is a connoisseur of traditional tailoring, particularly the work of the venerable Savile Row outfit KILGOUR. OKWUI traced his love of formality back to his days at an all-boys boarding school in Nigeria: "there were school uniforms for everything: something you would wear in the morning to go to class, a uniform for sports, there was a uniform for relaxation, and there was a uniform for the weekends, which was perfectly white khaki pants and a white starched shirt. It was just beautiful — you were not even allowed to roll up your sleeves. When I look at a picture of myself at 17 it seems that I've worn the same type of clothes ever since."

His influence in the art world grows apace. In 2002 OKWUI curated the 11th edition of DOCUMENTA, a major exhibition that takes place every five years in the German city of Kassel, and in 2015 he curated the 56th Venice BIENNALE titled ALL THE WORLD'S FUTURES. Arguably these are the two most important occasions in the art calendar. OKWUI is also the director of Munich's HAUS DER KUNST, a prolific writer on art and an occasional poet.

Portrait by Terry Richardson

Mr. PETER JEROENSE

Featured in issue nº 5 for Spring and Summer 2007

The work of the renowned fashion illustrator PETER JEROENSE was a regular feature of FANTASTIC MAN's early issues. Apparently effortless line drawings, these images are in keeping with the style of their creator. PETER himself was featured in the fifth issue of the magazine, dispensing how to look fantastic on a very low budget. It appears that the secret is a mastery of proportion, which PETER has in spades.

"I love how this outfit has lots of volume," he said of his sand-coloured oversized trousers by POLO RALPH LAUREN worn with an anonymous second-hand shirt. "I have been wanting to wear an outfit like this for years, but it took a while to get the look together. It started with those oversized trousers that I got in the sales, but it was only when I scored the shirt that I knew how to pull off this look." A long-term fan of the classic LEVI'S 501, PETER said, they "are my wardrobe's masterpiece! They're so high that they force you into a certain position — like a denim corset!" Although he buys his jeans from flea markets, PETER always takes them to the dry cleaners in his native Amsterdam.

Portraits by Anuschka Blommers & Niels Schumm

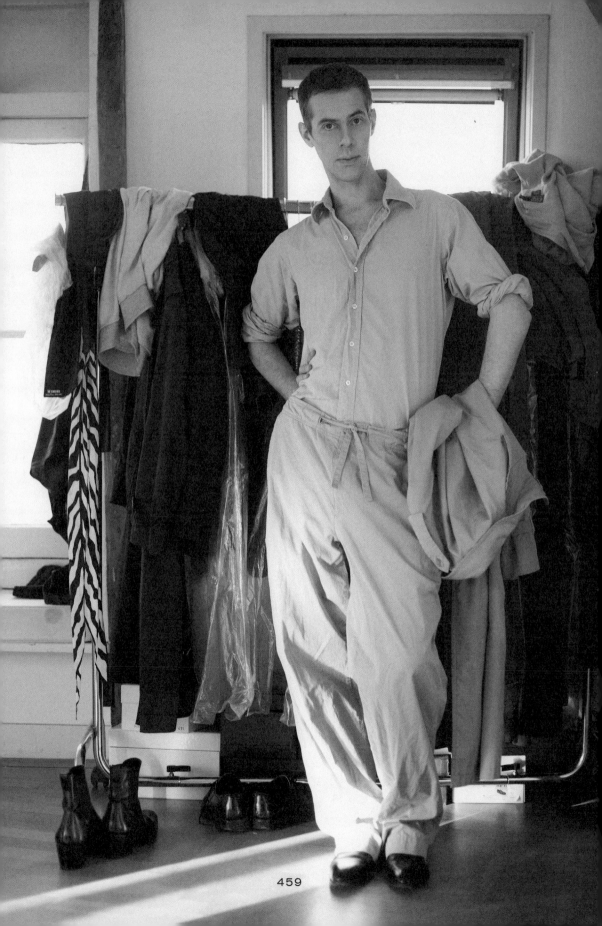

Mr. OLIVER SIM
Featured in issue n° 16 for Autumn and Winter 2012
Portraits by Willy Vanderperre
Text by Alex Needham

Mr.
OLIVER SIM

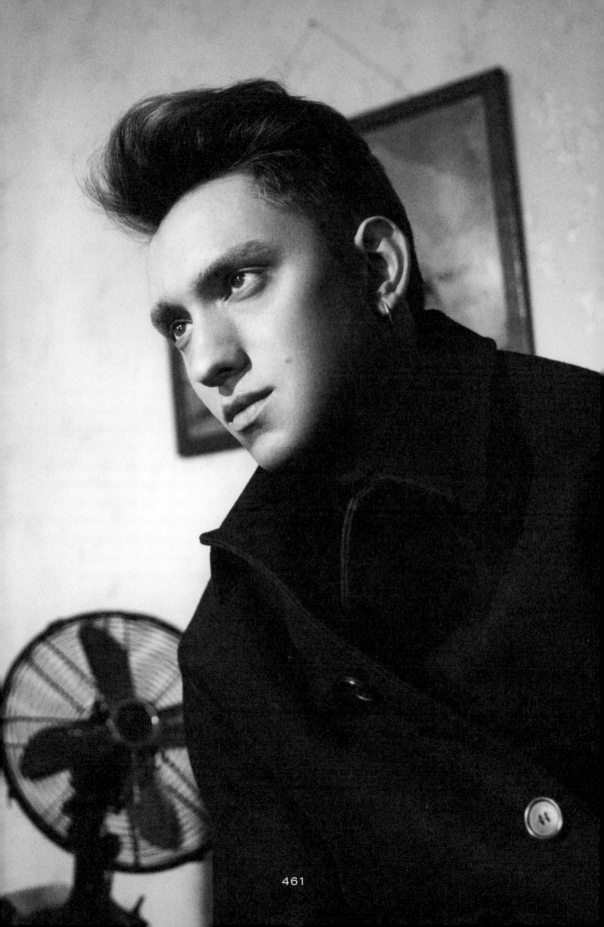

In the quiet days around Christmas 2008, OLIVER SIM and three of his school friends recorded an album that propelled their band, THE XX, to unprecedented critical acclaim. Then a peculiar and allegedly reclusive teenager, he was surprised to find his melancholy songs and deep, soulful vocals permeating every corner of the popular culture. Now, four years later, handsome and confident, OLIVER prepares for the release of his band's second album and finds himself, at 23, a man on the edge of global stardom.

OLIVER SIM's favourite time of day is the night. The bass player, co-vocalist and songwriter of THE XX says that, left to his own devices, he would spend hours after midnight hanging out on his own in a hotel room or his east London flat, before going to bed around 5am, just as the dawn starts to break. It's appropriate, then, that it's at 1am on a warm May night at the PRIMAVERA SOUND MUSIC FESTIVAL in Barcelona that the band take to the stage to unveil new material from their anxiously anticipated new album COEXIST, the follow-up to their 2009 MERCURY PRIZE-winning debut, XX.

When XX — which with its intimacy, moodiness and lyrical tension built on intense longing is arguably the ultimate nocturnal record — was released, the band, still in their teens, were so diffident on stage that they played with their backs to the audience. Now, they have grown into their twenties and instead of sheepishness they exude authority.

With two singers and no drummer, their line-up looks unconventional. In front of a giant, clear perspex letter X, keyboard player and percussionist Mr. JAMIE SMITH — known as JAMIE XX — triggers the rhythms and sonic textures that characterise the band's sound. To his right is Ms. ROMY MADLEY-CROFT, chic and composed in a black jacket and trousers, possessed of a voice deeply charged with yearning. And then there's Mr. SIM. Dressed entirely in black, his neck grazed by the strap of his bass and adorned with a leather collar, he has shed his nervousness of THE XX's early years to become a vulpine and charismatic presence, swaggering instead of hiding in the shadows. He's an alluring amalgam of his childhood heroes — PLACEBO's BRIAN MOLKO and QUEENS OF THE STONE AGE's JOSH HOMME — his voice, deep and gravelly, loaded with smouldering carnality.

When OLIVER and I meet, on the roof of the Hotel DIAGONAL ZERO, just outside the PRIMAVERA SOUND FESTIVAL site, I notice that, in the gap between albums, he has changed physically, not just emotionally, from boy to man. "I've taken up boxing," he says.

OLIVER is having a beer. It's early in the afternoon. He looks muscled and toned; his face is angular and striking, his hair slicked. The simple earrings he's always worn lend an air of androgyny to his figure, bestowing upon him the combination of butch and fey that has excited pop fans since the days of BILLY FURY in the '50s; an embodiment of the tension between opposites — masculinity and femininity, soul and indie, passion and repression — that makes up THE XX's allure.

In conversation, OLIVER is courteous and friendly, seemingly unaware of his own charisma. Musically and visually, he has a model's ability to radiate presence and emotion without doing very much at all. On the first album, his voice doesn't appear until over halfway through the second track, turning sleepily uttered lines into a grand entrance. Live, his stillness creates a tension so intense it can be released with a single movement. "He's very beautiful," says JAMIE-JAMES MEDINA, the documentary photographer who has followed the band's tours since 2010. Despite all of that, OLIVER claims that THE XX have never been natural performers. "I see people like FLORENCE WELCH and think, 'You're born to do this,' but performing is something we've really had to work at," he says. He also struggles to think of himself as a musician. "When I'm filling out visa applications and get to OCCUPATION I always think: 'What should I write?' It still feels a bit unreal, that that's my job. If a taxi-driver asks me, I say that I work in music, but that I work for a label. Otherwise, you end up having to answer questions you don't really want to deal with."

Mr. SIM was brought up in southwest London by parents who never ordered him to go to bed early. "I've always felt very looked after, but my parents have always given me a lot of freedom," he says, adding that the same was true for his band mates, both of whom were allowed to take themselves to Barcelona unaccompanied when they were just 13. OLIVER's parents and ROMY's are friends, and the pair have known each other since they were babies. "He's always been in my life," says ROMY on the phone, a few weeks after PRIMAVERA. "We've got quite a lot of photographs of us together from the age of three. He's like my brother, really."

The pair would frequently play truant from Elliott School, a comprehensive secondary with 2,000 pupils in Putney. When the pair were 12, the US government launched airstrikes in Afghanistan. They both bunked off to protest. Later, they used to get the 14 bus to school and stay on it all the way into Tottenham Court Road. "We'd go into Soho Square, drinking energy drinks and people-

watching," OLIVER says. They met JAMIE SMITH, often said to be so with-drawn that he makes OLIVER and ROMY look like motor mouths, when they were 13.

"JAMIE's become very good at talking now," OLIVER says, when I ask about his friend's bashfulness. "He made his own record, a remix album for GIL SCOTT-HERON, and he was forced to go out and talk about it on his own. He's literally been forced to speak and it's nice. He's very articulate." (When I try to get JAMIE on his mobile later, however, he doesn't respond to texts or pick up the phone.)

Inspired by a visit to the READING FESTIVAL at the age of 13, where, with OLIVER's mother, they watched PEACHES and THE WHITE STRIPES, and by his elder sister's love of AALIYAH and EN VOGUE, the three friends formed a band playing cover versions in their bedrooms and writing their own songs late at night. OLIVER and ROMY would write lyrics together via e-mail or instant message.

By the sixth form they were playing proper concerts and rarely bothering to go to school; OLIVER puts his attendance record at 35 per cent and he resents the way the school has since tried to take some of the credit for THE XX's success. Musicians from other bands, including BURIAL, FOUR TET, HOT CHIP and the MACCABEES also attended Elliot, but OLIVER puts this prolifer-ation of musical talent down to the sheer number of pupils rather than to any particular musical tuition they received. "It wasn't this haven where they played us great music," he says. "We were given loads of freedom but it was probably neglect. A lot of kids were pretty naughty and we weren't, so the teachers concen-trated on them, which meant we could go off into the music rooms and just play."

THE XX were so named because of the letters' ambiguous association with censorship, pornography, and kissing. The band also saw the name's strong graphic potential, which was later exploited on their brilliantly simple, die-cut album sleeve, and on mysterious but mentally indelible billboards and TV ads.

Their first album was recorded over Christmas 2008 in a small studio at the headquarters of their label, XL RECORDINGS, also home to THE WHITE STRIPES and ADELE. Music journalist Ms. JUDE ROGERS was one of the first to interview the band a few months later. OLIVER picked her up from the station to take her to the band's "horrible" rehearsal room. "It instantly struck me that he's incredibly charismatic even though he's very quiet," she says. "He was very polite."

At this point, THE XX had four members: guitarist Ms. BARIA QURESHI, another school friend, had joined after their first few gigs. She was kicked out of the band by text message, she claims, in October 2009, two months after the release of the album. "It's the most ruthless thing we've done as a band,"

OLIVER tells me, "but it wasn't something that just happened one day; it happened over months. About a month after the album came out we saw how much touring we had ahead of us. We knew we would just be further away from home, and at even closer quarters and for longer periods of time and it couldn't have kept on going. It still makes me sad. We've not spoken since October 2009."

Losing a band member did nothing to damage their momentum, however. Somehow on their first album, the band had created a completely modern kind of soul music, which fused guitar-based indie with the kind of dark, seductive atmosphere found in some R&B and dub-step records. The vocal interplay between OLIVER and ROMY, loaded with melancholy and lust, layered itself on top of a sound that managed to be both minimal and packed with epic emotional drama. "It's fascinating there are two front people in the group and they coexist — literally, as that bloody new album title seems so accurately to suggest," says author and pop theorist Mr. PAUL MORLEY. "He seems very strong and very powerful, with that focus that a cult leader often has. He and ROMY blend into each other and swap over telling stories in their own voices and yet in one voice. I like the idea that, in fact, they were fans of something like WHITNEY HOUSTON and ended up accidentally sounding like DURUTTI COLUMN. Like all great pop music, it aspires to be something and in its failure it becomes something else."

The band steadily picked up famous fans. In New York, COURTNEY LOVE appeared backstage at their gig at the Bowery Ballroom, while the aftershow party was attended by BEYONCÉ's sister SOLANGE KNOWLES. "She was all over them," says ROGERS, who was covering the show for NEW MUSICAL EXPRESS. "ROMY retreated a bit but you could see OLIVER starting to enjoy it."

OLIVER claims that THE XX's reputation for sullenness, bolstered by those earlier, back-to-the-crowd gigs, is overplayed. "As people in the band world, we were mutes," he says, "but I think if you take an ordinary person and put them in the situations we've been in, that would be the normal way of reacting. Most people don't want to put it all out there. Maybe by the standards of a generation where you can find out anybody's favourite colour on Google we're shy, but I think we're normal."

Even so, an air of reticence surrounds the band. OLIVER goes so far as to claim that he is the most outgoing member, then adds "but maybe that's not saying too much." Indeed I find that, the more I probe, the more he closes up, and that, the more he does, the more intriguing he becomes, in the same way that the most emotionally charged elements in THE XX's music are the silences and the almost subliminally deep bass sounds. As in a HAROLD PINTER play, the most significant moments are the pauses, before MADLEY-CROFT's guitar chimes in

or the two vocalists smokily swap lines. (Interestingly, they never harmonise. "Maybe on album three," OLIVER laughs.) "All I can hope is that people will connect with the music," says OLIVER. "That's why there are no 'hes' and 'shes' in the lyrics, and why we don't like to pinpoint a certain time or place."

On the subject of "hes" and "shes", ROMY came out in a joint interview with her girlfriend in TOURIST magazine — she's dating the fashion designer HANNAH MARSHALL. OLIVER was outed in the first interview he ever gave. "I felt frustrated about it to begin with," he says. "I hadn't wanted it to be a crucial part of who I was." On reflection, though, he's pleased that it was said so early on. "It doesn't seem a huge part of what we're doing as a band anyway," he says.

The first album was a slow burner, but ended up working its way into all kinds of unexpected places, from clubs to the BBC's NEWSNIGHT. INTRO was used as the soundtrack to its coverage of the May 2010 UK general election. "They managed to paint it in my mind as the ROCKY theme tune, which I'd never seen it as before," says OLIVER.

In September of that year, the band won the MERCURY, and by year's end, their music had suffused so far into British culture that the prime minister, DAVID CAMERON, and his wife were said to be fans. "I heard that they liked cuddling to it," shudders OLIVER. "It's something you don't want to give too much thought." The band was displeased that Mr. CAMERON took to the stage at the 2010 Conservative Party Conference to INTRO.

More happily, KARL LAGERFELD used their music in his Autumn/Winter 2011 show, and last year designer RAF SIMONS told this magazine that he had listened to the album every day for a year. One year later, he still has XX on extreme heavy rotation. "It will be the first thing I'll put on when I arrive," Mr. SIMONS says via telephone while he's driving to his rented summer house in Italy. He recalls contacting the band to perform at his menswear show in the summer of 2011, a collection that featured shirts and coats covered in diagonal crosses. "That was effectively a direct result of me listening to that album all the time," he says. Alas, due to conflicting schedules, the designer and the band never met.

Meanwhile THE XX were embraced by R&B and hip-hop superstars. RIHANNA sampled INTRO on her song DRUNK ON LOVE. In March, the band met breakthrough rapper DRAKE backstage at his gig in London and chatted about their mutual appreciation of SADE, the famously reclusive jazzy singer whose sultry sound can be seen to anticipate THE XX. "Me and ROMY have been pretty late to SADE and it's got to that teenage point where you look up her interviews," says OLIVER. "She takes quite complex emotions and delivers them quite simply. I think that's brave and honest and it speaks to me."

Of the emotions delivered in his own work, OLIVER claims that his lyrics

on THE XX's first album were mainly fantasy scenarios (he was 15 when he wrote them and had had little real-life romantic experience to draw on), but that this time round, with COEXIST, they are direct and literal. "I was surprised I was able to be as open as I was," he says, explaining that he has swapped places with ROMY, whose lyrics on the first album were autobiographical. She agrees. "We've opened up to each other and let a wall down," she says. "Before, we were writing almost like solo artists and collaging it together."

OLIVER and I meet again, in London, a few weeks later. OLIVER has spent the day having his photographs taken for this magazine — an experience that has left him feeling exposed, since he and his band mates are so close-knit. He orders a glass of red wine. "When we got home from touring, I figured we probably wouldn't hang out much at first, but we did, in the first week back." The longest he has been apart from ROMY since they were toddlers has been three weeks, when she went on holiday to Paris and Berlin. "I did feel a bit lost," he says. "Not lonely, just a bit confused."

Before we meet, I have attended a preview playback of COEXIST at the record company's headquarters. It's an album to get lost in — by turns searing, pensive, spectral and warm — and one that confirms how huge THE XX have the potential to be. It strikes me that the next few weeks, before it is released, might be OLIVER's last opportunity to enjoy any kind of anonymity at all.

That seems to be a prospect he is nervous about. At the moment, OLIVER rarely gets stopped on the street. Despite the pervasive success of the first album, and despite his peculiarly striking looks, he can walk amongst his fans in his east London neighbourhood unnoticed, which, by all accounts, is something he enjoys. ROMY claims that when the band are back in London, OLIVER "really does just like to spend time in his flat, watching films." "If I do get recognised I get called JAMIE," OLIVER says, when I mention how surreal it must be to be waiting in the wings of giddy global fame.

Mr. GILES DEACON

Featured in issue nº 2 for Autumn and Winter 2005

The British fashion designer GILES DEACON was the cover star of FANTASTIC MAN's second issue. GILES is known for wearing big glasses, of course, and the Dutch artist VIVIANE SASSEN photographed him in a variety of frames, including his own pair from DIOR HOMME.

GILES cut his teeth at BOTTEGA VENETA and GUCCI, before launching his own label with a show at the Chelsea Pensioners' Club in 2004. He makes dresses for women who like to make an entrance and is in a relationship with the actress GWENDOLINE CHRISTIE, who is known for her role as BRIENNE OF TARTH in the very successful HBO fantasy series GAME OF THRONES. A London dweller, GILES is often to be seen cycling the streets of Shoreditch or eating dinner at ST. JOHN. He is a practised user of the term "jolly".

Portrait by Viviane Sassen

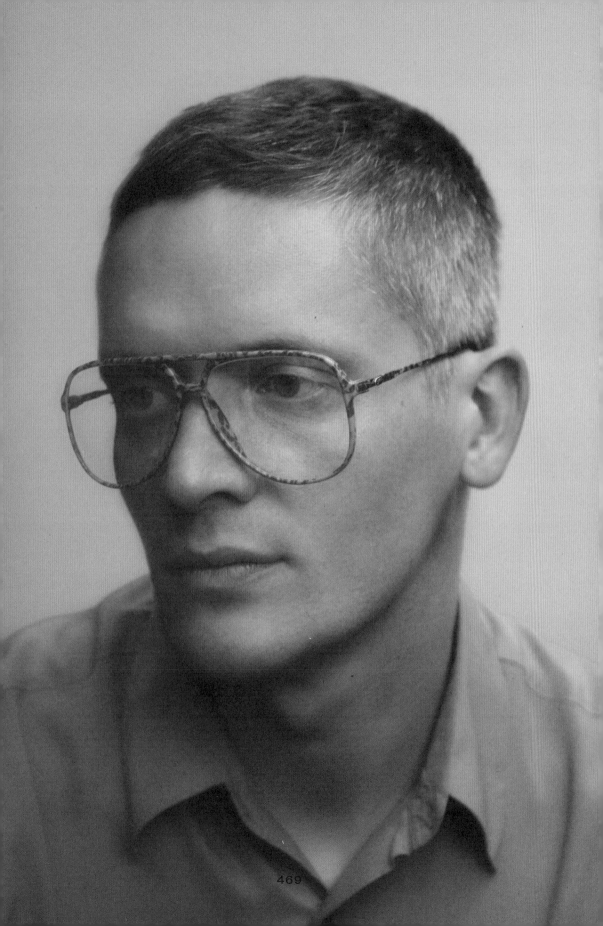

Mr.
JOE McKENNA

Mr. JOE McKENNA
Featured in issue nº 17 for Spring and Summer 2013
Portrait by David Sims
Text by Penny Martin

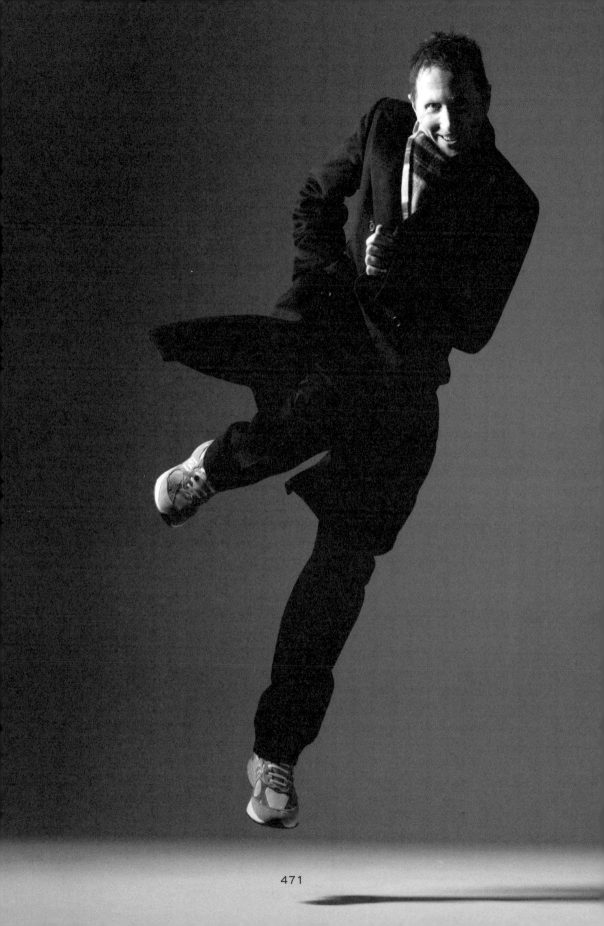

When success as the fashion industry's most rigorously precise stylist was still a phantasmagoria far beyond the horizon, Mr. JOE McKENNA was already enjoying a good measure of international fame as both a child actor and an exuberant pop star. Born in Scotland, McKENNA is as famous for his own, instantly recognisable appearance as he is for his doctrine of pared-back styling: he is an a chemist of the perfectly pressed, pristine white shirt. His official styling debut was made on the pages of the legendary magazine THE FACE, kick-starting an astonishing career that now spans four decades.

When JOE McKENNA first started putting clothes on models, there wasn't even a name for what he does so notoriously well. Yet "stylist", as everybody knows, is now the fashion industry's most desirable job title. Over the past three decades that he's been working in fashion, choosing exactly the right garments and assembling them correctly has transformed from an everyday task carried out by magazine staffers into a work of art performed by freelance *auteurs*; it is a mysterious service for which some designer brands are reportedly prepared to pay up to £15,000 per day. Yet of all the "super stylists" that are said to run the fashion system today, none is held in quite the same awe as JOE McKENNA. Superstar clients past and present go misty-eyed while recounting high points in their long collaborative histories, praising his "great artistic sense" and dogged commitment to "perfection" (JIL SANDER) or his "extraordinary point of view and precise sense of fashion" (DONATELLA VERSACE). Ex-assistants will fall silent at the mere mention of his name, whispering words like "authenticity" and "discipline". Hilarious insider tales of his exacting standards, withering put-downs and headstrong delivery are legion, but nobody will tell you precisely what he does and almost everyone begs to speak off the record. "I don't know why," says McKENNA, when we first meet, at a table on the street outside a café in Mayfair. He hugs his arms to his skinny body and grins broadly. "I think I'm a very approachable person."

When he's not on location shoots or consulting in Milan or Paris, McKENNA is at home either in his apartment overlooking a beautiful garden in

New York's West Village or in his flat in London's ultra-expensive Belgravia district. Both places are similar in scale and proportion, and McKENNA keeps them in an almost identical state, with as few items of furniture as he can manage. At the New York base, there's a sofa he's covered in a pale grey fabric and a nice set of tables by a famous Danish designer whose name he's forgotten, and that's about it. Unnecessary clutter is a bit like white noise to McKENNA, so he keeps most of his possessions in storage (books mainly; he has no sentimentality for clothes). There are a few framed prints by some of the star fashion photographers with whose careers he's so closely associated. Prints of his early work with BRUCE WEBER at the start of the '80s — glorious black-and-white portraits of athletic, happy boys that changed men's fashion photography forever — share wall space with a memento from his first shoot with STEVEN MEISEL, when McKENNA started at ROLLING STONE in 1988. He'd also purchased a few images when he first moved to New York in 1986 and started earning a decent salary at VANITY FAIR. "I bought some of ALLEN GINSBERG's photographs and a little SALLY MANN," he says, "but I wouldn't call it a collection. If I'd been really clever I'd have bought more."

Such international minimalist luxury is a far cry from Maryhill, the post-industrial district of north Glasgow in Scotland, where McKENNA grew up in the '60s. Nicknamed "the Venice of the North" for the canals along which its now-dismantled glass and chemical industries were built, the area is best known for the handsome sandstone tenement buildings that house its predominantly working-class population. McKENNA describes his as a classic Glaswegian childhood. His gregarious, FRANK SINATRA-loving mum, ISABEL, brought up three sons (McKENNA is the middle child), while her husband, JOE, worked six days per week, first as a bellboy and then a bookmaker, at times even taking on evening shifts at the dog track.

McKENNA fondly remembers "playing out the back, shouting up to the window for your mam to get you a piece and jam." But the neighbourhood was far from idyllic. Home to the world's first temperance society in 1824 and a trouble spot for knife crime since the 1950s, Maryhill still holds a reputation for being one of the city's roughest districts.

In search of somewhere safer, ISABEL and JOE moved their young family out to Kirkintilloch, a town to the northeast of Glasgow whose most recent claim to fame is its role in Scottish comedian FRANKIE BOYLE's routine about the worst place he's ever visited. "It wasn't a great move, ultimately," deadpans McKENNA. But by then he'd already set his sights on a life down south.

Outside our café, which is around the corner from TRUMPER's barbershop in Mayfair, where he's booked in for "the usual" haircut, McKENNA has asked me not to take out my notebook. Our meeting is taken up with more pressing matters,

like *who should do the portrait?* It's not merely a case of appointing the right photographer (McKENNA only works with the best), or securing a sitting with an A-lister during fashion's busiest season. Like so many of the image-makers responsible for shaping what fashion looks like, he's far more comfortable behind the camera than in front of it.

"Couldn't we just use a shot of me taken in the mid '80s?" he cajoles in his extra-enunciated Glaswegian brogue. Unfortunately not, but since he mentions it, I ask how old would he have been then. "Aaa-haaa! You're not going to catch me out like *that*," he says, shaking his head. McKENNA's age remains a closely guarded secret, even to his closest friends. "Ageing is difficult if you're not prepared for it," he says. "But I'm not going to do anything cosmetic to my face, so I'm just going to have to deal with it." McKENNA is not unaware of the myth-making power of concealing one's birthdate. When he started working with AZZEDINE ALAÏA in 1988, nobody had a clue how old the designer was, he says. "And I thought, 'You know, it's much cooler when it's never discussed.'"

Nothing hides a person's age and frees them from those prejudices quite as well as fixing one's appearance. WARHOL held back time with the grey wig long before his own hair had whitened. Consciously or not, McKENNA adopted a similar strategy at the end of the '80s, when he chose a look and stuck with it. "It wasn't really an idea at first," he explains. "When I joined ROLLING STONE, I used to wear these black LEVI'S that were too big for me. I remember them teasing me about it in the studio." What began as a trademark pair of jeans gradually transformed into a full ensemble that he still wears every day: a uniform consisting of a white shirt, a cashmere jumper, the aforementioned denims, grey NEW BALANCE trainers, a navy CROMBIE overcoat, a cashmere scarf and sometimes a little navy sunhat. Those items are so recognisably McKENNA's in the fashion industry that they were all that was needed for model STELLA TENNANT to pass as McKENNA on the cover of the issue of SELF SERVICE magazine that he creatively directed in the autumn of 2010. For McKENNA, limiting his clothing options is a subtle yet important way of distinguishing the style choices he makes as part of his job from those in his personal routine. "In the morning, I don't have to think about it and that's just great. All I have to do is make sure it's clean and well pressed."

He can't remember how he learned to be so fantastically good at ironing and quips that it's the one skill to which he truly owes his success. "I always ironed my own clothes when I was a kid. Neither of my brothers did... Maybe it's something to do with being a gay guy." Dressing up came as second nature. He started buying his own clothes at the age of seven. "There was always *something* that I'd seen in a shop window or on somebody in the papers," he says. "I'd think, 'I've got to find something like *that*.'" By his early teens, McKENNA was scouring jumble sales with a school friend, trying to replicate the looks they'd see on the

pages of magazines like 19 or HONEY. "Then we'd go back to my house, and I'd put a white sheet up in our loft; we'd do the hair and the make-up like we'd seen in her magazines," he says. "And I had a little 35mm camera so we'd have fashion shoots. I don't know what for."

Though the teenage McKENNA was at a loss to explain the purpose of his nascent styling exploits then, there is no question why leading fashion photographers and brands choose to work with him now. His ability to elevate a garment — an uncanny knack for recognising the most timely, definitive piece of a collection and then "improving" upon it in an image or show — sets his work as the benchmark to which other stylists aspire. "You book JOE for the know-how and the taste level," explains his long-time collaborator, fashion photographer DAVID SIMS. "And when you look back over his career, there are so many bloody good pictures that it's obvious he just really understands image-making."

Fastidious casting, classical subjects, rigorous fitting and minimal accessories are all hallmarks of his editorial input. Great hair and make-up, a brutally edited collection and maybe a little turned-up collar are all clues to his hand in a catwalk show. Yet what marks out all truly great stylists — that capacity to sharpen the vision of the different photographers or designers with whom they collaborate — is the very thing that prevents them from having one discernible aesthetic. What unites the fashion stories McKENNA makes with SIMS, INEZ and VINOODH and BRUCE WEBER, with the catwalk presentations he has honed for ALAÏA, JIL SANDER, VICTORIA BECKHAM, VERSACE and STEFANO PILATI at YVES SAINT LAURENT isn't just a question of style, therefore. It's down to the way McKENNA makes the clothes behave. "JOE is very rigorous and precise," AZZEDINE ALAÏA says of McKENNA's pre-show process. "His concentration and focus almost give the impression that he has fallen into a trance. His work has great elegance and is entirely void of vulgarity — he is highly demanding and refuses to accept the mediocre. He endeavours to bring to the surface everything the garments have to offer." In pictures, McKENNA's looks go beyond merely showcasing some fancy fabric or trend; they appear to take on their own life force. Radiating incredible precision and personality, they come close to upstaging the person wearing them.

His taste wasn't always so cleanly focused, though. McKENNA's old friend RUPERT EVERETT recalls him as being quite the natty dresser when they worked together in the costume department of a Royal Shakespeare Company production of CORIOLANUS at the Aldwych Theatre in London in 1978. In his waspish 2006 autobiography RED CARPETS AND OTHER BANANA SKINS, the actor describes McKENNA as a "tiny thin boy from Glasgow (...) He was 17 but still looked 12, and was trying to get into drama school in London. The first time I saw him he was dancing down the Strand (...) wearing a pair of beige shorts,

a white short-sleeved shirt with a bow tie, knee-length socks and sandals. In his hand was a tin lunchbox, and he was literally swinging around a lamp-post."

The stylist recounts his introduction to EVERETT rather differently. McKENNA had just been through an excruciating audition for London's Royal Academy of Music and Drama, for which he chose the wrong part—"I read BOTTOM from A MIDSUMMER NIGHT'S DREAM when I should have read OBERON"—and forgot all his lines. He was having a more successful try out for the Central School of Speech and Drama when he first spied EVERETT. "There was this very arrogant, tall, skinny student who was my prompt for the day," he says, "who made me more nervous each time I got through to the next round. Finally, I didn't get through and he said, 'I can't believe it. I thought you were absolutely great.' He was a nice guy after all."

It suits McKENNA to retell this story focusing on serious details over frivolity. Indeed, his modus operandi now depends greatly on being in control of everything. I discover from personal experience that missing one of his calls results in a litany of follow-up answer messages. An unanswered e-mail provokes an exact facsimile of the original, this time written in block capitals. Despite the lengths he goes to maintain his collected exterior, however, occasional glimpses of that joyful, lamp-post-swinging boy still break through. At one of our meetings he greets me by popping out from behind a polyboard with FRED ASTAIRE jazz hands, loudly suggesting "CAKE".

It was through EVERETT that McKENNA was first introduced into the fashion world, on a night out at the EMBASSY nightclub in Mayfair with their mutual friend, the actor TOM BELL. "TOM said, 'I know you're dying to get into fashion. Well, that lady over there is the London editor of VOGUE Paris," McKENNA says, referring to MEREDITH ETHERINGTON-SMITH, now a specialist at CHRISTIE'S and curator of the sales of MARILYN MONROE, ELIZABETH TAYLOR and PRINCESS DIANA's clothes at the auction house. Bold as brass, McKENNA buttonholed the redoubtable fashion editor, managing to procure her telephone number. "I said, 'I know this isn't the time or the place but I'm so keen to work in fashion and I hear you're looking for an assistant. This is my number.' She said, 'Okay. Write down mine.' And I tried to be really patient but two days passed and I'd heard nothing so I rang her."

ETHERINGTON-SMITH started taking McKENNA on shoots for PER LUI and LEI magazines, where he began learning the tricks of the trade. "I'd pick up her personal dry cleaning or she'd say, 'I'm shooting with CECIL BEATON for VOGUE; I don't need you to come but I do need some ties,'" he recalls. It wasn't such a leap from this world to that at TATLER, the English society magazine where he worked as a contributor, under the aegis of its legendary young editor, TINA BROWN. Initially, McKENNA was more valued for his wicked

continued on page 489

FANTASTIC MAN

CHAPTER I
WORDS ON MATTERS

CHAPTERS — Rare for a magazine, Fantastic Man favours chapters. This page introduces the first chapter of issue n° 11, Spring and Summer 2010, featuring writing on a variety of matters, and some photographic images too, though not that many.

CHAPTER TWO

2.

Profiles and features in which men discuss love, life, legacy, corruption, defiance and death, alongside photographic series that cover matters of elegance and taste.

– 73 –

TWO — The chapter page of the second section of the magazine, the profiles section, of issue n° 12, Autumn and Winter 2010.

CHAPTER 2

PROFILES,
CONVERSATIONS
AND
SCOOPS

SCOOPS — A chapter opener from issue nº 9, Spring and Summer 2009, comprising a short table of contents with brief descriptions set in enticing red.

GREA

TNESS

WORDS — Issue n° 17, Spring and Summer 2013, is divided into three chapters: "Nonsense", "Greatness" and "Discipline". The pink matches that of cover star Mr. JEREMY DELLER's sweatshirt.

I Feel Love

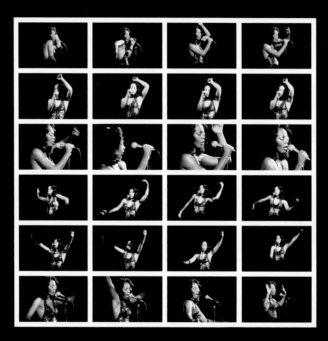

Donna Summer's dance moves in this 1978 performance of the legendary 'I Feel Love' simulate the energy and intensity of the track.

LOVE — References gathered on a single page, printed in black and white. DONNA SUMMER's dance moves illustrate a profile of musician GIORGIO MORODER in issue n° 16, Autumn and Winter 2012.

REFERENCES

100m freestyle
0:49.45

100m individual medley
0:56.74

100m freestyle
0:49.21

100m individual medley
0:56.33

200m freestyle
1:50.79

100m freestyle
0:48.73

Winning

Of the four main styles used in competitive swimming, freestyle, or front crawl, is by far Ian's strongest. His technique has been described as poetic, and its power and efficiency can be attributed to six factors: his body is held fully stretched and almost, but not completely, horizontal to the water; his head is held high in the water, never completely going beneath the surface; a long arm stroke is maintained, pulling with his entire arm; his extraordinary leg power is channelled into a variety of kicking styles, all starting from the hip and finishing with a full extension of the foot; the natural rotation of his body along the long axis, engaging his large trunk muscles and allowing his arms to recover; and of course, his humongous UK size 13 or EU size 48 feet.

DIVES — Six dives, six races, six very fast times from the Australian swimmer Mr. IAN THORPE.
A reference page from issue n° 15, Spring and Summer 2012.

PRINCE OF WALES

Pattern of check with overcheck, possibly designed for English landowners based in Scotland who were not allowed to wear the tartan. Also credited to KING EDWARD VII, grandfather of the famous DUKE OF WINDSOR, who possibly designed the check when he was PRINCE OF WALES, as livery for his shootings at ABERGELDIE HOUSE in Scotland.

CHECK — Prince of Wales check, one of four fabric patterns interspersed through issue n° 2, Autumn and Winter 2005. The others are Herringbone, Houndstooth and Polka Dot.

FANTASTIC
MAN

CONTENTS
FANTASTIC MAN N° 6 — AUTUMN AND WINTER 2007-2008
THE GENTLEMEN'S STYLE JOURNAL

COMPLETE — A comprehensive contents page from issue n° 6, Autumn and Winter 2007, accounting for the magazine's entire 164 pages, including 42 pages of advertisements.

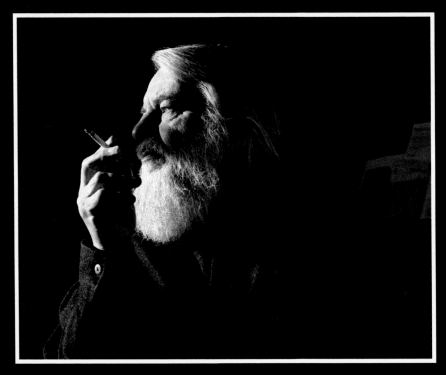

THE GREAT Mr. ROBERT

WYATT

AND HOW HE CAME TO SING WITH SUCH A TENDER VOICE...

Mr. ROBERT WYATT was interviewed by ALEX NEEDHAM
and photographed by PAUL WETHERELL

PROFILE — The opening page of a profile on Mr. ROBERT WYATT in issue n° 7, Spring and Summer 2008, elegantly combining Times New Roman, in white on black, with striking black and white photography.

FANTASTIC MAN

Usually slips like this one are inserted into publica-
tions after they have been printed in order to cor-
rect egregious errors that evidently went unnoticed.
However, the editors of FANTASTIC MAN are very
pleased to announce that to their knowledge this new
issue of the magazine contains no mistakes what-
soever. Should any grammatical blunder be noticed,
troubled parties can address any correspondence to
the FANTASTIC MAN office in Amsterdam for full
peace of mind.

Instead, the editors would like to take this opportu-
nity to wish readers the jolliest spring and summer
ever, endless sun-filled days only to be enhanced by
regular visits to www.fantasticman.com, where the
DAILY RECOMMENDATIONS will continue to de-
light and inspire when every single word in this maga-
zine has been read.

SLIP — A non-erratum slip, a risky enterprise tucked into issue n° 13, Spring and Summer 2011,
announcing a totally flawless magazine and "Daily Recommendations" online.

FASHION LABYRINTH

Enjoy navigating through this maze of merchandisers whose stock appears in this issue

MAZE — A playful take on stockists' information from issue n° 20, Autumn and Winter 2014. A reward awaits those who successfully navigate the fashion labyrinth.

sense of humour than for his fashion prowess. "I would do daft things at the front of the book," he says. "There would be a gallery of old dowagers and a series of handbags and you'd have to match the dowager to the bag—the headline would be, 'Old Bags'. I did another one called 'Old Woofters', where you had to link the elderly bachelor to his dog."

A conversation with McKENNA about the old days is chock-full of social glamour and industry lore, but try getting him to talk about the present state of fashion and he'll clam up. He wouldn't divulge his current list of clients on the day we finally began our interview, pleading discretion, despite his being named in reviews as the stylist of the VICTORIA BECKHAM women's and the JIL SANDER men's Spring shows. This perplexing piece of hyperprofessionalism explained itself a few days later, however, when it was announced that he'd been in negotiations to take up the high-profile post of fashion director at THE NEW YORK TIMES' T Magazine.

Reading the news, I was reminded of DAVID SIMS' exhibit in CHARLOTTE COTTON's contemporary fashion photography show at the V&A in 2000, IMPERFECT BEAUTY. Instead of prints, the photographer sketched a diagram of a football pitch as an explanation of his working process. Team SIMS favoured the conventional "four-four-two formation," with all 11 members identified by the photographer in pencil. He adopted a central position, with his then-agent JULIE BROWN behind him in goal. Right up front there was McKENNA as centre forward—the glamour position requiring clinical judgement and a killer finish. And under his marker, SIMS' immortal caption read: "JOE McKENNA. He plays the game."

The two issues of the magazine called JOE'S that McKENNA published in 1992 and '98 are perfect examples of how he navigates the perilous world of fashion politics through a combination of high expectations and charm. From BRUCE WEBER, PETER LINDBERGH, ELLEN VON UNWERTH, JEAN BAPTISTE MONDINO, STEVEN MEISEL and PAOLO ROVERSI to DAVID SIMS, JUERGEN TELLER, CRAIG McDEAN, MARIO TESTINO and MARIO SORRENTI, almost all his favourite photographic collaborators were given generous numbers of pages in JOE'S. "Everyone is so down on magazines in our little world these days, they forget that in 1992 everyone was complaining there was nobody to work for," he explains. "PER LUI and LEI had closed and VOGUE Paris didn't look the way it does today. FRANCA SOZZANI had only just taken over VOGUE Italia. So I thought, 'I'll just make a magazine that's as big as I like.'"

With unlimited space, McKENNA was free to showcase his styling at its most progressive, asserting himself as tastemaker bar none. A comparison of the 1992 and 1998 issues suggests a slight shift in his tastes from the powerful

classicism of the mid-to-late '80s, when he'd matured as an artist, to the post-grunge modernity of the late '90s, by which time he had become a major political force. And yet, viewed side by side, the two covers reveal an enduring interest in classical subjects that unites all his work: the first issue features a design by the American poet and artist RENÉ RICARD of the VIRGIN MARY at the foot of the cross, exhaling smoke, while the 1998 cover features a weeping cherub. McKENNA admits such a personal project would be much harder to pull off in the bottom-line-obsessed fashion world of today. That's the only thing preventing him from publishing the long-awaited third issue.

McKENNA can't bear "be-seen-in" restaurants "like THE WOLSELEY — too fashionable." So, for our second meeting, he booked a favourite haunt of his for our chat, the intimate LA FAMIGLIA in Chelsea's World's End. It's his pre-history — his career before fashion — rather than the future that he wants to discuss. "I just knew I wanted to be an actor and that never changed," he says. When he was nine, the McKENNAS went to lunch with family friends whose child was studying at the Royal Scottish Academy of Music and Drama. From that moment, McKENNA badgered his parents until they let him go to drama club every Wednesday night and Saturday morning. He wasn't really interested in theatre; he just wanted to be in TV or films. "I saw MARY POPPINS and that changed everything — the fantasy that I could just put up my umbrella and fly into the sky or snap my fingers and the job would be done."

His acting fantasy became a reality when a BBC scout spotted him, at the age of ten, which eventually led to his landing a part in the legendary long-running British soap opera CORONATION STREET. From 1977 to '78 McKENNA travelled up and down to Manchester with his mum to play the part of PETER BARLOW, son of one of the show's founding characters.

Over 17 half-hour episodes, McKENNA's PETER evolves from a truculent, TV-obsessed teenager to a self-possessed adult (he finally leaves to join the navy). And with it, we witness McKENNA developing into a competent, emotionally mature performer. In one memorable storyline, KEN takes PETER on a walking trip in the English Peak District for some father-son bonding and falls down a ravine, breaking his leg. Ignoring his ailing father's cries, the plucky 14-year-old sets off into the night for help, sleeping rough on the hills and finally enlisting assistance with little time to spare. The vision of a freckle-faced McKENNA charging heroically across the peaks with the Mountain Rescue team in tow, wailing, "I just want to help my Dad!" would surely warm the stoniest of hearts.

"I don't know how I got the job in first place," says McKENNA, whose boyfriend TOBY found some clips on YouTube recently. "Honestly, I don't think I was very good. I was overacting like crazy."

Our meal arrives. McKENNA has ordered off-menu, "the usual", which turns out to be delicious, angel-hair strands of pasta coated in chilli and olive oil with a steaming pile of fried zucchini on the side. The *contorni* arrive slightly before the *primi piatti*, which McKENNA points out drily to the waiter, throwing him into a crisis over whether to re-order the dish for us. Apparently unaware of the panic breaking out among the staff behind him, McKENNA continues. Since we're on the subject of short-lived careers, he'd like to clear up the matter of a surprising and short-lived foray he made into pop music.

"That record I did was a shambles, really, a complete flop," he says completely unprompted, referring to his 1982 single A CHA CHA AT THE OPERA. Neither of us mentions the video of McKENNA performing his one-hit-wonder on a German music programme, which surfaced online last year and has been doing the rounds of the fashion industry. But we exchange an awkward glance that confirms we both know its taste levels don't quite meet the immaculate standards he sets for himself. Nobody likes their childhood photos being passed around, I suggest. "Well, I was super fortunate that the demo got into CHRIS BLACKWELL's hands at ISLAND, and I got a great contract that paid for my first apartment in Notting Hill," he says tartly. "But I won't elaborate on it."

I once missed a live performance by McKENNA by mere minutes, arriving late to one of DAVID SIMS' infamous post-shoot karaoke sessions. The stylist had just brought the house down with a storming rendition of METAL GURU by T-REX. McKENNA reckons his GEORGE MICHAEL is better; he's always been a great mimic and loves making crank calls—it's on record that he and AZZE-DINE ALAÏA have called LINDA EVANGELISTA to send her to non-existent midnight castings—but that's the limit of his desire to stand centre stage these days. He was in JULIEN TEMPLE's film adaptation of COLIN MacINNES' novel ABSOLUTE BEGINNERS in 1986, where he played the Chelsea rent boy FABULOUS HOPLITE. But after that, McKENNA likes to say that show business gave him up. These days, he can't stand parties and only attends one or two fashion shows per season, saying his idea of a "great night out" is a TV dinner at home. He doesn't drink, can't cook and hasn't used his oven for anything other than heating up WAITROSE ready meals in eight years of living in the London flat. Aside from work, his sole pastimes are visiting his family in Glasgow and spending time with a small group of old friends (some industry, some not) who describe him as supportive, straight talking and intensely loyal.

His great friend BRUCE WEBER believes that these are the qualities that most characterise McKENNA. "JOE's a friend, first and foremost," he says. "We started out pretty much at the same time and we were always really nervous— I think it's healthier that way, trying to get better. His love for what you do as a photographer makes him really special; I think it's the way he touches a person

when he dresses them that really makes the shot. People almost always leave the sitting hugging JOE, feeling like they might want to call him up or work with him again."

This would seem to contradict McKENNA's reputation as the most feared man in fashion. DAVID SIMS concedes that he does seem intimidating at first. "But I think for me that was because I met him when I was young, at the beginning of the '90s, and he knew things about pictures that I didn't," he says. "JOE asks lots of questions to find out your point of view, and it was hard to articulate those answers at first." SIMS describes McKENNA's method of styling as "old-school", where he can visualise the principal ingredients of a good image without the tear sheets or digital monitors upon which most stylists and creative directors now rely. "There's this recent phenomenon where stylists will come to the set and sit on the client's lap for a couple of days and God forbid they have to get up off their arses and touch the clothes," he says. "JOE is so hands-on by contrast. When I was young, I used to show him the Polaroid and he'd say, 'Mmmm, I think you can do better.' It used to drive me nuts — he can be a total pain in the arse. And not everyone can take his honesty. He's very strong and forthright but I think a lot of that is driven by fear of the work not being relevant."

Certainly, McKENNA doesn't sound ready to slow down his pursuit of excellence. In the week of our lunch in London, he also visits Hamburg, Paris and LA and then returns wondering why he feels so run-down. Some people might look back over such an illustrious professional history and think they've earned a bit of latitude, I mention over a postprandial mint tea. "The shoot I did last week could have been better," he replies sharply. Or at least spend a bit of the money he makes? "I'm not really materialistic," he says. "Although in the past few years I have discovered going on holiday. TOBY and I have spent lovely holidays in the south of France, and the Adirondacks; last summer we had a great time in Spain. Anywhere near the water, though I'm terrified of it. I can't swim. Other than that, I've probably become more of a miser as I've got older." When he first started making money as a ten-year-old actor, McKENNA's parents instilled an ethic of saving in him that he's never shaken. "They were always saying, 'Put it in the bank until you've found something more regular.' And you know, I'm not always going to be doing this," he says, ending our lunch on a rather uncertain note. "You ask anyone I work with and they'll tell you I've been saying 'This is my last season' for the last 12 years."

I do ask around and McKENNA's closest friends all have their theories on what could possibly be the next twist in one of the most colourful and improbable careers in fashion. His very first agent, KIM SION, who took him on 27 years ago, imagines him moving into art direction since he so often exceeds what's expected of a stylist on set. DAVID SIMS says McKENNA has talked about owning a small hotel for years and has often brought estate agents' specs with him to

the studio. And BRUCE WEBER hopes that he'll go into film, believing him to have great potential as a costume designer. But he advises me to take McKENNA's threats of giving up completely with a liberal pinch of salt. "Let's just say if I had a horse and JOE was my jockey," he says, "then I wouldn't bet against them." AZZEDINE ALAÏA couldn't agree more: "In reality, JOE is capable of doing a great many things, but I would of course prefer that he continues to concentrate his efforts on working with me."

Mr. BENOÎT DUTEURTRE
Featured in issue nº 3 for Spring and Summer 2006
Portraits by Marcus Mam
Text by Bruce Benderson

Mr.
DUTEURTRE

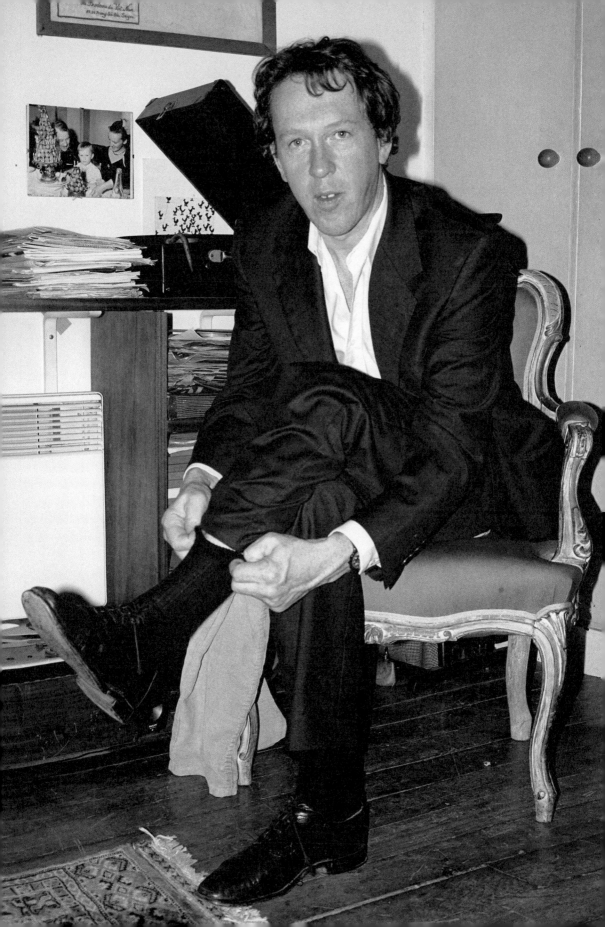

One has to be French and of certain descent to pull off the style négligé, a dazzling and strictly French-only mix of good taste, quality-brand clothing, shabby maintenance and a just-right unfashionability. It's considered to be mostly a man's thing. SERGE GAINSBOURG had it, and maybe JEAN-MICHEL JARRE, and nowadays definitely Mr. BENOÎT DUTEURTRE. Born in Le Havre of almost royal descent—former French president RENÉ COTY ('54–'59) was his great-grandfather—writer and music critic DUTEURTRE has an ironic X-ray eye that sees everything that's wrong with the present day, not wholly unlike his writer friend MICHEL HOUELLEBECQ. More of DUTEURTRE's work should be translated into English, although this oversight is slowly being rectified: later this year his novel THE LITTLE GIRL AND THE CIGARETTE will be published by MELVILLE HOUSE. BENOÎT lives in Paris in an elegant mess he calls "home".

I met gap-toothed, freckled, highly educated and charming BENOÎT DUTEUR-TRE in New York about 12 years ago, after we were both published in the same magazine. At the time, he was just a cultured, somewhat perverse French voyeur to me, a young writer who enjoyed tagging along on my trips through the after-hour clubs of old Times Square, which he accompanied with all kinds of caustic, Old-World humour. At the time, I really had no idea who BENOÎT DUTEURTRE was. It was only later, when I came to Paris and watched him command the best table at LE SELECT, or when I attended his dinners with old-style luminaries of the Parisian scene like actress LESLIE CARON or COCTEAU biographer CLAUDE ARNAUD that I realised I was hanging out with a Parisian semi-celebrity. DUTEURTRE is one of France's best-known novelists, the winner of the 2001 PRIX MEDICI, and a great-grandson of former French president RENÉ COTY.

Upon discovering this, I took a second look at the clutter in his cavernous apartment on the île-de-la-Cité, which is filled with stacks of classical music

scores, dirty ashtrays, CDs, books, elegant yet broken-down furniture and other signifiers of haute-bourgeoisie intellectual life, and I became fascinated by the distinguished details. These include a framed letter from JEAN COCTEAU thanking BENOÎT's great-grandfather for his gift of game from a hunt, as well as books dedicated to BENOÎT by his close friend MILAN KUNDERA.

My new take on my pal also caused me to re-evaluate his style of dressing, which I had written off as seedy. His eternal tweedy old DIOR jacket and wrinkled traditional business shirts (under the front collar of which often peeks a greying undershirt) suddenly took on the allure of the French style négligé, that singular Gallic manner of deliberately neglecting the details. This style may be the only thing that the famished mouth of global capitalism still finds indigestible about France, and it can't be reproduced. It goes all the way back to the 16th century, when a slightly embarrassed MONTAIGNE admitted: "I've purposely imitated that depravity seen in the way our modern youth wear their clothing. A coat that drags, a cape falling off one shoulder, a loose stocking, and all to represent their disdainful pride, their artful nonchalance."

Style négligé (not to be confused with the American "casual style") exists neither in Anglo-Saxon countries, where people think that clothing is an unambiguous language of the market, nor in wholly Latin countries, which find their rhetoric in the perfection of exaggeration. No one can teach it, because each of its strategies is personal, and also because those who practise it refuse to admit that they do.

Style négligé is a sign of social power, and therefore a talisman of the bourgeoisie. It says is: "I'm too important to be worrying about such insignificant details, but I've found a very subtle and precise way of making such a statement that actually takes a lot of forethought." Or, as BENOÎT put it, "The most vulgar thing I can think of is when a politician like JACK LANG wears some stylised couture shirt. I find that incredibly laughable."

JACKIE O, despite her money and her superb casual elegance, could not achieve style négligé . EMMANUELLE BÉART, JEAN TOUITOU and SERGE GAINSBOURG have had it as a reflex, but JACK LANG and BERNARD-HENRI LÉVY have never had it. BENOÎT DUTEURTRE has it, even though he would be the last to admit that he has any style at all.

"I've got a horror of buying clothes," he told me, holding a cigarette (smoking is, of course, another feature of style négligé). "I like clothing to be a bit too wide, a bit too long. I hate clothes that follow the contours of the body." Then, unfortunately, he added, "And there's one contemporary style I can't stomach: jeans with a T-shirt and a cheap pullover." Well, it was a Saturday afternoon in Paris, and I just happened to be wearing too-tight jeans (because of the rich French food) and a cheap pullover, whereas he, as always, was wearing a sports jacket with a dress

shirt, and the latter wasn't the slightest bit ironed.

I gave him a quick once-over, taking in his conservative "KENNEDY"-style haircut, which hadn't changed in the 12 years I'd known him; weighing those muted colours, all greys and browns, as if they'd been designed to cancel each other out; wondering at his nondescript shoes, which were also of the best quality. And I thought, "Is that all there is?"

Not really. Beneath DUTEURTRE's deceptively simple and respectable surface is the product of many years of elimination and refinement. His style is based on some old suits in a Normandy closet that have been in the family for years and are full of moth holes now. They represent a retro model of chic and are a bit English in style. DUTEURTRE is always looking for the same thing in stores, but he never, ever finds it.

"I used to have all my suits made on rue de Bièvre, the street where MITTERRAND lived," he admitted after a second single malt had loosened his tongue. "There was still this old tailor to whom I brought some suits that had been in the family, so that I could find the same fabrics. They date to a time when my uncle was a young man and my great grandfather was president. I wanted this tailor to reproduce them, and he did. But now they're all worn out and I have to do it again, and the tailor has retired."

DUTEURTRE's fashion is derived from this single sensibility, and sensuous as some other aspects of his life might be (young lover included), he's not ashamed of having a traditional side. "I detest double-vented jackets," he remarked, wrinkling his freckled nose ever so slightly. "It should have one vent in the middle or none. And I hate high collars."

Five years from now, in fact, BENOÎT will probably be wearing the same style of clothing. Yet, despite all this, he does not identify with the fading French bourgeoisie when he gets dressed. "I like clothes to disguise the angles of the body a little. Because of that, I often end up choosing the same casual clothes that Arabs in France do. They hate tight clothes, too, and they always like them a bit too long. The blacks, also. These are the truly elegant people these days; there's really a studied look in their choice of something as simple as a T-shirt. Sure they may drift toward hip-hop, but when they move a little more in the direction of French elegance, they always choose nice things."

DUTEURTRE's fashion taste for the classic past perfectly complements his image as a contemporary writer. He has been lauded and lambasted for his highly acidic, often hilarious attacks on politically correct modernity. No one has ever forgotten his polemic against gay marriage, which appeared a few years ago in the magazine LIBÉRATION. His contempt for the notion was taken so poorly by the gay community that a reading he was scheduled to give was cancelled after a bomb threat.

His new novel, LA PETITE FILLE ET LA CIGARETTE (THE LITTLE GIRL AND THE CIGARETTE), will soon see the light in the US. It's his ultimate revenge on the vulgar, sanitised world of this new century. It begins with a man sentenced to death in an unnamed country that resembles America, who asks for a cigarette as his last wish. Since the prison has just implemented a no-smoking policy to protect the health of its inmates, the prison officials must discuss whether the rule can be broken, and if so, how to turn off the smoke alarms, until they forget all about the poor man waiting to die, and his execution gets closer and closer. Other novels he has written mock America's romanticised notion of the French, gay politics or the Disneyfication of Paris. A non-fiction book he wrote, REQUIEM POUR UN AVANT-GARDE, was about the pretensions of the European avant-garde music scene, and it won him a host of enemies.

In another century, the delightfully derisive BENOÎT DUTEURTRE would have been a dandy wearing a green carnation and spotless spats worthy of the best of DORIAN GRAY. But today, as a bemused social critic, his image moves in the exact opposite direction—understatement. Being an admirer of new advances in French underwear, and finding myself staying at his place, I couldn't resist prying into his top dresser drawer one day—gauche as the gesture may have been.

"You'll be disappointed," he warned me. "All my underwear is vulgar French middle-class stuff. In winter I like to wear long underwear, top to bottom. Then I only have to wear a loose polo shirt over it, which gives the impression that I'm young and never cold and always relaxed, not bothered by the weather."

"Doesn't underwear turn you on?" I asked, a bit let down.

DUTEURTRE shook his head. "I'm attracted to faces, not to any style of dressing."

That seemed to bring the subject to a close; so I thought I'd ask DUTEURTRE a few questions about the dishevelled ambiance of his île-de-la-Cité apartment. In fact, it's two apartments, across the hall from one another. Both doors are always unlocked, so the two places function as one. You end up walking (or running, if you're not dressed) across the hallway to get from one to the other; and in either, you encounter piles of sheet music and books, someone who you don't know who is smoking hash, and one of the four unmade beds that DUTEURTRE has chosen to sleep in the night before.

"How can he live like that?" I wondered aloud.

"I like accumulations," DUTEURTRE explained. "Books, records, newspapers, piles in every corner; it creates a warm environment. But just ask for any CD at all and it's right at my fingertips. FRANCIS POULENC, 1925?" His fingers skimmed across the ribs of a pile of CDs and extracted it. What about all the dust, I wondered.

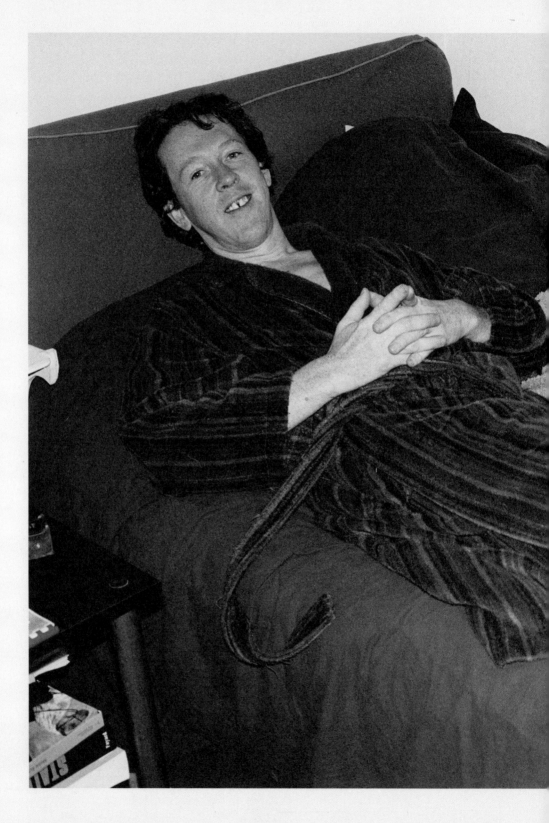

"I know there's a dust problem," he shrugged, "but it's too difficult to have a cleaning woman come because there are just too many things."

"Well, we Americans," I said a bit testily, "do prefer spotless bathrooms, and if they're not, it's LYSOL time." I made a little aerosal-button-pushing gesture in the air. "Yours isn't really dirty, but the fixtures are so old and rusted. Isn't that how you get Legionnaires' disease?"

DUTEURTRE snorted. "You need some grunge to stimulate your immunity. Do you know how many beautiful hotel rooms and apartments in France have been destroyed because of this American preference for spotless bathrooms? In Morocco, in France, they smashed everything up, just to redo the bathroom for Americans."

I felt chastened, because I knew that DUTEURTRE lacked any kind of phobia for any kind of place at all. Together we'd done the strip bars of Montreal, the after-hour crack clubs of early-'90s Manhattan and the glitzy parties of the CAFÉ DE FLORE in Paris. We'd lounged at the Normandy coast, in the gloomy villa where he regularly retires to work on his books, or in very dirty sand at the beach. Or we'd picked our way among the slimy rocks of Montauk in the middle of winter. But as always, his appearance, with its muddy browns and greys, remained unremarkable and unnoticeable for the chance passerby, always undercover.

Old Paris, on the other hand, always comes alive when DUTEURTRE takes me out in it, because he's eternally nostalgic for that nearly lost world. He's the kind of person who becomes a regular at his favourite fixtures in each quartier: bars, cafés and restaurants, some elegant and some sordid, but always places where he is given a special treatment. And whether the night before was one of debauchery or not, he always rises at 7.00 or 8.00am.

"Paris is so agreeable in the morning," he exulted. "It's less polluted, the city gets back its typically Parisian beauty. Those are the miracle hours, the time of day I prefer. I go down for a coffee. The little details are what provide an aesthetic for me; they put me in my mood. And then I like to write in the morning, at home; but most of all I like being tranquil, with the window open a little. Then usually I lunch with somebody, around 1.00 or 1.30pm. In fact, my day is kind of organised, punctuated by meals, like someone who has a salaried life."

BENOÎT is, as well, a link to a dying Parisian breed. Some of his friends, in fact, such as MADELEINE MILHAUD, the widow of the composer DARIUS MILHAUD, and IRÈNE AÏTOFF, YVETTE GUILBERT's still-surviving pianist, are over a hundred years old. With such a traditional lifestyle, and with such old, established friends, could he be a reactionary?

"Reactionary is a political term," he scoffed. "I'm a writer, an artist, so it's not in my register. I'm not reactionary, but nostalgic, and I'm not the first writer to prefer the past. Look at PROUST, who detested the idea of the future. It's true that

I've chosen to be melancholic for everything that's disappearing, and because of the way it is now. What I used to love about modernity was its transgression and imagination; but the kind of modernity we're living in, concrete modernity, is the exact opposite of that; it's the media, the gentrification of cities, official models. It's not imagination; it's real conformity."

Maybe DUTEURTRE is allergic to today's modernity, but in my opinion, he's also the symbol of everything that is still good about Paris, and everything that is good about Paris has always been something slipping away, including the style négligé. As an archetype of this disappearing style, DUTEURTRE stands for the rebellion of the individual against the increasing tyranny of convention, and at the same time, a respect for certain time-honoured traditions. This is a contradictory attitude that seeks to remain intangible; and it's exactly in this quality that the appeal of DUTEURTRE resides.

Mr.
FRANCESCO VEZZOLI

Featured in issue n° 8 for Autumn and Winter 2008
Portraits by Matthias Vriens

The cover star of issue n° 8, the artist FRANCESCO VEZZOLI was photographed for FANTASTIC MAN running through the streets of Los Angeles. The shoot took place on a hot summer's day, but photographer MATTHIAS VRIENS, who was perched comfortably on a vehicle out in front, nevertheless urged FRANCESCO to run as fast as he was able in order to achieve the desired dynamism.

FRANCESCO is known for his needlework and his film-making. He has a talent for assembling extraordinary casts, and among his collaborators are CATHERINE DENEUVE, JEANNE MOREAU, MARIANNE FAITHFULL, HELEN MIRREN, KAREN BLACK, COURTNEY LOVE, MILLA JOVOVICH, BENICIO DEL TORO, GORE VIDAL, CATE BLANCHETT, NATALIE PORTMAN, SHARON STONE and BERNARD-HENRI LÉVY. "The art world wants to be a new Hollywood, is obsessed with who is in, who is out, and they don't want to admit it. That's what I've been discussing in my work for ages but many people don't want to see it," he said.

In 2014 FRANCESCO had a solo exhibition titled TEATRO ROMANO at MoMA PS1. The show included five classical busts repainted in something akin to their original colours with the help of a team of restorers.

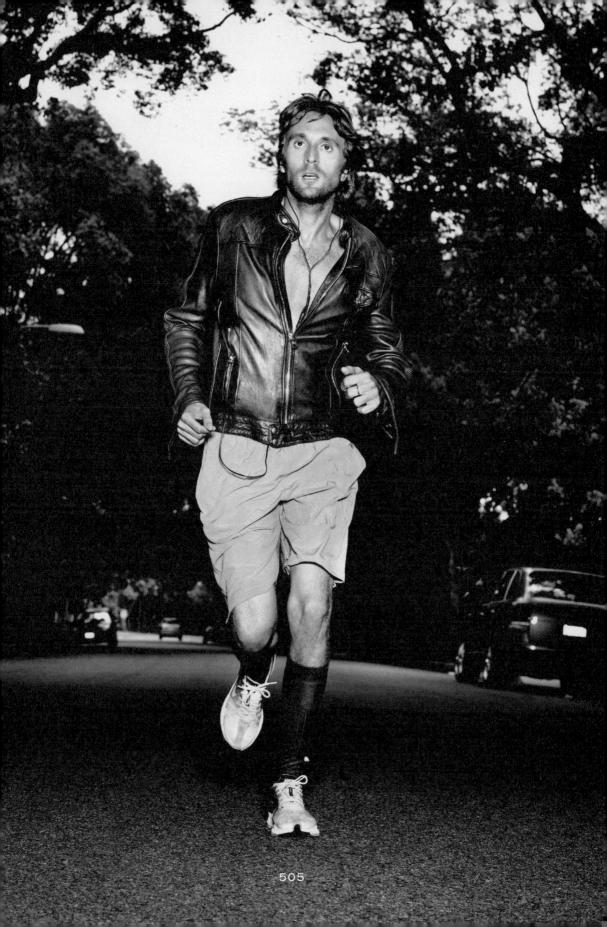

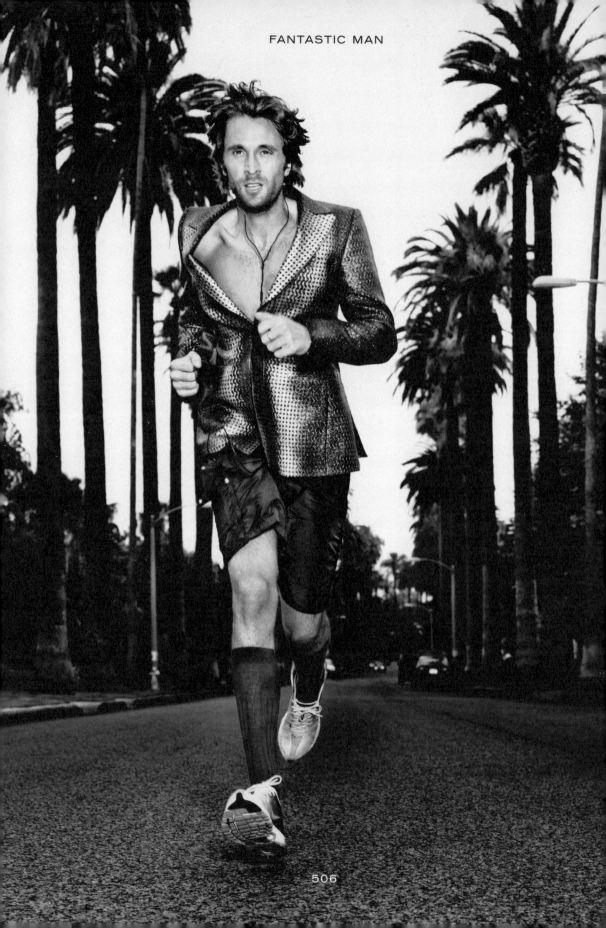

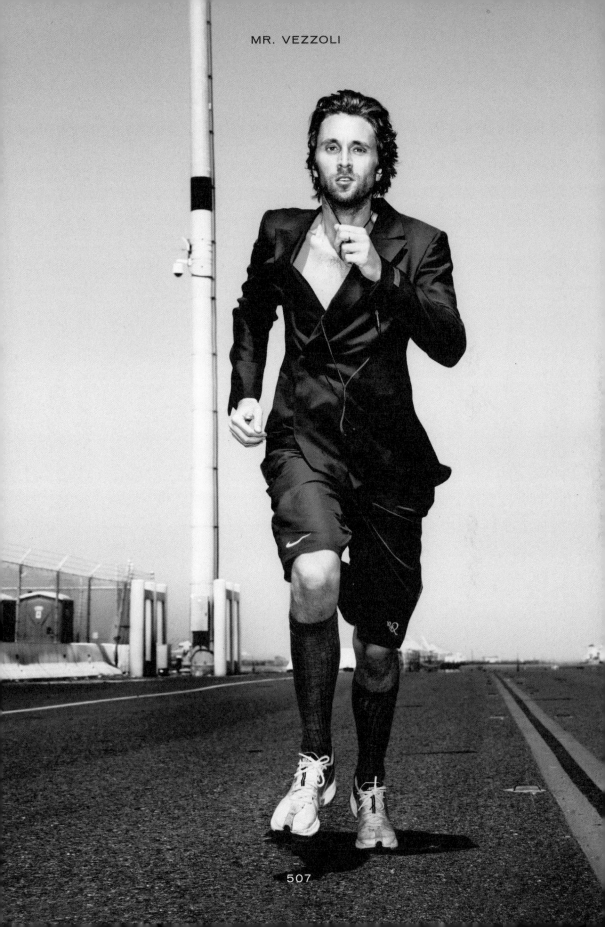

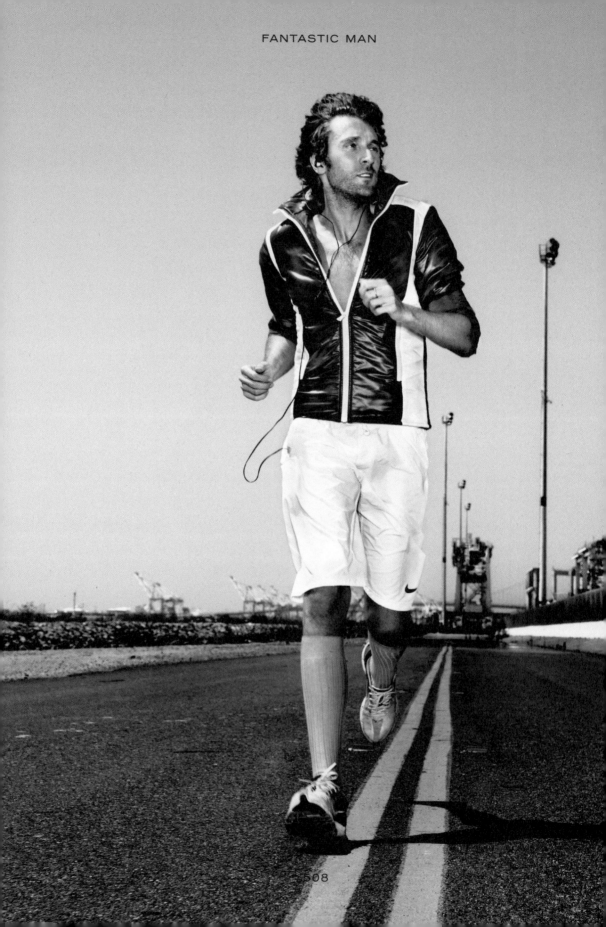

Mr. XAVIER DOLAN

Featured in issue nº 20 for Autumn and Winter 2014

FANTASTIC MAN interviewed XAVIER DOLAN just after his sixth film MOMMY had been the joint winner of the Jury Prize at the 2014 CANNES FILM FESTIVAL. He shared that honour with the 83-year-old French director JEAN-LUC GODARD. XAVIER, who hails from Quebec, was 25 years old.

At that point XAVIER was already something of a showbusiness veteran, having begun his career aged four as an actor and voice-over artist. A native French speaker, he has dubbed numerous roles in films and TV shows for French-Canadian audiences, among them RON WEASLEY in the HARRY POTTER films and JACOB BLACK in THE TWILIGHT SAGA. XAVIER wrote, directed and starred in his first film, a semi-autobiographical piece titled I KILLED MY MOTHER (J'AI TUÉ MA MÈRE). Conceiving the film aged 16, he was able to make it three years later. It was shown at CANNES in 2009 and received an eight-minute standing ovation.

Collaborating with the photographer BENJAMIN ALEXANDER HUSEBY, XAVIER played a clutch of characters on the pages of FANTASTIC MAN, from sweat-shirted Brat-Pack boy to silk-shirted Svengali.

Portrait by Benjamin Alexander Huseby

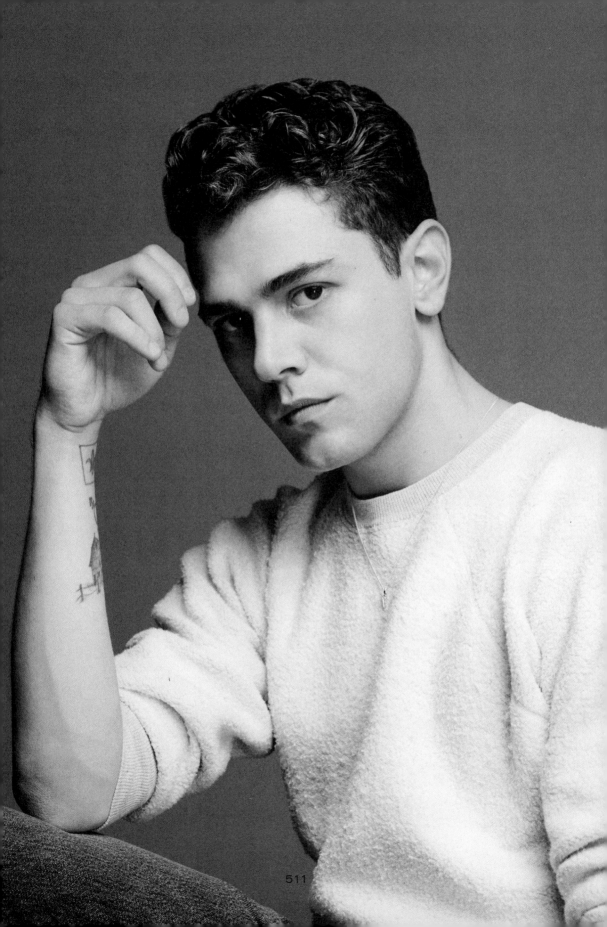

Mr.
CHRIS DERCON

Mr. CHRIS DERCON
Featured in issue n° 13 for Spring and Summer 2011
Portraits by Alasdair McLellan
Text by Thomas Bärnthaler

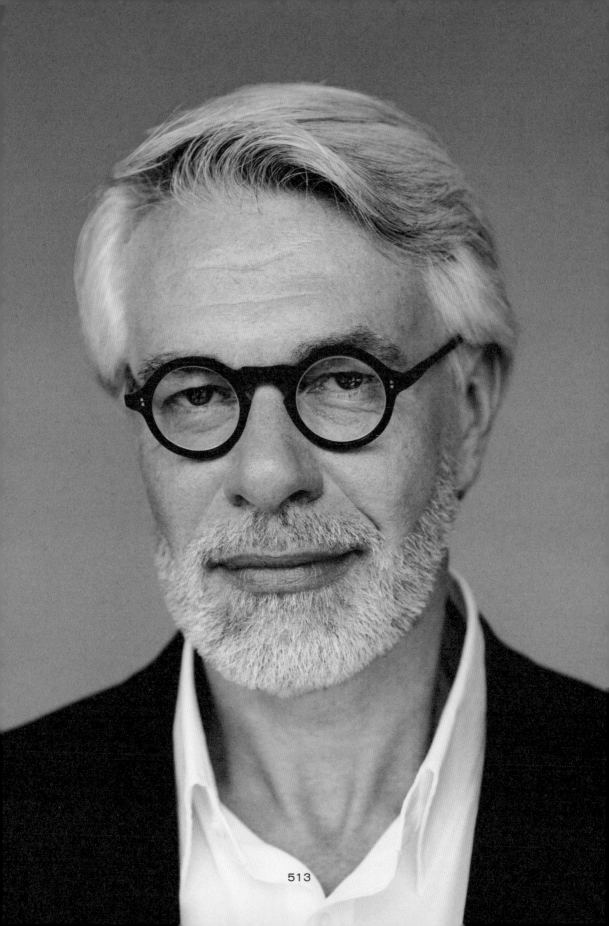

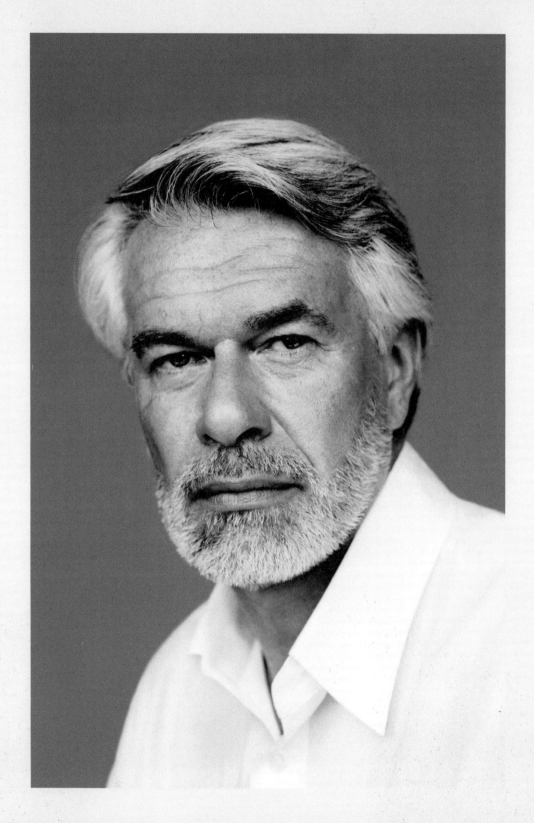

It's a thrilling combination: one of the most ambitious galleries in the art world, TATE MODERN in London, has just appointed one of the boldest curators, Mr. CHRIS DERCON, as its new director. In his previous posts, DERCON has drawn mass crowds for cerebral shows, proving that contemporary art has a place in populist discourse. Now his boundless ideas have a whole new stage, including the new extension being built by HERZOG & DE MEURON. Belgian by birth and gregarious by nature, DERCON is a fashion obsessive who displays his vintage design garments on mannequins at his home.

In the eight years since Mr. CHRIS DERCON started as the director of the HAUS DER KUNST in Munich, his office has become more and more of a trove. It is of high ceiling, with white walls and parquet flooring. He has a desk, as well as a long meeting table, and every surface is covered with piles of paper, books, CDs, letters, portfolios and massive stacks of newspapers. The wall behind DERCON's desk is pinned with photos, magazine snippets, notes and posters. There are runway images from a COMME DES GARÇONS show, a picture of JACKIE O., a poster of PATTI SMITH and another poster that says *"Die Utopie wird immer besser, während wir auf sie warten"* or "Utopia gets better and better the longer we wait for it".

The shelves are overloaded with even more piles of paper. "I'm the only one who knows where everything is," says DERCON, who is 52 and a Belgian national. "I can't work in a tidy or empty office. KLAUS BIESENBACH, the director of MoMA, has a completely empty office. I don't know how he does it. You should see my archive."

When DERCON speaks, he does so with this typically Benelux sound that gets stuck in the throat just long enough to come out sounding like a smooth rap. His voice is deep and soft, and when speaking English, he has a strong American accent, courtesy of his time in New York as programme director of MoMA PS1 in Queens in the late 1980s.

DERCON often uses the contents of his office as a starting point for his work. Although he has two secretaries, he doesn't let them organise his working

space; he does that himself. He arranges and rearranges the heaps of collected material; he filters it and re-filters it, until one day maybe an idea will grow into an exhibition. But for now that process is on temporary hold. Soon everything will be moved to London, where he is about to become the director of TATE MODERN, one of the most esteemed jobs in the art world and the next big scoop in his already illustrious career.

DERCON is leaving the HAUS DER KUNST on a high, having turned it from a state-run art temple with a difficult past into a contemporary museum of international importance. He has proven that art can be intellectually challenging yet still attract mass audiences. On his agenda, everything at the museum had equal importance: art, fashion, design, parties and politics. He had SONIC YOUTH and PATTI SMITH performing, and he brought art stars like AI WEIWEI and PAUL McCARTHY to Munich. Like no one before him, DERCON understood the peculiar beauty of the HAUS DER KUNST, and he invited artists to include the building's facade in their installation. In 2009, WEIWEI hung thousands of children's rucksacks on the outside; in 2005, it was McCARTHY who covered the building with giant balloons in a piece called INFLATABLE FLOWER BOUQUET.

It is this kind of experimentation that the TATE savours, with its vast Turbine Hall and its similar desire to involve the outside of the building as much as the inside. "Many people encouraged me to apply to the TATE," says DERCON of when the job came up. "Such application is like an offer and a challenge one cannot refuse." DERCON replaces Mr. VICENTE TODOLÍ as director of TATE MODERN and will report to Sir NICHOLAS SEROTA, who is director of the TATE overall. In the years running up to DERCON's appointment, SEROTA was often seen in Munich, meaning his new boss is more than familiar with his work. DERCON joins TATE MODERN in its 11th year, at a point where it has become the third most visited attraction in the whole of the United Kingdom, with 4.7 million visitors a year. DERCON will join the institution just as it prepares to launch its new extension, designed by HERZOG & DE MEURON, who also transformed the original power station at Bankside into TATE MODERN, and which will open in 2012.

It's too early for DERCON to reveal his specific exhibition plans for the TATE, but he knows how he wants to work on a wider scale. "TATE MODERN is like an art movement in itself," he says. "It will be an honour to direct and to be a part of such an excellent staff, who do not shy away from thinking in a radically different way about the future of the museum, and not only of the TATE but of museums in general." He sees his role as helping the TATE along a path, rather than being definitive. "We have to realise that TATE MODERN is a project that will never be finished," he says. "It shouldn't be. It should always be a work-in-progress, because the TATE lives off constant change."

In charge of this whole new building, along with TATE MODERN's already existing spaces, DERCON will be one of the art world's most influential thinkers. But, importantly for DERCON, he'll also be living again in a city of global stature. "I am happy to be going back to a place where the world is at home," he says. "I'm especially excited about south London, Little Nigeria, Little Punjab... I need that mixture of different cultures — clashing cultures — and the energy it gives." It's true: compared to contemplative Munich, London is an untamed monster. In Munich it doesn't get much more exotic than seeing veiled women from Saudi Arabia doing their weekend shopping on the fancy Maximilianstraße.

DERCON will be moving to London gradually. "I need at least half a year's incubation time," he says. Indeed, he will continue to work in Munich for the time being to oversee an exhibition by CARLO MOLLINO at the HAUS DER KUNST, scheduled for this autumn. When we meet, he is preparing to open the next exhibition in Munich: a retrospective of 30 years of Japanese fashion, which travels from the BARBICAN in London. DERCON, who is partial to wearing YOHJI YAMAMOTO's oversized coats, confesses that the topic is very close to his heart. Another of his great fashion treasures is a pair of '80s COMME DES GARÇONS trousers that he wore so often, he had to find a Parisian tailor to have them copied again and again.

Today, DERCON is wearing a grey V-neck shirt by MARTIN MARGIELA, a pair of washed-out LEVI'S 501 jeans and black trainers by PRADA. "I got them from MIUCCIA," he says. "She once told me she didn't like the shoes I was wearing. Two days later, her press office called me and asked for my size." The two are friends, and Mrs. PRADA has often flown in on her private jet just to attend his openings in Munich.

While talking, DERCON likes to run his fingers through his hair that's as grey as his ten-day beard. He has a white TUAREG scarf wrapped around his neck, and his dark blue duffle coat was a present from GAO YING, the mother of AI WEIWEI, who apparently made the coat herself. It's a casual but precise look.

An average workday for CHRIS DERCON starts at 6am. "The first two or three hours at home are important," he says. "It's the only time when I can work in peace, writing, editing, checking things on Google. Then I go to the office and drink my first cappuccino around 9.30." Which newspapers does he read? "The good ones, depending on where I am," he says. "I love to read them in advance. I must have spent a fortune on taxis to buy tomorrow's papers the evening before at the station. I'm addicted to them." He says his favourite papers are LE MONDE DIPLOMATIQUE, LETTRE INTERNATIONAL and LIBÉRATION. "I can identify them by their smell."

We meet at the Goldene Bar in the HAUS DER KUNST, a bar that used

to be a *Weinstube,* or wine parlour, where Nazi's once gathered and dreamt of a 1000-year-long German Reich. We're having green tea. When he took the post, DERCON no longer wanted to hide the history of the museum, which had been built on HITLER's orders and was finished in 1937. Many think DERCON was only able to do so because he is Belgian. After the Second World War, the bar was closed down and the walls covered with plywood. DERCON had it restored, and when the plywood came down, no swastikas were found beneath. Instead, there were gold-leaf murals, and a medieval-looking map of Europe with emblems of German wine-growing districts and Scottish whisky distilleries. The Nazis were bons vivants.

DERCON is not afraid of controversy. In his first exhibition he showed HITLER IN PRAYER, a sculpture by MAURIZIO CATTELAN. "We kept a few copies behind the scenes, in case the work was attacked or spat at," he says. DERCON's other decisions were no less abrasive. Once, he wanted to take down some of the trees behind the museum to open up the view to the English Garden beyond; the conservationists were up in arms. That's Munich. Then he excluded dogs from the museum. DERCON hates dogs, especially after a dog bit his wife while she was jogging. Ever since, a sign with a crossed-out dog has been on the doors of the HAUS DER KUNST.

For some in the city, DERCON was too fast and too loud, while others couldn't deal with his irony. But during his tenure, the queue of visitors became longer and longer. Today, everyone shares the same opinion: DERCON was a stroke of luck for Munich, influencing much more than just the art scene.

DERCON sees his time in Munich as one of study. "It was like a second university, where I met people who mean a lot to me and from whom I learnt a lot, like ALEXANDER KLUGE, the filmmaker, and KONSTANTIN GRCIC, the designer. And BARBARA VINKEN, who knows as much about fashion as she knows about 18th-century English literature. Sometimes my staff would send me an SMS saying for example: 'HUGH GRANT just walked in!' But for me it was just as important to get an SMS saying 'JÜRGEN HABERMAS is here!'" he says, referring to the German philosopher.

Mr. GRCIC says of DERCON: "His strength is his incredible intellectual energy. He can combine things that obviously have nothing to do with each other."

DERCON sees his work as chaos research. "I call it the principle of serendipity. It's the art of finding something that you've never been looking for. SALVADOR DALÍ called it the 'critical, paranoid method'." It is impossible to have a conversation with him without breaking new ground. DERCON walks like he thinks: fast. He drops names of artists, exhibitions and book titles until one starts to get dizzy. But it doesn't mean that he's not a good listener. In conversation he actually waits for input, like a ping-pong player waits for the

ball. (According to his old friend, gallerist Mr. RÜDIGER SCHÖTTLE, DER-
CON is also an exceptionally gifted ping-pong player.)

DERCON can't wait to show me his archive. It is a crammed room in the base-
ment of the HAUS DER KUNST and normally open only to DERCON and his
staff. There's industrial shelving floor to ceiling, with a desk in the middle, also
covered with books and papers. The floor is concrete. He wants to show me a
book that he says explains everything: THE LIBRARY AT NIGHT by
ALBERTO MANGUEL, about the vampirism of reading. But as soon as we enter
the archive, he picks up a book about carpet weavers in Eritrea. Then he starts
flipping through a book about the Indian city Ahmedabad, close to Mumbai,
where he recently spent a couple of weeks researching its connections with LE
CORBUSIER, BUCKMINSTER FULLER and JOHN CAGE. "This could be the
beginning of something," he says. "If you want to move forward, you have to let
yourself go — like a pinball. Everything is connected."

His archive is based on personal categories. "I was so jealous of ROLAND
BARTHES' index-card system. Or HARALD SZEEMANN's. Isn't it great to
have the discipline to organise and maintain a system like that? That's what I
wanted." DERCON has categories like 'Strong Women', where he collects mate-
rial about the likes of KIM GORDON, REI KAWAKUBO and LOUISE BOUR-
GEOIS. Sometimes people themselves become new categories, like 'PATTI
SMITH' or 'MARLENE DUMAS'.

"The other day I was trying to find a STEVEN MEISEL shoot from
VOGUE," says DERCON. "I looked in the 'Fashion' category, but I'd already filed
MEISEL under 'Photography'. Same for JUERGEN TELLER." Which means
that he considers both to be artists.

A significant category is dedicated to the Dutch architect REM KOOL-
HAAS, a long-time friend of DERCON. There's one for DAN GRAHAM, one of
his heroes, but there's also a section called 'Interesting Wine Labels'. Ideas for his
exhibitions grow slowly, he says. "If I'm interested in something, I'll start search-
ing and collecting. At some point I make collages, to see if anything happens. If
something happens, then I continue."

"That's me," DERCON says casually, as we pass by the shelves filled with his
own publications. He could just as well have meant the whole basement. "I try to
conceive of the archive as a map of the world, with enough room for new islands
to grow." DERCON doesn't have the ambition for his archive to be complete.
There's nothing on the artist NEO RAUCH, for example, but there is much mate-
rial on brass music from all over the world.

Brass music happens to be an obsession of DERCON's. "My uncle JOST
played the trumpet in a brass band. Us kids would join him on marches and at

funerals," he says. "As an adult, in Mexico, I found CHOPIN's funeral march in Oaxaca being performed on brass by slave descendants. I was in Addis Ababa recently and I spoke with the head of a local radio station because I desperately wanted to find a specific brass band from Eritrea." Days, weeks: DERCON spends much time on—and travels many miles for—his brass music research. He might not be aware of it, but he's probably an international expert, driven by nostalgia. "Brass music brings back a lot of childhood memories," he says.

CHRIS DERCON was born in 1958 in Lier, a Belgian town close to Antwerp. His father worked in Brussels as an engineer in an urban-planning agency. Before she became a full-time housewife to raise her five children, his mother taught tailoring. "When I think of my mother, I see her surrounded by tailor's dummies." DERCON has a couple of dummies in his apartment in Munich, dressed in early MARTIN MARGIELA pieces—he collects MARGIELA as art.

Wanderlust came early to DERCON. His father travelled often through Africa, and when DERCON was eight the family moved to Tervuren, close to Brussels and home of the ROYAL MUSEUM FOR CENTRAL AFRICA. "When I was a child, I wanted to be a missionary," says DERCON. "There were people ringing at our door constantly, collecting money for the mission. I just didn't know if I wanted to go to Africa or Brazil."

Eventually he went to Amsterdam instead, where he studied film theory, while also following art history and theatre studies in Leiden. In the middle of the archive DERCON stumbles upon a folder of private photographs. In one photo he is wearing a black motorcycle jacket. "That was the punk age," he says. "But I was a late hippie." His heroes were LOUDON WAINWRIGHT and FRANK ZAPPA. He was a vocalist in an art-rock band called OXFORD COMPANION TO ART. Another photograph shows him on stage. He has on aviator glasses and looks quite ambitious. "I recited words from the dictionary," he says. There is no trace of the band on Google.

After college, he started working for Belgian radio and television. "First I thought I was a journalist, but later I thought I was an artist—until I realised I was not a genius, but the worst European artist ever." For his military service he requested to be a warden at the Belgian military museum. The direction was kind of right, at least.

Since his career as a curator began, DERCON has never stayed anywhere too long. He worked as a freelance curator for museums in Belgium, the Netherlands, New York and Tokyo before he was at MoMA PS1 in New York for a year, five years at WITTE DE WITH art centre in Rotterdam, seven years at BOIJMANS VAN BEUNINGEN museum, also in Rotterdam, and eight years in Munich. He has three children on three different continents. He has an impressive air miles count.

Though he will eventually complete his move from Munich to London, he plans to keep his rented cottage in the Tyrolean Alps, near Kitzbühel. "I know it's a cliché," he says, "but I love the romantic idea of looking after myself and supplying myself. Cutting wood, making a fire, strolling through the woods. Well, within reason..." (The cottage has underfloor heating.) In the autumn, he often picks mushrooms. "You have to consult the locals. They can tell you the best places to find mushrooms. Places nobody else knows." He carries the spoils home in a basket.

DERCON has some simple advice for those that want to follow in his footsteps. "There are three key tips for tourists to get to know a city," he says. "Always walk. Visit a hairdresser. And go to the best market." DERCON loves markets. To him they're like topographical archives. "I know exactly where to find things," he says. He buys his Pyrenean lentils on rue Rambuteau in Paris. Sometimes his obsession with regional food brings its own complications. "I was once stopped at the airport in New York with a *confit de canard* in my bag. There was glycerine on the ingredients list, which the officer mistook for nitroglycerine. We had a long discussion, but I couldn't convince him."

After an hour in DERCON's archive, stumbling out over big boxes stuffed with material — "New arrivals!" — it feels good to breathe some fresh air. By now it's dark outside. We smoke a cigarette on the terrace. "I almost managed to quit," DERCON says. "In London, I want to start jogging again. I love Kensington Gardens." We never found THE LIBRARY AT NIGHT, but we found things we hadn't searched for. DERCON excuses himself. He needs to pack as he's flying to Beijing tomorrow morning to see PRADA's first catwalk show in China. He also plans to go visit AI WEIWEI. I look up at the ceiling of the arcade where we're standing. The mosaic stones twist together into swastikas.

Everything is connected.

Mr. JOHNNIE SHAND KYDD

Featured in issue n° 3 for Spring and Summer 2006

JOHNNIE SHAND KYDD is the British art photographer known for taking candid snaps of his immediate circle of glamorous friends. Spontaneous, black and white, not prettified yet dazzlingly attractive, his images make for instant nostalgia. When relieved of his camera, JOHNNIE is a wonderful raconteur. Recalling the story of the shoot that led to this picture from FANTASTIC MAN's "The Art of Smoking" series, he describes posing for the photographers face on, but being asked to turn clockwise, bit by bit, until the anonymous image was achieved. JOHNNIE is very attractive, but he remembers the photographers exclaiming "perfect!" as his visage disappeared from view.

The shoot was published at the start of the process by which the ban on smoking in enclosed spaces came into force in the United Kingdom in July 2007. Formerly a public activity, smoking became a private pursuit. Back then JOHNNIE claimed never to smoke on British soil. These days, he doesn't smoke at all. "It's the only vice I've managed to nail," he says.

Portrait by Anuschka Blommers & Niels Schumm

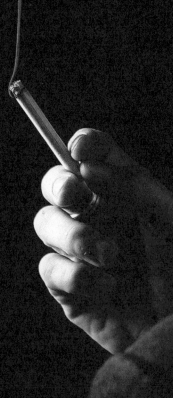

Mr. CLAUDE MONTANA
Featured in issue n° 5 for Spring and Summer 2007
Portraits by Alex Klesta
Text by Karl Treacy

Mr.
MONTANA

The legendary superstar designer of the '80s is a notoriously shy man whose life has had more than its fair share of drama. These days, Mr. CLAUDE MONTANA still designs for his diffusion line MONTANA BLU, a job he contractually holds for about another year. But the architect of razor-sharp shoulders and dramatic proportions, colour-blender of KLEIN blue, mustards, greys and metallics, and perennial champion of the fringed leather jacket has been busy with much more than simply business as usual.

Sitting across a table in the showroom of the fashion house that bears his name in a large, park-fronted, 17th arrondissement building with an entrance hall and stairway surely designed for a dramatic wow factor, CLAUDE MONTANA is not in a festive mood. Fighting back the effects of antibiotics from a cold he says just won't quit, he seems somewhat removed from the flamboyant figure who navigated his way, hips thrust out, through a soaring galleon of sharp-shouldered amazons, to take his bow at the end of the runway to soaring Wagnerian chords. Today, however, MONTANA seems almost kitten-like, tactile and tamed: someone you might distractedly share a bowl of popcorn with while you're both splayed out in front of the TV.

Odd, since this, after all, is CLAUDE MONTANA, whose wide-shouldered, wasp-waisted silhouette emerged in Paris in the late '70s and went on to influence and define fashion around the world throughout the '80s, before falling at the fence of grunge and deconstructionism in the '90s. The designer whose regimented, cheerlessly choreographed and powerful runway shows were a vision of an alarming future in an era when smiling, swishing models or uptight, polite couture presentations were the order of the day. The designer who, early on, saw the importance of menswear as an essential part of his, and his industry's, creative expression and growth, and who launched his own full-fledged men's line, MONTANA HOMMES, in 1981, a mere two years after the creation of his hugely influential house. His idea of menswear: fringed leather motor jackets, mustard-coloured broad-shouldered suits, peach and mint, asymmetrical zips, studs. Perfumes selling in the millions. Legions of licences. MONTANA's tale of triumph could be a typical rags-to-riches story, were it not laced with severe doses of tragedy and suffering.

Born in Paris into a bourgeois family in 1949, MONTANA was the last child by eight years of a German mother and a Spanish father who held a high-ranking position in the army. An unexpected arrival, young CLAUDE's presence severely impinged upon his mother's plans and patience. "She wasn't terribly happy to have, eight years later, a body that, you know... She was very conscious about how she looked," he explains, before admitting, "so I didn't feel that comfortable." It wasn't the most jovial welcome one could wish for. Add to that CLAUDE's refusal, as a teenager, and in spite of good grades, to follow his father's advice and study for a respectable profession, and MONTANA's future — and schism from his respectable family — was assured.

20-year-old CLAUDE found himself living in London, where he was squatting in a girlfriend's photographer boss' studio by night and fleeing in the morning, and baking papier-mâché Mexican jewellery to sell for basic funds, which led to an "in" at British VOGUE where that same colourful jewellery was seized upon for a two-page spread and an entry onto the London retail scene. When work-permit pressures forced Mr. MONTANA back to France, the retailers and editors of his native city were far less enthusiastic. This, after all, was Paris in the early '70s — not half as groovy as London.

In order to survive, MONTANA took a job at the Paris Opera, where he'd worked pre-London, and found, in spite of little monetary gratification, a creative milieu willing to help him out. One of those people he met, and the one to give him a much-needed push, was costume designer SAMUEL DE CASTRO, who forced his young charge to get a sketchbook and do some drawings. Well, one thing led to another, the drawings were seen at a dinner, and MONTANA was hired as an assistant at leather manufacturer MACDOUGLAS, where he received a first-class practical education, got control of a third of the whole collection when his boss moved on, and worked freelance for other non-leather fashion labels simultaneously. And — voilà! — a world-class designer was born.

His beginnings working in leather, when combined with his rampant imagination and technical skill, created his signature, sexy skins, the likes of which had never been seen before. MONTANA's designs perfectly corresponded to a mind that drew on sadomasochism and fascism as fertile fields ready to be pillaged for fashion. Would things have turned out very differently, one wonders, if he hadn't found his feet with leather? MONTANA: "Well, it turned out that way, so I don't bother to think about what might have happened if it didn't turn out. It just happened that way and that's all."

Mr. MONTANA, together with maybe THIERRY MUGLER, had the vision to see that sex, power and fetishism could blend together perfectly in a fashionable mix. If there was one look that would define the late '70s and the first half of the '80s, it was MONTANA's. His creations influenced how the world dressed,

when he was at the provocative pinnacle of his career. In ALICIA DRAKE's recent book THE BEAUTIFUL FALL: FASHION, GENIUS AND GLORIOUS EXCESS IN 1970s PARIS, which deals primarily with the life of Paris fashion from the '60s through the '80s, using KARL LAGERFELD and YVES SAINT LAURENT and their respective entourages as the uniting factor, MONTANA gets a number of mentions, some more glowing than others.

I ask Mr. MONTANA if he's read the book, or at least heard of it. He replies in the negative (which may not be all that surprising, as KARL LAGERFELD, for invasion-of-privacy reasons, had the book withdrawn from sales in France and from any subsequent translations into French). "Lots of people tell me there are a lot of books that mention me these days," he suggests.

DRAKE spoke to PAT CLEVELAND, one of the biggest models of the era, who remembered fittings for MONTANA as "total torture", and said, "He was chiselling away at you like you were a block of wood. He wouldn't let you go until he squeezed out every bit that was you and replaced you with himself. You could not be anything but CLAUDE."

MONTANA seems quite surprised by the intensity of CLEVELAND's admission. "It's strange that PAT said it was difficult. She said it was difficult?" he asks with a disbelieving sense of amused surprise and a faint flicker of hurt. It makes sense that a designer demands an involvement bordering on the obsessive. "You know, I was married to a famous model," he says, in a rare moment referring to his deceased wife WALLIS FRANKEN. "And it's true that she did tell me... You know, some designers just told you to put on that number, boom-tack, and that was it. For me a fitting was at least 45 minutes, for each girl, and sometimes in a season we had 45 girls. You can imagine the work it was. I wanted things to be almost perfect."

Almost perfect?

"Yes. I don't think you ever reach perfection. If you reach perfection you'd better leave that job and move on. But you should try to approach perfection as much as you can." Is he still a perfectionist? "Trying to be," he replies, adding, "Although, as I said, things have changed. It's more difficult now." For the first time I notice the classical music issuing forth from the stereo. "That's the music for my shows," MONTANA says, quite offhandedly, at the sound of a Wagnerian chorus, for he always tended to use the same music for his shows—deep, dark, classical, with crashing chords. Serious cerebral music that set the tone for work that was invested with a deep cerebral and technical rigor, the creative output of an exacting genius who was both part of but also outside his time.

Former ROCHAS designer PETER O'BRIEN recalls his college days at St. Martin's in London in the late '70s when he and his classmates would take trips

to Paris and sneak their way into shows. With its arresting music, robotic models, flashing lights and lasers, and futuristic clothes, MONTANA's was the show that everyone wanted to see the most. "It might not entirely have been to everyone's taste — and it was *very* of its time — but no one who went to one of those shows ever forgot it. It was unlike anything we'd ever seen," says O'BRIEN.

Although lots of publications laud the genuine elegance and jauntiness, the razor-sharp tailoring and strong silhouettes, and the perfectionism and exigence that defined MONTANA's collection, the Wikipedia blurb on MONTANA's career mentions his output as being "more focused on cut than detail," a criticism he takes particular exception to. "No, there were lots of details. You don't see that on the videos but there were lots of details," MONTANA stresses. "There was the cut, I mean, there were the shoulders and waist, the colours were important. The colours were *very* important. These days I don't think men going out in pale apricot is... that was another thing. People could buy a jacket like this (he picks up my lighter which is a sunset orange sort of colour) and pair it with black pants."

Indeed, Mr. MONTANA was never shy when it came to introducing colour into the lexicon of men's fashion. He set runways brimming with buff examples of masculinity strutting in broad-shouldered, softly-draped tailoring in dusky peach and zinging lime green, introducing a whole spectrum of colour to the grey-toned field of menswear, paving the way for the pastels of MIAMI VICE and for real men who have probably never since dared to wear these shades with such unabashed aplomb.

As for current names in men's fashion, Mr. MONTANA is drawn to the work of DIOR HOMME's HEDI SLIMANE, "I have a lot of respect for his design," he says. "He does a really simple thing, with a belt in a striking colour, and a sleeve-less hood in paillettes, and the mix makes something that maybe I could wear. Because it's something. And very modern. But there are very few people who understand that."

But he wouldn't wear anything like that, would he? After all, MONTANA seems to be wearing pretty much the same uniform of bomber jacket with tight (leather) trousers and cowboy boots since time immemorial, and he seems quite surprised when I point this out, gesturing towards his puffy jacket as illustration of his top-heavy silhouette of choice. "It looks puffy because it's cold outside. In the summer I wear light jackets," he says. But current house menswear designer FORD-HAMILTON HEJNA, whose attention is aroused by MONTANA's sartorial stand, disagrees with this summer-wear scenario, saying it's bombers year-round. "In the summertime you haven't seen me in..." MONTANA starts before HEJNA cuts him off. "I've seen you in bomber jackets in summer!" he says with a smirk. MONTANA replies with a fake mumble of displeasure. Okay, surrender. "That's been it for 25 years," he says of his uniform. "That's what

happens, I guess," after which he draws some similarities to KARL LAGER-FELD's diets and peculiar personal style. "It's a wonder, no?"

Speaking of diets and losing weight, healthy eating is the way for Mr. MONTANA. Generally an early riser, he forgoes coffee at breakfast in favour of yogurt, kiwis and the like, and is an avid swimmer, although he's a little out of practice as of late. "I'm not on a specific diet, but I'm very careful about what I eat. For seven years I was totally, how do you say, *macrobiotique*. And it wasn't easy to do. I decided it was over but I still don't like meat, stuff like that. My diet is very..." Simple and healthy? *"Trying* to be simple and healthy!"

He does, however, smoke the odd MARLBORO. He smokes one during our interview, and its effect is that of a sudden perk-up in a conversation that tends to wander off into silences and half-finished sentences. We drink a glass of water.

In 1993 CLAUDE MONTANA married WALLIS FRANKEN, a 43-year-old, American-born model who had been his friend, model, muse and collaborator for two decades and who, for a time, had had a singing career. It was a marriage that surprised the fashion world, as MONTANA is not, to use antiquated parlance, entirely the marrying kind. Three years later, WALLIS was dead, having fallen from the window of their third-floor, rue de Bellechasse apartment. Even now, over ten years later—a lifetime in fashion—FRANKEN's death is probably the second thing people mention when the subject of CLAUDE MONTANA comes up. It generally follows the "What's he up to now?" question, or the "I saw him having dinner at DAVÉ the other week" observation.

Now a part of the dark mythology of Paris fashion, it's not something MON-TANA talks about, and the subject isn't broached, although, weirdly, at some point I'm convinced MONTANA is talking about WALLIS. It's after I think it's time for the silly-question-of-the-day to liven up our sometimes stilted conversation, so I say, "So, do you have any pets?"

MONTANA is initially unsure what I mean, but then comprehends. "I used to. A beautiful one. Unfortunately she died. And I don't feel like..." he stops, his voice solemn, wavering slightly, before adding, "As I said, for the moment I'm living on my own, and I can't take care of an animal." Was it a dog? I ask, warily. "A shar-pei called CHINA. She was actually fabulous. And I tried to... because those dogs, you know, usually they live like 7, 8, 9 years, and she went until 15 so I think I took quite good care of her. And she was quite affectionate," he explains. "Lots of things happened at a certain moment in my life. I went through terrible times, people died around me, during a very, very short time, and that affected me a lot," he says quietly.

In more high-living times he numbered a large *château* among his properties which, according to a feature in THE SUNDAY TIMES MAGAZINE on French

designers' homes, if memory serves correctly, he used to reach via taxi, a fact that to me, then a 13-year-old in rural Ireland dreaming of Paris, seemed impossibly chic and fabulous. "I got rid of it. It was too much!" he says, chuckling to himself. "Yes, it was a beautiful place actually, but it was really a pain. The place was huge, huge, huge. Enormous; really too much."

For now, his life is lived primarily in Paris, and he has a house in Italy by the sea that he visits sometimes. "I travel less than I used to. For a while my life was... you know, the shows in Paris... I was doing two women's shows, cruise, two menswear, and two couture collections a year when I was at LANVIN (a short-lived but creatively spectacular gig in the early '90s when he designed haute-couture collections for the historic French house). That's like seven shows a year, in eleven months; that's quite a lot. Plus all the shows around the world, 'cause I think I am being quite humble, but I think I was one of the most honoured designers," he says, adding in a low voice, "I think the most, actually. The most at that time." He's referring to a clutch of fashion's most prized awards, from GOLDEN THIMBLES through to a host of best-designer and best-collection gongs, because even for a designer riding high on a wave of press hysteria, recognition by your intelligent peers is always something to be treasured.

At the moment his name is starting to crop up as young designers such as NICOLAS GHESQUIÈRE and PROENZA SCHOULER explain the inspiration behind their collections: MONTANA, MUGLER, ALAÏA, HERVÉ LÉGER, all masters of construction and, each in his own way, of seduction. So what's it like being referenced by other designers? "Feels like I've been doing so much during the past 25 years that I don't even remember what I've been doing, and it's very hard for me to copy myself again. I let them do it." Is it flattering or annoying? "Neither. I don't care." You really don't care? "No, I don't care," he responds in the world-weary manner of one who's seen and done it all. "It may be flattering if you like. But sometimes you see such awful copies of what you've done that it's not flattering at all!" he laughs.

Mr. MONTANA has been collecting art "since the beginning when I started to earn money... I don't have a huge collection, but I have..." A good one? "Well, it depends on your taste. I like the '30s. It's difficult to say if I have a favourite artist. There are lots of artists, and lots of artists you cannot afford to buy... Of course I met lots, lots of people. I regret not having worked with them, either for photographs, or buying paintings, or asking them to do something special for me," he says wistfully. "It was a time when things were much lighter than now."

His use of the word "lighter" when speaking about the creative world is a curious one. "It *was* much lighter, because you were able to do whatever you wanted to do. Nobody would come back, looking over your shoulder, saying this is right, this is wrong. As long as they trusted you they would let you do what you

wanted to do." Is this change fashion-specific? "I don't think it's just fashion, I think it's the whole world," he answers.

Even though over the years his skills grew ever more precise and his cuts more wondrous, throughout the '90s his position on fashion's front line began to weaken, due both to personal issues and the fact that his clear vision didn't translate well in an era of grunge and deconstruction. Instead of holding out 'til the bitter end, as a number of his contemporaries did, he ended up selling his house at the end of 1997 but remains in charge of the MONTANA BLU women's sportswear line for a contractually stipulated ten years—so he's almost there.

Designing inside a framework of owners and manufacturers that's no longer his own has proved a steep learning curve for MONTANA. I query if he's conscious of what's going on in fashion when he's designing. "I design what I want, but it's different. These days people want to find out what others are doing and stuff, which is something that I never did when I was designing on my own. I think that people are very afraid these days. They want to be sure. But for me it's... One has to follow his own intuition about fashion," he notes admirably.

What would MONTANA like to see these days when the models come down the runways in Paris, New York and Milan? "Something clean, something rather simple, beautifully cut, making the woman look her best."

As befits someone who's lived through enough to arrive at a point where the obvious isn't hidden behind a smokescreen masquerading as style any more, his response to a query about the direction fashion is taking at the moment is unsurprising. "For me it's a bit... too Baroque, somehow," he says after a long pause. "It's like out of this world. In a way I don't see any women in these kinds of clothes, not during the day and not at night. For men it's very easy to be elegant. I mean you put a black suit with a white shirt without a tie—and if you are... if you look fine, you look fine. And if you look great, you look even more great! But for a woman, they try to do all these paillettes and embroidery. I don't think they have understood that the poor little black dress is still the best thing to work around."

For a man who created seven very different collections per year to go to designing two diffusion collections must leave rather a sense of creative inertia, a gap ready to be filled. "We'll see," MONTANA replies evasively. "I have a contract until 2008, and we'll see what's going to happen. Otherwise, yes, I have projects, and I don't want to talk about them, because projects are projects." I start to gently prod and it gets his back up. Nothing will come of it.

"You can't tell me anything, can you?" I ask, surprised at the impasse. "No, I don't want to," he says sharply, clarifying, lest his refusal might not be clear enough. But in the interest of diplomacy and sweet friendliness, MONTANA softens when he says, "Being superstitious is very hard, no?"

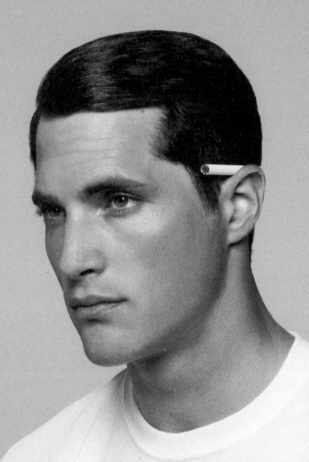

Mr. OLLIE EDWARDS

Featured in issue n° 18 for Autumn and Winter 2013

The entire third section of the eighteenth issue of FANTASTIC MAN was given over to experimentation in the form of "Workshop", a rigorous survey into men, women and modes of dress. Few who saw that series, which was shot over four days in New York City by the artist and photographer COLLIER SCHORR, will have been able to forget COLLIER's portraits of model OLLIE EDWARDS, one of the world's most photogenic men and a perennial presence in the advertising for the American house of RALPH LAUREN. A photograph from the same session graces the cover of this very book.

OLLIE was born in London, but his wholesome brand of handsome makes him particularly popular in the United States and he lives in Brooklyn with his English bulldog.

Known for his perfect skin, OLLIE prepares for shoots simply by getting an early night and drinking plenty of water. OLLIE has a spectacular scar running diagonally across his abdomen that is the legacy of a serious accident he had aged four while playing with a Slip 'n Slide in his back garden. He doesn't mind the scar, and gamely displayed it during the "Workshop" sessions. OLLIE loves to race Motocross, indeed calling the sport his one true passion. Sadly, the pursuit's terribly high injury rate makes it incompatible with regular modelling.

Portrait by Collier Schorr

Covers

21 iconic covers produced over
10 years, chronologically, each
accompanied by a pithy outline of the
respective issue's highlights

N° 1, Spring and Summer 2005

The debut issue of FANTASTIC MAN boasts actor RUPERT EVERETT on its cover and splashed across eleven pages inside, with a super funny interview by TIM BLANKS and handsome portraits by BENJAMIN ALEXANDER HUSEBY. Other unexpected subjects include designer THOM BROWNE in his first-ever substantial interview, highly entertaining music entrepreneur MALCOLM McLAREN, ballet dancer ANDER ZABALA and creative director DENNIS FREEDMAN, who hoards amazing art and design in his Hamptons hideaway.

Nº 2, Autumn and Winter 2005

The spectacled fashion designer and former horseback champ GILES DEACON graces the cover of the second issue of FANTASTIC MAN. Also in this issue are the interior design star JONATHAN ADLER, the inimitable gentleman Italian CARLO ANTONELLI, the artist CERITH WYN EVANS, the brothers RON and RUSSELL MAEL of the pop group SPARKS, the actors ADAM DUGAS and JEROEN WILLEMS and the mysterious menswear designer ADAM KIMMEL. What's more, mademoiselle AMANDA LEAR is styled in the latest men's fashions by KIM JONES and photographed by ANDREAS LARSSON.

N° 3, Spring and Summer 2006

The third installment of FANTASTIC MAN has a lace-bearded STEFANO PILATO on its cover, as photographed by INEZ & VINOODH. Other incredible subjects include ANT-ONY HEGARTY, without his band THE JOHNSONS, several smoking men including JOHNNIE SHAND KYDD and PETER SAVILLE, the grand master of modernism WIM CROUWEL, photographed at the beautiful RIETVELD SCHRÖDER HOUSE in Utrecht, the French writer BENOÎT DUTEURTRE, shown in his Parisian home, and the designer PATRIK ERVELL.

N° 4, Autumn and Winter 2006

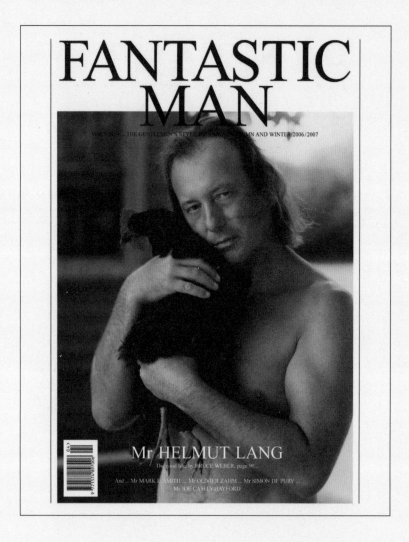

The fourth issue of FANTASTIC MAN has HELMUT LANG on the cover. It is the first time since his shock retirement from the fashion industry that the designer has spoken out, in this case to TIM BLANKS, with portraits by BRUCE WEBER. The Swiss baron SIMON DE PURY talks about auctioneering and his dreams of being a pop star, a status that fellow interviewee MARK E. SMITH of THE FALL has more than achieved. Also featured are OLIVIER ZAHM, with some great accompanying portraits by JUERGEN TELLER, and JOE CASELY-HAYFORD.

N° 5, Spring and Summer 2007

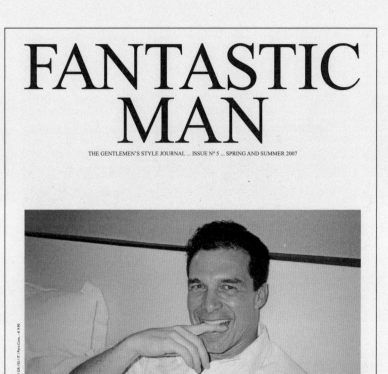

FANTASTIC MAN

THE GENTLEMEN'S STYLE JOURNAL ... ISSUE N° 5 ... SPRING AND SUMMER 2007

Mr ANDRÉ BALAZS
The hotelier and his empire, photographed by TERRY RICHARDSON, page 31 ...

And ... Mr CLAUDE MONTANA ... Mr LUCA TURIN ... Mr DAVID BAILEY ...
Plus ... THE BEST TIPS AND FASHIONS FOR SUMMER

Hotelier ANDRÉ BALAZS, photographed by TERRY RICHARDSON, greets us from the cover of FANTASTIC MAN n° 5. His conversation with ALICE RAWSTHORN is one of the many captivating exchanges within. LANVIN's menswear designer LUCAS OSSENDRIJVER leads us through Paris and, in the same city, the legendary CLAUDE MONTANA is interviewed in his final year at the house that bears his name. Also in this issue are the photographer DAVID BAILEY, the biophysicist and perfume critic LUCA TURIN and the illustrator PETER JEROENSE, who demonstrates his great yet affordable style of dress.

Nº 6, Autumn and Winter 2007

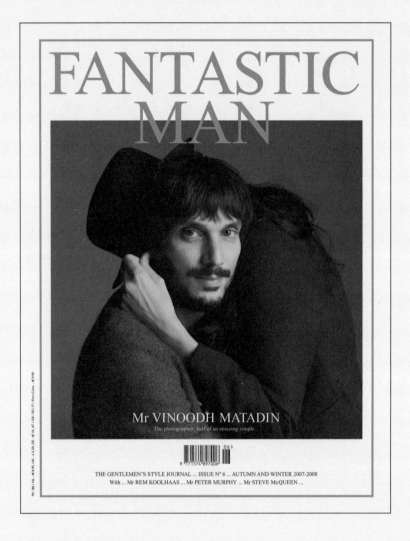

Appearing on the gold-trimmed cover of issue 6 of FANTASTIC MAN is the photographer VINOODH MATADIN, who is the life and work partner of INEZ VAN LAMSWEERDE. VINOODH is interviewed by PURPLE magazine's OLIVIER ZAHM. Also featured in this issue are the visionary architect REM KOOLHAAS, BAUHAUS singer PETER MURPHY and the Greek artist MILTOS MANETAS. Other notable personages who appear within its pages are MATTHEW SLOTOVER of FRIEZE, the artist and filmmaker STEVE Mc-QUEEN, the funny Frenchman ANDRÉ SARAIVA and the designer ADAM KIMMEL in a selection of his signature suits.

N° 7, Spring and Summer 2008

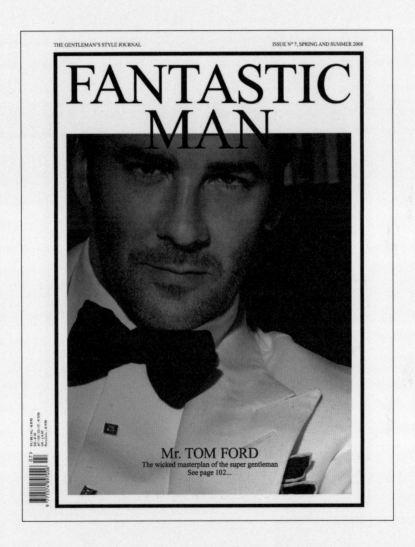

The designer TOM FORD graces the cover of the seventh issue of FANTASTIC MAN and, in the accompanying profile, he talks for the very first time of his soon-to-be-born son. Mr. FORD also appears in a fashion series photographed, as on the cover, by JEFF BURTON. Also in the issue are the SOTHEBY'S auctioneer TOBIAS MEYER, interviewed by JOAN JULIET BUCK, the Polish painter WILHELM SASNAL, the life story of the street photographer SCOTT SCHUMAN, better known as THE SARTORIALIST, and the British singer ROBERT WYATT.

N° 8, Autumn and Winter 2008

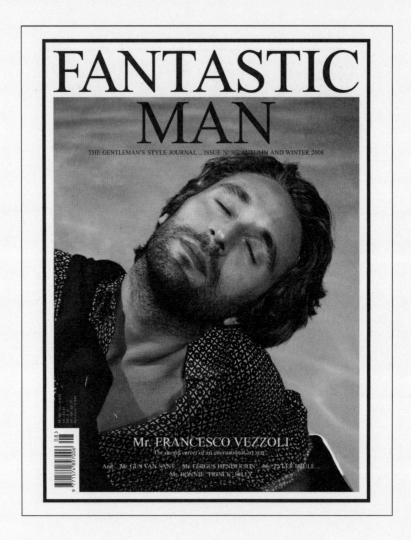

The cover star of FANTASTIC MAN No. 8, FRANCESCO VEZZOLI, was photographed in LOS ANGELES by his friend MATTHIAS VRIENS. Also in this issue are the esteemed curator OKWUI ENWEZOR, who talks about his favoured labels, the director GUS VAN SANT, who presents his first major film in eight years, the visionary chef FERGUS HENDERSON of the lovely ST. JOHN restaurant in Spitalfields, the mesmerising songwriter BONNIE "PRINCE" BILLY a.k.a. WILL OLDHAM and the international media personage TYLER BRÛLÉ.

N° 9, Spring and Summer 2009

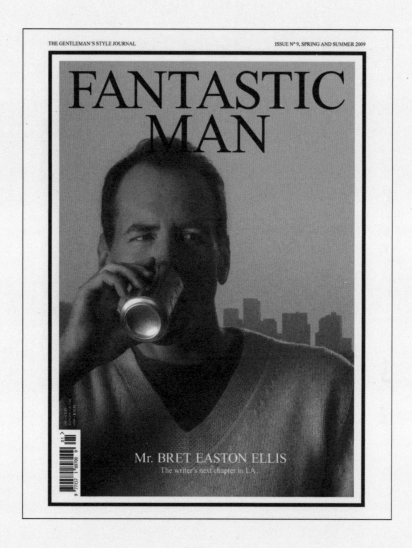

The cover of the ninth issue of FANTASTIC MAN features the American author BRET EASTON ELLIS drinking a DIET COKE. Inside, 14 more pages are dedicated to the man who brought AMERICAN PSYCHO to the world. Also featured in this issue are the legendary designer PIERRE CARDIN, the skin doctor FREDRIC BRANDT, the writer and artist PAYAM SHARIFI, who is interviewed in Moscow, and a profile of ANTONIO BRACCIANI, a man with absolutely perfect measurements. Plus, the German designer KONSTANTIN GRCIC models for some very special portraits by artist ERWIN WURM.

N° 10, Autumn and Winter 2009

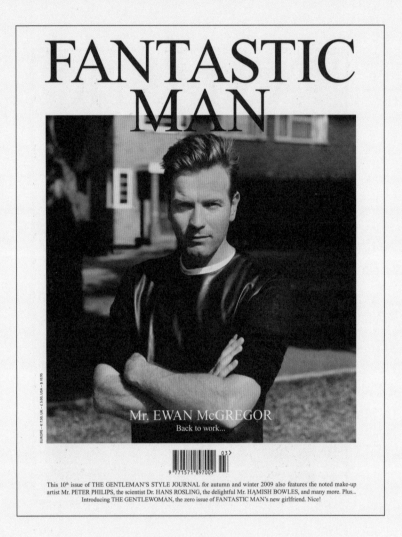

FANTASTIC MAN

EUROPE - €7.50, UK - £5.00, USA - $18.95

Mr. EWAN McGREGOR
Back to work...

This 10th issue of THE GENTLEMAN'S STYLE JOURNAL for autumn and winter 2009 also features the noted make-up artist Mr. PETER PHILIPS, the scientist Dr. HANS ROSLING, the delightful Mr. HAMISH BOWLES, and many more. Plus... Introducing THE GENTLEWOMAN, the zero issue of FANTASTIC MAN's new girlfriend. Nice!

The cover of the tenth issue of FANTASTIC MAN is graced with the British actor EWAN McGREGOR. Other men featured in this issue are the Swedish scientist and sword swallower HANS ROSLING, the make-up artist PETER PHILIPS of CHANEL and the vivid and exceptional journalist HAMISH BOWLES. All this and an exclusive preview of THE GENTLEWOMAN, the new title from the makers of FANTASTIC MAN. Three women are profiled: the PR super power KARLA OTTO, the gallerist MAUREEN PALEY and the stylist MELANIE WARD.

N° 11, Spring and Summer 2010

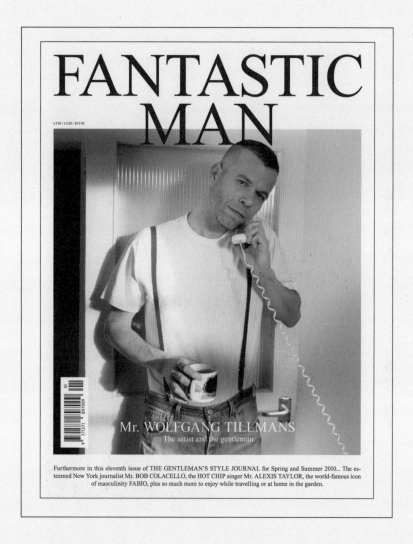

The cover of the 11th issue of FANTASTIC MAN shows the artist WOLFGANG TILL-MANS in his studio on the eve of his major exhibition at the SERPENTINE GALLERY in London. Also featured are ALEXIS TAYLOR of the pop group HOT CHIP, the legendary specimen of masculinity FABIO LANZONI, who was photographed by TERRY RICHARDSON in Los Angeles, the passionate pianist KONSTANTIN SHAMRAY and the celebrated VANITY FAIR journalist BOB COLACELLO.

Nº 12, Autumn and Winter 2010

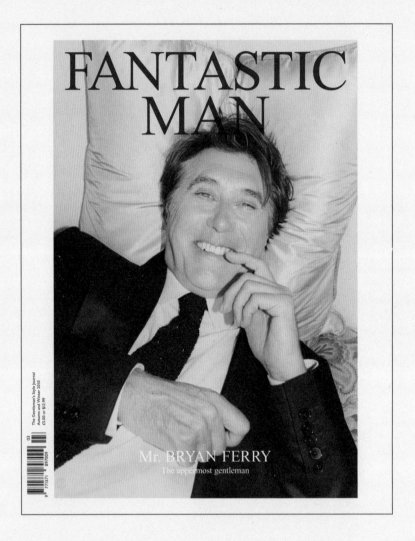

On the cover and inside the twelfth issue of FANTASTIC MAN is the incredible entertainer BRYAN FERRY, photographed at home by JUERGEN TELLER. Other subjects of in-depth profiles include the comedy actor DAVID WALLIAMS, the artist AI WEIWEI, FEDERICO MARCHETTI of the pioneering retail website YOOX and the editor of W magazine STEFANO TONCHI. Meanwhile CHARLIE PORTER, normally a casual dresser, reports on the challenge of wearing a suit for a whole month, no matter what the occasion.

N° 13, Spring and Summer 2011

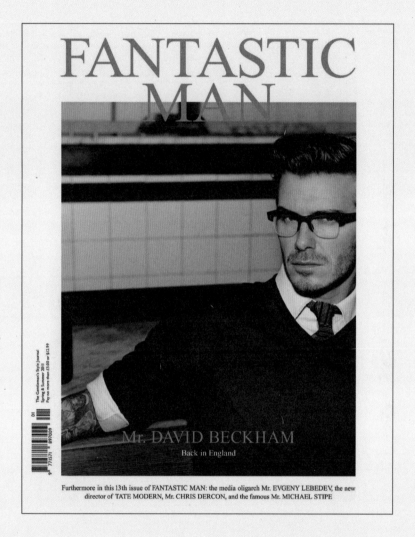

The cover of the 13th issue of FANTASTIC MAN shows the football player DAVID BECKHAM freshly coiffed by ALAIN PICHON and photographed at an east London pie-and-mash shop by ALASDAIR McLELLAN. Other notable profiles include the curator CHRIS DERCON, the media oligarch EVGENY LEBEDEV, the art-loving actor RUSSELL TOVEY and MICHAEL STIPE, who takes time to speak about his projects outside of the insanely popular band R.E.M.

N° 14, Autumn and Winter 2011

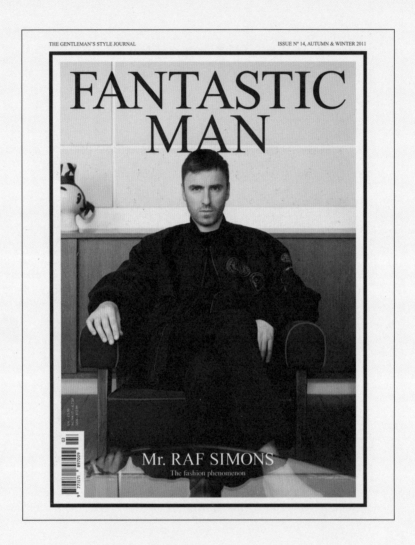

The 14th issue of FANTASTIC MAN features the phenomenal fashion designer RAF SIMONS on the cover, photographed at his home in Antwerp. Other interesting men profiled in the issue include the magician DAVID COPPERFIELD, the interior decorator RICKY CLIFTON, the London-based chef YOTAM OTTOLENGHI and the bodyguard brothers FABIO and FAUSTO COVIZZO. Plus conversations with KIM JONES, DIRK SCHÖNBERGER and JOHNNY MARR, the guitarist of THE SMITHS.

Nº 15, Spring and Summer 2012

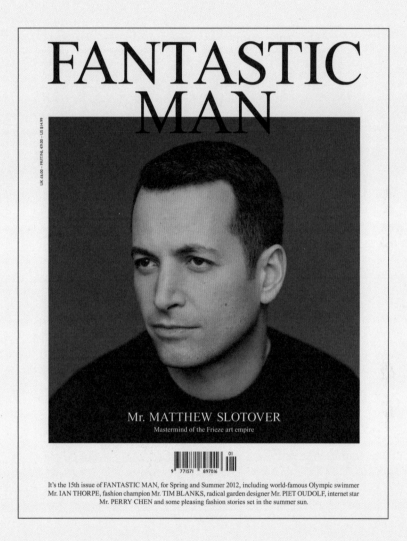

It's the 15th issue of FANTASTIC MAN, for Spring and Summer 2012, including world-famous Olympic swimmer Mr. IAN THORPE, fashion champion Mr. TIM BLANKS, radical garden designer Mr. PIET OUDOLF, internet star Mr. PERRY CHEN and some pleasing fashion stories set in the summer sun.

The cover of the 15th issue of FANTASTIC MAN features MATTHEW SLOTOVER, mastermind behind the FRIEZE art fair and magazine empire. Other remarkable men profiled in this issue include the heroic Australian swimmer IAN THORPE, the radical garden designer PIET OUDOLF, KICKSTARTER pioneer PERRY CHEN, the champion of fashion TIM BLANKS and the great American menswear designer of yesteryear, BILL ROBINSON. Alongside are conversations with JEAN TOUITOU, OWEN JONES and NIGEL STOWE, the maître d' of the DOVER STREET ARTS CLUB in London.

N° 16, Autumn and Winter 2012

Mr. OLIVER SIM
Yes, it is the singer of THE XX on the cover. This 16th issue of FANTASTIC MAN also features the film director Mr. ROMAN COPPOLA, the photographer Mr. RYAN McGINLEY, and the legendary Mr. GIORGIO MORODER.

The cover star of the 16th issue of FANTASTIC MAN is OLIVER SIM, lead singer of THE XX, who is featured on the verge of launching his second album. Alongside we meet a number of interesting men who have risen to the top of their chosen professions, among them the farmer THOMAS JONES, the dermatologist NICHOLAS LOWE, BARNEYS NEW YORK CEO MARK LEE, the film director ROMAN COPPOLA, the photographer RYAN McGINLEY, the pop sensation HOLLY JOHNSON, the disco supremo GIORGIO MORODER and the designer JONATHAN SAUNDERS.

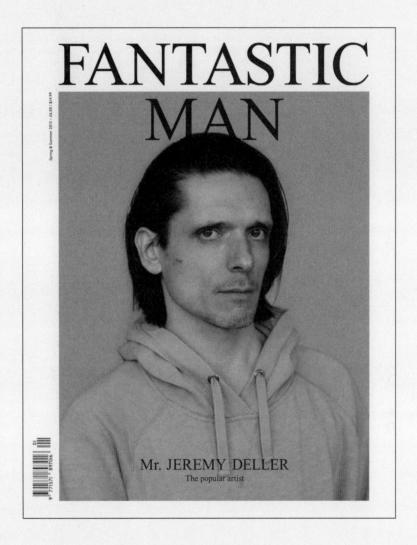

The artist JEREMY DELLER is featured on the cover of the 17th issue of FANTASTIC MAN as he prepares to represent Britain at the Venice BIENNALE. In addition there are profiles of TOMAS MAIER, the man whose Midas touch has transformed the house of BOTTEGA VENETA, the food activist MICHAEL POLLAN and that delightfully precise fashion stylist JOE McKENNA. Meanwhile ROBERTO BOLLE, principal dancer of the American Ballet Theatre, models suits in a number of spectacular positions over ten pages.

N° 18, Autumn and Winter 2013

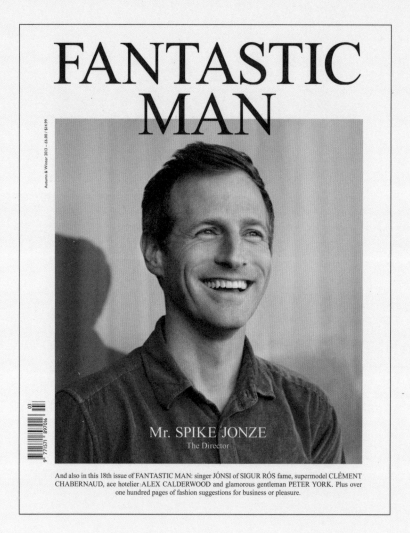

FANTASTIC
MAN

Autumn & Winter 2013 – €6.00 / $14.99

Mr. SPIKE JONZE
The Director

And also in this 18th issue of FANTASTIC MAN: singer JÓNSI of SIGUR RÓS fame, supermodel CLÉMENT CHABERNAUD, ace hotelier ALEX CALDERWOOD and glamorous gentleman PETER YORK. Plus over one hundred pages of fashion suggestions for business or pleasure.

The 18th issue of FANTASTIC MAN features the film director SPIKE JONZE on its cover, as photographed by COLLIER SCHORR. Also in the issue are the lead singer of SIGUR RÓS, JÓNSI BIRGISSON, the cultural commentator PETER YORK, who showcases his English approach to dressing, the illustrator TOM BACHTELL of THE NEW YORKER magazine, the French super-male-model CLÉMENT CHABERNAUD and the hospitality supremo ALEX CALDERWOOD. At the back of the magazine there is a thrilling examination of portraiture and fashion imagery entitled "WORKSHOP". Like the cover, it's by COLLIER SCHORR.

N° 19, Spring and Summer 2014

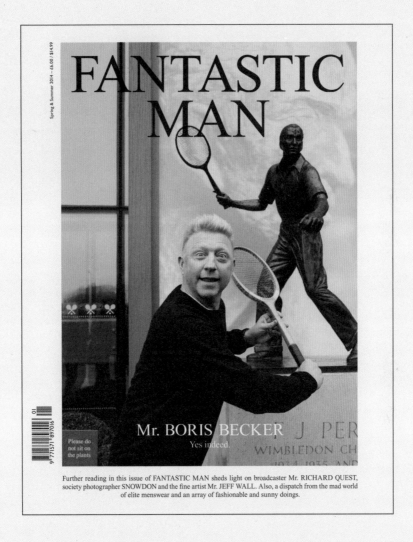

Further reading in this issue of FANTASTIC MAN sheds light on broadcaster Mr. RICHARD QUEST, society photographer SNOWDON and the fine artist Mr. JEFF WALL. Also, a dispatch from the mad world of elite menswear and an array of fashionable and sunny doings.

Tennis legend BORIS BECKER returns to action for the cover of the 19th issue of FANTASTIC MAN, photographed by fellow German JUERGEN TELLER at WIMBLEDON's tennis club. Other interesting gentlemen featured in this issue include singer STUART MURDOCH of BELLE AND SEBASTIAN fame, CNN International broadcaster RICHARD QUEST, Russian designer GOSHA RUBCHINSKIY, industrial designer MAX LAMB, artist JEFF WALL and society photographer SNOWDON. All this, plus a dispatch from the titans of luxury TOM FORD, BRENDAN MULLANE, STEFANO PILATI and ALESSANDRO SARTORI.

N° 20, Autumn and Winter 2014

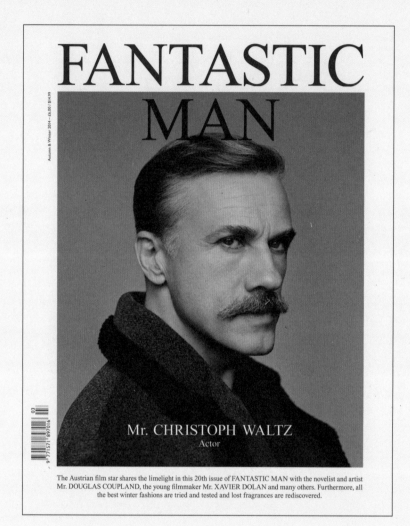

Mr. CHRISTOPH WALTZ
Actor

The Austrian film star shares the limelight in this 20th issue of FANTASTIC MAN with the novelist and artist Mr. DOUGLAS COUPLAND, the young filmmaker Mr. XAVIER DOLAN and many others. Furthermore, all the best winter fashions are tried and tested and lost fragrances are rediscovered.

The moustachioed figure on the cover of the 20th edition of FANTASTIC MAN is the Austrian actor and double OSCAR winner CHRISTOPH WALTZ. Also in this issue is a trio of impressive Canadians: the fashion commerce chronicler IMRAN AMED, the author and artist DOUGLAS COUPLAND and the phenomenal French-language actor and film maker XAVIER DOLAN. Meanwhile writer PAUL FLYNN reminisces about his formative years spent in the thrall of JOHN TIFFANY, now the toast of Broadway, and PENNY MARTIN enjoys a telephone conversation with hairstyling legend CHRISTIAAN.

N° 21, Spring and Summer 2015

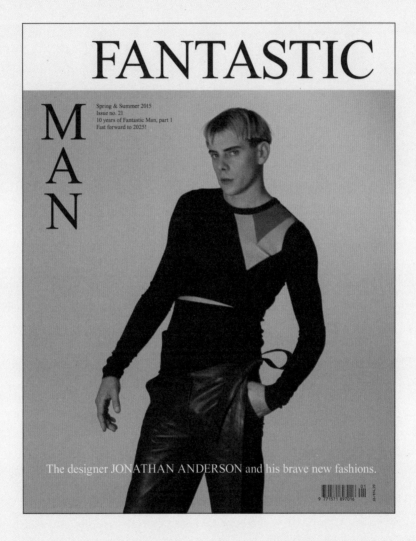

Celebrating FANTASTIC MAN's tenth anniversary year, this issue looks to the future, so who better to star on its cover than JONATHAN ANDERSON, the creator of the most adventurous clothing in men's fashion and the possessor of a totally modern business brain? Also interviewed are the splendidly named MATTHEW MONEYPENNY, the astonishing artist MARK LECKEY, the promising actor ALFRED ENOCH and the SoulCycle disciple MARVIN FOSTER Jr. Plus ALASDAIR McLELLAN creates a photo series exploring the future of masculinity, meanwhile the wardrobe of the future is unveiled by designers including KIM JONES.

Index

A directory of the 69 men featured in this book, alongside everyone else
mentioned in the articles or involved in making the magazine

THANK YOU

FANTASTIC MAN
The gentlemen's style journal
Est. 2005

Editors:
Gert Jonkers and Jop van Bennekom

The editors of FANTASTIC MAN would like to thank the following people for their incredible support over the years:

Fashion editors and directors:
Jodie Barnes, Julian Ganio, Simon Foxton

Contributing fashion editors:
Haidee Findlay-Levin, Hannes Hetta, Jamie Surman, Jay Massacret, Joe McKenna, Jonathan Kaye, Jos van Heel, Marina Bruini, Mark McMahon, Mattias Karlsson, Mel Ottenberg, Michael Philouze, Nancy Rohde, Olivier Rizzo, Sam Logan

Associate and deputy editors:
Charlie Porter, Isaac Lock, Mark Smith, Zac Bayly

Contributing editors:
Andrew Tucker, Felix Burrichter, Glenn Waldron, James Anderson, Matthew Stewart, Penny Martin, Tim Groen

Text and sub editors:
Ivy Pochoda, Jennifer Dempsey, Kim Renfrew, Laura Martz, Matthew Curlewis, Murray Healy, Pip Farquharson, Tom Johnston

Editorial assistants:
Andrew T. Vottero, Devin Blair, Jake Millar, Jordan Kelly, Kacper Lasota, Matthew Lowe, Megan Wray Schertler, Sebastiaan Groenen

Editorial interns:
Alex LeRose, Fernando Augusto Pacheco, Jean-Francois Adjabahoué, Maxim Voloshin, Steven van den Haak

Art directors:
Jop van Bennekom, Veronica Ditting

Designers:
Adrien Pelletier, Helios Capdevila, Jenny Eneqvist, Jop van Bennekom, Merel van den Berg, Veronica Ditting

Design assistants:
Alexander Shoukas, Aude Debout, Céline Wouters, Yin Yin Wong

Graphic Production:
Danny Calvi

Production:
Rosco Production

Managing director:
Magnus Åkesson

Office management:
Jane Kunze, José Olcina, Julia van Mourik, Sherif El Safoury

Associate publisher:
Adam Saletti

Advertising directors:
Adam Saletti, Elizabeth Sims, Fabio Montobbio, Michael Bullock, Mo Veld, Raffaella Giannattasio, Sherida Brindle

Website:
Andreas Schöfl, Denny Backhaus, Rob Meerman,

Contributing writers:
Aaron Ayscough, Adam Dugas, Ajesh Patalay, Alex Moshakis, Alex Needham, Alexander Fury, Alexis Taylor, Alice Fisher, Alice Rawsthorn, Alix Browne, Amelia Stein, Andrew Tucker, Angelo Flaccavento, Anthony Maule, Aric Chen, Armand Limnander, Bart Julius Peters, Ben Monetto, Billy Ballard, Brendon Wolland, Brian Molloy, Bryan Adams, Bruce Benderson, Caroline Roux, Casey Spooner, Cathy Horyn, Cesar Padilla, Charlie Porter, Chris Miller, Christopher Bollen, Christopher Frizzelle, Ciccio Sultano, Clive Martin, David Hughes, Eamonn Hughes, Edward Helmore, Elias Redstone, Emily King, Felix Burrichter, Geer Pouls, Georgia Frost, Gert Jan Hageman, Giorgio Armani, Glenn O'Brian, Glenn Waldron, Hadley Freeman, Harriet Quick, Henry Jeffries, Henry Urbach, Horacio Silva, Ian Yang, Isaac Lock, Italo Zucchelli, Jack Underwood, Jacob Swan Hyam, Jaimie Hodgson, James Anderson, Janathan Skan, Jason Schwartzman, Jeanne Detallante, Jeremy Lewis, Jesse Singal, Jina Khayyer, Jo-Ann Furniss, Joe Porrit, Johannes van Dam, John A. Vlahides, John Dickey, John Seabrook, Johny Pitts, Jon Savage, Karl Treacy, Kevin West, Lauren Parson, Lee Carter, Leonardo Manetti, Linder Sterling, Lord Snowdon, Luke Hersheson, Malcolm McLaren, Mark Smith, Maryam Malakpour, Massimo Piombo, Matthew Curlewis, Matthew Slotover, Matthew Stewart, Michael Bracewell, Michael Bullock, Michael Mann, Michele Bernhardt, Murray Healy, Nicholas de Jongh, Nicolas Bru, Olivier Zahm, Olly Mann, Patricia Schwoerer, Patrick Grant, Paul Bruty, Paul Flynn, Paul Wetherell, Penny Martin, Peter Saville, Philip Utz, R.J. Wheaton, Rachel Newsome, Raquel Franco-Garcia, Richard James, Richard O'Mahony, Roberto Rodriguez, Ryan Gilby, Sam Chermayeff, Sam Parker, Sarah Lerfel, Sean O'Hagan, Seb Emina, Shaun Walker, Stefano Tempofosco, Stéphane Gaboué, Stephen Todd, Steven Daly, Stuart Comer, Susie Rushton, Terumasa Mori, Theodore Bouloukos, Thomas Barnthaler, Thomas Persson, Tim Blanks, Tim Gutt, William Van Meter, Zac Bayly

Contributing photographers and stylists:
Adam Dugas, Adam Kimmel, Alain Pichon, Alasdair McLellan, Alex Klesta, Alexiei Hay, Alexis Brooks, An Thuy, Andrea Cellerino, Andreas Larsson, Andreas Skoularikos, Andrew T. Vottero, Anh Tran, Anita Keeling, Annemarieke van Drimmelen, Anthony Maule, Anuschka Blommers, Ashley Heath, Bart Julius Peters, Beat Bolliger, Ben Weller, Benjamin Alexander Huseby, Benjamin Sturgill, Benny Hancock, Brian Molloy, Bruce Pask, Bruce Weber, Bruno Staub, Buck Ellison, Carlo Antonelli, Carlos Contreras, Carlotta Manaigo, Cary Kwok, Cator Sparks, Charlotte Collett, Christiaan, Christian Eberhard, Duff, Ciara McCarthy, Cisa Takahashi, Cobbie Yates, Collier Schorr, Cori Barton, Damian Boissinot, Daniel Jackson, Daniel Riera, Daniel Shea, Danny Calvi, Daryoush Haj-Najafi, David Armstrong, David Sims, David Song, Davy Newkerk, Dennis Lanni, Devin Blair, Egor Zaika, Elgar Johnson, Emma Roach, Ernst van der Hoeven, Erwin Wurm, Filipe Salgado, Florence Samain, Gabriel

Feliciano, Gareth, Gareth Pugh, Garrett Gervais, Georgi Sandev, Go Miyuki, Gudrun Kosloff, Guido Palau, Halley Brisker, Hannah Murray, Hannes Hetta, Heinz Peter Knes, Helena di Fatti, Helena Lyons, Holli Smith, Ian Jeffries, Iris Alonzo, J. Patrick, Jacob K., James Main, James O'Riley, James Pecis, James Rowe, Janeen Witherspoon, Jason Evans, Jeff Burton, Jennifer Greenburg, Jenny Coombs, Jimmy Ming Shum, Joe Porritt, Joff, John Colver, John de Greef, John Guidi, Johnny Davis, Jonathan de Villiers, Jos van Heel, Josh Hight, Joshua Gibson, Juan Calet, Juergen Teller, Julia Beurq, Julian Ganio, Karim Sadli, Katy England, Ken Nakano, Kenchi, Kim Jones, Lard Buurman, Laura Parsons, Lee Machin, Leila Latchin, Lenna Boord, Liesbeth Abbenes, Liz Collins, Lucia Pica, Lucy Bridge, Luigi Morenu, Luke Hersheson, Manuel Estevez, Marc Kroop, Marcelo Krasilcic, Marco Minunno, Marcus Mam, Maria Martinez, Marion Anée, Marius W Hansen, Mark Hampton, Mark McMahon, Martin Klimek, Mary Cesardi, Matt Dainty, Matt Mulhall, Matthias van Hoof, Matthias Vriens, Maurice Scheltens, Max Bellhouse, Max Farago, Max Ortega Govela, Michael Mann, Michelle Class, Miguel Villalobos, Milan Zrnic, Miranda Joyce, Mizzie Logan, Moises Nunez, Monika Condreas, Nacho Alegre, Naoki Komiya, Natalie Bell, Natsumi Watanabe, Neal Franc, Neil Holmes, Nicola Formichetti, Niels Schumm, Oliver de Almeida, Oliver Woods, Olivia Paton, Oz Zandiyeh, Patricia Schwoerer, Patrick Long, Paul Hanlon, Paul Wetherell, Pernell Kusmus, Pete Lennon, Peter Jeroense, Peter Lindbergh, Peter Stigter, Philip Smith, Philip Vlasov, Radford Brown, Randall Mesdon, Raquel Franco, Richard Burbridge, Richard Schreefel, Robi Rodriguez, Roger Deckker, Roxane Danset, Roy Blakey, Rudi Lewis, Rufus Kellman, Sally Branka, Sam Logan, Samuel Francois, Sarah Sibia, Shelly Durkan, Shon, Sil Bruinsma, Simon Foxton, Simona Melegari, Simone Bremner, Slavica Ziener, Sophie Glasser, Stefano Marchionini, Steven Canavan, Stuart Williamson, Syd Hayes, Talia Shobrook, Teiji, Terry Richardson, Thomas Lohr, Tim Gutt, Tim Howard, Timothy Reukauf, Timur Celikdag, Tobias Regell, Todd Cole, Tom Jidai, Tom Pecheaux, Tomohiro Ohashi, Tracie Cant, Travis Blue, Trish Lomax, Tuan Go Utsugi, Valentino Perini, Veronica Ditting, Vinoodh Matadin, Viviane Sassen, Walter Pfeiffer, Wesley Younie, Will Vanderperre, William Graper, Wolfgang Tillmans, Yannick D'Is, Yeb Wiersma, Yun Lee, Zoë Ghertner

Additional styling credits for this publication: Andrew Richardson (p. 379, 384), Beat Bolliger (p. 209), Brian Molloy (p. 253, 258, 456), Haidee Findlay-Levin (p. 48, 49, 63, 68, 69, 524, 525), Jamie Surman (p. 469), Jay Massacret (p. 165), Jodie Barnes (p. 299, 302, 310, 311, 424, 425, 511, 536), Joe McKenna (p. 153, 156, 309), Joff (p. 431, 436), Jonathan Kaye (p. 21, 26, 124, 125, 143, 167, 174, 267, 268, 269, 270, 283, 333, 338, 397, 443, 513, 514), Julian Ganio (p. 295, 441), Katy England (p. 97), Marina Burini (p. 445, 446), Mattias Karlsson (p. 407), Nicola Formichetti (p. 111), Olivier Rizzo (p. 51, 56, 127, 134, 135, 251, 365, 372, 461), Rufus Kellman (p. 527, 530), Simon Foxton (p. 329, 523)

www.fantasticman.com

FANTASTIC MAN
Men of great style and substance

A compilation of portraits, profiles and other treats from the fantastic gentlemen's journal

Phaidon Press Limited
Regent's Wharf, All Saints Street
London N1 9PA

Phaidon Press Inc.
65 Bleecker Street
New York, NY 10012

www.phaidon.com

Editor:
Emily King

Commissioning editor:
Emilia Terragni

Project editor:
Joe Pickard

Production controller:
Alenka Oblak

Text editor:
Mark Smith

Design:
Jop van Bennekom, Helios Capdevila

Cover concept:
Jon Hares

Editorial assistance:
Jordan Kelly, Megan Wray Schertler

Artworking assistance:
Ana Schefer

Printed in Italy
First published in 2015
© 2015 Phaidon Press Limited
ISBN 978 0 7148 7039 7

A CIP catalogue record for this book is available from the British Library.